THE PELICAN HISTORY OF ART

Joint Editors: Nikolaus Pevsner and Judy Nairn

Benjamin Rowland

THE ART AND ARCHITECTURE OF INDIA

Buddhist | Hindu | Jain

Benjamin Rowland, who died on 3 October 1972, was a Professor of Fine Arts at Harvard University, his original interest being the history of Western art. On his special field of research, the Italian and Spanish art of the fourteenth and fifteenth centuries, he published a book and various papers. After a long journey to the Far East in 1932, his attention became particularly directed to the art and architecture of India; and the fruit of a second Eastern journey in 1936-7, particularly to Afghanistan, was his book on *The Wall-Paintings of India, Central Asia, and Ceylon*. In 1933 Dr Rowland began teaching Oriental art at Harvard. He was also a painter in water colour, and examples of his work may be found in various American museums.

Benjamin Rowland

THE ART AND ARCHITECTURE
OF INDIA

Buddhist | Hindu | Jain

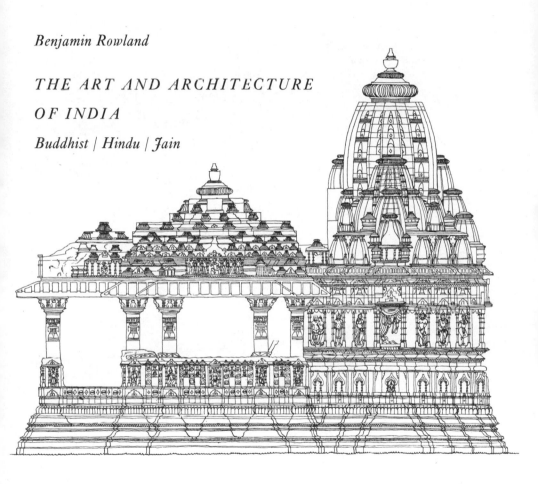

Penguin Books

Penguin Books Ltd, Harmondsworth, Middlesex, England
Penguin Books, 40 West 23rd Street, New York, New York 10010, U.S.A.
Penguin Books Australia Ltd, Ringwood, Victoria, Australia
Penguin Books Canada Limited, 2801 John Street, Markham, Ontario, Canada L3R 1B4
Penguin Books (N.Z.) Ltd, 182–190 Wairau Road, Auckland 10, New Zealand

First published 1953
Reprinted 1953, 1954
Second revised edition 1956
Reprinted 1959
Third revised edition 1967
First integrated edition, based on third hardback edition, 1970
Reprinted 1974
Reprinted with revisions and updated bibliography by J. C. Harle 1977
Reprinted 1981, 1984

Library of Congress catalog card number: 73–125676

Printed in the United States of America by
Kingsport Press, Inc., Kingsport, Tennessee
Set in Monophoto Ehrhardt

Designed by Gerald Cinamon

To Lucy and the girls

This edition is based on the first integrated
edition issued in 1970, with revisions and a
completely updated bibliography contributed
by Dr J. C. Harle.

The drawings were made by P. J. Darvall
and the maps by Sheila Waters.

CONTENTS

CHRONOLOGICAL TABLE OF DYNASTIES AND PERIODS

INDIA

Indus Valley Period (*c*. 2500–*c*. 1500 B.C.)
Vedic Period (1500–800 B.C.)
Śaiśunāga-Nanda Dynasty (642– 322 B.C.)
Maurya Dynasty (322–185 B.C.)
Śunga Dynasty (185–72 B.C.)
Early Āndhra Dynasty (*c*. 32 B.C.–*c*. A.D. 50)
Bactrian Monarchy (322 B.C.–*c*. A.D. 50)
Indo-Parthian Period (*c*. 200 B.C. –A.D. 50)
Kushan Dynasty and successors in north-west
 India and Afghanistan (*c*. A.D. 50– 7th cent.)
Later Āndhra Dynasty (*c*. A.D. 50–320)
Gupta Dynasty (320–600)
Period of the Hindu Dynasties
 Solanki Dynasty of Gujarāt (765–1197)
 Pāla and Sena Dynasties of Bengal (750–1200)
 Ganga Kingdom of Orissa (1076–1586)
 Chandella Dynasty of Bundelkhand (*c*. 800–1315)
 Chalukya Dynasty of the Deccan (550–642)
 Rastrakuta Dynasty of the Deccan (757–973)
 Hoyśala and Yadava Dynasties of Mysore (1111–1318)
 Pallava Dynasty (600–750)
 Chola Dynasty (*c*. 907–1053)
 Pandya Dynasty (1251–1310)
 Vijayanagar Dynasty (1370–1565)
 Rājput Dynasty (16th–19th cent.)

CEYLON

Early Period at Anurādhapura (4th cent. B.C.–8th cent. A.D.)
Late Period at Polonnāruwa (8th–15th cent. A.D.)

CAMBODIA

Pre-Khmer or Funan Period (5th–8th cent. A.D.)
Khmer, Early Classic Period (802–1250)
Khmer, Late Classic Period (1250–*c*. 1450)

SIAM

Dvāravatī Period (6th–10th cent. A.D.)
Khmer Period, Lopburi, etc. (10th–13th cent.)
Suk'otai Period (13th–14th cent.)
Ayudhyā Period (1350–1757)

JAVA

Indian Period in Western Java (1st–6th cent. A.D.)
Indian Period in Middle and Eastern Java (7th–8th cent.)
Śailendra Period (732–860)
Javanese Empire in Middle Java (860–915)
Eastern Javanese Period (950–1478)

BURMA

Pagān or Talaing Period (8th cent. A.D.–1287)
Burmese Empire of Shan-Thai (1287–1760)

PRONUNCIATION OF INDIAN WORDS

Sanskrit, Pali, Prakrit, and Vernacular

Avoid accent (stress) altogether, but pay strict attention to quantity (short and long vowels). Every letter must be sounded. The sound of each letter is invariable. Pronounce vowels as in Italian, consonants as in English. Note especially:

a as in America
ā as in father
e always long, as in late
i as in bit
ī as in eel
o always long, as in note
u as in foot
ū as in boot
bh as in cab-horse
c as in church
ch as in church-house
ḍ as in drum
dh as in mad-house
k̲h̲ as in inkhorn
ḷ as in lull
ṅ or ṁ as in sing
ph as in uphill
ṛi as in merrily
ṛī as in marine
ṣ as in shut
ṭ as in true
th as in anthill

Most important is the pronunciation of 'a' (never like 'a' in man or 'a' in late): in Himalaya, *ma* requires twice the time of the other syllables. Final 'a' is always lightly sounded; 'r' is rolled; 'ś' is sibilant; 'ṣ' corresponds to *sh*.

GLOSSARY

Ābhaṅga. Stance, or pose with slight flexion.

Abhāya mudrā. Gesture of reassurance. The right hand is held palm outward and the fingers extended upward.

Agni. Fire, Vedic fire god.

Āgnidhrīya. The sacrificial fire of the god Agni, or the place where it is kindled.

Airāvata. Elephant, the vehicle of Indra and symbol of the clouds.

Āmalaka. Crowning lotiform member of śikhara temple.

Aṇḍa. Egg, the hemispherical dome of the Buddhist stupa.

Apsaras. Nymph of the sky or atmosphere. Courtesan of Indra's heaven.

Āsana. Seat, throne.

Asura. Demon, enemy of the gods in Brahmanic epics.

Aśvamedha. 'Horse sacrifice', the ceremony performed by kings to ensure the welfare of the realm. A selected stallion, after being allowed to wander under the guardianship of royal youths for a number of years, was brought back and committed to ritual sacrifice.

Avadānas. Legends of the Buddha's life and acts.

Avalokiteśvara. Bodhisattva of Mercy.

Avatar. 'Descent', term usually applied to one of the descents or incarnations of Vishnu in animal or human form in each of the great cycles of time.

Āyaka. Term applied to pillars placed on platforms attached to stupas and sometimes to these altar projections themselves.

Barais. Artificial lakes or reservoirs constructed by Khmer ruler at Angkor and elsewhere.

Bhadra. In Orissan architecture a structure with a roof in the form of a terraced pyramid.

Bhakti. Devotion to a deity. Source of theistic development and imagery.

Bhūmi. Literally, the ground on which all things are founded. In architecture the successive planes or divisions of a Dravidian temple or the horizontal courses of a śikhara.

Bhūmisparśa mudrā. Earth-touching gesture. Used by the Buddha to call the earth goddess to witness his right to take his seat beneath the Tree of Wisdom.

Bodhisattva. In Mahāyāna Buddhism a being who, although capable of attaining Buddhahood, renounces this goal in favour of acting as a ministering angel to humanity; emanation of a dhyāna Buddha; a Buddha before Enlightenment.

Bot. Temple (Siamese).

Brahmā. The absolute creator of all things. Chief of the Hindu Trinity with Vishnu and Śiva.

Brāhmaṇas. Ritual texts of early Hinduism.

Brahmin. Hindu priestly caste.

Cakra. The wheel, emblematic of the sun and the dominion of the Buddha's law.

Cakravāla. The successive rings of mountain ranges which in Hindu cosmology are believed to encircle the world mountain, Meru.

Carana. 'Pillar', 'Motion', 'Force'. In Indian painting a type of composition in which the pictorial elements are centred or rotated around a main axis or pillar that stabilizes the whole arrangement.

Cetanā. In Indian painting the representation of the movement of life, sentience.

Chaitya. A sanctuary or shrine.

Channavira. A harness of crossing scarves worn above the waist, as seen in early statues of fertility goddesses.

Chattra, Chatta. Umbrella, emblem of dominion and of the heavens of the gods on mast of Buddhist stupa.

Chorten. A Tibetan stupa, generally in a distinctive shape, symbolizing the five elements in the divisions of the base, dome, and the superstructure.

Chunam. Lime plaster or stucco used for sculpture and architectural decoration.

Chūnar. A fine-grained buff sandstone from the Chūnar quarries on the Ganges, near the palace of the present Mahārāja of Benares.

Dagaba. Singhalese stūpa.

Deva. One of the thirty-three Vedic deities.

Devalokas. The worlds or heavens of the gods, thirteen

in number, from the paradise of Indra to the highest heaven of Brahmā.

Devatā. A divinity.

Devī. Consort of Śiva in her benevolent form.

Dhārāṇi. A magical prayer or collection of mystic syllables for casting spells in Vajrayāna Buddhism.

Dharmacakra. The Wheel of the Law, emblem of the Buddhist Dharma or Law, derived from an ancient solar symbol and intended to suggest domination of all by the Buddha's Law, as the sun dominates all space and time.

Dharmacakra mudrā. Gesture of teaching or turning the Wheel of the Law. The right hand is held before the chest with the tips of the thumb and index finger joined to touch one of the fingers of the left hand, which is turned palm inwards.

Dharmakāya. In the Trikāya doctrine the abstract body of the Law, conceived as an invisible essence permeating and animating the Universe.

Dhātu. Relics.

Dhoti. A skirt such as is worn by modern Hindus.

Dhyāna. Yoga meditation; visualization of a mental image.

Dhyāna Buddha. One of the Buddhas of the Four Directions and the Zenith in Mahāyāna Buddhism.

Dhyāna mudrā. Gesture or pose of meditation. The hands rest in the lap, the right above the left with all fingers extended.

Dohada. Longing of budding plants for the touch of foot or mouth, used to describe the quickening embrace of a yakshī and her tree and the motif of the woman-and-tree itself.

Drāviḍa. Southern or Dravidian style of architecture.

Durgā. Consort of Śiva in her terrible form.

Dvārapāla. Door guardian.

Gaja. Elephant.

Gajasimha. Monster; part lion, part elephant.

Gaṇas. Demigods, attendants of Śiva, usually represented as obese dwarfs.

Gandhārvas. Divinities of the sky and air, the musicians of the gods.

Gaṅgā. Goddess of the River Ganges.

Garbha griha. Sanctuary, inner room of a temple.

Garuḍa. Mythical sunbird; part man, part bird; the emblem and vehicle of Viṣṇu.

Gavakṣa. A blind window or niche in the shape of the chaitya-arch, used as an antefix on śikhara towers and on the cornices of Vesara temples.

Ghāts. Mountains, or steps on a river bank as on the Ganges at Benares.

Gopis. Milkmaids, the special loves of Viṣṇu.

Gopuras. Towers surmounting gates of South Indian temple enclosures.

Guṇa. Chief property or characteristic of all created things; goodness, passion, and darkness.

Guru. A spiritual preceptor who initiates a Brahmin youth prior to his investiture.

Hamsa. Goose, emblem of Brahmā, and in Buddhism of the flight of Buddhist doctrine to all realms.

Harmikā. Pavilion. Railed balcony surmounting dome of stupa.

Hinayāna. Small vehicle. Early Buddhism with emphasis on the doctrine, rather than on the worship of the Buddha.

Iśvara. Supreme deity, lord.

Jagamohan. In Orissan architecture an enclosed porch preceding the sanctuary, used as an assembly hall.

Jainism. A sect founded by Mahāvīra in the sixth century B.C. preaching a rigid asceticism and solicitude for all life as a means of escaping the cycle of transmigration.

Jātakas. 'Birth stories.' Tales of previous incarnations of the Buddha in either human or animal form.

Jina. See *Tirthāmkara.*

Kalaśa. Rain vase, container of elixir of life, finial of Hindu temples.

Kalpa. An incalculable cycle of time, sometimes described as a day of Brahma. At the close of each day or kalpa the world is destroyed by Śiva, and at the dawn of the next it is recreated with the re-birth of Brahmā from the navel of Vishnu.

Kanjur. Local name of a soft limestone used at Taxila.

Karma. The idea of retribution in the life cycle, whereby acts in previous existences lead to inevitable results in the shape of good or bad incarnations in later lives.

Kinnaras. Fabulous beings, half man, half bird. Celestial musicians.

Kīrttimukha. Grotesque mask.

Kongokai Mandara. See *Vajradhātu Maṇḍala.*

Kṛṣṇa (Krishna). The Black One. Incarnation of Viṣṇu. Hero of the Mahābhārata.

Kṣatriya. The princely or warrior caste in Hinduism.

Kṣetra. The 'field' or paradise of one of the Dhyāni Buddhas of the Four Directions.

Kuvera. Chief of the yakshas and guardian of the north.

Lakṣanā. One of the thirty-two superior marks distinguishing the anatomy of a Buddha; symbol, attribute.

Lakṣmi. Goddess of fortune.

Lamba tatuwa. A pointing machine consisting of a frame with suspended cords to indicate depth of cutting, used by sculptors in Ceylon.

Lāṭ. Pillar.

Līlā. A semblance or illusion as in a play or dance.

Liṅgam. Phallic emblem of Śiva.

Lota. Brahmin water-bottle.

Mahāpuruṣa. Great person, epithet applied to the Buddha. In Brahmanic belief the cosmic man, the source and substance of the universe, who at the beginning of the world sacrificed and divided his body for the creation of all things.

Mahāyāna. 'Great Vehicle.' Later theistic form of Buddhism, with emphasis on divine Buddhas and Bodhisattvas.

Makara. Crocodile, emblem of water.

Mānasāra. Ancient Indian architectural treatise.

Maṇḍala. Magic diagram of a Buddhist hierarchy or the imagined shape of the cosmos.

Maṇḍapa. Porch.

Māyā. The creation of any illusion or artifice, the power of the gods to assume different shapes. The gods in all existences are generated from one original undifferentiated universal substance, māyā, the inexhaustible and eternal font of all being.

Meru. The world mountain of Indian cosmology.

Mithuna. Amorous couple.

Mokṣa. Release from worldly existence or transmigration.

Mudrā. Mystic ritual gestures of the hands of deities, signifying various actions or powers.

Mukuṭa. A conical headdress for both Buddhist and Hindu divinities.

Nadānta. The dance of Śiva as Naṭarāja before the heretical rishis in the forest of Taragam.

Nāga. Mythical serpent god, symbol of water.

Nagara. The northern or Indo-Aryan type of temple, characterized by the śikhara tower.

Nagara. City or capital.

Nāgini. Female nāga or water-spirit usually represented as a mermaid with a human body and serpentine tail in place of legs.

Nandi. The bull of Śiva.

Naṭarāja. Śiva as Lord of the Dance.

Navagraha. In Indian astronomy the nine stellar mansions of the planetary divinities.

Nirmāṇakāya. In the Trikāya doctrine the noumenal body or the illusion of a mortal body which the Buddha assumed for the benefit of men.

Nirvāṇa. Death of the Buddha. Extinction of worldly desires and escape from transmigration.

Pañca āyatana. Type of temple with four shrines grouped around a fifth main sanctuary and attached to it by cloisters.

Pāsāda. See *Prāsāda.*

Pārvatī. Consort of Śiva.

Pipal. Sacred fig tree, *ficus religiosa.*

Prachedi. Siamese stūpa, tapering from a round base to an attenuated finial.

Pradakṣiṇā. Circumambulation of a sacred site.

Prāṇa. Breath or breath of life, regarded as an inner body of breath or air pneumatically or spiritually expanding and sustaining the fleshly body.

Prang. Siamese form of stūpa with a rectangular or polygonal base.

Prāsāda. Literally, palace; type of temple building in the shape of a terraced pyramid, generally characteristic of South Indian or Dravidian architecture.

Pratibimba. Representation. Reflexion or counterpart of real forms. In Indian art the term describes the mirroring or reconstruction of the imagined shape of the cosmos or celestial regions in architectural form.

Pūjā. Ritual of devotional service.

Purāṇas. Hindu sacred books of mythology and epic. There are eighteen Purāṇas and a number of secondary Purāṇas which include the *Rāmāyaṇa* and the *Mahābhārata.*

Rāma. Hero of the Rāmāyaṇa.

Rāsa. Theory of beauty as experience communicated by the artist.

Rath. Temple, car. Term applied to Pallava shrines.

Rekha. In Orissan architecture the śikhara type of temple.

Ṛṣi (Rishi). Patriarchal poet or sage, composer or seer of the Vedic hymns; a saint or anchorite in general.

Rūpakāya. 'Form-body', the manifest or visible shape of a divinity or Buddha.

Saddharma Puṇḍarika. The 'Lotus of the Good Law'; one of the first great books of Mahāyāna literature, containing the essence of the doctrine of the Great Vehicle.

Śakti. The active power of a god and thought of mythologically as his consort or feminine complement; the creative force in its feminine aspect.

Śāla. An Indian timber tree with red flowers (*Vatica robusta*).

Samādhi. The deepest form of yoga meditation.

Sambhogakāya. In the Trikāya doctrine, the body of splendour, that transfigured shape in which the Buddha reveals himself to the Bodhisattvas.

Saṁghāṭi. The monastic robe worn by the Buddha and the members of the Order.

Saṁsāra. The unending cycle of life and rebirth.
Saṅghārāma. Buddhist monastery.
Sannyasin. A Hindu religious mendicant.
Santhaghāra. Village assembly hall in the form of a flat-roofed edifice without walls.
Śāstra. A text or manual devoted to the rules and principles of a craft, i.e. architecture, painting, or sculpture.
Śikhara. Spire, tower. Typical form of Indo-Aryan architecture.
Śilpa śāstra. Manual of architecture, etc.
Śilpin. Craftsman.
Siṁhāsana. Lion throne.
Śiva. The third member of the Hindu Trinity, emblematic both of destruction and procreative power.
Stambha. Pillar.
Stūpa. Buddhist relic mound.
Stupika. The topmost portion of a South Indian shrine, usually including both the kalaśa or pot and the vertical finial above it.
Sūci. Needle, cross bar of a vedikā.
Śūdra. The serf class in Hinduism.
Sūtra. Sacred text, usually one attributed to the Buddha himself.
Sūtradhāra. Architect or carpenter.

Tāṇḍava. Śiva's dance in the cemeteries and burning-grounds, emblematic of his cosmic function of creation and destruction.
Taṅka. A Tibetan banner or sacred picture.
Tapas. The generation of concentrated energy by the gods for creation. In yogic practice the exercise of ascetic will power so concentrated that it dissolves or melts all resistance to lift the human to the divine or cosmic level.
Thalam. A palm, or the distance from brow to chin, used in systems of proportion for determining the height of Indian images.
Tirthaṁkāra. One of the twenty-four Jain sages or patriarchs who attained perfection in earlier cycles of time.
Toraṇa. Gate of the enclosure of a Buddhist stupa.
Tribhaṅga. Pose of the three bends in the dance and in art.
Trikāya. Doctrine of the three bodies of the Buddha in Mahāyāna Buddhism.
Trimala. The three superimposed rings of masonry at the base of a Singhalese dāgaba.

Trimūrti. Having three forms or shapes, as Brahmā, Viṣṇu, and Śiva. Sometimes applied to the triune aspect of Śiva Maheśa.
Triratna. Trident symbol of the three jewels: the Buddha, the Law, and the Order.
Triśūla. Trident emblem of Śiva.

Ūrṇā. Whorl of hair on the brow of the Buddha.
Uruśṛṅga. The small turrets clustered on the successive levels of a śikhara and duplicating its shape in miniature.
Uṣṇīṣa. Protuberance on head of the Buddha emblematic of his more than mortal knowledge and consciousness.

Vaiśya. The cultivator caste in Hinduism.
Vajra. Diamond, thunderbolt. Destroying but indestructible emblem of Buddhist and Hindu deities.
Vajradhātu Maṇḍala. In esoteric Buddhism, the magic diagram of the Spiritual World.
Vajrāsana. Adamantine throne of the Great Enlightenment.
Veda. Term applied to the four religious books containing the sacred knowledge for the performance of Brahmanic priestly ritual. The most famous of these works, composed in the first millennium B.C., is the Rig Veda.
Vedikā. Railing or fence of a sacred enclosure, such as the Buddhist stupa.
Vesara. Type of temple characteristic of Central India in the form of a Buddhist chaitya-hall.
Vihāra. A Buddhist monastery.
Vimāna. Term applied to a temple as a whole, comprising the sanctuary and attached porches.
Viṣṇu (Vishnu). The Preserver, second member of the Hindu Trinity.

Wāhalkada. Frontispiece or platform attached to Singhalese stupa or dāgaba.

Yajña. Sacrifice.
Yaksha and Yakshī. Dravidian nature spirits associated with fertility.
Yālis. Fantastic monsters made up of parts of lion, horse, and elephant.
Yaṣṭi. Mast or pole of Buddhist stupa.
Yoga. Communication with universal spirit by practice of ecstatic meditation.
Yūpa. Sacrificial post.

Miles

0 200 1000

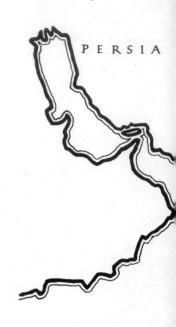

PERSIA

Sea

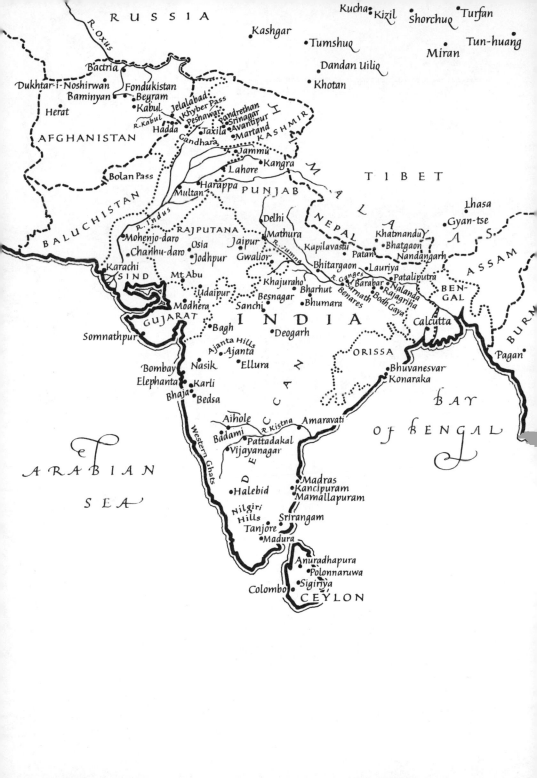

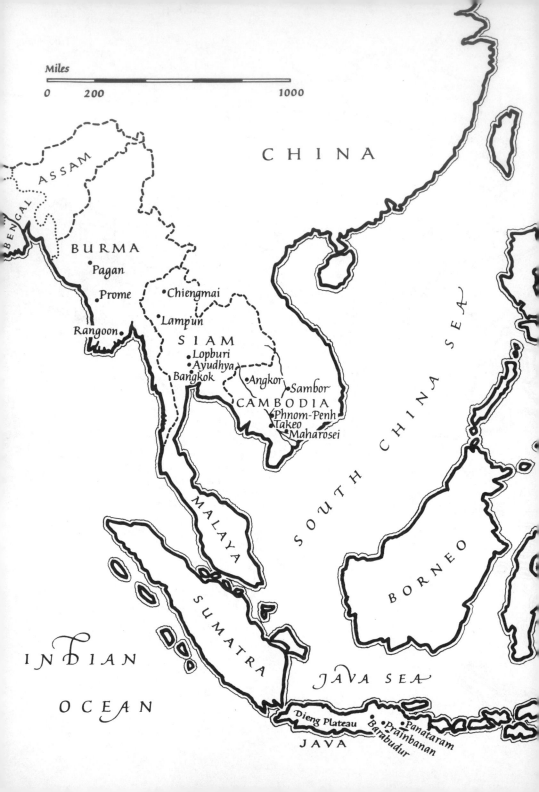

Miles

0 200 1000

CHINA

BENGAL

ASSAM

BURMA

• Pagan

• Prome

• Chiengmai

• Lampun

RANGOON •

SIAM

• Lopburi

• Ayudhya

• Bangkok

• Angkor • Sambor

CAMBODIA

• Phnom-Penh

• Takeo

• Maharosei

SOUTH CHINA SEA

MALAYA

BORNEO

INDIAN

OCEAN

SUMATRA

JAVA SEA

Dieng Plateau • Panataram

• Prainbanan

Barabudur

JAVA

THE ART AND ARCHITECTURE OF INDIA

THE PREHISTORIC AND EPIC PERIODS
IN ART AND RELIGION

CHAPTER 1

INTRODUCTION

In 1864 it was possible for a British professor of archaeology to write of Indian sculpture: 'There is no temptation to dwell at length on the sculpture of Hindustan. It affords no assistance in tracing the history of art, and its debased quality deprives it of all interest as a phase of fine art. It must be admitted, however, that the works existing offer very curious subjects of inquiry to the scholar and archaeologist.' Generations of archaeologists, as though spurred on by the very absurdity of Professor Westmacott's remarks, have brought to light the riches of Hindustan from the prehistoric culture of the Indus to the palaces of Akbar. We wonder how much real progress has been made since these pompous and ignorant lines were written towards a real understanding of Indian ideals either in art or in action, as related not so much to Western civilization, but to Indian civilization as a whole. To understand the Indian qualities of Indian art in its iconographic and stylistic aspects we must examine the fragmentary survivals of those ancient times, when these things were in their beginning, in neither a sentimental nor a patronizing fashion, but objectively.

This is a book written primarily for Westerners in a period when no approximation to the ancient Indian and Medieval Christian concept of art as a form of devotion any longer exists. Members of traditional societies such as Hinduism and Islam would not need an extensive description of the nature of traditional art, since obviously it has always been part of their lives, and not an aesthetic luxury. It is equally impossible to assume that the meaning of many forms of Indian art will be immediately clear to every reader, just as it would be absurd to suppose that the meaning of Christian art, aesthetic as well as religious, is immediately apprehended by modern men. The modern artist, undisciplined by any canonical restrictions, can represent God by a pure white canvas and the Devil by a black one, but he cannot expect us to understand immediately the 'profundity' of this personal symbolism or to enjoy such a complete negation of painting. In traditional periods, such as we are dealing with in India, understanding and enjoyment were implicit in the work of art. What we refer to as aesthetic reaction was completely involved in the worship paid to the object and the degree to which the icon, by the beauty and utility of its making, invited such devotion.

This book is not written for those unhappy few who, unable to adjust themselves to the materialistic present, seek refuge in the traditional past and, from their retreats, be they

Sufic mysticism or Tibetan Buddhism, decry our civilization while extolling these esoteric and exotic traditions that seem to offer a sanctuary in chaos. They forget that, since this is not a traditional age, we can hardly force artists or society into a traditional mould; such a change would have to come from within – as the late Dr Coomaraswamy observed – from a change of heart.

The writer has the greatest respect for traditional societies and traditional art, but, not being a member of such a society, he cannot pretend to the powers of a demiurge: to expound in the veiled esoteric terms of the popular travel book on exotic Asiatic regions the innermost metaphysical truths of Hinduism and Buddhism. Although it is perfectly true that art is religion in India, and religion art, this is a book intended to explain the visual aspects of a foreign culture in as clear and logical a fashion as possible with reference to the part played by iconography and material in the formation of what we call style. By style the writer means those peculiarities of outward visual appearance and structure in a work of architecture, sculpture, or painting conditioned by the reason for, and manner of, its creation that makes it typical – indeed, inevitable – for a definite moment in history.

For certain art historians style is a kind of sinister autonomous force which in all ages and all climes inexorably induces artists to produce works of art in a certain pre-ordained fashion, usually in an inevitable procession from archaic to Renaissance to Baroque, or from linear to plastic to pictorial expression. No circumstance peculiar to either cultural or historical conditions of any period has anything to do with the artist's production: he is created solely to enact this stimulating intellectual drama of stylistic evolution. It is useless to attempt to measure Indian art on any such Procrustean bed as Wölfflin's theory, or, for that matter, by any one of the arbitrary systems of aesthetic judgement evolved by modern art historians. It will be found that Indian art, like every manifestation of Oriental expression, is the product of certain religious and material circumstances which, rather than any vague force like 'space composition', or 'significant form', transcending time and place, determine its form in all periods.

It is hoped that this book will perform a service for the average reader and for Indian art, too, in presenting the subject in as straightforward a manner as possible. This is not intended as a prejudiced method, unsympathetic to the interpretation of Indian culture; it must be remembered that generations of sentimental, chauvinistic writers have probably done more harm to Indian art than good. This book is written for those who, understanding art as a universal means of human expression, wish to study one of the most significant and beautiful aspects of that expression in India.

Following the introduction to the fundamental concepts of Indian art, the actual historical consideration of the art of India will begin with chapters on the Indus Valley Period and the Vedic Period. The main body of the text will, properly speaking, be devoted to an account of Hindu and Buddhist art from the Maurya Period (322–185 B.C.), through the so-called Period of the Hindu Dynasties, to end in the eighteenth century. Mohammedan art, specifically the art of the Mogul Period, will not be mentioned in the present volume: although partaking of many elements of earlier Indian art, the art of the Mohammedan dynasties, not only dedicated to a foreign religion but essentially an outgrowth of techniques imported from Iran, belongs properly to a volume devoted to Islamic art. In our survey of Indian art it will be necessary to concentrate on the major arts of architecture, painting and sculpture, with, however, less detailed references to the minor arts of metal, textiles, and ceramics. It must not be supposed from this treatment that these forms of expression are not important for Indian art; indeed in modern

times the only creative vitality in Indian art has been in the perpetuation of craft traditions and in so-called folk art. It has been felt, however, that within the limited space available it would be more valuable to the reader to give a detailed analysis of the monumental aspects of Indian art together with a summary but concise account of types of decorative art at the end of each chapter.

In the matter of photographs the writer has tried to present reproductions of only the best and most characteristic monuments of each period. Photographs of purely archaeological interest, such as views of excavations, have been largely left out because such pictures, all looking very much alike, mean little to the general reader either aesthetically or archaeologically. Anyone sufficiently interested can find the most copious publications with reproductions of the actual archaeological work at sites like Mohenjo-daro and Taxila.

We may properly begin our introduction to the study of Indian art by a very brief survey of those geographical, climatic, and racial factors that from very earliest times have had their inexorable influence on the Indian people and their art. The discussion of the great religious systems of India is postponed to the chapter devoted to the history of art from about 2500 to 322 B.C., when all these ways of belief and thought came into being.

The history of India and its art has been so bound up with the geographic nature of this vast continent that something must be said of these physical characteristics. India has a kind of impregnable geographic isolation: it is in the shape of a great sealed funnel depending from the heartland of Asia. This peculiar shape of the peninsula made for an inevitable retention and absorption of all the racial and cultural elements that poured into it. The peninsula is bounded on the west by the Indian Ocean; on the east by the Bay of Bengal. Along the northern frontier India is almost sealed off from the Asiatic main-

land by the rocky curtain of the Himalayas from Baluchistan to Assam. The only openings in this formidable natural fortification are the various passes of the north-west, such as the famous Khyber and Bolan Passes, which wind through the mountains separating India from the Iranian plateau. Through these gaps came all the migrating tribes and conquerors that made themselves masters of the rich plains of India.

The cultural divisions of India proper have always been determined and dominated by the great river systems, the watersheds of the Indus and Ganges, the Deccan plateau, and South India. In western India is the plain, watered by the Indus and its tributaries, known as the Punjab or 'Land of the Five Rivers'. Along the lower Indus is the province of Sind, a region, now mostly desert, which was a flourishing jungle as late as the second millennium B.C. Another great river system of India is that of the Ganges, the sacred stream which flows over a thousand miles of north-eastern India through an immense fertile tract of land which has supported many of the splendid empires of the Indian past. In central India, south of the Vindhya mountain range, there rises the high and arid plateau of the Deccan, shut off from the Indian Ocean by the steep mountain wall of the Western Ghats and flanked by a similar continuous range of plateau-like peaks on the Bay of Bengal. These two chains of mountains unite in what is the stopper at the bottom of the Indian funnel, the Nilgiri Hills, which effectually seal off the southern tip of the Indian peninsula, so that from very early times this region has maintained a culture essentially its own.

Climate, no less than geography, has played its part in the development of the peculiarly indigenous traits of Indian history and art. All the races of martial character have grown up in the dry and hilly districts of the north-west and centre, whereas the fertile plains of Bengal have been inhabited by peaceful and unwarlike cultivators. For its rainfall a large part of the Indian

continent has depended on the monsoon winds which sweep across the Indian Ocean from June to October. These winds chiefly affect the west coast of India and extend to the southern slopes of the Himalayas.[1] Peninsular India is more dependent on these winds than the plains of the north, where the great rivers are fed by the periodic melting of the mountain snows.

The seasons in India begin with a dry and scorching spring from March to June, succeeded by a summer of almost continuous rainfall from July to October. Autumn and winter are dry and windy, but only in the extreme northwest do temperatures drop to levels normal in temperate zones. The almost entirely tropic nature of the climate has unquestionably had its effect on the racial and intellectual growth of the people that inhabit this region of the earth. In desert or temperate zones, where man is in control of his environment, monotheistic religions prevail, whereas in tropical regions, where nature is completely the master of humanity, men are apt to ascribe divinity to all the great and relentless powers that govern their lives. The overpowering nature of India has in a way forced upon the inhabitants an inability to act, a situation responsible for the Indian races having become lost in religiosity, for their maintaining through the centuries what is often described as a veritable 'hallucination of the absolute'.

Although nothing definite can be said about the earliest inhabitants of India, it is generally believed that the first indigenous people who once occupied the entire peninsula were of a dark Negrito stock. Sometime, perhaps as early as the third millennium B.C., these primitive black aborigines were gradually driven southwards and assimilated by Mongoloid invaders from the north. The race that resulted from this mixture of Negrito and Mongoloid blood developed the 'Dravidian' or pre-Aryan culture of India.[2] The Dravidians in turn were displaced by the Aryan invaders near the close of the third millennium B.C. The Dravidians are probably the Dasyus or 'black slaves' referred to in the ritual hymns of the Aryans. Although despised by their Nordic conquerors, the final victory belonged to the indigenous Indian population. As will be explained in the chapter devoted to religion, many of the dominant features of later Indian belief are of Dravidian origin, in the same way that Indian art in a general sense could be described as a combination of the abstract philosophical concepts of Aryan origin and the representational, even naturalistic trends of Dravidian civilization. The Aryan tribes had their original homeland in the region of the Caspian Sea. It was probably some natural cause, such as the insufficiency of grazing lands or hunting grounds, that forced this nomadic horde to undertake a march which led eventually through the passes of the Himalayas to the plains of northern India. The Aryans' superior armament, their knowledge of metals, and in a sense their superior religious outlook made them masters of India, probably partly by the process of conquest and partly by the process of assimilation of the established Dravidian population.

Speaking in very general terms, from the earliest time that we can judge them in the preserved writings of the Epic Period (1500–600 B.C.), the Indians reveal a tendency to religious thought and philosophical speculation on the nature of the world. This speculation leads to a mystic pantheism and the idea of the soul's absorption in the Universal Being. In comparison to this absolute the world of men becomes a delusion, a substanceless phantom. Also, as a result of this essential attitude, the gods of India could be described as abstractions of worship or philosophy. There is, in other words, a complete absence of that emphasis on the practical, on the real world, and on moral duty, which characterized the classical religion of Iran as codified by Zoroaster. In contrast to the entirely cosmic nature of pantheism in Iran, with its joyful affirmation of life and nature, the pantheism

of India is negative, denying the world and life, descrying its ideal in the cessation of existence achieved in the changeless, eternal absorption in the godhead. This definition of the Indian point of view can apply with equal validity to all the great Indian religious systems: Hinduism, Buddhism, and Jainism, and the even earlier philosophical concepts from which they sprang.

At first inspection, works of Indian art appear as strange and alien as the Indian myths which they illustrate. They are strange to us, of course, first of all because they are so different from the art and legends of Greece and Rome which have become a part of our culture and which we are able to understand and rationalize. The mystery of Indian myths and Indian art lies partly in the fact that it suggests rather than states. Greek sculpture, with its finite perfection of form, expresses clear external fact; Hindu sculpture transforms solid rock into the substance of dreams and defies explanation by either intellectualization or the usual rigmarole of aesthetic analysis. The reason for this is to be found partly in the fact that Indian art was not made primarily for aesthetic reasons; and so it is necessary for us to seek the meaning hidden in this art stemming from the sources of the inner life of a people strange to us. It could truly be said that Indian symbols of art voiced the same truth as Indian philosophy and myth. They are signals along the way of the same Pilgrim's Progress directing human energies to the same goal of transmutation. Our task, therefore, as students of Indian myth and symbol is to understand the abstract conceptions of India's philosophical doctrines as a kind of intellectual commentary on what stands crystallized and unfolding in the figures and patterns of symbolism and art and, conversely, to read the symbols as the pictorial script of India's ultimately changeless wisdom.

Indian art may, in a general way, be described as theological, hieratic, or, perhaps best of all, as traditional. The meaning of tradition in its relation to a civilization and its art has probably never been better explained than in the words of Marco Pallis:

Tradition ... embraces the whole of a civilization, in all its modes and departments, and tends to the obliteration of all antitheses, such as 'sacred and profane', even 'creator and creation'. A truly traditional civilization has its roots fixed in a doctrine of the purely metaphysical order. This doctrine gives to the whole a principal or sufficient cause. The other constituents of the Tradition, whether ethical, social, or artistic, down to the most petty activities of daily life, all derive their authority from this doctrine, to be exercised in their prescribed spheres. Ideas of a metaphysical order are the cement which binds every part together. ... The mechanism by which the Truth is made to circulate through the body is the Tradition from Master to pupil, which stretches back into the past and reaches forward into the future.[3]

The only unfortunate aspect of this definition is that in its context it is applied to describing an art stultified, rather than vitalized, by tradition. In the art of Tibet, dedicated to the most esoteric phase of Tantric Buddhism, the necessity for the most explicit accuracy in pictures, statues, and other paraphernalia in a ritual dominated almost entirely by magic was obvious. It was impossible for the artist to depart from specifications or to rely at all on experience or experiment. Traditional art does not necessarily imply the completely stifled and repetitious formalization of Tibetan art. It means, rather, the kind of healthy discipline conditioned by belief and prescriptions, calculated to produce cult images worthy of worship that yet allowed the artist the most extraordinary degree of freedom of expression. One has only to look at the great variety of interpretation in a single subject of Hindu art, such as the Chola metal images of the Dancing Śiva, or, for that matter, at the representations of the Apocalyptic Christ in Romanesque art, to understand that tradition could produce works of individual creative power. In both

cases the artists were trained in a guild tradition of imparted knowledge and followed a system of canonical proportion and technique, relying on inspiration through meditation; and yet, inevitably, their productions combine system and freedom, dream and reality, to produce at once works of individual genius and awesome religious power.

The purpose of Indian art, like all traditional art, is primarily to instruct men in the great first causes, which according to the seers, govern the material, spiritual, and celestial worlds. Art is dedicated to communicating these great truths to mankind and, by the architectural, sculptural, and pictorial reconstruction of the powers that maintain the stars in their courses, magically to ensure and strengthen the endurance of the conditions thus reproduced in material form: in this way, every Indian religious structure is to be regarded as an architectural replica of an unseen celestial region or as a diagram of the cosmos itself.

In traditional art the shape and colour of a religious image, its conventions and proportions, have depended not so much on the artist's having an uncontrolled aesthetic inspiration but directly on what the work of art is to express to the worshipper. These were the medieval and Oriental points of view which judge the truth or goodness of a work of art according to how it fulfilled this essential requirement. Like the Church art of the Middle Ages, Indian works of sculpture, painting, and architecture were devoted to revealing the divine personality of the gods and to increasing the dignity of the Church. Just such bands of workers as served the medieval cathedral were dedicated to the Indian temple. These workers had for their guidance whole manuals of aesthetic procedure, the śāstras, devoted to architecture, sculpture, and painting. Secular art as we know it did not exist.

In India all art, like all life, is given over to religion. Indian art is life, as interpreted by religion and philosophy. Art was dedicated to producing the utensils, the objects of worship in a life ordered by belief. Because the deity was thought of as present in man and in nature, the artist in his activity of making a work of art was regarded as sharing God's delight in creation. The texts of Buddhism and Hinduism specifically state that the making of images leads to heaven. The artist was not an eccentric individual, but a man trained to meet a universal demand. His vocation and training were entirely hereditary. The Indian artist was an indispensable, if anonymous, member of society; and, indeed, Indian art is more the history of a society and its needs than the history of individual artists. There never was in Indian art before the intrusion of Western influence anything corresponding to the copying of nature. The Indian artist does not seek to rival nature by imitation, but in a metaphorical sense creates forms parallel to nature. Only that which accords with the self-imposed canons of proportion and harmony is beautiful in the eyes of the discerning. In traditional art it is through the selection of such symbols as are truer than nature that the artist can hope to achieve a perfect work of art. There is nothing to be gained by a photographic imitation of something that already exists well enough. In an art based on these premises there is no room for the cult of the merely decorative nor for the cult of unintelligibility which dominates the modern field. It was the object of the Indian artist to express only the essential, to improve rather than to copy nature exactly. The Indian artist never draws simply what he sees, but rather, like the untutored but discerning child, draws what he means.

The aim of the Indian artist may be illustrated by his attitude towards portraiture. There is nothing to be gained by making a replica of a man's outward appearance. The aim would rather be to make something corresponding to that essential image of the man that the mind has in its conception of him. Obviously, the

success of the artistic production will depend on the intensity of the artist's realization of his mental image and his ability to communicate this realization to the beholder.

Indian art of all periods is close to life, not only to the life of the gods but to all creatures on earth. For this reason, naturalism, in the sense of drawing or sculpturing an object on the basis of actual observation of nature, is a tendency that cannot be ignored. Although the proportions, pose, and gestures of an image were unquestionably based on a strict metaphysical canon designed to ensure its fitness as an object of worship, within this framework the figure was made with an understanding of actual human anatomy, not only in its general articulation, but also in the maker's concern with connoting the essential character of the flesh in terms of stone or bronze. In Indian figure sculpture, as represented, for example, by the *yakshis* at Sāñchī, it is evident that in a period before the development of canonical prescriptions for the human form the sculptor, proceeding like any archaic artist, was intuitively striving to create a stone figure of a desirable female shape, not based, to be sure, on scientific anatomy, but on his intuitive knowledge of the human body. He relied on certain formulae acquired by experience that made the technical work easier, such as the essentially frontal pose and the definition of details in linear terms. The whole figure, while not articulated with anatomical accuracy, is the sum of many individual parts observed and described in stone and calculated, by the artist's exaggeration of certain features, such as the breasts, the ample hips, and crescent thighs, to appeal to the worshipper as a provocative goddess of fecundity. To an even greater degree naturalistic tendencies are to be discerned in the representation of the lower hierarchy of creatures, especially in the carving of animals. Even in the very earliest Buddhist reliefs, in which the individual parts of the beasts are combined with difficulty by artists unacquainted with the

problems of stone carving, the elephants, monkeys, and deer which we find in the reliefs at Bhārhut and Sāñchī show the most remarkable observation and recording of the precise articulation and movement characteristic of these animals. As a result of his complete awareness of their nature and life, the artist gives us an unequalled portrayal of these creatures in the universal sense, based on the observation of particulars. Naturalism in the Indian sense could be described as a visualization of what is essential on the basis of experience. It is only part of the overall purpose of Indian art to edify and instruct the devotee. When it was desired to show the Buddha's incarnation as a particular animal, it was both appropriate and necessary, for the conviction of the beholder, to make these creatures as every Indian knew them. In the final analysis this definition of naturalism is perhaps better described as a complete understanding of the subject. That this amounts to the artist's sympathetically identifying himself with his subject and experiencing its life is perhaps to be taken for granted.

In Indian art-practice the artist is enjoined to become one with the object to be portrayed in a self-induced state of trance. It is then that the image of the deity appears as a reflexion in his mind, conditioned, of course, by those forms and canons which the artist already knows from experience. In fashioning his icon from the mental image the artist employs that most ancient of Indian philosophical sciences: the method of *yoga* or ecstatic meditation. That such practices were not entirely unknown to Western artists is attested to by the story related about Fra Angelico's kneeling in prayer and meditation before beginning work on a panel.[4]

The Indian view of life and religion could be said to be based upon the idea that the ordinary world which we see around us is the only aspect of the infinite deity knowable to us. In Indian art the world is regarded as an appearance of God. This can in a measure explain the seemingly

'realistic' portrayal of many forms of nature in all periods of Indian art. The divine is thought of as present in man and in nature, present in the same way that the number one is present, though invisible, in two, three, four, and five. It is the Indian belief that man's preoccupation with practical ends and the understanding of practical behaviour over-emphasizes the material world. It is the aim of all the Indian religions – Hindu, Buddhist, and Jain – to break from these barriers in order to know the divinity directly. The methods of attaining the desired union with the divinity are infinite, and of these the one most important for art is the method of idolatry, the systematic creation of forms and symbols to represent the manifold invisible powers and mysteries of the supernatural world. The technique that grew up as a result of this necessity to express the unknowable qualities of the divine was both symbolic and anthropomorphic. Human effigies or diagrams could be used with equal convenience for representing the deity, since the human mind can apprehend the deity only through such images. The icon is, indeed, a diagram meant to express a definite religious concept, and never intended as the likeness or replica of anything on earth. The symbol is perfect in proportion to its ability to communicate the ultimate truth that it embodies.

When they were shown in anthropomorphic shape, the Indian gods were portrayed as supermen, fashioned according to canons of proportion intended to raise the beauty of the idol above the accidental beauty of any one human being. In the same way the images of many-armed gods are purely mental creations that have no counterpart in nature. Their multiple arms are necessary for the deities simultaneously to display the various attributes of their powers and activities. The supreme purpose of these images, as of all images in Indian art, is to present the believer with all the truths which he accepts and with all beings with whom he must obtain communication through prayer. There is nothing corresponding to idolatry in the narrow sense, since the worship is never paid to the image of stone or brass, but to what the image stands for, the prototype. The image, in other words, as a reflexion of the godhead, is as the diagram of the geometrician in relation to the great diagram in the beyond. The images in Indian art are first and foremost objects of utilitarian use, made by a process of contemplation, and intended to help the worshipper in communicating with the object of worship.

The persistence of magical symbolism and tradition in modern India may be illustrated by the combination of elements in the Indian flag. The solar wheel in the centre is at once an emblem of the ancient solar cults and the Wheel of the Buddha's Law dominating all regions traversed by the rolling wheel of the sun itself. The three stripes of the flag incorporate the three *gunas*, the threefold aspect of the one, the Brahmin worship of the sun at dawn, noon, and sunset, the three Vedas, etc.

Although the Indian artist's performance is seemingly rigidly prescribed by the traditions of religion and craft, he was not without the quality which we describe as imagination or feeling. This quality is described by the term *rāsa*, which may be translated as taste or joy or emotion. It is the reaction induced in the beholder of a work of art by the artist's manipulation of the feelings which formed the original inspirational centre of his consciousness in his vision of a certain aspect of the universe. It is the artist's aim to produce his own abstract or universal experience in art and communicate this experience to the beholder. The artist does not know that his work will produce rāsa, nor does he care. He is so much in love with his theme that he dedicates himself to the best of his training and ability to render it from the sheer abundance of his feeling, and, if the work is properly imbued with the creator's feeling, the beholder will share the artist's experience of rāsa. If he has the

original capacity to feel intensely, the artist's successful realization of his concept can be adumbrated by the practice of yoga. The evocation of rāsa depends, of course, on training and devotion to the rules of the craft and medium. It is not self-conscious expressionism, since the artist does not project his own personality or self into a work of art. He is simply the agent that causes it to materialize in intelligible form.

The attitude towards the religious image described above persists practically unchanged through at least the first three thousand years of Indian art history. Only later does it come to be replaced by a somewhat more lyric and mystical religious expression that transformed the earlier symbols into an imagist, pantheistic art. In this later phase, beginning as early as the Gupta Period, art strives to please and enchant the heart rather than the mind. The old mysteries become forgotten, and man replaces God.

Although a certain amount of repetition is to be expected in any traditional art, such repetition is not necessarily harmful or stultifying, as long as the canonical forms and prescriptions continue to provide a healthy discipline, and the beliefs behind the art an ever-renewed source of creative inspiration. Such a renewal implies neither blind adherence to rules nor a straying from the tradition. It is only when one of these two things happens that decadence ensues. In Siamese art of the later centuries we have a mechanical reiteration of an evolved formula and an attempt to improve on this exhausted form by all kinds of meaningless refinements in proportion, gesture, and pose, together with the attempt merely to be pleasing and decorative through the heavy embellishment of surfaces and richness of material. This analysis could be applied with little change to describe Roman Neo-Attic work, which in an exactly similar way re-works the formula of archaic sculpture in the direction of vapid grace and superficial decorative effect while entirely losing the plastic integrity and spiritual power of the originals. 'The formula is exhausted; there is nothing more to be said, because everything has been said, and only the phrase remains.'[5]

THE PROTO-HISTORIC PERIOD:

THE INDUS VALLEY CIVILIZATION

Before 1924 the history of Indian art in surviving monuments could not be traced farther back than the Macedonian invasion in the fourth century B.C. The entire concept of the early cultures of India was changed by the dramatic discovery of a great urban civilization that existed contemporaneously with the ancient culture of Mesopotamia in the third millennium B.C.[1] Although the chief centres of this civilization were brought to light in the Indus Valley, there are indications that it extended uniformly as far north as the Punjab and the North-west Frontier (Pakistan) and may have included all or part of Rajputana and the Ganges Valley.

The term Indo-Sumerian, sometimes used to describe this period of Indian history, derives from the resemblance of many objects at the chief centres of this culture to Mesopotamian forms. It is, in a sense, a misleading designation because it implies that this Indian civilization was a provincial offshoot of Sumeria, whereas it is more proper to think of it as an entirely separate culture that attained just as high a level as that of the great Mesopotamian empires. A better title would be the 'Indus Valley Period', since this designation is completely descriptive of the principal centres of this civilization. As will be seen, it is not so much the relationships to Mesopotamia and Iran that are surprising, as the complete separateness and autonomy of this first great civilization in Indian history in the major aspects of its development. Typical of the independence of the Indus Valley art, and the mysteries surrounding it, is the undeciphered script which appears on the many steatite seals or talismans found at all the centres excavated.[2]

The Indus Valley Period certainly cannot be described as prehistoric, nor does the evidence of the finds entirely permit the definition of chalcolithic in the sense of a bronze or copper age. In view of the many well-forged links with later developments in Indian culture, a better descriptive term would be 'proto-historic', which defines its position in the period before the beginning of known history and its forecast of later phases of Indian civilization.

The principal cities of the Indus Valley culture are Mohenjo-daro on the Indus River and Harappā in the Punjab. The character of the finds has led investigators to the conclusion that the peoples of the Indus culture must have had some contact with ancient Mesopotamia. These commercial connexions with the ancient Near East were maintained by sea and overland by way of Baluchistan. The dating of the Indus Valley civilization depends almost entirely on comparison with vestiges of similar architectural and sculptural remains in Mesopotamia and on the discovery of objects of Indian origin in a level corresponding to 2400 B.C. at Tel Asmar in Iraq. On the basis of these finds and other related objects found at Kish and Susa in Iran, the beginnings of the Indus culture have been fixed in the middle of the third millennium B.C. The latest evidence suggests that the civilization of Mohenjo-daro and Harappā lasted for about eight hundred years, until the seventeenth century B.C.[3] It was succeeded by an inferior and very obscure culture known as the Jhukar, which endured up to the time of the Aryan invasion in about 1500 B.C.

Allowing about five hundred years for the development of this civilization, the great period of the Indus Valley culture occurred in the later centuries of the third millennium B.C., and may be described as an urban concentration or assimilation of isolated and primitive village centres existing in Baluchistān and Sind as early as 3500 or even 4000 B.C. The trade relations that linked these settlements with early dynastic Sumer and the culture of Iran apparently continued as late as the period of Mohenjo-daro and Harappā. The Indus Valley culture was one of almost monotonous uniformity both in space and time: there is nothing to differentiate finds from Sind and the North-west Frontier; nor is there any perceptible variation in the style of objects, such as seals, found in levels separated by hundreds of years, although it is apparent that such forms of Sumerian art as were introduced early in the history of the culture were gradually absorbed or replaced by elements of a more truly Indian tradition.

The end of the Indus culture is as mysterious as its origin. Whether the end came in a sudden cataclysm, or whether the culture underwent a long period of disintegration and decline, is impossible to say.[4] The most likely explanation for its disappearance is that the great cities had to be abandoned because of the gradual desiccation of the region of Sind. The descriptions by Arrian of the terrible deserts encountered by Alexander in his march across Sind leave no doubt that the region had been a desert for some time before the Macedonian invasion. Indeed, even in Alexander's time the legend was current that fabled Semiramis and Cyrus the Achaemenian had lost whole armies in the deserts of Gedrosia. Later Greek writers described the region as filled with 'the remains of over a thousand towns and villages once full of men'. It is highly probable that the Aryan invasions from 1500 to 1200 B.C. coincided with the end of this Dravidian civilization.[5]

Viewed from an aesthetic point of view, the ruins of the Indus Valley cities are, as Percy Brown has remarked, 'as barren as would be the remains of some present-day working town in Lancashire'.[6] Certainly there is nothing more boring to the layman or less revealing than those archaeological photographs of endless cellar holes that might as well be views of Pompeii or the centre of post-war Berlin. Archaeologists have, however, been able to draw certain conclusions on the basis of these architectural remnants of the skeleton of the Indus culture that enable us partially to clothe that frame in flesh. The architecture, as one would expect of a commercial urban civilization, was of a startling utilitarian character, with a uniform sameness of plan and construction that also typifies the products of the Indus culture in pottery. The buildings consisted of houses, markets, storerooms, and offices; many of these structures consisted of a brick ground-storey with one or more additional floors in wood. Everything about the construction of the ancient city of Mohenjo-daro reflects a completely matter-of-fact, business-like point of view, from the city plan as a whole to the almost total lack of architectural ornamentation.

The excavations of Mohenjo-daro have revealed that the site was systematically laid out on a regular plan in such a way that the principal streets ran north and south in order to take full advantage of the prevailing winds [1]. This type of urban plan is in itself a puzzling novelty, different from the rabbit-warren tradition of city planning so universal in both ancient and modern times in India and Mesopotamia. It must have been introduced when such plans were already perfected in ancient Mesopotamia. The baked brick construction is perhaps the feature most suggestive of the building methods of the ancient cities of Mesopotamia, but the bricks of Mohenjo-daro and Harappā are fire-baked, and not sun-dried, like the fabric of

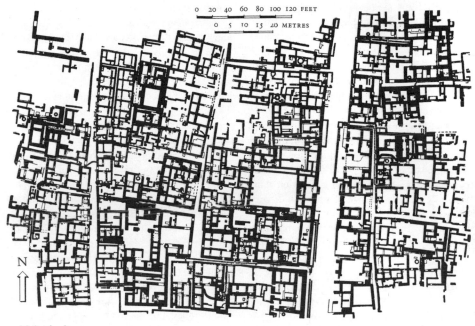

0 20 40 60 80 100 120 FEET

0 5 10 15 20 METRES

N

1. Mohenjo-daro

Sumer and Babylon. This technique obviously implies the existence of vast amounts of timber to fire the kilns, and reminds us once again that the province of Sind in these remote times was heavily forested, and not the arid desert we know to-day. Certain architectural features, such as the use of narrow pointed niches as the only forms of *interior* decoration along the Indus, are also found as *exterior* architectural accents at Khorsabad in Mesopotamia, and are suggestive of a relationship with the ancient Near East. Many examples of vaulting of a corbelled type have been discovered, but the true arch was apparently unknown to the builders of Mohenjo-daro. No buildings have been discovered at either Mohenjo-daro or Harappā that can be identified as temples, although at both sites there were great artificial mounds

presumably serving as citadels. On the highest tumulus at Mohenjo-daro are the ruins of a Buddhist stupa that may well have been raised on the remains of an earlier sanctuary. Among the more interesting structures at Mohenjo-daro were the remains of a great public bath, and it is possible that this establishment, together with the smaller baths attached to almost every private dwelling, may have been intended for ritual ablutions such as are performed in the tanks of the modern Hindu temple.

The regularity of the city plan of Mohenjo-daro and the dimensions of the individual houses are far superior to the arrangements of later Indian cities, as, for example, the Greek and Kushan cities at Taxila in the Punjab. Indeed it could be said that the population of the Indus cities lived more comfortably than

did their contemporaries in the crowded and ill-built metropolises of Egypt and Mesopotamia. Even more remarkable in comparison to secular architecture in Mesopotamia is the high development of rubbish-shoots and drains in private houses and streets. This superiority to, and independence from, the Near East may again be explained by the availability of fuel for the manufacture of terra-cotta in the Indus Valley. On the basis of the many innovations and conveniences in civic architecture, as more than one authority has stated, we are led to the conclusion that the centres of civilization along the Indus in the third millennium B.C. were vastly rich commercial cities in which the surplus wealth was invested for the public good in the way of municipal improvement, and not assigned to the erection of huge and expensive monuments dedicated to the royal cult.

Among the fragments of sculpture found at Mohenjo-daro is a male bust carved of a whitish limestone originally inlaid with a red paste [2].[7] Most likely it was a votive portrait of a

2. Limestone bust from Mohenjo-daro.
New Delhi, National Museum

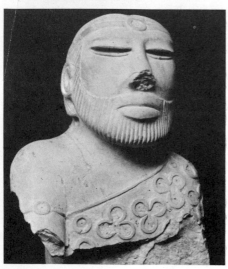

priest or shaman. There has been a great deal of speculation on the identification of this and other bearded heads found at Mohenjo-daro. Some scholars have argued that they represent deities or portraits of priests. In the present example the disposition of the robe over the left shoulder is not unlike the Buddhist *saṅghāti*. The way in which the eyes are represented, as though concentrated on the tip of the nose, is suggestive of a well-known method of yoga meditation, and would therefore favour the identification as a priest or holy man.

The similarities of these statues to Mesopotamian sculpture in the plastic conception of the head in hard, mask-like planes and certain other technical details are fairly close, and yet not close enough to prove a real relationship. The resemblance to Sumerian heads consists mainly in the general rigidity and in such aspects as the wearing of the beard and with shaven upper lip, the method of representing the eyebrows in salient relief, and the indication of the hair by lines incised on the surface of the stone. These devices of essentially conceptual portraiture, however, are too common a technique among all ancient peoples to permit us to draw any conclusions. Details such as the trefoil design on the costume, as well as the mode of hairdressing, may be matched in Sumerian sculpture. More suggestive of a real connexion between the sculpture of the Indus Valley and Mesopotamia are a number of statuettes reputed to have been excavated in the Indus Valley. They are quite comparable to the log-like statues of Gudea and other Mesopotamian statues of the third millennium B.C. One of these figurines has a cartouche inscribed in the Mohenjo-daro script. Presumably these idols are provincial – that is, Indian variants of Sumerian cult statues – and their presence in the Indus Valley reveals that at least some relation, perhaps religious as well as stylistic, existed between the civilizations of the Indus Valley and Mesopotamia.[8]

The most notable piece of sculpture that the Indus Valley excavations have brought to light is a small male torso in limestone found at Harappā [3]. The view chosen for illustration reveals its magnificent plastic quality to great advantage. Although it is impossible to tell the exact iconographic significance of this nude image, it seems almost certain that it must have been intended as a deity of some sort. In its present damaged condition no recognizable attributes remain; nor is there any explanation for the curious circular depressions in the clavicle region.[9] This statuette appears to us extraordinarily sophisticated in the degree of realistic representation, so much so that it has been compared by some scholars to the work of the great period in Greece. In the Harappā torso, however, there is no attempt to suggest the human body by harping on the muscular structure that was the particular concern of the naturalistically minded Greek sculptors of the fourth century B.C. and later. On the contrary, this statuette is completely Indian in the sculptor's realization of the essential image, a symbolic rather than descriptive representation of anatomy, in which the articulation of the body is realized in broad convex planes of modelling. The one quality which may be discerned here that is universally peculiar to many later Indian examples of plastic art is the suggestion of an inner tension that seems to threaten to push out and burst the taut outer layer of skin. Actually, this is a technical device by which the sculptor revealed the existence of the breath or *prāṇa* filling and expanding the vessel of the body. The fact that the figure appears pot-bellied is, therefore, iconographically completely right and truthful. It is not intended as a caricature in any sense, since this distension resulting from yogic breath-control was regarded as an outward sign of both material and spiritual well-being. We have in this statuette, too, what is certainly the earliest exhibition of the Indian sculptor's skill not only in producing a sense of

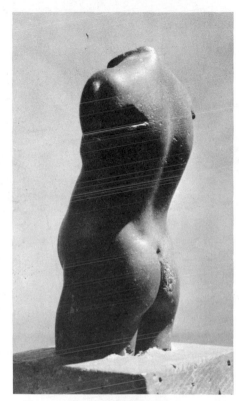

3. Limestone torso from Harappā.
New Delhi, National Museum

4. Limestone statuette of a dancer from Harappā.
New Delhi, National Museum

5. Copper statuette of a dancer from Mohenjo-daro.
New Delhi, National Museum

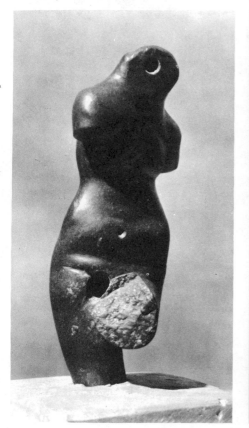

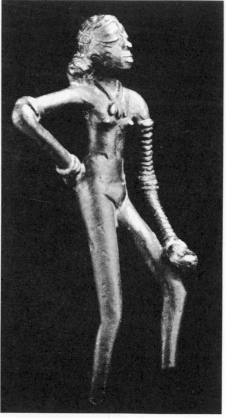

plastic volume but also in representing the soft quality of the flesh. This is not literal imitation, such as one finds in Western sculpture, but a suggestion of fleshiness by such properly sculptural and abstract devices as the interlocking of the smooth and softly modelled convex planes of the torso and the exaggeration of the depth of the navel to connote the enfolding softness and warmth of flesh without any textural manipulation of the surface.[10]

Another damaged statuette, also from Harappā, complements this torso in its striking forecast of iconographic and stylistic elements of the historical periods of Indian art [4]. This image, carved in greyish limestone, represents a dancing male figure, perhaps originally ithyphallic, four-armed and three-headed. These attributes, together with the dancing pose, make it possible that this is a prototype for the later Hindu conception of Śiva as Lord of the Dance. The modelling, again, is of an extraordinarily telling simplicity, that, in its assured establishment of form in the completely abstract plastic sense, suggests the work of a modern sculptor like Henry Moore. Even in its present fragmentary state, the figure is imbued with a vital, dynamic quality and a suggestion of movement imparted by the violent axial dislocation of the head, thorax, and hips, exactly the same device employed to suggest the violence of Śiva's dance in the great Hindu bronzes of the Chola Period.

No less surprising in its sophistication is a copper figurine of a dancing-girl from Mohenjodaro, which in such aspects as the extreme wiry attenuation is prophetic of metal-work of the Chola Period [5]. The pendulous exaggeration of the lower lip is perhaps a Dravidian physical trait, and the clothing of the arms in numerous bracelets explains the finding of bangles of every known precious material in the ruins of the Indus cities.[11]

The statues which we have examined, the male busts and idols from Mohenjo-daro and Harappā, represent the Sumerian and Indian aspects of the Indus Valley civilization. The indications are that such borrowings as there were from the Mesopotamian world existed parallel to completely Indian sculptural tradition.

The most numerous single type of object found in the cities of the Indus culture are the steatite seals, apparently used for sealing compacts and as amulets, with representations of creatures both fabulous and real, and almost invariably accompanied by a number of pictographic symbols.[12] These objects, never more than two and a half inches square, reveal the most consummate and delicate perfection of craftsmanship; the work was done by a combination of carving with small chisels and drills and polishing with abrasives. The finished seal was given a coating of alkali, which, when slightly fired, imparted a white lustrous surface to the stone. The seals are properly described as intaglios – carved in sunken or negative relief; the illustrations in this work are from photographs of impressions taken from the original objects. The seals provide the most comprehensive evidence for our reconstruction of the Mohenjo-daro religion and its relationship with the ancient Near East and the concepts of modern Hinduism. On a number of the seals we find a representation of a three-headed bovine monster [6], which has been interpreted as a reference to the ancient Mesopotamian legend of the primordial bull, the progenitor of all living things in the animal and vegetable worlds.[13] A few of the Indus Valley seals reveal another mythological link with Mesopotamia in the representation of a gigantic figure engaged in strangling two great beasts, presumably lions or tigers. This personage is certainly the great Mesopotamian hero, Gilgamesh, a sort of Oriental Herakles who slew the wild beasts and made the world safe for humanity.

The subjects of other seals are of the greatest importance for the relationship between the Indus Valley religion and later iconographic

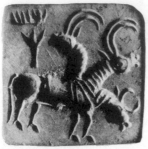
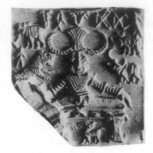
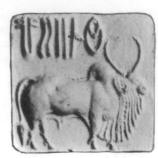

6. Seal with three-headed animal from Mohenjo-daro.
New Delhi, National Museum

7. Seal with three-headed god from Mohenjo-daro.
New Delhi, National Museum

8. Seal with representation of bull
from Mohenjo-daro.
New Delhi, National Museum

concepts. On one we find a horned deity seated in yoga posture, who is probably to be recognized as a prototype of the Hindu god Śiva [7].[14] The central figure has three heads, and the trident above his head is suggestive of the Buddhist symbol known as the *triśūla*. The horns are presumably a Mesopotamian survival, and are to be read as an indication of divinity. The central personage is surrounded by a number of wild beasts, perhaps as a reference to Śiva's function as Lord of Beasts or to suggest Śiva's dwelling as an ascetic in the wilderness. What is perhaps the most interesting aspect of this seal is that in it we have the earliest recognizable representation of a divinity in human form in Indian art. On other seals the representations of horned female figures in trees are certainly to be interpreted as the earliest portrayals of the yakshī, the fertility- and tree-spirit that figures so largely in later Buddhist art. Their appearance furnishes positive proof that the cult of tree-spirits mentioned in the *Yajur* and *Atharva Vedas* had its origins in the Indus culture.

By far the greatest number of the Indus Valley seals are carved with figures of bulls, either the zebu or the urus ox, some of them with objects resembling altars or mangers before them [8]. Here again, while the iconography cannot be positively identified, it seems likely that this popular bovine emblem is related to the cult of the bull as a fertility and lunar symbol in ancient Mesopotamia and perhaps as a prototype of Śiva's attribute, the bull Nandi. From the aesthetic point of view the designs of the animal seals of the Indus culture are the most satisfactory of all the finds. They are the exact equivalents in animal sculpture of the perfection of the human statuettes from Harappā.

It will be noted in the first place that whereas the head and body are shown in profile, the horns, eyes, and sometimes the hoofs are frontally represented; in other words, this is a conceptual rather than an optical rendering, which means that the figure is a combination of those different aspects of the body which appeared to be significant to the artist, combining a visual and tactile impression of the object. This is a method intended to give the most essential and complete impression possible of the object.[15]

The animal seals are among the world's greatest examples of an artist's ability to embody the essentials of a given form in artistic shape. These are not portraits of any individual bulls, but universal representations of a species. The carver has imbued his subject with an alive and vital character by his intuitive ability to define everything that is important for the nature of the animal he is portraying. The abstract organization of the folds of the skin and the muscular and bony structure are completely expressive of the massiveness and weightiness of the bull. It is this realization of the essential structure and character of the species that makes for the universal character of the work of art which transcends the mere imitation or portrait of a single real animal, such as a painting of a bull by Paul Potter.

The pottery of the Indus civilization has provided a special problem to archaeologists, largely by reason of its separateness from the wares of contemporary civilizations in Mesopotamia and Iran. The vessels, for the most part intended as storage jars, were all kiln-fired and covered with a red-ochre slip which was polished to a lacquer-like finish. The designs, which were applied in a black pigment before firing, consist of intersecting circles with occasional examples of foliate and beast patterns that bear little or no relationship to the designs of western Asia [9]. This type of pottery seems to have been made in all parts of the geographical limits of the Indus culture and, it has been pointed out, wares of a similar sort are still made in the village potteries of western India today.[16]

Under the heading of pottery we may include not only actual vessels but the figurines in the shape of toys or cult images that have been found in enormous numbers in all the sites inhabited by the Indus people. They belong more definitely to a popular, folk-art tradition than the sophisticated objects we have already examined. By far the most numerous in this collection are crude female effigies which have been

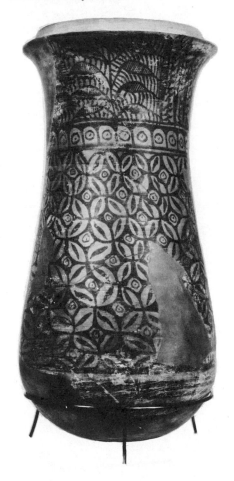

9. Storage jar from Chanhu-daro. *Boston, Museum of Fine Arts*

recognized as representations of a mother god-
dess. 'She is the Great Mother. It is she who
makes all nature bring forth. All existing things
are emanations from her. She is the madonna,
carrying the holy child. She is the mother of
men and animals, too. She continually appears
with an escort of beasts, for she is the mistress
of wild animals, snakes, birds, and fishes. She
even makes the plants grow by her universal
fecundity . . . perpetuating the vegetative force
of which she is the fountain-head.'[17] Most
likely this is the same great mother who under

various names enjoyed a cult in Asia Minor and
Mesopotamia and survives in modern Hindu-
ism as Kālī and as the Śakti of modern Indian
village cults. Some of these statuettes are so
primitive as to be comparable to the Cycladic
idols of the Aegean. Certain others, with fan-
like head-dresses, bear a resemblance to the
figurines discovered in various Mesopotamian
sites. These statuettes are really to be regarded
as symbols, rather than realistic representations.

A typical example is an elaborate statuette
from Mohenjo-daro, the largest and most

10. Terracotta mother goddess from Mohenjo-daro.
Karachi, National Museum of Pakistan

significant of the Indus Valley sites to have survived [10]. This fragment illustrates the *appliqué* technique universally employed in these images, whereby such features as the head-dress, eyes, nose, lips, breasts, and ornaments were attached as separate pinched pellets while the clay was still moist. At this period of Indian civilization the mould was unknown for clay figurines, which were built up by hand in exactly the same way as were the statuettes of the mother goddess discovered at such Mesopotamian sites as Tel Asmar and Khafajc at levels referable to about 2500 B.C. A notable attribute of the representations of the Indian fertility goddess is the prominence given to the hair and heavy head-dress, the depiction of jewellery, and the breasts and navel. These features, as well as the beaded apron worn by some of the statuettes, were fertility symbols, since both are also found in representations of the mother goddess from Mesopotamia and Iran.

Excavations conducted since 1956 at Kot Diji across the Indus from Mohenjo-daro and at Lothal in Gujarāt have somewhat changed our picture of the Indus civilization. The exploration of Kot Diji revealed a town, surrounded by a defensive wall with buildings of sun-dried brick, that presumably antedates the earliest levels at Mohenjo-daro and Harappā. Types of pottery and clay figurines found at this site appear to antedate the earliest finds at the more famous cities of the Indus Valley. This has led to the hypothesis that the finds at Kot Diji represent a civilization flourishing in the early third millennium B.C. which was destroyed by the advent of the Harappā people *c.* 2500.

The discovery of a city of the Indus civilization at Lothal on the coast of the Indian Ocean was a further step in revealing the extent of this proto-historic culture. The excavations at Lothal revealed not only the regular city-planning of Mohenjo-daro with its highly developed system of tanks and public drains but also the development of a great dock area pointing to the maritime importance of this coastal city. The finds at Lothal included the usual types of seals or talismans and the painted pottery found at Mohenjo-daro and Harappā. As we already know from the discovery of seals and other artefacts of the Indus Valley type at Tel Asmar, which may be dated *c.* 2500–2300 B.C., it is possible to date the high point of the Mohenjo-daro and Harappā civilization. Finds from the upper levels at Lothal appear to indicate that a late phase of the Harappā culture survived here and at other sites in Kuṭhiāwāḍ until 1200 B.C. or even later. It is as yet impossible to say whether the Aryans, generally thought to have been responsible for the downfall of the Indus culture, are to be associated with the type of debased pottery and other finds in the post-Indo-Sumerian strata of these excavations.

As a result of these latest explorations some scholars have come to the conclusion that the whole Indus culture was an indigenous growth, by no means dependent on the early cultures of Iran and Mesopotamia but developing its own, including the advanced systems of fortification and town-planning, from the still earlier phase of Indian civilization represented by the finds at Kot Diji. It must be admitted at the same time that some of the characteristic designs of Mohenjo-daro pottery, including the ibex and the antelope, seem to indicate borrowings from ancient Iranian culture that filtered in through the hills of Baluchistān.

*

The excavations conducted by a French mission at Mundigak in the now desiccated region north of Kandahar in Afghanistan have brought to light the remains of a civilization linking Afghanistan, Iran, and India of the Indo-Sumerian Period in the period extending from the late fourth to the late third millennium before Christ.[18] The growth of this culture paralleled the development in Mesopotamia in the gradual urbanization of thriving village settlements.

The earliest of the layers at Mundigak are contemporary with the Jamdet-Nasr Period of about 3000 B.C. and yielded pottery related to finds of approximate date at Susa and Anau and the earliest ceramic remains unearthed at Quetta in Baluchistān. Perhaps early in the third millennium there was an immigration of peoples from the region of Susiana, tribes who may have had an earlier ethnic relationship with the population of Mundigak. Pottery goblets in the shape of brandy ballons painted in black with representations of long-horned ibexes [11] are related to similar forms and patterns found at Susa and dating from about 2800 B.C. Similar designs occur on the pottery found at Kullu in Baluchistān, and other goblets with *pipal* leaf patterns appear to link this material to familiar ceramic designs from Harappā. A further possible connexion with Mohenjo-daro may be seen in terracotta figurines of the Mother Goddess, and even more notably in the small stone head of a man [12] which, in the mask-like simplicity of the face, has obvious connexions with the Sumerian type of sculpture found at Mohenjo-daro [2]. Mundigak was apparently deserted – perhaps as the result of hostile invasion – about 1500 B.C. and, until its recent excavation, was the domain of wanderers and shepherds who found shelter in the ruins of the citadel.

11. Goblet from Mundigak.
Kabul, Museum

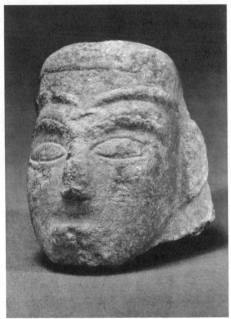

12. Head of a man from Mundigak.
Kabul, Museum

THE EPIC PERIOD:

VEDIC AND PRE-MAURYA CIVILIZATIONS

The period between the end of the Indus Valley civilization and the rise of the first Indian empire under the Mauryas includes the Vedic Period (c. 1500–800 B.C.) and, from the name of the first historical pre-Maurya dynasties, the Saiśunāga-Nanda Period (642–322 B.C.). After the period of initial conquest, when the Aryans were able to reduce the native population by the superiority of their armament, there unfolds a drama repeated many times in Indian history, in which the conqueror has become the conquered. Although they imposed their philosophical and social ideals on India and penetrated the entire fabric of Indian civilization with such forms as the caste system, the Aryans were inevitably absorbed into the Indian population and the main stream of Indian civilization. Long before 500 B.C. the culture of India was a mixture of Aryan and Dravidian elements. The surviving archaeological fragments from this remote period point to the predominance of non-Aryan ritual such as the substitution of *pūjā*, the worship of a god represented in the form of an image, in place of the Vedic *yajña* or sacrifice with praise and prayer to non-anthropomorphic deities.[1] Our knowledge of this epoch of Indian history is based on a few scattered remains, on literary evidence, and on conjecture. The conjectural reconstruction of its art is based on the many references to actual techniques and works of sculpture and architecture in the Vedic hymns, which were composed sometime between 1500 and 800 B.C. These hymns were the compositions of the Aryan invaders from the uplands of northern Asia, so

that the accounts of crafts and technical procedures are those of this conquering race. Mention is made of metals, such as tin, lead, and silver, as well as copper and iron, which are specified in the later Vedic books, and there are also references to woven stuffs and ritual vessels.

Considering the background of these agricultural nomadic invaders, it is not surprising that the architecture of the Vedic Period was neither monumental nor permanent nor concentrated in urban development. With the disappearance of the Indus culture and its cities, the new Indo-Aryan population was largely distributed in small settlements located in the plains and forests. Their building materials were those most readily available for constructing shelters: wood, bamboo, thatch, and, probably only later, brick. This was the only kind of building one would expect of a people without any kind of tradition of monumental architecture. Obviously, methods of construction in bamboo and thatch must have been practised by the Dravidians long before the intrusion of the northern invaders. What little we know of architecture in these remote times is the allusion to huts of round and square shape, as well as tower-like structures. The resemblance of these descriptions to the conical huts of the primitive Toda tribes in South India today suggests that these forms were of Dravidian rather than Aryan origin. Fire-altars and sacrificial halls are mentioned in the Vedas; presumably the dimensions and measurements of these and other structures were determined at a very early date, since the dimensions for buildings are

already specified in the *Sulva sūtra* of approximately 800 B.C. In the Indian epics, the *Mahābhārata* and *Rāmāyana*, are references to shrines and assembly halls. It is significant to note that stone is only occasionally referred to as a building material. Peaked huts are mentioned in Pali literature as well as *chaityas* (shrines) and *pāsādas* (palaces), and later *Brāhmanas* contain many accounts of actual altars, tombs, and shrines. All these structures were presumably of brick or wooden construction. The account of guilds in the *Jātakas*, or Buddhist birth-stories, confirms the antiquity of such fraternities in Indian art history. It may be assumed that, just as in the Indus Valley Period, some sort of cult images continued to be used, although they are not specifically mentioned. The technique of their manufacture, originally in some perishable material like wood or metal or ivory, was transferred to stone when the methods for working this durable material were introduced in the Maurya Period. It is certain, too, that many of the building forms characteristic of later periods of Indian art were already evolved in these centuries; for example, the Buddhist chaitya-hall reproduces in stone a pre-existing form in wood and thatch, in the same way that the marble architecture of Greece so clearly follows the joiner's technique of early wooden temple forms; the fondness of Indian architects for using massive stone slabs in the early examples of trabeated architecture may derive from the Dravidian dolmen form.

It is reasonable to assume also that the relationship with the ancient Near East, so pronounced in the monuments of the Indus culture, continued in the centuries after the Aryan invasion. Such motifs as battlements, and the palmette and rosette designs that appear so frequently in early Buddhist monuments, were introduced to India in the period before the development of any kind of monumental architecture or sculpture in stone. Among these borrowings from western Asiatic art one could mention the various fantastic monsters, such as the sphinx, chimera, and gryphon, as well as the use of addorsed animals in the so-called Persepolitan capital. Obviously, these forms, universally employed in the Maurya, Śunga, and Āndhra Periods, were not introduced at that time (second or first century B.C.) when the civilizations that had created them had long since disappeared. As already suggested by the examination of the Indus Valley material, India in the second millennium B.C. was not an isolated cultural pocket, but continued as a kind of eastward extension of the culture of Mesopotamia and Iran.

The descriptions of early architectural forms in the Vedas are complemented by representations of many of these types in the Buddhist reliefs of the first century B.C. at Bhārhut and Sānchī. Indeed, the very longevity of this era of wooden building is everywhere asserted in the copies of such structures, not only in reliefs, but in the rock-cut architecture of the Maurya, Śunga, and Early Āndhra Periods. Undoubtedly the gateway or *torana* of the Buddhist *stupa*[2] had its origin in a portal consisting of two wooden or bamboo uprights topped by a single horizontal bar that gradually developed into the elaborate form with three superimposed crossbars, such as is seen at Sānchī and Bhārhut. Fences of wooden uprights and crossbars were used as barriers and as enclosures for sacred trees and tumuli, before their development into the *vedikā* or rail of the Buddhist mounds. As many authorities have pointed out, the barrel-vaulted chaitya-halls of the Buddhist period, the rock-cut cave-temples of western India, are imitations of free-standing buildings in which the barrel roof was constructed of interlocking wooden ribs covered with thatch. In many of the cave-temples of western India, although the interior is really a cave cut from the living rock, the duplication of the wooden original is carried to the point of affixing actual wooden ribs to the socle of the solid stone roof. Such later features

of Hindu and Buddhist architecture as the horseshoe-shaped chaitya arch presumably had their origin in the Vedic Period. According to Percy Brown[3] thongs corresponding to the tie-rods of Italian Gothic constricted the chord of the wooden arch to the familiar horseshoe profile that we find carved in the 'rose windows' of the later Buddhist cave-temples.

One of the most important architectural developments of the Vedic Period was the layout of the Indo-Aryan village that is preserved for us in far later manuals of Indian architecture. This was the plan that, by reason both of its commodity and specific metaphysical implications, has survived in countless arrangements in the architecture of Hinduism and Buddhism. The characteristic plan, according to Havell,[4] derived from the fortified camps of the Aryan invaders, and was a rectangle with its sides oriented to the four quarters and intersected by two avenues terminating in four gateways. Although space does not permit our entering into a detailed account of the symbolism attached to every part of this layout, it can be stated briefly that the plan was intended as a kind of microcosm, with the five divisions of the village corresponding to the five elements of the universe, and each of the gateways dedicated to one of the four Vedic deities typifying the positions of the sun in its course through the heavens. These village plans also included a broad path girdling the buildings within the outer walls which the householders circumambulated with recitations to ensure the favour of the gods. This feature, together with the metaphysical symbolism attached to the gateways, is perpetuated in the plan and ritual of the Buddhist stupa. The regularity of these early plans, based on straight intersecting avenues, is possibly a survival of the systematic arrangements of the Indus cities adapted to the metaphysical and architectural needs of the new Aryan civilization.

We may presume that it was only towards the middle of the first millennium B.C. that the

resettlement of the population in urban concentrations gradually led to the replacement of wooden forms by stone, perhaps beginning with the necessity of erecting stone ramparts and fortifications. If we can credit the accounts of Hsüan-tsang (the seventh-century Chinese Buddhist pilgrim), concerning the conflagrations that destroyed King Bimbisāra's capital at Rājagriha, we may conclude that even as late as the sixth century B.C. whole cities were still constructed largely of wood and perishable materials.[5] The only surviving relics of stone walls are the ramparts of cyclopean rubble masonry at ancient Rājagriha, which, according to Hsüan-tsang, formed the enclosure of the inner citadel.[6] These ruins are generally assigned to the sixth century B.C.

The only monuments that may possibly be recognized as pre-Mauryan are a number of enormous mounds at Lauṛiyā Nandangaṛh.[7] These tumuli have the domical shape of the later Buddhist stupa and, presumably, mark the sites of royal burials. Consequently, there is every reason to recognize in them the prototype for the Buddhist relic mound. Wooden masts were found embedded in the centre of the solid earthen tumuli. These, as in certain Buddhist stupas, were inserted for their symbolic function of representing the tree or axis of the universe and also, perhaps even in these early examples, for the purpose of supporting an umbrella – the emblem of royalty – above the summit of the mound.[8]

In southern India a number of rock-cut tombs of the Vedic Period have been found at Mennapuram and Calicut in Malabar.[9] They have been described as hollow stupas, since they are domed chambers with a monolithic stone column at the centre, perhaps as a symbolic equivalent of the wooden masts penetrating the Lauṛiyā mounds. Intended for the burial of Aryan chieftains, these caves are presumably translations into stone of Vedic round huts of wood or thatch.[10] A circular Buddhist rock-cut

cave at Guntupalla keeps the form of the Vedic hut, even to the inclusion of wooden rafters attached to the domical roof.[11] In this connexion one should mention also a rock-cut structure, sometimes recognized as a fire-temple or *Āgnidhriya*, at Bangala Motta Paramba, which was equipped with a kind of chimney in the place of the *harmikā* or balcony above the dome of the Buddhist stupa.[12] The chief importance of the Vedic Period lies in the development of architecture as a science and the invention of types that survive in later Hindu and Buddhist architecture.

Various remains of undetermined antiquity, generally classified as neolithic or prehistoric, may belong to the Vedic Period, for example, the cromlechs found at Amarāvatī in southern India, erected around burial-places, and interesting as possible prototypes for the Buddhist railing or vedikā.[13]

In the mounds at Lauriyā were found two gold *repoussé* figures. One of these is chosen for illustration [13] because it is an object discovered

13. Gold plaque from Lauriyā Nandangaṛh

under reliable circumstances of excavation that can with certainty be accepted as the work of the pre-Maurya Period. The subject of this little statuette is presumably the earth goddess Prithvī. Her presence in the tomb is explained by a burial hymn in the *Rig Veda*: 'Go to thy mother, this earth, the widely extending, very gracious Prithvī. That maiden, soft as wool to the pious, may protect thee from the abode of destruction.' The implication is certainly that

the dead were to be entrusted to the tender care of the earth mother, who is another incarnation of the great mother goddess of all ancient Oriental civilizations. From the point of view of style the figure is an example in gold relief of the same additive process in constructing human figures which we have seen in the terra-cottas of the Indus Period.[14] The explicit emphasis on the attributes of fecundity, as well as the stark nudity of the figure, is intended to describe her character as a fertility goddess. This complete frankness of presentation, together with the persisting archaic conceptual nature of the figure, make it a link between the Indus figurines and the yakshī statues of Maurya and Śunga times.

Examples of terra-cotta figures of the mother goddess, generally classified as pre-Maurya, are interesting chiefly as evidence of the persistence of an iconographic tradition originating in the Indus Valley Period and the gradual development of specific Indian techniques and attributes that reappear in monumental sculpture of the historical periods. This would include the additive method of figure composition and the careful perpetuation of such emblems as the crossed scarves and the beaded belt which we have already found to be indispensable symbols of fertility spirits.[15] Some of the terra-cotta figurines of pre-Maurya date are closely related stylistically and iconographically to the gold plaques from Lauriyā and may for this reason be assigned to this same period. The example illustrated comes from Mathurā on the Jumna [14]: it has the same flatness and frontality and the same emphatic display of the attributes of fecundity, the heavy breasts and enormously exaggerated pelvis that are characteristic not only of the gold Prithvī from Lauriyā but of far earlier representations of the mother goddess found all over the ancient Near East.[16] The method of making – additive from both the technical and iconographical point of view – is, from the purely anthropomorphic aspect, an advance

over the Indus Valley statuettes [10], in that there is a definite suggestion of a possible human form rather than an abstractly symbolic figuration of it.

The only site that has yielded any kind of picture of a consecutive development of the pre-Maurya centuries is the Bhir mound at Taxila, dating from the fifth and fourth centuries B.C. Since these antiquities consist mainly of beads and lathe-turned stones with occasional terracotta figurines, they do not add very much to our conception of the major arts before the rise of the Maurya Dynasty. The buildings are no more than an ill-planned and rudely constructed conglomerate of rubble and earth which can scarcely be dignified by the term architecture.[17]

The very poverty of the remains at Rājagriha and Taxila leads us to stress in conclusion that, although in certain respects the art of the Vedic and pre-Maurya Periods testifies to the persistence of traditional forms in Indian art – in this case, continued from Indus Valley prototypes – this period is a kind of interregnum during which certain techniques, such as the art of town-planning and stone-carving, were lost. As will become apparent in the next chapter, the real importance of the Epic Age lay elsewhere.

More recent investigations of the great mound at Lauriyā Nandangarh have shown that in its final form this gigantic tumulus was actually a stupa, the dimensions of which exceeded even those of the great monument at Barabuḍur. It has been dated in the second or first century B.C. The structure in its final form apparently represented a number of enlargements of an originally small relic mound. At a depth of 35 feet a small stone stupa was unearthed. Its form seems to relate it to the shape of the Great Stupa at Sāñchī and some of the stupas in Nepal founded in the time of the Emperor Aśoka. These recent excavations, however, do not explain the golden image of the Earth Goddess, the presence of which may still indicate that the site was originally a burial mound of pre-Maurya times.[18]

14. Terracotta statuette from Mathurā.
Boston, Museum of Fine Arts

CHAPTER 4

THE EPIC PERIOD: THE RELIGIONS OF INDIA

If the period between the disappearance of the Indus civilization and the rise of the first Indian empire under the Mauryas is almost entirely barren of any kind of artistic remains, architectural or plastic, this span of nearly a thousand years is of inestimable importance for the emergence of all the great religious systems that have ever after dominated not only India but all Asia.

In this brief account of Indian religious systems it will be possible only to present the barest outline of their theologies, with specific reference to those aspects of belief that have a special bearing on the development of later iconographical forms in art.

The religions of the early peoples of India are known as the Agamic and Vedic, or Dravidian and Aryan.[1] The words 'Agamic' and 'Dravidian' refer to the beliefs of the indigenous population of India before the Aryan invasion at the end of the third millennium B.C. The terms 'Vedic' and 'Aryan' are used to describe the religious elements introduced by these foreign conquerors. These traditions contained the beliefs, the philosophy, and the gods that constitute the religion of modern Hinduism. This religion is, in other words, a combination of elements derived from Aryan and Dravidian sources that began its development as a separate system of belief early in the first millennium B.C. The Dravidians imposed the worship of the lingam and the mother goddess on later Hinduism. It was the purely Dravidian cult of devotion or *bhakti* that installed the worship of images rather than abstract principles. Among the Dravidian gods were innumerable place spirits, tutelary deities, and powers of nature conceived as personal beings.

First are the *yakshas*, whom we shall encounter in Indian Buddhist art; they were tree-spirits who were also worshipped as guardians of the mineral treasures hid in the earth and associated with the idea of wealth and abundance. The female counterpart of the yaksha was the yakshī, a sort of Indian dryad and the spirit of the fertility of the tree. By association the yakshīs came to be regarded as symbols of the sap, the waters, and thereby of the fertility of the whole vegetable and animal worlds. They were specifically invoked by women desiring children. Among the Dravidian genii we should mention also the *nāga* or water spirit, described as serpentine in form, though in later art the nāga is represented as a human with a cobra hood attached to the back of the shoulders. All these deities, so deeply rooted in the belief and superstition of the Indian people, inevitably came to be absorbed into the pantheons of both Hinduism and Buddhism and their art.

Just as Hindu worship is based on the Aryan householder's duty to his god, his family, and his tribe, and the Brahmanic daily ritual stems from the Vedic morning and evening worship of the sun, so, too, are the Hindu deities descendants of the Vedic titans.[2] The mighty beings that the Aryans recognized in the sun, the fire, the wind, or the water needed no personifying, although when we first encounter them in Buddhist and Hindu art they are anthropomorphically portrayed in accordance with the attributes assigned to them in the Vedas. In contrast with Dravidian ritual, which stressed the value of the worship of specific deities represented by images in shrines, the Vedic or Aryan tradition was a worship of the powers of heaven and earth

by hymns and sacrifices without idols or temples. Our knowledge of this religion is derived from the Vedic hymns which were composed at some time between 1500 and 800 B.C.[3]

Among the Aryan deities was Indra, at once a personification of the Aryan warrior, god of the atmosphere and thunder, and chief of the thirty-three Vedic gods. He is usually represented riding on an elephant, the age-old Indian symbol of the swollen rain-cloud. Sūrya, the sun-god, like Apollo of the Hellenic tradition, is shown driving a four-horse chariot trampling the powers of darkness. Other Aryan gods, like Varuna, a sky deity and a moral god related to Ahura Mazda, and Mitra, another solar god, are probably the same divinities that we encounter as the Hittite *arunas* and Mithra as assimilated into Greek or Roman mythology.[4] From the very earliest 'commentary' on the Vedas, Yāska's *Nirukta*, dating from about 500 B.C., we learn that the Vedic gods or Devas were classified according to their positions in the sky, the atmosphere, or earth – the threefold division of the world-system in ancient Indian cosmology, which also included the empyrean above the sky and the infra-cosmic waters below the earth. The vertical direction or axis was of great importance, too; it was sometimes thought of as a pillar of fire formed by the fire-god Agni, who, in his kindling, bears the aroma of sacrifice upwards to the gods. He is never represented in anthropomorphic form until the period of the Hindu Dynasties. In certain aspects of later Hindu and Buddhist iconography the axis is conceived as a great mountain pillaring apart heaven and earth, or as a Great Person who contains within his magic cosmic body all elements of the universe and supports the firmament above him (Mahāpuruṣa).

In connexion with the Indian concept of the world system, something should be said about the quality of *Māyā*. Māyā is at once existence and the cosmic flux and creative power that animates all things; it is a kind of all-pervading essence uniting the myriad atoms of a teeming universe, and in art, Māyā may be regarded as the representation of the emergence of material things from this formless primal substance. Māyā is the only mirage-like concept of ultimate reality that mortals can attain.

'Hinduism' conjures up for the Western reader images of fearful, many-armed gods, the terrible car of Jagannatha or 'Juggernaut', and the iniquities of the caste system. Actually, the Hindu religion is all this and much more, and is one of the oldest philosophical and religious systems in the world, that has produced some of the world's greatest kings, poets, and mystics. The entire Hindu tradition is founded on the Vedas and, indeed, the religion might be called Vedism, so entirely is it based on Indo-Aryan tradition. It is a development, in other words, from a system in which there was no one great god, but many personifications of natural forces in which the gods were represented as in eternal conflict with the powers of evil. As will be seen presently, some of the gods of modern Hinduism are descended from Dravidian, rather than Indo-Aryan sources.

By the period of the early Upanishads (800–600 B.C.) there had already developed the principal aspects of modern Hinduism in the evolution of sacrifice destined both to please and to coerce the gods through sacrifice and formulae; the concept of a disciplined, even ascetic, life; salvation through knowledge: perhaps most important of all, the possibility of winning everlasting peace through devotion or bhakti to a particular divinity makes its appearance in the *Mahābhārata* (c. 400 B.C.). It is also generally acknowledged that this was the time when modern Hinduism assumed the character of a polytheistic pantheism which the religion maintains to-day. This same period saw the development of the idea of *saṁsāra* or 'wandering'– the soul's transmigration through endless reincarnations in human or animal form as a result of good or bad conduct (*karma*). Of extreme importance

for later Hinduism and Buddhism are the means for avoiding this retribution that were already formulated in this period: the attainment of magic powers and escape from reincarnation through the practice of extreme asceticism and self-mortification; the science of yoga or ecstatic meditation, already directed to the practitioner's attainment of superhuman spiritual strength in overcoming the process of saṁsāra. The goal of life after death as absorption into a changeless and timeless state, more familiar to us by the Buddhist term Nirvāṇa, was already accepted by all sects of Hinduism.

The term Hinduism may perhaps properly be applied to this religious system at the moment when, probably no earlier than the beginning of the Christian Era, the Vedic gods were superseded by the worship of the Trinity or Trimurti of modern Hinduism: Brahma, Vishnu, and Śiva.[5] Their personalities are already defined in the Mahābhārata, the great epic of the post-Vedic period. Brahma may be described as the soul and creator of the universe, the self-created father of the world and indwelling spirit of the cosmic system. The first person of the Brahmanic Trinity has always been such a vague and nebulous deity that most modern Hindus are divided in their allegiance between devotion to Śiva and Vishnu.

Vishnu is a mild and benevolent divinity who offers salvation through personal devotion rather than the practice of ritual. This deity is believed to have had his origin in one of the Vedic sun-gods. He is the preserver of the world. According to the eschatology of Hinduism, at the end of each great cycle of time or kalpa the universe is destroyed. Brahma is then reborn of Vishnu, and recreates the world-system for him. In each of these great cycles in which he has rescued the cosmos, Vishnu has appeared in a different form or avatar. Among the popular subjects of Hindu art are representations of Vishnu in the form of the boar that saved the earth-goddess from the waters of the flood, or, in the form of a lion, when

he struck down an impious king who dared to question his universal divinity. One incarnation of Vishnu is in the shape of the hero Krishna, who first appears in the great Indian epic, the Mahābhārata, and in that most remarkable of devotional and mystical hymns, the Bhagavad Gītā, in which he offers salvation through union with the world-soul or Brahma. The fact that Krishna is frequently referred to as dark in colour has led some authorities to think of him as a divinity of Dravidian origin, and this racial distinction is maintained even in the iconography of Indian painting in the sixteenth and seventeenth centuries. The legends of the god's youthful exploits rival those of Herakles, and in his amours with Rādha and the milkmaids he surpasses the amorous prowess of Zeus himself. The loves of Krishna are generally interpreted as an allegory of the soul's yearning for union with the divine. More than any other member of the Hindu pantheon, he extends to his devotees the possibility of salvation through devotion to him.

The third member of the Hindu Trinity is Śiva. He is a severe and terrible god of destruction who moves his devotees by fear rather than love. He is generally regarded as a divinity of Dravidian origin, perhaps stemming from the Rudras, who were deities of destruction personified in the whirlwind, although the evidence of archaeology suggests that he may have been a deity worshipped by the Indus people in the third millennium B.C. Śiva came to symbolize the powers of destruction which are the bases of re-creation. He is the symbol of death, but only of death as the generator of life, and as a source of that creative power ever renewed by Vishnu and Brahma. The representations of Śiva as the Lord of the Dance are personifications of his enactment of the end of the world, when the universe falls into ruin and is recreated by Brahma and Vishnu. Śiva in his procreative aspect is worshipped in the shape of a lingam that is the phallic emblem and, by symbolic

inference, the tree and axis of the universe itself. An inevitable attribute of Śiva, especially in all late Hindu art, is his vehicle, the bull Nandi, presumably another survival of the cult of Śiva going back to the period of the Indus civilization. In the codes of later Hinduism, the *Purāṇas*, each god has assigned to him a *śakti* or female 'energy' who complements his power, as the ideal wife in the *Mahābhārata* is described as 'half the man'. These śaktis are worshipped in the so-called Tantric or 'Left-Hand' ritual: chief among them is Pārvatī, the consort of Śiva, more usually worshipped with bloody and obscene rites in her terrible form of Kālī or Durgā.

Following the association of all ritual with the cosmic forces worshipped in the Vedic Period, the Hindu gods came to occupy the position of regents of the points of the compass, formerly dominated by the Devas. The essential aspects or personalities of Vaishnavism and Saivism are already established in the post-Vedic period, a system in which Śiva presides over East and West – the points of the sun's birth and death – and Vishnu reigns as Lord of Life and Eternity at North and South. This is essentially a symbolical statement of the difference between the nature of these deities, with Śiva as both creator and destroyer, and Vishnu as eternal preserver. It is important to note that these stations of the cosmic cross are later appropriated by Buddhism, both in the circumambulation of the stupa in a sunwise or clockwise direction from the East, and in the assignment of events from Buddha's life to appropriate points of the solar round; i.e. his birth to the East, his Nirvāṇa to the North.

The one feature of Hinduism with which most Westerners are dimly familiar is the idea of caste. The caste system probably originated sometime during the Vedic period. It consisted in the beginning of a division into three classes or social groups: the Brahmins or priests,[6] the Kshatriyas or warriors, and the Vaiśyas or cultivators. To this classification the Aryans added

a fourth class; namely, the Sudras or serfs, the descendants of the aboriginal black inhabitants who were not admitted within the pale of Aryan society. Originally, of course, this was a system based on a natural distribution of functions. It is perhaps the one distinguishing feature of Indian society which has survived with little or no loss of vitality to the present day. Although in certain respects it was a system that exhibited a certain strength by imparting solidarity to the separate groups, and in its occupational division could be said to resemble the guilds of medieval Europe, it has been fundamentally a source of weakness: its very organization has made for a hopeless division of the Indian people. It is easy to see how, with the population sealed off in water-tight compartments in which every loyalty is directed towards the caste, the emergence of anything resembling a national spirit has been almost impossible until the present political unity.

From a study of the life of the modern Hindu we can see that every action in life is governed and dedicated by religious practice: the tending of the household altar, the sacrifices to the great gods; the construction of temple and house are determined by immemorial ritual and laws of geomancy intended both to stabilize magically the structure and ensure the happiness of its inhabitants. The whole life-plan of the Brahmin followed an inexorably fixed course: boyhood novitiate with a *guru*, the years as a householder, and, in the end, retirement to the life of a hermit or *sannyasin*. The ceremonies accompanying birth, puberty, marriage, and death all have their rituals designed to bring about the favour of the great gods. All these occasions necessitated the officiation of a member of the Brahmin priesthood.

Indeed, by the sixth century B.C. Hinduism had developed into an intellectual cult in which salvation could be attained only by a complicated and secret ritual administered exclusively by the Brahmins. Corruptions in the encourage-

ment of superstitions through insistence on the efficacy of magical powers of invocation, exploitation of the priestly rite to administer sacrifices, and the emphasis on self-torture as a means of gaining supernatural power, were factors that invited revolt against the Brahmins who had fallen from the original ideal of Aryan priesthood. Although probably at this early date the caste system had not yet grown into the rigidly compartmented divisions of modern Hinduism, nor the Brahmins assumed the position of infallibility that they came to enjoy in later Hinduism, this priestly caste had come to regard itself as the sole interpreter of the Vedas, enjoying a tyrannical monopoly in its ministrations to the religious needs of the community. At this moment of Asiatic history there arose a number of heretical movements that challenged the authority of the Brahmins and offered the opportunity of personal salvation to the individual. Such heretical movements were nothing new in Indian religious history, nor is it at all surprising that these reform movements should have been led by members of the *Kshatriya* or warrior caste, who in some parts of India, at least, regarded themselves not only as the rivals but the superiors of the Brahmins.

Among the many sects which disputed the authority of Hinduism in the sixth century B.C. was the religion of Jainism, the foundation of which is traditionally ascribed to the sage Mahāvīra (599–527 B.C.). The goal of Jainism was the attainment of salvation through rebirth, as escape from the retribution of conduct, or karma, whereby, according to the sins committed in earthly incarnations, men are destined to atone for these wrongs by being reborn into the world in the shape of an animal or a slave. Mahāvīra and his followers taught that salvation could be achieved through the practice of asceticism and through the scrupulous avoidance of injuring or killing a living creature. Mahāvīra, who as a Brahmin knew the various systems for the attainment of salvation offered by the Hindu Church,

was, like the Buddha, a leader of a revolt against the orthodox cult of Brahmanism. He denied the authority of the Vedas and the efficacy of sacrifice, offering the attainment of perfection and release from karma to all who, by the practice of abstinence and asceticism, could eradicate earthly passions. Mahāvīra is worshipped together with twenty-four other *jinas* or *tirthamkaras* who had attained this goal of perfection in earlier cycles of time. In Jain literature and art their lives are embellished with miraculous events that are allegories or direct borrowings of age-old Indian metaphysical concepts.

Of far vaster import for the later history of not only Indian but all Asiatic civilization was the greatest leader in this humanistic revolution: the personage known to history as the Buddha.[7] Born about 563 B.C. into the princely clan of Śākyas on the border of Nepal, the mortal Buddha is known by his personal name, Siddhārtha, by his surname of Gautama, or as Śākyamuni (the Sage of the Śākyas). Only the briefest possible survey can be given of the life of the historical Buddha, the events of which formed the subject for the art of Buddhism in India and all eastern Asia. During his youth as the prince of a royal house, Śākyamuni, through visions vouchsafed by the Devas, was made aware of the miseries of humanity, and determined to renounce the world in order to effect the salvation of his fellow men from the inexorable cycle of reincarnation. After his flight from his father's capital, known as the Great Renunciation, Śākyamuni studied under a number of Brahmin sages, who advocated extremes of penance and self-mortification as a means of acquiring the spiritual power or *tapas* to escape the retribution of karma or rebirth. After renouncing the way of asceticism, Śākyamuni found the goal of Enlightenment through the practice of yoga. This final Enlightenment took place as the result of his meditations under the Bodhi Tree, or Tree of Wisdom, at Gayā. The culmination of this trance was the attainment of Buddhahood

– the achievement of a state of cosmic consciousness as far above the mental plane of ordinary mortals as that level of human consciousness is raised above that of primitive men, young children, or animals. From that moment in his career when the deeper mysteries of the universe were revealed to him, the Buddha devoted himself to the paramount goal of winning for all humanity salvation or release from the endless cycle of rebirth. The essentially pessimistic doctrine preached by the Buddha was that all existence is sorrow; the cause of which stems from attachment to self and the ephemeral delights of the world of the senses. The cure for this universal malady lay in the suppression of the self and the extinction of the karma, that accumulation of past actions which, in the Brahmin belief, survives what is usually designated as the Ego, subject to endless reincarnation and suffering. The Buddha denied the efficacy of extreme asceticism and reliance on ritual formulas as efficient means of salvation. He recommended salvation by the individual's work and action – by following the Eightfold Path that included the practice of right belief, right thought, right speech, and right action; a way of life possible for all and easily comprehensible by all, and free of the onerous and expensive ritual of Brahmanic tradition.[8] This code of life, based on moral conduct rather than on belief and sacrifice, was first enunciated by the Buddha at the time of his first sermon at Sārnāth, when metaphorically he first began to turn the Wheel of the Law. For the remainder of his career the Buddha and a growing band of converts travelled through Magadha and Bihār, preaching the way of salvation open to all, regardless of caste or creed. In his eightieth year, the Master achieved his final Nirvāṇa or death.

There is no term in the whole history of Buddhism that has been the subject of more controversy than Nirvāṇa. The Master himself never explained his last end, and discouraged controversy upon it as unedifying. We may be reasonably sure that in early Buddhism the Buddha at his demise was believed to have entered a realm of invisibility 'where neither gods nor men shall know him', or to have achieved a complete extinction of karma and Ego. As we shall see presently, in later Buddhism Nirvāṇa came to mean that the immortal Buddha, who had manifested himself in mortal shape for the benefit of man, after 'death' resumed his place as the Lord of a Paradise, there to await the souls of the faithful through all ages. Even as early as the time of the Emperor Aśoka (272–232 B.C.), the goal of the Buddhist layman was already that of everlasting reward in Paradise, as opposed to the monk's ideal of the peace of Nirvāṇa to be achieved in part through the practice of yoga.

The life of Gautama, as recounted in many different texts of the Buddhist canon, although undoubtedly based upon the career of an actual mortal teacher, has assumed the nature of an heroic myth, in that almost every event from the hero's life is accompanied by miraculous happenings, and the Buddha himself invested with miracle-working powers. Many of the episodes from the Buddha's real life are interpreted as allegorical or anagogical references to cosmic phenomena, accretions from age-old Indian cosmology: the Buddha's birth is likened to the rising of another sun; on his Enlightenment, like the sacrificial fire of Agni, the Buddha mounts transfigured to the highest heavens of the gods; in his turning of the Wheel of the Law he assumes the power of the world-ruler or Cakravartin to send the wheel of his dominion, the sun, turning over all the worlds in token of his universal power. It is not surprising that some scholars have interpreted the whole of the Buddha story, as it appears in later texts, as a reworking of far earlier solar myths.

It is quite apparent that Buddhism early formed an alliance with the popular cults of the soil and of nature, accepting perforce those same

nature-spirits of Dravidian origin that survive even to-day in the popular cults of modern Hinduism. This must account for the presence of the yakshīs and the nāgas, the dryads and water spirits who appear in all the monuments of early Buddhist art. In order to explain the presence of these demi-gods and the meticulous recording of so many details of animal and plant life, it might be said that early Buddhism, in its acceptance of the doctrine of reincarnation, stressed the unity of all life, the identification of man with nature through the very forms of life through which the Buddha and man had passed before their final birth into the human world. This seemingly intense feeling for nature is something evoked by the idea of former births in animal form, and is not in any sense a pantheistic conception. Although occasionally in the Buddhist hymns we encounter what seem to be passionately lyrical writings on nature, the mention of natural objects is only metaphorical, like similar references to nature in the Psalms.

The mythology of Buddhism also came to include a collection of moral tales purporting to relate the events in the earlier incarnations of Gautama when, in either animal or human form, he was acquiring the merit that enabled him to attain Buddhahood in his final earthly life. These Jātaka stories, which are extremely popular as subjects of illustration in early Buddhist art, are almost all of them ancient folk-tales, with or without moral significance, that came to be appropriated by Buddhism. Their absorption into Buddhism suggests an influence of the Vaishnavite concept of the god's avatars. Another similarity to the mythology of Vishnu may be recognized even in early Buddhism in the idea of the Buddhas of the Past, who in earlier cycles of world history came to earth to lead men to salvation. In early Buddhist art these predecessors of Śākyamuni are symbolized by the trees under which they attained enlightenment or by the relic mounds raised over their ashes. Primitive

Buddhism also included the belief in a Buddha of the future, Maitreya, who will descend from the Tushita Heaven to preach the Law at the end of the present *kalpa* or cycle of time.[9]

Something should be said, too, of the position of the Vedic gods in early Buddhism and its art. The Buddha never denied the existence of these deities. They are regarded as angels somewhat above the mortal plane, who were just as subject to the external order as men, and equally in need of salvation. Time and again in the legend of Buddha's life Indra and Brahma appear as subordinates waiting upon the Enlightened One: it is Brahma who implores the Buddha to make his doctrine known to the world. It is not unusual to find the Vedic gods as personifications of various of the Buddha's powers, in much the same way as in early Christianity pagan deities served as allegories of Christ.[10]

As has already been said, the doctrine preached by Śākyamuni offered salvation through moral discipline rather than by the easier way of worship or sacrifice. A distinction should perhaps be made between 'Primitive Buddhism', referring to the doctrine as it existed in Śākyamuni's lifetime, and 'Monastic Buddhism', which developed following the master's death. Buddhism in the time of Gautama was open to all, with no distinction between clergy and laity, and the possibility of salvation by following the Eightfold Path accessible to every follower. When the religion assumed a permanent character after the Buddha's death, clergy and laity became separate, and salvation was reserved for those who could literally abandon the world to enter the order. There is no suggestion of the possibility of all creatures attaining Buddhahood, nor that they are possessed of the Buddha nature. Such an anti-social solution, however impractical for the man of the world, was probably not regarded as at all unusual at a time when the idea of monastic retreat was offered by many different sects. In the early faith, nothing beyond the

salvation open to those who could undertake the hard road to the entirely personal reward of arhatship could be offered to the vast majority of those who could not take up the monastic life. This was only one of the reasons that led to a change in the character of Buddhism. Such a change was brought about through the gradual intrusion of the idea of reward by worship, and also by competition with other sects that offered an easier way of salvation through devotion to the person of an immanent deity. It should be pointed out, too, that, whereas the Buddha was regarded by his earliest followers as an ordinary man who, by his intuitive perception of the cause of evil and its eradication, attained Nirvāṇa or the extinction of rebirth, in later generations the inevitable growth of devotion to the person of the founder led to his being regarded as a particular kind of being, not an ordinary man, but a god. Even as early as the time of Aśoka (272–232 B.C.), the worship of bodily relics of the Buddha was an established practice complete with ritual stemming from earlier Brahmanical practice. We should add to the accumulation of circumstances that led to the transformation of Buddhism into a universal religion rather than a moral code, the influence of the religions of Iran and Greece, with the idea of the worship of personal gods conceived of in anthropomorphic shape. This revised form of Buddhism, which is of inestimable importance for both the religion and art of all later periods of Indian and Asiatic history, was designated by its adherents as the Mahāyāna or Great Vehicle (of salvation), as distinguished from the Hinayāna or Small Vehicle, the term applied, not without contempt, to primitive Buddhism.

It can be stated with some assurance that Mahāyāna Buddhism came into being under the patronage of the Kushans in the early centuries of the Christian era. A complete statement of the doctrine is to be seen already in the *Saddharma Puṇḍarika* or Lotus Sūtra, a text which has been dated in the second century A.D. In Mahāyāna Buddhism the Buddha is no longer a mortal teacher but a god, an absolute, like Brahma, who has existed before all worlds and whose existence is eternal.[11] His appearance on earth and Nirvāṇa are explained as a device for the comfort and conversion of men. Whereas in primitive Buddhism we have the ideal of the Arhat seeking his own selfish Nirvāṇa, with no obligations beyond his own salvation, Mahāyāna Buddhism presents the concept of the Bodhisattva, a being who, although having attained Enlightenment, has renounced the goal of Nirvāṇa in order to minister eternally to allaying the sufferings of all creatures. The Bodhisattvas of the Mahāyāna pantheon are like archangels who pass from the remote heaven where the Buddha resides to the world of men. These Bodhisattvas are entirely mythical beings who, if they are not a reappearance of the old Vedic gods, may be regarded as personifications of the Buddha's virtues and powers. The most popular in the host of the Bodhisattvas, and most frequently represented in Mahāyāna Buddhist art, is Avalokiteśvara, the Lord of Compassion. This divinity is recognizable by the image in his headdress representing the Buddha Amitābha, regent of the Western Paradise. It is the idea of the Bodhisattva and the possibility of universal salvation for all beings that most clearly differentiate Mahāyāna Buddhism from the primitive doctrine. Mahāyāna Buddhism is entirely mythical and un-historical. How much its mystical theology is influenced by Mazdaean, Christian, or Hindu ideas can never be exactly determined; the fact remains that the elevation of the Buddha to the rank of a god is in part a development out of a theistic current that had always been present in early Buddhism. Even the representation of the Buddha by such symbols as the footprints and the empty throne in Hinayāna art not only implies a devotion to the person of the Teacher, but strongly suggests that he was already regarded as a supernatural personage. In Mahāyāna Buddhism the mortal Buddha Śākyamuni

appears only as a temporal manifestation of a universal and eternal Buddha.

One of the concepts of Mahāyāna Buddhism that finds its inevitable reflexion in the iconography of that art is the *trikāya*, or Three Bodies of Buddha. This triune division of the Buddha nature is, in a philosophical sense, analogous to the Christian trinity. In this triune nature we have the *dharmakāya* or 'law body', that is, the Law or Word of Buddha (the logos or silent, indwelling force or spirit of the cosmos, invisible and descriptive of the Buddha in his transcendent or universal aspect); the *sambhogakāya* or 'body of bliss', which is the aspect of the trinity manifested only to the Bodhisattvas as a kind of transfiguration; and the third body, the *nirmāṇakāya* or 'noumenal body', that mortal shape in which the Buddha periodically manifested himself in the world of men.[12]

A further step in the development of this theistic religion is the creation of the entirely mythical Buddhas of the Four Directions and the Centre of the World. Probably the earliest of these divinities was Amitābha, the Buddha of the West, whose Paradise is described in sūtras at least as early as the second century A.D. Yet other Buddhas presiding over 'Buddha fields' or *kṣetras* were added in the following centuries until, in the final development of Mahāyāna Buddhism in the eighth century, we have the complete *maṇḍala* or magic diagram of the cosmos, with a universal Buddha of the zenith having his seat at the very centre of the cosmic machine, surrounded by four mythical Buddhas located at the four cardinal points of the compass. This concept of five Buddhas may go back to earlier beliefs and numerologies, such as the Five Elements, the Five Senses, or as names to express the classic correlation of the human microcosm to the universe. This concept of the mythical Dhyāni Buddhas is only an adaptation of the Vedic and Brahmanic concepts of Brahma at the centre of a constellation of regent divinities governing the four directions. In the final and

esoteric phase of Mahāyāna Buddhism known as Vajrayāna, it is the mythical Buddha Vairocana, the Great Illuminator, who is fixed like a sun in the centre, and around him, like planets in the sky, are set the four mythical Buddhas associated with the four directions.

The central concept of Vajrayāna Buddhism is the worship of Ādi-Buddha, a self-created, primordial being who, when all was perfect void, produced the three worlds by his meditation. From Ādi-Buddha's meditation were produced the Five Dhyāni Buddhas. According to this doctrine, the individual soul is an emanation of the mystic substance of Ādi-Buddha, and will return to him when the cycle of transmigration is done. The attainment of the Buddha nature and the possibility of reunion with Ādi-Buddha at the end of life are now promised the worshipper through recourse to a great many expedients, such as reliance on the priestly recitation of magical spells invoking the names of the Buddhist deities, or the accumulation of merit through the consecration of stupas and icons, or meditation on maṇḍalas or magic diagrams of the cosmic system. As will be seen, the promise of spiritual reward merely through the dedication of stupas and images had at least a quantitative effect on the development of Buddhist art.

In explanation of these later developments it must be said that, throughout the centuries of its development, Buddhism had always been influenced by Hinduism, and, as we have seen, many of the original assumptions and tenets of the doctrine were taken over from the Vedic Hindu tradition. This is not the place to describe the various aspects of later Buddhist philosophy that have their origin in Brahmanical ideas. Suffice it to say that in later centuries Hinduism, which had continued to exist as a religion parallel to Buddhism, came to exert a stronger and stronger influence on the whole structure of the Mahāyāna Church and its iconography. In the end, Buddhism in India, instead of being a synthesis of the highest concepts

of all the schools of Hindu thought, becomes only another Hindu sect. The last phase of the religion offered salvation through the priests' recitation of unintelligible spells or *dhāranis* and magical formulas which could be neither understood nor recited by the devotees. Not only is this infallibility of the priests or gurus a parallel to the function of the Brahmin priests, but other, even more sinister, elements came to undermine the fabric of the Buddhist Church. It was an evil day for the Mahāyāna faith when the Buddhist holy man Asaṅga brought the Hindu gods to earth to aid men not only towards salvation but in the attainment of worldly desires. The Hindu gods infiltrated into Buddhism in the disguise of personifications of various powers of Buddha. It was not long before the Bodhisattvas themselves, endowed with many arms and heads, could scarcely be distinguished from the great gods of the Hindu pantheon. The most vicious phase of Asaṅga's doctrine was the introduction of the worship of the Tantra, which meant essentially devotion paid to the female energy or śakti, a concept borrowed from the more corrupt phase of Hinduism, that in its grosser aspects encouraged sexual practices of every description as a means of devotion, as a kind of physical enactment of union with the divine. This last phase of Buddhism flourished in Bengal from the eighth century until the extirpation of the religion by the Mohammedan invasions. From there it was transplanted to Nepal and Tibet, where the iconography and style of this last phase of Indian Buddhism are still preserved.[13]

However, the same centuries which marked the decline and final eclipse of Buddhism also saw the beginning of a true renaissance of Hinduism, and this developed into the philosophical and devotional system of worship that has claimed the faith of Indian millions for more than a thousand years. Nothing could more eloquently demonstrate the vigour and power of that religion than the magnificent works of Hindu art dedicated in this same millennium. The final phase of the Hindu Church represents the complete unity of worship and worshippers. Although the division of worship between the devotees of Vishnu, Śiva, and Krishna may appear clearly defined, then and now, and in the eternity of Indian time, all these gods are but manifestations of one god, the Great Lord in his final and ineffable form.

THE EARLY CLASSIC PERIODS

THE FIRST INDIAN EMPIRE: THE MAURYA PERIOD

The Maurya Period takes its name from a line of emperors who ruled over an India united from the Khyber to the Deccan, from 322 to 185 B.C. The prologue to the foundation of the Maurya Dynasty was the invasion of India by Alexander the Great. It will be remembered that, following the destruction of the Achaemenid Empire of Iran with the burning of Persepolis in 330 B.C., Alexander, seeking to emulate the legendary triumph of Dionysius in the Orient, led his phalanxes eastward to Bactria and, finally, in 327 to the plains of northern India. There the defection of one after another of the local Rajahs and the Macedonians' final victory over the king of Taxila enabled the conqueror to advance to the Indus. The one constructive result of Alexander's raid was the opening of India to the influence of the Hellenic and Iranian civilizations of the West. Alexander's military conquest was in itself shortlived. When Alexander was forced to retire from India to die in Babylon in 323 B.C., the eastern reaches of his world empire fell to his general, Seleucus Nicator. It was in 322 B.C., only a year after Alexander's death, that a certain Chandragupta Maurya by a series of *coups d'état* gained complete sovereignty over ancient Magadha in Bengal, and soon waxed so strong that he was able by show of force to compel the withdrawal of the Greek forces of Seleucus beyond the Hindu Kush mountain range. This brief passage of arms did not mean a severance of relations with the Hellenistic powers of the West, but rather initiated an era of more intimate cultural connexions between India and the Seleucid Empire, as is attested by the accounts of the Greek ambassadors, such as Megasthenes, at the Maurya court.

The empire that Chandragupta founded reached its greatest moment of political, religious, and artistic development in the middle years of the third century B.C. At this period in Indian history there rose above the waters of the Ganges the towers of Pāṭaliputra, the capital of the Maurya Emperors of India. Enthroned there in pillared halls, which in the words of Megasthenes echoed the 'splendour of Susa and Ecbatana', was Chandragupta's grandson, Aśoka, the earliest, most renowned imperial patron of Buddhism in Asia (272–232 B.C.).

The history of his conversion to the Dharma is probably part truth, part legend: how, like another Napoleon III at another Solferino, he was so overcome with horror at the countless windrows of the slain that littered the battlefields of his Orissan campaign, that he then and there determined to renounce all further bloodshed to dedicate himself and his reign to the propagation of the Law and the Peace of Buddha. Fabulous legends of Aśoka and his piety spread to the farthest corners of Asia: how he threatened to wither and die with the fading of the bodhi tree at Gayā; how, by the aid of the

yaksha genii, he raised eighty-four thousand stupas to the Buddha in a single night. History, rather than myth, is the record of Aśoka's missionary activities, such as the sending of Buddhist envoys to the kings of the Hellenistic world and to the green darkness of the Singhalese jungles.

Part of the Maurya heritage from ancient Mesopotamia and Achaemenid Iran was the ideal of world conquest and universal sovereignty. Aśoka in his regnal policy was seeking to embody in himself the ancient Babylonian and also Vedic concept of the Lord of the Four Quarters, designated in early Indian texts as Cakravartin, whom the celestial wheel (the sun) guides to dominion over all regions. Although in a practical sense the dominions of the Maurya Cakravartin extended from Afghanistan to Mysore, an actual world conquest was to be achieved, not by force, but peacefully by the spread of the Dharma.[1] This background to Maurya power, together with Aśoka's substitution of a kind of religious imperialism for his grandfather Chandragupta's rule by force, is important in considering the art of his period.

An examination of the ruins of the fabulous city of Pāṭaliputra, near modern Patna, is extremely important for an understanding of the whole character of Maurya civilization which Aśoka inherited and perpetuated. Following not only Indian but ancient Near Eastern precedent, the palace walls, the splendid towers and pavilions, were all constructed of brick or baked clay that has long since crumbled to dust or been swept away by periodic inundations of the swollen waters of the Ganges. Megasthenes tells of five hundred and sixty towers and sixty-four gateways in the circuit of the city walls. Describing the wonders of Pāṭaliputra, Aelian, who borrows from Megasthenes' account, tells us: 'In the Indian royal palace . . . there are wonders with which neither Memnonian Susa in all its glory nor Ecbatana with all its magnificence can hope to vie. In the parks tame

peacocks are kept, and pheasants which have been domesticated; and cultivated plants . . . and shady groves and pastures planted with trees, and tree-branches which the art of the woodman has deftly interwoven. There are also tanks of great beauty in which they keep fish of enormous size but quite tame.'[2]

Such a description might accurately portray a Persian royal garden or paradise in the days of Xerxes and Darius. Beyond the evidence of the actual excavations at Pāṭaliputra we can get an idea of the appearance of the city in the elevations of towns that form the backgrounds for Buddhist subjects in the reliefs of the Early Āndhra Period at Sāñchī. The panel on the eastern gateway representing the Buddha's return to Kapilavastu [15] and a similar panel of King Prasenajit on the northern portal show us a city surrounded by massive walls, topped by battlements and picturesque balconies enclosed by railings and surmounted by barrel-vaulted structures terminating in chaitya windows. Details in other reliefs enable us to visualize the presence of a moat surrounded by a palisade or railing of the type developed in the Vedic Period. It is to be assumed that all these superstructures were built of wood. In the relief representing the Buddha's departure from Kapilavastu we see that the actual portal in the city walls is preceded by a frontispiece in the shape of a simple toraṇa of the very same type that is constructed in stone at Sāñchī. The excavations of Pāṭaliputra revealed that at one time it was completely surrounded by a massive palisade of teak beams held together by iron dowels. This was, of course, an adaptation of the railings of the Vedic Period to the uses of urban fortification. The Chinese Buddhist pilgrim, Fa Hsien, visiting Pāṭaliputra shortly after A.D. 400, mentions 'the royal palace, the different parts of which he [Aśoka] commissioned the genii to construct by piling up the stones. The walls, doorways, and the sculptured designs are no human work.'[3]

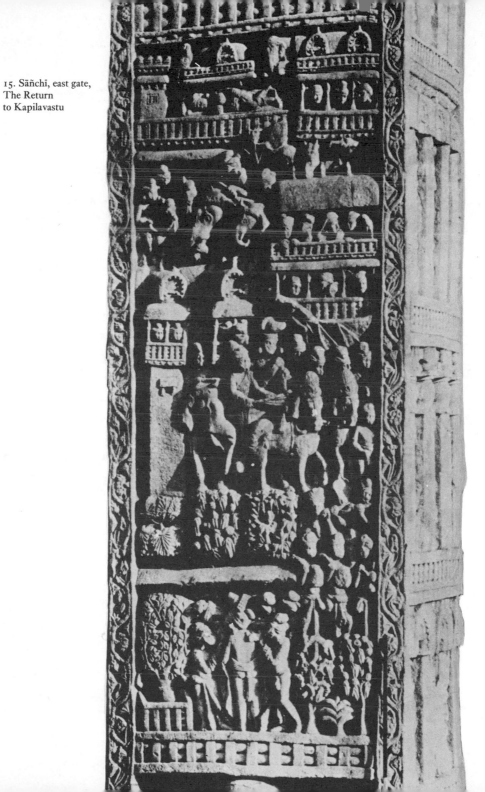

15. Sāñchī, east gate,
The Return
to Kapilavastu

16. Pāṭaliputra, Maurya Palace

17. Pāṭaliputra, excavations of palisade

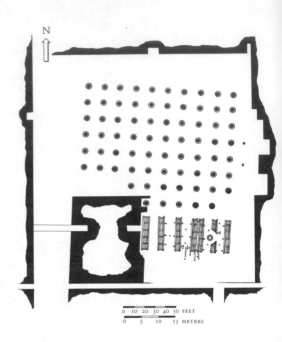

0 10 20 30 40 50 FEET
0 5 10 15 METRES

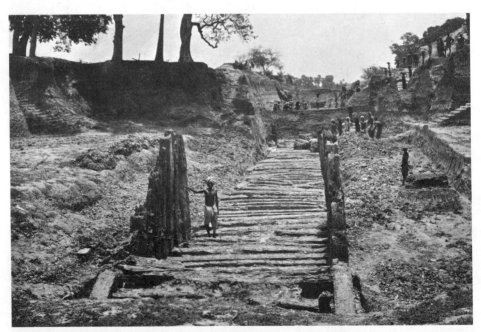

In addition to a ground plan of the palace area [16], a single illustration of the ruins of Pāṭaliputra is reproduced [17] to show the extraordinary craftsmanship and permanence of the city's girdle of fortifications. We see here a portion of what, according to the excavators, was an almost indefinitely extended construction, consisting of upright timbers fifteen feet high and fourteen and a half feet apart, with a wooden floor and, originally, a wooden roof. It is uncertain whether this tunnel was a passage within the ramparts, or whether it was intended to be filled with earth for added strength. It is as though a small section of the London tube, or the Holland tunnel beneath the Hudson, came to the attention of future excavators to give a slight clue to the complication and magnificence of vanished cities. Although it is difficult to clothe this fragment of Pāṭaliputra with towers and gateways rivalling the ancient capitals of Iran, it does give us some slight suggestion, by its vast extent and the enormous

strength of construction, of the great city of the Maurya Empire.

Even more interesting were the remains uncovered in the actual palace area: a great audience hall was preceded by a number of huge platforms built of solid wood in log-cabin fashion [16]. They formed a kind of artificial eminence or acropolis, like the palace platforms of ancient Mesopotamia and Iran; undoubtedly, these wooden structures were intended as foundations or rafts for the support of some kind of pavilions or stairways in front of the palace itself. The remains of this building – an audience hall or, to give it its Iranian name, *apadana* – consisted of row upon row of colossal sandstone columns, eighty in number, that once supported a timber roof. Although most of the ponderous monolithic shafts had sunk deep into the earth in the course of centuries of floods, enough fragments remained to show that the plan of this hall corresponded very closely to the arrangement of the great pillared

rooms of state that are among the most striking remains of the Achaemenid palace ruins at Persepolis in Iran. This is only the first indication of the tremendous influence exerted upon Maurya India by the art of the Achaemenid Empire that Alexander destroyed. The conscious adoption of the Iranian palace plan by the Mauryas was only part of the paraphernalia of imperialism imported from the West. This influence presumably began as soon as the Maurya Empire was firmly established, and it was furthered by the presence of actual envoys and even refugee artisans from Iran through the reign of the great Aśoka. The Indian perpetuation of the Achaemenid style undoubtedly came

through contact with the Hellenistic dynasties that replaced the line of Xerxes and Darius. When he ousted Seleucus from north-west India and Afghanistan, Chandragupta pushed his frontiers to the eastern boundary of Iran itself.

That Aśoka's tolerance and generosity to religious sects were not limited to his patronage of Buddhism may be illustrated by his donation of cells for the habitation of holy men of the heretical Ājīvika sect in the Barabār Hills near Gayā [18]. The most pretentious of the hermitages is the Lomas Rishi cave. The architectural carving of the façade of this sanctuary is completely Indian. It is an imitation in relief

18. Barabār, Lomas Rishi cave

sculpture in stone of the entrance of a free-standing structure in wood and thatch, with the sloping jambs of the doorway supporting a tympanum of repeated crescent shapes under an ogee arch that presumably represents the profile of the thatched roof. This is the first representation of a type of building that must have existed in wooden forms of the Vedic Period. The principal decoration of the so-called 'chaitya window' of the overdoor is a procession of elephants approaching a stupa. The naturalistic rendering of the articulation and gait of these elephants seems almost like a perpetuation of the style of the Indus Valley seals. The complete elevation of this miniature façade is repeated over and over again in the chaitya-halls of the Śunga and later periods, and is particularly significant in its showing that the forms of later Buddhist architecture were already completely evolved in the Maurya Period.[4]

The Iranian or, properly speaking, Achaemenid character of Aśokan India has often been mentioned: it is revealed very strikingly in the language of the edicts that Aśoka caused to be engraved on rocks and pillars in order to propagate to all his people the benefits of the Buddha's Law. The very idea of proclaiming decrees by engraving them in immortal stone is a borrowing from Iran, as witness the famous inscription of Darius on the cliff at Bisutun in northern Iran.

Nowhere do we find a clearer picture of the true character of Maurya civilization than in its sculpture; the surviving monuments reveal the same imperialist and autocratic character as Aśoka's rule in its essential structure; like so much of Maurya culture, they are foreign in style, quite apart from the main stream and tradition of Indian art, and display the same intimacy of relationship and imitation of the cultures of the Hellenistic Western powers and of Iran as the language of Aśoka's inscriptions and the Maurya court's philhellenic leanings. Side by side with this official imperial art, there existed what could be described as a folk art,

much more truly Indian in style and tradition and, in the final analysis, of far greater import for the future development of Indian art.

It has often been pointed out that one of the tangible results of Alexander's invasion of India and the continuation of Indian contacts with the Hellenic and Iranian West in the Maurya Period was the introduction of the technique of stone-carving and the first employment of this permanent material in place of the wood, ivory, and metal that were used during the Vedic Period. It is significant that, although many motifs, both decorative and symbolic, were the common property of pre-Maurya India and western Asia, not until the appearance of actual foreign stone-cutters from these same regions does the technique of monumental sculpture begin in India.

Little or nothing survives of Aśoka's Buddhist foundations beyond the ruins of a stupa at Piprāwā in Nepal and the core of the Great Stupa at Sāñchī, but monuments of another type survive to testify to his zeal for the Dharma. These stone memorials, erected as part of Aśoka's imperialist programme of spreading Buddhism throughout his empire and using the Law as a unifying force of government, consisted of great pillars or lāts, some more than fifty feet in height, and originally crowned by capitals of sculptured animals of both Buddhist and ancient Indian metaphysical significance. These columns were set up at sites associated with the Buddha's earthly mission and at various points along the highways linking Aśoka's India with the Himalayan valleys of Nepal.[5] On the bases of many of these pillars were inscribed Aśoka's edicts on the Dharma. Just as the employment of such permanent inscriptions is of western Asiatic origin, so the idea of such memorial columns is, of course, not Indian, but is yet another derivation from the civilizations of ancient Mesopotamia.[6]

One of the few Maurya pillars that remains in a perfect state of preservation is the column set

19. Lauṛiyā Nandangaṛh, lion column

up at Lauṛiyā Nandangaṛh near Nepal in 243 B.C.[7] It is typical of the original appearance of all of them [19]. The completely smooth shaft is a monolithic piece of Chunar sandstone, a material quarried near Benares and universally employed for all monuments of the Maurya Period. At the top of the pillar is a lotiform bell capital, the shape of which is only one of many decorative forms borrowed from the art of the ancient Near East. It is specifically reminiscent of the bell-shaped bases of the Achaemenid pillars. This member in turn supports the seated figure of a lion, probably intended as a symbol of Buddha as the Lion of the Śākya clan.

In addition to his Buddhist significance, the lion is, of course, an ancient solar symbol in Iran, Mesopotamia, and Egypt centuries before the formulation of Buddhist iconography. It may well be, as is suggested by the words of Aśoka's first and last edicts enjoining the carving of such inscriptions on rocks or on pillars *already standing*, that many of the so-called Aśokan columns, originally set up by an earlier Maurya emperor, were taken over and their symbolism, Brahmanical or zodiacal, syncretically reinterpreted for Buddhist usage.[8]

This type of column with a single animal at the top is the simplest form of Maurya pillar; others much more stylistically and icono-graphically complicated were crowned by a number of animals placed back to back that originally supported an enormous sandstone disk typifying the Wheel of the Law, the instrument of Aśoka's world conquest.

This essentially more baroque variety of pillar may be illustrated by the remains of a famous memorial that once stood in the Deer Park at Sārnāth [20]. The Chinese pilgrim Hsüan-tsang, who visited this site in the seventh century A.D., described the monument as follows: 'A stone pillar about seventy feet high. The stone is altogether as bright as jade. It is glistening and sparkles like light; and all those who pray fervently before it see from time to time, according to their petitions, figures with good or bad signs. It was here that Tathāgata, having arrived at enlightenment, began to turn the wheel of the law.'[9] The fragments of this memorial, consisting of the capital and bits of a gigantic stone wheel that crowned the top, are preserved in the Archaeological Museum at Sārnāth.[10] Examining the sculpture first from the stylistic point of view, we see that it embodies the same conglomerate of foreign ideas that we find in the entire fabric of Maurya civilization. The composite capital consists of a lotiform bell on which rests a plinth with carvings of four animals and four wheels or disks; above this are four addorsed lions which form the throne or support for the terminal wheel. This combination of bell capital and joined

heraldic animals is not notably different from the type of column or order which in many different forms is found in the palace architecture of Achaemenid Iran in the ruins of Persepolis and, for this reason, is designated as Persepolitan. The extremely lustrous finish of the stone is again a borrowing from the technique of the carvers of the palaces of Darius and Xerxes. The use of animals placed back to back as a supporting member has its obvious precedent in the Persepolitan form and so, too, has the essential shape of the stylized lotus. The stiff and heraldic character of the lions themselves is a continuation of the ancient Oriental tradition which we can see in the animal carvings of Achaemenid Iran. The mask-like character of the lion-heads, together with the

manner of representing the muzzle by incised parallel lines and the triangular figuration of the eyes, are among the more obvious resemblances to Iranian lion-forms.

It is at once apparent that the style of the four smaller animals on the plinth is quite different. These beasts are portrayed in a distinctly lively, even realistic manner. In them we can recognize at once a style related to Greek tradition. The closest geographical parallel to the horse [21] is the steeds on silver bowls made in Bactria during the Hellenistic occupation. The style of the monument is, in other words, a combination of Iranian and Hellenistic features; it is not unlikely that the workmanship was by actual foreign sculptors imported from Iran and the Hellenistic colonies on India's northern and

21. Lion capital from Sārnāth, detail.
Sārnāth, Archaeological Museum

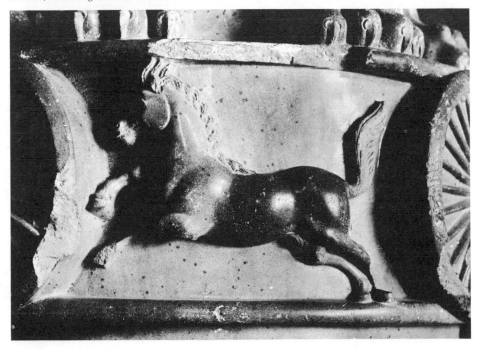

western frontiers. There is every reason to believe that this style, together with the technique of stone-carving, is an importation no earlier than the consolidation of the Maurya Empire.

If the capital at Sārnāth is completely un-Indian in its stylistic execution, the ideas these foreign shapes are intended to express are completely Indian and by derivation peculiarly Buddhist in character. In considering this monument, as indeed every religious memorial in Indian art history, we must keep in mind that its primary function was magical and auspicious, neither 'decorative' nor 'architectural'.

An example of the persistence of Indian symbolism even in modern times is a curious detail of the magical ceremonies attending the investiture of the nineteenth-century monarch of Siam, King Chulalongkorn. On the four sides of an artificial mountain erected in the capital for the occasion there were installed about a font the effigies of four beasts – the lion, the elephant, the bull, and the horse – in other words, the same group that parade around the plinth of the Sārnāth capital. During the ceremony the Prince received a baptism from these four gargoyles. This was no more nor less than a piece of magic for the investiture of a sovereign going back to the beginnings of Indian metaphysics and cosmology. It is an illustration of the principle of *pratibimba*, the reconstruction in architecture or sculpture of the imagined structure of supernatural things or regions, in order that men may have access to them or power over them through an imminent symbol. The artificial hill in Bangkok was the world mountain Meru, according to ancient cosmology, towering like a pillar between earth and heaven; the four beasts stood for the four quarters and the four rivers of the world, so that the whole structure was a kind of replica of the world system.[11] In Bangkok, the Prince's circumambulation of this fanciful stage-set was designed magically to ensure his dominion over

the universe reproduced there in a microcosm. The merry-go-round of the four animals at Sārnāth is simply an earlier example of the same principle in operation. Various early legends identify these creatures with the four great rivers that flow from the four openings of a magic lake situated at the world's navel in the Himalayas.[12]

One of the legends concerned with the magic lake, called variously Udaya or Anavatapta, relates that from the waters of this pool there rises a great shaft that uplifts a throne to uphold the sun at noon and then sinks again with the setting of the orb. The application of this rather elaborate symbolism to the Sārnāth column is not difficult to explain or understand: the shaft of the column is an emblem of the world axis, rising between heaven and earth, surrounded by the attributes of the four directions; at its summit is a lion throne which, again following the legend, upholds the great wheel or solar disk. The lesser disks on the plinth enter into the iconography, too: originally these wheels had a precious stone, different for each, inlaid in the hub. This is another part of the magic directional symbolism of western Asiatic origin, since in ancient Mesopotamia different colours and jewels were associated with the quarters, and so, too, were different planets; presumably the lesser disks that are replicas of the great wheel represented the four great planets that were in their ascendant, in conjunction with the sun, at the four equinoxes of the year, suggesting thereby the position of the sun at the four seasons of the year. In other words, it appears that the Sārnāth pillar was a time-and-space symbol, typifying the sun's yearly round through the heavens, and with the concept of the axis and the four directions, including the whole structure of the universe. This cosmology is, of course, pre-Buddhist, and, like so many other early myths and metaphysical ideas that accrued to Buddhism, has been assimilated as an appropriate emblem of the universal

dominion of the Buddha's Law. This emblem could be taken as a partial proof of the pre-Aśokan origin of the whole pillar. The Buddha's turning of the Wheel of the Law is anagogically a turning of the solar wheel, controlling the sun in its diurnal path through the skies. The turning of the Wheel is one of the powers inherent in the early Indian concept of the universal ruler or Cakravartin assumed by the Buddha; the Sārnāth column may be interpreted, therefore, not only as a glorification of the Buddha's preaching, symbolized by the crowning wheel, but also, through the cosmological implications of the whole pillar, as a symbol of the universal extension of the power of the Buddha's Law, as typified by the sun that dominates all space and all time, and simultaneously an emblem of the universal extension of Maurya imperialism through the Dharma. The whole structure is, then, a translation of age-old Indian and Asiatic cosmology into artistic terms of essentially foreign origin, and dedicated, like all Aśoka's monuments, to the glory of Buddhism and the royal house.

As has already been suggested, it is not certain whether all the Maurya columns were actually erected under Aśoka, or whether some of them set up by his predecessors were appropriated by this sovereign for Buddhist usage. This is especially likely in the case of those pillars which are surmounted by the shapes of single animals. The form suggests the royal standards or *dhvaja stambhas* used by pre-Aśokan rajahs; the idea of the animal symbol on a column is of ancient Mesopotamian origin. One of the finest examples of this simpler type is the bull capital from Rampurvā [22]. This is the capital of one of a pair of columns. The companion pillar was surmounted by a single lion, not unlike the finial of the *lāṭ* at Lauriyā Nandangarh. Iconographically, the exact significance of the bull as a symbol in Buddhism is rather difficult to discern; it may have been either a Brahmanic emblem or the heraldic

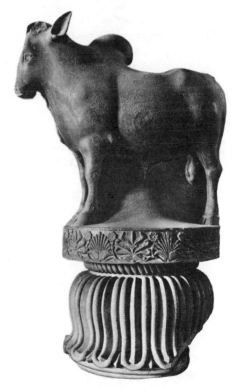

22. Bull capital from Rampurvā.
New Delhi, Presidential Palace

device of an earlier Cakravartin.[13] From the stylistic point of view we notice first of all that the body of the bull is still partially engaged in the core of the block of stone from which it was carved. Aesthetically this serves to connote the virtual emergence of the form from the matrix of the rock in which the sculptor saw it imprisoned. As a technical safeguard it prevents the legs of the image from breaking under the weight of the body.

Very much the same conglomerate rearrangement of older western Asiatic forms that characterizes the Aśokan columns is revealed in another relic of Maurya times, a colossal capital recovered during the first excavations at Pāṭaliputra [23]. It has the stepped impost block, side-volutes, and central palmettes of the Persepolitan order; the bead and reel, labial, and spiral motifs on the lateral face are all of western Asiatic origin; and the rosette ornament of the abacus recalls the frames of the great friezes at Persepolis. Although these elements are combined in a manner different from that of the Iranian capitals, they suggest not only this prototype but, largely through the

23. Capital found at Pāṭaliputra

profile of the projecting volutes, also the Greek Ionic. The explanation of this strange kinship probably lies in the fact that the Greek Ionic, the Persepolitan capital, and the present variant

at Pāṭaliputra are all parallel derivations from one original form such as the Aeolic or, as has been suggested by at least one scholar, from a Sumerian pictograph symbolizing polarity.[14] In the same way, the striking resemblance of this capital to what appears, at first glance, to be a debased form of Ionic in the architectural brackets found in the dwellings of modern Kurdistan, suggests that these simple wooden post-tops and the Maurya capital are both descended from forms of great antiquity, forms of folk art that survive almost unchanged through many strata of culture.[15] The form of the Pāṭaliputra capital with its distinctive projecting volutes is preserved relatively intact for at least a century, as may be illustrated by an example of the Śunga Period in the museum at Sārnāth.[16] Thereafter in the development of the Indian order it is replaced by the more truly Persepolitan form with addorsed animals. It should be stressed that this capital is more properly described as western Asiatic or Iranian, and must not be regarded as an imitation of Greek Ionic: the classic orders found their way to India only during the Parthian and Kushan occupation of the regions south of the Khyber Pass.

The official foreign art sponsored by Aśoka endured no longer than the rule of the Dharma which he sought to impose on his Indian empire: it was presumably unpopular, perhaps because it was symbolic of the Dharmarāja's suppression in his edicts of festivals and other aspects of popular religion. Of much greater final importance for Indian art was the stone sculpture of completely Indian type. Specimens of this survive in the shape of colossal statues of yakshas or nature spirits of Dravidian origin, one of which, now in the Archaeological Museum at Muttra, is more than eight feet high [24].[17] This statue has been the subject of considerable controversy since the time of its discovery at the village of Pārkham. It was once identified as a portrait statue of a king of the

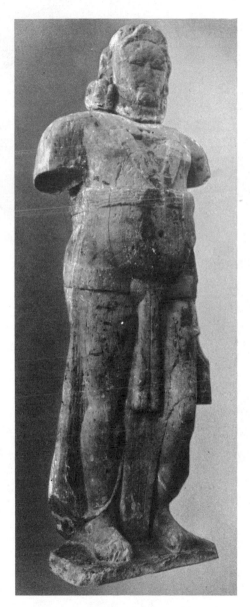

24. Yaksha from Pārkham.
Muttra, Archaeological Museum

Śaiśunāga Dynasty (642–322 B.C.), and at least one authority has tried to attribute it to the Śunga Period. The statue bears an inscription in Brahmi script of the Maurya Period, reading in part: 'Made by Bhadapugarin . . . Gomitaka, the pupil of Kunika'.[18] Except for the indication of torques and jewelled bands, the figure is nude to the waist. The lower part of the body is clothed in a skirt or *dhoti*, a garment worn by Hindus to-day, which consists of a long single piece of cloth wound about the waist and allowed to drop in front in two loops sheathing the legs almost to the ankles. The figure is conceived as frontal, so much so that the sides are completely flattened. It is as though the sculptor had executed a figure in relief to be seen from front and back, and then disengaged it from the enclosing panel. The statue is characterized by no real sense of physical beauty or spiritual meaning. It is a very direct and crude representation of a being or force which, as its superhuman size and power indicate, was to be propitiated by offerings – in other words, a very appropriate characterization of a nature spirit.

This image belongs to an art that is at once archaic and Indian. It is archaic in the completely conceptual representation of the effigy as a whole and in such details as the drapery folds, which are not realistic, but only indicated symbolically by zig-zag lines and shallow incisions in the stone. The statue is specifically Indian in the sculptor's realization of tremendous volume and massiveness, qualities which, together with the scale, give the idol such awesome impressiveness. The quality of surface tautness gives form through a kind of pneumatic expansion. This is no more nor less than a realistic representation of the inner breath or *prāna*; in this respect the yaksha of the Maurya Period is simply a perpetuation of the stylistic character of the torso from Harappā, dated 2500 B.C. The yaksha type, essentially a princely figure, is important, too, as a prototype for the later representations of the Bodhisattva in Buddhist

25. Yaksha from Patna.
Calcutta, Indian Museum

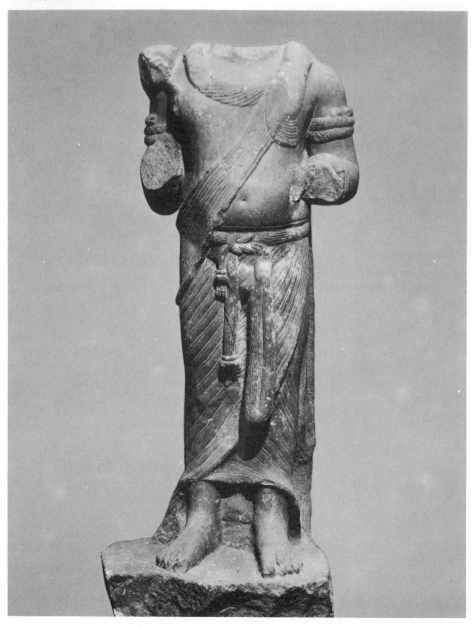

art of the Kushan and Gupta Periods. The crudity and stiffness of the figure, its conception as two reliefs placed back to back, are to be explained by the fact that it represents a translation into stone of methods practised for centuries on a small scale in wood and ivory; the first generations of Indian craftsmen to work in stone still had much to learn about the problems of monumental sculpture in this more difficult medium.

Even in the group of Maurya sculpture classified as popular or Indian, there are certain unmistakable indications of connexions with the art of Iran. The gigantic figure of a yaksha from Patna [25], which may be dated *c.* 200 B.C., has serpentine armlets of an Achaemenid type. And even the carving of the drapery, with its suggestion of texture through the contrast of incised lines and parallel quilted ridges, is reminiscent of the Persepolitan style. Over and beyond these features the figure is entirely Indian in its conception. It has to an even greater degree than the statue from Pārkham an almost overpowering weightiness and glyptic bulk. The very stockiness of the proportions only serves to emphasize the massiveness of the trunk and limbs of the earth spirit.[19]

We see in the art of the Maurya Period a spectacle repeated many times in the history of India; namely, the temporary intrusion and adoption of completely foreign forms and techniques and, what is more important, the development and transcendence over these borrowings of a wholly Indian manner of representing the world of the gods in stone.

*

Except for the ornaments represented in sculpture, like the Achaemenid armlets worn by the yaksha from Patna [25], we have little idea of the jewellery of the Maurya Period. The *Arthaśastra*, a work on statecraft, believed to have been composed by Kautilya in the third century B.C., does contain references to the

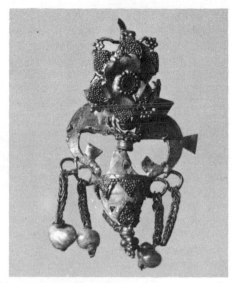

26. Ear pendant from Taxila.
Taxila, Archaeological Museum

adornments suitable for royal personages. Our scant knowledge of the material splendour of this first great period of Indian history is increased by a single earring found in the Bhir mound at Taxila and datable to the second century B.C. [26]. The principal element in this jewel is a pendant composed of an amphora-shaped turquoise encased in gold wire and surrounded by pearls supported by strands of gold filigree. This type of amphora pendant is well known in Greco-Roman and Etruscan jewellery, and may be either an import or a local imitation by Taxila craftsmen.

THE ŚUNGA PERIOD (185–72 B.C.)

The popular dissatisfaction with the religious autocracy of Aśoka, even during that Emperor's reign, led to revolts against the attempted maintenance of centralized authority by his successors. The later history of the Maurya Empire is one of disintegration culminating in the overthrow of the dynasty by one Pushyamitra, who in 185 B.C. murdered the last Maurya emperor and became the founder of the Śunga Dynasty. The centre of the Śunga Empire was still in Magadha – modern Bengal – and extended to Malwa in central India. Although the first Śunga ruler persecuted Buddhism, the religion of Śākyamuni and its art enjoyed one of its great creative periods under the later rulers of this house.

Shortly after the death of Aśoka another dynasty came into power in central and southern India. This was the dynasty of the Āndhras, a people of probable Dravidian origin, whose domains extended from the mouth of the Kistna River above modern Madras to Nāsik in the north-western Deccan, so that at the height of their power the Āndhras governed the waist of India from sea to sea.

The term 'Early Classic' is applied to all the artistic production of these two Indian dynasties because, as will be seen, it marks a gradual emergence from an archaic phase of expression towards final maturity, in much the same way that Greek sculpture of the Transitional Period (480–450 B.C.) bridges the gap between the Archaic and the Great Periods. Indian 'Early Classic' art retains the vigour and directness of archaic, as it prophesies the sophistication and ripeness of the final development of Indian art.

The sculpture of the Śunga Period consists in large part of the decoration of the stone railings and gateways that now surround the Buddhist stupa or relic mound. Examples of these monuments from the early periods have been discovered at Sānchī in Bhopal, Bhārhut in Nagod State, and Amarāvatī on the Kistna River. Before proceeding to an account of their carved décor, something should be said about the character and symbolism of these monuments as a whole [41 and 27].

The stupa or tope was in origin a simple burial-mound, like the pre-Mauryan tumuli discovered at Lauriyā.[1] At the demise of the Buddha, his ashes, following a custom long reserved for the remains of nobles and holy men, were enshrined under such artificial hills of earth and brick. These were the original Eight Great Stupas mentioned in Buddhist texts, all traces of which have long since disappeared. No pre-Aśokan stupas have been discovered, and there is no mention of veneration paid to relic-mounds in Buddhist literature before the Maurya Period. The Emperor Aśoka is probably responsible for the institution of stupa-worship as a part of his policy for using Buddhism as an instrument of imperial unity in his state. It is recorded that the pious Emperor distributed the surviving bodily relics of the Buddha into stupas erected in all the principal towns of the realm. Apart from the miraculous properties assigned to the Buddha's relics, the worship of his natural remains enabled the worshipper to think of the Buddha as an imminent reality, by conferring his personal allegiance and love on these fragments of the

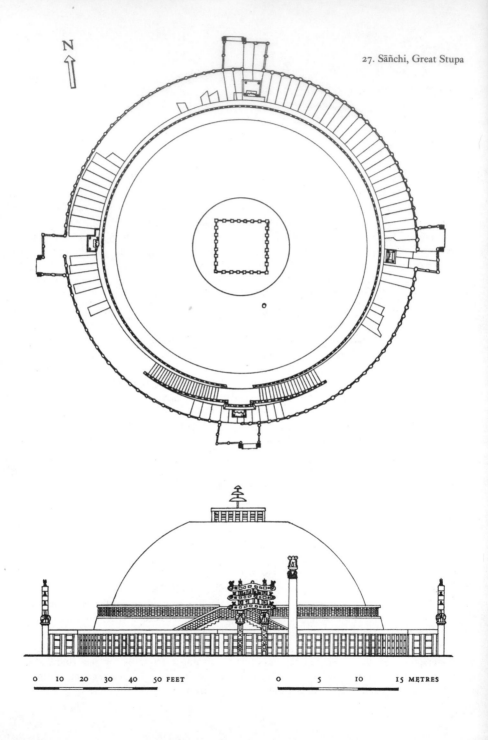

N

0 10 20 30 40 50 FEET 0 5 10 15 METRES

mortal body of the Buddha who had vanished into the void of Nirvāṇa. It followed that the stupa itself came to be regarded as an outward and visual manifestation of the Buddha. By conferring on the relics of Buddha the sepulchral monument reserved for royal burials, Aśoka can be said to have promulgated the concept of the Buddha as Cakravartin or world ruler.

It is definitely known that elaborate geomantic ceremonies determined the orientation of the stupa, and the most precise system of proportions fixed the measurement of the whole and its every member. It is for this reason that the stupas have something of the same mathematical perfection of sheer architectural form and mass that we find in the pyramids. The architectural effectiveness of the stupa depends on the alternation and balance of round and square shapes. The completely undynamic character of stupa architecture is thoroughly expressive of its function of enclosing and guarding the relic and its symbolism of the fixed cosmic structure. Over and above its purely funerary function, the stupa and its accessories had come to be invested with an elaborate symbolism, stemming in part at least from the cosmography of western Asia. Like the Mesopotamian ziggurat, the basic concept of the stupa was an architectural diagram of the cosmos. Above the square or circular base of the stupa rose the solid and hemispherical dome or *aṇḍa*, which was intended as an architectural replica of the dome of heaven, enclosing the world-mountain rising from earth to heaven. In the architecture of the stupa the presence of this world-mountain was suggested only by the *harmikā*, a balcony-like member at the summit of the mound that typified the Heaven of the Thirty-three Gods located at the summit of the cosmic peak enclosed within the dome of the sky. The symbolism was completed by the mast or *yaṣṭi* which rose from the crown of the dome. This member typified the world axis extending from the infra-cosmic waters to the empyrean,

and in certain stupas its symbolical function was made even more specific by an actual wooden mast penetrating the solid masonry dome. Above the dome proper this mast served as a support for tiers of circular umbrellas or *chattras* symbolizing the devalokas or heavens of the gods culminating in the heaven of Brahma. The stupa was in a sense also a sort of architectural body replacing the mortal frame which Śākyamuni left behind at his Nirvāṇa. The concept of the architecture of the stupa as a cosmic diagram and its animation by the enshrining of relics probably had its origin in the altar of Vedic times, which was animated at its dedication by the insertion of a human sacrifice, whose soul was regarded as a replica of the spirit of the Cosmic Man, Mahāpuruṣa.[2]

Just as these concepts of Mesopotamian and Vedic origin determined the form and function of the stupa-mound, so the architecture of the surrounding railing and the actual ritual of veneration may be traced to pre-Buddhist solar cults. The ground-plan of the railing, with the gateways at the four points of the compass describing the revolving claws of a swastika, is no accident, but a purposeful incorporation of one of the most ancient sun symbols. A reminiscence of solar cults may certainly be discerned in the prescribed ritual of circumambulation, in which the worshipper, entering the precinct by the eastern gateway, walked round the mound in a clockwise direction, describing thereby the course of the sun through the heavens. This would seem to bear out the theory maintained by many scholars that the Buddha's mortal career was adapted later as an allegory of solar myths. The practical function of the railing or vedikā was to separate the sacred precinct from the secular world. The decoration of the stupas of the early period was limited almost entirely to the sculpture of the railing and the gateways.

One of the principal stupas surviving from Śunga times is the relic-mound at Bhārhut in north central India. Remnants of its railing and

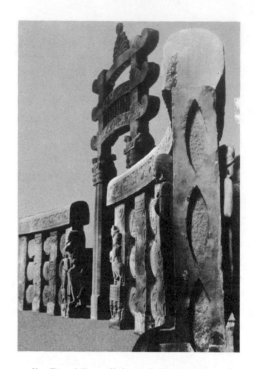

28. Railing and gateway from Bhārhut.
Calcutta, Indian Museum

gateway are preserved in the Indian Museum at Calcutta and in a number of European and American collections [28]. At Bhārhut and elsewhere the gateways or toraṇas are imitations in stone of the wooden portals of early Indian towns, and in the same way the construction of the railing itself is an imitation in stone of a post-and-rail fence with lens-shaped rails fitted to openings in the uprights [41 and 27]. At Bhārhut there are three rails surmounted by a heavy stone coping. The decoration of the one surviving gateway is a conglomerate of forms of western Asiatic origin, including palmettes and Persepolitan capitals in the shape of addorsed sphinxes. Most prominent in the decoration of the railing are the carvings of yakshas and yakshīs on the uprights. These divinities who populate the ambulatory at Bhārhut are really only a degree above humanity. They are the wild and bloodthirsty nature-spirits of the earlier Dravidian religion subdued and brought into the fold of Buddhism in much the same way that pagan deities took their place in the hierarchy of Christian saints. In addition we find medallions filled with floral motifs, busts of turbaned rajahs, Jātaka tales, and scenes from the life of Buddha.

One of the most frequent motifs of the Bhārhut railing is the *dohada*, a woman or yakshī embracing a tree, usually the flowering *śal* [29]. This is a symbolism that goes back to a period in Indian history when trees were regarded as objects of worship, and is associated with old fertility festivals, when youths and maidens gathered the flowers of the śal tree. Although the exact original meaning of the motif is not known, there are many Indian legends relating the power of women and yakshīs to bring trees into immediate flowering by embracing the trunk or touching it with their

29. Yakshī (Chulakoka Devatā) from Bhārhut.
Calcutta, Indian Museum

30. Kuvera, King of the Yakshas, from Bhārhut.
Calcutta, Indian Museum

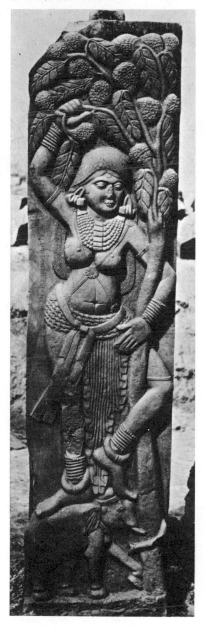

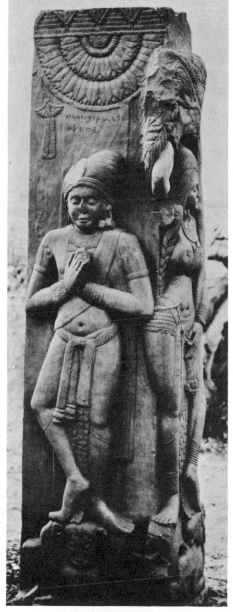

feet. The embrace of the yakshī and the tree that yearns for her quickening touch is a memory of some ancient fertility rite, and may be interpreted as symbolical of the soul's union with the divinity, often typified in India by the metaphor of sexual union. In Indian mythology the yakshī is first and foremost a fertility symbol. She is not only the bride of the tree, but she stands for the sap of the tree, the life-fluid, and she may therefore by association be interpreted as emblematic of the life-fluid of all creation, as typified by the great waters, in which all life was believed to have its origin. The male counterparts of the yakshīs, or yakshas, are also represented on the Bhārhut railing, and Kuvera, chief of the yakshas and guardian of the North, is among these deities precisely identified by an inscription [30].[3]

The carving of these figures of tutelary spirits, as well as the workmanship of the medallions and gateways, varies considerably in quality and technique. These differences are probably to be explained by the fact that the sculpture was a work extended over many years and executed by many different craftsmen from all parts of India, as attested by the masons' marks which are incised in the stones. These figures carved in relief are essentially a continuation of a stylistic and technical point of view already discerned in the sculpture of the Maurya Period. The representation of the human figure is in every case conceptual rather than realistic. In the portrayal of the yakshīs there is an emphasis on the attributes of fertility in the swelling breasts and ample pelvis. Certain attributes of fertility already recognized in the prehistoric figurines are still present in the shape of the beaded apron and the crossed scarves or *channavira*. The veritable harness of necklaces and strings of amulet boxes, with which the figures are bedecked, serves a function beyond the possible iconographical significance and the reflexion of contemporary taste, in that the very sharpness and precision with

which these jewelled ornaments are carved connote by contrast the softness of the flesh parts that are rendered in smooth, unbroken convex planes. As in the free-standing statues of the Maurya Period, the conception of the body in terms of a collection of interlocking rounded surfaces is the sculptor's device to suggest the expanding inner breath or prāṇa, as well as the quality of flesh in stone.

The figure sculpture at Bhārhut must be described as completely archaic in character. The individual figure is composed of an enumeration of its multiple details, as though, by this cataloguing, the sculptor was striving to give a cumulative account of the subject and to disguise his inability to present it as an organic whole. A typical example of this method is to be seen in the treatment of the drapery of the standing yakshī figure [29]. Although the garment itself is completely flat, there is an emphatic definition of the borders and seams of the skirt, so that the whole can be described as an ideographic and entirely legible presentation of the idea of drapery, without in any way suggesting its volume or separateness from the body enclosed. The conventionalization of the drapery folds in long parallel pleats, with borders in the shape of chevrons or the letter 'omega', reminds us of the treatment of drapery in such archaic Greek figures as the Acropolis maidens. This resemblance may be explained either as an influence coming through the relief sculpture of Achaemenid Iran or, perhaps more logically, as an illustration of an entirely parallel development, whereby sculptors in the archaic phase arrive at similar formulas or conventions in their struggle to represent reality. The descriptive character of the style extends to the very precise definition of every detail of the multiple necklaces and anklets worn by the figure. These details, for all the nicety of their carving, by the very insistence of their attraction to the eye, actually serve to destroy the form in its entirety. The body as a whole is, of course, no

more than the sum of its parts almost mecha-
nistically joined. There is a certain attempt on
the part of the sculptor to impart rhythmic
movement to the figure by the repeated shapes
of the left arm and leg. Neither this nor any of
the figures at Bhārhut suggests the idea of a
volume that could exist three-dimensionally.
They are all conceived fundamentally as reliefs,
and appear to be quite consciously flattened as
much as possible against the background of the
uprights to which they are attached. It is
possible that this flattening of the relief was a
conscious attempt to make the figure an integral
part of the vertical accents of the railing
uprights.

At this stage of Indian sculpture it is probably
reasonable to conclude that such rhythmic
posturing of the body as is achieved by the alter-
nation of thrusts of arms and legs is intuitive,
and not the result of the sculptor's following any
prescribed recipe for effective and appropriate
posture. The exquisite precision of carving, the
delight in surface decoration, and the essentially
shallow character of the relief make it appear
likely that the sculpture as well as the architec-
ture of Bhārhut is a translation into stone of the
wood-carver's or ivory-carver's technique. The
figures are all characterized by a certain rigidity
combined with a rather wistful *naïveté*. That the
craftsmen were aware of some of the problems
of monumental architectural sculpture is re-
vealed by the way in which the contours of the
forms are cut at right angles to the background
of the panel, so as to ensure a deep surrounding
line of shadow to set the figure off against its
background.

The composition and technique of the railing
medallions are in every way similar to the
figures carved on the uprights. A single medal-
lion from the railing at Bhārhut will serve to
illustrate the method and the capacity of these
carvers [31]. Entirely typical are the illustrations
of Birth stories, such as the *Ruru* or *Mṛga
Jātaka*, when the Buddha lived as a golden stag

31. Medallion with Ruru Jātaka from Bhārhut.
Calcutta, Indian Museum

in the forest of the Ganges Valley. On a certain
occasion he rescued a wastrel nobleman from
drowning in the river. When this ingrate heard
that a reward was offered by the King of Benares
for information regarding the location of a
miraculous golden deer seen by his Queen in a
dream, the nobleman reported his discovery to
the monarch. When the King set out to hunt the
golden stag, he was at once persuaded to drop
his bow by the eloquence of the creature's
speech. In the panel at Bhārhut the story is
related in three consecutive episodes contained
within the frame of the circular panel: in the
lowest zone is the stag rescuing the drowning
man from the river; at the upper right the Rajah
of Benares draws his bow, and in the centre of
the panel clasps his hands in reverence before
the golden stag. The panel is illustrative of the
extremely elementary method of continuous
narration employed by sculptors at this stage of
the development of a narrative style. The figures
symbolized in the consecutive episodes of the

story are in a way quite effectively isolated from one another, so that the observer is persuaded to regard them as separate happenings. The details of setting consist of only three conceptually represented trees in the upper part of the medallion and five does at the left that represent the herd of the golden stag. There is only the most rudimentary suggestion of space within the relief created by very timid overlappings and the placing of figures one above the other. The result of this treatment is the creation of a strangely timeless and spaceless ambient that is not without its appropriateness for the narration of heroic myth.

The representation of the Jātaka stories and scenes from the life of the Buddha could again be described as conceptual, since the figures of men and animals are invariably represented from that point of view which the memory recognizes as most typical of a thing or a species. As we have seen, the method of continuous narration is universally employed; that is, a number of successive episodes from the same story are represented within the confines of the same panel. In this archaic method, to suggest the fluctuations of happening, the chronological associations which are stored all together at one time in one picture in the artist's mind are represented simultaneously as they exist in the mind of the craftsman. The method of continuous narration, the employment of vertical projection and conceptual form, should be regarded partly as naïve and due to the inability to resolve representational problems, and partly as the result of the traditional craftsman's realization that events from the world of myth, apart from time and space, cannot properly be represented in any other way. In the archaic art of India, as in the traditional art of all ancient civilizations, the artist represents what his mind knows to be true, rather than what his eye reports. In the magic world of the heroic legend, a world of no time and no place, where anything can happen as it does in dreams, there is no need for scientific accuracy. Since, in the world of the gods, space and time are one, it would be impossible to think of anything corresponding to the Western Classic world's interest in the fugitive moment. The problem of the sculptor of the decorations of the stupa railing was to present the worshipper with the most direct and easily readable symbols of the Buddhist legends, a problem in which the extreme simplification of the theme was conditioned in part, at least, by the shape and dimensions of the medallions. The necessity for simplification imposed the isolation of the individual elements of the composition like so many parts of a pattern against the plain background. For all its effectiveness, technical as well as iconographical, one cannot overlook the fact that this method of carving must have been the result of the workman's unfamiliarity with the stone medium.

Another set of carvings – perhaps the very earliest monuments of Śunga art – that clearly demonstrates the painful emergence of a native tradition of stone-carving is the ornamentation of the second stupa, generally designated 'Stupa 2', at Sānchī in Bhopal State. This relic mound, located to the west and below the Great Stupa of the Early Āndhra Period, was a foundation of the Śunga rulers of Malwa in the last quarter of the second century B.C. When it was opened in the nineteenth century, the dome was found to contain relics of two disciples of the Buddha, together with remains of ten Buddhist saints who participated in the Buddhist council convened by the Emperor Aśoka in 250 B.C. The stupa proper is of the simplest type, consisting of a circular base supporting the actual hemispherical cupola; around this was constructed a sandstone railing with its gateways disposed like the claws of a swastika attached to the circular plan of the enclosure. The sculptural decoration consists of medallions carved on the uprights of the interior and more complicated rectangular panels emphasizing the posts of the actual entrances. The subjects of the medallions

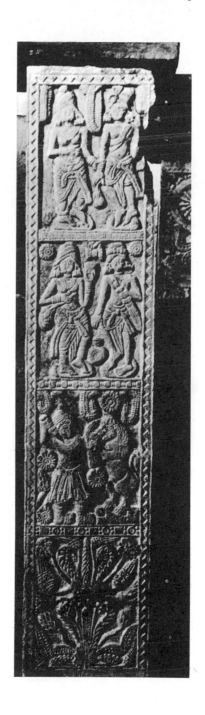

32. Sāñchī, Stupa 2, medallion with Yakshī Assamukhi

33 (*right*). Sāñchī, Stupa 2, railing pillar

[32] are generally restricted to a single figure or
a motif set off by realistic or decorative foliate
forms, such as the Wheel and the Tree, to
typify moments from the life of the Buddha, or
animals and birds intended to evoke the stories
of his former incarnations. The repertory of
motifs is not large, and is probably copied in
stone from ready-made prototypes in wood or
ivory. Typical of this earliest phase of relief
sculpture are the panels decorating the outer
jamb of the eastern gateway [33]. In the upper
panel are represented a man and woman who
may perhaps be identified as donors or as an
early instance of the *mithuna*, the auspicious
pair emblematic of fruitful union. In the lower
panel is a turbaned personage with shield and

dagger confronted by a rampant lion. This latter motif, reminiscent of a favourite subject of the Achaemenid art of Persepolis, showing the great king in combat with a leonine monster, almost certainly represents a borrowing from the repertory of western Asiatic art forms. In both these reliefs the figures and the floral accessories that fill every available space are carved in only two planes. The contours of every element in the composition are cut directly at right angles to the flat background, as though the sculptor were too unfamiliar to venture any subtleties of transition. This is a method of carving that in a way recommends itself for the glare of Indian sunlight, since it provides a deeply shadowed reinforcement to the silhouettes of individual forms that comes to be very subtly exploited in later periods of Indian art. The treatment of these flat, decorative figures is entirely conceptual, and in the ground of the lower panel we see the first instance of the block-like, almost cubistic stylization of rock-forms that survives as a

34. Cakravartin from Jaggayyapeṭa Stupa.
Madras, Government Museum

35 (*opposite*). The Paradise of Indra from Bhārhut.
Calcutta, Indian Museum

regular convention of Indian painting and sculpture of later centuries. A very curious detail in the upper panel is to be seen in the plinths or pedestals on which the figures are standing. This might be taken as a convention to indicate that they are placed on some solid mound or eminence. Another explanation, which cannot be proved, is that these are representations not of personages real or mythical, but of cult images or statues, since even in the Maurya Period the yaksha figures were fashioned with attached bases or plinths.

These same supports are placed under all the figures in a relief from eastern India that must be dated in exactly the same period of development. This is a carving from the stupa at Jaggayyapeṭa near Amarāvatī on the Kistna River [34]. It represents the Cakravartin or ruler of the world, surrounded by the Seven Jewels of his office.[4] This relief, carved in the greenish-white limestone characteristic of this region of eastern India, is in every way the stylistic equivalent of the sandstone panels of

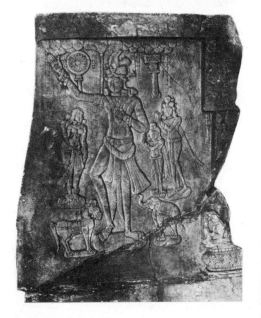

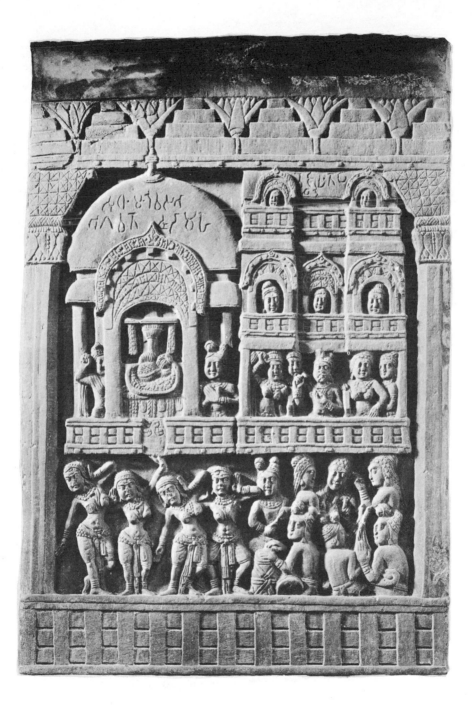

Sāñchī. It is an illustration of how little regional differences exist between works of art made in widely separate parts of India. We find here the same mechanistically constructed figures, flattened out and attached to the background in exactly the same fashion. The modelling consists of little more than a slight rounding of the contours, and the detailed definition of every feature of costume and ornament is executed almost entirely by linear incisions in the stone. The only real differences between these two carvings from the opposite coasts of India lie in the greater precision of carving in the Jaggayyapeta slab, made possible by the nature of the stone, and the more elegant attenuation of the figures in this same relief that seems to herald the towering, graceful forms in the sculpture of the Later Āndhra Period at Amarāvatī.[5]

We have already encountered this same tendency to isolation and enumeration of detail in the medallion reliefs from Bhārhut. Although many of these are scarcely more developed in style than the carving of the oldest stupa at Sāñchī, some of the sculptors at Bhārhut were adventurous enough to assay relatively complicated arrangements of figures and setting. Such, for example, is the representation of the veneration of the Buddha's head-dress in the Paradise of Indra [35]. We shall return to this relief presently, since it furnishes us with a representation of a free-standing chaitya-hall which will be compared with the rock-cut sanctuaries to be discussed below. The figures of dancing celestial maidens and the gods watching the nautch are carved with some concern for their relative scale to the building, and the carver has even attempted to create an illusion of space by overlapping figures.

The decoration of the stupa at Bhārhut was at one time dated as early as 150 B.C., but a comparison with the carvings ornamenting Stupa 2 at Sāñchī clearly reveals that the Bhārhut fragments must belong to a later period

of development, probably no earlier than 100 B.C. The Bhārhut sculpture represents a distinct improvement over these primitive efforts. Although still too descriptive in the enumeration of surface details, the sculptors of the figures of yakshas and yakshīs are certainly more successful in evoking a feeling of plastic existence in the forms. The sculptors of the panels and medallions are no longer restricted to stock decorative themes and a few figures painfully combined in relief, but now venture into a more complicated relation of narratives from the Buddha story involving the manipulation of many separate figures and the illusion of their existence in space.

A monument certainly to be associated with the very early Śunga Period is the old *vihāra* at Bhājā, a sanctuary located in the green hills of the Western Ghats to the south of Bombay [59]. The vihāra, a monastic retreat for the Buddhist brethren during the rainy season, consists of a rectangular chamber or porch hollowed out of the rock, with individual cells for the accommodation of the brothers. The carved decoration of the Bhājā monastery consists of panels with representations of yakshas and, on either side of a doorway at the east end, reliefs of a deity in a four-horse chariot, and, confronting him, a personage on an elephant striding through an archaic landscape. We would certainly be right in identifying the subjects of these reliefs as representations of the Vedic deities Sūrya and Indra [36 and 37]. Sūrya, like the Greek Apollo, drives the solar quadriga across the sky, trampling the amorphous powers of darkness that appear as monstrous shapes beneath the solar car. Gigantic Indra rides his elephant Airāvata, the symbol of the storm-cloud, across the world.[6] It might at first seem difficult to explain the presence of these Vedic titans in a Buddhist sanctuary. Actually, they are here, not *in propria persona*, but as symbols of the Buddha who has assimilated their powers. Sūrya and Indra are

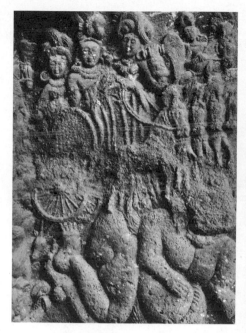

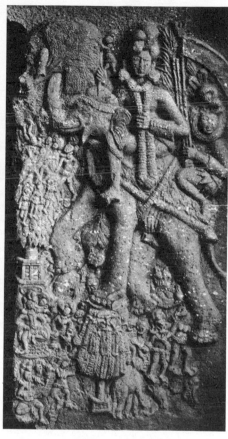

36. Bhājā, vihāra, relief of Sūrya

37 (right). Bhājā, vihāra, relief of Indra

allegories of Śākyamuni, as Orpheus in early Christianity is an allegory of Christ. Sūrya is there to designate the Buddha as the sun and spiritual ruler of the universe, or Buddha as the sun that illuminates the darkness of the world. Indra, the chief of the Vedic gods, is here to designate the temporal power that the Buddha wields to maintain the stability of the universe. The landscape through which Indra drives, unaffected by the storm of the god's passage, is made up of a variety of interesting details. At the centre left is a tree surrounded by a railing proclaiming its sanctity, and from its branches hangs a sinister fruit, the bodies of human victims sacrificed to the spirit of the tree. Below this is a dancing-girl performing before a seated Rajah. Far to the right, in the lowest zone, is a favourite subject of early Buddhist sculpture: the cannibalistic, horse-headed yakshī, Assamukhi, who was converted from her man-eating habits by the power of the Buddha. This relief at Bhājā is a perfect translation into stone of the Indian concept of the universe as a mass replete with formless, fine matter, of which all living forms are concretions and transformations. Just as the Indian conception of the universe peoples

every atom of space with a million million sentient beings and devas, so the relief at Bhājā is crowded with an infinite variety of forms. Here again, as at Bhārhut, is the simultaneous action and simultaneous space of the dream-image. The device of vertical projection is employed at once to indicate recession in space and to communicate the simultaneous happening of all these events. We notice also that not only the form of Indra, but all the separate forms in the relief, are carved as though emerging from the matter of the rock that imprisons them, to indicate that eternal process of becoming, that emergence of all living things from the limitless space-matter or *māyā*. Here, as throughout the whole fabric of Early Classic art in India, we have a syncretic combination of philosophical and metaphysical tenets of Vedic and Upanishadic origin, and a piquant and powerful naturalism that marks the coalescence of the Aryan and Dravidian heritage in Buddhism and its art.

Another monument which should be mentioned to complete our survey of Buddhist art in the Śunga Period is the railing at the famous Mahābodhi temple at Bodh Gayā. Originally erected to enclose the area where the Buddha walked after his Illumination, the ground-plan of the railing is rectangular rather than round. The carving consists in the decoration of uprights and railing medallions and, presumably, is a Śunga dedication of the middle decades of the first century B.C. The medallions are filled with a repertory of fantastic beasts of western Asiatic origin, which, in the heraldic simplicity of their presentation, are prophetic of later Sasanian motifs.[7]

A typical relief from one of the uprights is a representation of the sun-god Sūrya [38]. Here, as at Bhājā, the Vedic deity is present in an allegorical capacity, with reference to the Buddha's solar character.[8] Sūrya is represented in his chariot, drawn by four horses and accompanied by the goddesses of dawn, who

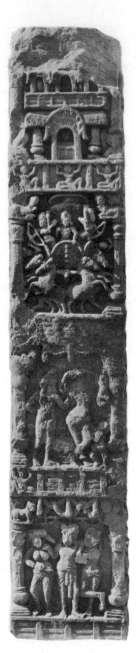

38. Bodh Gayā, railing pillar with Sūrya

discharge their arrows at the demons of darkness. This representation of the sun-god in a quadriga is sometimes interpreted as an influence of Hellenistic art, although stylistically there is nothing beyond the iconography to remind us of the characteristic representations of Helios in Classical art, in which the solar chariot is invariably represented in a foreshortened side view. The concept of a sun-god traversing space in a horse-drawn chariot is of Babylonian and Iranian origin, and spread from these regions to both India and Greece; so that the representation is simply an interpretation of the iconography, and not the borrowing of a pre-existing stylistic motif. In the Bodh Gayā relief the chariot is seen in front view, but the horses are deployed to right and left of the axle-tree so as to be shown in profile. This is simply another instance of the conceptual point of view. It is an arrangement that also conforms to the archaic fondness for symmetrical balance. Although constructed on this essentially archaic framework, the relief displays considerable skill in the carving of the group in the deep, box-like panel with a definite suggestion of the forms emerging from space, achieved by the overlapping of the forms of the horses and the discomfited demons.

Another Vedic god whom we encounter on the railing at Bodh Gayā is Indra [39]. He is represented carrying a handful of grass, in allusion to the occasion when, disguised as a gardener, the chief of the gods brought the straw on which the Bodhisattva took his seat beneath the bodhi tree.[9] The figure of Indra is so deeply carved as to seem almost as if stepping out from the flat background of the pillar. Although essentially frontal in its conception, the figure is cast in an almost violent pose of *déhanchement*. It is as though the sculptor were trying to suggest the figure actually walking forward to present the bundle of grass. The body is carved with the same interest in revealing the fleshly fullness of form that Indian

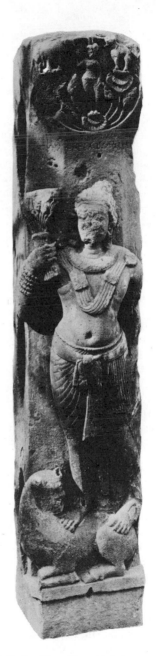

39. Bodh Gayā, railing pillar with Indra

sculptors of even earlier periods had possessed, but for the first time with a suggestion of the body as an articulated whole, rather than as the sum of its individual parts. This figure need only be compared with the representations of nature-spirits at Bhārhut [30] to see the change that has taken place in the craft of sculpture in less than one hundred years. A feature of iconographical note that is of special importance for the later representation of the Buddha in human form, is the topknot, perhaps a 'realistic' portrayal of the Brahmin hairdressing, but clearly a prototype for the Buddha's *ushnisha* or cranial protuberance. At the top of the pillar above the figure of Indra is a low relief medallion representing Lakshmī, the goddess of dawn, receiving a lustral bath from two elephants.[10]

The recent excavation and conservation of the cave temples at Pitalkhora has added another chapter to our knowledge of Early Classic art in India.[11] This site, the Petrigala of Pliny, is located in a remote and picturesque defile of the Deccan within a radius of fifty miles of Ajaṇṭā and Ellūrā on the ancient trade route that linked these sites with Karlī, Nasik, and Bhājā in its progress from the coast. These caves, first superficially explored in the nineteenth century, comprise some thirteen chaityas and vihāras. The earliest are Hinayāna sanctuaries of the second century B.C., and a later group was added in the fifth and sixth centuries A.D. One of the most impressive of these grottoes is Cave IV, the great vihāra. It was originally decorated with a massive sculptured façade which has largely disintegrated with the breaking off of huge blocks through the fissuring of the stone. The fragments recovered from this debris reveal the importance and richness of the relief treatment, which is far more elaborate than any rock carving at other early sites. A number of inscriptions in this monastery may be dated in the second–first centuries B.C. This chronology is supported by the style of a fragment of relief representing a royal couple with attendants

[40]. Probably this was part of a long frieze representing a Jātaka story. As in some of the later reliefs from Bhārhut [35], the relief is densely crowded with figures in several overlapping planes. In spite of the friable character of the trap rock, the carving is remarkably sharp and precise, with an enumeration of textural details, such as the fur cover of the royal couch, that surpasses anything found at Bhārhut. This technical trait extends to the portrayal of the elaborate jewels that decked the queen and her attendants. This relief is one of the earliest examples of the portrayal of elegant, sensuous relaxation that has so often engaged Indian sculptors and painters. As though enacting a rapturous dream, the faces of the royal lovers are imbued with a drowsy sweetness of expression complemented by their soft, lolling poses. Although the rather short proportions and the additive method of composing human forms favoured at Bhārhut are still in evidence, the figures, especially the more svelte forms of the king and queen, are, properly speaking, more organically articulated, and their lithe, sensuous bodies anticipate the climax of Early Classic art at Sāñchī, as does the new pictorial depth of the relief.

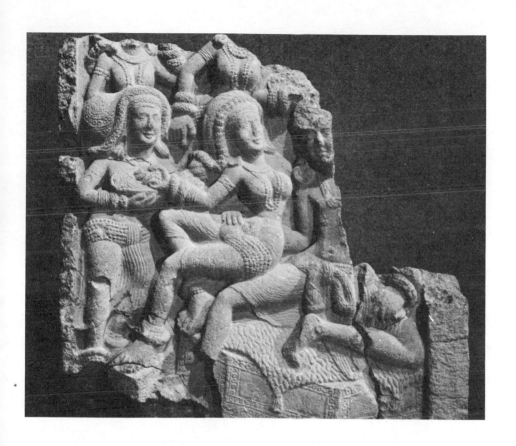

40. Relief with a royal couple from Pitalkhora.
New Delhi, National Museum

THE EARLY ĀNDHRA PERIOD (72–25 B.C.)

The final and perfect balance of the tendencies described in the preceding chapter is attained in the great monument of the Early Āndhra Period: the sculptural decoration of the four gateways of Stupa No. 1 at Sāñchī [41]. The mound of the great stupa at Sāñchī was originally an Aśokan foundation which was enormously enlarged by the patronage of the Āndhra Dynasty. It was probably in the early decades of the first century A.D. that the monument received its principal embellishment in the form of the railing and the toraṇas at the four points of the compass. Unlike the enclosure at Bhārhut, the Sāñchī railing is completely devoid of ornament, and the sculptural decoration is concentrated upon the gateways. The southern portal is usually regarded as the earliest of the four, and is remarkable chefly for its lion capitals, which were almost certainly copied from the Aśokan column that stood not far from the site. This work was followed, in order, by the carving of the north, east, and west portals.

The most notable of the four toraṇas from the iconographic and artistic point of view is the eastern gateway [42]. It should be pointed out that, since there is no unified iconographic scheme either for the sculptural decoration of the monument as a whole or for the ornamentation of the individual portals, it may be that the disparate subjects haphazardly combined may have been dedicated by individual donors who specified what they wished the craftsmen to

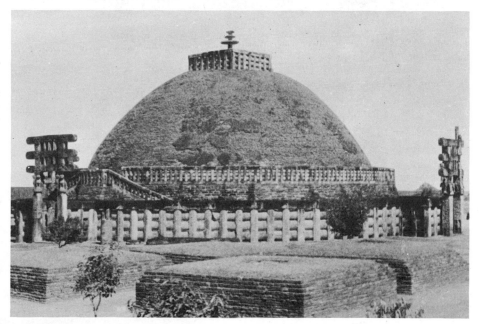

41. Sāñchī, Great Stupa, from the north-east

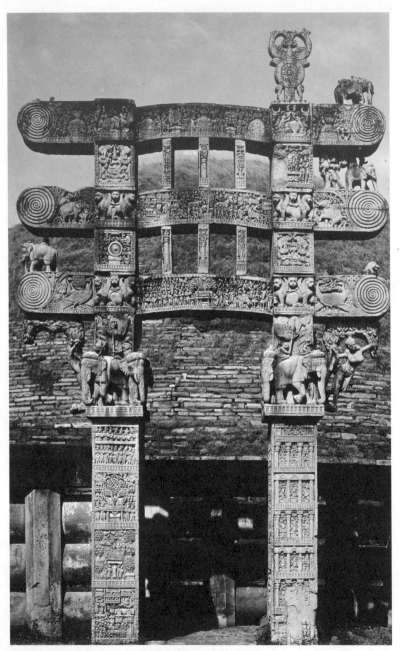

42. Sāñchī, Great Stupa, east gate

represent in the allotted space. Students of Far Eastern art will recall that in the Chinese cave-temples of Yün Kang and Lung Mên we find innumerable individual dedications of Buddhist figures and reliefs carved without regard to any unified iconographical scheme.

Our photograph of the outer face of the east gateway illustrates the architectural arrangement usual to these toranas and the distribution of their iconography. The superstructure is supported by massive blocks, sculptured with figures of elephants shown as though processing round the actual capital. Between the cross-bars or architraves are square blocks with symbolical representations of events from the life of the Buddha. There are two panels of Lakshmī typifying the Nativity; the Enlightenment is indicated by the tree and empty throne; and the Preaching at Sārnāth, by the wheel. Further references to these same themes with the throne and what appears like a relief of an Aśokan column occur on the vertical props between the cross-bars. These architraves are built as though actually passing through the uprights in a manner suggestive of earlier wooden architecture. It is possible that these long horizontal panels terminating in tightly wound spiral volutes are a transference to stone of popular picture scrolls partly unrolled for exhibition.[1] In our view of the gateway we can recognize in the upper cross-bar representations of the Buddhas of the Past, typified by stupas; in the centre, the Great Departure; and, in the bottom panel, Aśoka's visit to the Bodhi Tree. To right and left of the main subject in this lowest bar may be seen richly carved peacocks, perhaps intended only as decoration, but very possibly referring to the heraldic emblem of the Maurya Dynasty. The top of the gateway at Sāñchī was originally crowned with triśūla or trident symbols, one of which remains in place at the right, and probably by a central palmette motif, such as may still be seen on the one surviving gateway from Bhārhut [28]. The complete gateway to be seen in illustration 42 shows the decoration of the outer jambs of the torana: at the left, reading from top to bottom, the Great Enlightenment, the Conversion of the Kāśyapas, and the Departure of King Bimbisāra from Rājagriha; at the right, representations of the Heaven of Brahma and the Paradises of the gods.

Originally there were two figures of yakshīs in the round, supported by a mango bough enclosed as a spandrel between the uprights and the lowest architrave. One of these figures to the north is still in position [43]. It is a drastic and dramatically effective adaption of the woman-and-tree motif that we have already encountered at Bhārhut. Although the thrust of the body and limbs is conceived with a wonderful intuitive sense of the architectural appropriateness of this particular figure for the space it was to fill, the form, perhaps by the sculptor's intent, is not conceived in the full round, but is sculptured as two high reliefs placed back to back, with little or no modelling bestowed upon the lateral sections. Actually, the figure was meant to be seen only from directly in front, or in the rear view afforded the visitor from the upper processional path on the drum of the stupa. Although functionally the image plays no part in the support of the gate, it would be hard to imagine anything more simple, yet more dramatically effective both from the iconographical and aesthetic points of view, than this presentation of the tree-spirit. Her legs thrust with the force of a buttress against the trunk of the tree, and from this magic touch its encircling boughs flower and receive the caressing grasp of the yakshī, so that she seems like a living vine, part of the tree that she quickens. The figures of yakshīs at Sāñchī, like the reliefs at Bhārhut, are here as survivals of earlier nature cults which had been accepted by Buddhism and which nothing would eradicate from the popular mind. 'These figures of fertility spirits are present here because the people are here. Women, accustomed to invoke the blessings of a tree spirit,

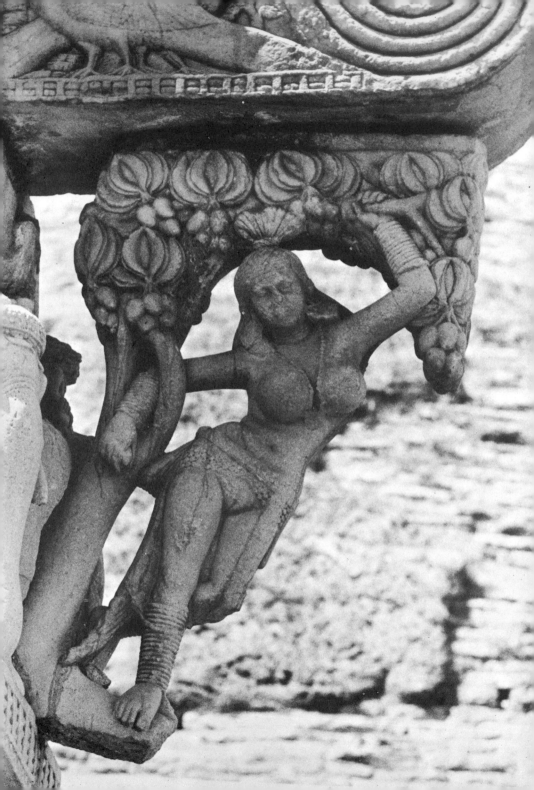

would approach . . . (these) . . . images with similar expectations.'[2] Although their presence confirms acceptance by the Buddhist Church, their provocative charms seem almost symbolic of that world of illusion that the worshipper leaves behind when he enters the sacred precinct. The effectiveness of this yakshī and the figure from the south gate of Sāñchī in Boston [44] does not, in comparison with the Bhārhut yakshī, depend on any closer imitation of a natural model, but on the sculptor's more successful realization of form within essentially the same conceptual framework. The advance is not within the direction of naturalism, but in the more plastic articulation of the body itself and the dynamic vitalization of the form. We have an even more notable connotation of the quality of flesh in stone achieved by the essential shapes and interlockings of smooth convex surfaces that suggest, rather than describe, the softness and warmth of a fleshly body. The suggestion of flesh and the swelling roundness of form is denoted further by the constricting tightness of the belt and by the contrast of the straight and angular tubular limbs with swelling convexities of bust and pelvis. A sense of vitality is communicated by the tense twisting of the torso on its axis. In the frankness of their erotic statement the Sāñchī yakshīs are a perfect illustration of the union of spiritual and sensual metaphor that runs like a thread through all religious art in India.

43. (*left*) Sāñchī, east gate, yakshī

44. Yakshī from south gate, Sāñchī.
Boston, Museum of Fine Arts

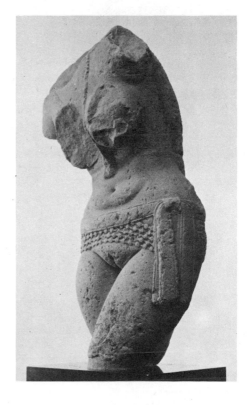

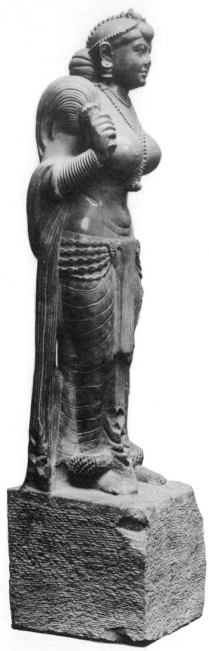

45. Yakshī from Dīdargañj (Patna).
Patna, Archaeological Museum

As has been already mentioned in the preceding chapter, the gigantic statue of a yakshī found at Patna [45], formerly assigned to the Maurya Period, finds its proper chronological place in the same period with the figures of tree-spirits on the Great Stupa at Sāñchī. In the Patna figure and its counterparts at Sāñchī we see for the first time the sculptural realization of a full and voluptuous form with a definite sense of its organic articulation. Many of the devices of the Sāñchī sculptors are here, such as the pendant necklaces falling in the hollow between the breasts and setting off their globular fullness, and the tightness of the beaded apron compressing the flesh of the hips and abdomen to emphasize the fullness and softness of the swelling flesh. The whole figure is conceived with an almost abstract sense of mathematical volumes, so that the dominantly spheroidal shape of the head is echoed in the bosom, and again in relief in the rounded contours of the abdomen. It seems almost unnecessary to point out that this sculpture reveals a degree of accomplishment that would have been beyond the powers of the artisans of the reliefs of Bhārhut. Like the yakshī of the Sāñchī gateway, the figure is flattened at the back with only a perfunctory indication of modelling. Just like the terracotta figurine of the Indus Period, this colossal portrayal of a yakshī is composed in an additive way. Although it has the same frontality and something of the rigidity of the figure from Pārkham, there is, as explained above, a much greater ease in the suggestion of sculptural volume and a greater crispness and precision in the carving of details. Indeed, here, as so often in Indian sculpture, the very precision and hardness with which jewels and metal ornaments are rendered in stone serve, by contrast with the smooth planes and surfaces of the flesh parts, to suggest the essential soft and warm quality of the flesh connoted in stone.

Turning to the relief sculpture of the Sāñchī gateway, we notice in such a panel as the repre-

46. Sāñchī, east gate, The Great Departure

sentation of the Great Departure [46] that, in contrast to the Bhārhut reliefs, in which individual forms were attached to a shallow background, here the figures and details of setting are so deeply cut that they seem to swim against a dark background of shadow. The resemblance of this type of colouristic relief to Roman fourth-century sculpture is certainly coincidental, and must be explained by quite different means. From a technical point of view this method of deep background carving may be regarded as the result of the Indian sculptor's desire to have his compositions tell as a pattern in black and white completely and instantaneously legible in the glare of the Indian sun. From the iconographical point of view the technique provides the same illusion as the Bhājā panels of the forms emerging from a kind of universal matter connoted by the enfolding shadow. The method of presenting

the story, in comparison to the Bhārhut medallions, is a more elaborate form of the mode of continuous narration made possible by the greater and more suitable dimensions of the long, rectangular panel. In the composition in question we have both the cause of the Great Departure and its enactment within the confines of the same panel. In the centre of the composition the empty seat beneath the rose apple-tree typifies the Buddha's first meditation on the miseries of living creatures that resolved him to relinquish the pomps of the world and seek the salvation of humanity. Although this event in the legend and the actual flight from Kapilavastu are separated in time by a number of years, the Indian sculptor finds the topographical and historical unity of the happenings of greater consequence than any unity of time.[3] This is another illustration of how in Indian art time

and space become one in depicting the heroic legends. In the relief under discussion the Departure is presented in the usual symbolical fashion, with his footprints establishing the Buddha's presence and the form of the horse Kanthaka repeated several times relating the progress of the flight from his father's palace. The precision of the carving of this and other panels tends to confirm the inscription on the western gateway that the sculpture was the work of ivory-carvers from the nearby town of Bhilsa.

We may select as typical of the reliefs of the toraṇa pillars the panels of the outer face of the eastern portal. Most interesting of these is the scene of the Conversion of the Kāśyapa Clan, in which the Buddha confounded these heretics by performing the miracle of walking upon the waters [47]. His actual presence is indicated only by a kind of plinth or plank floating on the river. The Kāśyapas are shown twice, once in a boat ready to rescue Śākyamuni, and once again on the shore reverencing the Buddha at the successful conclusion of the miracle. If this relief in certain aspects reminds us of Egyptian or western Asiatic prototypes, it is simply because, as has been pointed out before, Indian art perpetuated the ideals of all those ancient traditional societies in which the artist's aim was the communication of a theme in its most readily apprehensible form. In accordance with this conceptual method of presentation, every element of the composition is portrayed from its most characteristic point of view, without regard to its position in space and time, so that, whereas the river is shown from above and its waves are indicated by parallel rippling lines, the trees on the banks are shown in profile and, to indicate their species, the leaves are enormously enlarged within these ideographic contours. It will be noted that in this, as in other reliefs at Sāñchī, the emphasis is entirely on the delineation of the various elements of the composition in terms of shadows reinforcing the outlines and interior

drawing in the form of incised lines. There is no intent to establish any space beyond the plane of the main figures and accessories and the background plane behind them. Although there is a slight modelling of individual forms so that they have some substance beyond a mere silhouette, the conception of the relief seems almost to be in terms of drawing rather than sculpture, with no suggestion of the illusionistic depth that we find in later periods of Indian art. If the Sāñchī reliefs in certain details reveal a kind of intuitive naturalism in the recording of plant and animal forms, it is because they are the productions of a religion in which the humanity of the founder and his kinship with all nature were still stressed. For people whose real faith rested in large part on the worship of the Dravidian nature-spirits and the barely disguised folk-tales that were the Jātakas, the validity of the real world could not be suppressed. Here is a reflexion of 'an attitude to life in which any dualism between spirit and matter, or between the mystic and the sensuous, is inconceivable'.[4]

Everywhere the early Indian sculptor displays a loving awareness of the material world that surrounds him. The varieties of trees, flowers, birds, and beasts are not recorded from the point of view of a naturalist bound to catch the precise texture and structure of these forms based on scientific observation and dissection, but rather – and this could be a definition of the conceptual point of view in art – are these accessories of the natural world set down as the artist knew them or remembered them, revealing with the selective intensity of the memory image the most characteristic aspect of the growth and articulation of specific plants or animals. Landscape as such does not exist. The curtain before which the dramas, religious and popular, are played – the green prison of the jungle, the towering peaks – is reduced to the barest essentials abbreviated as a stage design is, in order to set off, and not distract from, the activities of the actors. By the same method we have already

47. Sāñchī, east gate, The Conversion of the Kāśyapas

seen employed for living creatures, mountains are reduced to pyramidal, block-forms; ponds and rivers are spread like carpets, with an engraving of parallel lines to indicate by this symbolism the nature and movement of water. All these conventions are present not only in the sculpture but also in the remains of wall-paintings in the Early Classic Period.

Although there are copious references to painted decorations in the Jātakas and other early Buddhist texts, the only surviving examples of wall-painting from the early period are to be found in a rock-cut chaitya-hall at Ajaṇṭā in the Deccan.[5] Various inscriptions in the cave confirm its dedication in the second century B.C., and the fragments of wall-painting in the interior are probably to be dated no later than the first century B.C. The principal wall-painting in Cave X is devoted to the *Saddanta Jātaka*, which recounts the story of the Buddha's sacrifice of his tusks during his incarnation as an elephant [48]. Its arrangement recalls the scheme of the Sāñchī architraves, since the composition is presented in the form of a long frieze in which the action progresses from episode to episode, as

in a Far Eastern scroll-painting. It should be emphasized, in view of the later compositional developments in Indian wall-painting, that the picture is entirely confined within the borders of its frame, and does not cover the entire wall. Only about one-third of the painting is given over to the actual martyrdom and the dénouement of the tragedy. The greater part of the space is devoted to a most wonderfully naturalistic recording of the elephants in their home in the deep forest. We see them bathing, resting, feeding, and apprehensively awaiting the hunters. The composition is crowded, and yet one has the impression of the beasts moving with perfect freedom in the space that the artist assigns them. Every available area that is not occupied by the forms of the pachyderms is filled with the portrayals of floral and foliate forms, and serves to give a dramatic illusion to the density of the jungle. Although the elephants are types, just as much as the human figures in the composition, the artist has given us a marvellous impression of their immense dignity and weight, and their ponderous frolics. The nearest comparison in sculpture is in the representation

· 48. Ajaṇṭā, Cave X, Saddanta Jātaka

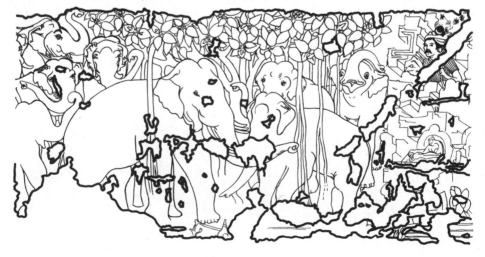

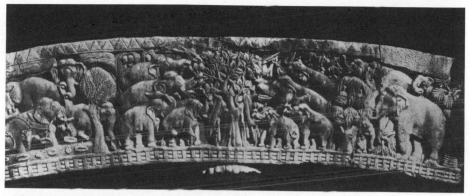

49. Sāñchī, west gate, Saddanta Jātaka

of the same story on the cross-bars of the south-ern and western gateways of Sāñchī [49]. The same method of continuous narration is employ-ed, so that the figure of the six-tusked elephant (the future Buddha) is repeated no fewer than four times. In the relief only the intrusion of the figure of the hunter at the extreme right suggests that this is more than a jungle idyll. The method for suggesting space in these animal subjects is exactly the same as that in dealing with human figures in both sculpture and painting. The forms in the foreground slightly overlap those behind, which are placed above them in one or more tiers to the top of the composition. As in all periods of Indian art, we are struck with the artist's complete assurance and mastery in ren-dering the animals in literally dozens of poses, every one of which is completely characteristic of the species. The elephants at Ajaṇṭā and Sāñchī are rendered with such consummate knowledge of their specific articulation and gait that it is difficult to think of a memory-image intervening between the artist and the realiza-tion of his design.

The setting, especially in those portions of wall-painting dealing with the activity of human figures, is entirely formalized, and exists only as a background. There is already a completely evolved convention whereby rocks are symbol-ized by a series of block-like cubes, and moun-tains are represented simply by duplication of these same forms. These shapes, by their square-ness and hardness, serve to connote the idea of rock or mountain without the necessity of any really structural or textural description of the form. This is the equivalent of the archaic meth-od of representing trees, whereby leaves of the different species are attached to a mere ideograph of the trunk-and-branch structure. Neither the backgrounds of the Sāñchī reliefs nor those of the early Ajaṇṭā wall-paintings are to be taken as early landscapes in the development of a landscape tradition, for the simple reason that landscape never developed beyond this point in any later period of Indian art. This stage of de-velopment which remains unaltered approxi-mates that of European landscape in the work of Giotto and his followers, in which the presence of any necessary setting was indicated by the most meagre details generally presented in the same conceptual fashion. Actually, there was no reason why a tradition of landscape painting should develop in India at all. In no phase of Indian philosophy or religion was there any suggestion of the immanence of the deity in the world of nature, nor any romantic attachment

to the beauties of the wilderness for its own sake. Nature for the Indian was essentially a combination of constantly menacing, even dangerous, forces. There was nothing lovable about the jungle, nor the succession of scorching heat and torrential rains and inundations, that could produce an Indian Claude or even a Salvator Rosa. Just as the anthropomorphic personification of every natural force in Greece militated against the development of an Hellenic school of landscape painting, so in India the Dravidian tradition of personifying every ele-

50. Copper lota from Kundlah.
London, British Museum

ment in nature, hostile or friendly, in the shape
of a spirit anthropomorphically described
obviated the necessity for the development of
landscape. As the dryad in Greece personified
the grove, so in India the human shapes of
yakshī and nāga represented tree and lake. Only
such details of natural settings as were necessary
to the interests of his didactic narrative con-
cerned the Indian artist. As in Giotto a single
oak could represent the whole forest of St
Francis's wandering, a single banyan suffices
to suggest the home of the elephants in the
depths of the great forest.

It should be mentioned before leaving the
subject of art in the Early Āndhra Period that
the late Dr Heinrich Zimmer recently proposed
a date of first century A.D. for the gates at Sāñchī:
an inscription of King Śrī Śatakarni (c. 15–30
A.D.) appears on the southern toraṇa, and the
others presumably were completed within a
relatively short period after the work was begun.
This chronology does not, of course, affect
the position of the Āndhra sculpture at Sāñchī
in its relation to the earlier art of the Śunga
Period and the development in the Later
Āndhra Period.

51 and 52. Silver plaques from the Oxus Treasure.
London, British Museum

*

Turning to the minor arts in the Early Classic
Periods, we may begin our account by examin-
ing a copper *lota* or water jar, found at Kundlah
in the Kulū Hills, and probably a work of the
Śunga Period [50]. The engraved attenuated
figures with their tubular limbs immediately
suggest the reliefs of Bhājā and the primitive
carvings of Stupa 2 at Sāñchī [32, 36, and 37].
A number of silver medallions, originally part
of the Oxus Treasure, with representations of
elephant-riders [51 and 52] are the smaller metal
counterparts of similar designs found at Sāñchī
and in the roundels of the Bhārhut stupa.[6] These
are the Indian counterparts of the classical
design of the Bactrian plate in illustration 87.

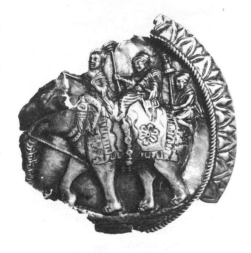

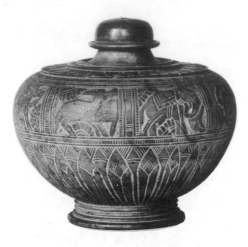

53. Relic bowl from Sonari.
London, Victoria and Albert Museum

54. Ivory mirror handle from Pompeii (front).
Naples, Museo Nazionale

55. Ivory mirror handle from Pompeii (back).
Naples, Museo Nazionale

The technique is repoussé, with engraving of the details of the interior drawing. A steatite relic bowl from Sonari [53] is a work that may be associated with the Early Āndhra domination of the Sānchī region. The design consists of engraved lotuses embracing the foot of the vessel and a band of rectangular panels running around the body of the vase. These compartments are filled with various animal forms represented by incision and the shallow cutting away of the background. The raised surfaces have been polished and contrast with the greyish core of the stone. These formalized beast forms suggest the similarly abstract animals of the railing of Stupa 2 at Sānchī.[7]

Although no examples of jewellery and the like have survived from the Śunga Period, we can gain some idea of the character of personal ornaments from the detailed realistic representation of these accessories from the sculpture at Bhārhut. The devatā from this site [29] shows the deity wearing an elaborate series of necklaces. These strands appear to be made up of metal beads, rather than precious stones. At the centre of each is a little box or casket to contain amulets or spells to ward off evil forces. As will be seen later, this type of amulet container per-

sists in the jewellery of the Kushan Period. The goddess's adornments include heavy anklets of a type that persists until Kushan times, and above these 'stockings' of thin bangles matched by similar massed bangles on her wrists.

Belonging properly to the realm of the minor arts is one of the most beautiful surviving objects of Early Āndhra carving. This is a mirror handle in the shape of a courtesan and two attendants carved in high relief, almost in the round [54 and 55]. This remarkable object was found in the Via dell'Abbondanza at Pompeii, which establishes its date as prior to A.D. 79, the year of the fateful eruption of Vesuvius which buried this ancient Campanian city.[8] The style of this figurine, with the provocative emphasis on the sexual aspects of the anatomy, is a miniature version of the famous yakshīs of the toraṇas of Sānchī [43 and 44]. The figure is still composed on the additive principle noted in many other examples of Early Classic art in India. Like the Sānchī goddesses, the lady of the Pompeii ivory is carved in such a way that the figure appears as two high reliefs placed back to back rather than as a form in the full round. The strong resemblances between this work and its stone counterparts only reinforces

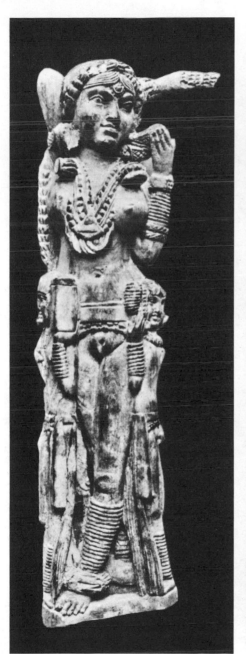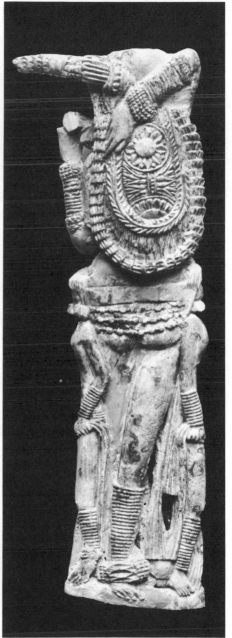

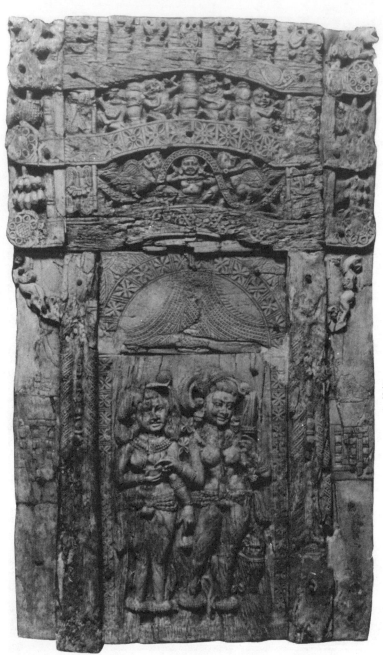

56. Ivory plaque
from Begrām.
Kabul, Museum

what has been suggested elsewhere, namely, that monumental sculpture in early India was simply a transference of the style and technique of work in perishable media, like ivory and wood, to stone. The elaborate jewellery worn by the central figure, notably the 'stockings' of metal rings, give us some idea of the nature of this type of personal adornment in Early Āndhra times.

Related to this work are some of the superb ivory plaques found at Begrām in Afghanistan.[9] They originally decorated a massive throne. Certain examples, like the oft-repeated motif of women standing under a toraṇa [56], are again suggestive of the Sāñchī style in the full, rather squat canon of proportion and the luxurious elaboration of surface detail. The carving in its depth and crispness is the prototype for the work wrought in stone by the ivory-workers of Bhilsa who, according to one inscription at Sāñchī, dedicated a gateway and presumably their services as well.

The close affinities between ivory carving and monumental sculpture in the early centuries of Indian art may be supplemented by further comparisons between terracotta sculpture and the reliefs of the Early Classic Period. So, for example, a small circular plaque from Patna with a representation of Sūrya in his chariot [57] provides a very exact parallel for this same subject as carved at Bhājā [36]. Even the treatment of this relief on a tiny scale approximates the suggestion of the emergence of the forms from the background. The medallion shape of this object of course suggests a favourite composition of the early Buddhist railings.

Another terracotta relief from Kauśambi [58], though of a somewhat later period, represents a royal couple embracing on a throne. The background is strewn with rosette-like flowers. Both the types of the figures and the delicate animation of the surface by shallow linear engraving cannot fail to suggest the beautiful relief from Pitalkhora [40] of a similar subject.

57. Terracotta plaque from Patna. *Patna, Museum*

58. Terracotta plaque from Kauśambi. *New Delhi, National Museum*

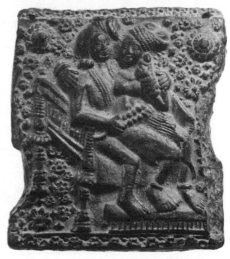

THE ROCK-CUT SANCTUARIES OF EARLY BUDDHISM

The earliest temples of Buddhism, properly speaking, were buildings of wood and thatch erected when the demand arose for actual shrines to enclose some cult object, such as a memorial stupa, to concentrate the worship of the Buddha's followers on some material reminder or symbol of his earthly mission. Prior to this, the services had been conducted in the open air, in groves or forest clearings, such as the Buddha was wont to select for gatherings of his disciples. These earliest structural buildings of Buddhism have, of course, disappeared, but we can get a very clear impression of their appearance from the sculptural replicas of such edifices as began to be carved from the living rock in various parts of India as early as the Maurya Period. These are the so-called cave temples of western India. The word 'cave' is actually rather misleading, since it implies a natural grotto that is the home of wild beasts or savages, whereas these entirely man-made recesses are among the most sophisticated examples of religious art in all Indian history. 'Rock-cut sanctuaries' is a better definition for these enormous halls of worship hewn from the rock in imitation of free-standing architectural types. The definition, chaitya-hall, sometimes applied to these monuments, is derived from the word chaitya, which refers to any holy place. The rock-cut temples are only the most ambitious examples of the development of monumental stone-carving that followed on the invasion of Alexander the Great and the re-establishment of relations with western Asia. Although there is no direct resemblance to the many examples of such sculptural architecture in Egypt, Asia Minor, or Iran, there can be little doubt of the influence of such prototypes as the tombs of the Achaemenid emperors at Naqsh-i-Rustam, in which the carved façade represented the elevation of a palace at Persepolis in much the same way, we shall see, as the façades of the Indian chaitya-halls reproduced those of actual buildings. In both cases we are dealing with works of sculpture rather than architecture, and in both cases there was an appeal in the very permanence that was promised in the carving out of tombs or temples from the very bones of the earth. In the Indian examples there was probably already the idea of preserving the Buddha's Law through the bad times at the end of the *kalpa*. Such grotto sanctuaries appealed to the early Buddhists through their association with caves that even in Vedic times had formed the abodes of hermits and *rishis*. The development of the religion from the isolated practice of asceticism to the formation of a monastic organization required the enlargement of the single rock-cut cell provided for the retreat of holy men by Aśoka to the monumental rock-cut assembly halls that we find in western India to-day. All these principal sanctuaries of Hinayāna Buddhism are located within a radius of two hundred miles of Bombay. They are hollowed out of the almost perpendicular bluffs of the Western Ghats. They are exact imitations of pre-existing structural forms, and in almost every one the reminiscence of these prototypes is carried to the point of having many parts of the model fashioned in wood and attached to the rock-cut replica. The relief of Indra's Paradise at Bhārhut accurately reproduces the appearance of an actual wooden chaitya-hall [35].

We may take as a typical example of the earliest type of chaitya-hall the rock-cut cathedral at Bhājā, datable in the early part of the first century B.C. Its plan [59] consists of a nave separated by rows of columns from smaller aisles terminating in a semi-circular apse, in which was located the principal symbol of worship, a rock-cut stupa. Although this arrangement does suggest the plan of a typical Classic or Early Christian basilica, the resemblance is no more than accidental, since the plan of the chaitya-hall was specifically evolved to provide for the rite of circumambulation around the symbol of the Buddha's Nirvāṇa and to provide space for services within the main body of the church. The method of carving the chaitya-hall at Bhājā and the many more elaborate examples that followed it was of course a sculptural, rather than an architectural, problem. After the perpendicular rock wall had been cleared and

smoothed off, the outline of the intended façade and entrance was indicated upon it. As may be seen from certain unfinished caves at Ajaṇṭā, the workmen began by tunnelling into the cliff at the level of the intended height of the vault of the interior. In this way it was unnecessary to erect any scaffolding. After the ceiling and roof were completed, the workmen continued quarrying downward, removing the debris of rock through the open façade and disengaging the columns and the carved stupa at the rear of the edifice. The earliest chaitya-halls, of which Bhājā is an example [60], could be described as half-timbered, since not only were wooden transverse ribs imitating the structure of free-standing buildings affixed to the vault, but the entire façade was once constructed of wood. The most striking feature of this wooden frontispiece was a kind of rose window constructed of a number of wooden members following the

59. Bhājā, chaitya-hall and vihāra

curvature of the vault that divided the window into a number of lunulate openings. The lower part of the façade consisted of a wooden screen with openings into the nave and aisles, and probably decorated with the balcony and merlon motifs that are carved in stone above the entrance to the chaitya proper. The blind chaitya niches and balconies joined by carved railings are reminiscences of the picturesque architecture of contemporary palace forms: exactly similar building forms may be seen reproduced in the reliefs at Sāñchī. The columns of the interior of Bhājā are completely plain octagonal shafts. They are staggered inward, so that the top of the shaft is something like five inches out of alignment with the base. Presumably this is a strict imitation of the arrangement in a structural wooden building, in which this expedient was necessary to support the weight of the roof. It could probably be said as a general rule that

60. Bhājā, chaitya-hall, façade

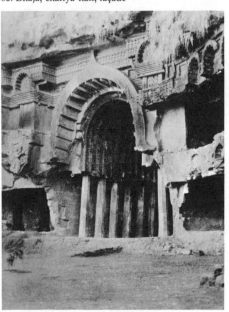

the greater the slant of the pillars in a rock-cut sanctuary, the closer it is to actual wooden prototypes, and, by the same token, earlier in date. It will be noted that in the latest of the Buddhist basilicas, such as the chaitya at Kārlī, dated about 100–125 A.D., this reminiscence of wooden originals has entirely disappeared. It would be impossible to give, either in words or photographs, any adequate idea of the enormous impressiveness of these Buddhist cathedrals. This impressiveness comes, not from the builders' providing a sense of space, as in a Gothic cathedral, for here space is completely controlled and restricted, but from the beauty and austerity of the architectural members and the mystery provided by the twilight which in these interiors seems to make everything melt and almost disappear, so that the visitor feels himself in a magic world of unreality.

It is not unlikely that the early Buddhist temples, both free-standing and rock-cut, embodied something of the same metaphysical symbolism that was attached to the stupa form. Just as the medieval cathedral in Europe, with its cruciform ground-plan and the encyclopaedic character of its decoration, was a symbolical likeness of the body of God and a reconstruction of the universe in a microcosm, so, too, the chaitya might be thought of as a realization in material form of that cosmic house which is the universe, its entrance the door of the world, the frame in which Indra fixed the air. Often the universe is referred to as a house built of timber, and the timber of that structure is Brahma. The solar symbolism of the great lotiform window seems as implicit here as in the Gothic rose.

By far the largest and most magnificent of the cave temples of the Hinayāna period is the sanctuary at Kārlī, only a short distance from Bhājā [61 and 62]. In front of the façade one can still see one of two massive free-standing columns or stambhas that originally had enormous metal wheels supported on the lions above the lotiform capitals. The actual order of these pillars is

a continuation of the arrangement of the lāṭs of the Maurya Period; the fluted shafts probably rested in a form suggesting the Brahmin water-bottle or *lota*. The erection of such shafts at the entrance of the temple has many precedents in ancient Mesopotamia and Egypt, and must be accepted as yet another survival of early Indian contacts with western Asia. The Kārlī chaitya differs from others of the type in that the façade screen is of carved stone, with the exception of the lotus window, which consists of the usual teakwood framework. The sculpturing of this entrance wall is extraordinarily rich and colourful. The whole structure appears to rest on the backs of elephants that were originally fitted with metal ornaments and ivory tusks. A few reliefs in this narthex are centuries later than the dedication of the cave in A.D. 120 and belong to a period when the sanctuary was converted to Mahāyāna worship. (Recent research by Dr Walter Spink of the University of Michigan reconsidering the historical, epigraphical, and numismatic evidence for the date of the Āndhra Dynasty suggests that a date of *c.* 32 B.C. marked the beginning of this era. Accordingly, the dates of the earliest and latest chaitya-halls at Bhājā and Kārlī should be revised to *c.* 50 B.C. and A.D. 120.)[1] The interior [63] of this largest of the rock-cut temples is one hundred and twenty-four feet in length by forty-six and a half feet in width, and the vault rises forty-five feet above the floor; so that the scale of the shrine is that of a Gothic church. The basilican plan persists with the usual rock-cut stupa located in the circumference of the ambulatory. Only in the ambulatory of the apse do the plain octagonal shafts

61. Kārlī, chaitya-hall, façade

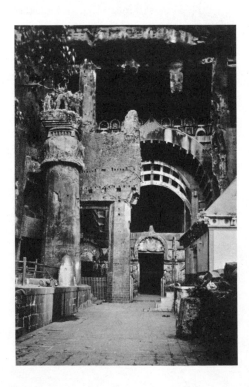

62. Kārlī, chaitya-hall

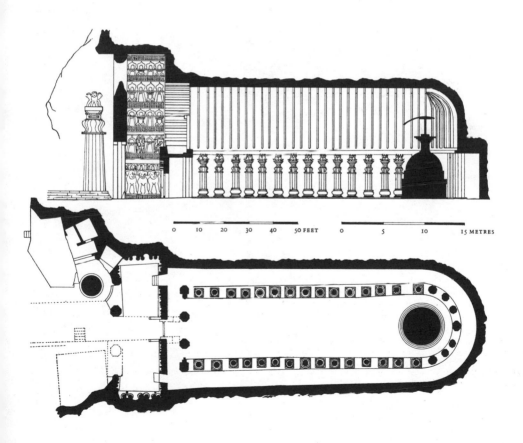

0 10 20 30 40 50 FEET 0 5 10 15 METRES

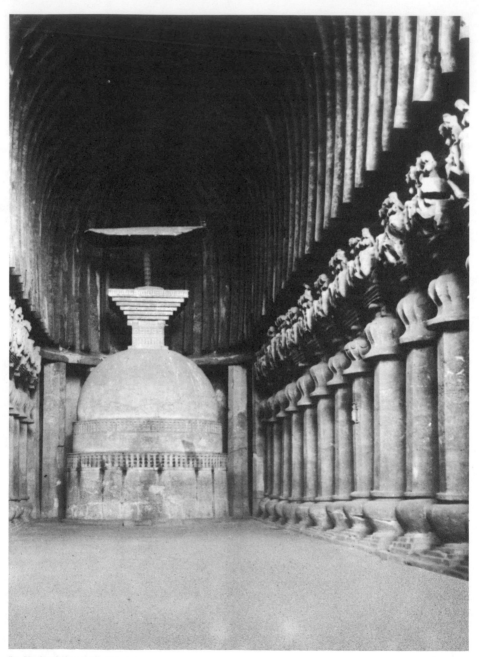

63. Kārlī, chaitya-hall, interior

of the earliest chaityas appear in the colonnade. The columns of the nave have become rich and elaborate in treatment. Each individual column rests in a water-jar, like the stambhas of the exterior. The sixteen-sided shafts support loti-form bell capitals, and above these rise inverted pyramids, which in turn support elaborately carved groups of elephants with male and female riders on their backs. There is no suggestion of the staggering practised at Bhāja. The sculptural groups of the capitals of the nave columns are so deeply carved and set so closely together that they give the effect of a triforium frieze of continuous sculptural ornament. The richness of this decoration provides a luxuriant contrast with the relative austerity of the other members. The chaitya at Kārlī, with the façade screen intact, gives us some idea of the original effect these cathedrals produce, with the light streaming through the timbered rose-window to illumine the interior with a ghostly half-light, so that the very walls of the rock seem to melt into an envelope of darkness and the sensation of any kind of space itself becomes unreal.

The only other architectural form of the Hinayāna Buddhist period that has survived is the purely monastic structure known as the vihāra. One of the very oldest is the rock-cut verandah with the reliefs of Indra and Sūrya already studied at the site of Bhāja. A more elaborate type contained a single large hall, square or rectangular, from which the individual rooms for the monks opened. This monastic type of rock-cut building was not limited to Buddhism. Many vihāras dedicated to the Jain faith and dating from the second and first centuries B.C. are at Udayagiri [64], not far from Bhuvaneśvar in Orissā. These establishments follow no regular plan. Some of them are even carved on two levels. Most of them are characterized by the elaborate carving of the projecting verandahs supported by pillars with every member – columns, doorways, and overhanging thatched roof – clearly imitated from structural prototypes. Features like the forms of these columns and the 'roll cornice' of the overhanging roof appear over and over again as fixed motifs in the later architecture of Buddhism and Hinduism.

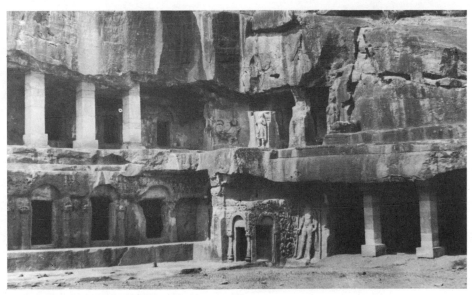

64. Udayagiri, Orissā, Rānī Gumpha

ROMANO-INDIAN ART
IN NORTH-WEST INDIA AND CENTRAL ASIA

CHAPTER 9

ART UNDER THE KUSHANS

I. GANDHĀRA: GRECO-ROMAN FORM AND INDIAN ICONOGRAPHY

The designation Kushan art may properly be applied to all the productions of architecture, sculpture, and painting in Afghanistan, north-western India, and the Punjab, and present-day Pakistan from about the first to the seventh centuries A.D., when these territories were under the domination of the Kushan or Indo-Scythian Dynasty of rulers. Art under the Kushans, however, divides itself into two completely distinct categories. Whereas in the northern portions of their domains, comprising the ancient province of Gandhāra, the Kushan patrons of Buddhism availed themselves of the services of journeymen craftsmen from the Roman East who produced a form of Late Antique art dedicated to Buddhism, at the southern capital of Mathurā (Muttra), on the Jumna River, the construction and embellishment of the Buddhist and Jain establishments were a continuation of the techniques of the native Indian schools. The peculiarly hybrid character of the art that flourished in these regions can be explained only by devoting considerable space to the history of north-western India both before and after its conquest by the Kushans.

The earliest reference to Gandhāra and its people is in the Bisutun inscription of Darius (c. 516 B.C.), in which the region of Gandhāra, separate from India, is numbered among the nations subject to the Achaemenian Empire. Presumably this subjection to the first great Persian empire continued until Gandhāra was invaded by Alexander the Great in the cold season of 327 B.C. The influence of Alexander's raid in northern India has been greatly exaggerated, and this is particularly true of the region of Gandhāra and its art. The actual rule by Macedonian Greek captains in India lasted only until the death of Alexander in 323 B.C. The successor to Alexander's Indian dominions, Seleucus Nicator, was forced to relinquish all claim to Indian territory south of the Hindu Kush by the consolidated power of the first of the Indian emperors of the Maurya Dynasty, Chandragupta. Under the great Buddhist sovereign, Aśoka, the region was converted to Buddhism, and the rock edict of Aśoka at Shāhbāzgarhī, some ten miles to the east of Mardan, gives positive proof of the proclamation of the Buddha's Law in Gandhāra. The gradual break-up of the Maurya Empire following the death of Aśoka in 232 B.C. again opened the Peshawar Valley to foreign aggression.

Although the might of Chandragupta Maurya

had forced Alexander's successor, Seleucus Nicator, to withdraw his garrisons beyond the Hindu Kush, this withdrawal only made for an even stronger consolidation of Hellenistic power in the ancient province of Bactria, the territory centred around the modern Afghan city of Balkh. In about 250 B.C. the over-extended empire of the Seleucids began to disintegrate. Iran was claimed by a dynasty of obscure origin known to history as the Parthians, and the province of Bactria declared its independence under a Greek prince, Diodotus. Now completely separated from the Hellenistic world of the West by the Parthians in Iran, the independent kingdom of Bactria continued to maintain some semblance of Hellenistic culture. Although its rulers were perforce a military aristocracy, it is extremely likely that this isolated Eurasian Greek colony had much to do with the perpetuation of Hellenic artistic ideals in Asia and also the minting of a magnificent series of coins [65, A–C]. Its history is one of almost continous warfare and displacement: Gandhāra and the Kabul Valley were reconquered by the grandson of ·Diodotus, Demetrius, in about 190 B.C.; the successors of Demetrius were almost immediately dispossessed of Bactria and Gandhāra by Eucratides, the ruler of a rival Greek clan. Although, following the establishment of a dynasty by Eucratides, princes with Greek names continued to hold these territories until after the middle of the second century B.C., the years of this unhappy band of Hellenic exiles were numbered. As early as 135 B.C. they were driven out of Bactria by an invading horde known as the Śakas. These people of Scythian origin later became intimately associated with the rulers of Parthia, and indeed, as early as the first century B.C., seem to have displaced the Parthians in eastern Iran and in the region of western Afghanistan known as Śistan. A Śaka ruler by the name of Maues or Moga conquered north-western India in about 90 B.C., thereby

constricting the rule of the last of the Greek sovereigns to the Kabul Valley.[1]

It was not long before the Śakas in turn were forced out of Bactria by another race of Scythic origin, the Yüeh-chih, whose homeland was originally in the province of Kansu in north-western China. These people, known in Indian history by the name of the most powerful tribe, the Kushans, gradually increased their power until in the first fifty years of our era they made themselves masters not only of the Kabul Valley but also of the region of Gandhāra. This conquest involved the displacement of the Śakas and the overthrow of the last of the Greek sovereigns, Hermaeus.[2] The date of A.D. 64 is usually accepted as marking the sack of the city of Taxila and the final establishment of Kushan domination in north-west India. The founder of the line, Kujula Kadphises, is remembered not only for his conquest of Gandhāra and the Punjab, but also for the establishment of an intimate commercial and political relationship with the Roman Empire of Augustus.

Of far greater import for the history of Gandhāra was Kujula's follower, Kanishka, the most powerful and renowned of the Kushan sovereigns, who made Peshawar his winter capital and extended his conquests from central Asia to Bengal. Kanishka is frequently referred to as a second Aśoka for his efforts on behalf of the Buddhist religion. His foundations included the great tower at Shāh-ji-kī-Dherī, which, from the accounts of the Chinese visitors of the fifth and seventh centuries, must have been one of the wonders of the Asiatic world. It was in the ruins of this monument that the reliquary of King Kanishka was recovered in 1908.[3] Although the Buddha himself never visited Gandhāra, the texts composed by Buddhist sages under the Kushans made of the region a veritable holy land of Buddhism by the association of various sites with events in the previous incarnations of Śākyamuni.

65. Bactrian, Śaka, and Kushan coins.

(A) Euthydemus, King of Bactria, late third to early second century B.C. AR. Tetradrachm.
(B) Demetrius, King of Bactria, c. 190–167 B.C. AR. Tetradrachm. (C) Eucratides, King of Bactria, 167–159 B.C. AV. 20-stater piece. (D) Maues, Śaka King, first century B.C. AE. (E) Kanishka, coin with moon goddess Nanaia, second century A.D. AE. (F) Kanishka, coin with wind god Vado, second century A.D. AE. (G) Kujula Kadphises, coin with head of Augustus, first century A.D. AE. (H) Kanishka, coin with Buddha, second century A.D. AV. (I) Kanishka, coin with Mithra, second century A.D. AV. (J) Kanishka, coin with Śiva, second century A.D. AV. (K) Huvishka, coin with goddess Roma, second century A.D. AV. (L) Huvishka, coin with Ardoksho, second century A.D. AV. *British Museum, London,* except (G), *American Numismatic Society, New York*

Although coins are generally regarded as minor art, for periods like that of the Kushan Scythians they furnish evidence invaluable for the interpretation of the major arts. They provide us with the complete evidence of the strangely syncretic character of Kushan art and religion. Just as postage stamps to-day furnish the philatelist with symbolical commentaries on the economic and cultural environment of the countries of issue, the Kushan coins provide an advertisement of the religious and cultural relationships of this dynasty. Kujula Kadphises imitates the coins of Augustus [65 G]; deified Rome has her place on the money of Huvishka [65 K]. Judging from the array of deities to be found on the coins of Kanishka and his successors, the pantheon of the Kushans included not only the Buddha [65 H], but, in addition to Śiva [65 J], representatives of the divinities of Iran and Greece [65 E, F, I, and L], all identified by inscriptions in corrupt Greek letters.

Under the Kushan emperors Gandhāra enjoyed its period of greatest prosperity, and it is to this era that the finest Gandhāra sculpture is to be assigned. The dates of Kanishka's reign have been the subject of considerable dispute among scholars. Although the years A.D. 128 and 144[4] have been suggested for the beginning of his reign, recent evidence favours a date from 78 to 110 as the year of his accession. Such a date conforms very well with the development of the Buddhist art of Gandhāra, for which he may well have been largely responsible. The dynasty of Kanishka lasted about a hundred and fifty years, since in A.D. 241 an invasion by Shāpur I of Iran brought to an end the rule of the last sovereign of Kanishka's line, Vasudeva.[5] In c. 390 a lesser Kushan dynasty established itself in north-western India until the fifth century A.D. For the later history of Gandhāra we are dependent almost entirely on the accounts of Chinese pilgrims who, as early as the fifth century, undertook the long journey to the holy land of Buddhism. Fa Hsien, who travelled through the Peshawar Valley shortly after A.D. 400, describes the foundations of Kanishka and his successors as flourishing and well cared for. When his successor, Sung Yün, visited the region in 520, the country had already been overrun by Mihiragula and the White Huns. It was indeed only a few years after Sung Yün's visit that this ferocious barbarian virtually extirpated Buddhism in Gandhāra by his destruction of the monasteries and butchery of the population. When the last of the Chinese pilgrims, Hsüan-tsang, came to north-west India a century later, he found the country in a ruinous, depopulated state, with most of the Buddhist establishments in a state of complete decay. Although all Buddhist art in Gandhāra proper came to an end with the invasion of the Huns, the style survived in Kashmir and in isolated Buddhist establishments in Afghanistan as late as the seventh or eighth century A.D.

Although the period of its florescence follows after the early Indian schools of the Maurya, Śunga, and Āndhra Dynasties, the art of Gandhāra is not in any way a continuation of this indigenous tradition. Its geographical position and the contacts between the Kushan rulers and the West made for the development of a style quite apart from the main stream of Indian tradition, and in certain aspects almost entirely Western in form. The subject-matter is, however, Indian. The repertory of motifs already known to the early Indian schools and the technique of archaic Indian sculpture are to a limited extent carried on in this outlying province of Indian culture. There never was any real fusion of Indian and Western ideals in Gandhāra. The arts of India and Gandhāra advanced along separate paths in different directions. Inevitably, the inappropriateness of the humanistic Classic forms of Western art for the expression of the mystical and symbolic beliefs of Indian Buddhism led to the disappearance of this imported style with the development of the truly Indian ideals of the Gupta Period.

The patronage of foreign artists by the Ku-shans is actually no more difficult to understand than their espousal of Buddhism. Being foreign-ers in India, they could not be accepted into the Hindu faith, and presumably both their adop-tion of Buddhism and support of a foreign culture were parts of a policy designed to maintain their autonomy in the conquered land.[6]

The art of Gandhāra is, properly speaking, the official art of the Kushan Emperor Kanishka and his successors. The term 'Gandhāra art' is applied to this school of architecture, sculpture, and painting, which flourished in north-western India from the first to the fifth centuries A.D. This designation comes from the ancient name of the region, and is to be preferred to 'Greco-Buddhist', a term sometimes applied to the same art, but distinctly misleading, since it implies a derivation from Greek art. This is the carving which Kipling, describing Kim's visit to the Lahore Museum, wrote of as 'Greco-Buddhist sculptures, done savants know how long since, by forgotten workmen whose hands were feeling, and not unskilfully, for the mysteriously trans-mitted Grecian touch'. Actually, the Gandhāra sculptures have little to do with Greek art either in its Hellenic or Hellenistic phase, and are much more closely related to Roman art. The Gandhāra school is, indeed, perhaps best des-cribed as the easternmost appearance of the art of the Roman Empire, especially in its late and provincial manifestations.[7] The subject-matter of the Gandhāra carvings is almost entirely Bud-dhist. Although Kanishka, through his patron-age of Buddhism, has rightly been regarded as the great patron of the Gandhāra school, there is ample evidence that Hellenistic art in the form of achitecture and sculpture was intro-duced into north-western India during the reign of the Śaka-Parthian Dynasties, as may be illustrated by a number of temples and sculp-tured fragments from the city of Sirkap at Taxila.[8] Gandhāra sculpture also began in this period.

This influence came in part from objects of unquestioned foreign origin that have been found at various points in the Gandhāra region. These would include Alexandrian metal statu-ettes of Harpocrates and Dionysius, found at Sirkap in Taxila, a bronze Herakles from Nigrai, in the British Musuem, and numerous steatite plaques or cosmetic dishes with erotic scenes. These latter objects are also of Alexandrian origin, and have been found in large numbers at Taxila. An even more considerable treasure of imported objects of art, including Syrian glass and Roman metal and plaster sculpture, was unearthed at Begrām in Afghanistan. The im-portance of all these finds was a confirmation of the intimacy of the relations, commercial and cultural, between Gandhāra and the Roman West.

Although the presence of this material in a way provides a, properly speaking, Hellenistic background for Gandhāra art, it was unquestion-ably the introduction of bands of foreign work-men from the eastern centres of the Roman Empire that led to the creation of the first Bud-dhist sculptures in the Peshawar Valley It is not difficult to find in all collections of Gand-hāra sculpture fragments resembling Roman workmanship of all periods, from the time of the Flavians, Kanishka's contemporaries, to the very last style of Roman sculpture of the fourth century, usually designated as Late An-tique. It may certainly be assumed from this evidence that, from the days of Kanishka until the end of Buddhism and its art in north-west India and the Punjab, the practice of importing foreign artisans continued. It must be necessar-ily supposed, however, that the vast majority of the sculptures are by native craftsmen following these successive waves of foreign influence.

Although the subject-matter of Gandhāra art is predominantly Buddhist, many of the motifs discernible in the sculptures are of either west-ern Asiatic or Hellenistic origin. Such Mesopo-tamian motifs as the Persepolitan capital and

merlon crenellation, and fantastic monsters like the sphinx and gryphon, had already been assimilated by the ancient Indian schools. Other forms, such as the atlantids, garland-bearing erotes, and semi-human creatures like the centaur, triton, and hippocamp, were all part of the repertory of Hellenistic art introduced by the Romanized Eurasian artists in the service of the Kushan court.

What we refer to as Gandhāra art – that is, the sculpture of the Peshawar Valley dedicated to Buddhism – probably had its beginnings in the later decades of the first century A.D. under the patronage of the first Kushan emperors to rule in north-western India. The theory that a Hellenistic school of art existed in Bactria as a background for the Gandhāra school can no longer be discounted. The present excavation of a Bactrian Greek city at Ay Khanum is destined to change our whole conception of the intrusion of Hellenic art into Asia. The finding not only of Corinthian capitals but also of fragmentary statues of gods and heroes and the laureated portrait of a prince or magistrate demonstrates for the first time the existence of a school of Greek sculpture in Bactria. Even though this art and the civilization which enacted it were wiped out by the Śaka invasion, at least the memory of this Hellenistic foundation may lie behind the school of Gandhāra. But, as will be demonstrated, the character of this Indo-Classical style can only be explained by contacts with the Roman world.[9]

The chronology of the sculpture of the Peshawar Valley still remains a vexing problem, owing largely to the absence of any definitely datable monuments. A number of pieces of sculpture do bear inscriptions with a reckoning in years of an unspecified area.[10] It is, however, possible to arrive at a tentative chronology for this material; especially with the help of monuments datable by reference to the works of Roman art which they closely resemble. Among the earliest examples is the famous reliquary of King Kanish-

ka, which bears a date from the first year of the ruler's reign [73]. Like all Gandhāra primitives, its style is a mixture of the archaic formulae of the early Indian school combined with iconographical borrowings from the West, such as the garland-bearing erotes circling the drum of the casket. The stucco sculptures ornamenting the base of Kanishka's pagoda, Shāh-jī-kī-Dherī, belonged to the same style and period.

The earliest Buddhas datable by inscriptions belong to the second and third centuries A.D.[11] They reveal a style of drapery clearly derived from Roman workmanship of the Imperial Period. The very latest examples from such Afghan sites as Begrām, the ancient Kapiśa, have the drapery reduced to a net of string-like folds, very much in the manner of the sculpture of Palmyra on the trade route to the Mediterranean.[12] The proportions of the body have a ratio of five heads to the total height, exactly as in late Roman and Early Christian sculpture. The soft, effeminate Apollonian facial type of the early Buddha statues gradually assumes the mask-like, frozen character of Late Antique sculpture that prevails over the Roman world from the third to the fifth centuries A.D.

The Gandhāra school is usually credited with the first representation of the Buddha in anthropomorphic form. The portrayal of Śākyamuni as a man, rather than as a symbol, probably is linked with the emergence of devotional sects of Buddhism at the time of Kanishka's Great Council. The quality of bhakti or devotion in the later Buddhist sects demanded a representation of the master in an accessible human form.[13] The earliest Buddha images were a compound of iconographical and technical formulae adapted by the foreign sculptors from the repertory of the Late Antique world. Images of this type appear on Kanishka's coins [65 H], one may imagine, as part of this sovereign's propagandizing of the Buddhist religion. These representations, like those on Kanishka's reliquary [73], are in a way abstract or simplified by reason of

their small size, so that it is impossible for us to say that they are 'conventionalized' derivations from some supposedly pre-existing naturalistic or Greco-Roman type. In Gandhāra the translation of Buddhist iconography into ready-made foreign patterns is essentially the same process that took place in the formation of Early Christian art, so that it is not surprising in the earliest Gandhāra Buddhas to find Śākyamuni with the head of a Greek Apollo and arrayed in the pallium or toga, carved in deep ridged folds suggesting the Roman statues of the period of Augustus. In exactly the same way the earliest representations of Christ show him with the head of the Greek sun-god and dressed in the garb of the teachers of the ancient world.[14]

The analysis of any typical Gandhāra image will reveal the indebtedness to prototypes in the repertory of Roman art in the first century A.D. We may select the image of Buddha, formerly installed in the Guides' Mess at Hoti-Mardan, near Peshawar [66]. The resemblance of the head, with its adolescent features and wavy hair, to the Apollo Belvedere is immediately apparent. As in countless other Gandhāra images, the cranial protuberance or ushnisha has been disguised by an adaptation of the top-knot or *krobylos* of the Greek sun-god [67]. The only reliance on the descriptions of the magic marks or *lakṣanā* appropriate to a Buddha is to be observed in the elongated earlobes and the definition of the *urna* or 'third eye' between the brows. Even the pose of this image with the Praxitelean *déhanchement* of the body beneath the robe might have been borrowed from the Greek Apollo type. The over-garment itself, recognizable as a representation of the Buddhist mantle or saṅghāti, is carved in a manner extremely suggestive of Imperial draped statues of the first century A.D. in Rome. The entirely successful realization of the mantle as a free-standing voluminous substance separate from the body beneath, and the definition of the folds in a system of deeply carved parallel swags, are

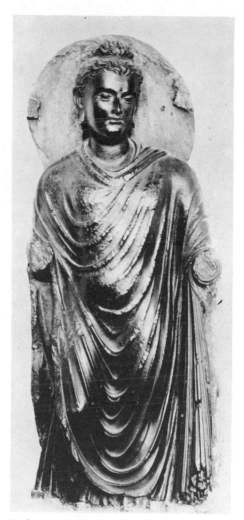

66. Standing Buddha from Hoti-Mardan. *Hoti-Mardan, Guides' Mess (formerly)*

immediately reminiscent of such familiar Roman prototypes as the statue of Augustus as Pontifex Maximus in the Museo Nazionale, Rome. The statue from Mardan belongs to the most Classic phase of Gandhāra sculpture, and might

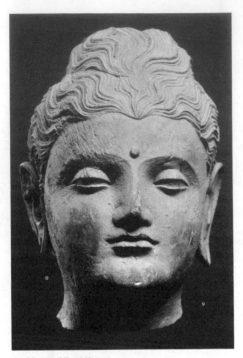

67. Head of Buddha.
London, Spink & Son (formerly)

be dated in the late first century A.D. It illustrates the process repeated in countless other Buddhist images and narrative reliefs, in which the foreign craftsmen responsible for the initiation of this school adapted the Roman iconographical and technical methods to meet the requirements of their Kushan Buddhist employers.

The florescence of the Gandhāra school, as far as stone sculpture was concerned, was extremely short-lived, and there is reason to believe that as early as the third century all stone sculpture and perhaps work in stucco, too, came to an end. A few late examples of Gandhāra Buddhas in stone have been found, however, in centres where the school survived the Sasanian invasion of A.D. 241.[15] A typical illustration is the Buddha of the Great Miracle, from Pāitāvā in Afghanistan, a piece that reveals the transformation of the Classical style of the statue from Hoti-Mardan into an approximation of the standards and techniques of Late Antique art in the twilight of the Roman West [68]. Probably this is an entirely parallel development. The Oriental tendencies that are usually credited with the breakdown of the humanistic style of the West are here represented by Indian iconographical and technical concepts. The now completely un-Classical appearance of the Pāitāvā Buddha is to be explained by the replacement of foreign by native Indian talent. The whole figure is more hieratically and less humanistically conceived, and so in a sense is more in conformity with the truly Indian ideals of the religious image. The Apollonian face of early Gandhāra Buddhas has taken on the mask-like character of the heads of Indian images of earlier schools. The face is spheroid, and to it the individual features are attached, with only a schematic suggestion of their organic relationship. The formerly voluminous drapery has been reduced to a system of strings or ridges. This reduction of the Classical garment to a linear formula is perpetuated in later Indian schools of sculpture and spreads even to the Buddhist sculpture of China and

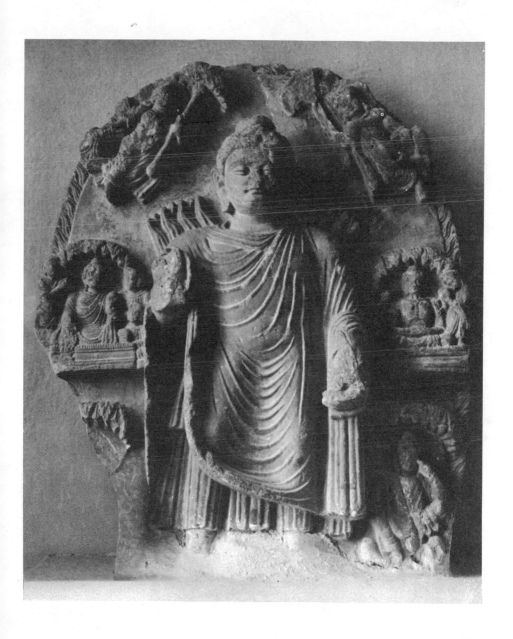

68. Buddha of the Great Miracle from Pāitāvā.
Dar-ul-Aman, Kabul, Museum

Japan.[16] Iconographically, this relief is interesting because it reveals the development of a new tendency whereby the enormously enlarged figure of the Buddha with appropriate gestures and attributes stands for the event illustrated and replaces the earlier narrative treatment of such scenes.

Much more of a real invention than the standing image of Buddha was the representation of Śākyamuni seated with his legs locked in the characteristic yoga posture. There was no Classical precedent for such a representation, so that, perforce, the conception had to be based on the observation of actual models, combined with the Eurasian sculptor's repertory of late Classical types and techniques.[17]

A typical example of the seated Buddha of the Classical type is the relief from the monastery of Takht-i-Bāhi, now in the Dahlem Museum,

69. Seated Buddha from Takht-i-Bāhi.
Berlin-Dahlem, Staatliche Museen

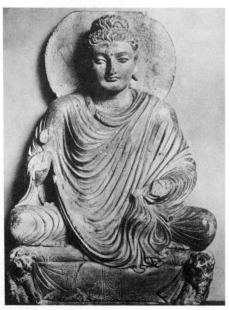

West Berlin [69]. The word 'relief' here is advisedly used, because, even though they suggest the full round when viewed frontally, neither this nor any other Gandhāra Buddha is executed in the round. Probably for the reason that they were meant for installation in the niches of Buddhist chapels, Gandhāra images are generally left entirely flat and unfinished at the back. The present seated figure is stylistically the exact counterpart of the image at Mardan. Here is the same Apollonian facial type, and the deeply pleated drapery reminiscent of Roman workmanship of the first century A.D. Although in the present instance there is some suggestion of the presence of an actual body beneath the mantle, the seated Buddha type in Gandhāra quickly degenerates into a completely inorganic formula in which the head and trunk of the figure are placed on top of a bolster-like shape intended to represent the folded legs.

Since even the best of the seated Gandhāra Buddhas are no more than a representation of a draped Greco-Roman adolescent in an unusual pose, it is easy to see that the humanistic Classical formula was entirely inadequate to the task of portraying a personage imbued with the ecstatic inner serenity of yogic trance. The Gandhāra sculptor has only established the type and form of the anthropomorphic Buddha. It remained for later generations of Indian sculptors to suggest by appropriately abstract and ideal means the pent-up, dynamic force and self-contained power of the Enlightened One.

In addition to the origin of the Buddha image, the Gandhāra school is probably to be credited with the invention of the Bodhisattva type [70]. The portrait-like character of these figures suggests that they may have been representations of noble donors divinized as the Bodhisattvas Siddhārtha or Maitreya in the same way that the Khmer rulers of Cambodia were shown in the guise of Hindu or Buddhist deities. The type of royal figure arrayed in all the finery of a contemporary Indian Rakah is essentially the

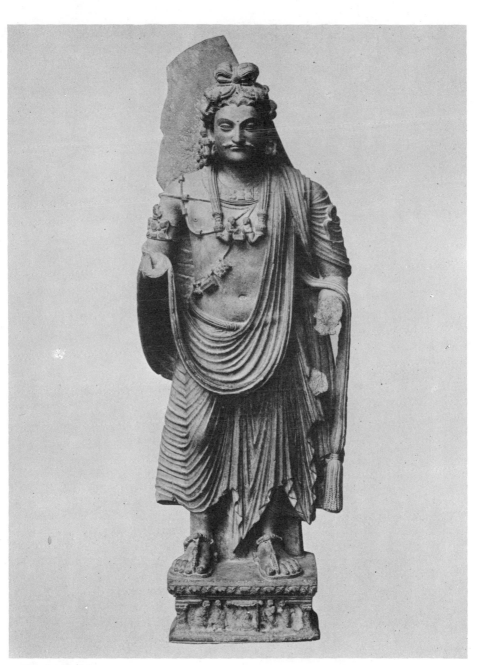

70. Standing Bodhisattva.
Boston, Museum of Fine Arts

same as had been used in the Maurya and Śunga Periods for representations of yakshas. The Gandhāra Bodhisattvas are all shown wearing turbans, jewellery, and muslin skirts – a costume that is certainly a literal adaption of the actual dress of Kushan and Indian nobles. The jewellery of these royal statues may be duplicated in the finds of Hellenistic and Sarmatian gold unearthed at Taxila and elsewhere. The style of these Bodhisattva images is a mixture of techniques of Western origin, so that, for example, the stiff swallow-tail folds of the dhoti are obviously an adaptation of the neo-Attic style that flourished in Rome under Hadrian, and the carving of the faces varies from imitation of Roman models to a rigid and hard precision suggestive of the grave figures of Palmyra.

Another definite borrowing from Roman art in the Peshawar Valley was the method of representing the story of the Buddha legend in a series of separate episodes, in much the same way that the pictorial iconography of the Christian legend was based on the approved Roman method of portraying the careers of the Caesars by a number of distinct climactic events in separate panels. It will be noted that this is a break from the device of continuous narration

that was inevitably employed in the ancient Indian schools.

The Gandhāra reliefs show no less stylistic variety than the statues of Buddhas and Bodhisattvas. They reveal once again a dependence on Roman and Indian art of many different periods: certain reliefs in which figures of definitely Classical type are isolated against a plain background are reminiscent of the Flavian revival of the Greek style of the Great Period; others, in which complicated masses of forms are relieved against a deeply cut, shadowed background, display the method of the early Āndhra reliefs at Sāñchī which in a way approximates the 'illusionism' of Roman relief of the Constantinian Period. Gandhāra relief sculpture owes its rather puzzling character to the fact that it is technically an impossible mixture of archaic and developed styles of carving: the narrative method and conceptual point of view of the old Indian schools combined with the illusionistic spatial experiments of Roman art of the Imperial Period.

The first type of relief may be illustrated by a steatite panel of a stair-riser from a site in the Buner region [71]. Although sometimes identified as the Presentation of the Bride to Prince

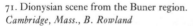

71. Dionysian scene from the Buner region.
Cambridge, Mass., B. Rowland

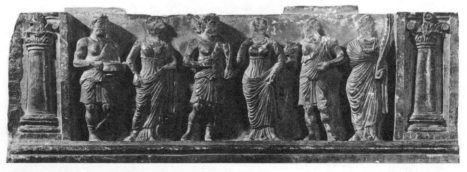

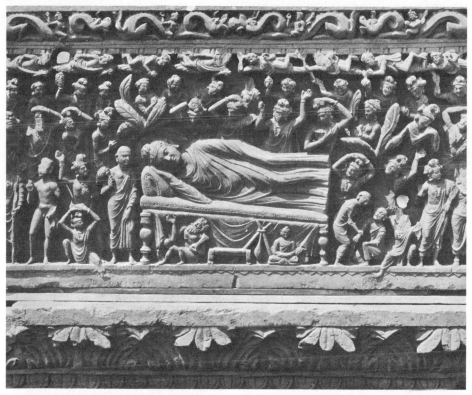

72. The Nirvāṇa of Buddha from Loriyān Taṅgai.
Calcutta, Indian Museum

Siddhārtha, the subject is more like a dionysian scene. The carving is characterized by the isolation of the figures against a plain background, although the forms themselves are related by their postures and gestures. These features, together with the fully rounded carving of the individual forms, remind us of Flavian or Hadrianic reliefs and other examples ultimately based on the Greek relief style of the fifth century B.C.[18] It may well be that this relief and many others in the same style – some with actual pagan subject-matter – should be considered the very earliest examples of the Gandhāra school, and that only somewhat later was this type replaced by imitations of the more typically Roman illusionistic manner.[19]

A typical Gandhāra relief that illustrates the more complicated aspects of the style is a large panel, nearly two feet high, representing the Nirvāṇa of Buddha [72]. At first glance it might almost be mistaken for a Roman carving of the time of Septimus Severus. The many tiers of

figures emerging from the depths of the shadowed background are obviously carved in such a way as to provide a very rich and dramatic contrast in light and shade. The relief is a perfect illustration of the strangely unhappy stylistic mixture resulting from the combination of the technically advanced and realistic methods of Roman craftsmanship and the essentially archaic and conceptual point of view of the native Indian tradition. The whole is a strange combination of the illusionistic depth and dramatized chiaroscuro of Roman relief combined with the old intuitive method of indicating spatial perspective by placing the consecutive rows of figures one above the other that we have already seen at Sāñchī and elsewhere. Another distinctly non-Indian feature is the violent expression of emotion, not only the gestures, but the facial contortions of many of the figures emphasizing their grief at the Lord's demise. This concern with the expression of pathos and inner feeling, suggestive of the so-called barbarian sarcophagi of third-century Roman art, comes to be exploited to an even greater extent in the final or 'Gothic' phase of sculpture in Gandhāra. A final illustration of the irreconcilable mixture of Classical humanism and the iconographical demands of Buddhism may be discerned in the figure of the dying Buddha himself. According to the ancient principle of hieratic scaling, the figure is enormously larger than the forms of the mourning disciples. This dualism becomes the more apparent when we realize that the form is not really conceived of as a reclining body at all, but, like Western medieval tomb effigies, is simply a standing Buddha type placed on its side. This panel is probably to be dated in the heyday of foreign workmanship in Gandhāra, in the late second or early third century A.D.[20]

We are probably safe in concluding that, whereas in the early centuries of Gandhāra sculpture the favourite medium for carving was the blue schist and green phyllite of the region, stucco or lime-plaster was employed for sculpture as early as the first century A.D., and by the third century A.D. had largely replaced stone as the material for the decoration of stupas and vihāras. The malleable nature of this medium made for a freedom of expression that eluded the carvers of the intractable slate. Both stone and stucco images were originally embellished with polychromy and gold leaf. The use of stucco for architectural decoration had its origin in Iran, and it may well be that the Sasanian invasion of A.D. 241 was responsible for the late, almost universal employment of stucco in all Gandhāra. Although the famous Afghan site of Haḍḍa has become world-renowned as a centre of late Gandhāra sculpture, it should not be overlooked that there are many fine specimens in stucco from such north-west Indian sites as Taxila, Sahri-Bahlol, and Takht-i-Bāhi near Peshawar. In the last centuries of the Gandhāra school it is difficult to make any distinction in either style or technique between the sculptures of the Kabul Valley, the Peshawar region, and the religious establishments of Taxila in the Punjab.

The sculpture of Gandhāra seems to confirm the testimony of the Chinese pilgrims on the predominance of the Hinayāna sect of Buddhism.[21] The subject-matter of the single statues is for the most part restricted to representations of the mortal Śākyamuni and the Buddha of the Future, Maitreya. The reliefs, with the exception of Bacchanalian scenes and other subjects of Hellenistic origin, are devoted entirely to illustrations of the life of Buddha and the legends of his earlier incarnations. A number of statues identifiable as the Bodhisattva Avalokiteśvara and reliefs with multiple Buddha images may be taken as the earliest examples of Mahāyāna Buddhist sculpture.

Undoubtedly there was at one time a great corpus of Gandhāra sculpture in metal, of which only a few small statuettes survive. There are, however, even more interesting survivals in this medium: from the early decades of the nine-

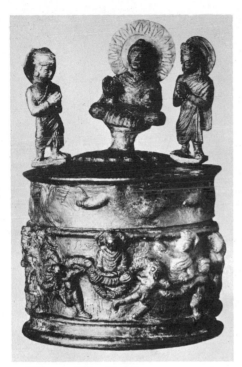

73. Reliquary of King Kanishka
from S̲h̲āh-ji-ki-Ḍherī.
Peshawar, Archaeological Museum

teenth century, when treasure-hunters and ama-
teur archaeologists first began to open the stupas
or topes of north-west India and Afghanistan,
there have come to light a number of reliquaries
containing corporeal fragments of Buddhist
saints, some of which are of considerable
importance for the history of art in this no-
man's-land between East and West. The official
excavation of the ruins of the principal stupa
of King Kanishka at S̲h̲āh-ji-ki-Ḍherī, near
Peshawar, resulted in the discovery of what is
believed by many to be the actual metal relic
box deposited by this greatest of Kushan sove-
reigns. The object itself is a round pyxis, made
of an amalgam of precious metals [73]. It bears
an inscription that has been interpreted as refer-

ring to the first year of Kanishka's reign. The
sovereign referred to may have been Kanishka
II or III, who ruled in the late second and early
third centuries A.D. The ornamentation of the
lower band of the drum consists of representa-
tions in relief of garland-bearing erotes and a
Kushan sovereign, presumably Kanishka, be-
tween the divinities of the sun and moon; on
the side of the lid is a zone of *haṁsa*, emblems of
the spread of Buddhism. To the top of the
cover are fastened free-standing statuettes of
the Buddha, flanked by Indra and Brahma. The
style of these images in the round and of the
repoussé reliefs is extremely crude, and more
closely related to imitations of Gandhāra sculp-
ture at Mathurā; so that, actually, the reliquary
might have been imported to Peshawar.[22] The
most Classic feature of the object is the Greek
name of the maker, Agesilas, probably a Eura-
sian in the employ of the Kushan court.

An even more interesting fragment of Gan-
dhāra metal-work is the so-called Bīmarān reli-
quary in the British Museum [74]. It is a round
box of pure gold *repoussé*, inlaid with rubies.
This also was a container for fragments of Bud-
dhist relics. It in turn was enclosed in a stone
box, when discovered by that pioneer in Indian

74. Reliquary from Bīmarān.
London, British Museum

archaeology, Charles Masson, in the ruins of a stupa at Bīmarān near Jelālābād in Afghanistan.[23] From the fact that a number of coins of the Śaka ruler, Azes, were found with the reliquary, it used to be assumed that the casket must be dated in the first century B.C. Deposits of coins, however, are rather unreliable for purposes of dating, since they could have been and often were inserted long after the burial of the relics. Stylistically, this little piece of metalwork provides very valuable evidence for the dating of the Gandhāra style and its origins. The decoration of the reliquary consists of a band of cusped niches enclosing figures of Buddha, flanked by Indra and Brahma, just as on the Early Christian sarcophagi we find a trinity of Christ revered by Saints Peter and Paul. This combination of figures and architectural setting, described by Focillon as '*homme-arcade*', is not found in Roman art before the Sidamara sarcophagi of the second century A.D. This characteristic motif of Late Classical decoration is repeated endlessly on the drums and bases of stupas in north-western India and Afghanistan. All these examples obviously can be no earlier than the third century A.D. The style of the figures on the Bīmarān reliquary, with their voluminous Classical mantles, likewise corresponds to the most Western type of Gandhāra sculpture of the late second and early third centuries A.D. – the style most closely related to Roman prototypes of the first and second centuries A.D. It should be noted, however, that the arches of the arcade are not at all Classical, but have the familiar ogee form of the chaitya window.

Probably owing to its political isolation from India proper and the maintenance of continuous contacts with centres of artistic activity in the Roman West, Gandhāra art enjoyed a greater longevity and also maintained a monotony of expression unlike that of any other Indian school. It is the very repetition of type and techniques over a period of nearly five centuries that makes any kind of chronology on a stylistic basis so

very difficult. In so far as one can be didactic about this problem, it can be stated that the school reached its highest point of production and aesthetic effectiveness in the first and second centuries A.D., the period coinciding with the closest contacts with the Roman world.[24] In the last centuries of its existence the style becomes closer to the orientalized style of production of the Eastern Roman Empire, in which the old Oriental tendencies towards frontality, abstraction, and hieratic scaling were beginning to assert themselves over the humanistic Classical forms of earlier times.

Presumably the disastrous invasion of the White Huns in the fifth century put an end to all further productive activity in Gandhāra beyond the execution of repairs on such monuments as survived this raid. The Chinese pilgrim Hsüan-tsang's account of the ruined monasteries that greeted him everywhere in the Peshawar Valley is probably an accurate description of the terrible desolation of this once flourishing Buddhist centre. The final chapters of Gandhāra art have their setting, not in Gandhāra, but in Kashmir and such remote centres as Fondukistan in Afghanistan, where artistic activity continued at least as late as the seventh century A.D.

The architecture of Gandhāra reveals the the same compound of Classical and Indian decoration and technique as has been exemplified by the sculpture. It must be remembered that, like the sculpture, the history of architecture in Gandhāra is in reality a separate, foreign interlude in the development of Indian art. A twentieth-century parallel suggests itself in the attempt of the deposed Afghan King Amanullah to foist European styles on his country: his gutted palaces at Jelālābād, the villas standing deserted and ruinous amid the flower-beds at Darul-Aman near Kabul are a modern repetition of the Kushan policy of importing foreign styles. Anyone who has seen these melancholy relics of imitations of Sans Souci and Swiss chalets can appreciate how strange and unaccep-

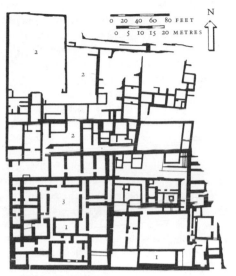

75. Sirkap, Taxila, palace
 1. Halls of audience 2. Women's quarters
 3. Private court and men's quarters

table to Indian ideals the Romanized architecture of Gandhāra must have appeared.

The earliest examples of architecture in this region are the buildings in and around the ancient city of Taxila, notably the site of Sirkap, which was the capital of the Greek and Śaka-Parthian sovereigns who ruled in the Punjab before the advent of the Kushans. Only the ground plan of the royal palace at Sirkap survives. It reveals an arrangement not unlike that of the ancient palaces of Mesopotamia, with a division into the king's apartments, audience chambers, and harem [75]. The foundation of an interesting structure on the main street of Sirkap is characteristic of the partly Greek, partly Indian culture of the first century B.C. This is the so-called Shrine of the Double-headed Eagle [76]. It consists of a square base that at

76. Sirkap, Shrine of the Double-headed Eagle

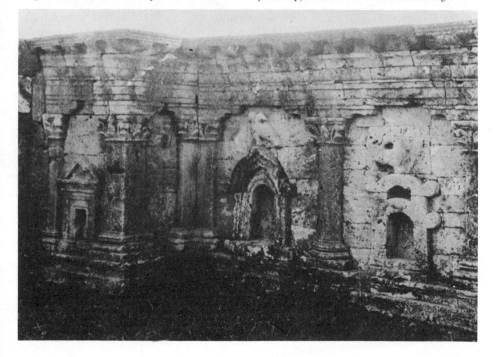

one time supported the hemispherical dome of a stupa. The principal façade is faced with blocks of the local *kanjur* stone (a variety of porous sandstone). It is ornamented with pilasters of a composite type, and between these pilasters are reliefs of architectural monuments, including a representation of a Classical pedimented aedicule, a torana or Indian gateway, and a chaitya arch. On the summit of the last is a double-headed eagle, from which the shrine derives its name. The use of the engaged order is, of course, suggestive of Roman precedent. But the capitals themselves are completely non-Classical, and even debased in proportion.

The only building at Taxila with a plan remotely approximating a Classical shrine is the so-called Fire Temple at Jandial. The plan is that of a peripteral temple *in antis* [77]. Originally, there were four Ionic pillars between the *antae*; behind this, a room corresponding to the *cella*, and a second apartment corresponding to the inner shrine of the Parthenon. The outer circumference of the temple consisted of rubble masonry piers spaced at regular intervals in a manner suggesting the colonnade of a Greek temple.[25] Actually, the plan corresponds much more closely to the plans of the fire temples of Iran in the Achaemenid and Parthian Periods. That the sanctuary may have been dedicated to Mazdaean worship is suggested by the absence of any kind of imagery and by the presence at the back of the shrine of a platform, perhaps originally supporting a wooden fire-tower. The Ionic columns of the portico are built with drums in accordance with the Greek method [78]. The capitals and bases approximate late Greek provincial examples of the order and confirm the dating of the temple in the time of Parthian supremacy at Taxila (*c.* 50 B.C. to A.D. 65).

The principal contribution of Gandhāra to architecture was in the development of buildings dedicated to the Buddhist religion. We may take as an example the vihāra at Takht-i-Bāhi, an isolated site not far from Peshawar, near the supposed location of the capital of the Parthian Gondophares [80]. The basis of the plan is a series of connected courts open to the sky, surrounded either by cells for the accommodation of the monks or by niches to house the devotional objects of the monastery [79]. Larger cham-

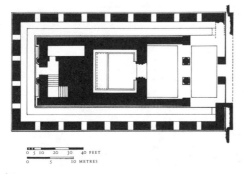

0 5 10 20 30 40 FEET
0 5 10 METRES

77. Jandial, Taxila, temple

78. Jandial, Taxila, temple, Ionic capital and base

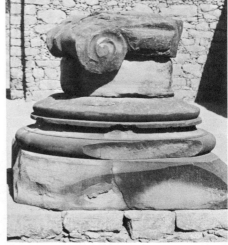

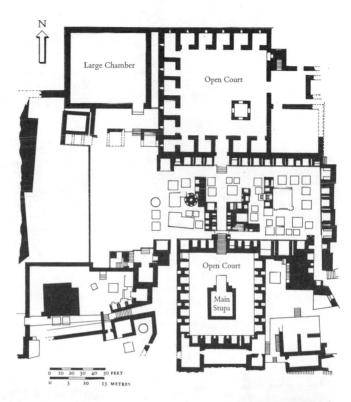

79 and 80. Tak<u>h</u>t-i-Bāhi, monastery

N

Large Chamber

Open Court

Open Court

Main Stupa

0 10 20 30 40 50 FEET
0 5 10 15 METRES

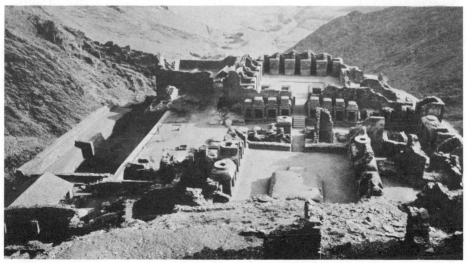

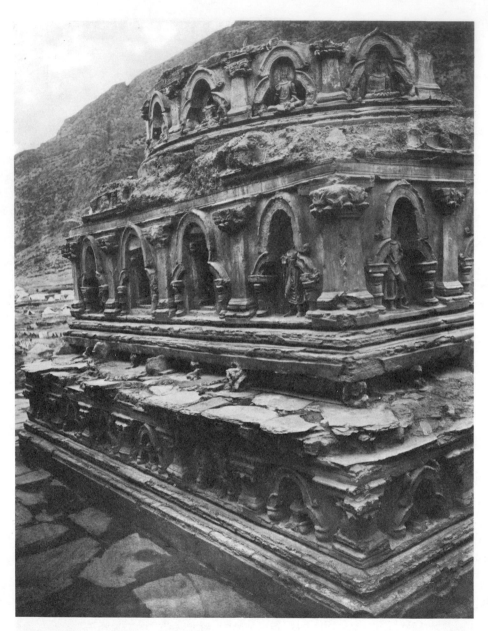

81. Ali Masjid stupa, Khyber Pass

bers served as assembly halls or refectories. Some of the outdoor enclosures are crowded with stupas of varying sizes, the gifts of individual donors, clustered around a larger stupa that contained the principal relic of the establishment. The buildings at Takht-i-Bāhi, like their counterparts at Taxila and elsewhere in Gandhāra, are constructed of stones of varying sizes arranged in diaper fashion. Certain elements, like the heavy, overhanging cornices of the niches, are obviously imitations of prototypes in thatch. We must imagine that originally the entire surface of this stone fabric, together with the statuary it housed, was covered with a heavy layer of lime plaster, richly polychromed and gilded [84].

The stupa in Gandhāra marks the gradual elaboration of the primitive types known at Sānchī and Bhārhut. This elaboration takes the form of the all-over sculptural ornamentation of base, drum, and hemispherical dome. Especially notable is the greater emphasis on the superstructure. Not infrequently the Gandhāra stupas have an attenuated, tower-like appearance, whereby the height of the finial dwarfs the size of the base and dome; and it is highly likely that from such models the earliest pagodas of China were developed. As an example of this architectural type in Gandhāra, the Ali Masjid stupa in the Khyber Pass may be taken [81]. The illustration shows the monument immediately after excavation and before its figural decoration was demolished by iconoclastic Pathan tribesmen. This monument, orginally more than forty feet high, is characteristic of even larger Gandhāra stupas in its elevation, consisting of two square bases, a drum, probably originally in two storeys, and surmounted at one time by the usual superstructure of harmikā and finial of tiered umbrellas. The ornamentation of the façade is the combination of Indian and Classical elements so universal in every aspect of Gandhāra art. Supporting the second storey

of the basement are caryatids in the shape of crouching yakshas and lions. The principal scheme of decoration consists of a stucco revetment of arcades attached to the façade. These arcades on bases and drums alike consist of chaitya arches supported on stubby balusters framed in debased Corinthian pilasters. The effect recalls the ornamentation of the Bīmarān reliquary, and is ultimately derived from the engaged orders of Roman architecture. This architectural ornament is carried out entirely in lime plaster attached to the core of the stupa, which was constructed of the usual mixture of boulders and small stones. The sculpture installed in the niches of the Ali Masjid stupa comprised a heterogeneous assortment of Buddha and Bodhisattva images – not arranged, apparently, according to any unified iconographic scheme, but representing only different aspects of the deified Buddha of the Mahāyāna faith. This relic mound is characteristic of Gandhāra in the elaborateness of its decoration, applied now to the stupa, and not to its surrounding railing. The architect's interest in greater height is suggested by the repetition of the storeys of the base and drum.

The most famous stupa in Gandhāra, a veritable Buddhist wonder of the world, was the great tower raised by King Kanishka in Peshawar. Excavations at the site of Shāh-jī-ki-Dherī have revealed a massive square platform richly decorated with stucco images of the Buddha, and with staircases leading to an upper level. According to the description of the Chinese pilgrim, Sung Yün, who visited the site in the sixth century A.D., the superstructure was built of 'every kind of wood' and the monument in thirteen storeys rose to a height of seven hundred feet; it was dominated by an iron mast supporting thirteen gilded copper umbrellas, an element which, through its attraction of lightning, led to the destruction of the tower.[26] One may gain some idea of its original appearance

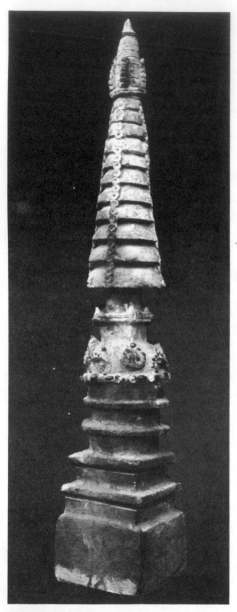

82. Model stupa from Jaulian.
Taxila, Archaeological Museum

from the miniature stupas of tower-like proportions found at Taxila and elsewhere [82].[27]

Although, as we have already seen, the Ionic order was used in buildings during the Parthian period at Taxila, Corinthian is almost universally employed in the structures erected during the Kushan era. The Corinthian capitals of Gandhāra have their nearest prototypes in Roman provincial examples in Syria and Palestine. There is nothing organic about the arrangement of leaves and helices; even the calyx cups from which the spiralling fronds emerge in Classic Corinthian have disappeared. In certain examples [83] such an application of acanthus leaves to a form recalling the ancient Indian bracket type of capital results in a complete loss of the basket-like shape of the Corinthian. In many examples of Gandhāra Corinthian capitals figures of Buddhas and Bodhisattvas are introduced into the foliage, a combination of elements suggestive of the Composite form of Roman order. Indeed, the predominance of the Corinthian order, together with an almost total absence of the Doric and Ionic in Gandhāra architecture of the Buddhist period, is one of the strongest arguments in favour of the entirely Roman origin of the whole school.

Sir John Marshall has attempted to establish a chronology for Gandhāra architecture on the basis of the types of masonry found in buildings of consecutive strata at Taxila. The buildings of the Parthian Period, like the temple at Jandial prior to the Kushan occupation in the first century A.D., have their walls constructed of rubble, a heterogeneous mixture of large and small stones [78]. This type was replaced in the earliest Buddhist structures by a variety of diaper-patterned rubble with the interstices filled with small stones or snecks [84]. In the latest types of Gandhāra buildings at Taxila, dating from the third century and later, this method was improved by introducing courses of precisely cut ashlar masonry alternating with layers of rubble.

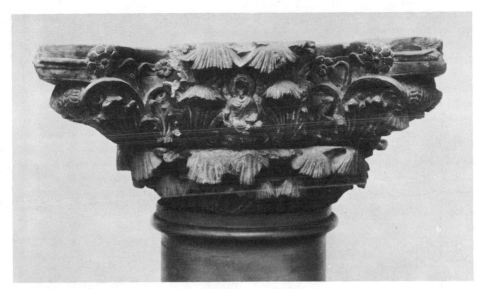

83. Corinthian capital from Jamālgaṛhi.
London, British Museum

84. Ta<u>kh</u>t-i-Bāhi, stupa court

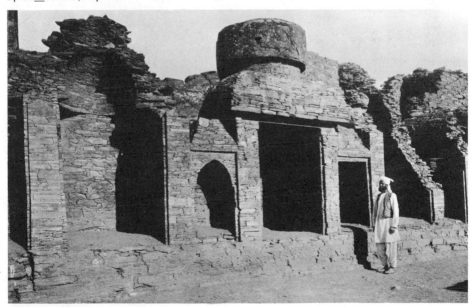

None of these different types of construction was meant to be seen. They served only as a base or a core for an outer decoration of polychromed stucco.

Excavations at Surkh Kotal in northern Afghanistan have brought to light a fire temple with a plan recalling that of the Jandial sanctuary and earlier examples in Iran [85]. Another temple was apparently dedicated to the cult of the Kushan king.[28] An inscription in Greek found at this site records the dedication by the great King Kanishka to Oanindo, the Kushan genius of victory. Among the statues found at Surkh Kotal is a fragmentary effigy resembling the portrait of Kanishka at Mathurā [96] and a second image, perhaps of a Kushan prince, represented wearing a fur-lined mantle or *pustin* [86]. The rigid frontality of these statues is strongly suggestive of Parthian portrait sculpture, and the indication of the drapery in a convention of raised ridges approximates the technique of late Gandhāra sculpture [68].

Many of the Kushan royal portraits have haunting resemblances to Parthian prototypes at Hatra and elsewhere. Fragments of a great many royal effigies have been found in the vast palaces of ancient Chorasmia (Khwarezm, U.S.S.R.), and it is possible that the Kushan

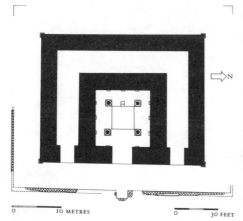

0 10 METRES 0 30 FEET

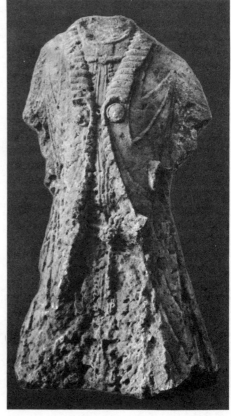

85. Surkh Kotal, fire temple

86. Kushan prince from Surkh Kotal.
Kabul, Museum

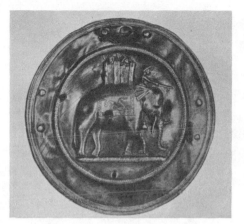

cult images at Mat and Surkh Kotal may be derived from this former part of eastern Iran in the early centuries of the Christian era.

*

Although the first examples of actual Greek sculpture have only recently been discovered in Bactria, a number of magnificent silver plates and bowls, most of them in the collection of the Hermitage at Leningrad, have often been identified as actual examples of Bactrian metalwork. Many of these were undoubtedly exports from the Seleucid West, but some at least, for example two phalerae with representations of war elephants [87], have haunting technical and stylistic features that would appear related to this isolated Hellenistic province.[29] The princely personage riding in the fortified howdah bears a marked resemblance to the coin portraits of the Bactrian king Eucratides [65C]. The saddle-cloth is decorated with a representation of a hippocamp, of a type that later makes its appearance in the sculpture of Gandhāra and in the toilet trays discovered at Taxila and elsewhere.[30]

An entire chapter could be devoted to the hoards of precious objects in gold and silver found at Taxila of the Śaka-Parthian and Kushan Periods, so that only a small number of representative pieces may be conveniently dis-

cussed here. This material represents the same mixture of Classical, Iranian, and Indian forms and techniques that characterizes the art of Gandhāra. Most of these objects found at Sirkap were presumably buried at the approach of the Kushan invaders in A.D. 64. Among the objects of metalwork are a number of silver goblets with carinated and fluted bodies [88]. A tiny foot supports the vessel; the shape has no relation to any classical type and is possibly derived from similar types in prehistoric pottery. Exactly similar drinking vessels appear in early Gandhāra bacchanalian reliefs [71].[31] The examples of jewellery found at Taxila often duplicate the

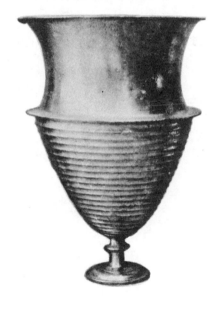

87 (above left). Plate with war elephant from Bactria. Leningrad, Hermitage

88. Silver goblet from Taxila. Taxila, Archaeological Museum

89. Gold amulet boxes from Taxila.
Taxila, Archaeological Museum

ornaments worn by the Gandhāra Bodhisattvas [89]; for example, a string of amulet boxes that is an inevitable feature of these princely figures [70]. These little containers of charms against evil forces represent the persistence of an age-old Indian magic. A gold repoussé plaque representing Cupid and Psyche is possibly an actual example of the type of turban pins often decor-

ating the head-dresses of the Bodhisattva figures [90]. The Classical theme has been translated into the rather heavy semi-Indian forms of Gandhāra sculpture.

Belonging to the end of the Śaka-Parthian Period at Taxila are a number of gold earrings of the 'leech-and-pendant' type, a pattern also known in Greco-Roman jewellery. The clasp in

90. Gold plaque with Cupid and Psyche from Taxila.
Taxila, Archaeological Museum

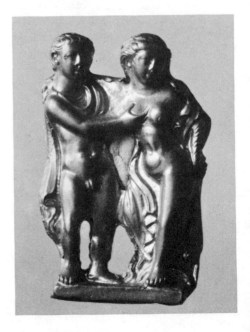

91. Ear pendant from Taxila.
Taxila, Archaeological Museum

92. Silver anklets from Taxila.
Taxila, Archaeological Museum

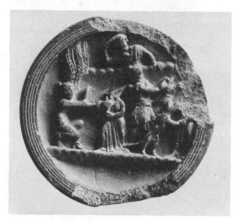

the example illustrated [91] is ornamented with a tiny female bust set in a lotus rosette. From a beaded circlet hangs a trefoil pendant in granulated gold filigree. The massive silver anklets [92] are of a type often represented among the ornaments of the Kushan yakshīs of Mathurā [100].

Among the minor finds at Taxila and elsewhere in north-western Pakistan are numerous steatite dishes, usually described as toilet trays. The subjects carved on these little bowls are almost all Classical. The earliest specimens are usually associated with the Śaka-Parthian Period (first century B.C.) and are related to similar objects found in Egypt.[32] In the example illustrated [93], it will be noted that the Diana and Actaeon are carved nearly in the full round, as in the reliefs of the Sārnāth capital [21].

One of the prime examples in the art of Gandhāra of the rather uneasy merging of Indian religious themes and the motifs and

93. Steatite dish with Diana and Actaeon from Gandhāra.
London, British Museum

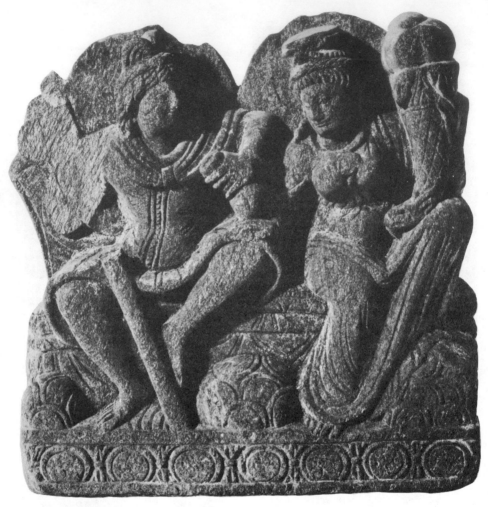

94. Pāñcika and Hāritī.
Oxford, Ashmolean Museum, Department of Eastern Art (Hailey Gift)

styles of Western classical art is the stone reliefs showing Pāñcika and Hāritī seated side by side in a manner probably suggested by the tutelary couples of Roman art [94]. Pāñcika was originally a *yakṣa* general whose name was eventually taken over by Kubera, god of wealth and regent of the north; his consort, Hāritī, is an Indian demoness associated with children and smallpox and worshipped, in one guise or another, in Indian villages to this day. She is depicted, however, wearing a gown reminiscent of classical Greek dress and she holds a cornucopia like the Greek goddess Demeter; he is shown wearing 'Scythian' garb and holding a long lance, but the style of both figures is essentially derived from Roman art.

ART UNDER THE KUSHANS

II. MATHURĀ: THE INDIAN PHASE

The completely Indian art created at Mathurā (modern Muttra) on the Jumna River in the early centuries of the Christian era, unlike that of Gandhāra, did not appear as a sudden outburst of creative activity inspired by Kushan patronage. It may be properly regarded as an outgrowth of the ancient Indian schools: inscriptions and fragments of sculpture take the history of Mathurā as a centre of religious art back to c. 200 B.C.; a number of dated fragments from the early first century A.D., mostly from Jain monuments, are the stylistic equivalent of some of the more advanced works at Bhārhut. The great period of Mathurā's florescence coincides with the great century of Kushan rule under the reigns of Kanishka and his successors (c. A.D. 144–241), and is thus exactly contemporary with the school of Gandhāra. The city continued as an important religious and artistic centre in the Gupta Period. The sculptured decoration of the religious establishments at Mathurā, from pre-Kushan times through the Gupta Period, was all carved from the red sandstone quarried at Sikrī, near the Kushan capital. This is an exceedingly ugly stone, frequently marred by veins of yellow and white, so that streaks and spots of these lighter colours disfigure the surface. For this reason, there can be little doubt that the whole carved surface was originally covered with a concealing layer of polychromy or gilt.

Before examining the specimens of purely religious art, it will be useful to consider a group of portrait statues separated in style both from the Gandhāra school and the native techniques of Mathurā. This group of statues consists of portraits of Kanishka, his predecessor, Wima Kadphises, and a Kushan satrap, Chashtana, who ruled in Sind. Given their intimate connexion with the royal patrons of Buddhism in northern India and their autonomous stylistic character, these effigies make an interesting starting point for the consideration of the contribution of the school of Mathurā. All the portraits were found together in the ruins of a structure that presumably was exclusively devoted to a royal cult.[1] It should be emphasized first of all that, although representations of donors, typical rather than realistic in character, do occur on Gandhāra reliefs, these are the sole examples of portrait sculpture known in ancient India.[2] This factor alone suggests a foreign influence behind their manufacture and installation. Probably this influence is to be traced to the Kushans' knowledge of the Roman practice of erecting likenesses of the deified Caesars or the Parthian commemorations of mortal sovereigns. From the stylistic point of view, the latter possibility seems more probable. The statue of Wima Kadphises, dated in the sixth year of Kanishka's reign (A.D. 134 or 150), represents the ruler seated on a lion-throne, wearing the short tunic and heavy felt boots so familiar on the coin portraits of these same Kushan kings [95]. Only the breadth of shoulders and fullness of the form suggest a

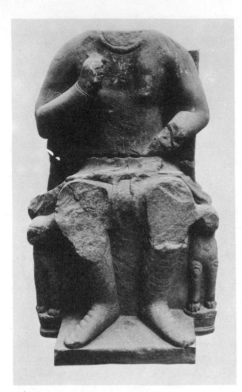

95. Wima Kadphises from Mathurā.
Muttra, Archaeological Museum

96 (*opposite*). Kanishka from Mathurā.
Muttra, Archaeological Museum

continuation of the Indian figure style. The image has a massiveness and crudity immediately suggestive of fragmentary Iranian portrait-statues of the Parthian Period published by Herzfeld.[3] It might be mentioned, too, that the precise carving of the ornamental border of the cloth draped over the throne reveals an almost exact copy of the designs of woven silks from Palmyra – one more indication of the close commercial and cultural links between the Kushan Empire and the West.

The companion statue of Kanishka [96] is identified by an inscription cut across the bottom of the mantle: 'The great King, the King of Kings, His Majesty Kanishka'. The statue shows the monarch standing rigidly frontal, his hands resting on sword and mace. The statue is headless, but the resemblance of the whole to the likeness of Kanishka on his coins is so close that one could reconstruct the image by adding the massive bearded head with peaked cap that we invariably see in the coin-portraits [65 G and H]. Kanishka in this official statue is clad in a stiff mantle and heavy, padded boots of a type still found in Gilgit. This costume, so entirely unsuited to the heat of Mathurā, was perhaps assumed for ceremonial purposes, since it is a dress imported from the homeland of the Kushan invaders. No effigy of an Assyrian king or Roman Caesar gives a stronger impression of authority and power than this image of the conqueror from the steppes, an effect conveyed by the arrogant pose and the hieratic, almost idol-like rigidity of the form. The image is rather like a relief disengaged from its background with no suggestion of three-dimensional existence. It consists of hardly more than a stone slab carved into the silhouette of a cloaked figure. The whole emphasis is on the eccentric silhouette provided by the sharp and angular lines of the military mantle, exactly as in the coin-portraits of the same ruler. The indication of drapery consists only of crudely incised serpentine lines across

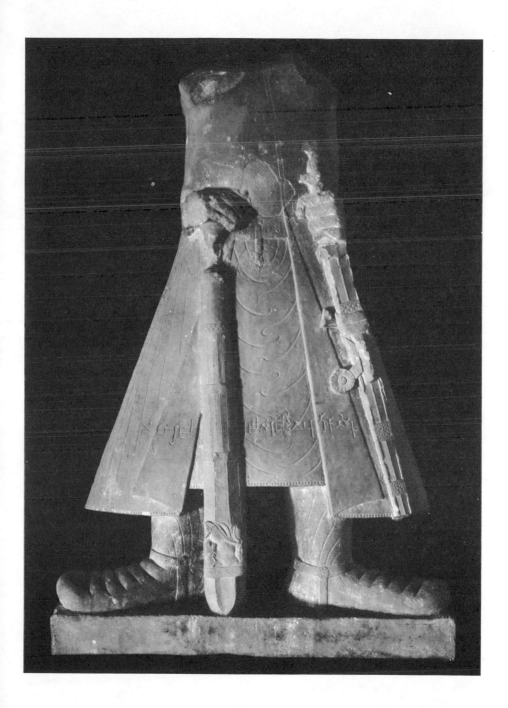

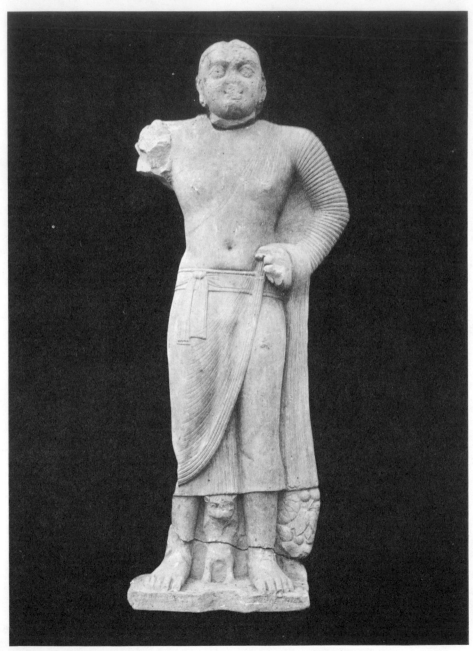

97. Bodhisattva dedicated by Friar Bala
from Mathurā.
Sārnāth, Archaeological Museum

the front of the skirt, and the sole suggestion of
Indian workmanship might be discerned in the
careful rendering of the *makara* head of the
sovereign's mace. One is left with the feeling
that the primitive and crude quality of these
portrait statues is perhaps partly due to the
Indian workman's complete unfamiliarity and
lack of sympathy with this form of art: without
the systems of proportion and tradition that
determined his operations in carving Buddha
images, he could produce only the crudest
ideograph of a portrait.

The sculptors of Mathurā undoubtedly
deserve credit for creating the earliest, entirely
Indian representations of the Buddha. Whether
these statues are earlier, or later, or exactly
contemporary with the first Gandhāra Buddhas
is a question that has been discussed a great deal
but is of little real interest, except for those
determined to establish a chauvinistic priority
for the entirely Indian type evolved at Mathurā.

What was presumably one of the very first
images of Buddha to be carved at Mathurā is a
more than life-sized standing figure found at
Sārnāth [97]. It bears an inscription noting its
dedication by a certain Friar Bala and a date in
the third year of Kanishka, corresponding to
either A.D. 131 or 147.[4] The statue represents
Śākyamuni standing erect, his feet firmly
planted, the right hand raised in the gesture of
reassurance, the left on the hip supporting the
folds of his robe. It has been suggested that he
is shown as a Bodhisattva, rather than Buddha,
since the figure is nude to the waist and wears
the characteristic Indian dhoti. The massive
proportions of this and related figures of the
same type, its connotation of weight and
expansive volume, as well as the dress, clearly
link it to the colossal yaksha statues of the
Maurya Period. The carving of both flesh and
drapery is much more subtle; although greatly
simplified and still represented by the archaic
technique of incised lines, the carving of the
drapery suggests not only texture but the

existence of the stuff as a volume separate from
the form it clothes. The subtle rounding and
interlocking of the planes of the torso contrive
to give a suggestion of the warmth and firmness
of flesh and, as in the Harappā torso, a powerful
feeling for the presence of the inner breath or
prāṇa.

When it came to the carving of the Buddha
image, Indian sculptors were no longer able to
depend on the kind of loving reporting of
surrounding nature that gives the early Indian
sculptures such an extraordinary vitality; the
nature of the subject – the Buddha already con-
ceived of as a transcendant personage, one who
had passed beyond Nirvāṇa – almost forced a
reliance on preconceived ideals of divine beauty
and a dependence on certain superhuman
proportions and attributes which would proper-
ly assure the image's assuming an appropriately
iconic aspect of divine perfection. It is this
enforced method of visualization that bestows
such an awe-inspiring and hieratic character on
the representations of the Great Teacher.

The making of an image of the Buddha
involved much more than the mere carving of a
human effigy and designation of it as Śākya-
muni. While Western art sought to make an
aesthetically beautiful form by portraying
human figures which were models of physical
perfection and athletic vigour, Indian art
started with abstract spiritual concepts which
had to be translated into physical shape. A
proper likeness of the Buddha had to show his
achievement of the final yoga state of serenity
and complete mental equilibrium, and in addi-
tion it had to incorporate all the lakṣaṇā or
thirty-two major signs of superhuman per-
fection distinguishing the body of a Buddha
from those of ordinary mortals. As ruler of the
universe, Buddha assumes the physical em-
blems or signs, perhaps originally of astrological
origin, which characterize the body of a
Mahāpuruṣa or Great Being and a Cakravartin
or World Ruler. These signs of physical and

spiritual perfection include the protuberance, or ushnisha, on the skull and the urna or tuft of hair between the eyebrows; in addition, the body of Buddha is like that of a lion, the legs are like those of a gazelle, and on the soles of his feet appear two shining wheels with a thousand spokes. The carving of images on the basis of such descriptions was almost literally meta-phorical, and imposed certain inevitable abstractions on the conception of the form.

The Indian maker of images had also to reproduce the mudrās or hand gestures that very early came to be associated with various actions and events in the career of Śākyamuni. The earth-touching mudrā came to be identified specifically with the Enlightenment; and the so-called wheel-turning gesture stood for the First Preaching at Sārnāth. The most common of all is the *abhāya mudrā*, the gesture of reassurance. This might be described as a gesture of blessing. Although in early Buddhist art the number of these mudrās is very limited, the iconography of later esoteric Buddhism enlarged the repertory to include an enormous number of these hand positions to designate the mystic powers of the countless members of the Mahāyāna pantheon.

In the rendering of sacred figures certain fixed canons of proportion made their appear-ance at a relatively early period. The unit of measurement, which has no reference to any actual physical anatomy, is an entirely arbitrary one designed to produce an ideal rather than a human proportion. This modulus is the *thalam*, roughly a palm or the distance between the top of the forehead and the chin, which is divided nine times into the total height of the figure. These canons of measurement were specifically designed to ensure an appropriately heroic stature for the representation of the divinity. Both the system and the result of its use are comparable to the invention of a superhuman physical anatomy for figures of gods in Egypt and Greece of the Archaic Period.

98. Seated Buddha from Katra.
Muttra, Archaeological Museum

The Indian type of seated Buddha may be found in numerous early examples from Mathurā, such as a specimen from Katra in the Archaeological Museum at Muttra [98]. The carving is of the same rather vigorous, often crude type that distinguishes the group of Friar Bala statues. The treatment of the body in broadly conceived planes, with the suggestion of the pneumatic distension through prāṇa, is at once apparent. The face is characterized by its warm, 'friendly' expression. Again, as in the standing images, it is evident that the sculptor has translated into stone the various metaphors or lakṣanās: he is very careful to represent the distinctive magic-marks on the hands and feet. Another interesting feature of this relief is that it appears to be an early example of the trinity in Indian art; the attendants presumably may be identified as Indra and Brahma, who later are replaced by Bodhisattvas. It seems likely that in origin the trinity motif stems from a literal representation of the Descent from the Tushita Heaven, with the Buddha accompanied by the great gods of the Brahmanic pantheon; it needed only a hieratic isolation of the three figures to produce the first conception of the trinity.[5] It will be noted that, just as in the stand-ing figures of the second century, so in the seated examples, the Buddha is represented clad only in a dhoti; it is only in the Kushan reliefs, apparently under Gandhāran influence, that Śākyamuni is depicted with the monastic robe covering the body; in these the drapery, conceived as a series of string-like ridges or in overlapping shingle-like pleats, is an evident imitation of the classical drapery of the Gandhāra school.

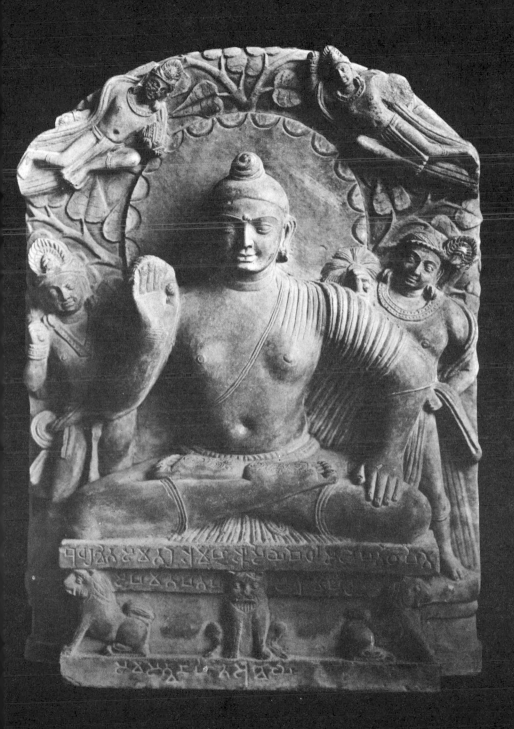

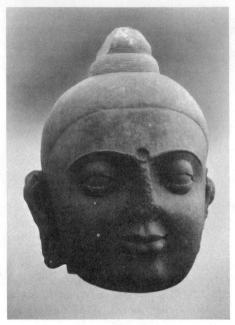

99. Head of Buddha from Mathurā.
Muttra, Archaeological Museum

Nothing could be more striking than the contrast of the typical Gandhāra and Mathurā heads reproduced in illustrations 67 and 99. Nor could anything more emphatically reveal the contribution of the school of Mathurā to Indian Buddhist art. If the ushnisha of the Gandhāra example was disguised by the *krobylos* borrowed from classical art, this cranial extension is fully revealed in the Mathurā head as a kind of tiered snail-shell structure. The Gandhāra head is a curious mixture of abstraction and realism: the brows and eyes are modelled with the hard dryness of carving characteristic of Late Antique art, whereas the lower part of the face is sculptured with apparent concern for the realistic definition of the structure of the mouth and chin, so that the result is at once mask-like and inconsistent. The head of the Buddha from Mathurā is, on the contrary, completely consistent in the sculptor's self-imposed abstraction. The individual features are integrated into the essentially spheroidal mass of the head, and no lingering over exactitude of anatomical detail interferes with the primary concern for the presentation of the solid volume of the whole. No less than in the bodies of Kushan Buddhas is there a suggestion of expansive inner force achieved by the composition of the head as a collection of subtly interlocking and swelling planes, from the curve of cheek and jowl to the related curvatures of eyelids and brows.

In contrast to the cold and often rather vapid expressions of the Gandhāra Buddhas, the faces of the statue dedicated by Friar Bala and other examples from the Kushan school at Mathurā are characterized by an open, radiant expression: the eyes are fully open, the cheeks round and full, the mouth ample, with lips drawn into a slight smile. This smile is probably the earliest appearance of the only possible device by which the Indian sculptor could indicate the inner contentment and repose of the Buddha's nature; in later schools, like the

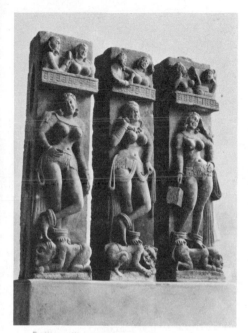

100. Railing pillars with yakshīs from Bhūteśar.
Muttra, Archaeological Museum

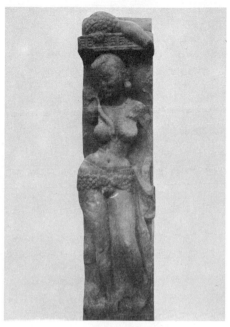

101. Railing pillar with yakshī from Jaisinghpura.
Muttra, Archaeological Museum

Cambodian sculpture of the Classic Period, it comes to be a kind of mannerism or cliché. The Indian sculptors employed at Mathurā were much more orthodox than their Gandhāran contemporaries in their representation of the various lakṣaṇā: in the Sārnāth statue, although the individual curls are not shown, the hair is indicated as cut short and forming a sort of cap on the skull; the lion-shaped torso, the tapering arms and legs, all correspond to the textual descriptions of the Buddha's superhuman anatomy. In most Mathurā images, like the seated figure from Katra, the carvers scrupulously represent the marks of the wheel, triśūla, etc., on the palms and soles. The general impression given by the Sārnāth statue – grandiose, weighty, and yet characterized by a certain athletic litheness – marks the gradual development of the Indian ideal of physical beauty that reaches its mature expression in the work of the Gupta Period.

The architecture of Mathurā was so thoroughly demolished by the Islamic invaders of Northern India that it is impossible to select any one building as typical of Kushan times. Characteristic types like the stupa were presumably only an elaboration of earlier forms: at Mathurā the relic mounds were surrounded with the usual railing, the uprights of which were generally carved in high relief with representations of yakshīs of a flamboyance and sensuality of expression surpassing anything known in the art of earlier periods [100 and 101]. In their provocative and frank display of the beauties and delights of the courtesan's art, these reliefs mark the culmination of a tendency

already noted in the carvings at Sāñchī and Bhārhut. Not only is there a thoroughly convincing suggestion of solidity of form, but the articulation of body and limbs is achieved with complete mastery and no suggestion of the mechanistic joining of individual parts that characterized the work of the archaic schools. The figures of the fertility spirits are usually represented in attitudes of violent *contrapposto*,

with the body broken as many as three times on its axis. This sinuous and moving type of pose, as well as the eloquent and really flower-like gestures of the hands, suggest very strongly the active imitation by the carvers of the poses and gestures of the Indian dance. The question may well be asked: what is the purpose of such frankly sensuous figures on a Buddhist monument? The answer is that possibly they

102. The yaksha Kuvera and his court
from Pal Khera.
Muttra, Archaeological Museum

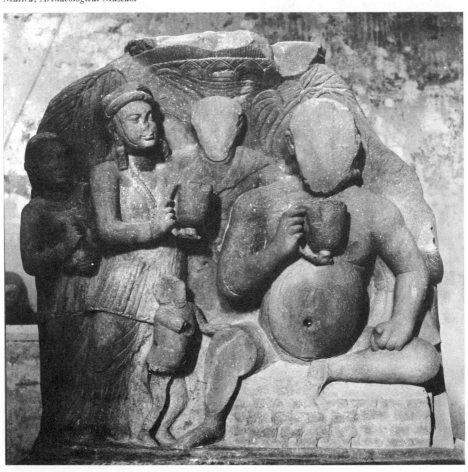

represent a pointed reference on the *exterior* of the sacred enclosure to the transitory life of pleasure, outside the peace of the world of Buddha; again, it may be that, like the mithunas of later Hindu art, they represent an allegory of the desirability of the soul's union with the divine in the forms of these beautiful dryads that so actively suggest the desirability of sexual union.

Although a certain number of Buddha images datable in the second and third centuries A.D. clearly suggest a crude imitation of the Romanized drapery of Gandhāra, there is little indication of any strong Western influence in the art of the southern portions of the Kushan realm. In the early decades of archaeological investigations there were found in and around Mathurā a number of similar reliefs all representing a nude fat man being plied with drink by maidens or supported in a complete state of intoxication [102]. These were at first identified as Indian representations of the story of Silenus; it seems much more reasonable to suppose, however, that they are intended to portray the Paradise of the Yaksha Kuvera, in which eternal inebriation was believed to be one of the delights of this Buddhist Guardian and his entourage. Since it had become Kuvera's function to guard the establishments of Buddhism, the appropriateness of these Dionysian representations of his kingdom becomes apparent.

At least one Kushan pillar relief shows a positive imitation of a type of Classical divinity, probably for decorative rather than religious reasons [103]. This is the so-called Herakles with the Nemean Lion, in the Indian Museum, Calcutta. Although the theme and the Praxitelean *déhanchement* of the body might be borrowed from some classical source, the style of the relief is entirely Indian, distinguished by the same general traits of modelling employed in earlier examples of figure sculpture. Here the organic realization of the form as a whole is even

more marked than in such figures as the Indra at Bodh Gayā. The body is conceived in thoroughly sculptural terms, with the subtle curvature of the planes of the muscular anatomy contributing to the wholly Indian feeling of fleshly warmth and fullness.

Sculpture in relief under the Kushans at Mathurā is in many respects an outgrowth of the styles of the archaic period, although at the

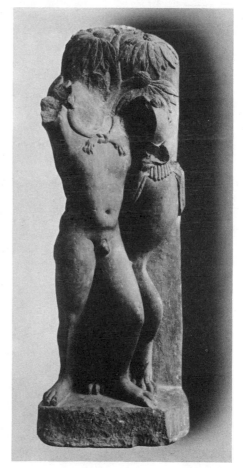

103. 'Herakles and the Nemean lion' from Mathurā. *Calcutta, Indian Museum*

same time it is undoubtedly influenced by innovations from Gandhāra, most notably in the inclusion of Buddha in anthropomorphic form. Both in the relation of Jātaka stories and events from the life of Buddha the sculptors of Mathurā evolved what could be described as a shorthand manner of presentation, in which the various episodes are stripped of all details of action and setting, so that the event is often typified only by the figure of the Buddha in characteristic pose and mudrā. In the example illustrated [104], the Enlightenment is represented by the figure of the master in earth-touching gesture and surrounded by the three daughters of Māra, typifying the Temptation. The Buddha's First Preaching shows the master seated with his hand on a symbolical wheel. An interesting iconographical detail shows us the Nativity of the Buddha, symbolized by the sun-god in his chariot. In the lower register we see four of the seven Buddhas of the Past; and, as a

Bodhisattva, Maitreya, the Buddha of the Future. Generally, the panels carved at Mathurā are not conceived with that illusionistic depth of cutting distinguishing the Sāñchī reliefs; the figures and setting, again suggestive of a Gandhāran device, are isolated against a plain background with little or no overlapping. It seems more likely that this method of relief carving is a continuation of the archaic style of Bhārhut, rather than an influence of Gandhāra reliefs in the Augustan style. It will be noted that the diminutive figures of the Buddha portray him in the saṅghātī or Buddhist mantle in an evident imitation of the draped Buddha figures of Gandhāra.

A hitherto entirely unsuspected phase of Kushan art was revealed in the course of the excavations of the Kushan capital at Begrām in Afghanistan, the ancient Kapiśa, known to both Classical writers and Chinese pilgrims. There, in the ruins of the palace of Kanishka and his

104. Relief with scenes from the life of Buddha from Mathurā. *Lucknow, Provincial Museum*

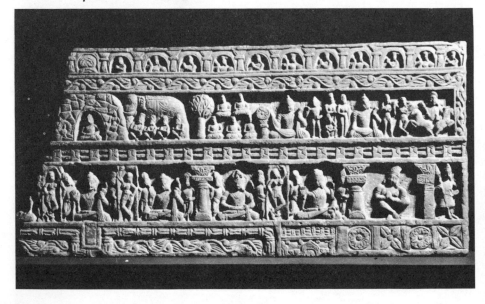

successors, was uncovered a great treasure of Syrian glass, Roman metal and plaster sculpture, Chinese lacquer, and, of special interest to us at this point, a magnificent collection of fragments of Indian ivory carvings. All this material was presumably buried when the Kushan city was destroyed by Shāpur I of Iran in A.D. 241. The ivories from Begrām consist of brittle carved plaques that were once attached to the wooden frames of boxes that have long since crumbled to dust. The variety of subjects and treatment is immense, and includes types of ancient Near Eastern, Classic, and purely Indian origin. Some of the largest of the ivory plaques, which originally formed the lids of cosmetic boxes, are among the loveliest relics of Indian art. The technique is one of extreme delicacy and sophistication. The individual figures and decorative details are carved with deeply incised contours providing an enveloping line of shadow for the forms. The carving is

in a kind of *rilievo schiacciato*, with the most subtle nuances of modelling, conveying a feeling of roundness to the flattened figures. This exquisiteness of definition is entirely in keeping with the elegant and aristocratic conception of the figures. In some of the reliefs, as in the beautiful group of a lady and her handmaid [105], traces of colour still remain on the eyebrows, eyes, nose, and mouth. The border of this panel is interesting, too. The inner frame consists of a Greek fret; and, outside this, a wider frame encloses a vine meander, in which we may discern representations of a bird and a grotesque combination of a human head and a horse. The outer border consists of a clearly recognizable bead-and-reel pattern. The subject of the central panel is a kind of Indian counterpart of the scene of a court lady at her toilet by the Chinese painter Ku K'ai-chih, in the British Museum. How completely these ivory carvings belong to the tradition of Kushan

105 and 106. Ivory plaque with harem beauties from Begrām. *Paris, Musée Guimet*

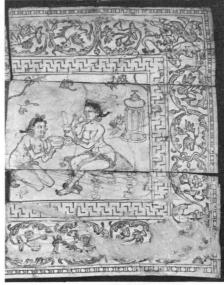

sculpture at Mathurā may be illustrated by a comparison of a female attendant from one of the larger plaques from Begrām [106] with a yakshī from a railing pillar at Mathurā [101]. The pose and accessories are nearly identical, and only the fuller roundness of the relief in the sandstone maiden makes her appear heavier than the light and elegant figure of the ivory plaque. Both are representative of an art that had reached the apogee of perfection both technically and in the evocation of a gently erotic mood and provocative sensuality unmatched anywhere in the art of the world. All these figures are almost literal translations into sculptural form of the descriptions of auspicious signs characterizing the forms of beautiful women in the *Bṛihatsamhitā*, by the sixth-century writer, Varāhamihira. 'Broad, plump and heavy hips to support the girdle, and navel deep, large and turned to the right, a middle with three folds and not hairy; breasts round, close to each other, equal and hard . . . and neck marked with three lines, bring wealth and joy.' The *tribhanga* pose of the two figures is one found repeated over and over again in countless examples of Indian sculpture and painting. In both the ivory panels illustrated the whole conception of the figures has something of the exquisite artificiality of the ballet. The gesture of the hand of the standing figure epitomizes the studied interpretative beauty of the gestures of the Indian dance. All these panels have a flavour of intimate erotic charm without the least vulgarity, which prophesies the romantic genre scenes of the Rajput miniatures. They illustrate how, when occasion demanded, the Indian sculptor, in his great versatility, could suggest form through effective moving contour by relief executed almost entirely in terms of line drawing.

A fragment of an ivory comb in the Victoria and Albert Museum from Mathurā or Uttar Pradesh and datable in the early Kushan period

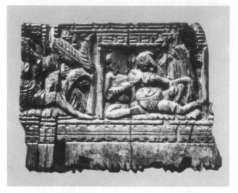

107. Ivory comb from Mathurā or Uttar Pradesh. *London, Victoria and Albert Museum*

[107] affords an interesting counterpart for the representation of court scenes in the relief from Pitalkhora [40] and the terracotta plaque from Kauśambi [58]. The technique is a combination of the carving in depth with some foreshortening and surface engraving to be seen in many of the Begrām ivories [56], and the railing motif of the cornice of the pavilion is popular in Mathurā reliefs [104].[6]

It is only in the accounts of Chinese visitors like Fa Hsien and Hsüan-tsang that we can get any idea of the sumptuous splendour of Buddhist architecture in the days of Kanishka and his successors. As has been already noted, the temples and monasteries of Mathurā were reduced to such a jumble of destruction by the Islamic invaders that not a single structure remains standing or even sufficiently intact to provide a reconstruction beyond a ground plan.

We have already discussed the famous tower of Kanishka at Peshawar in the previous chapter. Another Buddhist skyscraper, the foundations of which are linked to the Kushan Dynasty, is the Mahābodhi temple at Bodh Gayā that replaced a simple hypaethral shrine erected by Aśoka to enclose the bodhi tree. It was built to house an image of the Buddha at his

Enlightenment. The Mahābodhi temple is a rectangular structure supporting a tower in the shape of a truncated pyramid; smaller replicas of this central mass echo its shape at the four corners of the building [108]. When first constructed, the Mahābodhi temple consisted of a base or podium twenty feet high and fifty feet wide that served as a support for a single tower rising one hundred and eighty feet above ground; the subsidiary turrets, according to most authorities, represent a later addition. Some idea of its original appearance may be gained from a plaque discovered at Patna;[7] in this one may clearly discern the arched niche housing the miracle-working statue of Buddha. The inscription in Kharoshthi script of the second century A.D. is another bit of evidence suggesting its foundation in Kushan times.[8] As it stands to-day, the temple has been altered by restorations by Burmese Buddhists – the last in the eighties of the nineteenth century. The

architectural revetment of the façade, as well as the statuary that filled the niches, belongs to the Pāla-Sena Period (A.D. 750–1200) of Buddhist history. In spite of all these changes, it seems reasonably certain that one of the most striking features of its construction, a series of brick arches and vaults in the main sanctuary, must have belonged to the original fabric [109].[9] These arches were constructed of bricks joined with mortar. The bricks constituting the voussoirs were laid flatwise and made to adhere sufficiently to those behind to enable the builders to complete each arch or ring without any kind of support or centering. This is a technique that closely resembles the construction of the great arch at Ctesiphon, dating from the period of Khusrau I; it is just possible that this method of vaulting, so completely un-Indian, was introduced through the Kushan contacts with Sasanian Iran. It might be noted further that the original appearance of the Mahābodhi

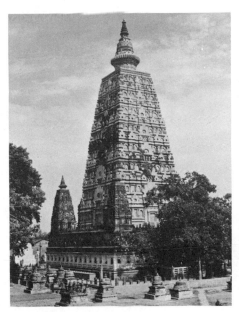

108. Bodh Gayā, Mahābodhi temple

109. Bodh Gayā, Mahābodhi temple, vaults before restoration

temple, with a great arched niche rising to the full height of the façade, must have been distinctly reminiscent of the *iwans* of such structures as Ctesiphon and the grotto of Taq-i-Bustān.

It can be stated in all fairness that the Kushans or Indo-Scythians themselves were not an artistic people: they had been nomadic in origin, and when they came to India they were exhausted by centuries of almost continuous migration across the roof of Asia; if they had any art at all, it may be assumed to have consisted of the metal horse-trappings and hunting gear that are generally the only and necessary form of expression in such races.[10] All the art produced in the regions of India conquered by the Kushans was made for them:

in Gandhāra, by foreign artisans and Indians trained under Near Eastern supervision; at Mathurā, by Indian workshops that were a continuation of the ancient native tradition of sculpture and architecture. The chief contribution of the Kushans to Indian and Asiatic art history was the patronage which made possible the flourishing of two of the most important schools of Indian art:[11] the Gandhāra school, with its development of the iconography of the Buddha image and the Buddha legend, and the Mathurā school, that marked the first really Indian development of a mature language of form dedicated to religious art. As we shall see, these two contributions, iconographic and stylistic, fuse in the magnificent Renaissance of Gupta art.

AFGHANISTAN: THE ROAD TO CENTRAL ASIA

Afghanistan may be described geographically and culturally as a no-man's-land lying between India, Iran, and Central Asia. This land of towering ranges of mountains and arid wastelands, populated by peoples of fierce pride and barbarous standards, has for generations loomed as a beckoning and mysterious El Dorado for romantic and dangerous adventure and exploration. Afghanistan came to notice through Byron's contemporaries and spiritual confrères, the unsung adventurers and soldiers of fortune whose romantic wanderlust took them to the court of the Amir before the days of the First Afghan War. The savagery of Afghan tribesmen has been immortalized by Kipling's exaggerations in story and verse. Some of the early visitors, like Lieutenant Burnes, in addition to their geographical exploration, discovered the archaeological wealth of the Kabul Valley in the great hoards of Bactrian coins and occasional fragments of Gandhāra sculptures; but, owing to the unfavourable political conditions and intense anti-foreign sentiment, no scientific excavation or exploration became possible until a French archaeological mission was able to secure the rights for excavation in 1922. On the results of the work of such distinguished and devoted archaeologists as Alfred Foucher and the late J. Hackin and J. Carl is based all our knowledge of art on this threshold of Central Asia.

Although the early remains belong to what we know as Gandhāra art, the development of Buddhist art in Afghanistan requires separate treatment. The region, it is true, has always been intimately connected, both geographically and politically, with north-western India, but its position in relation to Iran and Central Asia

has made it a kind of melting-pot and a centre for the diffusion of Indian, Iranian, and Classical forms and techniques. It is important to note at the outset that southern Afghanistan, mainly the valley of the Kabul River, belongs geographically to India; once across the continental divide of the Shibar Pass in the Hindu Kush, however, we find ourselves in the watershed of the Oxus; this northern region of Afghanistan, in other words, belongs culturally as well as geographically to Central Asia.

In the fourth century B.C., Afghanistan, then part of the Achaemenid Empire of Darius, was overrun by the armies of Alexander and garrisoned by Greek troops at strategic points on the road to India. We have already referred to the coins of Alexander's successors in Bactria [65] as evidence for the penetration of Hellenism. Excavations begun in 1965 near Khodjagan on the Oxus are uncovering the remains of the Greek city of Ay Khanum, and the Greek sculptures discovered at Nisa in Russian Turkestan are actual examples of Hellenistic art in Asia. The types of Buddhist architecture in Afghanistan are no different from what may be seen in Gandhāra proper. In the mountains near Kabul and along the Kabul River by Jelālābād rise the ruined cores of stupas built in the same shape and of the same mixture of boulders and small stones used at Taxila. Originally, like the buildings excavated at Haḍḍa and the Ali Masjid stupa [81], they were brilliantly decorated with polychromed stucco.

The earliest site of consequence that has been excavated is the ancient Kushan capital of Kapiśa, the present hamlet of Begrām on the banks of the Panjir River. Kapiśa, which over a period of centuries was the northern and

summer capital of the Kushan rulers, was also a site famous in the annals of Buddhism; it is described by Hsüan-tsang as a flourishing centre of Mahāyāna Buddhism, with splendid and imposing stupas and saṅghārāmas.[1] Nothing could be more appropriate to the nature of the finds at Begrām than Hsüan-tsang's remark, 'Here also are found objects of merchandise from all parts'.[2] The finds in the early Kushan palace included metal statuettes of Greco-Roman (probably Alexandrian) type, plaster replicas of the *emblema* of Hellenistic metalwork, and quantities of Syrian glassware, together with lacquer boxes from Han China. Here was a complete record of the luxurious and international character of Kushan taste. All these finds antedate the Sasanian sack of A.D. 241. The Buddhist sculpture found at Begrām and the nearby sites of Pāitāvā and Shotorak is of the usual Gandhāra style. Most of it probably dates from the third or fourth century: the Buddha images, like the one illustrated in Chapter 9 [68], have the folds of the robe conventionalized in a system of raised ridges giving the body the appearance of being caught in a network of strings, not unlike the drapery of Palmyran sculpture of the second and third centuries.

Near the modern town of Jelālābād are the ruins of Haḍḍa, the ancient Nagarahāra. Fragments of sculpture from this site made their appearance as early as the nineteenth century, but it was not until the French excavations of 1922 that the full significance of the remains could be appreciated.[3] The sculpture of Haḍḍa differs from the Gandhāra products already examined in being made entirely of lime plaster or stucco, single figures, reliefs, and architectural decorations in this material being affixed as decoration to the exterior of the innumerable stupas and monasteries of the site.[4] There can be little doubt but that all the stucco sculpture both in Afghanistan and north-western India was originally brilliantly coloured.

In the course of excavations of the ruined monastery at Teppe Marandjan in Kabul, a number of specimens of lime-plaster sculpture was found preserved in a pristine condition. The flesh parts were tinted a pinkish terra-cotta shade, with lines of deeper red to indicate the folds of the neck, lips, nostrils, etc. Brown irises defined the eyes, which were outlined in blue and brown. The robes of these Buddhist figures were painted a deep cinnabar; various colours, including a rich lapis-lazuli blue, were used to pick out the jewelled ornaments and head-dress.

Hsüan-tsang in his description of Haḍḍa says that 'the saṅghārāmas are many but the priests are few; the stupas are desolate and ruined'.[5] It seems likely that most of the remains date from the third to the fifth centuries of our era, although additions and repairs were, probably, made right up to the time of the disastrous invasion of the Huns in the sixth century.

The repertory of sculpture at Haḍḍa includes an enormous variety of ethnic types – Indian, Iranian, and European – as well as an equally great number of stylistic variants ranging from seemingly Hellenistic to purely Indian techniques. Among the more Classical pieces is a fragment of a figure holding a lapful of flowers [110]. As was pointed out when the relief was first discovered, this is no more nor less than a transference to Haḍḍa of the Roman portrait in the Lateran of the Emperor Hadrian's favourite Antinoüs as Vertumnus. Not only the type and the floral attribute, but also the conception of the form and modelling appear entirely Roman to an even greater degree than the stone sculpture of Gandhāra – perhaps for the reason that the malleable medium of lime plaster afforded the greater freedom in the desired realistic expression. The sculpture of Haḍḍa has been made famous chiefly by the comparisons published by French scholars between certain pieces from this site and typical heads of the Gothic period. Some heads of Brahmin ascetics bear comparison with the 'Beau Dieu'

110. 'Antinoüs' from Ḥaḍḍa.
Paris, Musée Guimet

111. Head of Brahmin ascetic from Haḍḍa.
Paris, Musée Guimet

of Amiens [111]. In many cases there is certainly a marked resemblance in the quality of spirituality in the features, the same modified realism found in thirteenth-century Gothic art. This supposed anticipation of Gothic art in Asia a thousand years before the carving of Chartres and Rheims is not so remarkable if we pause to consider that, just as the art of Haḍḍa is ultimately Roman or Hellenistic in origin, with a strong suggestion of the Hellenistic emphasis on passionate and pathetic expression, so, too, Gothic sculpture, especially the finest examples of the school in the carvings of Rheims and Amiens, are unquestionably based on Classic prototypes.

There is also a spiritual explanation for the similarity: the emotional, more personal type of Buddhism, with its emphasis on salvation, that developed in the early centuries of this era came to demand an artistic emphasis on the individual,

on individual expression, in much the same way that the mystical Christianity of the thirteenth century brought into being a new and humanized style of artistic expression.

The stucco head of a *devatā* in the Museum of Fine Arts, Boston [112], is a particularly fine example of this type of sculpture. It does not come from Haḍḍa, but from one of the countless ruin sites around Peshawar that have been robbed by local treasure-hunters for generations.[6] It should be noted at this point, in order to explain the great preponderance of stucco heads from both Afghan and north-west Indian sites, that the bodies to which these heads were attached were made of mud with only an outer slip of lime-plaster that has long since crumbled to dust. Examining the Boston head in detail, we find that the upper part of the face has apparently been made with a mould, as is suggested by the sharpness and dryness of the planes. But the soft, wavy hair and the mouth and chin were modelled free-hand with extraordinary vivacity and freshness. A slight asymmetry in this and other examples adds to the aliveness and piquancy of expression.[7]

The collection of sculpture from Haḍḍa and the later sites at Taxila is, in a sense, a persistence rather than a reappearance of the eclectic repertory of the Hellenistic–Augustan period. In the same way the scores of typical Gandhāran masks of Buddha are the perpetuation of a more purely Indian hieratic mould.

In other words, while preserving the drily spiritualized formula of early Gandhāra art for the Buddha image, the sculptors of Taxila and Haḍḍa in the fifth century, in lay figures and grotesques, present a living array of types which is without doubt the end of a style that had its beginnings in the early, most Classical phase of Gandhāra art. The vitality of the late sculpture of north-western India is strongly suggestive of the dynamic character of Roman provincial art: the so-called 'Gothic' character of the Haḍḍa sculpture is far from difficult to reconcile with

112. Head of Devatā from near Peshawar.
Boston, Museum of Fine Arts

Roman provincial art,[8] since this same quality is present in monuments made by the 'barbarians' on all the fringes of the Roman world empire. The 'realism' of Germanic carvings, like the heads in the Neumagen Memorial, for instance, differs from early Roman portraits in its intensity and heightened impressionistic treatment just like the similar heads from Haḍḍa.[9] The quality of pathos and dynamic realism that we note in late Roman, Byzantine, and north-west Indian work at Taxila and Haḍḍa is really the modification of a tendency already dominant in Hellenistic art, and not the sudden and simultaneous result of some vague aesthetic force asserting itself on all the boundaries of the Roman world.

One could say in explanation of the expressiveness of late Gandhāra art that, just as neo-Platonism introduced spiritual, even supernatural, life into the art of the Late Antique Period in the Mediterranean world, Buddhism – especially the various Mahāyāna cults emphasizing salvation – may in part have been responsible for the spiritual qualities, the 'soul', in this manifestation of the Late Antique in Asia.

Again, the persistence of an essentially realistic tradition in sculpture with an emphasis on the pathetic-dramatic type of Hellenistic art, side by side with the hieratic cult image, is not too difficult to explain in a region whose population, especially the artist population, was until the very end of the school in part Western or Eurasian in character, having the same humanist heritage as the artists of Byzantium. It was no more strange for the dynamic realistic tradition of Hellenistic art to survive with the official and frozen Buddhist cult image than it was for generations of artists in the Byzantine world to perpetuate, largely in profane art, the remembered realistic style of Late Greek art at the same time that the forms of Christ and his saints remained frozen and abstract in the appropriate golden world of mosaic. In the same way that the survival of a realistic, dramatic, and colour-istic tradition in Byzantine neo-Hellenistic art led eventually to the humanist art of the Gothic period, so the surviving Hellenistic art of the first century A.D. in north-western India culminated in the so-called Gothic art of Haḍḍa.

Certain dramatic archaeological discoveries within recent years are bound to affect our judgement of the sculpture of Haḍḍa and its place in the evolution of classical art in Asia. The Late Hellenistic or Greco-Bactrian clay sculpture found in the Kushan palace at Khalchayan in Uzbekistan (U.S.S.R.), dating from the first century B.C., appears as a direct antecedent of the many Hellenistic elements in the Haḍḍa stuccoes.[10] The most recent finds at Tapa-i-Shotur at Haḍḍa[11] have revealed a wealth of new material, including the extraordinary plastic stucco ensemble of the Buddha's encounter with the Nāgā Apalāla.[12] The hundreds of statues in relief uncovered at this site are of very high quality and can probably be dated as early as the second or third century A.D. The arrangement of the complex itself, as well as the style of many individual statues, appears to have a distinct relationship to examples of belated Hellenistic sculpture in Russian Central Asia, as, for instance, the famous frieze dedicated to local river gods at Pyandhzikent.[13]

A site important not only for Indian art, but even more for its intimate relationship to the art of Iran and Central Asia, is the great monastic establishment at Bāmiyān, dramatically overlooking a fertile valley between the Hindu Kush range and the Koh-i-Baba in north central Afghanistan. This beautiful and romantic site of former Buddhist power has been described by the Chinese pilgrim Hsüan-tsang, who visited it in the seventh century. Legend has it that Genghis Khan put the entire population of Bāmiyān to the sword. In the nineteenth century it was visited by many early adventurers in Afghanistan, and it was here that the British captives were housed during the First Afghan

War. The monasteries and temples at Bāmiyān are carved entirely from the face of the sandstone cliff, which for more than a mile is honeycombed with a great series of sanctuaries and assembly halls.

Parenthetically enclosing this vast complex are cut two niches, each housing a colossal Buddha statue. At the eastern end is the image a hundred and twenty feet high [113], which Hsüan-tsang designated as Śākyamuni, and at the west a colossus rising to a hundred and seventy-five feet [114], which the pilgrim described simply as a 'Buddha image'.[14] These two statues in themselves are extraordinarily interesting to illustrate the cosmopolitan nature of Buddhist art at Bāmiyān. The smaller statue is simply an enormous magnification of a typical Gandhāra image with its voluminous drapery reminiscent of the style prevalent in

north-western India in the second and third centuries A.D. [113]. The image at Bāmiyān is not completely carved. Only the armature, a rough approximation of the body and head, was actually cut from the sandstone cliff. Over this the features and the folds of the drapery were modelled in mud mixed with chopped straw, with a final coating of lime-plaster to serve as a base for polychroming and gilding. Traces of pigment may still be discerned on the robe and chin. Hsüan-tsang mistakenly described this statue as made of metal, probably because at the time of his visit it was entirely covered with gold-leaf and metal ornaments.[15]

About a mile to the west is the larger of the two Buddhas [114]. It is set in a vast trefoil niche directly overlooking the miserable mud buildings of the modern bazaar at Bāmiyān. This colossus is in quite a different style, although the

113. Bāmiyān, 120-foot Buddha

114. Bāmiyān, 175-foot Buddha

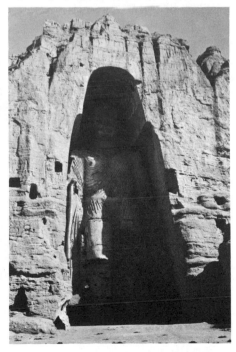

method of construction is essentially the same. In this case the individual folds of the Buddha's robe were modelled on ropes attached to wooden dowels driven into the stone core. This technical expedient was doubtless intended to reproduce on an enormous scale a late Gandhāra statue in which the Buddha's robe is reduced to a series of strings clinging to the surface of the body. It seems likely that if the smaller of the two colossi is to be dated in the second or third century A.D., the larger is at least two hundred years later in execution.

These two statues present us with the first appearance of the colossal cult image in Buddhist art. There are a number of reasons, both stylistic and iconographic, for these more than life-size representations of the Great Teacher. We have, of course, the precedent of the famous colossi of the Greek world, and, more nearly contemporary, the later Roman fashion of erecting colossal images of the deified Caesars. The purpose of a colossal image is twofold: to attract attention and command respect by its gigantic dimensions and, by the same token, to suggest the superhuman nature of the personage portrayed. If the giant statues of Constantine were intended to represent that Emperor's role as *Kosmokrator*, the Bāmiyān

statues, no less, were meant to indicate the status of the Buddha as *Mahāpuruṣa*, or as Brahma comprising all worlds within himself. The iconography of the paintings decorating the niches of the two colossi at Bāmiyān leaves no doubt that both were conceptions of Śākyamuni as Lokattara or Lord of the World. The influence of these first colossi of Mahāyāna Buddhism on the Buddhist art of the entire Far East is inestimable: one has only to think of the rock-cut colossi at Yün Kang and Lung Mên in China; and even the great bronze Vairocana dedicated at Nara in Japan of the Tempyō Period (720–810) is an ultimate descendant of the giants at Bāmiyān.

The rock-cut architectural remains at Bāmiyān are interesting chiefly for the reproduction of various domical forms that are iconographically and stylistically derived from Greco-Roman and Iranian sources. It may be supposed that all these types existed in now vanished free-standing buildings in Gandhāra. It is likely that these cupolas roofing the sanctuaries and assembly halls at Bāmiyān were, in addition to their structural function, symbolical embodiments of the sky.[16] In some of the grottoes of Bāmiyān there is a representation of arched squinches making the transition

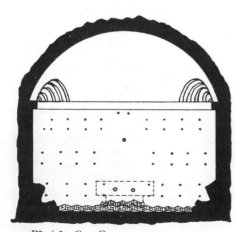

115. Bāmiyān, Cave G

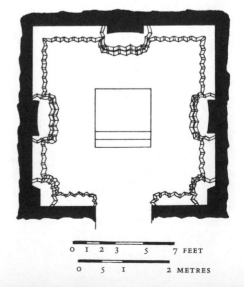

0 1 2 3 5 7 FEET

0 5 1 2 METRES

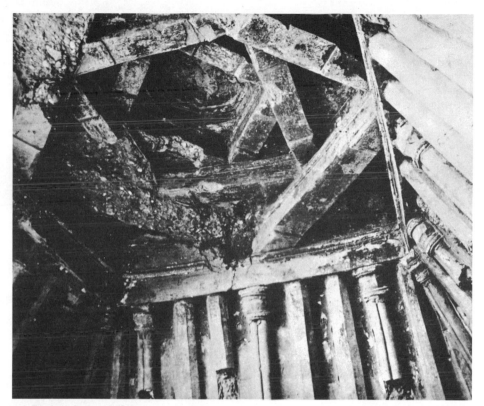

116. Bāmiyān, lantern roof

from the square of the chamber to the circle of the cupola [115]. This type has its true structural prototype in the four-columned fire temples of the Sasanian Period in Iran. These sanctuaries are in a way the distant cousins of such European churches as St Germain-des-Prés. Another type of roof that is found in a number of caves at Bāmiyān is the lantern roof, a very simple and primitive type of dome that is perhaps the ancestor of all more complicated domical constructions. The lantern roof, which is known in modern wooden constructions literally from Armenia to Central Asia, was probably invented somewhere on the Iranian plateau and introduced to both western Asia and Turkestan. It is

a method of roofing whereby beams are laid diagonally across the corners of a square and the process is repeated in successive tiers, so that finally only a small opening remains at the summit of this arrangement in diminishing squares.

A literal rock-cut copy of such a structure may be seen in one of the caves to the west of the larger Buddha at Bāmiyān [116]. The whole was probably painted at one time with representations of Buddhist deities. The triangles left over, as each successive smaller square was inscribed in the larger, provided room for sculptural decoration, so that the whole arrangement was not only a roof, but a kind of maṇḍala or

schematized representation of the celestial regions and the mystical Buddhas presiding over them. Numerous examples of the lantern roof may be seen in the rock-cut architecture of Central Asia. The form was reproduced in the stone temple architecture of Kashmir that in many respects was a prolongation of the architecture of Gandhāra. It is finally reduced to a completely flat design and typifying a maṇḍala painted on the ceilings of the Thousand Buddha Caves at Tun-huang in China. Cave XI at Bāmiyān, immediately to the east of the one-

117. Bāmiyān, Cave XI, dome

118. Bāmiyān, Cave XI, reconstruction of dome

hundred-and-seventy-five-foot Buddha, has a dome composed of an elaborate coffering of triangles, diamonds, and hexagons around a central octagon in a six-pointed star [117]. This central space, as well as the hexagonal compartments and the niches at the base of the cupola, were originally filled with seated Buddha images, so that this dome, too, was a kind of maṇḍala with the Buddhas of all the directions of space circling about the Buddha of the zenith [118]. The stylistic arrangement of this ceiling comes direct from the Roman West, where similar coffering may be seen in the Temple of Bacchus at Baalbek and in Roman mosaics.[17]

The surviving fragments of wall-paintings at Bāmiyān present no less interesting and even more complicated problems than the remains of sculpture. Three categories or styles of painting may be found at this site: one pure Sasanian, one Indian, and a third that can only be described as Central Asian in character. The actual technique of all is essentially the same. The rock walls and vaults of the caves and niches were covered with a layer of mud mixed with chopped straw. A final thin layer of lime plaster provided the ground for the actual painting in colours largely manufactured out of local earths and minerals. The paintings still decorating the top of the niche and the soffit of the vault above the one-hundred-and-twenty-foot Buddha are entirely Sasanian in style. The massive figures of donors that alternate with figures of Buddhas on a level with the head of the great statue are the pictorial equivalents of images in the Sasanian rock-cut reliefs at Naqsh-i-Rustam and Shāpur. The same massive bulk and frozen lifeless dignity that characterize the reliefs of the Iranian kings are here translated into painting. Typically Sasanian, too, is the essentially flat, heraldic patterning of the forms that is particularly noticeable in the enormous decoration of the ceiling of the niche representing a solar divinity in a quadriga [119]. It is a pictorial version of the relief of Sūrya at Bodh

119. Bāmiyān, painting of sun god
on vault of niche of 120-foot Buddha

120. Bāmiyān, painting of flying divinities
in niche of 175-foot Buddha

Gayā [38]. Probably we are to recognize a representation of Mithra as a symbol of the Buddha's solar character.[18] The central figure is dressed in a mantle like that worn by Kanishka in his portrait statue at Mathurā [96]; round about are figures of the dawn goddesses costumed like Pallas Athena, and, in the upper spandrels of the composition, divinities of the wind. The whole is an emblem of the sky dome over the head of the colossus. The colours for all portions of this ensemble are applied in flat areas demarcated by hard outlines with no indication of shading.

In attempting to systematize the development of art in Central Asia, of which Bāmiyān is a part, it is possible to think of a belt of eastern Iranian or provincial Sasanian art on the arc of a circle with its centre in Iran and running through Varaksha, Balalik Tepe, and Pyandh-zikent in Russian Turkestan, and Dukhtar-i-Nōshirwān and Bāmiyān in Afghanistan. The painting of all these sites is in many respects an

eastward extension of Sasanian art, as is abundantly demonstrated by the resemblance of forms and decoration to Sasanian sculpture, metalwork, and textiles.

The second of the two styles of painting at Bāmiyān may be designated as Indian, since it bears a resemblance to the surviving examples of wall-painting in India proper of the fifth and sixth centuries A.D. To this classification belong the fragments of the decoration that once clothed the entire niche and vault of the one-hundred-and-seventy-five-foot colossus. In so far as it is possible to tell, the whole concept was at one time a unified iconographical scheme. The side walls of the niche from top to bottom were painted with row upon row of figures of seated Buddhas, each in a different and characteristic mudrā. Above this, under the cusp of the arch, may be seen medallions with flying divinities scattering jewels and flowers, and finally, on the vault of the niche, a whole pantheon of Bodhisattvas. The significance of

the entire scheme was probably not unlike that of the maṇḍalas of Mahāyāna Buddhism in Tibet and Japan; that is, a figuring of all the mystic Buddhas and Bodhisattvas that, like constellations, move around the magic axis of the cosmic Buddha Vairocana. Whether or not the actual sculptured Buddha in the niche can be identified as Vairocana is problematical. As we have already seen, it is certainly a representation of the Buddha in his transcendental aspect, as he appears transfigured in such Mahāyāna texts as the *Saddharma Puṇḍarika* and the *Avatamsaka* sūtras.

The paintings in this complex have suffered not only from exposure, but from having served as targets for generations of iconoclastic Afghan marksmen. Among the better preserved sections

are the medallions at the springing of the vault, in which are represented flying deities or *apsaras* [120]. Their jewelled head-dresses and striped muslin skirts bear a close resemblance to details of costumes in the cave-paintings at Ajaṇṭā [184]. The supple bodies depicted in positions of easy, even flowing movement have no relation to the frozen effigies of the Sasanian style at Bāmiyān. The actual canon of proportions and the metaphorical composition of the forms again suggest parallels with the paintings of Gupta India.

Examining a single figure of one of the Bodhisattvas painted on the vault, we may discern even further points of resemblance [121]. Not only do we find the same sensuous fullness of bodily form and the same languorous,

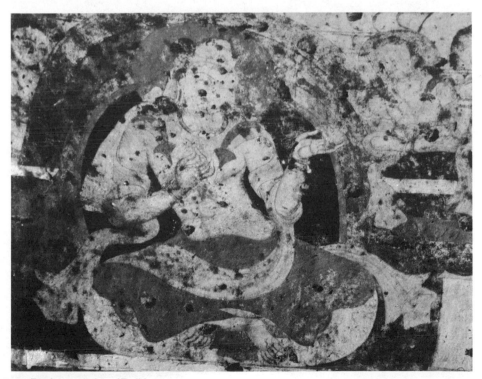

121. Bāmiyān, painting of Bodhisattva on vault of niche of 175-foot Buddha

almost somnolent relaxation that characterize certain figures at Ajaṇṭā, but also we may note the employment of the same kind of abstract shading that is so notable a feature of the painting of Gupta India. In the case of the Bāmiyān example this chiaroscuro consists in a thickening of the outlines of the features and the parts of the body with a deep orange pigment, which, although obviously not recording any possible effect of lighting, gives a feeling of plasticity and roundness to the form. Both from the point of view of drawing and the handling of the arbitrary chiaroscuro the Bāmiyān paintings strike us as much more harsh and conventionalized than anything found in India proper. This quality is, of course, the result of that simplification which always takes place with a transplanting of a highly sophisticated and completely developed style of art to a provincial setting. The difference between Ajaṇṭā and

122. Bāmiyān, painting of female figure
on vault of niche of 175-foot Buddha

Bāmiyān is like the style of Simone Martini in Italy compared to the work of his followers in the Palais des Papes at Avignon.

The completely Indian female figure [122] standing beside one of the Bodhisattvas of the vault is probably a śakti or female counterpart of the divinity – a certain indication of the influence of Hindu concepts in late Buddhist art. The figure is entirely nude, except for earrings and bangles. The elegance of gesture

huang.[19] This style in Bāmiyān cannot be described as purely Indian because certain details, such as the foliate motifs of the Bodhisattva's throne, are ultimately of Gandhāra origin, and the flying ribbons of the head-dress are definitely Sasanian.

Although, as we have just seen in the analysis of the paintings in the niche of the Great Buddha, all the styles at Bāmiyān are hybrid in character, it is possible to find yet a third

123. Bāmiyān, Group E, painting on vault

reminds us of the Begrām ivories, and the shading is of the same arbitrary type described above. As we shall find presently, this provincial Indian style at Bāmiyān spread to the Buddhist centres of Central Asia, and examples of it may be found even in the earliest wall-paintings at the Chinese Buddhist monastery at Tun-

manner, which from its resemblance to paintings at Kizil and other sites in Turkestan may be described as pure Central Asian. We may take as an example the Bodhisattva painted over the head of a now ruined Buddha statue in the principal cave of Group E [123]. The figure of the Bodhisattva, like the *Pantokrator* of Roman-

esque art, is represented seated on a rainbow. On either side rise slender colonnettes with extremely conventionalized Corinthian capitals. The space behind the figure is filled with heraldically drawn lotus buds falling from the sky. In this particular style at Bāmiyān there is a mixture of elements drawn from many sources, both Western and Indian, that results in the formation of a really original manner, in much the same way that a coalescence of Classical and Oriental forms produced the style of Byzantium in the First Golden Age.

Analysing the elements of this Central Asian style one by one, we note first of all that the drapery of the figure, especially the drawing of the flying scarves, bears a marked resemblance to the neo-Attic drapery of the Gandhāra Bodhisattvas. There are slight suggestions of the arbitrary shading of the Indian tradition. The completely frontal, static, and rather frozen quality of the conception is immediately reminiscent of the completely Sasanian paintings in the niche of the one-hundred-and-twenty-foot Buddha. The colour scheme is dominated by the lapis-lazuli blue of the robe and the background. This beautiful ultramarine presumably came from the famous mines at Badakshan that also supplied the Roman market with this precious mineral. The most notable stylistic feature of the painting is the definition of both contour and form by hard, wiry lines of even thickness. It is the combination of line drawing and areas of flat, brilliant colour that gives the composition such a heraldic appearance and most closely relates it to the painting of Central Asia, notably the paintings of Kizil. The same combination of line and brilliant tone with no interest in the definition of plastic form imparts an extraordinarily ghostly character to the figure of the Bodhisattva, and is the prototype for much of T'ang Buddhist painting and the famous cycle of paintings at Hōryūji in Nara.

Although the surviving paintings at Bāmiyān are perhaps the most famous and best preserved,

they are by no means the only examples of painting in Afghanistan from the second to the seventh centuries A.D. In an isolated monastery at Fondukistan in the Ghorband Valley were found decorations of an almost completely Sasanian style. These, like the fragments of sculpture found at the same site, probably belong to the very last period of Buddhism in Afghanistan, approximately the seventh century A.D. At this time large portions of the northern and central sections of Afghanistan were ruled by Hunnish or Hephthalite vassals of the Sasanian Dynasty in Iran.[20] The painted clay figure of a Bodhisattva from Fondukistan [124] serves to show to what a remarkable degree a completely Indian style has at the last replaced the earlier reliance on Classical and Iranian prototypes. This image is in a way a sculptural counterpart of the Indian forms in the paintings at Bāmiyān. The perfect realization of this entirely relaxed and warmly voluptuous body, sunk in sensuous reverie, is as exquisite as anything to be found in the art of Gupta India. The modelling, in its definition of softness of flesh and precision of ornament, is only the final and entirely typical accomplishment of a tradition going back to the beginnings of Indian art. The extraordinarily affected elegance and grace of this figure and its exquisite and frail refinement appear as a Mannerist development out of the Gupta style, a mode that seems to anticipate the Tantric art of Nepal [cf. 202].[21]

A fragmentary Buddha from this same site is of interest both stylistically and iconographically [125]. As will become clear when we turn to the analysis of Gupta sculpture in a later chapter, this figure is in several respects a reflexion of this great Indian style. The head is a plastic compromise between the dry, mask-like treatment of Gandhāra and the fullness of Kushan Buddhas, and, as in innumerable fifth-century Indian Buddhas, the hair is represented by snail-shell curls. The robe, indicated by grooves incised before the clay was baked, is still in the

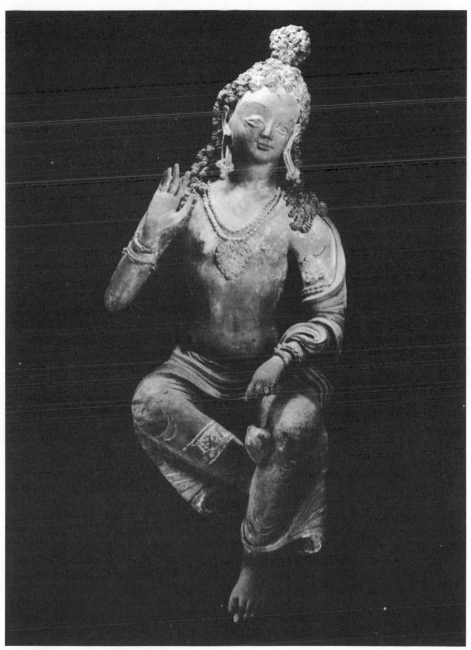

124. Bodhisattva from Fondukistan.
Kabul, Museum

Gandhāra style, but the bodily form is conceived with a suggestion of mass that is entirely Indian. What is of peculiar iconographical interest is the three-pointed, jewel-studded chasuble that the Buddha wears over the monastic garment. This attribute, as well as the heavy earrings – seemingly inappropriate for one who had renounced worldly riches – are a symbolical device to indicate that this is Buddha in his transcendent, glorified form, the apotheosis in which he reveals himself to the host of Bodhisattvas. It is quite possible that originally Hinayāna statues of the monastic Buddha were transformed into Mahāyāna icons of the transfigured Śākyamuni by being 'dressed up' in actual jewels and garments which in time came to be represented in statues like the one from Fondukistan. The so-called 'bejewelled Buddha' is seen in many statues of the last phase of Mahāyāna Buddhism in India and in the art of regions like Tibet, Nepal, and Indonesia which were directly influenced by the Buddhism of Bengal from the eighth to the late twelfth century.

The art of Fondukistan is in many respects a flamboyant phase of the classic elements inherent in Gandhāra and Gupta sculpture and painting. To apply the word Mannerist to this phenomenon is perhaps a dangerous parallel, but it is evident that this art contains many strangely anti-classical elements that certainly indicate the appearance of a new aesthetic. In the examples of this late phase of classic Buddhist art, as we see it at Teppe Marandjan, at Fondukistan, at Bāmiyān, every effort was directed towards the graceful, the elegant, the provocative, and towards a kind of refined realism that achieved a new poetry in the very distortion of the forms, an erotic, world-weary expressiveness suggestive of the German sculptor Lehmbruck. It will become apparent, too, that this transplanted Gupta art was never entirely understood when it was copied in the Buddhist oases on the road to China.

125. Buddha from Fondukistan.
Paris, Musée Guimet

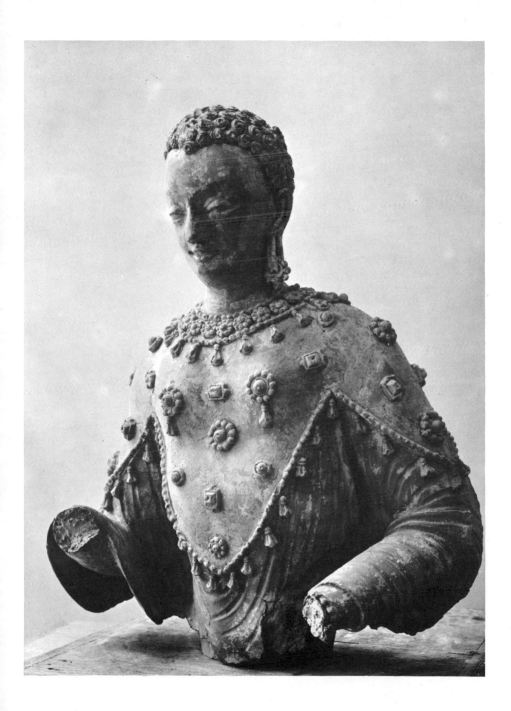

BUDDHIST ART IN TURKESTAN

For our purpose of indicating the spread of Indian art beyond the actual geographical boundary of the Indian peninsula, the history of art in Central Asia can be said to begin with the introduction of Buddhism to this region in the early centuries of the Christian era. By Central Asia we mean the territory extending to to the north and east of the Hindu Kush and Pamir mountain ranges eastward to the Gobi Desert. It is a plain without outlet, bounded on the north by the T'ien Shan range, by the Pamirs on the west, and by the Altai and Kuen-lun mountains of Tibet to the south. Eastward lies China. In such a region life was sustained on a chain of oases girdling the desert basin or along the courses of rivers like the Tarim. Throughout the period in which we are interested – roughly the first millennium of our era – a northern and southern trade route skirted the edges of the Taklamakan Desert. The two routes join at Kashgar, and at this point east of the Pamirs was the 'Stone Tower' (*Lithinos Pyrgos*) mentioned by Ptolemy as the meeting-place for silent barter between traders from the two ends of the world.[1] It was along these arteries that the Buddhist kingdoms separating India and China sprang up at the isolated oases on the fringe of the desert. They provided both a barrier and a link between the two poles of the Buddhist world.

As early as the first century A.D. these territories were disputed by the Kushans and the armies of Han China. Kanishka is believed to have extended his conquests as far east as Khotān. For the next four or five hundred years the oases along the highway linking the western world with China were dominated by a number of semi-independent kingdoms, tributary in some measure to either India or China. We can get a remarkably clear idea of the importance of Central Asia for Buddhism and its art from the accounts of the pilgrims Fa Hsien and Hsüan-tsang, who travelled over Turkestan in the fifth and seventh centuries A.D. Their descriptions of the courts of Kucha and Khotān are hardly less enthusiastic than their admiration for the great sites of Buddhism in India proper.

The extraordinary riches of Buddhist art in Central Asia were revealed by many archaeological expeditions in the first decades of the twentieth century. A number of German expeditions headed by Albert von Le Coq brought to light the wall-paintings at Kizil and Turfān. The most arduous and scholarly exploration of sites along those northern and southern trade routes was conducted by Sir Aurel Stein over a period of nearly three decades. Other expeditions sponsored by the Japanese under Count Otani and the Imperial Russian Government under Baron Oldenburg added further to our knowledge of this once flourishing centre of Buddhist civilization.

The art of Central Asia divides itself into two main parts: one, centred around Kashgar and Kizil, at the western end of the trade route, the other farther east, located in the Turfān oasis. The paintings and sculptures of the former sites were for the most part decorations of Hinayāna Buddhist establishments, and should be dated no later than the sixth century A.D. The work at Turfān, some of which dates from as late as the ninth century A.D., is really a provincial form of Chinese art of the T'ang

Period, with only a remote connexion with Indian prototypes. It will be possible to give only a sampling of this enormous amount of material.

In Central Asia, as at Bāmiyān, which is in itself in the westernmost reaches of Turkestan, we are confronted with a great variety of styles in sculpture and painting, many of them existing contemporaneously, and likewise testifying to the cosmopolitan or international character of Central Asian civilization. What are probably the earliest remains of Buddhist art in Central Asia were discovered by Sir Aurel Stein at the oasis of Mirān on the southern trade route about three hundred miles to the west of Tun-huang. In the ruins of a circular edifice enclosing a stupa there was brought to light a considerable collection of stucco sculpture and wall-paintings that are the easternmost extension of the Gandhāra style.[2]

The paintings at Mirān, which at one time completely covered the interior walls of the circular sanctuary, consisted of a frieze of Jātaka scenes and a dado painted with busts of winged divinities and erotes supporting a garland. These paintings bear the signature of a certain Tita or Titus, who was presumably a journeyman painter from the eastern provinces of the Roman Empire. The Jātaka scenes are a translation into pictorial terms of the same subjects as treated in Gandhāra relief sculpture. The decoration of the dado with the winged busts and planetary divinities framed in the swags of a garland [126] has its equivalent in Gandhāra sculpture, most notably on the famous reliquary of King Kanishka. The origins

126. Mirān, sanctuary, detail of painting on dado

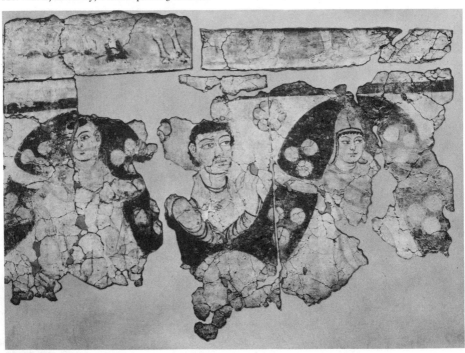

of this motif are, of course, to be sought in the carving of the sarcophagi of the Late-Roman and Early-Christian worlds. As in the case of Gandhāra sculpture, so in the case of this cycle of Gandhāra painting, the stylistic origins may be found in the painting of the Eastern Roman Empire, where the Classical style underwent a considerable conventionalization in the hands of Oriental craftsmen. The heads of the angels at Mirān, with their enormous ghostly eyes and a suggestion of plasticity through the thickening of the contours, are immediately reminiscent of the grave-portraits of Roman Egypt. There are no comparable cycles of wall-paintings in India proper or Afghanistan, but the third-century Roman mosaics at Shāpur in Iran may serve as the nearest stylistic prototype from both the geographical and chronological points of view. Both may be dated in the late third century A.D.

The sculpture and paintings discovered by Sir Aurel Stein in the ruins of the oases of Khotān and at Shorchuq (Kara-Shahr) near Turfān, reveal the same mixture of Classical and Indian styles as we have already encountered at Bāmiyān. The description of this kingdom by the seventh-century pilgrim Hsüan-tsang leaves us with the impression of a very cosmopolitan culture dividing its religious affiliations between Buddhism and Mazdaeism. It was from this Indo-Iranian principality that the culture of silkworms was introduced to Byzantium in A.D. 552. The principal sculptural remains found at Khotān were the lime-plaster reliefs decorating the Rawak vihāra excavated by Sir Aurel Stein in 1904.[3] This decoration, which consisted in Buddha and Bodhisattva figures applied in high relief to the base of the walls, recalls the decoration of the monastic buildings at Haḍḍa and Taxila. The same style is shown in our illustration from Kara-Shahr [127]. The technique of figures moulded in mud and then covered with a layer of lime plaster is essentially identical. The style of the figures, with the drapery represented either by incised lines or

string-like folds, corresponds to the late Gandhāra sculpture of the third and fourth centuries A.D. as we have seen it in stone sculpture and in the colossi at Bāmiyān. A number of fragments showing a Buddha standing in a halo filled with miniature Buddhas reveal the beginnings of the Mahāyāna concept of Vairocana and his countless emanations.

Also in the Khotan oasis are the ruins of Dandān Uiliq, where wall-paintings of quite another character were discovered. The charming detail of a water sprite or river goddess reveals an eastward extension of the provincial style of Indian painting observed in the niche of the Great Buddha of Bāmiyān [122 and 128].

Although perhaps originally reinforced with shading, the drawing of the figure is so sure that the linear outline alone suggests the form and

127. Kara-Shahr, stucco reliefs

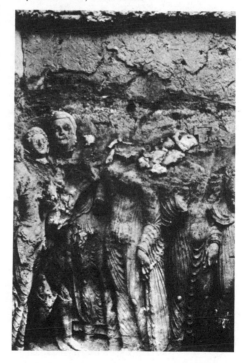

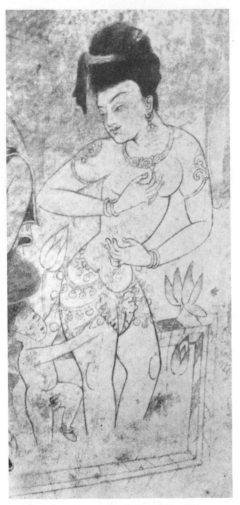

128. Dandān Uiliq, wall-painting of female figure

pose that are unmistakably Indian, related to the Begrām ivories and the Gupta wall-paintings at Ajaṇṭā. It has nothing to do with those odd provincial mixtures of Classical, Iranian, and Indian styles that we have seen at Bāmiyān and shall find again in Turkestan.

The terracotta reliefs from Tumshuq in the Musée Guimet are closely related to the late Afghan sculptural style of Fondukistan, and are marked by the same fusion of Indian and Late Antique elements [129]. The deeply recessed box in which the large figure group is set reminds us of the more illusionistic style of Gandhāra relief. The drapery is a simplification of the Gandhāra Classical type with a continuation of the characteristic neo-Attic 'swallow-tail' scarves already seen in the Gandhāra Bodhisattvas and the painting of Cave E at Bāmiyān. The individual figures have the same softness, the relaxed ease and grace, that typify the Bodhisattva from Fondukistan [124]. The resemblance to this figure extends to such minutiae as the head-dress and type of jewellery. The faces of the Tumshuq images have a dry, mask-like vapidity, with an endlessly repeated smiling mouth that unmistakably reveals the use of moulds for these portions of the figures.[4] The reliefs from Tumshuq were originally en-framed in a wide border enclosing a vine meander pattern of an ultimately Late Antique type. This is another instance of a transference to Central Asia from Gandhāra of a motif universally employed in Roman architectural decoration. This last phase of the Gandhāra style continues eastward to such sites as Kizil, and ultimately finds its way to the earliest centres of Chinese Buddhist sculpture at Tun-huang and Yün Kang.

Of all the Buddhist kingdoms of Turkestan, by far the richest and most famous was Kucha, on the northern trade route. This principality, which maintained its independence until it was overrun by China in the seventh century, was famed at once for the beauty of its courtesans

fullness of the body and a perfectly articulated suggestion of movement. One is tempted to think of this as the work of an Indian craftsman, since, unlike the examples of a more typical Central Asian style which we shall find at Kizil, this painting reveals a sophistication of draughtsmanship and an elegant aliveness of

129. Buddhist relief from Tumshuq.
Paris, Musée Guimet

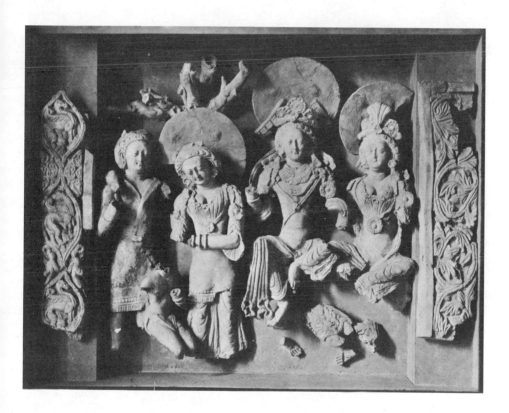

and the learning of its monastic establishments. Some idea of the material and spiritual wealth of the Kucha visited by Hsüan-tsang can be gained from the magnificent wall-paintings at the site of Kizil discovered by von Le Coq.[5] Like Bāmiyān, the site of Kizil comprised a vast series of sanctuaries and assembly halls hollowed out of the loess cliffs. The later designation of Ming Oï, meaning 'thousand caves', testifies to the vast number of cave temples honeycombing the mountain-side. Outside scattered pieces of stucco sculpture, the most interesting remains at Kizil consisted of the acres of wall-paintings covering the interior of its countless

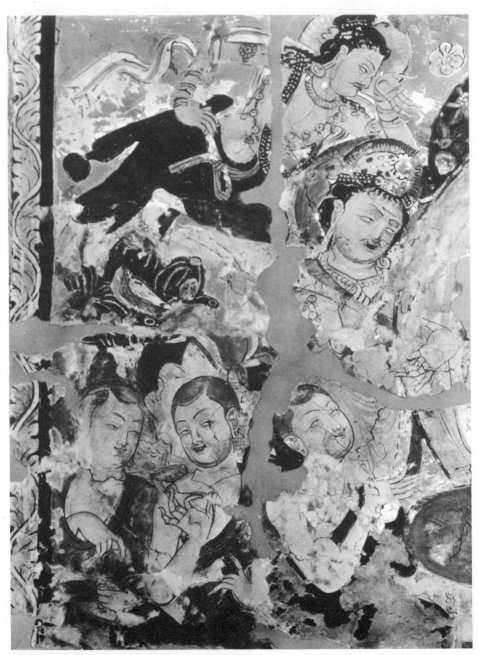

130. Kizil, Cave of the Painter, wall-painting.
Berlin-Dahlem, Staatliche Museen

sanctuaries. As at Bāmiyān, a number of distinct
styles are represented, and there is no positive
indication that they should be divided into a
strict chronological sequence. It is just as likely
that they were all executed more or less contem-
poraneously by craftsmen of varying stylistic
backgrounds.

The earliest of the styles may best be studied
in the decorations, datable by an inscription of
the early sixth century, in the Cave of the
Painter. This is essentially a provincial Indian
manner of painting. The svelte and languorous
forms in the panel from the Cave of the Painter
[130] emanate the same sensuous warmth and
grace that we find in the more truly Indian
wall-paintings, such as the medallions in the
niche of the one-hundred-and-seventy-five-
foot Buddha at Bāmiyān. The heavy, plastic
shading, characteristic of Indian painting, is
largely absent in this technique, and the colour
scheme, limited to dark reds and browns and
malachite green, lacks the richness and tonal
range of the famous Indian murals at Ajaṇṭā,
but closely approximates to the colours of the
Bāmiyān paintings.

A second Indian manner – or a variant of the
first – which we have already seen exemplified
in the Bodhisattvas painted on the vault above
the one-hundred-and-seventy-five-foot Bud-
dha at Bāmiyān, is to be seen in numerous
examples of paintings from Kizil, such as the
specimen from the Treasure Cave in illustration
131. The dancing figure in our detail presents
the closest possible comparison with the śakti at
Bāmiyān [122]. It is characterized by the use of
an arbitrary scheme of chiaroscuro, whereby the
contours of the figures and the interior drawing
of the flesh parts are heavily reinforced by
broad lines of orange pigment. In some figures
at Kizil the result looks like a schematic re-
duction to abstract terms of the heavily muscled
anatomy of classical paintings of Herakles [132].
This second Central Asian style has been
defined by the German scholars as Indo-

131. Kizil, Treasure Cave,
wall-painting of female figure

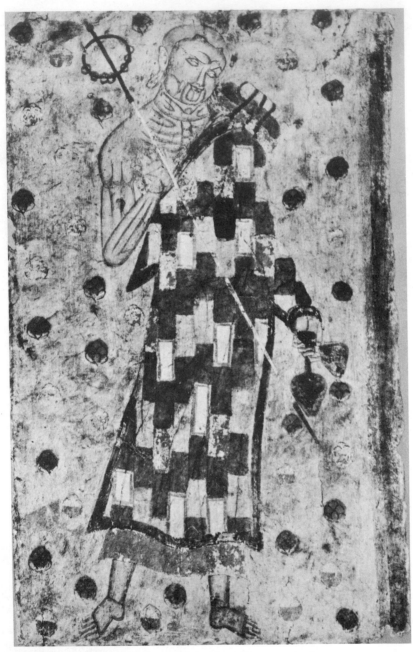

132. Arhat from Kizil.
Berlin-Dahlem, Staatliche Museen

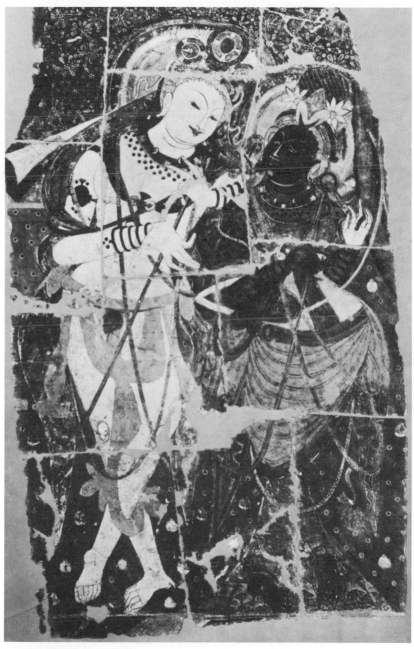

133. Two divinities from Kizil.
Berlin-Dahlem, Staatliche Museen

Iranian.[6] This phase of Turkestan painting is distinguished by its strident brilliance of colouring: malachite green, orange, and lapis-lazuli blue are the dominating hues in this completely non-realistic palette [133]. Strangely inarticulated figures have their faces and bodies outlined with thick bands of orange shadow that confer a certain plasticity on these mannikin-like forms without in any sense recording actual effects of illumination; in the dark figure in our illustration this shading is reinforced by white highlights. Whereas this technique is presumably Indian in origin, the round, placid faces, the types of head-dresses and jewels are reflexions of the art of Iran in the Sasanian Period. An abstract flatness characterizes the treatment of the costumes, in which the pattern of the stuff is represented without consideration for either the foreshortening of the folds or the form of the body beneath [132]. Frequently, as in the example illustrated [133], the figures appear as though standing on tiptoe or levitated in the air. This is the result of the ground having become completely merged with the background, the same abandonment of spatial organization in favour of a completely spaceless and decorative conventionalization of figures and setting that may be compared with the Byzantine mosaics of Saint Demetrius in Saloniki. The strange combination of plastic and patternized elements in the figures themselves reminds us of the hieratic forms of Byzantine mosaics of the First Golden Age, in which the heads, set on substanceless bodies, retain something of the solidly realistic qualities of Roman art.

The Central Asian style that has just been described is represented at Bāmiyān by the Bodhisattva in Group E. An even closer stylistic approximation to the Bāmiyān example may be seen in a variant of the Indo-Iranian style in this example from Kizil, in which the outlines of the figure at the left are replaced by lines of an even thickness and iron-hard quality.[7]

It is worthy of note that paintings in both the provincial Indian and Indo-Iranian techniques may be found among the sixth-century wall-paintings at Tun-huang in westernmost China. In some of the Jātaka scenes painted at Kizil the wall is divided into many interlocking chevron shapes; each one of these conventionalized mountain silhouettes frames an isolated figure or episode. This abstraction of what is essentially a landscape background may be seen in a further state of development in some of the earliest wall-paintings at Tun-huang. The site of Kizil also yielded a collection of highly polychromatic sculpture, obviously derived from the art of Gandhāra. The perpetuation of this Romanized Indian manner until such a late date is probably to be explained by the use of moulds. The architecture of the cave-temples at Kizil is very simple, and cannot in any way be compared in scale to the grandeur of the grotto-temples of India, although certainly the idea of making such rock-cut sanctuaries is of Indian origin, most likely in imitation of the caves at Bāmiyān. The most common type of temple at Kizil is either square or rectangular in plan, usually with a small stupa in the centre of the chamber. In a slightly more elaborate type a porch or vestibule precedes the sanctuary, an arrangement also found at Bāmiyān. Occasionally the shrine is in the form of a single, long, narrow chamber with a barrel vault cut out of the rock. The so-called lantern roof, already seen at Bāmiyān, is also found at Kizil, and from there found its way to the Thousand Buddha Caves at Tun-huang.

The paintings from the eighth to the tenth century, recovered from Bezeklik in the Turfān oasis in north-eastern Turkestan, are almost completely Chinese in style [134]. During these centuries this territory was under the rule of the Uighurs, a strong Turkish tribe, whose civilization was largely Western in character. It is evident from both the types and costumes represented in the paintings of Turfān that this

134. Buddha from Bezeklik.
Berlin, Museum für Völkerkunde (formerly)

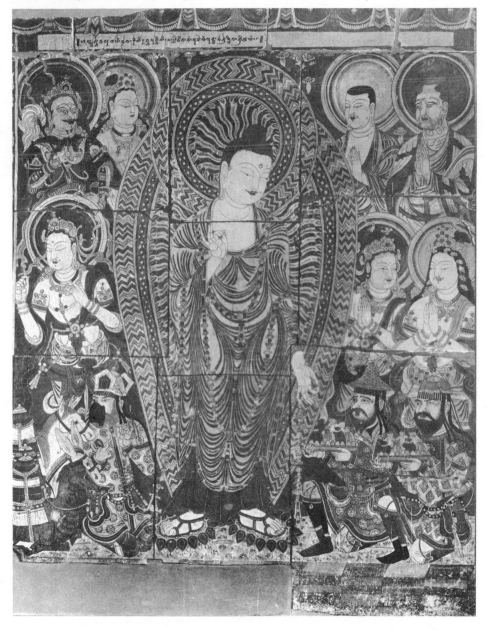

Turkish culture with many elements of Western and Iranian origin was greatly influenced by its contact with the Chinese. The great series of wall-paintings from the monastery of Bezeklik, divided between the Museum for Central Asian Antiquities in New Delhi and the Ethnological Museum in Berlin, bear inscriptions in Chinese and Brahmi. The principal panels consist of enormous, almost identical compositions representing the Buddha Śākyamuni in various earlier incarnations, greeting the Buddhas of these past eras.[8] The figures themselves show exactly the same synthesis of Indian and Chinese elements as distinguishes the mature art of the T'ang Period in China. Both Chinese and Indian types are represented: the draperies of the Buddhas are drawn in linear version of the Gandhāra formula; the architectural details and the floral patterns of the frames are completely Chinese. The heads of the Buddhas, in their suggestion of the spheroidal mass of the head in a completely linear technique, conform to Chinese Buddhist painting of the eighth and ninth centuries A.D.

Among the archaeological finds in the Turfān region were numerous illuminated manuscripts dedicated to the Manichaean faith, a syncretistic religion of Iranian origin that had found favour with the Uighur chiefs. The style of these brilliantly coloured book-illustrations has many reminiscences of Late-Antique and Near-Eastern art forms. It probably represents a perpetuation of a Sasanian style of painting kept alive by the Manichaean tradition.[9]

The Buddhist art of Central Asia comes to an end with the eastward advance of Mohammedanism. As early as the eighth century, the monasteries of Kizil were devastated by the Islamic ruler of Kashgar, and by the tenth century only the easternmost reaches of Turkestan had escaped the rising tide of Mohammedan conquest. The Uighur civilization in this region was finally overwhelmed by the Mongol invasion of Genghis Khan in the twelfth century.

From classical times to the days of Marco Polo Central Asia was the bridge of trade, religion, and culture that spanned the world between East and West. The stations along the Silk Roads were visited by traders when Ptolemy wrote his *Geography* and by the Chinese pilgrims who recorded their travels in diaries from the fifth to the ninth centuries A.D. Even in these remote periods life in the centres of culture along the trade routes was always one of precarious tension before the ever-present menace of the barbarian nomads who moved in waves across the wastes of Siberia to the north. Although the little kingdoms of Khotān and Kucha enjoyed autonomy under the eyes of the great powers of India and China, they were for many centuries hardly more than protectorates of these states. Life depended on trade and on the constant vigilant supervision of the irrigation systems that alone made possible the fertility of the oases. Once these systems were destroyed, as they were by the Arabic and Mongol invaders, the desert quickly and inexorably buried the silent palaces and temples. This total desolation along the length of the old Silk Roads makes the landscape of Central Asia appear like vistas on the moon. The setting of the civilization which the early expeditions of Stein and von Le Coq resurrected from its shroud of sand gives the impression of the total death of a culture even more than ancient Egypt and Mesopotamia, so deserted and totally removed do these poor ruins appear from any ensuing culture. It is perhaps this complete extinction that makes it possible to regard Central Asia and its art with a complete objectivity and detachment. The ravages of the Mongols, and the mortifying hand of Islam that has caused so many cultures to wither for ever, aided by the process of nature, completely stopped the life of what must for a period of centuries have been one of the regions of the earth most gifted in art and religion.

*

The ruin sites of Central Asia from Khotān to Turfān have yielded innumerable examples of the minor arts, including metalwork, wood-carving, textiles, and jewellery. These objects reveal perhaps even more tellingly than the remains of religious painting and sculpture the cosmopolitan nature of this civilization. They illustrate the same assimilation of Classical, Iranian, and Indian forms already demon-strated in the major arts.

Among the many silk textiles found in the graveyard of Astāna in the Turfān district is a design of a pearl-bordered medallion enclosing a heraldic boar's head [135]. Such fragments, cut from a large textile, were used to cover the face of the dead. This is either an import or a local imitation of Iranian silk-weaving in the Sasanian Dynasty.[10] This motif, perhaps a symbol of the Iranian god of victory, Vera-thragna, occurs in Sasanian stucco sculpture and is represented among the paintings of Group D at Bāmiyān.[11]

A pottery amphora from Khotān represents

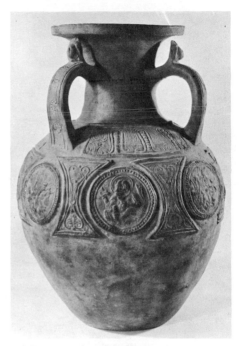

136. Pottery amphora from Khotān.
Berlin-Dahlem, Staatliche Museen

the classical tradition in Central Asian art [136]. Not only is the shape a familiar form in Greek ceramics and metalwork but the designs em-bossed in medallions around the shoulder include such classic motifs as palmettes, lion heads, and a Silen.

The many fragments of carved wooden furniture from the Niya site to the east of Khotān and datable to the second or third century A.D. present a strange mixture of Indian and Iranian forms, including the jar of plenty, stylized winged dragons, and rosettes that look like provincial derivations of the ornamental repertory of Kushan and Sasanian art [137].[12]

A fascinating object, reputed to have been found at Kucha or Kizil, is a painted wooden relic casket [138].[13] On the drum are representa-

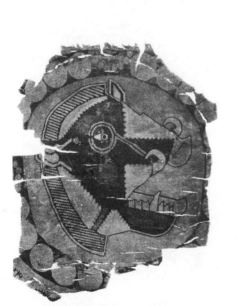

135. Silk textile from Astāna.
New Delhi, Museum for Central Asian Antiquities

tions of musicians and masked ceremonial
dancers, and on the pointed lid of this pyxis-like
object are painted winged genii with musical
instruments. Each is enclosed in a roundel with
pearls, recalling the favourite enframing motif
of Sasanian textile designs. The figures of the
erotes, and even their tonsures, recall the semi-
classic figures of Mirān [126]. The whole is a
combination of the same Iranian and classical
elements so often found in Central Asian wall-
paintings. On the basis of its resemblance to the
Mirān and Kizil styles, as well as for its Sasanian
characteristics, this object may perhaps be
dated as early as the fourth or fifth century A.D.

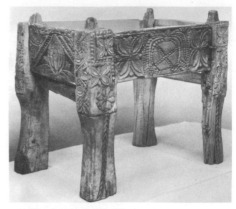

137. Wooden chair from Niya.
London, British Museum

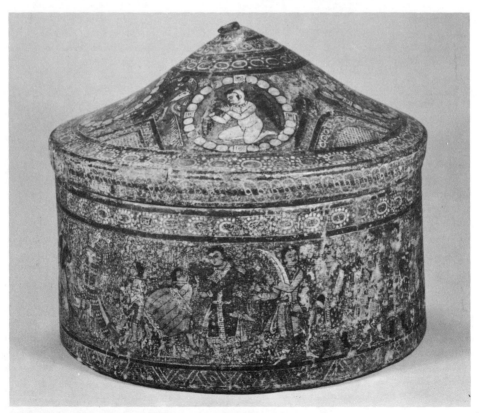

138. Relic casket from Kucha or Kizil.
Japan, private collection

THE ART OF KASHMIR

The development of art in Kashmir presents us with the evolution of a really autonomous national idiom, in spite of the close historical and geographical connexions of this region with the great empires of the classical Indian and Central Asian past. Seemingly isolated at a height of six thousand feet above sea level in the foothills of the Punjab Himalayas, the Vale of Kashmir was intimately connected with the empires of Aśoka and Kanishka. Its geographical isolation made for the development of a truly indigenous culture. This geographical separation became an almost complete political isolation with the advent of the Mohammedans in North India. Presumably, Kashmir was an independent kingdom by the time of Harsha in the seventh century A.D., when its territories included not only the Punjab Himalayas but ancient Taxila and parts of the province of Sind. The region was visited by a number of Chinese pilgrims, including Hsüan-tsang, and diplomatic relations were maintained with the court of T'ang China. The history of art in Kashmir may be divided between an early period from c. A.D. 200 to the seventh century and the great period from the seventh century to A.D. 1339, when the accession of a Mohammedan dynasty terminates the great era of Buddhist and Hindu building.

The first great era of artistic expression in Kashmir came under the reign of Lalitāditya (724–60). To this period belong the dedications at Harwan and Ushkur.[1] The excavations conducted at both these sites have revealed the foundations of stupas located at the centre of a large surrounding courtyard. This plan is simply the enlargement of the stupa court found in the monasteries of Gandhāra, like the arrangement at Takht-i-Bāhi. The actual construction of the masonry, varying from a mixture of mud and pebbles, combined with ashlar, to rubble walls faced with terracotta tiles also employed as paving, seems like a provincial variant of the type of diaper masonry universally employed in the buildings at Taxila and elsewhere in Gandhāra.

Certain distinctive characteristics of architecture in Kashmir are present even in the very earliest examples. These characteristics are to be discerned in the tympana, consisting of a triangular pediment enclosing a trefoil arch, the pyramidal roofs of the shrines, and the universal employment of fluted pillars, faintly reminiscent of the Classical Doric and Ionic orders.

Among the dedications of Lalitāditya was an impressive Buddhist foundation at Parihāsapura, consisting of a stupa enclosed in a square courtyard one hundred and twenty-eight feet on a side. This plan is repeated in later structures at Martand [140] and Avantipur.[2] The plan of the stupa at Parihāsapura is of particular interest. It could be described as a square with projecting stairways at the quarters, making a cruciform design. The stupa originally had two platforms providing passages for circumambulation on two levels. Both the plan and the elevation seem to bear a relationship to the enormously complicated stupa at Barabuḍur in Java. An actual influence is not beyond the bounds of possibility, since in the fifth century Guṇavarman, a monk from Kashmir, introduced Mahāyāna Buddhism to Sumatra and Java. It is conjectured that the whole monument at Parihāsapura with its finial of umbrellas

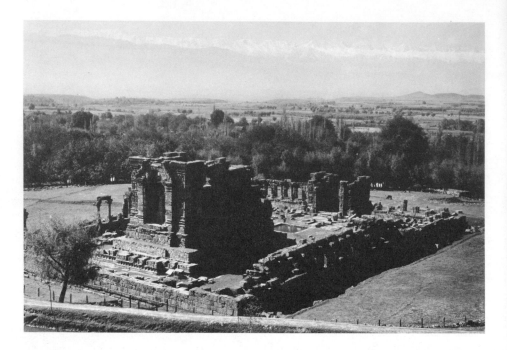

must have risen to a height of one hundred feet above the ground. The remains of a Buddhist chaitya have also been discovered there. This temple, erected on a square double platform, consisted apparently of a cella of massive proportions which, originally, was probably only a larger version of the small Kashmir temples of a later period. The construction at Parihāsapura is characterized by the literally gigantic size of the blocks of ashlar masonry employed. These great stones were apparently joined together by gypsum mortar and iron dowels. The largest stone of all was the great block, fourteen by twelve feet, that formed the floor of the Buddhist temple.

Another phase of the classical architecture of Kashmir is represented by the Brahmanical buildings dating from the eighth to the thirteenth century A.D. Of these structures the most impressive is certainly the sun-temple at Martand, which appears to have served as a model for all later Brahmanical shrines [139 and 140]. The great beauty of the setting on a high plateau framed by distant mountains contributes enormously to the impressiveness of the temple. The central shrine is again placed in the middle of a rectangular court with a surrounding cellular peristyle two hundred and twenty by one hundred and forty-two feet in dimensions. It was built by King Lalitāditya in the middle of the eighth century A.D. The temple differs from other examples in Kashmir in the addition of a portico to the central building for the accommodation of special rites in conjunction with the worship of the sun. Between the portico and the *garbha griha* or cella is another small chamber corresponding to the *pronaos* of a Greek temple. The shrine was originally covered by a pyramidal roof, and attained a height of close to seventy-five feet. The massive decoration of its exterior contains elements specially typical of the architecture of Kashmir.

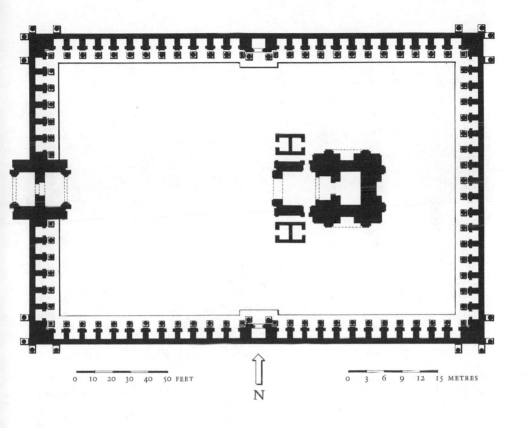

0 10 20 30 40 50 FEET

N

0 3 6 9 12 15 METRES

139 and 140. Martand, Kashmir, sun temple

141. Pāṇḍreṇṭhān, Kashmir, Śiva temple

On each of the four façades is a pediment supported on fluted pseudo-Doric pilasters enclosing a trefoil arch that originally held the statue of a deity. This triangular pediment is undoubtedly another borrowing from the Roman Orient transmitted by way of Gandhāra.[3] The trefoil is derived from a shape already seen in the cella of the stupa courts of Gandhāra and in the trilobed niche at Bāmiyān [114]; probably its ultimate origin is to be sought in the profile of the chaitya-hall with a section of the nave and side aisles representing the three lobes of the ornament. The effectiveness of these temples depends on their truly impressive scale and on the rich pattern of chiaroscuro achieved by the varying depths of the members of the façades.

The original appearance of the ruined temples of the early period can partly be reconstructed from the small shrine of the twelfth century, located in a willow grove at Pāṇḍreṇṭhān near Śrīnagar [141]. Presumably it was dedicated to Śiva in A.D. 1135. Since it is open on all four sides, it has been described as a maṇḍapa or 'porch' type of shrine. The temple is square in plan, seventeen and a half feet on a side, with projecting gable pediments on each façade. The construction is again of ashlar blocks on a scale commensurate with the size of the temple. The bold projection of the pilasters supporting the pediment makes for a more effective and lively chiaroscuro than has been observed in earlier buildings. The cella is covered by a pyramidal roof in two tiers that is an obvious, and not entirely successful, imitation of wooden forms in stone. The interior support of this superstructure is in the shape of a lantern dome [142]: there are three overlapping squares, and the triangles formed by their intersection are filled with reliefs of flying apsaras reminiscent of Gupta prototypes. This architectural form, probably of Iranian origin, has already been seen in the cave-temples at Bāmiyān [116] and in the Buddhist grottoes of Kizil in Central Asia; it survives practically

unchanged in the wooden architecture of modern Afghanistan. The temple at Pāṇḍreṇṭhān is distinguished by the massive severity of its composition which, together with the regular employment of an ultimate derivative of Roman Doric, contrives to give the building a distinctly European appearance. On the exterior the pyramidal roof is undoubtedly an imitation in stone of towered roofs consisting of overlapping wooden planks, such as may still be seen in the Mohammedan architecture of Kashmir and in the relatively modern shrines of western Tibet.[4]

The sculpture of Kashmir presents a development paralleling that of her architecture in the derivation of styles from Western and Indian sources. The earliest examples consist of fragments of stucco and terra-cotta, originally parts of large reliefs decorating the ruined stupa at Ushkur. The technique of ornamentation in stuccoed relief is entirely reminiscent of the decoration of the monasteries at Taxila and

142. Pāṇḍreṇṭhān, Kashmir, Śiva temple, lantern roof

143. Head of a girl from Ushkur.
Lahore, Central Museum

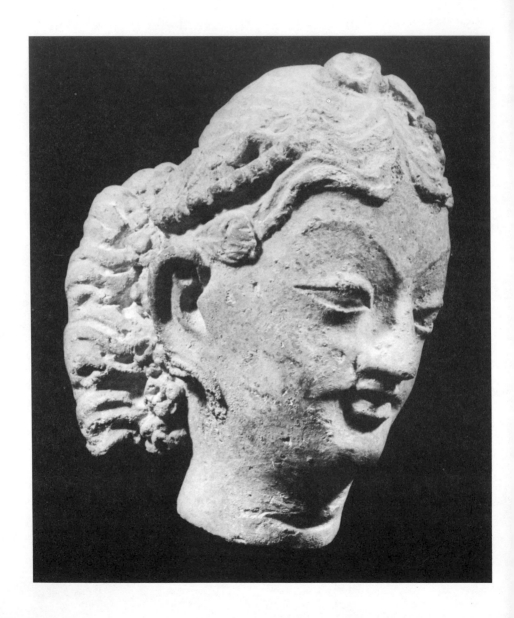

THE ART OF KASHMIR · 205

Haḍḍa. The heads of Buddhas, Bodhisattvas, and lay personages from this and other eighth-century sites are in a style equivalent to the last phase of Gandhāra sculpture, in which the Classical types have been endowed with a certain sensuousness and warmth by the infiltration of the Indian Gupta style. Actually, the nearest equivalent for this phase of Kashmir sculpture is to be found in the semi-Classical, semi-Indian figurines in terra-cotta from the seventh-century monastery of Fondukistan in Afghanistan [124].[5]

A head from Ushkur in the Lahore Museum is typical of this early phase of sculpture in Kashmir [143]. It represents the same rather successful fusion of Late Antique and Indian ideals that has been noted above. The free and impressionistic treatment of the hair and the softly expressive mouth remind us of the Gandhāra stuccoes from Taxila and Haḍḍa, while the arching brows and lotiform eyes are certainly Indian and correspond closely to the Kushan and Gupta styles. Another resemblance

to late Gandhāra developments is perhaps the suggestion of a 'wistful' expression and a perfect serenity and gentleness that characterize this whole phase of Kashmir sculpture.

The sculpture of the later Brahmanical period of art in Kashmir is represented by numerous examples of bronze statuettes of Hindu deities which present in varying degrees the same admixture of Classical and Indian elements notable in the architecture of the same centuries.[6]

Within recent years, a large number of bronze and brass Buddhist images, mostly unpublished, presumably of Kashmiri origin, have appeared on the Western art market. Some show a marked resemblance to the Mannerist style of Fondukistan, and presumably are to be dated in the seventh or eighth century. The stray finds of Hindu marble carving from Kashmir seem to be related to similar types found in the region of Kabul – most likely from the period of Lalitāditya in the eighth century.

THE GOLDEN AGE AND END OF BUDDHIST ART

CHAPTER 14

THE LATER ĀNDHRA PERIOD

The foundation of the Āndhra Empire of South India goes back to the period of confusion following the death of Aśoka in 232 B.C. Although for art-historical purposes the artistic achievements of the Dynasty are generally divided into Early Āndhra (72–25 B.C.) and Later Āndhra (25 B.C. to A.D. 320), it must be noted that these categories represent two different moments of artistic development in the history of the same ruling house. At the height of their power the Āndhras, a race of Dravidian origin, were in possession of the entire region of the Deccan from sea to sea, and, as may be gathered from certain inscriptions, this vast tract was united by a magnificent system of roads in addition to the maritime communication possible between the ports of the western and eastern coasts. As early as the first century A.D. these same ports were opened to the trade of the Roman Empire; indeed, as mentioned by such classical geographers as Ptolemy, there were Roman trading posts established on both coasts. This fact, coupled with the finding of hoards of Roman coins and pottery fragments, has led some to look for actual Roman influence in the art of South India.[1] The Later Āndhra Buddhist communities were also in close contact with their contemporaries in Ceylon; inscriptions testify to their missionary activity in Gandhāra, Bengal, and China. A close commercial relationship was maintained with Indonesia, Burma, and China. As we shall discover, a purely Indian tradition of art appears to have been stronger and less affected by foreign influences here in the south than it was in the territories of the Kushans.

We have already seen in the example of a slab from Jaggayyapeṭa considered in relation to the Śunga carving at Sāñchī, that there was a flourishing tradition of Buddhist art in the eastern domains of the Āndhras as early as the first century B.C. Other dedications of this early phase would include a number of Buddhist chaitya-halls at Kanheri and at Nāsik on the west coast.

The high point of development in South Indian Buddhist art was attained in the so-called Later Āndhra Period in a collection of monuments dedicated by the Āndhra sovereigns at Amarāvatī at the mouth of the Kistna River. Although this region had been converted to Buddhism as early as the third century B.C. and some of its remains actually date from the Early Āndhra Period, the dedications of the first and second centuries of our era surpass all these earlier monuments. There are indications that the Buddhist establishments were supported by the queens of the ruling house, while the kings were followers of Hinduism.

As exploration of the desolate region around the Kistna River has shown, there must have been at one time literally scores of stupas and

chaityas gleaming white in the sun. The ruins of great stupas with surrounding monasteries have been found at Ghaṇṭaśāla, at Nāgārjunakoṇḍa, at Goli Village, and Gummadidirru, to mention only the more important sites. The most famous of all the Later Āndhra shrines was the Great Stupa at Amarāvatī. Begun as early as 200 B.C. the original structure was enlarged and embellished with great richness in the second century A.D. As proved by inscriptions at Amarāvatī, the railing and casing slabs of the Great Stupa were added during the time of the Buddhist sage Nāgārjuna's residence in the Āndhra region.[2] Prior to this it was, like Aśoka's stupa at Sāñchī, presumably a simple mound of bricks and earth, although already a venerable site. When first investigated by European archaeologists in the nineteenth century, the stupa was so largely demolished that only a conjectural idea of its original size could be arrived at. The diameter of the dome of the stupa at ground level was approximately one hundred and sixty feet and its over-all height about ninety to one hundred feet; it was surrounded by a railing thirteen feet high consisting of three rails and a heavy coping. Free-standing columns surmounted by lions replaced the toraṇas of earlier structures at the four entrances to the *pradakṣiṇā* enclosure. Like Sāñchī, the Amarāvatī stupa had an upper processional path on the drum of the structure; this path also had an enclosing railing consisting of uprights joined by solid rectangular panels. Originally, not only the parts of the two railings, but also the drum, were covered with elaborate carvings in the greenish-white limestone of the region. Because of the difficulty in fitting a stone revetment to a curved surface, plaster reliefs supplemented the stone casing for the decoration of the cupola.[3] It will be noted in the slab illustrated [144] that another unusual feature of this stupa consisted of offsets or platforms located at the four points of the compass and surmounted by five pillars carved with repre-

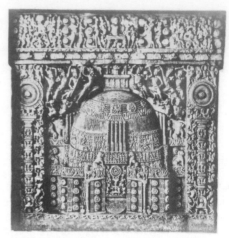

144. View of the Great Stupa on casing slab from the Amarāvatī stupa. *Madras, Government Museum*

sentations of Buddhist symbols such as the Wheel and Stupa.[4] In the decoration of the base a number of images of the Buddha can be seen, a clear indication that, although probably originally dedicated to Hinayāna Buddhism, the shrine was, under the influence of Nāgārjuna, transformed into a Mahāyāna sanctuary.

In the centre of the frieze at the top is a seated Buddha which is clearly related to the type of Śākyamuni in yoga pose already developed at Mathurā. On either side of this representation of the Temptation of Mara with the Buddha in anthropomorphic form are symbolical portrayals of the empty throne beneath the bodhi tree. It is as though the Later Āndhra Buddhists, even though followers of the Great Vehicle, were loath to give up the old Hinayāna emblems, or perhaps attached a certain authority and appropriate sanctity to the early forms of the art of their religion. To right and left of the main section of the relief are vertical framing panels with representations of stambhas with lion capitals upholding the Wheel of the Law.[5] At the foot of each pillar there again appears the empty chair signifying the presence of the

Buddha, as the *etimasia* of Early Christian and Byzantine art symbolizes Christ. These details are again a repetition of the type of aniconic symbol found in Early Āndhra sculpture at Sāñchī. In connexion with the analysis of the Amarāvatī relief style in this chapter, attention should be called to the dense crowding of the composition and the nervous activity and attenuation of the forms.

Although great numbers of these beautiful limestone carvings at Amarāvatī had been burnt for lime by the owner of the site in the nine-teenth century, large collections of the surviv-ing fragments remain and are preserved in the Government Museum at Madras and in the British Museum. They are datable from the time of the renovation in the second century A.D. The subjects comprise purely decorative fragments, like the lotus medallions of the cross-bars, Jātaka stories, scenes from the life of Buddha, and, on the coping, a procession of yakshas bearing a garland-like purse. In addi-tion to the reliefs a number of free-standing Buddha images were found in the stupa precinct; probably, like similar statues at the Singhalese site of Anurādhapura, they were originally placed round the base of the monu-ment [291].

A single one of these statues will serve as a useful point of departure for an analysis of the Amarāvatī style [145]. The Buddha, excavated at Nāgārjunakoṇḍa, is represented standing directly frontal, wearing the Buddhist robe or *saṅghāṭī* with the right shoulder bare. The heavy, massive conception of the figure, together with the definition of the drapery by a combina-tion of incised lines and overlapping ridges indicating the course of the folds and seams, is distinctly reminiscent of the Buddha images of the Kushan school. Iconographically, the con-ception is related to Gandhāra in the repre-sentation of the Buddha wearing the monastic robe, but beyond this there is no indication of any direct stylistic influence from this centre of

Greco-Roman art. The lines of the drapery, unlike the folds of Gandhāra statues, no longer have the rather dry, inert character due to the mechanical copying of Late Antique formulae, but are organized in an ordered rhythm of lines undulating obliquely across the body and imparting a feeling of movement as well as reinforcing the swelling expansiveness of the form beneath. Peculiarly characteristic of the Buddha images of the Amarāvatī region is the heavily billowing fold at the bottom of the outer mantle where it falls above the ankles. This may be derived from the heavy roll-like mantle edge of Kushan Bodhisattva statues [97].[6]

Owing to its commercial and religious affili-ations, the influence of the art of the Āndhra

145. Standing Buddha from Nāgārjunakoṇḍa.
New Delhi, National Museum

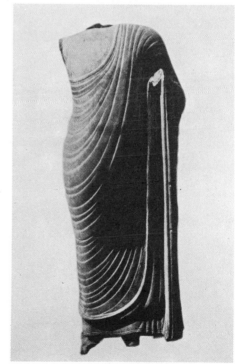

Empire was enormously widespread; not only, as will be explained later, was the style of Amarāvatī extended to Ceylon, but Buddhist images in the Āndhra style of the second and third centuries A.D. have been found as far away as Dong-duong in Champa (modern Indo-China)[7] and at Sempaga in the Celebes.[8]

A typical head of a Buddha from Amarāvatī [146] reveals a certain relationship to the heads of Kushan images in the general fullness and warmth of conception, but, in contrast to the roundness of the facial contour of the Mathurā Buddhas, the heads from Amarāvatī are of a more narrow oval shape. All the heads of Buddha from this site invariably have the hair represented by snail-shell curls, following the scriptural account of the Buddha's appearance. In many respects these Later Āndhra heads are

147. Submission of the Elephant Nālāgiri, railing medallion from the Amarāvatī stupa. *Madras, Government Museum*

146. Head of Buddha from Amarāvatī. *Paris, Musée Guimet*

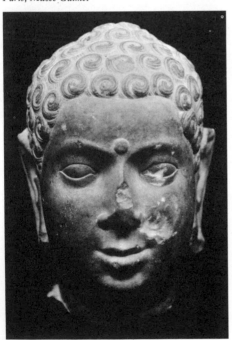

more softly and plastically modelled, with less reliance on linear definition of the features.

Many individual figures from the reliefs of Later Āndhra also show a relationship to the school of Mathurā: the figures at the back on illustration 147 with their attenuated, indolent grace are in every case a refinement of the rather coarse and sensual concept of beauty developed by the Kushan sculptors. It will be recalled that this fondness for elongated figures has already been noted in the Early Āndhra relief of a Cakravartin from Jaggayyapeṭa.[9] The relief compositions at Amarāvatī are iconographically much more complicated in their illustration of the Buddha legend than anything found in either Gandhāra or Mathurā; in many of them the old device of continuous narration widely used in the Early Āndhra reliefs at Sāñchī is still in evidence. The conception of these relief panels also differs from anything we have hitherto seen in the way they are organized as all-over patterns of dynamic movement, sometimes rising to a kind of maenadic frenzy, and also in the highly

dramatic character of some of the scenes like the Submission of the elephant Nālāgiri, with its surging crowd of terrified spectators, contrasted with the static calm of the group of the Buddha and his followers [147]. These two new factors – the way in which the whole composition is unified through the rhythmic lines provided by the movements and directions of the figures and the dramatic content – seem to lead direct to the reliefs of the Pallava and Chalukya Periods. These later carvings give the impression of being inspired by spectacular stage productions and are likewise integrated by dynamic movement. Presumably this likeness is not entirely accidental, since the later Hindu dynasties of the Deccan continued the artistic traditions that flourished in these same regions during the centuries of Buddhist domination.

Stylistically the Amarāvatī sculptors have a fondness for a very complicated and perhaps un-Indian arrangement of figures and settings in a number of planes. This deep cutting that transforms panels and medallions into stage boxes might be regarded as a natural development of the technique of the Sāñchī carvers: the frequent use of overlapping figures and an equally confident handling of foreshortened forms is perhaps a basis for suspecting Roman influence. The panel of a battle scene from Nāgārjunakoṇḍa [148] is like a translation of a Trajanic relief into Indian terms. In such respects as the deep pictorial space and the composition in multiple planes, the conception appears markedly Roman. At the same time, the wiry, ferocious figures whirling in a wild crescendo of action introduce us to a new phase

148. Battle scene and mithuna from Nāgārjunakoṇḍa.
New Delhi, National Museum

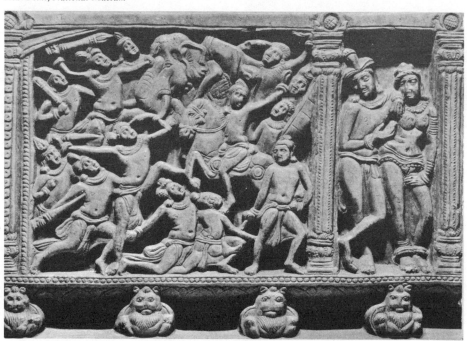

of Indian sculpture which, in its Baroque turbulence and depth, directly anticipates the style of later centuries in South India.

The excavation of a palace area at Nāgārjunakoṇḍa has brought to light what may be described as secular carving in Later Āndhra times [149]. The pillars of this structure were decorated with panels representing personages in Indo-Scythian dress and a singularly Dionysian figure, nude to the waist and holding a rhyton. This hauntingly classical youth in a Praxitelean pose may have been copied from a Roman gem. This is the most Greco-Roman of all Āndhra sculpture and provides further evidence for the penetration of Roman influence.[10] This detail,

149. Figure holding a rhyton
from the palace area, Nāgārjunakoṇḍa.
Nāgārjunakoṇḍa, Archaeological Museum

like so many of the Later Āndhra carvings, has a delicacy and precision of execution in every crisp detail that suggests the technique of the Begrām ivories. This technical refinement and the languorous attenuated beauty of the figures make the Later Āndhra reliefs 'the most voluptuous and delicate flower of Indian sculpture'.[11]

Buddhism apparently went into a decline at the same time that the Āndhra Dynasty collapsed in the early fourth century; already in the seventh century, when Hsüan-tsang visited the region, he describes the Buddhist establishments as 'mostly deserted and ruined'.[12] This disappearance of Buddhism and its art in South India is probably to be explained in part by the gradual rise of Hinduism,[13] always strongly entrenched in the Deccan, and in part certainly by the decline of patronage due to the inevitably diminished prosperity after the ending of the sea-borne trade with the Roman West.

The Great Stupa at Amarāvatī is only the most important monument of a great style; other sculptural fragments no less distinguished in execution have been found at Nāgārjunakoṇḍa and at Goli Village, both in the Kistna region. The latter reliefs were carved as late as A.D. 300.[14] The dimensions of the Buddhist stupas of the Kistna region were so great that they could not be constructed by the usual method of simply piling up a mound of brick and rubble. Some interior support or binding for these great mountains of earth had to be supplied. Usually this was accomplished, as in the stupa of Nāgārjunakoṇḍa, by having an interior system of brick walls. The ground plan [150] of the stupa is that of a wheel with the hub represented by a solid brick pillar, and with the cells formed by the intersecting concentric rings and spokes of brick walls filled with earth. The stupa at Nāgārjunakoṇḍa, which takes its name from the famous Buddhist 'Church Father', presumably dates from the same period as the Great Stupa at Amarāvatī, and its sculpture

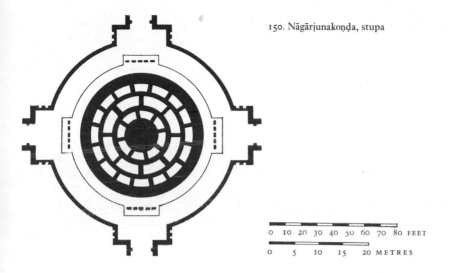

150. Nāgārjunakoṇḍa, stupa

```
0   10  20  30  40  50  60  70  80 FEET

0      5      10      15      20 METRES
```

belongs to the same style. The diameter of this sanctuary is one hundred and six feet, and it reached an original height of seventy or eighty feet. The ground plan of the stupa is also of interest for the hidden symbolism of these relic mounds. It will be noted that the plan suggests the idea – already mentioned as inherent in the symbolism of all stupas – of the cosmic axis surrounded by concentric rings, just as the world mountain Meru of Indian cosmology is imagined to be girdled by successive mountain ramparts, the Cakravala.[15] The presence of the axis was of course indicated on the exterior by the harmikā emerging from the dome typifying the sky.[16] It would be justifiable to assume, too, that the arrangement and the number of compartments formed by the walls of the interior structure were disposed in the form of a maṇḍala, just as Hindu temples were raised on a foundation of such magic squares. The establishment at Nāgārjunakoṇḍa also included temples of the familiar chaitya plan, together with the remains of palace structures and vihāras. The former are certainly the earliest surviving examples of actual structural build-

ings in the chaitya form. The monasteries include one, building specifically reserved for resident monks from Ceylon. It has the typical plan of a court surrounded by individual cells.

A new chronology for the Amarāvatī sculptures has been suggested in a recent work by Douglas Barrett. He proposes a shorter chronology extending from the second to the fourth century A.D. for the entire development in the Amarāvatī region. The author states: 'Before the 1st century A.D. there was neither the social organization nor the economic wealth to erect a series of monuments in Andhradeśa. It is not even certain that its inhabitants professed the Buddhist religion.' According to Barrett's arrangement, the sculptures may be divided into an Early Phase (c. 125–150 A.D.), Middle Phase (c. 150–200 A.D.), and Late Phase (third and fourth centuries A.D.) which would include the carving at sites like Nāgārjunakoṇḍa and Goli. Barrett believes that the Sānchī sculpture immediately preceded the Early Phase at Amarāvatī and provided the inspiration of its style. If we follow Barrett's chronology, illustration 34 would represent the Early Phase; 145

and 149, the Middle Phase; and 144, 147, and 148, the Late Phase in the development.

There are some indications based on recent excavations in the Amarāvatī region that the so-called Later Āndhra style may have survived there even after the rise of Gupta power in the fourth century; indeed, until the rise of the Pallavas. The persistence of this late phase of Āndhra sculpture, represented largely by Buddhist images of a debased type, would seem to be supported by the continued copying of Āndhra models in the sculpture of Ceylon from the eighth to the thirteenth centuries.

It is unfortunate that the reliefs of Amarāvatī are not better known. Certainly from the point of view of complex and yet always coherent composition, of massing of chiaroscuro, and aliveness of surface treatment they have seldom been surpassed in the history of relief sculpture. It is well to reiterate in conclusion that, for the later history of Indian art, not only for sculpture in the Gupta Period, but even more for the dynamic carving under the Hindu dynasties that succeeded the Āndhras in the South, the importance of the work at Amarāvatī is immeasurable.

CHAPTER 15

THE GOLDEN AGE: THE GUPTA PERIOD

The Gupta Period takes its name from the founder of this dynasty, Chandragupta, crowned King of Kings at Pāṭaliputra in A.D. 320, who asserted his power over the Ganges Valley. The conquests of this Kshatriya sovereign, Chandragupta I, and his successors, notably his son, Samudragupta, came to include all of northern India from Orissa to Ujjain. Once more, as under the Mauryas, Magadha in the Bengal Valley was the centre of the Empire. Chronologically the Gupta Period may properly be extended to include the reign of Harsha of Kanauj (606–47), who revived the glories of the dynasty following the interregnum after the invasion of the White Huns in the fifth century. Although temporarily under the rule of the first Gupta sovereigns, the regions of north-western India, the ancient Gandhāra, were overrun by the White Huns, and even after the death of the last of these inhuman conquerors one hundred years later, these provinces remained apart from India proper. Neither the Gupta kings nor the mighty conqueror, Harsha, were able to extend their conquests to South India, which continued to be governed by independent dynasties like the Pallavas and Chalukyas, who had inherited the ancient domains of the Āndhras.

We gather from the accounts of the Chinese visitors, Fa Hsien and Hsüan-tsang, that Buddhism, both in its Mahāyāna and Hinayāna forms, flourished throughout the Gupta Empire. Although some of the old centres, like Kapilavastu and Śrāvastī, had fallen into decay and depopulation, and even Gayā was a ruinous waste, the monasteries and towered stupas shone golden in the sun at Mathurā and Pāṭaliputra; at Nālandā was the great university centre of Mahāyāna Buddhism, its cloisters so crowded as to tax the defences and revenue of the Empire. These centuries of Gupta rule also marked the beginning of a Hindu revival centring about a new cult of Vishnu, with emphasis on Krishna as the exponent and divine teacher of Vaishnava doctrine. Mahāyāna Buddhism in this period was hardly different from other divisions in the Hindu faith, and was undergoing a process of intellectual absorption into Hinduism that led to the final disappearance of the religion of Śākyamuni from India.

Although often referred to as the Indian Renaissance, the Gupta Period is not properly speaking a rebirth, except in the political sense as a reappearance of a unified rule that had not been known since the extinction of the Maurya Dynasty in the third century B.C. Purely Indian ideals were never more fully expressed than in this span of centuries, if only by reason of the isolation from the Western world that ensued with the gradual collapse of the Roman Empire culminating in the appearance of the Goths in 410: foreign contacts, cultural and religious, were now with the Far East and with south-eastern Asia, and in this exchange India was the giver, the Far East the receiver.

Seldom in the history of peoples do we find a period in which the national genius is so fully and typically expressed in all the arts as in Gupta India. Here was florescence and fulfilment after a long period of gradual development, a like sophistication and complete assurance in expression in music, literature, the drama, and the plastic arts. The Gupta Period may well be described as 'classic' in the sense of the word describing a norm or degree of perfection never achieved before or since, and in the perfect balance and harmony of all elements

stylistic and iconographic – elements inseparable in importance.

Sanskrit became the official language of the Gupta court. The great Indian epic, the *Mahābhārata*, underwent a final recension as a document of a unified India under a godly Imperial race; the *Rāmāyaṇa* enjoyed a renewed popularity because it was regarded as emblematic of the virtues of the Kshatriya prince conquering in the service of Vishnu. It is in this period that the Indian theatre, which, just like Western drama, traced its origins to the performance of church spectacles or miracle plays, reached the extraordinary perfection of dramatic structure and richness of metaphor that characterize the *Toy Cart* and the famed Kalidasa's rich and sensuous poetic drama, *Śakuntala*. King Harsha himself was a dramatist and a distinguished grammarian. This is a period when for the first time we find the amateur not only as patron but as practitioner of the arts. As Coomaraswamy has stated, this is a period when the works of the classic Sanskrit dramatists and the wall-paintings of Ajaṇṭā 'reflect the same phase of luxurious aristocratic culture'.[1] We may be sure that the aesthetic of Indian art expressed in the *Vishnudharmottaram* was only finally formulated in the Gupta Period, and that the *śāstras* governing the arts of architecture and sculpture received their final codification in this age of universal accomplishment.

As in the Maurya Period, the very political unity of India made for an artistic unity transcending regional boundaries, so that examples in sculpture and architecture differ on the whole only in the local materials used in their manufacture. From the Gupta Period onward we are fortunate in having preserved intact many more examples of architecture, complete with their sculptural decoration. All the arts are now so much a part of a single unified expression that a completely separate treatment would be not only difficult but misleading. We find it best, therefore, to deal with

this interrelated material by discussing first the chief architectural monuments by location and types, together with their plastic ornament, if it is still *in situ*; then, free-standing cult images and ·separate pieces of typical carving; and, finally, painting.

In architecture we meet with a final development of many types already found in earlier periods. Thus for example, the rock-cut chaitya-hall that we have analysed in its beginnings continues as an accepted architectural type. Cave XIX [151] at Ajaṇṭā is a work of the Gupta Period and will serve to reveal the changes that have taken place since the dedication of the shrines at Bhājā and Kārlī. The essential basilican plan is perpetuated in this Mahāyāna Buddhist sanctuary. Inside, the round shafts of the pillars of the nave arcade are decorated with bands of foliate ornament, and

151. Ajaṇṭā, Cave XIX, interior

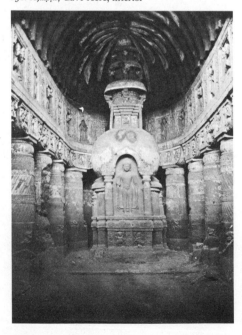

152. Ajaṇṭā, Cave XIX, exterior

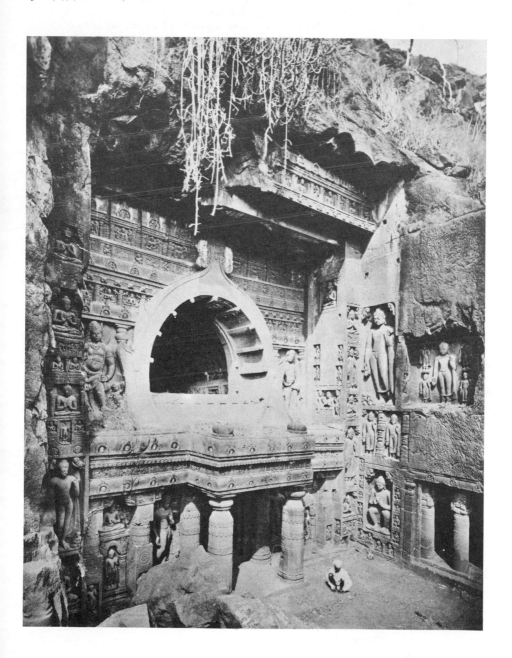

at the top is a lotiform member forming a necking under the bracket-shaped capitals. These capitals are so closely spaced that they provide an almost continuous 'triforium' frieze of deeply carved relief. The haunch of the vault is ornamented with a kind of clerestory of deep niches containing standing or seated Buddhas alternating with panels of foliate ornament. The whole effect is extremely rich and 'baroque'. This luxuriant carving of the nave is complemented by the character of the stupa in the ambulatory. This structure is as elaborate in comparison with the simple rock-cut hemispheres of Bhājā and Kārlī as the pillar and frieze decoration of the nave is in relation to the unornamented interior of the early chaitya-hall. It is a richly carved monolith reaching almost to the summit of the vault. The original drum and hemispherical dome have been made into a pillared niche and canopy to accommodate the figure of a standing Buddha. Above rises an attenuated finial, in which one may still recognize the elements of harmikā and umbrellas now surmounted by a vase or kalasa. The enormous elaboration of the stupa, as well as the decoration of the nave, is the direct result of the development of Mahāyāna Buddhism, with its emphasis on the anthropomorphic nature of the Buddha; the multiple Buddha images are undoubtedly symbolical of the myriad Buddhas of the Quarters mentioned in the Saddharma Puṇḍarīka, just as the stupa itself is reminiscent of the fantastic miraculous structures described in the pages of this sūtra.

No less elaborate is the decoration of the façade [152]. The familiar lotiform window of the early chaityas is still recognizable; below it is a free-standing portico supported by two richly carved pillars of the same order as those of the nave. The portions of the façade around the window and on the side walls of the 'court' formed by the recession of the cave-front are completely covered with niches of varying size filled with high-relief statues of Buddhas and Bodhisattvas. These images are more or less symmetrically balanced according to an all-over decorative scheme, which iconographically may be regarded as a kind of maṇḍala or diagram depicting the host of the mystic Buddhas. On each side of the chaitya window are two guardian figures or yaksha-dvārapālas; their heavily muscled physique, a kind of abstract Indian parallel for Michelangelo's terribilità, is intended to suggest the power of these divinities to ward off the enemies of the Buddhist Church. Iconographically they are the descendants of the railing figures at Bhārhut and Sāñchī. Both these figures and, indeed, the whole arrangement of multiple Buddha images covering the entire wall surface are the prototype for the rock-cut sanctuaries of China of the Six Dynasties (220–589) and T'ang Periods (618–906).

In the Gupta Period the chaitya-hall makes its appearance as a free-standing temple of permanent materials. One of these is a shrine located at Chezarla in Guntur District [153]. At present the building is dedicated to Śiva, but there is little doubt that it is an ancient Buddhist temple converted to Hindu usage. That free-standing chaityas were built at a very early period has already been mentioned. The foundations of such an apsidal building of the first century A.D. have been found in Sirkap (Taxila), and a temple of similar type at Sāñchī rests on very ancient foundations. The temple at Chezarla, built entirely of brick, is in reality a chapel of modest proportions measuring approximately twenty-three feet in length by nine in width. The interior is approximately twenty-two feet high. The most striking feature of the building is its vaulted roof, which is constructed wholly of brick masonry, each horizontal course having a slight offset inward as it rises to the ridge. There is, in other words, no true arching but only a form of corbelled

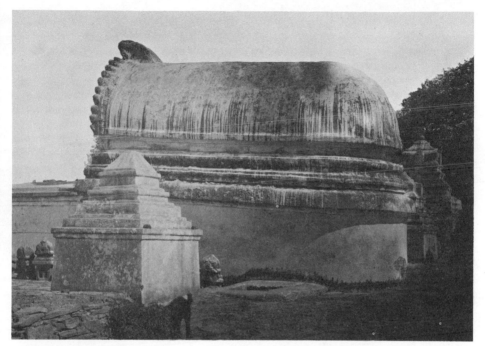

153. Chezarla, chaitya-hall

vaulting. The façade of the building presents the characteristic chaitya-arch form of the rock-cut chaitya-halls which at one time probably enframed a Buddhist subject in relief. There is a similar shrine at Ter [154], also dating from the Gupta Period, which is preceded by a walled-in porch or maṇḍapa, an element that seems to have come into general usage for sanctuaries of all types, both Hindu and Buddhist, in the fourth and fifth centuries.

A free-standing chaitya-hall at Sāñchī, probably built on earlier foundations, shows that this type still persisted in the fifth century; the columns as restored may be seen to the right in illustration 155. Probably this chaitya was roofed with wood and thatch over the stone columns of the nave.

A much more significant structure at this same famous Buddhist site is the small temple standing to the left of the chaitya-hall in

154. Ter, Trivikrama temple

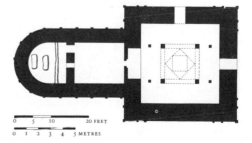

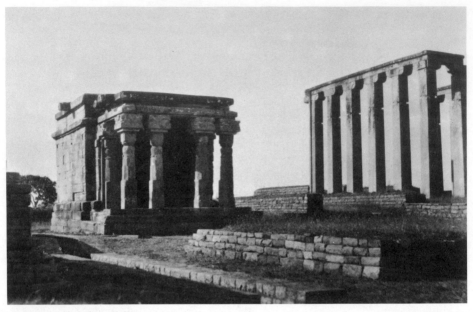

155. Sāñchī, Temple 17 (*left*)

illustration 155. It is designated as Temple No. 17. It consists of an enclosed cella preceded by a columned portico. This plan of the sanctuary or garbha griha with the porch or maṇḍapa in front forms the nucleus of all later temple-building in India both Hindu and Buddhist. It is the outgrowth of a necessity to provide a suitable enshrinement for a central cult image of the deity. Probably it is not a translation into stone of wooden prototypes, but an entirely appropriate, not imitative, use of the stone medium. Among the characteristics of Gupta temple architecture is the flat roof with spouts to drain off rain-water. The exterior of the cella consists of entirely plain and closely joined ashlar blocks; a continuous entablature embraces the sanctum and the porch as well. As so often in Gupta art, we find a combination of an entirely new and fresh concept with elements of tradition. Thus the columns of the portico are a modification of the Aśokan order: the octagonal

shafts of the columns rise from rather high square bases and are surmounted by both a bell capital and, above that, a massive abacus in which rather dryly carved lions are placed back to back as in the old Persepolitan type.

It would be impossible and unprofitable to attempt to prove that the chaitya-hall type is specifically Buddhist and the cella-and-porch type of temple a Hindu invention: the fact remains that both are used with modifications for ritual by both sects throughout the Gupta Period.

Many varying examples of these types can be found at Aihole, near Bādāmī. There, in the squalid modern village and in the overgrown wasteland of prickly-pear forest surrounding it, are about seventy old temples, variously used for dwellings, storerooms, and cowsheds. Only a handful have been reclaimed by modern archaeologists. A late Gupta shrine of the chaitya type at Aihole is the Brahmanical Durgā

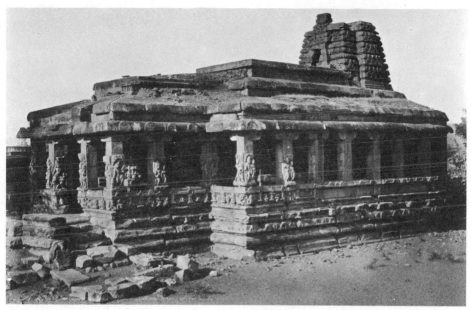

156. Aihole, Durgā temple

temple [156]. It is an example of a modified structural chaitya-hall with the familiar basilican plan of nave, aisles, and apse [157]. A flat roof with stone slabs over the nave replaces the barrel vaults. In place of the ambulatory of the rock-cut chaityas, it has a *pteroma* running round the exterior of the cella. The plain and very massive bracket capitals of this arcade are a type that reappears with variations in all later periods of Indian architecture. These capitals are in a sense a severe or rustic version of those seen in Cave XIX at Ajaṇṭā. Another and even more interesting new element is the little spire or *śikhara* rising above the apsidal end of the structure. The śikhara, which some writers see as a specifically North Indian development, becomes more and more prominent in the architecture of the Gupta and later periods. The origins of the śikhara have been one of the great points of dispute in Indian archaeology. Some see in it a development from the stupa, or a

157. Aihole, Durgā temple

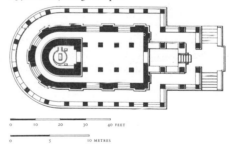

translation into stone of a wooden processional car. Others have suggested an adaptation from primitive beehive huts or a figuration of the *mukuṭa*, the towering head-dress of Vishnu. Coomaraswamy's proposal that the śikhara tower was developed by the piling up of successive storeys, as suggested by the representation of the crowning *āmalaka* at each level or roof, is perhaps the best solution.[2]

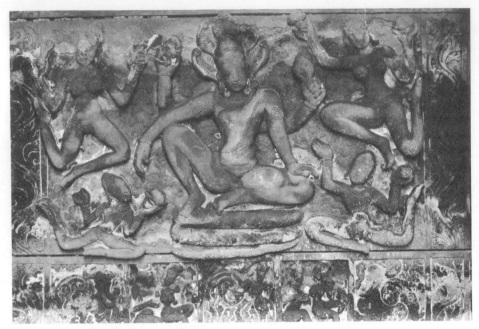

158. Aihole, Haccappya's temple, Vishnu on Nāga

The sculpture of the temples at Aihole includes some of the finest reliefs in all Indian art. The panel with Vishnu on Nāga from Haccappya's temple [158], although perhaps as late as the eighth century, resembles the carving at Deogarh [162] in the abstract purity of modelling and the organization of the relief. These small narrative slabs are adaptations for structural architecture of the epic themes that fill the great cave temples of the Deccan [246]. The figures have the same sense of emergence from the limitless background; their faces reveal a rapt, entranced expression of absorption in their own being; and the forms move in easy curvilinear rhythms, their contours intermingling with the fluidity of waves or flames.

Still another type of architecture is represented by the Lādh Khān temple at the same site dating from c. 450 [159]. This is a rectangular building with a flat roof of stone slabs.

159. Aihole, Lādh Khān temple

0 10 20 30 40 50 FEET
0 5 10 15 METRES

Stone grilles admit light from two sides, and the eastern end opens into a pillared porch. The wall is in reality a peristyle of massive stone posts, between which the latticed slabs have been placed like screens. The interior consists of a single large hall containing two groups of columns that provide a double aisle all round. This unusual plan, as Percy Brown points out, derives not from any pre-existing religious shrine, but from the arrangement of the Indian village meeting-hall or *santhaghāra*.[3] The actual sanctuary for housing the Saivite emblem of worship is simply a room built into the back wall of the interior of the hall, an arrangement suggesting the temple at Bhumara to be discussed below. Although its thoroughly unusual and inappropriate arrangement was not perpetuated, the Lādh Khān is important in furnishing us with the earliest example of the massive bracket-like capital that continues in

use throughout the Hindu Renaissance Period. According to Dr S. R. Balasubramanyam, the Lādh Khān should properly be referred to as the Sūrya Narayana temple.

In so far as one can tell from the ruins of such structures as the Dhāmekh stupa at Sārnāth, the free-standing monuments of this type reveal the same tendency towards attenuation that is notable in the rock-cut stupas at Ajaṇṭā. The Dhāmekh stupa was presumably a memorial erected to commemorate the Buddha's ordaining of his successor, Maitreya. Its solid brick core consists of a high basement surmounted by a drum; the hemispherical dome and superstructure have disappeared, but must have risen to a considerable height. The most notable feature of this ruin is the very elaborate relief decoration surrounding the niches for images lct into the drum [160]: the ornament consists of chevron patterns and the most luxuriant vine

160. Sārnāth, Dhāmekh stupa, detail of carving

patterns, carved with the utmost delicacy and feeling for effective shadow. This is the exact sculptural equivalent of the magnificently painted ceilings of the Ajaṇṭā cave temples which will be considered later.

One of the few surviving gems of Hindu architecture of the Gupta Period is the temple of Vishnu at Deogaṛh. This fragmentary building is one of the most ornate and beautifully composed examples of Gupta architecture. The temple itself occupies the innermost enclosure of a maṇḍala of nine squares [161].[4] It probably dates from the fifth century. The shrine as it survives consists of a cubic block of finely joined ashlar masonry, surmounted by a ruined pyramidal tower that at one time rose to about forty feet in height. This cella was originally surrounded by four porticoes, one leading to the sanctuary, the other three serving to set off and protect the reliefs of Brahmanic subjects set in the remaining walls of the edifice [162]. These panels are deeply sunk in an elaborate framework of pilasters of the Indian order and a frieze of foliate scrolls and lion heads. This ornament is not far removed from the work on the

Dhāmekh stupa. The carving of the frame complements the richness of the reliefs. Their baroque depth in their box-like settings gives the effect of a spectacle on a stage and seems to prophesy the dynamic chiaroscuro of later Hindu sculpture. The voluptuous grace of the figures and the already familiar metaphorical conventions of anatomy and features remind us of the style of Gupta Buddhist sculpture at Sārnāth. But the richness and dramatic conception of relief are far more moving than anything to be found in Buddhist art of the fifth and sixth centuries, and are an unmistakable indication of the real renaissance that was taking place in the art of the Hindu Church. Originally the temple platform was decorated with a continuous frieze representing events from the epic *Rāmāyaṇa*, a text popular in Gupta times for its heroic account of the triumph of a godly race. This is the earliest example of a motif that is repeated over and over again in the architecture of Java.

The main doorway of the temple at Deogaṛh may serve as an example of the extremely ornate type of portal that makes its appearance now

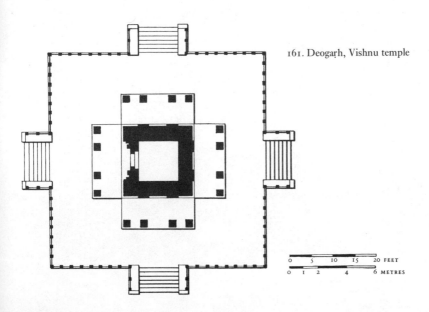

161. Deogaṛh, Vishnu temple

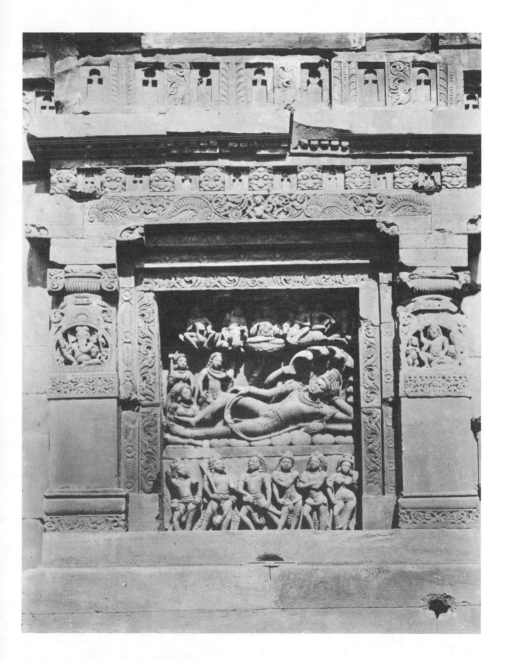

162. Deogaṛh, Vishnu temple, Vishnu on Sesha

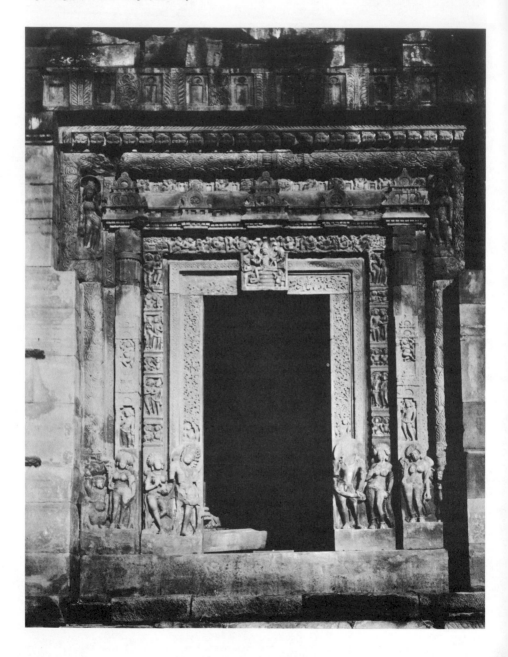

[163]. A feature found in almost all temple entrances is the projecting lintel-cornice. It overhangs the elaborate frame of the doorway proper. The main motif here consists of richly decorated pilasters, alternately square, octagonal, and sixteen-sided in section, supporting an architrave in the shape of an elongated vesara or chaitya roof ornamented with chaitya dormers. Within this framework are enclosed narrow vertical bands of decoration with representations of mithunas or auspicious couples; in the centre of the over-door slab is a plaque of Vishnu on the great nāga. Around the frame of the doorway itself are panels with crisply carved foliate details. To right and left at the top and outside the main zone of the frame are reliefs of the river goddesses of the Ganges and Jumna. This is a motif that occurs repeatedly in this position in the buildings of Gupta times. At the bases of the overlapping frames of the door are carvings of dvārapālas or door guardians and female divinities. The richness of this sculptured portal is, like the reliefs of the false windows, set off by the plain surfaces of the ashlar masonry.

A unique and important building of the Gupta Period is the brick temple at Bhītārgāon near Cawnpore. The structure, which depends for its effect on flat wall decoration, is so ruinous that its arrangements can be seen better in an architectural drawing than in a photograph [164]. It dates from the fifth century, and is one of the few surviving examples of Indian architecture in brick. Originally a Brahmanical dedication, it was intended as a sanctuary for images. The brick tower, raised on a high plinth, is thirty-six feet square, and contains a cella joined to a small vestibule by a barrel vault. Domical brick vaults cover the sanctuary and porch. On the exterior we see a structure with doubly recessed corners ornamented by double cornices enclosing a recessed frieze of carved brick. The superstructure, rising in diminishing stages with a decoration of chaitya arches, was

originally crowned by a hull-shaped roof of the chaitya type that we shall see in the Pallava examples at Māmallapuram and Gwalior. The blind chaitya arches in the horizontal courses enframe heads of divine beings, the first appearance of the gavaksha, an architectural motif that recurs in Pallava architecture and in the pre-Khmer buildings of Indo-China. If only in its shape, the temple seems to bear some relation to the original tower sanctuary at Bodh Gayā, and it furnishes a remarkably close prototype for many later shrines in Java and Indo-China. The panels of carved terracotta from the exterior revetment are among the most beautiful examples of Indian work in this ancient medium. Like the decorative stone panels of the Gupta period, these reliefs are characterized by their extreme beauty of finish, softness of form, and crispness of detailed definition.

164. Bhītārgāon, brick temple

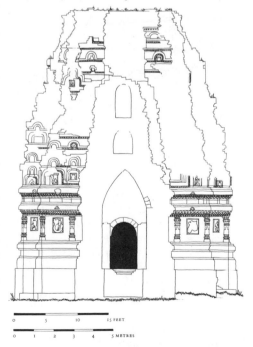

0 5 10 15 FEET

0 1 2 3 4 5 METRES

165. Bhumara, shrine of Śiva

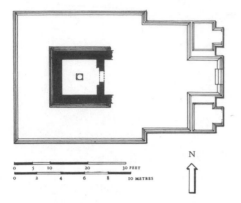

N

complicated foliate growth. The frond-like motifs belonging to no botanical species writhe and twist with explosive vigour. The repetition of the curling motifs large and small creates an effect of constant uneasy movement over the surface, the movement of a flame consuming itself. One has the feeling that in the very exuberance of this rococo fantasy the creative invention has a vigour and freshness still far from the exhaustion and dryness of expression found in the late Hindu periods of Indian art.

Sculpture in the period of Gupta supremacy, like the allied arts of painting and architecture, must not in any sense be regarded as a revival or rebirth, but rather as the logical culmination

Closely related to this type of temple and plan is the shrine of Śiva at Bhumara in Nagod State [165]. This sanctuary, dated in the late fifth century, consists of a square cella or garbha griha, which was itself originally contained in a larger walled chamber, so that an indoor processional path was formed around the holy of holies. This enclosure in turn was preceded by a maṇḍapa. It is difficult to say whether this arrangement is the origin of the typical late Indian temple plan, but it can easily be seen that by linking the porch direct to the holy of holies, the form of the Hindu and Buddhist temple of the Gupta Period was completely evolved.

In Gupta temples, both Buddhist and Hindu, the decorative carving was effectively crowded into the ornament of the doorways, windows, and panels let into the otherwise plain wall-surfaces, so that the resulting contrast of small areas of sparkling relief against the expanse of unadorned ashlar is not unlike the effect of Plateresque architectural ornament in Spain. A single red sandstone panel from the shrine at Bhumara will serve to illustrate the exuberant richness of this type of architectural carving in the Gupta Period [166]. It represents a *gaṇa* or goblin climbing the stem of an enormously

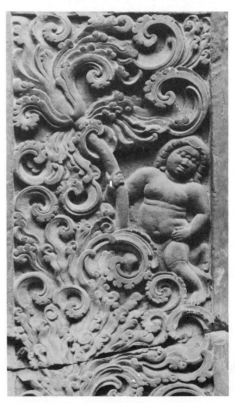

166. Door jamb with floral scroll from Bhumara.
Allahabad, Municipal Museum

of several continuous traditions. The traditions out of which it developed are mainly the entirely Indian school of Mathurā, and the Greco-Roman art of the north-west frontier. All Gupta sculpture, regardless of its place of manufacture, is marked by a finished mastery in execution and a majestic serenity in expression that have seldom been equalled in any other school of art.

We may take as a typical example, to illustrate what we might call the processes leading to the emergence of Gupta sculpture, any one of the images of Buddha carved at Mathurā from the fourth century onwards [167]. From Hsüan-tsang's description of this former Kushan capital there can be no doubt that the city continued as a flourishing centre of Buddhism. The fifth-century Buddha from Mathurā differs from the early Kushan effigies of Śākyamuni in showing the Teacher entirely covered by the monastic garment. This in itself may be regarded as an iconographical borrowing from Gandhāra. The style of the drapery bears a a marked resemblance to certain late Gandhāra Buddhas; what were once realistically represented Classical folds have been reduced to a series of strings, symbolically representing the ridges of the folds, that clothe the body in a net of parallel loops following the median line of the figure. In the Mathurā Buddhas the rather hard conventionalization of the late Gandhāra drapery formula has been reworked into a rhythmic pattern quite apart from its descriptive function; that is, the repetition of the loops of the string-like drapery provides a kind of relief to the static columnar mass of the body. This is the final development of a formula already noted in the Buddhas of the Later Āndhra Period. The conception of the actual form of the Buddha is entirely Indian. We note a perpetuation of the heaviness and volume of the early Kushan Buddhas: this quality, together with the commanding height of the figures, conveys a feeling of awesome dignity and power. It is notable, however, that the archaic crudeness of

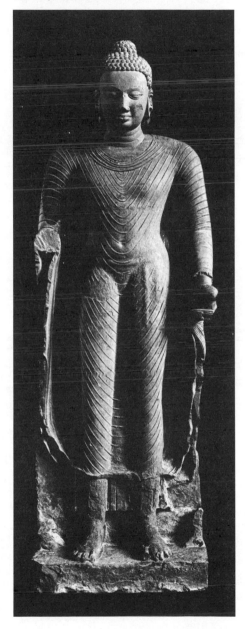

167. Standing Buddha from Mathurā.
Calcutta, Indian Museum

the prototype has disappeared. We may be reasonably sure that these figures were carved according to a fixed set of proportions intended to guarantee the more than mortal ideality of the conception; likewise, individual parts of the body continue to be fashioned in accordance with the entirely metaphorical description of the Buddha's person contained in the lakṣanās.

The head of this typical Gupta Buddha from Mathurā reveals essentially the same coalescence of the Indian and Gandhāran traditions. The sharp definition of the planes, as, for example, the razor edge that separates the brow from the eye-socket, is similar to the hard precision of the Gandhāra Buddhas, with the difference that the Mathurā types avoid the mask-like coldness of the Gandhāra Buddha head by the swelling roundness of the interlocking planes which in an almost geometric fashion combine to impart to the face a feeling of warmth and fullness. The individual features are again composed in a metaphorical manner and still, as in archaic sculpture, combined in an additive, rather than an organic, manner. The eyes are lotiform; the lips have the fullness of the mango; the hair is represented by the snailshell convention which we have seen in the example from Amarāvatī. The sculptors are always at pains to represent the ushnisha as a definite protuberance growing from the summit of the skull, and in similarly orthodox fashion the marks of wheel, fish, triśūla, etc., are engraved on the palms of the hands. Among the most beautiful features of the Mathurā Buddhas are the carved haloes, the ornament consisting of concentric rings of floral pattern about a central lotus. Aesthetically this final evolution of the Buddhist cult image is extremely moving in the feeling of tremendous and fully realized sculptural mass and the awesome spiritual dignity of form and features that is achieved by their combination of Late Antique convention and Indian metaphor and feeling for plastic volume.

'The figure of their Great Master they stealthily class with that of Tathāgata; it differs only in the point of clothing; the points of beauty are absolutely the same.'[5] This accurate observation by Hsüan-tsang on the dependence of Jain art on Buddhist prototypes may be applied to any number of Jain images of all periods. A sizeable statue of a Tīrthaṁkara in the Archaeological Museum at Muttra [168] could be mistaken at first glance for a Buddha in *dhyāna mudrā*, were it not for the complete nudity of the figure. The proportions of the body and the technical aspects of carving are identical with Buddha images of the Gupta Period, down

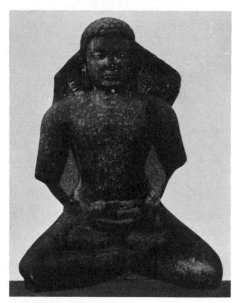

168. Jain Tīrthaṁkara.
Muttra, Archaeological Museum

to such details as the lotiform eyes and the representation of the hair by snail-shell curls. The impression of hieratic stiffness and austerity in this and other Jain images is due not only to the rigid geometrical construction of the body set like a column on the base of the locked legs, but

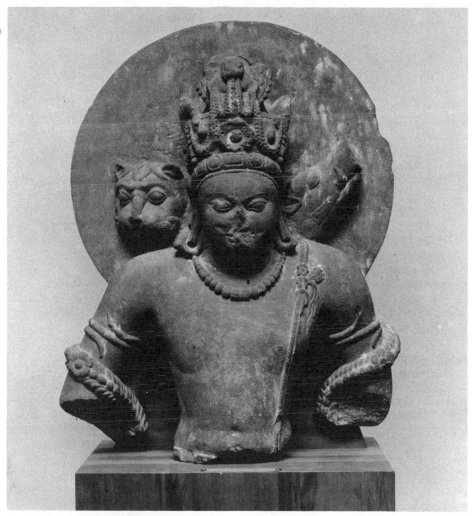

169. Vishnu from Mathurā.
Boston, Museum of Fine Arts

to the emphasis on the abstract treatment of
surface and volume inherent in the entirely un-
adorned body. Looking back to the earliest
example of Indian treatment of the nude, the
Harappā torso, it is interesting to see how for
very good reasons all suggestion of muscular
structure has been suppressed in favour of an
entirely abstract conception of the body in
smooth and unencumbered curved planes,
which in their entirely generalized treatment
impart a feeling of tremendous volume and are
intended to connote the perfection of a great

man in yogic trance, a spiritual state of being in which the body becomes immaculate – purified of the dross of material existence.

In the Gupta Period, as at all other moments of Indian art history, no distinction in style can be made between works of art produced for the various religions. A typical Brahmanical fragment from the Mathurā workshops of the fifth century reveals the same tradition and stylistic idiom as the Buddha images from the same site [169]. This is a fragment of the Hindu deity Vishnu with the heads of a lion and a boar placed to left and right of the central human head to indicate the *Narasiṁha* and *Varāha* avatars of the god. The body is represented with the same herculean proportions as employed for the icons of Buddha; the carving in smooth, very simplified planes is the final perfection of the style of the early Kushan school. The human face in the centre in its roundness and in the character of the individual features could scarcely be distinguished from a Buddha mask. A distinctive Vishnu attribute is, of course, the elaborate jewel head-dress or mukuṭa which reveals the same luxuriant fancy in decorative invention as is typical of all Gupta ornament.

Very close in feeling and detail is a magnificent Vishnu torso in the New Delhi Museum [170]. We notice here how the Indian sculptor, following a device going back to the archaic periods, exploits to the full the contrasts between the precisely carved jewellery and armlets and the unadorned expanse of the nude torso. In the Buddhist sculpture of the Pāla-Sena Period this insistence on the definition of the jewelled ornamentation becomes a kind of end in itself, and the carving assumes a dry, mechanical aspect that is totally absent in the statues of the Gupta Period, in which there is always a perfect balance between the massive plastic realization of the form and the surface details serving by their very delicacy of execution to relieve the statues' almost overbearing heaviness.

One of the most flourishing centres of Buddhist sculpture in the Gupta Period was the great monastic complex at Sārnāth. The material that the sculptors used for carving the innumerable Buddhas and Bodhisattvas that once decorated the stupas and vihāras was the chūnar sandstone that had served the craftsmen of the Maurya Period. One may choose as typical of the standing Buddha type evolved at this site any one of the many images recovered in the course of excavation [171]. This statue was

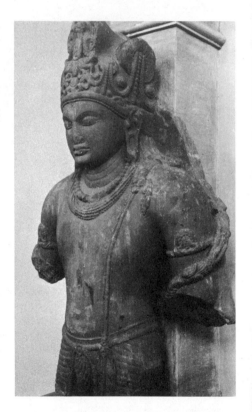

170. The god Vishnu.
New Delhi, National Museum

171 (*opposite*). Standing Buddha from Sārnāth.
New Delhi, National Museum

dedicated in the year A.D. 474, in the reign of Kumaragupta, by a holy man named Abhaya-mitra. Several other images donated by this same monk bear inscriptions with the phrase 'made beautiful through the science of *citra*'. The term *citra*, usually applied to painting, may be roughly translated as artistic expression and is one of the first indications that we have that the aesthetic properties of the icon were considered as part of its effectiveness as a religious image. The statue shows an even further

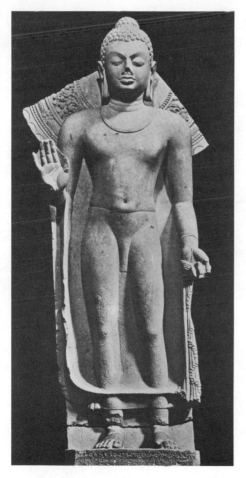

departure from any adherence to the style of Gandhāra than the Mathurā Buddha in the complete disappearance of any indication of the structure of the folds of the drapery; it is as though the mesh of strings typical of the Buddhas of Mathurā had fallen away, leaving the Buddha clothed in a smooth sheath-like garment that completely reveals the form of the body beneath it. Another immediate difference that strikes us is the position of the figure: in marked contrast to the columnar rigidity of the Buddhas of Amarāvatī and Mathurā, the body is slightly broken on its axis in a kind of Praxitelean *déhanchement*, a device that imparts a certain litheness and moving quality to the Sārnāth type. Very possibly this is an adaptation for Buddhist usage of the characteristic pose of the Indian dance, the tribhanga, in which, it will be remembered, the body is similarly broken on its axis. It is perhaps not too bold to think that this posture was intended to suggest to the worshipper that the Buddha image was actually moving or walking towards the suppliant, its hand raised in the gesture of reassurance. Like their counterparts at Mathurā, the Sārnāth images are certainly composed according to a fixed system of proportion; from what we know of later compilations of the śāstras in the Hindu tradition, some such ratio as seven, or even nine, thalams (the distance from brow to chin) to the total height of the image would have been employed. The ratio varied according to the 'stature' both physical and hieratic of the deity to be represented.

In all the Buddhas of the Sārnāth workshops the planes have been so simplified that the sculpture takes on an almost abstract character; it is as though, by the very perfection and unbroken smoothness of the subtly swelling convex surfaces which compose the modelling of the body, the sculptor strove not only for a beautifully refined plastic statement of form and volume, but for an expression of the ineffable perfection of the body of the Buddha as well.

234

172. Buddha preaching the First Sermon
from Sārnāth.
Sārnāth, Archaeological Museum

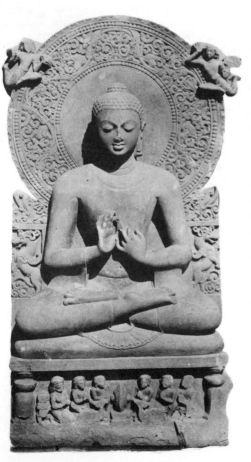

One of the great masterpieces of Gupta
sculpture and, indeed, of Indian art of all
periods is the high-relief statue of Buddha
preaching the First Sermon, discovered in the
ruins of Sārnāth [172]. It is, as usual, carved of
Chūnar sandstone which retains traces of red
pigment on the robe. The Teacher is repre-
sented seated in yoga posture, his hands in the
wheel-turning or *dharmacakra mudrā*; below,
on the plinth, may be recognized the figures of
Śākyamuni's earliest followers who, after a
period of apostasy, returned to him at the
sermon in the Deer Park. Between the two
groups of kneeling monks is the symbol of the
preaching, the Wheel, and, to give the setting,
two badly damaged figures of recumbent deer.
The back-slab, representing a throne, is carved
with hybrid monsters or *yālis* and makaras.
Iconographically the relief is the final step in a
development that transformed the events from
the life of the Buddha into hieratic symbols,
rather than mere stories of Śākyamuni's mortal
career. In early representations of the First
Preaching, as in the reliefs of Gandhāra, the
Deer Park sermon is represented as an actual
event, with the Buddha surrounded by his
disciples, with all figures on the same scale. In
the Sārnāth relief it is the enormously enlarged
figure of the Buddha in *dharmacakra mudrā* that
stands for the event; the narrative elements of
the episode have been relegated to the base.
Both the svelte attenuation of the Sārnāth
Buddhas and the quality of sensuous elegance
that distinguishes them are a kind of develop-
ment out of the Later Āndhra style. The seated
Buddha is presumably carved according to a
system of five thalams to the total height of the
figure, and the image is composed in a triangle,
with the head as apex and the legs as the base.
The relief shows the development of the
Mahāyāna point of view: it is the eternal aspect
of the turning of the wheel, typified by the
Buddha and his gesture, that is important,
rather than the actual episode from the hero's

mortal career that appealed to the Hinayanist Church. There could be no more appropriate nor beautiful illustration of the metaphorical conception of the cult image and its separate parts than this icon: the line of the brows follows the tensile curve of the Indian bow; the eyes are lotiform; the face has the perfect oval of the egg; and the body once again is a combination of the various allegories of great strength and beauty contained in the lakṣanās. One of the most

173. Avalokiteśvara.
Calcutta, Indian Museum

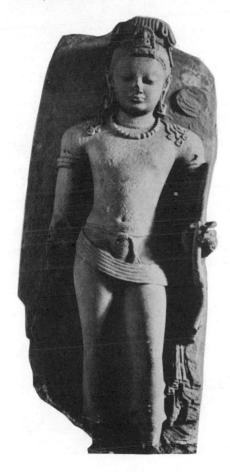

beautiful features of this and other Gupta Buddhas from Sārnāth is the carving of their haloes. In the present example the ornament of the nimbus consists of a wide band of deeply cut foliate forms framed in a pearl border with flower-bearing apsaras on either side.

No less aesthetically moving than the Buddha images of the Sārnāth school are the statues of Bodhisattvas that are the earliest recognizable personifications of these archangels of the Mahāyāna pantheon. A particularly beautiful example is an image of Avalokiteśvara clearly recognizable by the attribute of the small figure of Buddha Amitābha in the towering diadem [173]. The radiant face, softly modelled in gently fusing abstract planes, has that air of half-sensuous, half-spiritual introspection that in an exaggerated form appears in the provincial Indian sculpture of Fondukistan [124]. The body, which appears almost nude through the transparent *dhoti*, reveals the same soft, pliant rhythm as the Buddha images of the Sārnāth school and their painted counterparts in the Gupta murals of Ajaṇṭā [183]. These Bodhisattva images of the Gupta Period are the artistic ancestors of the later icons of the Pāla Period [197].

Not the least important aspect of the Sārnāth school of Buddhist sculpture is its great influence on Buddhist art outside India. The earliest Buddha images to be carved in Siam and Cambodia are all provincial variants of the Sārnāth types, and a final and beautiful development will be seen in the Buddhas ornamenting the great shrine of Barabuḍur in Java.

In relief sculpture the Gupta workshops of Sārnāth achieved a synthesis of Gandhāran and Kushan elements paralleling the development of the Buddha image. A number of steles with scenes from the life of Buddha very clearly show the perpetuation of the iconography for each episode as evolved in Gandhāra [174]. The figures in the reliefs are themselves miniature replicas of the monumental statues. The style of

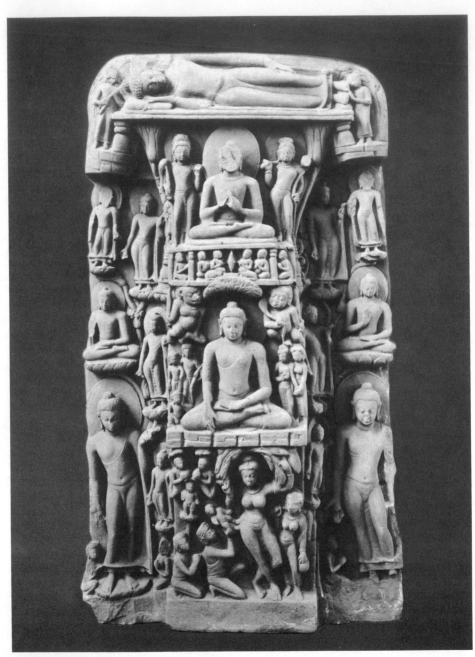

174. Scenes from the Life of Buddha from Sārnāth.
Sārnāth, Archaeological Museum

the relief carving with the forms outlined against a deeply shadowed background may be regarded as a development of the archaic style found at Sānchī and elsewhere. In the individual scenes the story is related in a very clear shorthand manner, with the inclusion of only those figures necessary to the action. There is a perpetuation of the manner of continuous narration, so that all the events related to the Buddha's Nativity (Māyā under the Śal tree, the Seven Steps, and the First Bath) are included within the confines of the same panel. The reduction of the narrative to the most essential figures is already prophesied in the relief style of the Kushan Period at Mathurā.

Some mention must be made of sculpture in metal, which at one time certainly existed in a quantity approximating that of the surviving examples in stone and stucco. The only remaining metal statue of any size is the colossal copper image of Buddha from Sulṭāngañj, in the Birmingham Museum [175]. Stylistically, the figure is the equivalent of the fifth-century stone Buddhas of Sārnāth in the smoothly rounded attenuation of body and limbs, and in the way that the drapery entirely reveals the form beneath. Parallel incisions on the surface are all that indicate the presence of folds in front of the body. Modelling in the shape of the archaic chevron pattern connotes the fullness of the garment at the borders. The figure, standing erect and majestic like the Sārnāth statues, has a feeling of animation imparted by the unbalanced stance and the movement suggested by the sweeping silhouette of the enveloping robe. Indeed, much of the impressiveness of this figure derives from the position of the arms unfurling the mantle on either side of the body like giant wings outspread.

Just as important aesthetically and historically are the small figures of Buddha and Buddhist divinities in bronze that have been unearthed both in Gandhāra and the Ganges Valley, if only because it is highly likely that such small portable statues were imported into China by Buddhist pilgrims like Hsüan-tsang and served as models for the religious sculpture of the Far East.[6]

Among the statuettes in bronze that have been found in Gandhāra, which are reported to have been excavated at Sahri Bahlol, is an

175. Copper Buddha from Sulṭāngañj.
Birmingham Museum

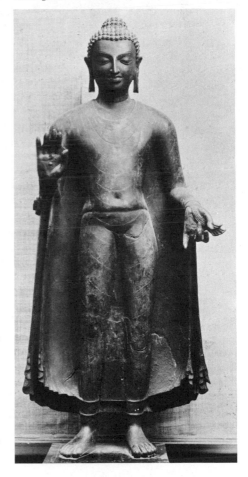

example in the collection of Pierre Jeannerat [176]. It represents the Buddha standing in *abhāya mudrā*. In a general way, the figure, with the voluminous folds of the mantle indicated by incised lines,[7] but conceived as a volume separate from the body, is a miniature replica of the stone Gandhāra Buddhas of the second and third centuries. There are certain features, however, which point to the image's having been made at a somewhat later period, when the Classical influence was being replaced by artistic ideals of a definite Indian nature; the round fullness of the face, prominent ushnisha, and snail-shell curls are positive hallmarks of

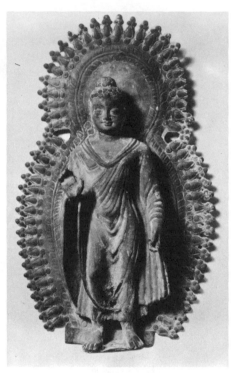

176. Bronze standing Buddha from Sahri Bahlol.
Radlett, Herts, Pierre Jeannerat

177 (*right*). Bronze standing Buddha
from Dhanesar Khera.
Kansas City, Nelson Art Gallery

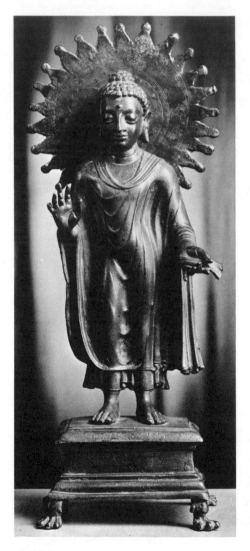

the Gupta style at centres like Mathurā, so that the object should probably be dated no earlier than the fourth or fifth century. Characteristic of the Gandhāra metal figures is the rayed nimbus and aureole or body halo.

A typical example of a statuette of the Gupta Period is the bronze figure of Buddha from Dhanesar Khera, now in the museum at Kansas City and dated *c*. 400 [177]. The head is a reduction to a small scale of the heads of fourth- and fifth-century Buddha statues from Mathurā. The proportions of the body beneath the drapery likewise correspond to the Gupta type, but the robe itself is still modelled more in conformity with the semi-realistic style of Gandhāra. Again, the halo, with its projecting rays, is typical of these small metal images both in Gandhāra and later Indian examples.[8]

Sculpture in the Gupta Period is of course not limited to the production of the ateliers at Mathurā and Sārnāth; there was, on the contrary, an enormous amount of carving of Hindu and Buddhist images all over India, and many of these can vie in quality with the masterpieces of the famous centres in the north. A great many images and reliefs, Hindu, Buddhist, and Jain, have been collected in the Museum at Gwalior. Among these the mother goddesses and a Narasimha from Besnagar, several reliefs of flying apsaras, and a Nativity relief, either Hindu or Jain, are worthy of special mention. Also from a temple at Besnagar is a relief of the goddess Gangā, now in the Boston Museum of Fine Arts. The figure reveals the attenuated sensuous grace of the Sārnāth style, and the foliage and water patterns are carved with that combination of convention and inventive fancy that characterizes all Gupta ornament. Among the most monumental of Gupta carvings is the colossal relief of the boar avatar of Vishnu at Udayagiri, Bhopal [178]. All these examples from western India are in the same style as the work at Sārnāth; that is, the sculptural conception, the proportions of

figures, and their metaphorical composition are all parts of the unified Gupta tradition. Sāñchī continued as a Buddhist centre well through the reign of Harsha of Kanauj, and some of the later dedications include Buddha images of considerable dignity and plastic significance. We have already studied the later cave-temples at Ajaṇṭā

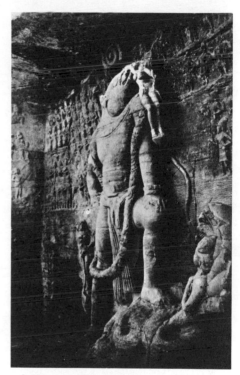

178. Udayagiri, Bhopal, boar avatar of Vishnu

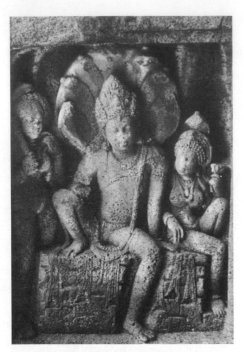

179. Ajaṇṭā, Cave XIX, Nāgarāja

as examples of rock-cut architecture; some of the sculptural decoration, notably the fine panel of a *Nāgarāja* and his queen, outside Cave XIX, deserve to rank with the great examples of the period [179]. The figures have the same feeling of elegance and repose which, as we shall see presently, distinguishes the Gupta wall-paintings at the same site. It will be observed that all the reliefs mentioned have a common classic quality in being rigidly contained within a box-like frame. There is no indication of the baroque qualities of later Hindu reliefs, in which the figures are disposed without any confining enclosure.

A beautiful slab from Sondani near Gwalior illustrates the mature development of figure sculpture in the Gupta Period [180]. Represented are a *gandhārva* and an *apsaras* – supernatural aerial beings – divinities of fragrance and music, once the attendants of Indra. Appropriately, the divinities are shown flying through the air, and it should be noted that the effect of weightless, endless, soaring motion is imparted not, as in Christian angels, by the unconvincing addition of wings, but by the direction of the legs and by the upward swirling lines of the billowing scarf that supports the divine pair like a celestial parachute. As Stella Kramrisch has pointed out, the device of the upturned feet, brushing against, but not supported by, the steps in the frame at the right adds to the illusion of the effortless flight of the angels.[9] Again, the very heaviness of the massive, intricate coiffures, worthy of Fuseli's courtesans, seems to add by contrast to the lightness of the simply modelled bodies. The beautiful apsaras in this group is the Sāñchī yakshī in Gupta terms, a fully modelled form in relief, but suggesting the possibility of existence in the round. Note the wonderful contrast of the close-pressed roundness of globular breasts and almost abstractly tubular limbs and, as in all great Indian figure sculpture, the expansive swelling roundness that makes these beings appear 'as if breathing'.[10]

Gupta Buddhist sculpture in western India may be illustrated by a panel carved on the narthex screen of the chaitya-hall at Kārlī at the time when this sanctuary was transformed into a Mahāyāna temple [181]. This relief could be described as an apotheosis of Buddha as he appears transfigured in the Lotus *sūtra*. The Buddha is enthroned on a lotus in the sky at the summit of an axis supported in the nether waters by nāgas. To complete the representation of the old Vedic concept of the division of the cosmos into air, earth, and nether waters, the level of the earth and a reference to the Buddha's preaching may be discerned in the Wheel and the deer, emblematic of Sārnāth. The Buddha is

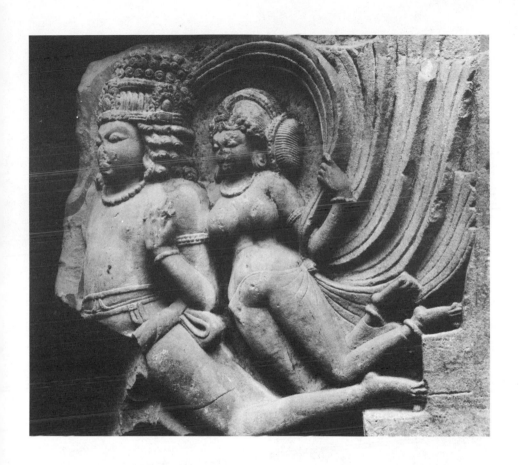

180. Gandhārvas and apsaras from Sondani.
Gwalior, Archaeological Museum

flanked by the Bodhisattvas Avalokiteśvara and Maitreya, the principal members of the celestial congregation who were vouchsafed a vision of the Body of Bliss or *Saṁbhogakāya*. Above the Buddha's head are angels supporting a stupa, symbol of his final Nirvāṇa. The style of the individual figures, like the Gupta sculptures at

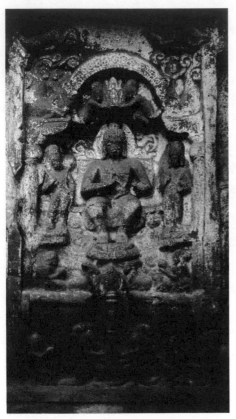

181. Kārlī, chaitya-hall, Transfiguration of Buddha

Ajaṇṭā, is a rough, even crude provincial derivation from the fifth-century school of Sārnāth, a resemblance to be discerned in the smooth tubular bodies and limbs and extending to such details as the wheel and the flanking deer.

Painting in the Gupta Period, like architecture and sculpture, is merely the culmination, not the renewal, of a very ancient tradition. References to Indian painting occur in literature of all periods as early as the Maurya, and it may be assumed that techniques and traditions had been formulated long before the Gupta era. The principal source for an understanding of the aesthetic of Indian painting is the *Vishnudharmottaram*, which classifies the types of painting appropriate to temples, palaces, and private dwellings, and differentiates between 'true', 'lyrical', and 'secular' painting. Great stress is laid on the necessity of following canonical proportions and, of even greater import, the expression of emotion through appropriate movement.[11]

Six Limbs or Essentials of Painting are enumerated in the commentary of Yaśodhara on the *Kāma sūtra*, a work essentially of the Gupta Period. These canons may be understood as a reference to standards which every painter would necessarily observe. They include the proper representation of inner feeling or mood, ideal proportion, as well as attention to proper pose, and the preparation of colours and use of the brush. These Indian canons are on the whole practical injunctions, and have nothing to do with the Six Canons of the fifth-century Chinese painter Hsieh Ho.

That a certain *trompe l'œil* through the suggestion of relief was specifically intended in Indian painting is hinted at by certain passages in the *Lankavatāra sūtra*: 'As a picture shows highness and lowness while (in reality) there is nothing of the sort in it . . . it is like the painter's canvas on which there is no depression or elevation as imagined by the ignorant.'[12]

It is significant indeed that the *Vishnudharmottaram* mentions the impossibility of attaining a proper expression of emotion without a knowledge of the art of dancing. This comment in itself serves to explain that wonderfully vibrant gesture and pose that characterizes the

great painted forms of Ajanṭā and invests them with a kind of swaying, flower-like grace and movement. Painting in the Gupta Period came to be a social accomplishment no longer limited to ecclesiastical use but practised by amateurs as well as professional craftsmen.[13]

Remains of Gupta and post-Gupta or Early Chalukya wall-paintings exist at Ajanṭā (Caves I, II, XVI, XVII, and XIX), at Bāgh, in the Gupta caves at Bādāmī, and in a Jain sanctuary at Sittanavāsal near Tanjore.

Nowhere else in Indian art but at Ajanṭā do we find such a complete statement of indivisible union of what in the West is referred to as sacred and secular art. Like the poetry, the music, and the drama of Gupta India, this is an art of 'great courts charming the mind by their noble routine' – all different yet united re-flexions of a luxurious aristocratic culture. As Coomaraswamy so admirably phrased it, in the splendid settings of the Ajanṭā wall-paintings the 'Bodhisattva is born by divine right as a prince in a world luxuriously refined. The sorrow of transience no longer poisons life itself; life has become an art, in which . . . the ultimate meaning of life is not forgotten . . . but a culmination and a perfection have been attained in which the inner and outer life are indivisible; it is this psycho-physical identity that determines the universal quality of Gupta painting'.[14]

In the Ajanṭā wall-paintings we feel a definite change from the art of early Buddhism, with its emphasis on the symbolic quite apart from the world of reality. Here is a turn to a sort of religious romanticism of a really lyric quality, a reflexion of the view that every aspect of life has an equal value in the spiritual sense and as an aspect of the divine. Sensuous physical beauty is as an emblem of spiritual beauty. One is reminded of the Hindu god Krishna and his scriptures, in which it is written: all men and women are his forms.

The technique of the Ajanṭā wall-paintings is not markedly different from that described in the paintings at Bāmiyān. The rough surface of the wall or vault is first covered with a layer of clay or cow dung mixed with chopped straw or animal hair. When this has been smoothed and levelled, it is given a coating of gesso (fine white clay or gypsum), and it is on this ground that the actual painting is done. Although Indian wall-paintings can never be described as fresco in the true sense of the word, it is notable that the plaster ground was kept moist during the application of the pigment. The composition was first entirely outlined in cinnabar red; next came an under-painting corresponding to the terra verde of medieval Italian practice. The various local tints were then applied and the painting was finished by a general strengthening of outlines and accents. A burnishing process gave a lustrous finish to the whole surface.

The most famous paintings at Ajanṭā are in Cave I, and date from the late Gupta to early Chalukya Period; roughly, that is, the late fifth

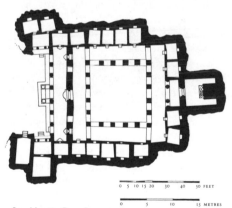

182. Ajanṭā, Cave I

to early seventh century. The cave has the form of a square hall with the roof supported by rows of pillars [182]. At the back of the shrine is a deep niche containing a rock-cut image of a seated Buddha. Originally, of course, the entire interior surface of the cave, even the pillars, was

covered with paintings; among the most un-usual details from this cave that we shall examine are parts of the complete decoration of the flat ceiling. Although the painted decoration does not form a complete or unified icono-graphic scheme, large portions are thought of as parts of a single concept: the two colossal painted figures of Bodhisattvas on each side of the niche at the back of the hall may be regarded as parts of a Trinity, with the sculptured image of the Buddha in the sanctuary as the central figure. Both these Bodhisattvas are of the *carana* type of composition in which a principal figure serves as stablizing factor and guide to the entire arrangement; for example, on the left-hand wall, the enormous figure of a Bodhisattva with a Blue Lotus stands in a landscape teeming with forms of all sorts, related not by any laws of spatial composition but by their relation to the object of their veneration, the Deity of Com-passion represented at the moment that he manifests himself to this group of devotees. The spectator does not take in the entire huge composition at a single glance, but his eye, following the directions suggested by the gestures and movements of the forms, and al-ways returning to the dominating shape of the Bodhisattva, comes gradually to explore and apprehend the entire arrangement.

The figure of the Bodhisattva is worthy of detailed analysis [183 and 184]. Following the principle of hieratic scaling, it is enormously larger than the attendant figures; this device not only serves an iconographical function but provides a dominant vertical axis around which the composition literally revolves. We may be sure. that the form, just like the sculptured Buddhist images of the period, was composed according to a system of canonical proportion, probably nine thalams to the total height of the figure. The pose of the body with its pro-nounced *déhanchement* contrives to impart a feeling of swaying grace and movement that is carried out in the exquisite tilt of the head and the gesture of the hand. As an example of that metaphorical rather than organic composition of human forms, this figure has few equals. We may see how feature by feature the parts of the face and body are drawn with reference to the shape of certain forms in the animal and vegetable world, which by their beauty and finality recommended themselves as more fitting than any transitory human model for creating the imagined superior and eternal ana-tomy of a god:[15] the face has the perfect oval of the egg; the brows curve as an Indian bow; the eyes are lotiform. We recognize again the elephantine shoulders and arms, the leonine body, and, perhaps loveliest of all, the hand, which in its articulation suggests the pliant growth of the lotus flower it holds.

It will be observed in the figure of the Bodhisattva and his attendants that the flesh parts appear to be modelled in light and shade. Actually this chiaroscuro has nothing to do with the recording of any effects of illumi-nation; like the highly similar modelling of Trecento painters such as Giotto, its sole func-tion is to impart a feeling of solidity and plasticity to the forms. In a completely arbitrary way areas of shadow are placed on both sides of the bridge of the nose of the Bodhisattva, and in some of the dark-skinned attendants bold high-lights are painted on the saliencies of features and body further to enhance the feeling of existence in the round. In the examples at Ajaṇṭā and elsewhere in India this abstract shading has a much softer *sfumato* effect than in the provincial Indian painting at Bāmiyān, where the technique is in process of becoming a convention.[16]

Here is 'an art that reveals life . . . as an intri-cate ritual fitted to the consummation of every perfect experience'.[17] In a marvellous reconcili-ation of beauty, physical and spiritual, the Great Bodhisattva is realized as the very embodiment of that compassion and tenderness that his mission of allaying the miseries of the world

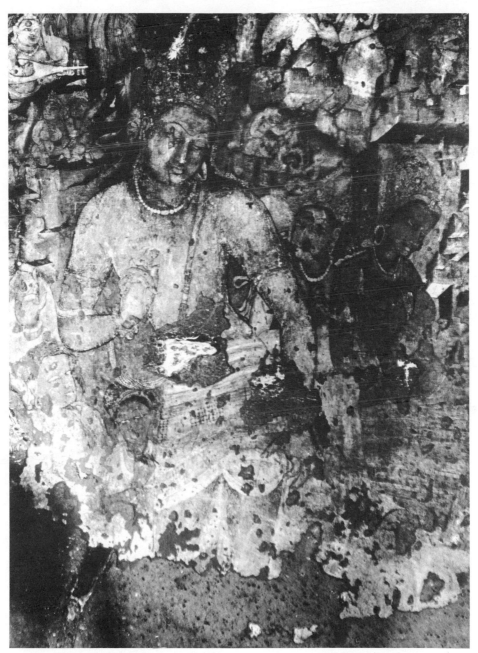

183. Ajaṇṭā, Cave I, wall-painting of Great Bodhisattva

implies. The flawless opalescent smoothness of the skin, like the generalized modelling of Gupta statues, the eyes half closed in reverie, the physically unreal proportions of the face suggest a beauty beyond reality; this is a loveliness so refined away from transitory human appearance that it becomes a symbol of celestial beauty and purity. The head, almost like a heavy flower on the strong stalk of the neck, bends slightly forward; an Olympian majesty sits on the tensile arc of the brows. The face is veiled in a lyric, pensive abstraction that almost reminds one of the half-sensual, half-spiritual ghostliness that animates the faces of Michelangelo's demi-gods. The figure as a whole in its tranquil suavity and virile sweetness is the perfect realization of this deity of salvation and refuge. The proper expression of the qualities of a Bodhisattva is no happy accident nor solely the result of any aesthetic inspiration; it is the result of the artist's knowledge and possession of the entire body of the painter's tradition – proportion, drawing, technique – together with an understanding of the drama of pose and gesture which, as in the dance, conveys the essential nature of the deity. The figure gives an impression of being arrested in a moment between tranquillity and movement, an impression that

is also given by some of the great bronze statues of the Hindu Renaissance; this suggestion of the potentiality of movement as though the figure were about to 'come to life' is, of course, the express result of the wonderfully rhythmic disposing of pose and gesture.

At the right, among the companions of the Bodhisattva, we recognize a beautifully drawn female figure of dusky complexion who wears a towering head-dress that closely resembles the elaborate mukuṭa, crowning the Bodhisattva himself. This is a representation of the śakti or female of the Bodhisattva, one of the many indications of the intrusions of Hindu concepts into Buddhism. It is only the beginning of a trend that ultimately led to the reabsorption of Buddhism into Hinduism in the Hindu Renaissance. The strangely cubistic rock-forms that loom behind the Bodhisattva and support the shapes of *kinnaras* and peacocks praising his manifestation might be compared to the similarly block-like mountain forms in Early Christian and Byzantine art. Actually it would be absurd to look for any 'influence' in this or other details that bear a resemblance to the forms of Western art; these conventions for rocks are simply an outgrowth of the already conceptual, ideographic treatment of geological formations in

184. Ajaṇṭā, Cave I,
detail of wall-painting of Great Bodhisattva

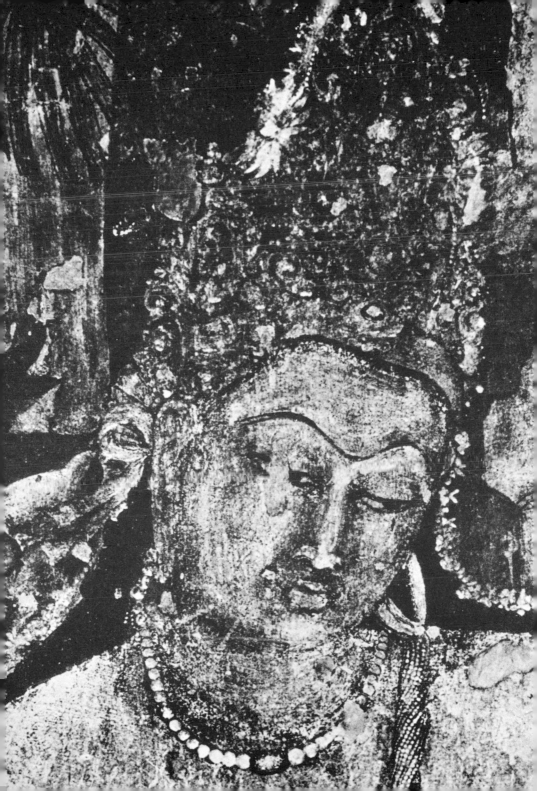

early Indian relief sculpture and in the 'stage sets' that form the backgrounds of the earliest wall-paintings in Cave X at Ajaṇṭā.

The painting of the ceiling of Cave I at Ajaṇṭā is executed in a more flat, properly speaking decorative, style than the work on the walls of the vihāra. The space is divided into a number of contiguous panels square and rectangular in shape, which are filled with subjects and ornamental motifs. A composition, which with slight variation is repeated no less than four times, shows a bearded personage dressed in a peaked cap, mantle, and boots, attended by musicians and cup-bearers [185]. Although at one time this group was identified as a representation of Khusrau II of Iran, who actually sent an embassy to the Deccan, it seems more reasonable, as Coomaraswamy suggests, that it is a representation of Kuvera, the god of riches, whose Dionysian aspect we have already encountered in the sculpture of Mathurā. The extremely restricted palette used here, and the silhouetting of the figures against a light background sprinkled with rosettes, give the panel a very flat, textile-like character. This is even truer of the floral and vegetable forms that fill the panels surrounding this figure composition [185]. These are perfect examples of the Indian artist's ability to abstract the essentials of natural forms and turn them to decorative

185. Ajaṇṭā, Cave I, painting of Kuvera on ceiling

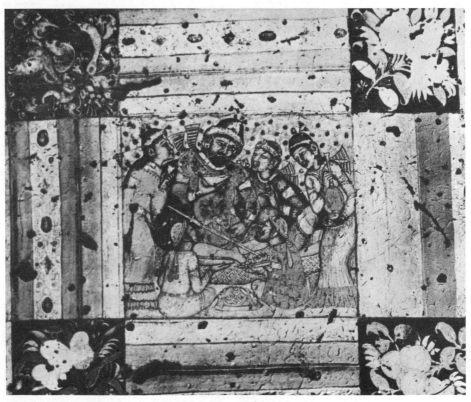

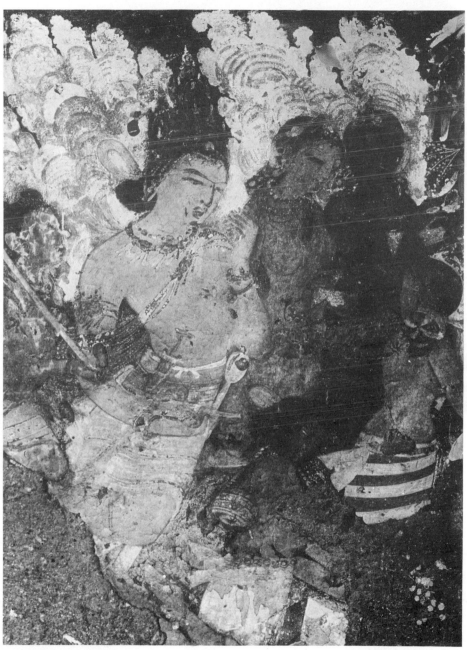

186. Ajaṇṭā, Cave XVII,
wall-painting of Indra in porch

organization without in any way losing the sense of growth and proper articulation of the plant structure.[18]

Scarcely less important, but unfortunately more damaged than the paintings of Cave I, are the fragments of wall decoration surviving in the porch of Cave XVII. This shrine bears an inscription of the last quarter of the fifth century, which may be assumed to correspond with the period of the wall-paintings. One of the subjects on the back wall of the verandah represents Indra and his entourage of celestial musicians flying to greet the Buddha at the time of his visit to the Tushita Heaven [186]. In many ways this beautiful detail bears comparison with the sculpture of flying gandhārvas at Gwalior [180]. The suggestion of endless, effortless flight is imparted by the direction of the bent legs and by the jewels sweeping backward over the breast of the god, who is differentiated from his companions by his light colouring and magnificent crown. In addition to the noble beauty of the god, one should note particularly the wonder-

fully animated figure of a flute-player at the right, half turning to glance at Indra. Behind Indra and his train are towering clouds, conventionalized by striated curving lines of ultramarine blue of varying thickness against a nacreous white background. This detail illustrates with what great breadth and sureness the figures are drawn. Note how the individual features, like the nose and eyes, appear to be defined with a single sweep of the brush, the thickness of the line providing a plastic reinforcement. Although parts of the design may now appear flat, it is apparent that originally there was a suggestion of relief through shading and highlights. In the figure of the dusky apsaras at the right there are traces of the highlights that originally gave saliency to the features, as, for example, the sharp stroke of light pigment on the nose.

Another part of the wall of the court in Cave XVII illustrates a portion of the *Viśvantara Jātaka* [187], in which the chief episode shows the princely hero announcing to his wife the

187. Ajaṇṭā, Cave XVII,
wall-painting of Viśvantara Jātaka in porch

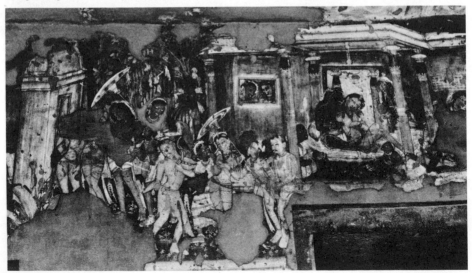

news of his banishment from his father's kingdom. At the right of the composition, in a pavilion with orange walls and red pillars, a swarthy lord clasps his swooning consort; her drooping pose is accented by the bend of her head, and the relaxation of every limb emphasizes her distress. This detail of the fresco is an illustration of how in Indian painting states of mind or moods are, as in a play, precisely indicated by pose and gesture and glances. This is exactly what is implied in the Six Limbs of Painting mentioned above and in all later treatises on the art of painting. The anxiety of the princess is revealed by the way in which she clings to her lord for support; the prince's solicitude, by his offering of the cup of wine. The atmosphere of concern is further heightened by the figure of the dwarf glancing upward at the couch and the maid servant with the carafe who hovers behind the couple. It will be noted how the directions of the glances of the principal actors are fixed on the figure of the hapless prince. He and the princess appear again with umbrella-bearing attendants in the part to the left of this detail, where one should also notice the wonderfully characterized figure of a beggar with bowl and crooked staff. Behind this group is a boldly patterned background of exotic foliage, in the rich variety of its greens suggesting European tapestry design.

The effect of the whole composition in its employment of dramatic and emotional gestures, the device of continuous narration, and the feeling of stirring movement that leads across the shallow stage and animates the individual figures, is like a translation of the technique of the Amarāvatī reliefs into terms of painting. It should be noted further in connexion with this wall-painting that the representation of the palace with its heavy cornice supported by slender colonnettes is probably a reasonable approximation of the domestic architecture of the period.

Among the most important surviving examples of Gupta wall-painting are the damaged fragments of decoration in the verandah of Cave IV at Bāgh. In so far as one can tell from their present condition, the style is identical with the work at Ajaṇṭā. Represented are an elephant procession and what appears to be a dancing scene with beautifully rhythmic figures of young girls moving in a circle around a personage in Kushan or Iranian dress.

Hindu wall-paintings with a date corresponding to 578 decorate the porch of Cave III at Bādāmī. The style is closely related to the later Ajaṇṭā paintings and to a cycle of Jain wall-paintings at Sittanavāsal.[19]

In its relation to the Buddhist art of all of south-eastern and eastern Asia, the importance of the Gupta Period can scarcely be overestimated. In the iconography and style of painting and sculpture we find the establishment of a norm that lent itself to adaptation in the hands of all the peoples who followed the Buddhist religion. The paintings and sculptures of Gupta India are more than prototypes for the religious art of Asia; they occupy a position corresponding to that of Greek and Roman art in the West. The perfection and balance achieved in India of the fourth and fifth centuries recommended themselves as the final solution of problems of form and content in religious art that could not be improved on, just as the perfection and authority of Classic art persisted as a norm in the European tradition. Wherever it was introduced, Gupta art provided a firm basis for the evolution of original artistic expression. Exact imitation of Gupta models of the school of Sārnāth marked the beginnings of Buddhist art in the jungles of Siam and Cambodia, but the quick realization and assimilation by native sculptors of the essential plastic qualities of the Indian originals produced some of the greatest works of sculpture in Further India. The wonderful conjunction of serenity of expression and plastic majesty survives in Singhalese art to the end of the Buddhist tradition. Javanese

Mahāyāna sculpture, as exemplified by the carvings of the Great Stupa at Barabuḍur, marks a final crystallization of the Gupta ideal. The impact of Indian art on Central Asia has already been examined; it was through the intermediary Buddhist kingdoms of Turkestan, as well as through the importation of actual models by Chinese pilgrims, that the Gupta style was introduced to China and Japan of the sixth and seventh centuries.

<center>*</center>

Among the few surviving examples of early Buddhist ivories is a Trinity in high relief representing a Buddha with attendant Bodhisattvas [188]. Whatever its date, perhaps as late as the seventh century, the central figure is like a miniature reduction of a typical Mathurā image of the Gupta Period with the folds of the

garment represented in a succession of sharp ridges [167]. The fragmentary attendant figures of Bodhisattvas or Tārās appear to anticipate the style of Nepalese sculpture of the seventh century and later [202]. This object and related pieces have sometimes been attributed to Kashmir, but in the absence of any definitive evidence it is perhaps better to regard them as of Indian origin.[20]

The making of jewellery, like other forms of metalwork, goes back to remote antiquity. Poetically, many types of personal ornaments derive their names from flowers, of which these necklaces and pendants are the precious counterparts, not imitations, in gold and gems and enamel. The names for necklaces (garlands of enchantment) and earrings (ear-flowers) are mentioned in Panini's grammar of the fourth century B.C. Other ancient texts, like the

188. Ivory Buddhist Trinity.
Boston, Museum of Fine Arts

189. Ajaṇṭā, Cave XVII, apsaras

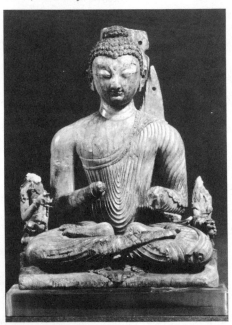

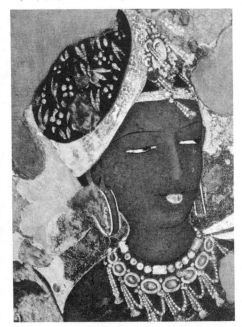

Dhammapada and the *Pattinapalai*, are filled with the most extravagant and loving descriptions of the ornaments which have always been the special delight of Indian women. How in early periods these adornments were consciously used to enhance the physical charms of the wearer is revealed in the sculptural representations of yakshīs and courtesans from Śunga to Kushan times [29, 44, 45, 100, and 101].

The beautiful flying apsaras of Cave XVII at Ajaṇṭā [189] is a splendid illustration of the wealth of jewellery worn by princesses of the Gupta Period. Her throat is circled by a necklace of large pearls separated by square-cut sapphires. Below this she wears a strand of sapphires, perhaps set in diamonds. Suspended from this chain are looped pendants of seed pearls. These jewels swing with the apsaras' flying movement, and so do the pearl bangles of her toque, which appears to be richly embroidered with foliate motifs. This one picture evokes this delight of Indian women in jewels and the pleasure and power these gems bestowed on their wearers. One has only to think in this connexion of the splendid and fabulous wealth described by writers who visited the courts of Vijayanagar and the Mogul emperors in later centuries.

The manufacture of textiles in India goes back to the Indus Valley Period, as indicated by the finding of fragments of cotton at Mohenjodaro. Our knowledge of this craft in the early periods, however, is limited almost entirely to literary references and the representation of garments in early painting and sculpture.[21] Although in many examples of sculpture of the Early Classic and Kushan Periods the figures of yakshas and yakshīs are shown wearing embroideries and transparent muslin [29, 100, and 101], it is not until the Gupta Period in the portrayals of textiles in the paintings of Ajaṇṭā that we find recognizable representations of the many types of cloth for which India is famous. In the Ajaṇṭā murals we can find representa-

tions of embroideries, *bandhāna* or tie-and-dye work, brocade, and muslin weaving. Indian muslins were renowned in Rome as early as the first century A.D. In the sculpture of the Kushan Period this diaphanous clinging material was represented, appropriately enough, only by indicating the hem of the garment [100]. At Ajaṇṭā the Bodhisattva of Cave I [183] wears a muslin dhoti of a striped pattern with floral motifs in the darker bands of colouring. The same type of cloth may be seen in the dress of Indra and his attendants of Cave XVII [186]. Floral scrolls or bands of geese are also known in the repertory of woven motifs in the Ajaṇṭā wall-paintings.

A rare example of Gupta metalwork is an object that has been identified as an architect's plummet [190]. This object, made of iron coated with bronze, was found in the Surma River in

190. Architect's plummet
from the Surma River, Bengal.
London, British Museum

Bengal and may be dated to the sixth century
A.D. On the neck of this object is a plaque with a
representation of a group of dancing figures
reminiscent of the bacchanalian reliefs of the
Kushan Period at Mathurā. The weight is
framed in prongs terminating in lotus buds
which recall the pliant, decorative plant forms
of ornamental Gupta sculpture in stone.

Among the most splendid examples of the
minor arts in the Gupta Period are the gold
coins of the reigning dynasty. Especially
notable is a coin of Chandragupta II, showing
the king slaying a lion [191]. The lithe, surging
figure of the royal lion-slayer echoes the tense
curve of his bow, and the whole design appears
as a miniature reflection of such Gupta carvings
as the reliefs of Gwalior and Aihole [158 and
180]. This medal and another gold piece of

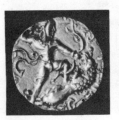 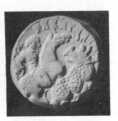

191 (*far left*). Coin of Chandragupta II
from the Bayhana hoard.
Muttra, Archaeological Museum

192. Coin of Kumaragupta I from the Bayhana hoard.
New Delhi, National Museum

Kumaragupta I from the famous Bayhana
hoard, showing a king attacking a rhinoceros
[192], are like distant echoes of the scenes of the
hunt on Sasanian plates and, like them, are
intended as symbolic references to the valour
and invincible prowess of the sovereign.[22]

LATE BUDDHIST ART IN INDIA, NEPAL, AND TIBET

1. LATE BUDDHIST ART IN BENGAL: THE PĀLA-SENA PERIOD

By the seventh century A.D., as we have already learned in earlier chapters, Buddhism had largely disappeared from northern India, following the invasion of the White Huns. In the south the rise of Hinduism had gradually supplanted the religion of Śākyamuni. Only in Bengal does Buddhism survive as an important force until the final annihilation of its establishments by the Mohammedan invasions of the twelfth century. This final chapter of Buddhist history in India is at once a prolongation and a degeneration of the Gupta tradition. Buddhist art in this last phase of its development in India was produced under the patronage of the Pāla and Sena Dynasties (730-1197) that were the heirs of Harsha's Empire in the Ganges Valley.[1]

The Buddhism of the Pāla Period represents that outgrowth of Mahāyāna described as Tantrism, a syncretic assimilation into Buddhism of many elements of Hindu origin, such as the concept of the śakti or female energy of the Bodhisattva and the reliance on magic spells and ritual. The worship of the mystical Dhyāni Buddhas of the Four Directions and the creator, Ādi-Buddha, a kind of Buddhist Brahma, completely replaces any devotion to the person of the mortal Buddha. It is this phase of Buddhism, usually described as the Vajrayāna, that, together with the paraphernalia of its art, finds its way to Tibet and Nepal in the eighth and ninth centuries. Progressively until its extinction in the twelfth century, Buddhism takes on the aspects of Saivism and Vaishnavism. The principal site of this last centre of Indian

Buddhism and its art was the great university city of Nālandā.

Among the inscriptions found at Nālandā is one recording a dedication by a certain Baladeva, ruler of Sumatra and Java, in 860, a clear indication of the intimate relations existing between this last stronghold of Indian Buddhism and the Śailendra Empire in Indonesia. The description of the monasteries of Nālandā by Hsüan-tsang, who saw them at the height of their splendour in the seventh century, is worth quoting *in extenso*:

The whole establishment is surrounded by a brick wall, which encloses the entire convent from without. One gate opens into the great college, from which are separated eight other halls, standing in the middle of the Sangharama. The richly adorned towers, and the fairy-like turrets, like pointed hill-tops, are congregated together. The observatories seem to be lost in the vapours of the morning, and the upper rooms tower above the clouds. ... All the outside courts, in which are the priests' chambers, are of four stages. The stages have dragon-projections and coloured eaves, the pearl-red pillars, carved and ornamented, the richly adorned balustrades, and the roofs covered with tiles that reflect the light in a thousand shades, these things add to the beauty of the scene.[2]

The actual monasteries or vihāras excavated at Nālandā are ranged one next to another like so many adjacent colleges in a university complex. The plan of the individual vihāras is nearly identical in the structures excavated, and consists of many small cells grouped around the four sides of an open courtyard, an arrangement already found in earlier examples of the type. In another place Hsüan-tsang observed: 'To the north ... is a great vihāra, in height about three

hundred feet. . . . With respect to its magnificence, its dimensions, and the statue of Buddha placed in it, it resembles the great vihāra built under the Bodhi tree.'[3]

The actual excavations at Nālandā have revealed little of the magnificence described by Hsüan-tsang. Certain buildings are sufficiently preserved to give an idea of the architectural character of this last stronghold of Indian Buddhism. A stupa that was disengaged from the masonry of a larger structure built around it at a later period reveals a style that is a continuation of Gupta architectural forms [193]. The building rests on a podium. The elevation of the base consists of two storeys, the first filled with Buddhas and Bodhisattvas in niches separated by columns derived from the Gupta order; the second zone is decorated with chaitya arches framing smaller images. Above this is an attic storey separated into two levels by projecting roll cornices. The drum of the stupa is octagonal, with its faces alternately plain and decorated with Buddha statues in niches. The whole is surmounted by a saucer-like dome. The treatment of the façade is not unlike that of the Mahābodhi temple as we see it to-day [194]. As the view of the ground storey reveals, the revetment of the Mahābodhi shrine dating from the

193. Nālandā, stupa at Site No. III

194. Bodh Gayā, Mahābodhi temple, detail

Pāla Period consists mainly of multiple niches separated by square engaged pillars ringed by garland collars and surmounted by lotiform capitals. This arrangement was repeated on every successive level of the shrine proper and the pyramidal tower. Originally these recesses contained Dhyāni Buddha images, probably placed with reference to the Four Directions; at present, the niches are filled with a haphazard collection of sculpture recovered in the course of the nineteenth-century restoration. The wall space, as in the stupa at Nālandā, is repeatedly divided into horizontal zones by projecting string courses; and above the band of niches is a massive frieze of lion heads supporting a continuous ribbon-like garland. If the reader will examine the plate of the temple as a whole [108], he will note that just as on the śikharas of the late Gupta temples at Aihole, the storeys of the tower are marked by lotiform quoins at the corners of each level, and the finial of the spire comprises a complete āmalaka that is repeated at the lower stages. The style of the figure sculpture in stucco at Nālandā is a dry repetition of the Gupta statuary of Sārnāth, as may be seen by comparing the statue in the topmost niche with the famous preaching Buddha [172]. Since these statues are so much in the style of early Mahāyāna imagery before the development of Tantric forms, this structure and its decoration may be dated as early as the seventh century. It seems highly likely that the original form of the great vihāra described by Hsüan-tsang was only a larger version of this same type of monument.

What must have been one of the greatest religious establishments of the Pāla Period is to be seen in the ruins at Paharpur in Bengal [195]. The remains consist of a vast square court nearly a thousand feet on a side, surrounded by an enclosing peristyle consisting of more than one hundred and seventy-five individual cells. In the centre is a shrine in the form of a Maltese cross with a number of recessed projecting corners between the arms. In elevation this sanctuary consisted of a pyramid of three superimposed terraces and at the summit a square cella with projecting porticoes on all four sides. The shrine can be described as a prāsāda or Meru type of temple, in which the diminishing terraces magically symbolize the steps and peak of the world mountain. The decoration consisted of multiple terra-cotta relief plaques attached to the brick façades, as in the Gupta temple at Bhītārgāoñ.

Since there is no mention of this imposing monument by Hsüan-tsang, it has been dated in the late seventh or eighth century. The indications are that it was originally a Brahmanic installation, later taken over by the Buddhists. As may be seen by a glance at the ground plan, the arrangement is unique among Indian temples, although its general disposition is reminiscent of the shrine at Parihāsapura in Kashmir. Actually the closest approximations to the temple at Paharpur, both in plan and in the elevation in successive levels for circumambulation, are to be found in Java in such temples as Loro Jongrang and Candi Sewu at Prambanam and, ultimately, the vast temple-mountain at Barabudur. It furnishes the clearest possible evidence for the close relations between Bengal and Java already suggested by the Nālandā inscription. The common ancestor for all these monuments is the great stupa at Lauriyā Nandangarh in northern Bihar.

Characteristic of the sculpture of the Pāla and Sena Periods are the numerous examples of images carved in hard, black stone found at Nālandā and many other sites in Bengal. All of them are characterized by a great finesse and precision of execution. Many of these icons give the impression of being stone imitations of metal-work, and in almost every case the sense of plastic conception is lost under the intricacy of surface detail.

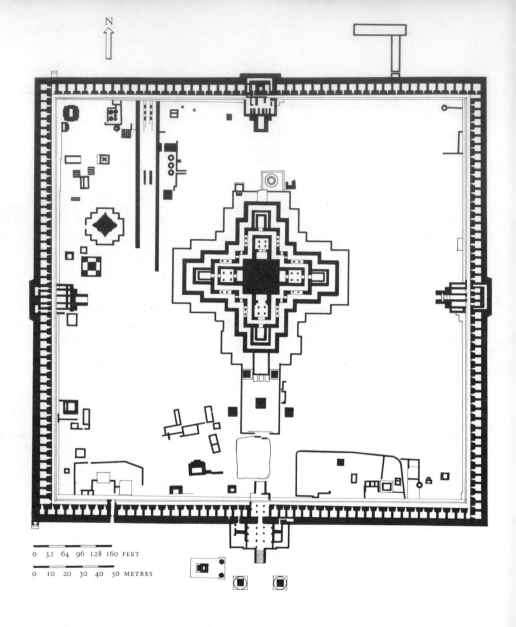

N

0 32 64 96 128 160 FEET

0 10 20 30 40 50 METRES

195. Paharpur, temple

196. Buddha from Bengal.
Boston, Museum of Fine Arts

A typical example is the seated Buddha in the collection of the Museum of Fine Arts, Boston [196]. The Buddha is represented in the yoga pose and earth-touching gesture of the Enlightenment. A feature that might at first strike the observer as a rather strange anachronism is that the Buddha wears the crown and jewels of a royal personage, the very worldly attributes discarded at the time of the renunciation. This can best be explained as part of the process of the Buddha's deification in Mahāyāna Buddhism; the crown and jewels not only proclaim his power as Cakravartin or universal sovereign, but are intended to suggest that state of radiant splendour or transfiguration attained at the supreme moment of Enlightenment. The iconography is the same as in the Buddha from Fondukistan discussed in an earlier chapter.[1] The actual style of the carving is a kind of desiccated perpetuation of the Gupta school of

the fifth and sixth centuries; in it one is much more conscious of the precise and sharp definition of the detail of jewelled ornaments than of the plastic significance of the bodily form that seems to exist as a framework for these attributes.

A very famous example of Indian sculpture, generally accepted as of Gupta date, is more likely an exceptional masterpiece of the Pāla Period; this is the so-called Sānchī torso in the Victoria and Albert Museum in London [197]. From both the stylistic and iconographic points of view it seems to correspond closely to the sculptural technique of Bengal in the centuries of Pāla domination. The fragment serves as an illustration of a technical method practised in all periods of Indian sculpture: the suggestion of the nature of flesh in stone by the contrast between the hard, cold definition of the metal accessories with the rounded smooth planes that

interlock to give the structure of the body; the softness of the flesh is suggested again by the device of the constricting belt raising a welt of flesh below the navel. In addition to the exquisite refinement in the carving of details, the torso has a certain athletic litheness imparted by the breaking of the body on its axis, a pose already familiar to us in many earlier examples. Not only the similarity of the technique to other examples of Pāla sculpture, but the attribute of the antelope skin worn as a scarf across the body point to the Pāla Period, since this emblem was used to identify the esoteric deity Khasarpāṇa Avalokiteśvara, whose worship, related to Saivite concepts, does not begin before the rise of Tantric Buddhism. The Sānchī torso, probably datable between the seventh and ninth centuries, is a masterpiece of its kind, in which emphasis on technical finish and virtuosity of carving and plastic modelling are maintained in perfect equilibrium; whereas in the vast majority of Pāla sculptures the elaboration of surface detail militates against the properly sculptural conception of the whole.

197. Torso of a Bodhisattva from Sānchī. *London, Victoria and Albert Museum*

Of greater aesthetic as well as iconographical interest than the stone sculpture of Bengal in the last centuries of Buddhist power are the large numbers of bronze images found at Nālandā and elsewhere [198]. Like the stone images, they reveal a development reflecting changes in the character of Buddhism from Mahāyāna types to purely Tantric forms of Saivite and Vaishnavite derivation. Many of these images were exported for dedication all over south-eastern Asia in the centuries when Nālandā was in close touch with the Śrīvijaya and Śailendra Dynasties in Malaya and Java. Indeed, at one time it was uncertain whether these metal statuettes were made in India or in Java, so exact was the correspondence and so large the numbers of examples found in the two regions.[5]

Some examples of Nālandā bronze images appear to be close imitations of earlier types of the Gandhāra and Gupta Periods, and it may well be that some of these were specifically intended as more or less faithful replicas of famous images venerated at the holy sites of Buddhism. The vast majority of them, like their stone counterparts, perpetuate the Gupta style of Sārnāth. They are characterized by the same kind of stylized elegance and fondness for precise definition of detail that characterize the stone figures. This finicky and often 'rococo' manner is, of course, more suited to malleable metal than stone. It is on the basis of the Pāla style of metal imagery that the whole of later Nepalese and Tibetan sculpture is founded; and there are indications that this manner was also translated to Kashmir.

2. NEPAL

As has already been noted, the last phase of Buddhist art in India has enjoyed a prolongation of nearly a thousand years in the Himalayan regions of Nepal and Tibet. For this reason it seems logical to deal with this aspect of pro-

198. Bronze Buddha in abhāya mudrā from Nālandā.
Nālandā, Museum

vincial Indian Buddhist art before proceeding to the account of the last stages of development of Hindu art in India.

The beginnings of art as well as history in Nepal are so obscured in legend that nothing can be said with any certainty of early civilization in the so-called Valley of Nepal, that beautiful little tract of ground, surrounded by the peaks of the Himalayas, which has supported an extremely interesting culture for more than two thousand years. The original settlers of Nepal were presumably immigrants from Tibet who became the ancestors of the ruling Niwar race and contributed a distinctive Tibetan character to the religion, language, temperament, and appearance of the people. Although pious legend records a visit of the Buddha himself to Nepal, it is unlikely that the religion of Śākyamuni was introduced to this Himalayan fastness before the days of the Emperor Aśoka. Persistent tradition ascribes many monuments to the piety of Aśoka, and it is quite possible that some of the surviving stupas were originally dedicated by the great *Dharmarāja*. The entire later history of Nepal has been linked with India, especially after the foundation of a feudal dynasty by the Licchavis from India in the second century A.D. Nepal and Tibet perpetuated the forms and the art of Indian Buddhism after the extinction of the religion in India.

According to tradition, a great many of the surviving stupas in Nepal are relics of the legendary visit of Aśoka, and it is quite possible that the essential structure of some of these goes back to the third century B.C. Traditionally, the oldest stupas in Nepal are the monument at Sambhunath and the Bodhnath shrine in Bhaṭgāon, which very possibly were built around tumuli of Mauryan origin. In its present form the Bodhnath has a typically Nepalese form [199]. On a square platform rises a rather flat, saucer-like tumulus, suggestive of the mounds at Lauṛiyā-Nandangaṛh. This is surmounted by a square, box-like construction,

equivalent to the harmikā of the Indian relic mound. The four sides of this member, at Bodhnath and elsewhere, are decorated with enormous pairs of eyes painted or inlaid in ivory and metal. This is perhaps the most distinctive and striking feature of Nepalese stupa architecture. Now interpreted as representing the all-seeing eyes of the supreme Buddha of the Nepalese pantheon, it is likely that in origin the symbolism referred to the eyes of Prajāpati or Puruṣa, who, as Universal Man and world axis, properly had his eyes at the summit of the sky-dome. Above the harmikā at Bodhnath rises a stepped pyramid in thirteen storeys typifying the thirteen heavens of the devas. This is surmounted in turn by the finial of the mast or *htī*, which in Nepalese stupas was literally a single

199. Bhaṭgāon, Nepal, Bodhnath stupa

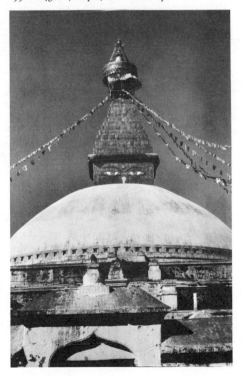

tree rising from the foundations of the stupa and here supporting a final parasol and *kalasa* finial. On the Sambhunath stupa is a range of thirteen parasols representing the heavens of the devas.[6] Around the drum of that monument are relief sculptures representing the mystic Buddhas of the Four Directions and Vairocana, executed in a style ultimately derived from the Pāla school of sculpture in Bengal.[7]

An even more characteristic form of Nepalese architecture is to be seen in the many wooden temples erected in the ancient capitals of the realm. It is quite possible that some of these structures preserve now lost styles of early Indian construction. A typical example is the Bahavānī temple at Bhaṭgāon, which, although in its present form dedicated only in 1703, probably repeats the shape of earlier prototypes. The sanctuary proper is raised on a stone pyramid in five stages, and itself consists of a five-storeyed wooden tower with sloping roofs supported by wooden brackets. One is im-

mediately reminded of the pagodas of China and Japan. The explanation for this resemblance probably lies in the fact that the Nepalese towers and their Far Eastern equivalents have common prototypes in now lost wooden architectural forms in India. We have already seen pyramidal stone roofs of a similar type in Kashmir. The skyscrapers of ancient Nālaṇḍā, as described by Hsüan-tsang, or even the famous wooden pagoda at Peshawar, may well have furnished the inspiration for this and similar Nepalese temples.

The eighteenth-century temple at Pāṭan in our illustration [200] is typical of Nepalese ecclesiastical architecture, not only in its high podium and in the form of the tiers of sloping roofs supported by elaborately carved wooden struts or brackets, but also in the combination of an underlying brick fabric with an overlay of intricately carved woodwork.

Another type of Nepalese building is the Krishna temple which may be seen at the right

200. Pāṭan, Nepal, Buddhist temple

201 (*far right*). Pāṭan, Nepal, Durbar Square

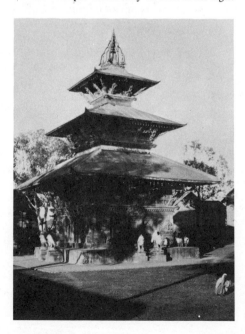

in the illustration of the Durbar Square in Pāṭan [201]. Roughly it is a copy with Nepalese modifications of the Indian śikhara mounted over a single cell and perpetuating many details of the Indian prototype, such as the attached turrets and fluted finial. Nepalese temples were not meant to accommodate a congregation but, like the typical Hindu shrine, were intended only for the housing of images. Also, like its Indian prototype, the temple was itself an object of worship. The present example has no maṇḍapa, but is surrounded on the ground-storey by an arcade with monolithic octagonal columns branching into elaborately carved bracket capitals characteristic of the Nepalese 'order'.

The same illustration also shows another typical Nepalese monument, a memorial column of the eighteenth-century ruler, Bhupatindra, which is a distant descendant from the pillars of Aśoka. The kneeling bronze image of the king overlooks the Durbar Hall – like a Hima-layan Farnese Palace – with its heavy cornice overhanging the severe façade. This building is characteristic of Nepalese secular architecture in the brick masonry used in combination with windows of elaborately carved wooden frames and screens with tooled metal sills.

Among the earliest examples of Nepalese sculpture are a number of bronze statuettes in the collection of the Boston Museum of Fine Arts [202]. These figures very clearly reveal the derivation of Nepalese sculpture from late Gupta or Pāla models. The Padmapāṇi in the Boston collection has the svelte elegance of the carved Bodhisattvas of the Pāla Period. The belt and armlets of this and other early Nepalese figurines were originally studded with turquoises. Another interesting characteristic is the persistent archaism of the swallow-tail convention of the drapery scarves, a mannerism ultimately derived from the Gandhāra Bodhisattvas, which, as we have seen, also enjoyed a great longevity in Central Asia and found its

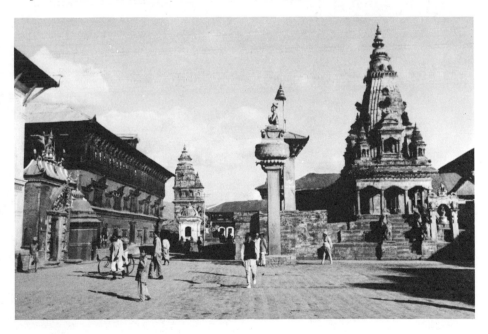

way at last into the earliest Buddhist sculpture of China at Yün Kang and Lung Mên.

Of definitely Indian inspiration, too, are the scanty fragments of early Nepalese painting. A

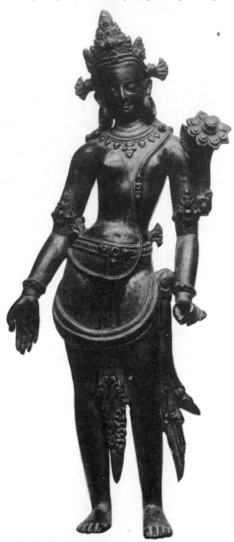

202. Bronze Padmapāṇi from Nepal.
Boston, Museum of Fine Arts

manuscript, also in the collection of the Boston Museum [203], dated 1136, reveals a hieratic linear style which, in the character of the figure drawing and ornamental frame, is extremely close to the surviving examples of Pāla painting. The manuscript is in the form of a palm leaf prayer book enclosed in painted wooden covers and contains invocations of the divinities in the Tantric pantheon with illustrations of the principal beings in the hierarchy. The miniature illustrated is of Tārā, offspring of the tears Avalokiteśvara shed for the miseries of the world. It is completely characteristic of the style of later Buddhist painting. Although the figure preserves something of the sensuous elegance of the Ajaṇṭā manner, the entire conception has become flat and decorative, with the figure of the divinity of no more importance than the ornamental accessories. The conception is entirely linear with an employment of flat, jewel-like colours – a close imitation of the surviving fragments of manuscripts from the Pāla school in Bengal.[8]

3 . TIBET

The art of Tibet is in certain respects only another example of the prolongation of the religious art of Bengal under the Pāla and Sena Dynasties. The social and historical factors that influenced Tibetan art may be summarized briefly. Before the introduction of Buddhism the Tibetans were followers of Bonpo, an animistic religion including many elements of sorcery and sexual mysticism. Perhaps the most important single historical happening in Tibet was the marriage in A.D. 630 of the first king to a Nepalese princess and the alliance that the same sovereign formed shortly afterwards with the daughter of the Chinese Emperor T'ai Tsung. These unions in a sense are a symbol of the whole Tibetan civilization which forever afterwards has been composed of elements drawn

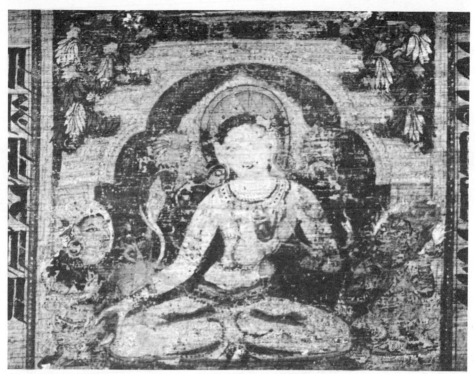

203. Tārā from Nepalese manuscript dated A.D. 1136.
Boston, Museum of Fine Arts

from India and China. The country had already been converted to Buddhism by the Nepalese queen in the seventh century, but the real foundation of the religion dates from the missionary activity of the priest, Padmasaṁbhava, who came to Tibet from Kafiristan in the eighth century. He is remembered for his introduction of Tantric Buddhism that appealed particularly to the Tibetan tendencies to sorcery and mysticism, based on terror and sexualism. The final form of Tibetan Buddhism was established by the holy man, Atīśa, as a mixture of Buddhist magic and animism. Beginning as early as the ninth century, when Tibetan conquests included Tun-huang in north-western

China, the destinies of Tibetan art had been largely determined by contacts with the Far East. In the period following the invasion of the Mongols, Tibetan Buddhism was officially accepted in China. A sculptor named A-ni-ko is reputed to have worked for Kublai Khan.

There is not much to be said on the subject of Tibetan architecture from the Indian point of view, beyond the rather interesting fact that various types of Tibetan stupas dedicated to great events from the Buddha's life, such as his Nativity and Nirvāṇa, are perhaps originally derived from famous prototypes in India. The most usual form of Tibetan stupa or *chorten* has a bulbous dome set on one or more square bases

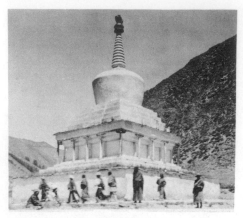

204. Chorten in Western Tibet

and, like the Nepalese type, is surmounted by a square harmikā, and a mast upholding a tier of 'telescoped' umbrellas surmounted by a flame finial [204]. A large monument at Gyan-tse [205] shows a rather unusual plan and elevation: it is erected in five stepped terraces on a polygonal plan with multiple recessions or step-backs;[9] on

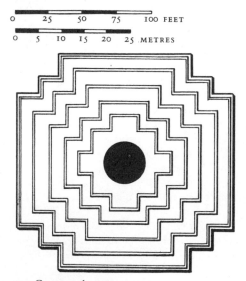

205. Gyan-tse, chorten

this pyramid or prāsāda was built the actual stupa dome; circumambulation was possible at each successive level.[10] The interest in this monument from our point of view lies in its resemblance to the great Mahāyāna sanctuary of Barabuḍur in Java. Both may derive from a common Pāla prototype. A more original form of Tibetan architecture is represented by the fortress-style of monasteries and palaces, perhaps ultimately derived from ancient Near-Eastern prototypes. These skyscraper structures, like the Potala at Lhasa, are built of stone and sun-dried bricks with the white-washed walls thicker at the bottom so that their sloping lines echo the contours of the surrounding mountain peaks. Doors and windows repeat this rhythm in becoming narrower at the top.

Our main interest in the art of Tibet lies in the perpetuation of the forms and iconography of the last phase of Buddhist art in India. The almost unbelievably conservative nature of Tibetan art enables us to discern these survivals even in modern examples of Tibetan art, made either at Lhasa or in the Lama temple at Peking. In Tibetan sculpture we can find the perpetuation of the form and iconography of Indian images of the early periods. Any number of gilt bronze images dating from the sixteenth to the twentieth century faithfully reproduce the drapery formula of the late Buddhist statues of Gandhāra, in which the folds are reduced to a network of strings affixed to the surface of the body. The actual proportions, facial types, and ornaments of these and other Tibetan images are invariably reminiscent of the sculpture of Bengal from the seventh to the twelfth centuries.

The earliest known examples of Tibetan painting are a number of fragments discovered at Tun-huang that presumably date from the period of Tibetan occupation of this site in the tenth century. We may choose as a typical illustration the banner of Avalokiteśvara, surrounded by forms of the goddess Tārā and scenes from the litany of the Bodhisattva of

206. Banner of Avalokiteśvara from Tun-huang.
London, British Museum

207. Banner of the White Tārā from Tibet.
Cambridge, Mass., B. Rowland

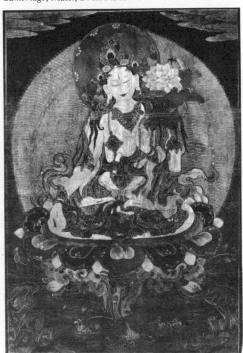

Compassion [206]. The central figure of Avalo-kiteśvara is immediately reminiscent of the types of Bodhisattvas found in the fragments of Pāla manuscripts from Bengal and Nepal, as may be seen in the sensuous elegance of the proportions and the dry, linear definition of form. The surrounding little scenes illustrating the perils from which this Bodhisattva delivers the devotee are entirely Chinese in costumes, setting, and execution.

A comparison of this painting with a banner of the goddess Tārā in the author's collection [207], dating presumably from the late eighteenth or early nineteenth century, reveals how little change has taken place in nearly a thousand years. The resemblance is almost unbelievable between the two figures, in pose and attributes as well as drawing. Both are of course ultimate derivations from the late Buddhist school of

Bengal, as seen also in the Nepalese manuscript in the Boston Museum [203]. In the illumi-nation of Tārā only the painting of such accessories as the clouds, flowers, and the waves beneath Tārā's lotus throne reveal an assimi-lation of Chinese decorative forms. It is this admixture of Chinese motifs that more than anything else distinguishes the late *tankas* from their age-old prototypes.

The principal subjects of the votive banners are scenes from the life of Buddha, the Dhyāni Buddhas, Bodhisattvas, Tārās, etc., local saints and heroes, and Bonpo themes.[11] As has often been said, there is no variety, even stylistic, in Tibetan painting beyond that which comes from the multiplicity of subjects and the rich-ness of the Buddhist pantheon. Indeed, Tibetan art furnishes us with the supreme example of how all creative effort without any freedom or

real vitality is reduced to a merely mechanical process by the rigid control imposed by an un-changing traditional society; it reduces the ideal of traditional art, as defined in the quotation from Marco Pallis in our Introduction, to a meaningless and repetitious formula.[12]

*

What may be an example of ivory-carving of the Pāla Period is a small plaque representing the Buddha attended by Brahma and Indra, a composition illustrating the descent from the Tushita Heaven [208], and occasionally illu-strated in steles of the Gupta Period.[13] Both the shape of the Buddha's halo and the completely linear definition of the drapery recall the bronzes of Nālaṇḍā [198], and the face of the umbrella-bearing Indra at the right is typical

of the new canon of Pāla Buddhist art [196]. This heart-shaped face and the sinuous delicacy of this figure anticipate the art of Nepal [202].

The decorative arts in Nepal and Tibet may be represented almost entirely by objects of liturgical use. None are presumably earlier than the eighteenth century; many, however, are undoubtedly derived from earlier Indian shapes, but, as in painting and sculpture, Chinese influ-ence has dominated Tibetan art for the last three centuries. A remarkable and unique object is a silver dharmacakra, originally the emblem of a local king dispossessed by the Gurkha invasion of the eighteenth century [209]. The shape has unmistakable reminiscences of earlier Indian emblems of this type, and the ancient association of this symbol with the Cakravartin explains its survival as the palladium of

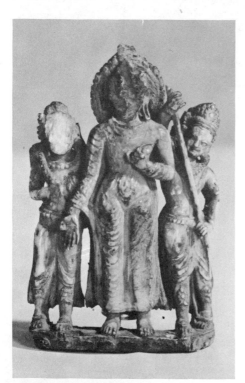

208. Ivory Buddhist Trinity from Tibet.
New York, private collection

209. Silver dharmacakra from Tibet.
Newark, New Jersey Museum

royalty.[14] The *phurbus* or magic daggers were used by Tibetan sorcerers to stab the evil spirits of the air [210]. The raging masks of Hayāgriva on the hilt recall the demoniacal types of Indian sculpture of the Pāla Period of the age of the Hindu Dynasties.[15] Surviving Tibetan textiles, such as the *ketas* or scarves often used as coverings for tankas, are either of Chinese weave or made in imitation of Chinese designs. Among the occasional examples of ivory carving from Tibet is a beautiful plaque in the Victoria and Albert Museum, with representations of scenes from the life of Buddha [211]. Both the style of the individual figures and the iconography of the episodes from the sacred story are, like so much of the art of the trans-Himalayan kingdom, derived from the Pāla sculpture of Bengal.[16]

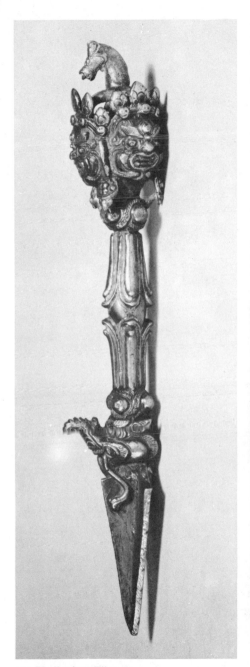

210. Phurbu from Tibet.
London, British Museum

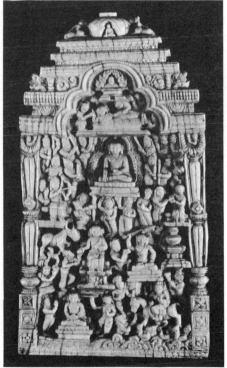

211. Ivory plaque with scenes
from the life of Buddha from Tibet.
London, Victoria and Albert Museum

THE HINDU RENAISSANCE

THE PERIOD OF THE HINDU DYNASTIES

1. INTRODUCTION

The term 'Medieval', which is universally employed in all books on Indian art to designate the historical periods of art after the fall of the Gupta Empire, is an extremely unfortunate one: first, because it invites comparison with the Medieval Period in the West, and secondly, because the word, in its European usages a synonym for the Middle Ages, implies an interregnum – between two moments of supreme cultural achievement, the Classical and the Renaissance. The art described by 'Medieval' in India has nothing to do with the European Middle Ages except perhaps in a parallel iconographic sense, and it can in no way be regarded as an interlude or interruption. It is rather the final and inevitable development out of the maturity of Gupta art. Actually, for those who like to apply the names of European periods to the East, the word 'Baroque' both as a description and a parallel is much more appropriate for the character of this final phase of Indian culture from the point of view of its tremendous power and dynamic richness of expression. What above all determines the character of Indian art for the last fifteen hundred years is the revived power of the Hindu religion, which, as has been noted above, entirely ousted Buddhism as a universal Indian faith. For our purpose, therefore, it is proposed to use the title 'Period

of the Hindu Dynasties' to describe this final phase of art in India.

The amount of material for study is so enormous that some arbitary division in the analysis is imperative. The greater portion of the chapter will deal with the most important works of Hindu architecture, sculpture, and painting. In so far as is possible, the treatment will be chronological, with sub-divisions by styles, dynasties, and geographical location. Even more than in the Gupta Period no strict separation of architecture and sculpture is possible, so that only the final developments in painting, culminating in the Rajput style, will receive a separate treatment. Only a relatively small portion of the material from the late periods of Indian art can be treated in our chapter, and only the most significant examples in every medium can be discussed. The selection of those to be analysed has been based on their intrinsic importance for Indian art and for later developments in Further India. In some cases the choice has had to be limited by the photographs of monuments actually available to the author.

2. LATE HINDU ART AND ARCHITECTURE

As we have already seen in our consideration of the architecture of the Gupta Period, the temple form was actively in process of evolution. This was only the beginning of the final establishment

of types of buildings that persist for all the later tradition of religious architecture in India.

Besides the evidence of the monuments themselves, our chief sources for the understanding of later Hindu architecture are the various builders' manuals or śāstras. These are late compilations of far earlier oral tradition, because the śilpins or initiated craftsmen for many centuries handed down their lore entirely by word of mouth in the instruction of apprentices in the guild. In some cases the śāstras contain only such dimensions and rituals as were likely to be forgotten, since the essentials were the common heritage and knowledge of the class of architects. Among the śāstras existing in English translation is the *Mānasara*, a compendium of sculpture and architecture for the śilpins who are designated as the descendants of Viśvakarman, god of craftsmen.[1] An Orissan document is the *Bhuvanipradīpa*, a text devoted entirely to the methods for constructing religious edifices.[2] Many of the observations in this book, which is ascribed to Viśvakarman himself, hold good not only for Orissan buildings but for Hindu architecture in general. These works, and the many documents cited by Stella Kramrisch in her monumental work on the Hindu temple,[3] deal with such matters as the types of structures suitable for various deities or secular use, the selection of an auspicious site, the laying out of the plan with proper magical rites, and the most specific instructions for every last detail of the shrine's elevation.

Throughout the entire consideration of this last phase of building activity, it must be remembered that every work of Indian architecture, Hindu, Buddhist, or Jain, must first and foremost be regarded from its metaphysical aspect, that is, as a kind of magic replica of some unseen region or sacred being; and that it was precisely this metaphysical factor that determined the plan and elevation, rather than any aesthetic or functional consideration. The temple or *vimāna*

is at once the house and body of the deity, its fabric the very substance of the divinity.

The plan is prescribed by the most elaborate geomantic rites designed to ensure the security of the shrine on the earth upon which it is built and to make it in every way the proper microcosm which its plan and shape are intended to reproduce. The plan is laid out in a square, the perfect magic diagram repeating the imagined shape of the world. This square or maṇḍala is divided into a number of smaller squares dedicated to the gods concentrated around the central Brahma, and with specific reference to the influence and positions of the earth and the heavenly bodies in the eight directions of space.

This whole aspect of Indian architecture, so vast and so complicated in origin and history, can never be disregarded in a consideration of its essential nature, since it transcends and determines what we call style. The only possible comparison in the West for building entirely for metaphysical rather than physical needs is the Christian architecture of the Middle Ages, in which we know that a similar concern for reproducing the image of the world or of God in architecture prevailed, combined with a regard for the magic of numbers and proportions, to ensure the harmony of the structure with the cosmos that it reproduced. In such an architecture as that of India an emphasis on the vertical is not determined by any aesthetic or structural necessities as in the skyscraper, but because this vertical, the śikhara or spire, is literally meant to point to God, to be the very embodiment of that magic axis that pillars apart heaven and earth and is variously symbolized by the mountain, the tree, or the Universal Man, Puruṣa.

Every slightest measurement in the temple is determined by the most specific laws of proportion, in a manner comparable to the employment of the Golden Mean, since the dimensions of the building were designed not only for security and appropriateness, but to put the struc-

ture in harmony with the mystical numerical basis of the universe and time itself. The measurements of the temple plan, precisely drawn with a gnomon in the form of a maṇḍala appropriate to it after the auspiciousness of the site had been determined, were co-ordinated with the measurements of the elevation. Putting it as simply as possible, we can say that the architectural modulus was generally the outer width of the wall of the shrine enclosing the garbha griha; this shrine is always in the form of a cube, so that the height is the same as the width; the śikhara is made to measure twice the height or width of the temple.[4] In the same way the curve of the śikhara was not left to chance but was determined by a system of geometric progression taking into account the intended height and width of the base of the tower. In parts of India the same effect is achieved by making the width of the shoulder of the tower three-quarters the measurement of the base and the total height twice the width.[5] Ritual and dedication extended to the selection and laying of every piece of material of which the temple was built, since this fabric itself was the mystic equivalent of the body of Puruṣa. Various types of stone or wood came to be regarded as especially appropriate for the shrines dedicated to the multiple gods of the Hindu pantheon. The word śikhara means 'mountain peak'. It is implicit in temples designated by names like Meru and Kailāsa that the building is specially intended as an architectural facsimile of the world mountain or the sacred peak of Śiva, so that the worshipper might, by thus having the mountain literally brought to him, receive the beatification and merit that would be his through an actual visit to these abodes of the gods. The temple is in more ways than one to be thought of as heaven on earth.[6]

Unlike the Christian cathedral or the Buddhist chaitya, the Hindu temple was never designed for congregational worship. Like the Greek temple, it was itself a concrete object of devotion, the dwelling-place of the gods on earth. From what has been said above, it is not surprising that all through Indian history magical properties were attributed to the builder's art. Many temples are traditionally ascribed to semi-divine beings or to the design of the architect of the gods, Viśvakarman.

In the history of Indian architecture the life of the craftsman has always been within a guild, the maintenance of which was often upon a hereditary basis, with whole families and generations of one family dedicated to the profession. As in the guild system of medieval Europe, learning was entirely by practice and reiteration. The metaphysical laws governing site and structure were, properly speaking, the first principles to be learned by the builder's apprentice. He had for his guidance those compendiums of canonical recipes, the śastras. They were intended as grammars of the craft and designed to preserve the integrity of the art. These books of architectural techniques, corresponding to the writings of Vitruvius, are known to go back at least as far as the Gupta Period, although very probably they consist of a codified body of material based on immemorial practice. That this seemingly rigid control of an architect's imaginative faculty did not lead to complete uniformity is eloquently shown by the temples themselves. Like all Indian art, they demonstrate what is so often forgotten in modern times, that true originality and creation can flourish under discipline of mind and hand.

The classification of types of temple architecture in the later Hindu Period is an enormously intricate problem that can be only briefly outlined in a work of this kind. The problem is complicated further by the fact that no very strict geographical or stylistic division is possible, so that temples belonging to one traditional type borrow elements from buildings in another category. In the most ancient surviving

sources mentioning temple architecture we find that the sanctuaries are classified as *nagara, drāviḍa,* and *vesara.* Geographically, these types are assigned respectively to northern India from the Himalayas to the Vindhyas, to southern India from the Krishna River to Cape Comorin, and to central India from the Vindhyas to the Krishna River. Although actually the differences in these types extend to the orders and the smallest details of ornament, for purposes of clarity we may differentiate them by their most salient feature; namely, the treatment of the spire or superstructure.

The first type, or nagara, sometimes known as Indo-Aryan, is generally conceded to be not only the earliest but the most important temple form. Its dominant feature is the spire or śikhara, which in many later examples forms the entire roof of the sanctuary proper. It is conical and convex in form and is usually crowned by a vase-shaped member or kalasa.

Whereas the profile of the nagara temple is always convex and curvilinear with an emphasis on the continuous verticality of the spire, the effect of the drāviḍa type of temple is that of a tower ascending in a series of horizontal terraces. In the architecture of Dravidian India the term śikhara is applied only to the topmost major member of the edifice, a round, square, hexagonal, or octagonal dome-shaped feature. This crowning member is repeated on the corners of the successive levels of the structures. In Dravidian architecture the emphasis is both symbolical and structural. It is on the successive terraces or *bhūmis,* each one of which, in a hieratic scale, is assigned to a different divinity.

The third type of temple building, the vesara, is, as we have already seen, largely restricted to western India and the Deccan. This type of building with its barrel roof is obviously derived from the old Buddhist type of chaitya-hall, and, although it survived in comparatively late monuments, never enjoyed the widespread popularity of the nagara and drāviḍa types.

Throughout the later period of Indian architecture it is not possible to make any division of styles on any sectarian basis. Buddhists, Jains, and Hindus all used the same style with slight modifications of structure to meet their ritualistic needs. In the same way Dravidian types of buildings are known in northern India and the Indo-Aryan type is found in the south, so that actually it is better to think of the three types in the same way that we think of the Greek orders, designated by geographical names, without implying any geographical limitation to their usage. In describing later Indian temples there is a certain number of terms that must be used for convenience. The sanctuary as a whole is known as the vimāna; the spire is known as the śikhara; the actual cella for the cult image is the garbha griha. The sanctum proper is preceded by one or more porches or maṇḍapas dedicated to the performance of music and dances in honour of the gods.

Stone continues to be the principal building material throughout the later periods of Indian architecture. Usually the masonry is dry, and iron dowels were employed to hold the blocks together, although there are occasional notices of the use of resinous lacquer and other materials as a cement. Brick, both in combination with stone and separately, is universally employed as a building medium. The use of brick goes back to the making of altars and tombs in Vedic times, so that a certain sanctity became attached to it as a particularly appropriate fabric for the building of sacred edifices. Needless to say, the most complicated rituals were employed in the setting of both stone and brick foundations in conformity with the magic ground-plan or maṇḍala of the shrine. In some cases plaster was used for ornament in addition to carved stone and terracotta, and it should be noted that many of the great shrines, like the Kailāsa at Ellūrā, were originally painted white to stress their symbolic relationship to the sacred snow-capped peaks of the Himalayas.[7]

We have dwelt at such length on the icono-graphical and ritualistic determination of In-dian forms in art so that the reader may be warned that, although, as one would expect in a traditional art, Hindu temples and images ex-plicitly follow the recipes of the śāstras, such a conformity to sacred texts is not in itself the final criterion of the aesthetic worth of the monu-ments, any more than a glassy-eyed and simper-ing saint by Carlo Dolci is a work of art, however exactly it may have met the anti-aesthetic re-quirements of Jesuit propaganda. For the same reason, works of Indian art – especially for the Western student – must be subjected to an analysis from the point of view of their final aesthetic as well as iconographic effectiveness. As we have tried to stress, one of the great values of the seemingly rigid prescriptions of the śāstras was that, in addition to ensuring the magical appropriateness of an icon or a temple, they were certainly intended to maintain a norm of aesthetic and technical probity by the estab-lishment of methods and canons arrived at and found right through generations of experience in workshop tradition.

From the historical point of view the great period of Hindu architecture is that of the var-ious dynasties that succeeded to the Gupta Empire in the seventh century. In western In-dia and the Deccan the Chalukya Dynasty was in power until 750, when it was overthrown by the Rāshṭrakūṭas. In south-eastern India, mean-while, the Pallavas ruled as far south as the Kaveri river. These were Hindu kingdoms, and it was, as we have seen, only in the Ganges Valley that Buddhist art survived under the Pāla and Sena Dynasties.

3. PAṬṬADAKAL:
THE GENESIS OF LATER HINDU STYLES

We have already considered some of the build-ings in the territories of the Chalukyas in the Gupta Period, notably the late cave temples at

Ajaṇṭā and the earlier shrines at Aihole. Another great centre of temple-building was at Paṭṭa-dakal, near Bādāmī and Aihole, where there survive today numerous temples dating from the late seventh and early eighth century.

Paṭṭadakal is an insignificant little village in the sandstone hills near Bādāmī. Above the roofs of the modern mud houses one sees the splendid temple towers of what must once have been a great stronghold of Hindu worship. At this one site we can see standing side by side four or five examples of Indo-Aryan and Dravidian temples.

Of these the most pretentious is the Virūpāk-sha temple, dedicated to Śiva in 740 [212]. It was built by the monarch Vikramāditya II, who died in 746 or 747. It has been surmised that this king was so much impressed with the architec-ture of Kāñcīpuram, which he had conquered, that he persuaded architects and workers from that site to return with him to Paṭṭadakal. An inscription on the Virūpāksha seems to con-firm this, since it speaks of the shrine's having been built by 'the most eminent sūtradhāri of the southern country'.[8] It is of the typically Dravidian type, with a series of terraced roofs above the sanctuary, dominated by the characteristic stūpika of the Dravidian order. The main shrine is preceded by an assembly hall and a small porch; in front is a separate shrine for Śiva's bull Nandi [213]. The horizon-tality of these structures is emphasized by the employment of heavy overhanging cornices, which are evidently an imitation in stone of some earlier thatched construction. The same type of entablature crowns the individual panels with reliefs of Hindu deities that are let into the walls of the temple proper and the Nandi porch. Light is admitted through pierced stone grilles in the walls of the enclosed hall. Each one of the buildings is supported on a high basement or podium ornamented with reliefs of lions and fantastic monsters. The thatch-like entablature decorated with blind chaitya arches is repeated

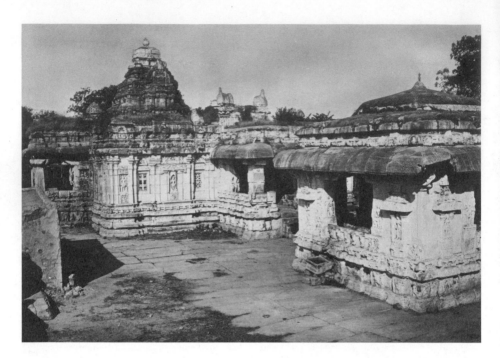

in each of the higher levels of the superstructure of the main temple, so that one gets the impression, as so often in Indian architecture, that the whole is a component of many cell-like organisms infinitely repeated in its structure. This effect is echoed also in the repetition of the shape of the terminal stūpika in smaller replicas at the corners on the successive levels of its terraced spire.

The many Indo-Aryan temples which may still be seen in the nearly deserted temple-city of Paṭṭadakal are all perfect examples of the early development of the northern śikhara. A typical example is the Saivite Galaganātha temple that dates from this same period of building activity in the late seventh century [214]. It is constructed of massive, closely joined blocks of ashlar. The actual form of the spire proper,

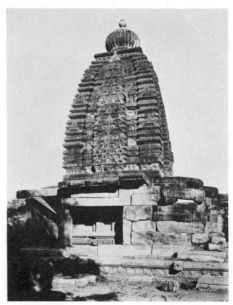

214. Paṭṭadakal, Galaganātha temple

212 (*left*) and 213. Paṭṭadakal, Virūpāksha temple

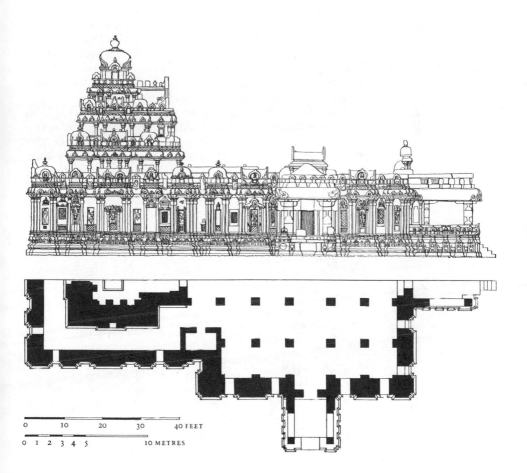

convex and curvilinear in profile, with the angles of alternate storeys marked by the heavily rusticated āmalaka form, is essentially the same as the towers over the sanctuaries of the late Gupta shrines at Aihole. Whereas in buildings like the Durgā temple at Aihole the śikhara was installed as a kind of cupola on the roof of the cella, here, at Paṭṭadakal, the tower has grown to form a complete roof over the sanctuary, so that its four sides rest directly on the four walls of the garbha gṛiha. The shape of the channelled āmalaka quoins was repeated in the bulbous shape of a crowning āmalaka – now lost – so that here again the unified effect of the whole building results from the repetition of the shapes of

215. Paṭṭadakal, Jain temple

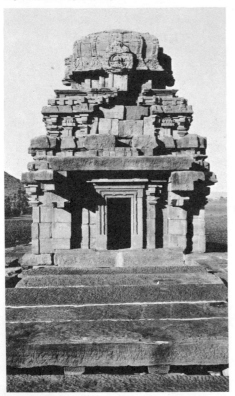

its structure. False doorways containing images, as in the Gupta temple of Deogaṛh, decorate three sides of the tower base; at the fourth is the entrance to the cella preceded by a shallow porch. The employment of the high podium, as well as the profiles of the encircling cornice, are hardly different from the disposition of these members in so-called Dravidian temples, which may be taken as a clear indication that in origin, at least, the Indo-Aryan and Dravidian types of temples were constructed in part from the same repertory of architectural motifs.

The most simple type of Dravidian shrine is represented at Paṭṭadakal by an old Jain temple [215] that stands about a mile to the west of the village.[9] The elevation of the surviving tower sanctuary shows the regular method of stepped diminishing storeys characteristic of the Dravidian order. The whole is crowned by an elaborate stūpika. The general shape and flaring profile of its silhouette are repeated in the profiles of the cornices of the successive terraces.

4. INDO-ARYAN ARCHITECTURE: ORISSĀ

As has already been stated in the introduction to Late Hindu architecture, the term Indo-Aryan or nagara style of architecture is used to designate the temple-building characteristic of northern India in the dynasties that succeeded to the power of the Gupta Empire. This is a type already anticipated in some of the Gupta temples at Aihole and Paṭṭadakal. One of the chief sites where Indo-Aryan temples were built as early as the eighth century A.D. is the holy city of Bhuvaneśvar in Orissā.

In our study of Orissan temples we are fortunate in having preserved a considerable body of śāstras, furnishing the most precise directions for the laying out and erection of the temples. In these Orissan texts the temples are classified under the designations *rekha* and *bhadra*. The rekha is the conical, beehive-shaped spire; the bhadra a terraced pyramid. The rekha is divid-

ed into elements entitled shin, trunk, neck, and skull, analogies that suggest that the temple was regarded as a microcosm of Prajāpati, the Cosmic Man. The rekha is further divided into stages or bhūmis, each one of which is presided over by its specific deity. Not infrequently, these same śikharas are designated as mountains to certify that they were regarded as architectural replicas of Mount Meru or Kailāsa.

The earliest example of Indo-Aryan architecture at Bhuvaneśvar is the Paraśurāmeśvara temple of *c.* A.D. 650 [216]. It consists of a tower sanctuary of the rekha type with an attached enclosed porch. This tower is simply an enlargement of the types already seen in the sanc-

tuaries of the Gupta Period and the Galaganātha at Paṭṭadakal. The successive storeys or bhūmis are marked by heavy corner quoins in the lotiform āmalaka shape, and the tower is capped by a complete āmalaka supporting a metal trident of Śiva. Although the tower clearly consists of identical repeated storeys diminishing in size towards the summit, neither this emphasis on horizontal division nor the heavily rusticated character of the exterior decoration in any way detracts from the soaring curvilinear profile of the spire. The porch, which is covered with corbelled slabs of heavy masonry, is decorated with pierced latticed windows in stone and low reliefs of dancing dwarfs. The raised courses of

216. Bhuvaneśvar, Paraśurāmeśvara temple

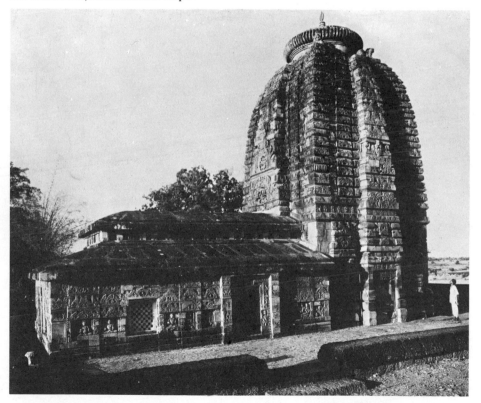

masonry framing the corners and dividing the faces of the śikhara give the impression of the tower being tied in by ribs converging in the crown or āmalaka. The precise curvature of these members was carefully regulated by the śāstras. Just as the ascent and meeting of these members symbolically connoted for the worshipper the aspiration and ultimate absorption of all in the godhead, their presence in an architectural sense provided the strongest impression of verticality to offset the static horizontal lines of the porch and spire itself.

The latest example of the Orissan style of architecture at Bhuvaneśvar may be seen in the Liṅgarāj temple of A.D. 1000 [217]. The śikhara is now a completely beehive-shaped structure

217. Bhuvaneśvar, Liṅgarāj temple

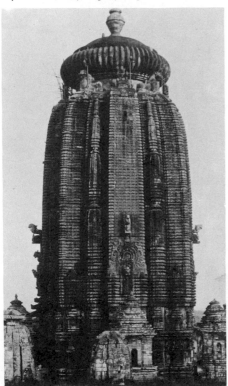

in which the original or cubical form of the cella is entirely merged into the curvilinear profile of the tower. Inserted one above another in alternate converging ribs of the spire are turrets repeating the shape of the tower as a whole: these are the Orissan version of the *uruśriṅgas* that appear as more salient projections in the temples of Khajurāho. It should be pointed out that even the most elaborate of the Orissan temple towers are extremely primitive in construction. They are built entirely on the principle of corbelled vaulting, so that in section we would see a hollow pyramid with overlapping courses of masonry roofed by the terminal cap of the structure. The śikhara shrine of the Liṅgarāj temple was preceded by a number of porches of the bhadra type reserved for the accommodation of worshippers and the performance of religious spectacles.

The final achievement of Orissan builders is the Sūrya Deul or Temple of the Sun at Koṇāraka [218]. This sanctuary was erected in the reign of Narasiṃhadeva (1238–64). It stands to-day a desecrated and impressive ruin on a lonely stretch of sea-coast north-east of Puri.[10] The temple was never finished, perhaps because the problems of construction proved too much for the builders, so that the rekha or tower already familiar to us from examples at Bhuvaneśvar is only a stump of masonry behind the massive assembly hall or *jagamohan* that precedes it. The plan of the temple is, as would be expected, a repetition of arrangements found in earlier Orissan shrines: the holy of holies or garbha griha was to have been located in the sanctuary tower, and was entered through the frontispiece already mentioned. This shrine was originally a dedication to the sun-god Sūrya. One of the most striking features of the design of the temple is that the entire sanctuary was conceived as an architectural likeness of the god's chariot or vimāna; around the circumference of the basement platform on which the temple proper rests are affixed twelve great

wheels intricately carved in stone [219], and, to complete the illusion of the solar car, colossal free-standing statues of horses were installed in front of the main entrance, as though actually dragging the god's chariot through the sky.

The principal fragment which survives at Koṇāraka consists of the lofty porch or ceremonial hall. It is conceived as a great cube of masonry measuring a hundred feet on a side and rising to a height of a hundred feet. The incomplete spire presumably would have attained a height of nearly two hundred feet. The exterior decoration is in entire harmony with the line and mass of the building as a whole. The basement storey is ornamented first with the stone wheels standing free of the fabric; in

the lowest zone of the base is a continuous frieze representing a great variety of genre scenes dealing mainly with the hunting of elephants and other wild animals; above this, arranged in two separate friezes, is a series of niches separated by widely projecting pilasters filled with sculpture of a very interesting and highly erotic type; the façades of the hall proper are divided into a base and two distinct friezes by heavily accented and repeated string courses [219]; above this rises the pyramidal roof that we have already found in the bhadra types at Bhuvaneśvar. Three distinct terraces recede to the crowning member in the shape of a gigantic stone lotus of the āmalaka type. The terraces are emphasized – in ascending order – by six

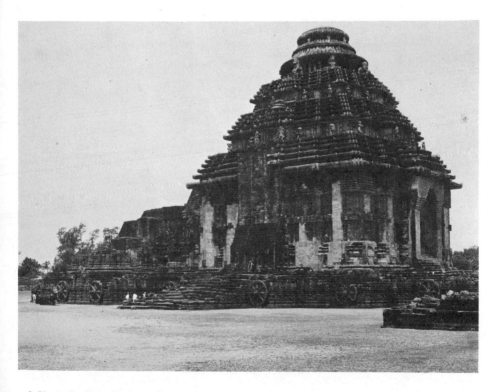

218. Koṇāraka, Sūrya Deul temple

219. Koṇāraka, Sūrya temple,
detail of basement storey

220 (*opposite*). Koṇāraka, Sūrya temple, erotic figures

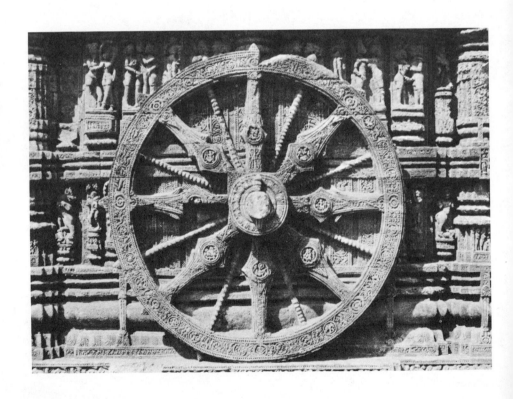

and five separate string courses. These string courses follow the various setbacks or recesses of the plan so that a distinct impression of a kind of wavy or curvilinear movement relieves any feeling of straightness or rigidity in the mass.

Returning to the subject of the sculpture, we must be aware of the fact that the Black Pagoda has achieved a great deal of notoriety through the frankly obscene nature of most of the carving decorating the basement and also the exterior of the porch. This carving might be described as a literal illustration of the erotic recipes of the *Kāma Sūtra*: it represents numerous couples engaged in a great variety of amorous antics, some of them of a definitely perverse nature [220]. This endless round of dalliance is a kind of sculptural apotheosis of the relations between men and women. These figures are representations of mithunas or auspicious pairs, which in less extreme forms were employed in Indian art from a very early period.[11] Their embraces have been interpreted as typifying the idea of *moksha* or union with the divine, the achievement of that primordial unity broken at the time Puruṣa divided himself to create the world. In a further metaphysical sense the couples represent the mortals' wedding with the divine or the idea of the gods' cosmic procreation of the universe. Human beings, following the devas and their śaktis in the sexual act, assume an identity with the love-play of the immortals. This is an expression of love found in Indian literature from the *Upanishads* to the romance of *Śakuntala*,[12] but it seems that at Koṇāraka the function of these endlessly repeated pairs in dalliance must have had something to do with actual orgiastic rites conducted in association with a special cult of the sun as universal fructifying force.[13] It is unfortunate that, for obvious reasons, none of these mithunas can be reproduced in detail; each is a separate masterpiece of relief composition in which the feeling of movement, as well as the

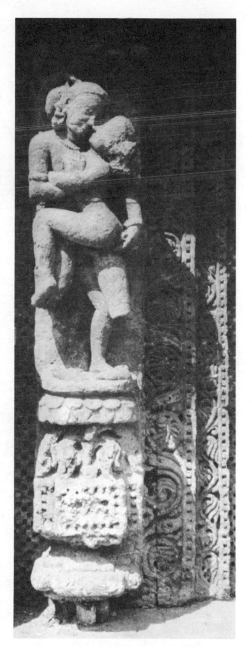

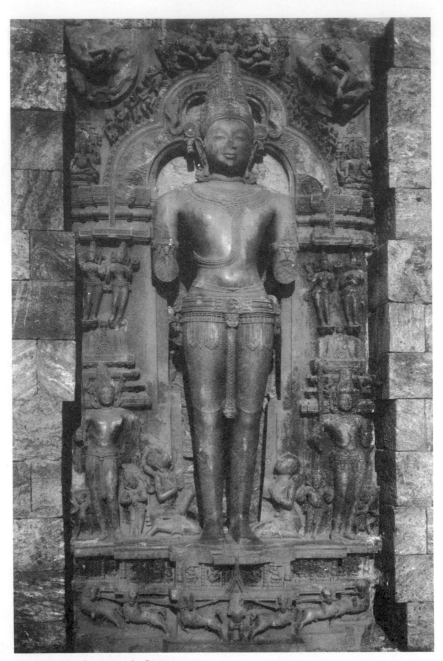

221. Koṇāraka, Sūrya temple, Sūrya

marvellous suggestion of the participants melting with love, transcends the character of the action.

In some of the niches of the arcade are representations of fantastic hybrid monsters, notably *gajasimha* – a combination of elephant and lion – that are among the most powerful and dynamic realizations of the fantastic that Indian art has given us. These hybrids, possibly, are allegories of the sun's (lion's) triumph over the rain (elephant), or possibly symbols of the soul's wandering from one shape to another in the endless process of *samsāra*.

In addition to this sculpture, the shrine at Koṇāraka originally included a number of reliefs of the sun god Sūrya, carved in green chlorite [221]. The figure of the sun-god is shown standing in a static frontal position in the *samabhanga* pose used for divinities in a state of spiritual equilibrium, inviting the prayers of the devotees. On the chariot with Sūrya are the twin figures of his charioteers and the kneeling dawn maidens. These pendant figures are set off against miniature stūpikas, and Sūrya himself is framed in a trefoil chaitya arch capped by an apotropaic monster mask or *kīrttimukha*. Below, on the plinth, in very small scale, are the horses of the quadriga, deployed to right and left of a central charger in frontal view, in accordance with a conceptual method of presentation that we have seen used for this same theme at Bodh Gayā [38]. It is an 'archaism' that enhances the hieratic effectiveness of the idol. These carvings at Koṇāraka are among the last examples of Indian sculpture in which a perfect balance is maintained between the realization of the form as a plastic mass and the extreme delicacy and precision in the carving of the ornamental accessories which, as so often, enhance the fullness and sculptural character of the smooth surfaces of the semi-nude body on which they are strung. The carving has, to be sure, a certain dry and hard quality about it, but the general conception of the figure is still in a direct line of descent from the great tradition of sculpture in the Gupta Period.

5. CENTRAL INDIA: KHAJURĀHO

It could well be said that the culmination of the Indo-Aryan genius in architecture was attained in the extraordinary group of temples erected at Khajurāho in central India. These magnificent shrines were dedications of the Chandella Rājput sovereigns, who are remembered chiefly for their enterprise in the construction of reservoirs and other undertakings of a utilitarian character. Only twenty of the original eighty-five temples are now standing, and all but one of these are out of worship. They arise like mountains of bluff masonry above the dusty plain. Although the surviving shrines are dedicated to Śiva, Vishnu, and the Jain patriarchs, there is no essential difference in their architectural character. This is simply another illustration of what we have seen so often in the history of Indian art, that it is impossible to make any sectarian difference with regard to style in the art of a given period.

We may take as a typical example of this magnificent architecture the temple of Kaṇḍāriya Mahādeo [222], which was dedicated *c.* 1000. Like the most ancient Indian stupas and earlier Mesopotamian citadels, the temple proper is elevated on a high masonry terrace. Quite different from the Indo-Aryan temples of Orissā, the shrine is a compact architectural unit, not a group of connected separate buildings; so that, for example, in the Mahādeo temple the successive maṇḍapas, leading to the garbha griha, share a common high base or podium, and the contours of their domical roofs like successive mountain peaks are hieratically designed to culminate in the highest śikhara above the cella.

In general, it could be said that the enormous effectiveness of the shrines at Khajurāho depends on their beauty of proportion and contour and the vibrant texture of their surface ornamentation. The plan is generally that of a

222. Khajurāho, Kaṇḍāriya Mahādeo temple

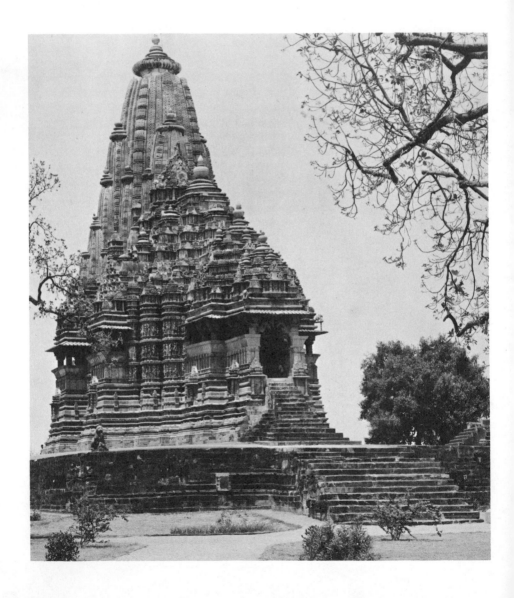

cross with the entrance at the east and one or two transepts radiating from the cella. In this plan the garbha griha and maṇḍapas are only cells of a unified organism. The dominant impression of the Khajurāho shrines is that of a number of separate superstructures, each with its āmalaka finial building up to a great mountain of masonry. The vertical is emphasized throughout, from the high base through the successive walls and roofs to the ultimate range of lesser peaks that constitute the main spire. These temples may also be regarded as a perfect balance of vertical and horizontal volumes with the vertical ascent interrupted by friezes of dynamic figure sculpture girdling the entire structure.

In comparison with the towers of Orissā, the spires at Khajurāho are domical rather than pyramidal in contour. The curvature of these śikharas is more accelerated and impelling than those of eastern India, and a refinement peculiar to the architecture of Khajurāho is to be seen in the turrets or uruśringas let into the masonry of the main tower at successive levels of its construction; so that in the duplication, and even triplication, of these towered shapes there is almost the effect of the eyes travelling from lesser ranges to the summit of a distant mountain. The whole mass of the śikhara is a kind of wonderful rising crescendo of curves, the curves of the lesser turrets and the ribs of the main tower having their separate points of intersection, and yet leading inevitably to the āmalaka that at once crowns and girdles the whole.

The symbolism of these final buildings of the Indo-Aryan architects is only an enlargement of the metaphysical meaning inherent in the simplest structures of Vedic times. The temple is no more than an architectural replica of the imagined world mountain Meru which as a pillar separates heaven and earth, or, anagogically, an equivalent of the body of Puruṣa, the Universal Man, whose body comprehends this universe. Accordingly, the final āmalaka, in shape like a lotus flower or a solar halo with rays, typifies the passage to heaven, the sun-door at the summit of the world mountain, or the dome of the skull of the Universal Man. As we have already seen, the stressed verticality of every architectural member leads the worshipper upward to that centre of magic union with the divine. And, in like manner, the sculptural decoration of the temple points the way to that desired union. This is the meaning implicit in the multiple representation in the frieze of mithunas or men and women in erotic embrace, which in their ecstasy typify the ultimate union of the soul with the divine, the reconstitution of the primordial wholeness that was destroyed when Puruṣa divided himself into a polarity separating human and divine.

Seen from the exterior, the temples of Khajurāho impress the beholder with the same grandeur of unified design that we recognize in a Gothic cathedral, whether or not we are acquainted with its iconographic significance. The magnificent balance of horizontals and verticals is maintained throughout. The eye travels upward from the successive levels of the base divided by string courses and shallow friezes to the level of the principal rooms of the shrine. There open porches with overhanging eaves provide a temporary horizontal interruption to the successive levels of the main tower constituted of the repeated shapes of the smaller śikharas building up to the dominant profile of the main tower.

Typical of the veritable flowering of temple sculpture during this final period of Hindu architecture in Central India is the ornamentation of the Vamana Temple at Khajurāho in illustration 223. We look upon a double tier of naked apsaras in a celestial chorus, vaunting their voluptuous charms in an infinite variety of attitudes displaying a 'languid and calculated eroticism', rendered the more provocative by the contrast between the slim bodies and the

towering complication of the head-dresses. These dancers in the heaven of Indra are, according to legend, creatures not made of gross flesh but constituted rather of the air and the movements that compose their heavenly dances; they are here as appropriate 'entertainers' in the reconstructed heaven that is the fabric of the sanctuary.

Although ostensibly only so many spots or accents in the total decoration of the facade, they have an irresistible individual attraction: 'With every movement of the eye of the beholder a new perspective shows the images from a different angle; to avoid being bewildered he has to concentrate on each of them . . . and then give his attention to the next.'[14] Each figure carved almost in the complete round stands on its own platform and is shaded by an individual canopy. In addition to their separate fascination for the eye, the figures perform the function of contributing so many vertical accents in the ascent of the śikhara. Individually these celestial maidens possess a great vitality expressed in their tortuous movements and the provocative warmth and fullness of the modelling of their flesh. As in some of the very earliest examples of Indian sculpture, the roundness and softness of the breasts and belly are emphasized by the contrasting exaggerated straightness of the arms and limbs.

6. RĀJPUTĀNA

In the days of the great Brahmanic revival during the eighth and ninth centuries the plains of Rājputāna must have flowered with temples. Most of these temples were distinguished by their pillared maṇḍapas, and the fragments of scores of such porches were appropriated by Moslem builders of the Qutb mosque at Delhi, which in its four hundred and eighty separate columns includes the material of nearly thirty temples.

In spite of the ravages of time and the iconoclasm of the Islamic invaders, the number of ancient temples still standing in Rājputāna is so great that it would be impossible even to mention them all. We may take as representative of the best of Indo-Aryan architecture in northern India the group of temples erected from the eighth to the tenth century at Osiā, near Jodhpur. All these shrines, in what once must have been a flourishing religious community, now stand deserted and in ruins. The sanctuaries include both Brahmanic and Jain dedications. Most of the temples belong to the pañca āyatana class, a designation meaning that four extra shrines (making five in all) were originally attached by cloisters to the main sanctuary. Most of the temples at Osiā, like the temples at Khajurāho, are raised on plinths or podiums. The śikharas follow most closely the early Orissan type, as exemplified by the Paraśurāmeśvara temple at Bhuvaneśvar. The maṇḍapas, in almost every case, take the form of an open pillared hall. The jambs and lintels of the doorways of the sanctuaries at Osiā are ornamented with a richness equalling the carving of the Sun temple at Koṇāraka.

A typical example of the Indo-Aryan style in Rājputāna is the Sūrya temple at Osiā [224]. The four lesser shrines surrounding the sanctuary have disappeared and only the cella with its open porch survives. The building presumably dates from the tenth century. The cella and the open maṇḍapa are erected on a raised platform. The colonnade of the maṇḍapa is augmented by two pillars rising from the ground level. The spaces between the pillars on the porch were originally filled with elaborately carved stone screens like the pierced decoration to be found in some of the Chalukya temples at Paṭṭadakal. The rather squat śikhara with its heavy rustication and massive āmalaka quoins is also reminiscent of Paṭṭadakal. The columns of the Osiā temples belong to the same order that is seen in

223. Khajurāho, Vamana temple, apsaras

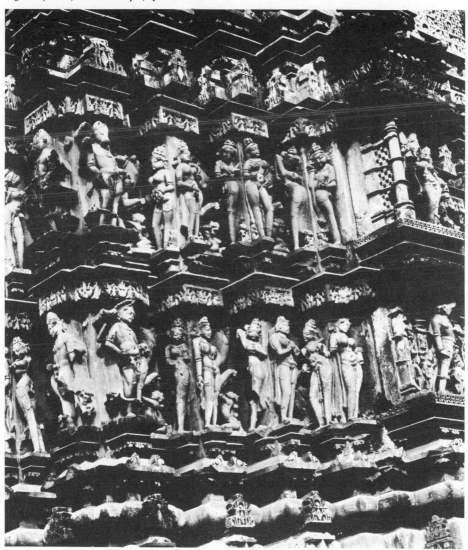

the countless examples appropriated for the Mohammedan shrines of Delhi [225]. The carving is concentrated on the base and bands of tracery interrupting the shaft of the column.

These pillars consist for the most part of a high square base, from which grows an octagonal shaft that supports a richly carved capital. Both shaft and capital have a repeated motif of a vase

or kalasa wreathed in foliate detail. This order is simply an elaboration of the columns of the Gupta Period, with every face of the pillar richly embellished with a veritable lace-work of figural and foliate motifs. Some have discerned in this afterglow of the Gupta Period a reflexion of that sensuous love of nature, the perfumed descriptions of the floral bowers in which is enacted the love-poem of *Śakuntala*. The principal doorway of this temple is typical in its richness and iconography of the portals of the Brahmanic temples at Osiā.[15] The lintel is decorated with representations of the planetary divinities or *navagraha*, together with representations of *garuḍas* and nāgas. The jambs are covered with different avatars of Vishnu and lesser members of the Hindu pantheon. The river goddesses which flanked the lintel of Gupta temples have

been moved to the base of the jambs. The other Brahmanic temples at Osiā, such as the shrines of Hari-Hara, present only slight variations of the same typically Indo-Aryan style. The same could be said of the Jain sanctuary of Mahāvīra that differs only in the character of the śikhara. This tower with lesser turrets echoing its shape corresponds more closely to the special type of architecture seen at Khajurāho.[16]

7. GUJARĀT AND WESTERN INDIA

Of a special richness and delicacy are the ruined Indo-Aryan temples of Gujarāt. Although some of these shrines and also those of Kaṭhiāwāḍ and Kach were begun in the tenth century, the majority of the structures may be dated between 1025, the year of Mahmud of Ghazni's icono-

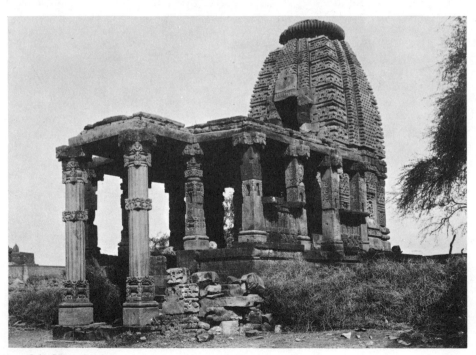

224. Osiā, Sūrya temple

clastic raid on Somnāth, and the final conquest of this whole region by the Delhi Sultans in 1298. The present ruin of most of these splendid structures is due not only to the fury of the invaders but to a cataclysmic earthquake that devastated western India in the nineteenth century. The magnificence of these shrines was made possible by the commercial wealth of Gujarāt under the Solanki Dynasty, a period when the ports of western India were a clearing-house for the trade between the Eastern and Western worlds. These originally jewel-encrusted temples were not entirely the result of royal patronage, but were communal dedications in the true sense of the word, in that they were erected through voluntary subscriptions and contributions of skilled labour of all kinds. A further parallel to the communal interest in the Church in the Gothic period lies in the fact that they were the work of builders' guilds under the direction of master masons who transmitted their knowledge of the śāstras to successive generations of apprentices down to modern times.

Almost all the western Indian temples are so ruinous that it is difficult to select a single example of the style to illustrate their character. The most famous of the Gujarāt temples was the Śiva shrine at Somanātha-Pāṭan that was the special object of Mahmud of Ghazni's fury and religious zeal against idolatry, when, in 1025, he smashed the jewelled lingam and put the temple to the sack. The shrine, although restored after this desecration, was totally wrecked by the final Mohammedan invaders at the end of the thirteenth century. The plan, which is

225. Delhi, Qutb mosque, pillars from Hindu temples

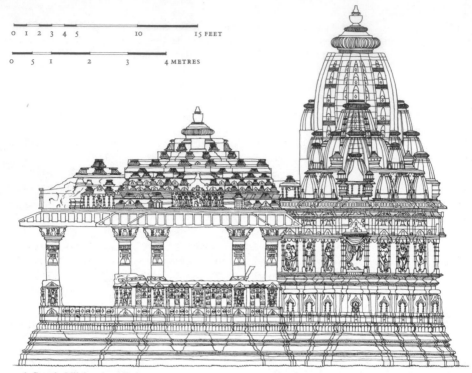

0 1 2 3 4 5 10 15 FEET

0 5 1 2 3 4 METRES

226. Sunak, Nilakantha temple

approximated in other examples in Kaṭhiāwāḍ, consisted of a closed pillared hall, octagonal in shape, preceding a square cella surmounted originally by a śikhara.

Something of the same arrangement is found in the ruined temples of Navalakha at Sejakpur and Ghumli. The polygonal hall with its multiple step-backs in plan precedes a cella set in the core of an attached śikhara. These pillared porches in western India were covered with low terraced roofs, some of them perhaps originally in several storeys.[17]

On the exterior the temples of Gujarāt and Kaṭhiāwāḍ are generally divided into three zones of horizontal ornament and mouldings including the base, the main body of the wall up to the cornice, and the roof or attic; over the cella, of course, the roof is replaced by the śikhara. These divisions are in turn separated into numerous horizontal courses, each specifically named and its exact measurement prescribed in the śāstras. The śikharas differ from the usual Indo-Aryan type in being composed of clustered turrets or uruśriṅgas, each a replica of the main tower, and almost free-standing from the fabric of the principal spire. The reconstruction of the temple of Nilakantha at Sunak [226] gives us a very good idea of the original elevation of these sanctuaries.

Among the better-preserved examples is the Sūrya shrine at Modhera in Gujarāt [227]. It is built of the soft golden-brown sandstone of the region, and its derelict splendour is romantically reflected in the disused tank or pool for ablutions

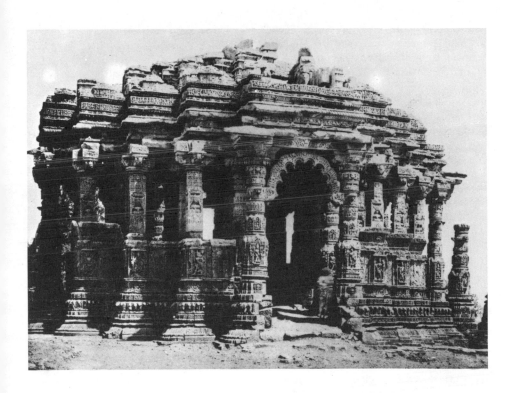

227 and 228. Modhera, Sūrya temple

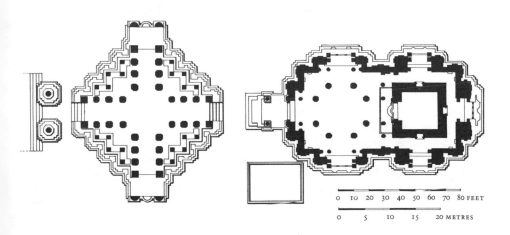

0 10 20 30 40 50 60 70 80 FEET

0 5 10 15 20 METRES

that lies beneath its eastern approach. One of the most impressive features of the Modhera temple and other Gujarāt shrines is the entirely organic plan in the relation of all the parts of the shrine to the whole and its functional arrangement of all the architectural accessories of religious worship. The Sūrya temple consists of an open pillared porch connected by a narrow passage to a building containing an assembly hall and the garbha griha itself [228]. The seemingly separate portions of the structure are related by the horizontal lines of the mouldings that follow the usual tripartite division of the wall. A similar division in the proportion and decoration of the pillars of the interior brings them into unity with the whole scheme.

The carving typical of the Solanki Period is at once extremely luxuriant and exquisitely refined in the rendering of detail. Special attention should be called to such beautiful ornamental motifs as the toraṇas or cusped arches introduced as tympana to the entrances and also linking the summits of the columns in the interior of the porch. Always there is such a depth to the relief that the effect is almost that of pierced and applied metal-work rather than stone. In the technique of this extremely delicate carving, which certainly must have been done by laborious abrasion rather than direct cutting, the sculpture at Modhera is not far removed from the famous carved domes at Mount Ābū.

The renowned Jain sanctuaries of Mount Ābū in Rājputāna, for generations among the favourite tourist attractions in all India, are in a sense the final baroque culmination of the Gujarāt style. These buildings – the Dilwara shrine of the tenth century and the thirteenth-century Tejpal temple [229] – are constructed entirely of white marble brought up from the valley below their lofty setting. In their own ornate way they can be counted among the architectural wonders or curiosities of the world. Although the exterior of the temple is in no way

229. Mount Ābū, Tejpal temple, dome

distinguished, the interior of the pillared hall reveals a dome rising in many concentric circles supported on a circular arcade of dwarf pillars joined by cusped arches. The dome culminates in a richly carved pendant, like a stalactite hung in the centre of the vault. Placed athwart the lower rings of the dome are brackets with representations of Jain goddesses of wisdom. In their semi-detached projection they appear like struts actually upholding the cupola. It is difficult to give an adequate account of the effect of this extraordinary decoration. Any real sense of architectural construction is lost beneath the intricacy of the carving and the profuseness of detail. The very texture of the stone is destroyed by the elaborate fretting. There is, to be sure, true beauty in the pearly radiance reflected from what seems like a huge and weightless marble flower. Looking up at this ceiling is to behold a dream-like vision looming, in the half-light, like some marvellous underwater formation in coral and mother-of-pearl. The deeply pierced working of the figures and the unbelievably delicate foliate motifs have the fragility of snowflakes. Writing of the Mount Ābū temples, Percy Brown observes, 'There remains a sense of perfection ... but it is mechanical perfection, with an over-refinement and concentration on detail implying the beginning of a decline'.[18] At the same time this monument of Jainist religious zeal possesses a complete consistence in that every portion of each dome, arch, and pillar is covered with the same exuberance of surface ornament. 'It is one of those cases where exuberance is beauty.'[19]

A centre of Indo-Aryan building in western India is the city of Gwalior, on the main railway between Delhi and Bombay. A little group of disused and largely ruined temples and fragments of shrines crowns the plateau of Gwalior

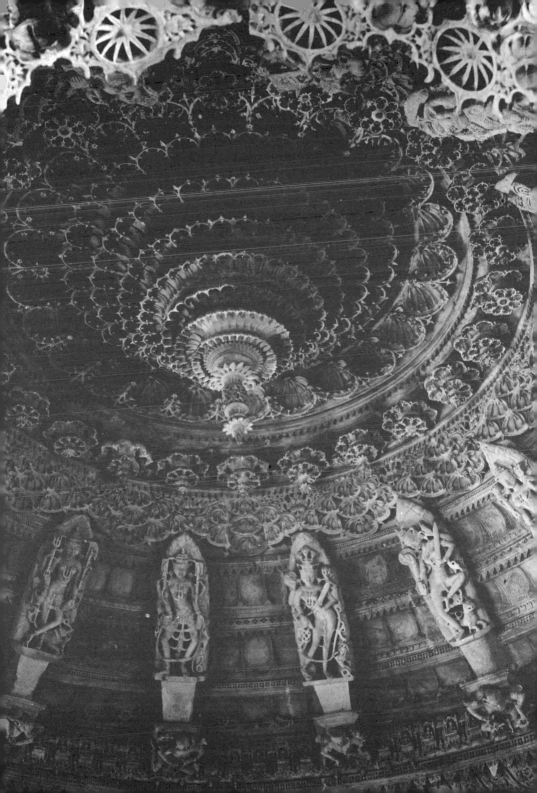

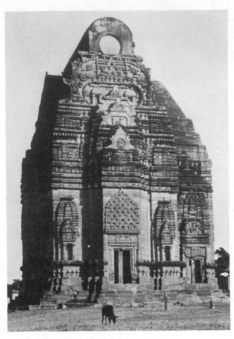

230. Gwalior, Teli-ka-Mandir

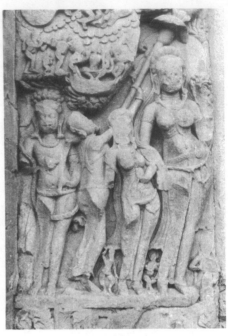

231. Gwalior, Teli-ka-Mandir, relief

Fort. The earliest of these is the Teli-ka-Mandir of the eleventh century [230]. The structure as it stands today is better described as a shrine than a complete temple. The building rises to a height of eighty feet and is in the shape of an oblong, a plan repeated in the cella and the porch. Not only is this design unique in later Hindu architecture, but so, too, is the roof that it necessitated: the crowning member is in the shape of a barrel-vaulted chaitya with the sun-windows of the Buddhist type plainly indicated at each end; the resemblance to the Buddhist basilica type extends to the representation of arcades in memory of the nave columns of the chaitya on the lateral façades. This is one of the last appearances of the rare vesara type of temple which we shall note again among the rock-cut sanctuaries at Māmallapuram. The deeply sculptured panels on either side of the main entrance, although badly damaged by icono-clasts, are magnificent examples of later relief carving [231]. In both we see a female personage, possibly a river goddess, with three attendants, one of whom holds an umbrella over her; in the subtly swaying movement of the elegantly attenuated figures and the contrast between the broadly realized forms and exquisitely defined details of ornament, the style is a prolongation of the magnificent Gupta workmanship in western India which we have already examined in a relief from the Gwalior region [180].

Also at Gwalior are the remains of two build-ings known as the Great and the Small Sās Bahu temples. Only the former of these, dedicated to Vishnu in 1093, need detain us [232]. It is not a complete sanctuary, but only the porch or hall

four gigantic stone piers to support the great
mass of masonry of the superstructure. The
carving of the under-surfaces of the massive
stone beams in an all-over foliate design does
much to relieve the heaviness of these members,
an effect of lightness and delicacy continued in
the dome, which in the intricacy of its fretted
carving is suggestive of fan vaulting.

8. DRAVIDIAN ARCHITECTURE.
EASTERN INDIA:
THE PALLAVA STYLE

Of the greatest significance for the later develop-
ment of Dravidian architecture are the shrines
dedicated by the rulers of the Pallava Dynasty
who were the successors of the Āndhras in
eastern India from the fifth century through
the ninth. For our purposes the most important
contributions in the genesis of the style were
made under the Māmalla Dynasty (625–74) and
the Dynasty of Rājasiṁha (674–800). Whereas
the earlier dedications consisted of rock-cut
shrines, the later activity was devoted entirely
to structural buildings.

From the Māmalla Period there date the re-
markable rock-cut temples of Māmallapuram
or 'Seven Pagodas' on the sea-coast below
Madras. The work here was under the patron-
age of the king, Narasiṁha. The principal archi-
tectural monuments consisted of some temples
or *raths*[20] that are really free-standing sculptural
replicas of contemporary structural temples
carved from the granulitic outcrops on the shore
[233A, B]. These monuments are of the greatest
importance for the later development of Dravid-
ian architecture because they reveal the depen-
dence of the later Hindu style on pre-existing
types of Buddhist architecture. Especially re-
vealing for this latter aspect of the style is the
Dharmarāja rath [233A]. It has a square ground-
storey with open verandahs, which forms the
base of the terraced pyramidal śikhara above. It

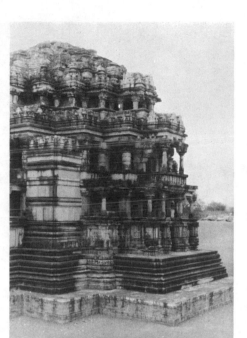

232. Gwalior, Great Sās Bahu temple

in front of one now vanished. Viewed from the
exterior, the temple is divided into three storeys
of open loggias separated by massive archi-
traves. The penetration of the mass of the build-
ing by these deep balconies provides a feeling of
lightness and elegance; the design is also helped
by the alternation of accents of light and shade
provided by the columns set off against the
enshadowed porches. On the exterior the build-
ing terminates in a rather flattened terraced
pyramid which continues to the very summit of
the structure the eccentric and picturesque plan
with its multiple set-backs and recesses. Inside,
the impression is that of a single large hall rising
to the full height of the building, rather like the
crossing of a cathedral. The effectiveness of this
motif has been partially spoiled and an effect of
crowding introduced through the necessity for

has been rightly suggested that this typical Dravidian form is an adaptation of a Buddhist vihāra, in which successive storeys were added for the accommodation of the monks.[21] The terminal member of the structure is a bulbous śikhara, which is repeated in smaller scale on each of the lower levels of the terraced superstructure. Perhaps the most distinctive feature of this and the other raths at Māmallapuram lies in the open verandahs on the ground-storey. The pillars are of a distinctive Pallava type with the shafts of the columns supported by the bodies of seated lions.

A different type of structure is represented by Sahadeva's rath, which must be classified as a vesara temple [233B]. It is a longitudinal building with a barrel roof of the so-called elephant-back type, faithfully reproduced in the carving. This vault, terminating in the semi-dome of an apse and with the chaitya motif at its opposite end, is very obviously a survival of the Buddhist chaitya-hall that, as we have seen, had persisted in such structural temples as the Gupta example at Chezarla and, to a modified extent, the Durgā temple at Aihole.

Bhima's rath, so called, is distinguished by a simple barrel roof with its cross section, a chaitya arch, at either end. It is crowned by a row of stūpikas. A later structural development of the form of Bhima's rath may be seen in the Vaital Deul at Bhuvaneśvar in Orissā. It has been suggested that we are to see here the prototype for the *gopuras* or porch-towers of the later architecture of southern India. Another distinctive element of the Pallava style may be seen in the *gavaksha* motif of chaitya arches framing busts of deities that crown the entablature. These framed protomes, already seen at Bhītārgāoṅ, become a regular feature of Dravidian architecture and may also be found in the earliest Hindu and Buddhist shrines in Cambodia.

A third type of building represented among the raths at Māmallapuram may be seen in

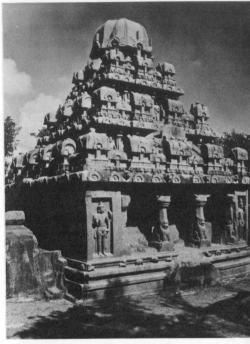

233A. Māmallapuram, Dharmarāja rath

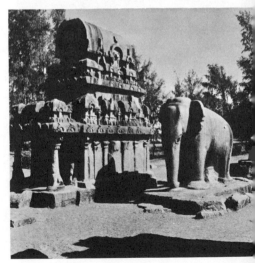

233B. Māmallapuram, Sahadeva rath

Draupadī's rath. It consists of a one-storey square cell surmounted by an overhanging, curvilinear roof, suggestive in its shape of the modern Bengali huts. There is every reason to believe that this, like so many forms of structural Indian architecture, is an imitation of a prototype constructed of bamboo and thatch. The resemblance to the śikhara suggests that this most characteristically Dravidian element may also have had its origin in the form of a bamboo hut or temple car.

In the consideration of the art of the Hindu Renaissance it is impossible to treat of sculpture apart from architecture, since to an even greater degree than in the earlier periods the carving literally melts into the architectural enframement that supports it. The plastic adornment of the raths consists of images of Hindu deities set in niches on the exterior of the shrine, and also of panels illustrating legends of Hindu mythology ornamenting the interior of the sanctuaries. The figures appear to be a development from the style of the Later Āndhra Period, rather than from the Gupta school. They retain the extremely graceful attenuation of the forms at Amarāvatī, and are animated by the same feeling for movement and emotionally expressive poses and gestures. A new canon of proportion is notable in the heart-shaped faces[22] with their high cheekbones and the almost tubular exaggeration of the thinness of the arms and legs. In the reliefs decorating the raths the forms are not so completely disengaged from the background as in the Āndhra Period, but seem to be emerging from the matrix of the stone.

The greatest achievement of the Pallava sculptors was the carving of an enormous granite boulder on the seashore with a representation of the Descent of the Ganges from the Himalayas [234]. To give the reader an idea of the scale of this gigantic undertaking, it may be pointed out that the scores of figures of men and animals, including those of the family of elephants, are represented in life size. The subject of the relief is that of all creatures great and small, the devas in the skies, the holy men on the banks of the life-giving flood, the nāgas in its waves, and the members of the animal kingdom, one and all giving thanks to Śiva for his miraculous gift to the Indian world. The cleft in the centre of the giant boulder was at one time an actual channel for water, simulating the Descent of the Ganges from a basin at the top of a rock. We have here a perfect illustration of that dualism persistent in Indian art between an intensive naturalism and the conception of divine forms according to the principles of an appropriately abstract canon of proportions. We have, in other words, the same distinction between the divine and the earthly as is noticeable in El Greco's 'Burial of the Count of Orgaz', in which the figures in the celestial zone are drawn according to the Byzantine canon of attenuated forms for supernatural beings, whereas the personages in the lower, earthly section of the panel are painted in a realistic manner. In the relief at Māmallapuram the shapes of the devas, moving like clouds across the top of the composition, have the svelte, disembodied elegance of the art of Amarāvatī. By contrast, no more perfect realizations of living animal types are to be found anywhere in the sculpture of the Eastern world. This vast, densely populated composition, like the Chalukya paintings of the Ajaṇṭā caves, is no longer confined by any frame or artificial boundary, but flows unrestrained over the entire available surface of the boulder from which it is carved [235]. Just as the space of the relief as a whole is untramelled and, indeed, seems to flow into the space occupied by the spectator, so the individual forms in it are only partially disengaged from the stone which imprisons them. One has the impression, indeed, that they are in continual process of emerging from the substance of the rock itself. There is the same suggestion of the birth of all form from Māyā that was so apparent in the Śuṅga reliefs at Bhājā. As the late Dr Zimmer expressed it:

Here is an art inspired by the monistic view of life that appears everywhere in Hindu philosophy and myth. Everything is alive. The entire universe is alive; only the degrees of life vary. Everything proceeds from the divine life-substance-and-energy as a temporary transmutation. All is a part of the universal display of God's Māyā.[23]

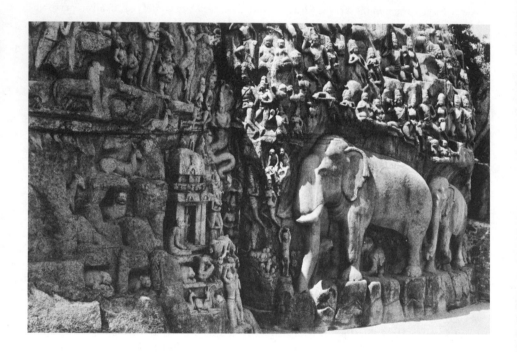

234 and 235. Māmallapuram, The Descent of the Ganges, details

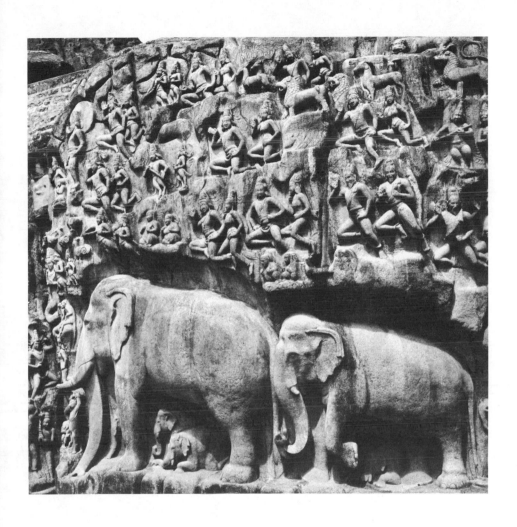

The very epitome of the art of the Pallava
sculptor is to be discerned in the free-standing
group of a monkey family in front of the tank
below the great relief [236]. Although separate
from the great composition, it was certainly
intended to be considered a part of it. The
understanding of the essential nature of the ani-
mals and the plastic realization of their essential
form could scarcely be improved upon. This
piece of sculpture is the very embodiment of
the quality of cetanā, the vitalizing principle
mentioned in relation to the Indian canons of
painting. The shapes, although only partially
adumbrated, connote the finished form and pro-
claim the nature of the glyptic material from
which they are hewn.[24]

236. Māmallapuram, monkey family
from The Descent of the Ganges

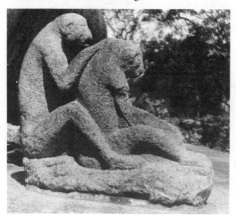

237. Māmallapuram, Durgā
slaying the demon buffalo

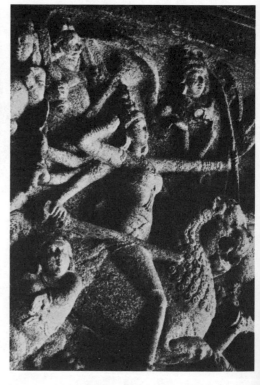

A fine relief depicting Durgā[25] fighting the
demon buffalo Mahisha, an episode from the
Puranic legends, is carved on a panel in a cave at
Māmallapuram [237]. The goddess is seated on
a lion in this splendid example of the Pallava
style at its finest. She is eight-armed, and holds
the weapons such as the bow, discus, and trident
lent her by Śiva and Vishnu for the epic struggle.
Her ornaments include a towering head-dress
(karana mukuṭa), necklaces, and jewelled belt;

and her arms are covered with bracelets like those of the Dancing-Girl from Mohenjo-daro [5]. This figure, like all Pallava sculpture, belongs to the earliest and at the same time classic phase of Dravidian art. Ultimately it is an outgrowth of the Later Āndhra figure style in the elongation of the form with long tubular limbs, but the whole conception is invested with a peculiarly dynamic quality that is always characteristic of Dravidian Hindu art. We can see once more in this single figure the suggestion of the emergence of the form from the stone – achieved here by the gradually more salient disengaging of the successive planes of relief with the details of the ultimate plane being entirely merged with the background. Certain aspects of

the figural canon differ from earlier practice, as may be discerned in the heart-shaped face already noted at Māmallapuram. The figure of the triumphant goddess has a militant energy conveyed by the moving pose and the deployment of the arms in a kind of aureole. This is combined with a suggestion of complete serenity and feminine softness, as is entirely appropriate to the conception of the divinity.

The death of the Pallava monarch Narasimha in A.D. 674 brought to an end all work on the five raths and other sculptural undertakings at Māmallapuram. The dedications of his successor, Rājasimha, were all structural buildings. One of these was the so-called Shore Temple [238], erected on the beach not far from the great

238. Māmallapuram, Shore temple

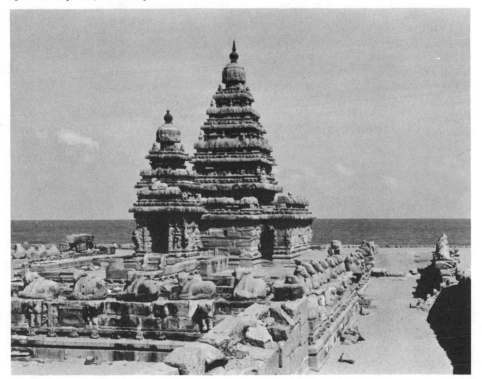

relief of the Descent of the Ganges. The temple was planned in such a way that the door of the sanctuary opened to the east, in órder to catch the first rays of the rising sun. This in itself resulted in a rather peculiar arrangement, since it necessitated the placing of the maṇḍapa and the temple court at the rear or west end of the main sanctuary. The terraced spires crowning both shrine and porch very clearly reveal a development from the form of the Dharmarāja rath. In the Shore Temple, however, the dependence on the vihāra type is less marked, owing to the new emphasis on the height and slenderness of the tower, like an attenuated version of the Dharmarāja rath. Actually, the characteristic Dravidian form of a terraced structure with the shape of the terminal stūpika echoed in lesser replicas on the successive terraces still prevails, but these recessions are so ordered as to stress the verticality of the structure as a whole. Such hallmarks of the Pallava style as

the pilasters with the rampant lions persist in the decoration of the façade of this structural monument.

Another building of the Pallava Period is the Kailāsanāth temple at Kāñcīpuram (Conjeeveram), which must date from c. 700 [239].[26] In plan it consists of a sanctuary, a connecting pillared hall or maṇḍapa, and a rectangular courtyard surrounding the entire complex. The pyramidal tower of the main shrine is again very obviously a development out of the Dharmarāja rath. The storeys are marked by heavy cornices and stūpikas echoing the shape of the cupola. Around the base of this central spire are clustered a group of supplementary shrines that again rhythmically repeat the form of the terminal stūpika. This shape is repeated once more in the row of cupolas crowning the parapet of the courtyard. The gateways of the enclosure, surmounted by hull-shaped members of the vesara type repeating the form of Bhima's rath

239. Kāñcīpuram, Kailāsanāth temple

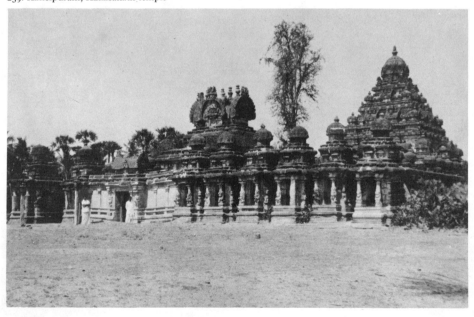

at Māmallapuram, suggest the form of the temple-towers or gopuras of the last phase of Hindu architecture at Madura. As in the Shore Temple, pillars rising from rampant leonine forms are employed throughout.

9. THE DECCAN

Closely related to these Pallava shrines is one of the greatest monuments of Dravidian art: the Kailāsanāth temple at Ellūrā in the Deccan [240]. This monument to Śiva was a dedication of Krishna I (757–83) of the Rāshṭrakūṭa Dynasty. The Rāshṭrakūṭas were the successors of the Chalukyas in central India and were at the height of their power in the eighth century. This great sanctuary, occupying an area roughly the same as that of the Parthenon and one and a half times as high, is not a structural temple, but an enormous monolithic rock-carving in architectural form.[27] The entire precinct, including the temple, its maṇḍapas, a pillared shrine for Śiva's bull Nandi, as well as the monumental portico, are all hewn directly out of the great quarry of rock. Although we may marvel at the amount of labour that went into such a gigantic carving, it should be pointed out that there was probably less expenditure of work in literally quarrying the entire complex from the mountain-side than would have been required for transporting the cut stones necessary to build it. Described as briefly as possible, the technical method followed by the carvers of the temple of Ellūrā was to cut three great trenches down into the quarry of rock and carve the free-standing buildings from the isolated block of stone remaining. Masses of rock had to be left intact, not only for the main sanctuary and its basement storey, but also for the two free-standing stambhas or columns and the lifesize carving of an elephant on the floor of the surrounding courtyard. Bridges connect the main temple with the halls and subsidiary shrines cut in the surrounding 'walls' of the quarry. The disadvantage of

this technique is that the temple is left enshadowed at the bottom of a deep pit. At Ellūrā the carvers sought to compensate for this defect by placing their shrine on an enormously high base.

The Kailāsa temple is dedicated to Śiva, who is enshrined as a giant lingam in the innermost sanctuary. As its name implies, the monument is intended as an architectural replica of the sacred Mount Kailāsa, on the summit of which is Śiva's eternal home. Indeed, the profile of the building, with its central spires somewhat above the summits of the roofs of the maṇḍapa, and Nandi porch, seems to follow the actual contour of the real Mount Kailāsa in the Himalayas. The dependence of the architectural form on Pallava prototypes is especially evident in the terraced spire that has for its ultimate model the Dharmarāja rath at Mamallapuram. Characteristic of this Dravidian style are the replicas or refrains of the finial on the lower levels of the terraced pyramid. Actually, the arrangement of sanctuary, porches, and Nandi pavilion is distinctly reminiscent of the Virūpāksha temple at Paṭṭadakal, so that, by the same token, the Kailāsa temple is a lineal descendant of the shrine at Kāñcipuram.

As has already been noted, the main elements of the Kailāsa temple are all placed on a podium twenty-five feet high, so that they appear to stand on an upper storey raised above the level of the courtyard. The essential plan of the Kailāsa temple proper is that of a cella preceded by a spacious hall with pillared maṇḍapas extending as transepts to east and west [241]. In front of the porch on the main axis is a shrine for Śiva's bull Nandi. Two lesser portions radiating from the main narthex give the temple a roughly cruciform plan. Around the sanctum are carved five lesser shrines, like chapels in an ambulatory. The exterior decoration of all these structures and of the Nandi porch preceding the main complex consists of niches enclosing statues of deities and engaged columns of the Dravidian order

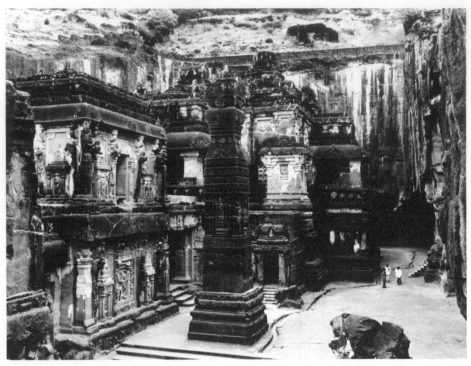

240. Ellūrā, Kailāsanāth temple

[240]. These niches consist of slender colon-
nettes supporting an overhanging cornice of
the Bengali roof type, surmounted in turn by a
finial in the shape of a chaitya arch. The same
type of heavy convex cornice is repeated in the
entablature of the main buildings. All these
elements, like the formation of the central spire,
are completely Dravidian in character and clear-
ly derived from Māmallapuram. Although at
Ellūrā we find occasional examples of the 'jar-
and-foliage' capital typical of Indo-Aryan build-
ings, the vast majority of the columns reveal the
Dravidian order almost entirely evolved. The
pillars have a square or polygonal base, suc-
ceeded by an octagonal shaft; at the summit
of the shaft the reeded neck of the pillar is
constricted beneath a bulbous cushion type of

capital which continues the lines of channelling
on the neck. A modification of this type can be
seen in the free-standing pillars in the court,
and, in its usual form, in the columns of the
maṇḍapa.

A spectacular feature of the Kailāsa temple is
the deeply carved frieze of the podium, con-
sisting of very freely disposed lions and elephants
that appear to be effortlessly supporting the
massive superstructure on their backs. The
architectural carving of the Kailāsa temple is not
limited to the almost incredible achievement of
the main shrine, but includes lesser sanctuaries
dedicated to the river goddesses and other mem-
bers of the Hindu pantheon, forming an almost
continuous cloister around the great pit in
which the principal temple is isolated.

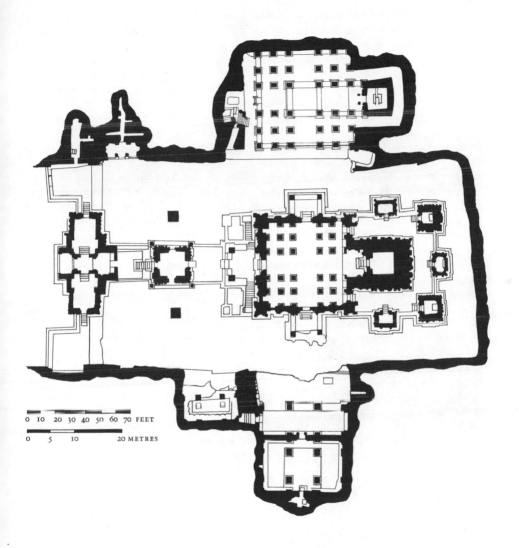

0 10 20 30 40 50 60 70 FEET

0 5 10 20 METRES

241. Ellūrā, Kailāsanāth temple, upper storey

Iconographically and structurally part of the Kailāsa temple is the sculpture of Saivite themes and episodes from the *Rāmāyana* that almost entirely clothes it [242]. The most dramatic of a number of reliefs, all monumental in scale, is one illustrating a famous legend of Mount Kailāsa [243]. On a deeply shadowed stage we see a block-like representation of the mountain peak itself and, seated on the summit, the divine lovers, Śiva and Pārvatī. We have here an illustration of the moment in the *Rāmāyana* when the Singhalese giant, Rāvaṇa, attempts to uproot the sacred mountain in order to use it as a kind of dynamo of magic spiritual energy in his war against Rāma and his allies. In the upper part of the composition the figure of Śiva, in an elegant pose of effortless command, is set off by the plain back wall of the stage. His outstretched foot, barely touching the ground, imprisons the demon giant in the bowels of the mountain. The

242. Ellūrā, Kailāsanāth temple, Rāvaṇa and Jatayu

shrinking Pārvatī clutches her lord's arm as she feels the mountain quake. She reclines before the darkness of the background, into which rushes the terrified figure of a maidservant. Below, in a cavern of almost Stygian gloom, appropriate to his nature and purpose, is the trapped giant. In writing of this relief Stella Kramrisch states: 'Depth and darkness are parcelled out according to the demands of the psychological suggestiveness with which the artist invests each single figure.'[28]

Space and light and shade have been employed to heighten the emotional effect in the same way that these elements were used in a Baroque tableau, like Bernini's Saint Teresa. We have here a new type of relief composition, in which some of the figures are carved completely in the round, and the whole action takes place in a deep box. Indeed, the whole effect is not unlike that of some of the elaborate dramatic effects achieved in the performance and setting of the Indian theatre. In this new conception of relief sculpture there seems to be no longer any limitation in space. We have the feeling that we are not looking at a relief in the usual sense, but as seen taking place in the same general space or atmosphere which we occupy and with which the space of the carving is co-extensive. This is a quality vaguely suggested by the Amarāvatī reliefs and partially realized by the great carving of the Descent of the Ganges at Māmallapuram. But the extraordinarily dynamic conception of the Kailasa relief and the dramatic emotionalism of the individual forms are creations of the Dravidian imagination in its finest hour of artistic expression.

From the stylistic point of view, the figures of Śiva and Pārvatī, with their long, pointed faces and attenuated grace of proportions, are closely related to the shapes of the gods at Māmallapuram. The communication of emotional tension through pose and gesture, rather than through facial expression, was, it will be remembered, already highly developed in some of the

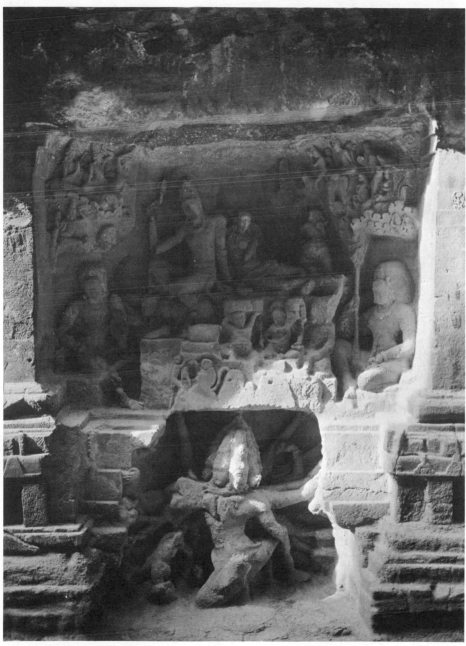

243. Ellūrā, Kailāsanāth temple,
Rāvaṇa shaking Mount Kailāsa

Later Āndhra reliefs, which were, of course, the artistic prototypes of the Pallava style. Not the least important element in this gigantic theatrical tableau is the figure of the giant Rāvana. His multiple arms, indicative of his manifold powers, are spread out like the spokes of a wheel, their arrangement effectively communicating the idea of the superhuman pressure that he is exerting against Śiva's mountain throne.

The last great achievement of architectural sculpture in western India is the cave temple on the island of Elephanta in the harbour of Bombay. This sanctuary was ruthlessly desecrated by the Portuguese in the sixteenth century. A stone panel with a lengthy inscription, presumably including the date of dedication, disappeared at the same time, so that the age of the temple remains a matter of conjecture, but its date is no earlier than the eighth or ninth century.

The temple proper is a pillared hall roughly ninety feet on a side with six rows of six columns 'supporting' the roof of the cave. The arrangement of the sanctuary is an outgrowth of such earlier plans as the temple at Bhumara in which space was provided for an interior circumambulation of the shrine [244]. Actually, since at Elephanta the main object of worship is attached to the back of the hall, the arrangement more nearly resembles the interior of the Lādh Khān temple, where the shrine occupies a similar position and pradaksina is impossible [159].

As in many cave temples, the pillars show the greatest irregularity not only in alignment but in individual details of carving; in many the corners of the bases are not even true right

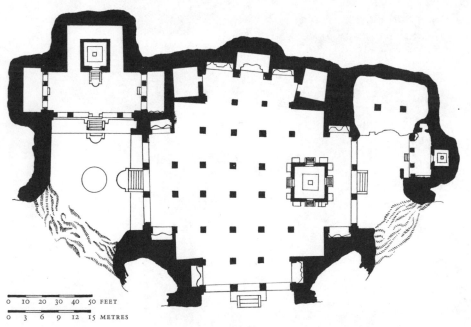

0 10 20 30 40 50 FEET

0 3 6 9 12 15 METRES

244. Elephanta, Śiva temple

angles. These imperfections, due to the enormous difficulties in disengaging these members in the process of hollowing out the interior, might be regarded as architectural accidents which add aliveness to the conception. The individual columns are essentially of a Dravidian type, with a high, square base growing into a round, channelled neck surmounted by a flat, ribbed, cushion-shaped capital, the final development of the form already seen at Ellūrā. Between the capital and the roof-beam are an abacus block and a bracket-like member, which, in structural examples, supported the weight of the rafters.

The interior contains no less than ten enormous and spectacular carvings of the legend of Śiva [245]. Most awe-inspiring of all, at the end of the nave, opposite the northern entrance to the temple, is a gigantic carving of a Saivite Trinity. This triune conception presents the supreme form of Śiva Mahādeva as the central of the three faces; at the left, in profile, is the skull-crowned head of Aghora-Bhairava, Śiva the Destroyer; and, balancing it at the right, the face of Umā, the beautiful wife or śakti of the third member of the Brahmanic Trinity. As in some of the reliefs at Ellūrā, the figures are set in an enormously deep, box-like niche, so that they seem to emerge from an unlimited and nebulous darkness. The three gigantic heads are perfect embodiments of the iconographic concept they signify: the impassiveness and august serenity of the supreme Śiva made manifest; the moving, satanic countenance of the wrathful Aghora-Bhairava; and the youthful peace and beauty of the face of Umā.

245. Elephanta, Śiva temple, Śiva Mahādeva

The subsidiary tableaux at Elephanta are arranged like so many Stations of the Cross, each dedicated to a significant aspect of Śiva Mahādeva. They are, like the great Trinity, a perpetuation of the Ellūrā style. The treatment of the subjects, ranging from the *Trimurti* and such dynamic conceptions as the Naṭarāja (Śiva as Lord of the Dance) to a panel like the Betrothal of Śiva and Pārvatī [246], reveal the extraordinary ability and scope of the Dravidian sculptor in presenting themes both terrible and lyrical. The representation of Śiva's Wedding is a timeless scene of bliss, its setting a deep grotto, the cavern of the heart, 'wherein the fire of life, the energy of the creator, is quick with the ardour of its eternal source and at the same instant throbbing with the pulse of time'.[29] This is a scene of complete tranquillity and peace. The columnar figures of Śiva and his

246. Elephanta, Śiva temple,
Betrothal of Śiva and Pārvatī

spouse are set off against a recess of darkness, in which hover the forms of countless airborne devas come to praise the climax of the god's union with his Himalayan bride, a wedding that typifies the world and all its myriads proceeding from the reunion of the One who was never divided. The mood of untrammelled, ideal love is enhanced by every aspect of pose and gesture – the tenderness with which Śiva turns to his consort, and the gentle swaying of Pārvatī's youthful body. Like the reliefs at Ellūrā, the colossal panels at Elephanta suggest spectacular presentations on a stage, their dramatic effectiveness enhanced by the bold conception in terms of light and shade. Probably such a resemblance to the unreal world of the theatre is not entirely accidental; for in Indian art, as in Indian philosophy, all life, even the life of the gods, is a *līlā*, an illusion or play set against the background of eternity.

It may be noted in conclusion that current investigations by Dr Walter Spink of the style of the sculpture of Elephanta, supported by comparisons with carvings of the fifth and sixth century at Ajaṇṭā, suggest that the truly classic aspect of this noble monument may be explained by regarding it as a work of the late Gupta or immediately post-Gupta Period.

10. SOUTHERN INDIA

The great period of Dravidian structural architecture in southern India culminated under the Chola Dynasty, which became paramount in power over all India as far north as the Ganges and extended its sway at one time as far as Ceylon and Burma. The history of the Chola monarchy reached its climax under Rājarāja the Great (985 – 1018). This ruler, like all the Chola kings, was a devotee of Śiva. He recorded his conquests in an inscription girdling the base of the great temple that he raised to Śiva at Tanjore, the Rājrājeśvara temple, erected *c*. A.D. 1000 [247].

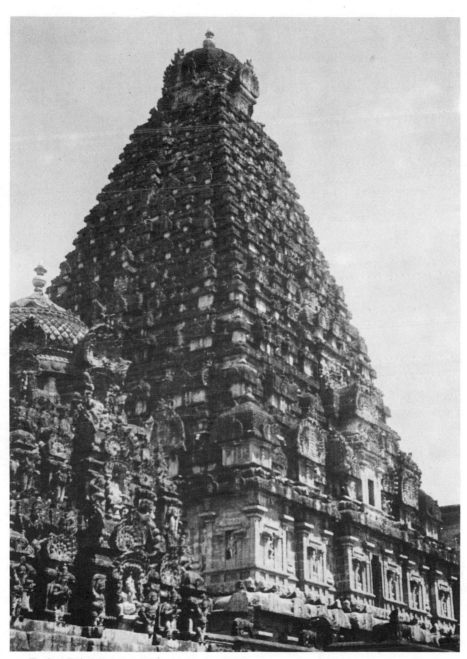

247. Tanjore, Rājrājeśvara temple

This building is one hundred and eighty feet long and has a tower rising one hundred and ninety feet in the air. The elevation comprises a pyramidal structure rising from a square base about fifty feet high and surmounted by a domical finial. The top of this spire is covered by a single stone weighing eighty tons. A ramp four miles in length was required for its installation. Far more important than these dimensions testifying to the colossal nature of the achievement and the labour that went into its making is the actual aesthetic effectiveness of the monument. The steep tower is not only enormously impressive, rising above the empty sea of courtyards around it, but extremely beautiful in its proportion. The width of the apex is one-third that of the base. The form of the tower is that of the Dravidian śikhara, but the horizontal dividing lines of its thirteen storeys have been suppressed so as not to interfere with the effect of soaring vertically achieved by the converging lines of the truncated pyramid in profile. The massiveness of this pyramid and its composition in straight lines is offset by the curvature and lightness of the dome. This member is now octagonal and topped by the usual Dravidian stūpika. Attached to it at the points corresponding to the sloping faces of the tower are chaitya arch-shaped 'horns', composed of an ornament formed of nāgas and a terminal *kirtimukha* or demon-mask, a shape that is rhythmically repeated many times in the ornamentation of both the tower and the base that supports it.

Like so many temples of the Hindu Renaissance, this structure proves upon close inspection to consist of the repetition of many identical elements, comparable to the cells in a biological organism. We notice here, for example, the reiteration of the shape of the terminal cupola in lesser replicas at the corners of all the thirteen storeys. Between these on every level of the terrace are aedicules with hull-shaped roofs, clearly reminiscent of this form at Māmallapuram. Indeed, not only in such details but in

the employment of the roll cornice, on the basement storey and on every successive level of the superstructure, it is not difficult to discern the survival of elements of Pallava origin.

The decoration of the basement, divided into two levels, consists of deep-set niches filled with free-standing figures of deities, an arrangement that again has its origin in the raths at Māmallapuram; and, under the lowest row of niches, is a frieze of unfinished busts of lions, and beneath this a wide band of masonry given over to an inscription of Rājarāja's campaigns.

It should be noted that the plan of the Rājrājeśvara temple, consisting of the garbha griha under the central spire preceded by a pillared maṇḍapa, is only an enormous enlargement of the very simplest form of Indian sanctuary. The wonderful balance between architectural mass and verticality, together with the subordination of enormous detail to the complete form, makes this temple at Tanjore perhaps the finest single creation of the Dravidian Hindu craftsman in architecture. As we shall see in later chapters, the importance of the Chola style in architecture, from its plans to its smallest details, is not limited to the actual domains of the Chola emperors, but was to exert a powerful influence on all the architecture of south-eastern Asia.

The stone sculpture of these Chola temples is typical of the creative vitality of this last great period of South Indian civilization. Although parts of a vast iconographic scheme, the images on the temple façades are still worthy of analysis as individual works of art. The main themes are, of course, the various manifestations of the great gods of the Hindu pantheon. As on the gateway of the Great Temple at Tanjore, we find the gods set in niches, framed in engaged columns that repeat the order of the Rājrājeśvara temple. The individual figures, like the doorkeeper in our illustration 248, are characteristically Dravidian in the suggestion of dynamic movement and the massive conception of the form. The iconography of this most dramatic

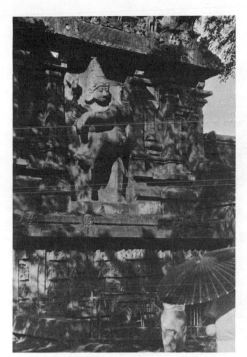

248. Tanjore, Rājrājeśvara temple,
gateway, doorkeeper

aspect of Śiva will be found fully developed in
the magnificent bronze images of the Naṭarāja
of the Chola Period.[30] The bronze medium by
its very nature afforded the craftsman greater
freedom to express the movement and passion
of Śiva's Dance; but even in this stone figure,
which is actually a high relief, there is a sugges-
tion of the boundless, whirling energy of the
cosmic measure. The sense of violent and yet
effortless movement is conveyed by the *contrap-
posto* of the figure and by the co-ordinated
rhythm of the left leg and arm.

I I. VIJAYANAGAR

It could be said that if the temple at Tanjore may
be described as typical of the Renaissance of

Hindu architecture, then the fantastic architec-
ture of the city at Vijayanagar suggests the most
florid phase of European Baroque. The roman-
tic history of this principality is linked up with
the final stand of Hindu India against the
Mohammedan invaders. According to tradition,
Vijayanagar, the City of Victory, was founded
by refugees from the Mohammedan invaders
in the rocky wilderness on the banks of the
Kistna River. The accounts of Arabic, Portu-
guese, and Italian visitors present a picture
of the fabulous wealth and luxury of this bul-
wark against Islam. The capital of this chivalric
Dravidian dynasty was located in a landscape of
a wild and desolate character, dominated by
huge fantastic boulders, so that probably even
in the days of the glory of Vijayanagar the effect
was that of a city rising on a dead planet. The
picturesque irregularity of the terrain not only
aided the builders in erecting fortifications that
repelled the Mohammedans for more than two
centuries, but perforce made for a close associa-
tion between the buildings and their solid rock
foundations, so that it is sometimes difficult to
tell where nature leaves off and the work of man
begins. When the Mohammedans finally con-
quered Vijayanagar in 1565, the victors devoted
an entire year to destroying the city methodi-
cally with fire, gunpowder, and crowbar, so that
today only the broken skeleton of the mighty
fabric remains.

In contrast to what we have seen at Tanjore
and elsewhere, the architecture at Vijayanagar
consisted of groups of small structures rather
than single large temples. Perhaps the most
famous single temple was the Viṭṭhala sanctuary,
begun by Krishna Deva in A.D. 1513. The struc-
ture consisted of two maṇḍapas and a garbha
griha, two hundred and thirty feet long and
twenty-five feet high. The most striking feature
of this edifice is the immense pillared hall of
fifty-six columns, each twelve feet in height.
Each one of these piers is really a complete
sculptured group rather than an architectural

249. Śrīraṅgām, Trichinopoly, maṇḍapa

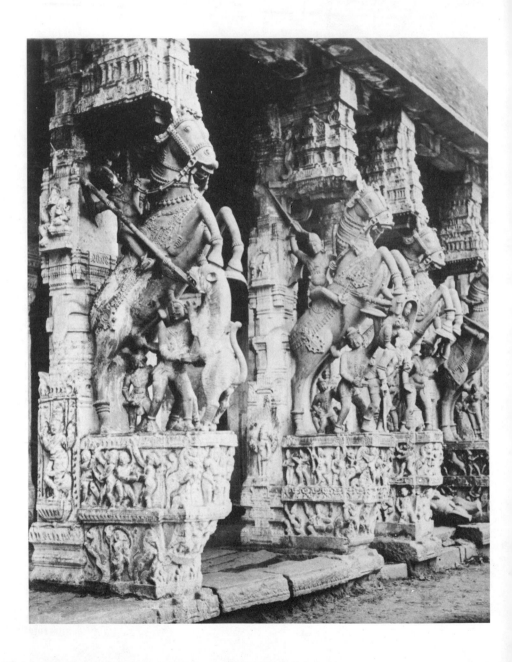

order, composed of such motifs as rearing chargers, trampling barbarians, and fantastic monsters. These gigantic pillars flowering into immense brackets and entablatures were described by the Portuguese visitor, Domingo Paes, as 'Romanesque' and 'so well executed that they appear as if made in Italy'.[31]

The Vijayanagar style of sculpture persisted in South India long after the fall of the City of Victory. A notable example is the maṇḍapa of the enormous seventeenth-century temple at Śrīraṅgām, where we see an entire colonnade of rearing horsemen, each steed nearly nine feet in height [249]. These charging cavaliers are in a sense the final fantastic evolution from the column supported by a rampant animal, which begins in Pallava architecture. It here attains an extravagance that has an inevitable suggestion of the grotesque and fanciful quality of some European medieval art. This motif, suggestive of St George and the Dragon, was, according to Percy Brown, inevitable for a civilization like that of Vijayanagar, which in so many respects parallels the chivalric period in the West.[32] The precision and sharpness with which the highly polished chlorite stone is carved into the most fantastic and baroque entanglements of figures almost make it appear as though they were wrought in cast steel, rather than stone. This extraordinary dexterity in the working, or, perhaps better, torturing, of the stone medium is as much a sign of decadence in sixteenth-century India as it is in Italy of the Baroque Period.

12. MADURA

The final chapter of Dravidian architecture is the building activity of the Nayak Dynasty of kings who were established with their capital at Madura in the seventeenth century. The temples of this last Dravidian dynasty, exemplified by the shrine at Tiruvannāmalai and the Great Temple at Madura [250], are distinguished first of all by a great expansion of the temple precinct. It is veritably a city in itself [251]. This expansion is due to the corresponding enlargement of the Hindu ritual with specific reference to the spiritual and temporal aspects of the deity. The immense courtyard surrounding the central shrine was designed to accommodate the crowds who would gather to see the processions, when the gods, like temporal rulers, would be taken from their shrines and displayed to the multitude. The temple grounds are now surrounded by a high boundary wall with immense portals surmounted by towers or gopuras located at the cardinal points. These structures can best be described as rectangular towers, concave in profile and surmounted by hull-shaped roofs of the vesara type. The gopuras in their immense scale completely dwarf the central shrine within the temple enclosure.

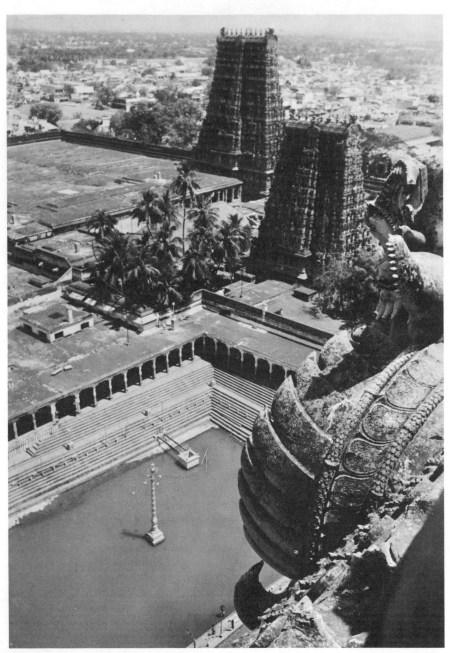

250. Madura, Great Temple

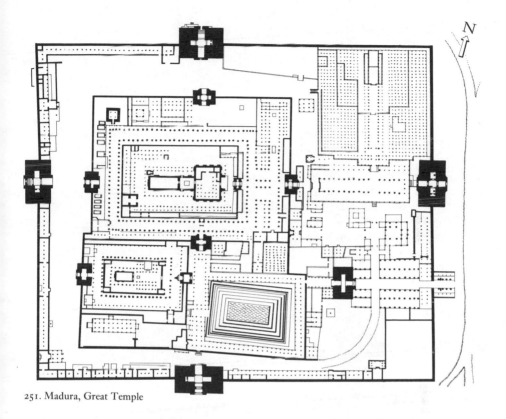

N

251. Madura, Great Temple

These immense structures are covered from top to bottom with a vast number of heavily stuccoed images of the Hindu pantheon. It is hard to believe that each of these hundreds of drily carved and vulgarly finished images was the work of a śilpin and held in the same regard by their makers as we consider the few surviving masterpieces of the Gupta Period. This sculpture, important only in its iconographic aspect, is an illustration of the stultifying effect of adherence to technical recipes and systems of canonical proportion in a period of mass production.

Within the outer walls of the temple compound we finally come to the central shrine through a maze of covered courts and colonnades. The whole purpose of this huge complex is to stir the emotions of the devotee. It has been pointed out that the plan is not unlike that of the temples of ancient Egypt, in that the worshipper enters by an awe-inspiring pylon or gopuram, and through a series of immense hypostyle halls is ultimately led to the innermost ghostly gloom of the holy of holies. At Madura the maṇḍapas of the early Dravidian style have been expanded to vast pillared halls. Indeed, the number of individual columns at this famous shrine is more than two thousand. A new element is a tank or basin for ritual ablution surrounded by a columned cloister. For all the novelty of its huge but unsystematic plan, the architecture of Madura represented only an exaggeration of already established forms in every detail of its structure, rather than a new development.

Thus it might be appropriate to close our consideration of Dravidian architecture with a more charming example of the style. This is the Subrahmaṇiya temple which was erected in the enclosure of the Rājrājeśvara temple at Tanjore as late as the eighteenth century [252]. Its plan is very simple, consisting of a garbha griha preceded by a completely enclosed maṇḍapa. Its effect is considerably more ornate than that of the Great Temple which adjoins it. In comparison with earlier works of Dravidian architecture the style can be described as Rococo, since the architectural impressiveness of the temple is dependent not so much on the proportions of the structure as a whole as on the animation of the entire surface through very delicately carved sculptural and architectural detail. A very pleasing lightness is achieved through the character of the sculptural decoration of the tower and cornice and the attenuated engaged columns that are affixed to the wall more as decoration than as part of an organic architectural scheme. The immense quantity of delicate carving is part of that insatiable desire for richness of effect which seems to have overwhelmed Indian architects of this last period, the period that has been well described as one of brilliant decadence.

13. MYSORE

What is sometimes regarded as an intermediate type of temple building related both to the Indo-Aryan and Dravidian traditions is rep-

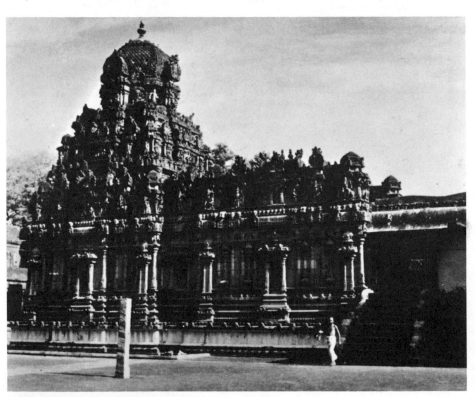

252. Tanjore, Subrahmaṇiya temple

resented by a large group of shrines erected under the Hoysala Dynasty in Mysore between the years 1050 and 1300. These sanctuaries, of which the Kesava temple at Somnāthpur may be taken as a typical example, have certain features that separate them from the rest of India and yet partake of the main stylistic developments of the North and South. Among such peculiarities are a star-shaped plan with three shrines grouped around a central pillared hall. The śikhara towers over each cella carry upward the indentations of the ground plan. Also characteristic are the high podium, intricate grille windows, polished and apparently lathe-turned pillars, and, above all, an almost incredible richness of sculptural decoration. The temple at Somnāthpur [253], erected in 1268, is

a small but perfect illustration of the type with the radiating stellate plan of three shrines attached to a central hall plainly visible in the illustration. It will be noted that the śikharas do not have the continuous parabolic silhouette of the northern type, but are constructed in well-defined horizontal tiers, so that even in the spires the general effect of horizontality is carried through These towers could be described as a compromise between the Aryan and Dravidian types.

The most extraordinary feature of the Hoysala temples, and one that makes them so extraordinarily photogenic, is the incrustation of sculpture that covers them literally from top to bottom. The material of most of these shrines is chloritic schist, a very fine-grained stone much

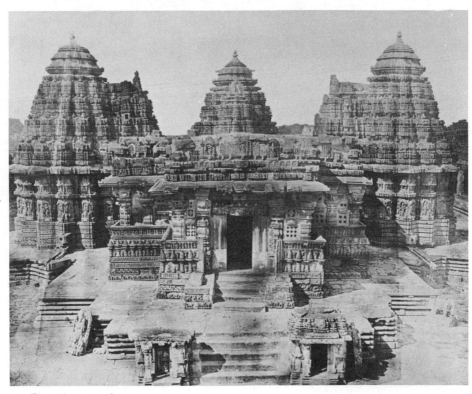

253. Somnāthpur, temple

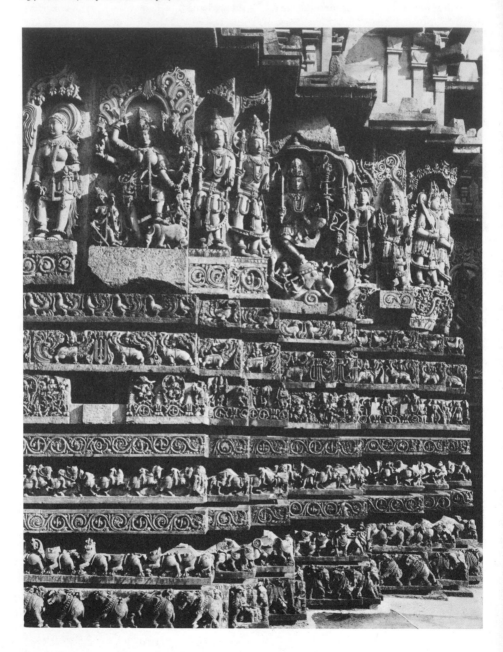

more tractable to the chisel than sandstone or granite. It has the added virtue of being soft to work when first quarried and turning to adamantine hardness on exposure to the air. In the hands of the Mysore craftsmen the exterior of the temples is a Churrigueresque riot of carving that defeats description. Underlying this plastic exuberance there is, of course, a strict iconographical framework governing the installation of divinities and epic narratives. A detail of the Hoyśaleśvara temple at Halebid, built in 1141–82 and surpassing all others in the prodigality of its sculptural embellishment, shows the fixed order of decoration for the base [254]: in the lowest tier is an endless defile of elephants, symbols of stability; next, a row of lions, emblems of valour; above, a tier of horsemen for speed, and, in still higher horizontal registers, makaras, and haṁsa, the geese, or birds of Brahma. Above this, as may be seen also at Somnāthpur, is a frieze of divinities conceived like so many separate panels or *bibelots* set side by side, and each, in the amazing virtuosity of the carving, suggesting an enormous enlargement of a small sculpture in sandalwood or ivory. It is difficult not to admire the skill of these craftsmen, but at the same time we must recognize here, as in the late architecture at Tanjore, a kind of Rococo over-ripeness and decadence, a style that, as Percy Brown has observed, might better be described as applied art than as architecture. It should be remarked, however, that, even though the architecture seems smothered in carving, what we would call this 'wedding-cake' embellishment actually carries out and does not interfere with the main structural lines of the building it ornaments.

255. Bronze Śiva from Tanjore.
Kansas City, Nelson Gallery of Art

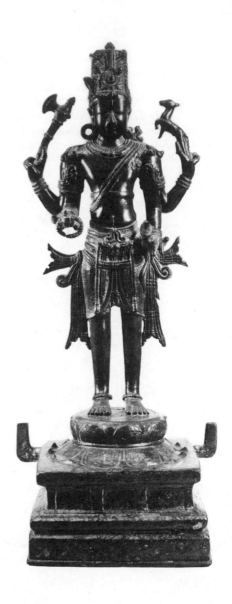

SOUTH INDIAN BRONZES

The earliest metal sculpture in South India is closely related to the style of stone carving, just as the Gandhāra and Gupta bronze statuettes are the counterparts of images of the Buddha in stone [175–7]. A beautiful example of metal work in the Pallava Period is a bronze statue of Śiva [255]. This figure represents a period when the full possibilities of bronze as a medium for fluid and dynamic expression had not been realized. The image, as though lifted from a relief at Māmallapuram, has something of the static and rigid quality imposed by carving in stone. It is the metal counterpart of the Durgā of illustration 237 and is filled with the same vibrant feeling of self-contained ecstasy. This figure is like a stone relief, confined to a very few planes with the arms and scarves deployed in semaphoric fashion to right and left. Unlike the later bronzes it does not give the impression of the form's embracing space and moving freely in an unlimited ambient.

The final, and in many ways the finest, chapter of Dravidian art is the history of metalwork in southern India. The art of southernmost India, the home of the Tamil race, has in historical times been dedicated entirely to the Hindu religion and, especially, to the worship of Śiva. The popularity of the great Yogin, at once creator and destroyer, began in the eighth century, when bands of Saivite holy men, real troubadours of Hinduism, journeyed through the country singing hymns with reference to every shrine they visited. Their success in conversion was so great that by the year 1000 all traces of Buddhism and Jainism had practically disappeared.[1]

The South Indian metal images were made of bronze with a large copper content, and the method of casting them was essentially the *cire perdue* or 'lost wax' process.[2] The South Indian icons were made according to just such canons of proportion as determined the forms of Buddha statues of earlier days. The total height of the statue in proportion to the number of thalams or palms that comprised it depended on the hieratic status of the deity represented. Likewise three distinct poses were employed to express the spiritual qualities of special deities. These varied from a directly frontal, static position reserved for gods in a state of complete spiritual equilibrium, to poses in which the image was broken more or less violently at two or three points of its axis, a pose reserved for the great gods personifying cosmic movement or function. In addition to these poses there was also, as in Buddhist art, a great repertory of mudrās, the enormously formalized and cultivated language of gesture, in which the worshipper might read not only the special powers and attributes of the god, but also the particular ecstatic mood or feeling that the deity personified. Also rigidly prescribed were the types of head-dresses and jewellery appropriate to the deities of the Hindu pantheon.

Typical productions of the South Indian school of the eleventh century and later are the images of Śiva saints. One of the most popular of these is Sundaramūrtiswāmi, whom Śiva claimed as his disciple on the youth's wedding day. The example illustrated [256] is typical of the personifications of this Hindu psalmist, showing him as though arrested in sudden ecstasy at the vision of Śiva and his court. It will be noted that the figure is cast in tribhanga pose, which we have seen so many times in images from the Śunga Period onward. It is the moving

line of the silhouette provided by this *déhanchement*, together with the exquisite gestures of the hands, that imparts such a feeling of tremulous movement to the form. The actual exaggerations of features and proportions, such as the lotiform eyes and leonine torso, are the same that had been employed for more than a millennium of Indian art. The peculiar combination of all these traditional elements, subordinated to a kind of elegant attenuation and litheness, is a moving characteristic of all the great South Indian bronze images.

Like some of the masterpieces of the Gupta Period, the icons of this type appear as marvel-

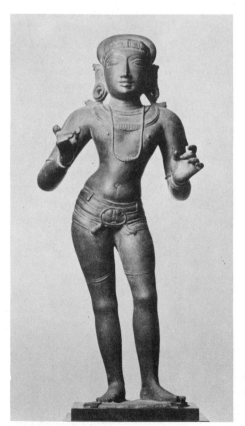

256. Bronze Śiva saint,
perhaps Sundaramūrtiswāmi, from South India.
Kansas City, James Baldwin

lous realizations of a moment between movement and tranquillity, together with a suggestion of a quality of breathless rapture denoted by the gestures and the tension of the form. These statues of Śiva saints might be regarded as personifications of the quality of devotion. They reveal the ecstatic readiness of the devotee for his divinity, the whole figure seemingly vibrating in response to the divine communication. Although differentiated as types and by attributes, they are really not so much 'portraits' of individual Hindu seers as they are concrete presentations of the idea of bhakti in plastic form, just as a Byzantine mosaic of a saint is not a likeness but a symbol of dedication to God.

An extraordinary South Indian bronze is the image of Pārvatī in the Freer Gallery in Washington [257], where it is dated in the eleventh or twelfth century A.D. Like many of the South Indian metal statues, this was a processional image, as may be seen by the lugs for the insertion of poles at the base. The figure has an extreme attenuation of nine thalams to the total height; this svelteness, together with the elongated limbs, give the goddess an air of aristocracy and grace, suggestive of the refinement of figures in the Mannerist style in Europe, for the reason that this quality is achieved by a similar exaggeration of bodily proportions. As may be seen by an examination of the torso, the body is animated by the same inner torsion that imparts such dynamic aliveness to the classic figure of the Sānchī tree-goddesses. The roundness of the breasts, corresponding to the traditional description as 'golden urns', is emphasized by the cord that passes through the narrow channel between them. In spite of the hieratic proportions and the archaic rendering of the features, this statue has the same feeling of lightness and animation that characterizes all the great masterpieces of South Indian metalwork.

A quite different type of bronze is the statuette of Kālī from Tanjore, now at Kansas City [258]. Kālī the 'Black One' is the

257. Bronze Pārvatī from South India.
Washington, D.C., Freer Gallery of Art

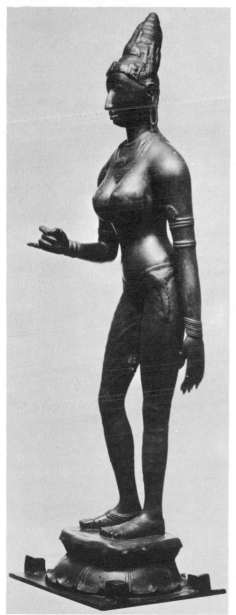

terrible aspect of Śiva's spouse Pārvatī. She is
the goddess of destruction and death, worship-
ped at the noisome Kālī temple at Calcutta, who
claims the blood of millions in pestilence and
war. She is shown as a dreadful, emaciated hag,
squatting in the burning-ground and holding
the cymbals which clash the measure of her
ghoulish dance. The same suggestion of tension
and imminent movement observed in other
South Indian bronzes is present in this statue.
Protruding tusks specifically proclaim her de-
moniacal aspect, and the modelling of her
enormous eyes, scored with lines repeating their
outline under brows in the familiar shape of the

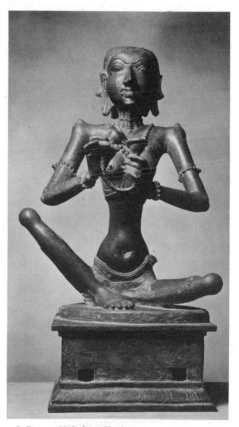

258. Bronze Kālī from Tanjore.
Kansas City, Nelson Gallery of Art

bow, emphasizes their strange and burning intensity. There is in this figurine an appropriately horrid suggestion of the famine victim and, in the spider-like limbs, a reminder of those artificially made cripples that flail their broken legs in every Indian bazaar. The rendering of the emaciated figure has nothing to do with the realistic definition of wasted anatomy as we know it in such Hellenistic works as the Alexandrian statuette of a sick man:[3] the very abstraction of the tubular limbs and the exaggerated attenuation of the torso, especially in the great distance between pelvis and thorax, not only emphasize the nature of the famine-racked body, but impart a certain grandeur to the seated figure by thus increasing its height and bestowing a regal bearing on this most frightful of Indian goddesses.

The most famous and dramatic of the images of the South Indian school are those of Naṭarāja, or Śiva as Lord of the Dance [259]. To the

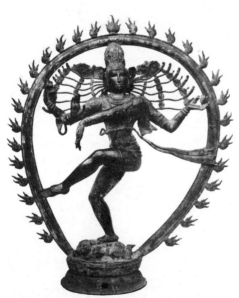

259. Bronze Naṭarāja from South India.
Madras, Government Museum

Dravidian imagination, Śiva's dance, the Na-dānta, is the personification of all the forces and powers of the cosmic system in operation, the movement of energy within the universe. In him they have their dayspring and in him their death.[4] 'This plastic type, more than any other, expresses the unity of the human consciousness, for it represents equally religion, science, and art. This unity has illumined the imagination of the philosophers of many races; but the Indian Naṭarāja may well be claimed as the clearest, most logical, and impassioned statement of the conception of life as an eternal Becoming'.[5] Śiva's dance personifies his universe in action and destruction. This is his dance in the last night of the world when the stars fall from their courses and all is reduced to ashes, to be ever rekindled, ever renewed by the boundless power of the Lord. Śiva is personified as the universal flux of energy in all matter and the promise of ever-renewed creative activity.[6] The dionysian frenzy of his whirling dance presents a symbolic affirmation of the eternal, unseen spectacle of the dynamic disintegration and renewal, birth and death, of all cosmic matter in every second as in every kalpa of time – the same illusion of endlessly appearing and vanishing forms that is implied in great monuments of Indian art from Bhāja to Māmallapuram.

One of the greatest Naṭarāja images is preserved in the museum at Colombo [260]. It was found in the ruins of one of the Hindu temples at Poḷonnāruwa, and may have been imported from the workshops of Tanjore in the eleventh century. The figure, a perfect fusion of serenity and balance, moves in slow and gracious rhythm, lacking the usual violence of the cosmic dance; this is a cadenced movement communicated largely by the centrifugal space-embracing position of the arms and the suggestion of the figure's revolving in space. The turning effect that comes from the arrangement of the multiple arms, one behind another, and the torsion of the figure, emphasized by the directions of

260. Bronze Naṭarāja from Poḷonnāruwa.
Colombo, Museum

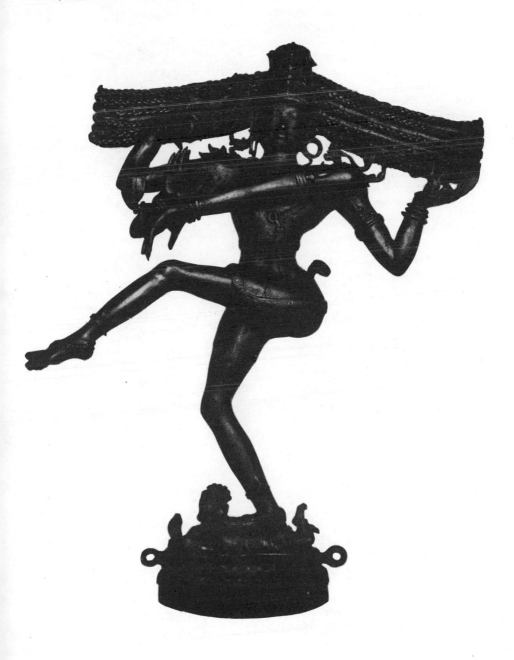

the limbs, give something of the effect of the *figura serpentinata* in Mannerist sculpture that seems to coerce the beholder into a consecutive inspection of the image from every angle.

In their canon of absolute, rather than human, beauty, and the almost mathematical purity and clarity of form, these images are the perfect symbols of the Indian ideal. Although cast in human shape, the abstraction of modelling and iconographic explicitness give them the power of a diagram. Like all Indian images, they were emblematic evocations, not descriptions, of a deity that the worshipper had always in his heart and mind. Indeed, the art of these South Indian icons is not the language of any one time or any one place, but a language that can be understood everywhere and eternally in the hearts of spiritual men.

<p style="text-align:center">*</p>

The number of objects belonging to the decorative arts surviving from the Period of the Hindu Dynasties is so vast, especially in the remains from later centuries, that only a small sampling of this material can be presented, and only the most unusual and interesting types described. The account of this aspect of later Indian civilization may be divided into accounts of objects in metal, ivory, textiles, and jewellery. As in previous sections, I have chosen objects that may be integrated with the account of monumental art.

Metalwork is one of the most ancient and splendid crafts in India, and the forging of iron was far in advance of any methods developed in Europe before the nineteenth century. Precious metal, as well as tin and lead, are mentioned in the *Yajur Veda*, and there is a possibility that the making of steel may have even originated in India and was known to the Greeks and Persians. The subject of Indian arms and armour is vast and specialized, and one can only mention as examples the magnificent swords and elephant goads forged and chiselled with intricate designs

261. Steel sword from South India.
London, Victoria and Albert Museum

at Tanjore and elsewhere in South India in the seventeenth century [261]. Damascening, or inlaying by the pressing of gold and silver wire into grooves prepared on the surface of the metal, has been practised for centuries for the embellishment of all kinds of weapons and metal objects in steel or brass.

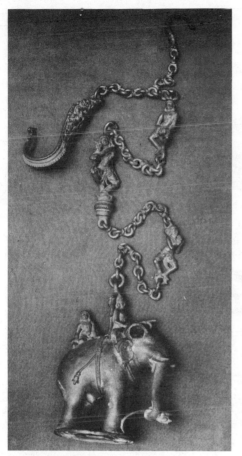

262. Bronze temple lamp and chain
from the Jogeśvari caves, Bombay.
Bombay, Prince of Wales Museum

in Hindu sanctuaries. The figures of dancers interrupting the links of the chain remind us of Chalukya sculpture [242 and 243], and the beautifully wrought elephant recalls the characterization of these beasts at Māmallapuram [234 and 235]. Metal objects of this sort were cast solid, according to the cire-perdue process. A number of literary works of the Pallava and Chalukya Periods refer to the art of bronze casting, notably the *Manasollasa* of the Western Chalukya king Someśvara (1122–38).

Another early example of metalwork in South India is a large round bronze basin supported by elephant caryatids, which was found in the Kistna region [263]. This object is probably of Pallava or early Chalukya date. The elephant as

263. Bronze basin from the Kistna region.
London, Victoria and Albert Museum

One of the earliest examples of metalwork from the Period of the Hindu Dynasties is a chain for a temple lamp found in the Jogeśvari caves (Bombay) [262].[7] This object may be dated in the eighth century, the period of the Western Chalukyas. Such chains were used for swinging lamps, like censers, at evening worship

a supporting member is familiar in the architecture of Gandhāra and on a monumental scale on the base of the Kailāsa temple at Ellūrā and in the platform, or 'Elephant wall', supporting the Ruvanveli dāgaba at Anurādhapura.[8]

Among the great works of minor art from the Period of the Hindu Dynasties are the jewel

caskets with revetments of ivory plaques. These objects are usually attributed to South India and, specifically, Madura, although some may have been carved in Ceylon in imitation of Tamil models. A very complete and beautiful example is in the British Museum [264]. The 'façade' of this jewel box is like a miniature elevation of a Hindu temple, with its superimposed friezes of lions and rosettes, dancing figures, and a cornice of swans recalling the distribution of such subjects on the temples of Halebid [254] or on the classic Singhalese buildings of Poḷonnāruwa [304]. This South Indian tradition of ivory carving survives in Travancore and Mysore to the present day, and is descended from the beautiful craftsmanship of eighteenth-century Madura. This classic technique is represented by a superb plaque of Krishna and Radha entwined in erotic embrace, a tiny repetition of the *mithuna* theme favoured earlier at Konāraka and Khajurāho [265].[9] The manner in which these smooth, seemingly boneless bodies intertwine and literally melt one into another adds to the provocative charm of a work in which originally the addition of colour and gold set off the creamy lustre of the bodies. As usual in South Indian ivory carvings the figures are in high relief against the openwork background.

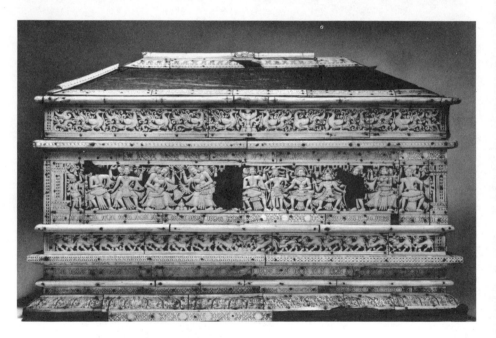

264. Ivory jewel casket from South India.
London, British Museum

Not a single fragment of textile from early centuries of the Period of the Hindu Dynasties has survived in India, but a great collection of cotton fragments discovered at Fostat, near Cairo, is composed of actual Indian textiles of the twelfth and thirteenth centuries or, as some think, Egyptian copies of Indian designs.[10] The presence of block prints in imitation of real tie-and-dye work has led some to suppose that these are local imitations; but other scholars assert that from the thirteenth to the sixteenth centuries India was the sole producer of printed cottons and linens. Certain motifs, like that of geese or haṁsa in lozenges [266], are reminiscent of the Ajaṇṭā ceiling paintings,[11] and a scene of combat between men and beasts has many analogies with Gujarāt manuscript painting, notably in the beak-like noses and the attachment of a second eye to a profile view.[12] The designs, in addition to the haṁsa and elephant patterns, include lotus wheels and many others omnipresent in Indian painting and sculpture.

The textiles of western India may be represented by the embroidered and painted palampores of Gujarāt. As early as the sixteenth century these magnificent 'callicoe hanginges', as they were called in early inventories, were exported to Holland, Portugal, France, and

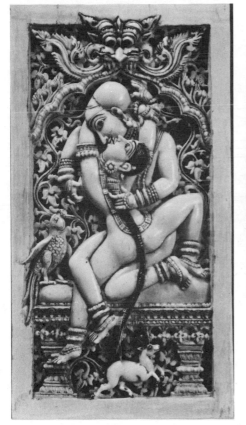

265 (left). Ivory plaque with Krishna and Radha from South India.
London, Victoria and Albert Museum

266. Cotton textile from Fostat.
Cairo, Museum

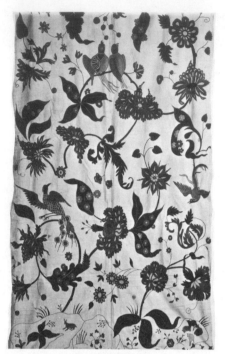

267. Embroidered cotton bed-hanging from Gujarāt.
Ashburnham, Sussex, Lady Ashburnham

268. Embroidered knuckle-pad from Jaipur.
London, Victoria and Albert Museum

England. Their patterns are made up of elements of European, Indian, and even Chinese origin, produced to satisfy the Western taste for the exotic, but united into an individual design by Indian hands [267]. There is evidence that the same stencils were used for painted, as well as embroidered, quilts. Generally, chain stitch was the technique, but in later examples many fancy stitches were employed to show off the glossy fineness of the satin threads. Among the most splendid of all Indian textiles are the painted cotton hangings of Golconda.[13] These cotton paintings were produced by guilds of Hindu craftsmen in the first half of the seventeenth century for the markets of Persia, the Mogul Empire, and Europe. Presumably they were assembled from pattern books based on an earlier tradition, perhaps the mural art of Vijayanagar. The designs were transferred to cloth by means of elaborate stencils. A particularly beautiful seventeenth-century hanging, formerly in a Japanese collection [269], is perhaps the earliest of all, and shows unmistakable connexions with the wall-paintings of the Lapakshi temple.[14] We recognize such mannerisms as the heads and feet presented in profile and the flaring draperies with repeated rippling lines. Such details as the typically South Indian temple pavilions at the top of the composition, and the pattern of monkeys in flowering trees, occur in many other examples of these textiles. Typical of later Indian embroidery are the knuckle-pad covers for shields of the Rajput Period. These are usually worked in cross stitch and silver thread. The early eighteenth-century example depicting a lady and a peacock [268] is from Jaipur, and is like a translation of a Central Indian miniature into textile design.

An epitome of the jewelled ornaments of the Rājput courts may be seen in eighteenth-century Jaipur miniatures, such as the painting of a Lady arranging her Hair [280] and a large cartoon for a wall-painting of Krishna in the Metropolitan Museum of Art, New York.[15]

269. Āndhra textile from the Kalahasti region.
Japan, private collection (formerly)

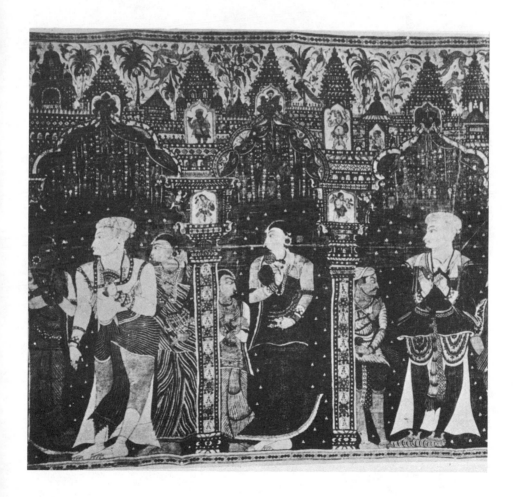

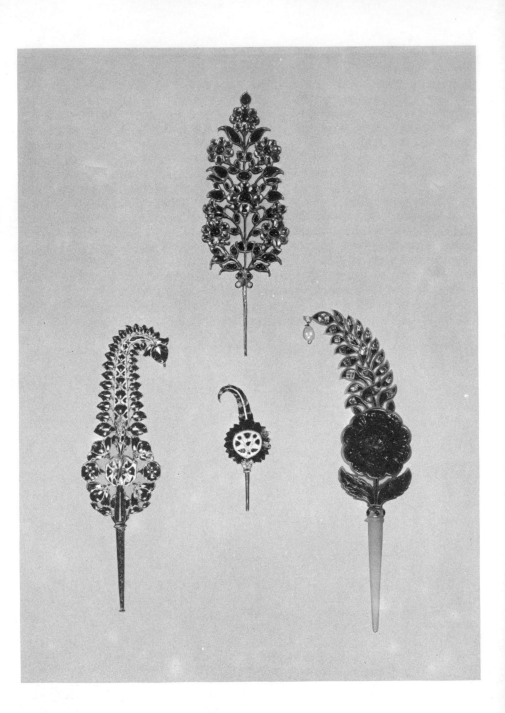

These princely personages wear ropes of pearls. The hair or turban pins and ear pendants may be duplicated in many actual jewels of this period of splendour, such as the superb *sarpesh* or turban pin of white jade combined with diamonds, rubies, and emeralds set with pearls in gold and enamel [270] and a pearl-studded ear-pendant also in the collection of the Victoria and Albert Museum [271]. It should be noted that, as in the miniature paintings of the seventeenth and eighteenth centuries, the jewellery of this time is always a mixture of Rājput or Indian and Mogul styles and techniques.

270 (*left*). Turban pins.
London, Victoria and Albert Museum

271. Ear-pendants.
London, Victoria and Albert Museum

PAINTING OF THE PERIOD OF THE HINDU DYNASTIES:

WALL-PAINTINGS AND MINIATURES

Although probably at one time the great temples of the Hindu Renaissance were many of them decorated with wall-paintings both on the interior and exterior of sanctuaries and maṇḍapas, the actual remains of late painting in India are fragmentary indeed. Among the few remnants of post-Gupta wall-painting are the decorations of a Jain temple at Sittanavāsal, near Madras. These pictures do not lend themselves to photographic reproduction, so a drawing of the main ceiling is shown here [272].

The composition represents a celestial region in the form of a pond in which apsaras, geese, elephants, etc., are sporting in a thicket of enormous lotus-blossoms and fronds. The style perpetuates the Ajaṇṭā wall-paintings of the late Gupta and early Chalukya types, both in drawing and colouring. As even the line-drawing shows, the fanciful and intricate setting is portrayed with the greatest clarity and a feeling for the decorative possibilities of the multiple lotus-flowers and buds set off against the enormous

272. Sittanavāsal, Jain temple, ceiling painting

leaves. The direction of the lines in the composition inevitably suggests a movement across the panel, as though a wind were bending the heavenly blossoms.

These Jain paintings are not far removed in date or style from the earliest paintings in the Kailāsa temple at Ellūrā. Two layers of painting exist on the ceiling of the western maṇḍapa of the Kailāsa temple. The earlier paintings are almost certainly datable to the period of the temple's dedication. These fragments, especially the decorations in the spandrels around the carved lotus boss in the centre of the ceiling [273], are very close in style to the decorative panels on the roof of Cave I at Ajaṇṭā. Both the technique and the subject of celestial beings and elephants playing in a gigantic lotus pond are almost a duplication of the Jain fresco at Sittanavāsal. The upper layer of paintings in the Kailāsa temple [274], datable no earlier than

the late eighth or early ninth century, contains a representation of Vishnu and Lakshmī surrounded by Garudas. Although we may recognize some trace of the Ajaṇṭā paintings in the general composition and colour scheme, certain changes have taken place, particularly in the figure drawing, that proclaim these paintings as a definitely individual style. This is to be discerned in the way that the faces are drawn with extremely sharp features, typified by beaklike noses and bulging eyes, mannerisms which definitely suggest the style of the later Jain miniatures of Gujarāt.[1]

Certain later fragments of painting at Ellūrā are, on the contrary, a direct continuation of the Gupta tradition, as represented by the Ajaṇṭā wall-paintings. These are the ninth-century Jain paintings in the Indra Sabhā cave.[2] The figures of apsaras are reminiscent of the earlier style, but are distinguished from it by an almost

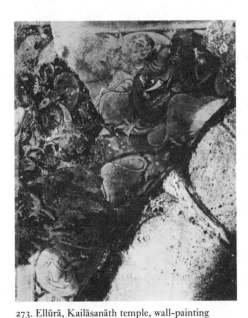

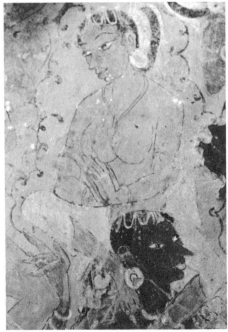

273. Ellūrā, Kailāsanāth temple, wall-painting

274. Ellūrā, Kailāsanāth temple, wall-painting of Lakshmī

Manneristic exaggeration of the canon of the feminine form, as seen at Ajaṇṭā, and by an even more marked employment of entirely abstract plastic shading.

Among the few examples of ancient wall-painting in South India are the decorations of the Rājrājeśvara temple at Tanjore.[3] The figures in this cycle are devoted to the life of Sundara-mūrtiswāmi in a completely Chola style, in which the poses, gestures, and facial types are the pictorial equivalents of the great South Indian bronze images.

Although no example of wall-painting has survived from the Bengal Valley, a very few surviving specimens of illuminated manuscripts give us some idea of the type of painting that flourished under the Pāla Dynasty.[4] The illustrations consist of scenes from the life of Buddha and portrayals of Buddhist divinities. The latter, like the subject-matter of Pāla sculpture, is completely Tantric. Although the technique and compositions frequently reveal a perpetuation of classical prototypes, the difference between these paintings and their Gupta models is the same as that between Pāla sculpture and the great masterpieces of the fourth and fifth centuries. The drawing has become more delicate and nervous in outline. There is the same combination of elegance and sensuality, together with a loss of really plastic modelling, that distinguishes the late Buddhist statuary of the Ganges Valley. These Pāla manuscripts are perhaps chiefly important as the ultimate prototypes of all later painting in Nepal and Tibet.

If the Pāla paintings are the final development of what Tāranātha described as the ancient Eastern school of painting, the final evolution of his 'Western school' is to be found in the Jain painting at Gujarāt. These illuminations, which date from the thirteenth century and later, are all of them illustrations of Jain texts, such as the life of Mahāvīra, or the *Kalpa sūtra*. Invariably, these pictures are as stereotyped as the texts

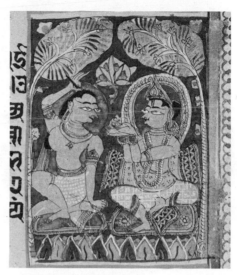

275. Jain manuscript from Gujarāt. *Washington, D.C., Freer Gallery of Art*

they illustrate [275]. They consist of square panels set into pages of text, and the compositions are borrowed from traditional arrangements in earlier Jain or Buddhist art. The Jain manuscripts generally are characterized by their brilliant, even jewel-like colour, and by the type of accomplished linear decoration of every element in the drawing. The individual figures invariably are drawn in three-quarters view, with long pointed noses and protruding eyes. The curious mannerism whereby the cheek farther removed from the spectator is made to project almost beyond the nose is only an exaggeration of a formula already seen at Ellūrā. Although many individual Jain manuscripts have a certain charm in their wiry drawing and brilliant colouring, there is a monotony of execution that is paralleled in the elegant but entirely mechanical Jain figure sculpture of Mount Ābū.

The final chapter of Indian painting is in the work of the Rājput schools. Rājput painting is the work of artists attached to the princely

courts in Rājasthān, Central India, and the Himalayan foothills of the Punjab from about the sixteenth to the nineteenth centuries. It is a style of painting that is apart in subject-matter and conception from the exactly contemporary work of the artists attached to the courts of the Moguls.[5] Whereas Mogul painting is modern in its recording of subjects peculiar to the courts of Akbar and Jehangir, Rājput painting always remains entirely traditional in its illustration of the Indian epics, romantic Vaishnava literature, and musical modes. The development of the Rājput school of painting is the pictorial counterpart of the vernacular literature of Hindustan. The Rājput miniatures are derived from earlier classic styles in eactly the same way that Hindi vernacular writing stems from classical Sanskrit. In this regard Rājput art might be presented as a merging of folk art with hieratic and classic traditions. The Rājput paintings are in a sense the product of the development of popular Vaishnavism centred particularly on the devotion to Rāma and Krishna who typified the worship of Vishnu and Śiva in their more accessible and loving aspects rather than in the hieratic form in which they were venerated according to Vedic ritual. The rise of popular Vaishnavism coincides with the renaissance of Hindu literature and the beginnings of Rājput painting in the late sixteenth century. Rājput paintings are usually on a small scale, although many of them are very obviously reductions of themes originally employed in mural compositions.

Actually, the technique is not much different from that of classic wall-paintings, although the pictures are done on paper. The elements of the composition were first outlined with the brush in light red, possibly over a preliminary hard pencil outline. After the entire surface had been covered with a white priming of starch paste, the main lines were re-drawn in black. The background was coloured and the underpainting of the figures then covered with appropriate local pigments and a final definition of the outlines. The technique, in other words, is exactly the same as that of the Ajaṇṭā frescoes. Over and above this perpetuation of classical technique the Rājput school continues many motifs and the rhetoric of the ancient schools. There is in no sense any drawing from life, but rather a presentation of elements according to formulas imparted by workshop tradition which, as in earlier Indian art, are designed in heroic idealizations beyond the accidentals of ordinary existence. Rājput painting has probably never been better defined than in the words of the late Dr Coomaraswamy:

Sensitive, reticent, and tender, it perfectly reflects the self-control and sweet serenity of Indian life, and the definitely theocratic and aristocratic organization of Indian society. It lends itself to the utterance of serene passion and the expression of unmixed emotions.[6]

In the study of Rājput painting we must always keep in mind the influence of the exactly contemporary schools that flourished at the courts of the Mogul emperors. Whereas Mogul painting was dedicated to realism and the conquest of natural appearance, Rājput painting was, as Sherman Lee has observed, lyrical and emotional rather than intellectual, appealing more to the heart than the mind.[7] Many early Rājput miniatures, especially the albums of Rājasthān and Central India, have a bold, primitive quality, lacking the refinement of Mogul and Persian painting and suggesting the abstract use of form and colour in modern art.

The history of Rājput painting may be divided into an early period (sixteenth and early seventeenth centuries) and a late period from c. 1630 to 1825. According to a geographical division, the miniatures may be assigned to the schools of Rājputāna and central India, generally designated as Rājasthānī, and the work done in the Punjab Himalayas and Garhwāl, referred to as Pahārī.

The Pahāṛī group comprised the work of many local schools. The most important centres for this late flowering of the Rājput style were at Basohli, Jammū, Guler, Kāngrā, and Gaṛwhāl. The great days of this art were in the eighteenth century, but in many of the more remote localities the tradition lasted until the present century.

All Rājput painting, both early and late, may be considered according to the themes represented. The first of these is the illustration of Rāgas and Rāginīs. In this category we find the illustration of the thirty-six musical modes that are associated with seasons, months, days, and hours and are actually regarded as personifications of different phases of love, or various emotional situations in human experience that find their perfect expression in one of these modes. The second category comprises the illustrations of the Indian epics and romances, such as the *Mahābhārata* and the *Rāmāyana*, as well as the epics of Rājput chivalry. A third group of subject-matter is based on Puranic and Tantric texts, and includes such subjects as the Birth of Brahma, the Churning of the Sea of Milk, as well as pictures of śaktis of the great gods. One might include as a subdivision of this class of illustration the innumerable paintings dedicated to the legend of Krishna. A final class of Rājput paintings is concerned with the theme of *Śṛingāra*, 'the flavour of love', with pictures representing in rhetorical fashion the various phases of love and types of heroines and lovers. In all the Rājput schools occasional pages, under the influence of Mogul fashion and technique, present scenes of courtly life, the hunt, and portraits of contemporary personages.

In our consideration of Rājput painting it will be possible to discuss only a few notable examples to illustrate the main historical and stylistic development of the whole school. The transition from the early Jain manuscripts discussed above, to the mature style of Rājasthān, begins with an illustration of the

Bhairavi Rāginī from Mandu in Central India, which may be dated *c*. 1550 [276]. The picture represents a lady kneeling in ardent supplication of a lingam, the phallic emblem of Śiva.

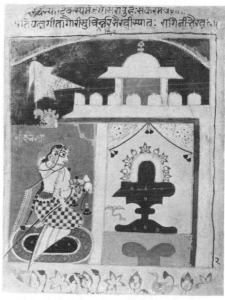

276. Suppliant lady in the *Bhairavi Rāginī* from Mandu.
London, Victoria and Albert Museum

Although there may be lingering reminiscences of the Persian decorative manner, a strongly Indian primitive character asserts itself in the boldly patterned areas of flat colour and the drawing in sharp, angular forms. Invariably in Rājput miniatures the colours play a symbolical role; in this case the red ground is intended to suggest the burning passion of unfulfilled desire.

A quite different school of painting came into being in Mandu in the early sixteenth century. From 1469 to 1501, this Central Indian State was under the sovereignty of the Sultan Ghiyas-ud-din-Khilji, a potentate renowned not only

for his patronage of art but for his insatiable zest for women, a taste which led to his establishing a 'city of women' staffed by 15,000 comely girls from all parts of India, Khorasan, and Bokhara. In addition to pursuing his hobby for Persian girls, Ghiyas-ud-din and his successor, Nasir-ud-din, also maintained cultural affiliations with Iran, and Persian artists undoubtedly contributed a Turcoman reflexion of the Shiraz style to the famous manuscript, the *Nimatnāma*, or 'Book of Delicacies', an illuminated compilation of the ruler's favourite recipes [277]. Such elements as the formalized blossoms, the dress of some of the women, and the abstract beauty of colour are Persian, but the jewellery and vessels, the types of feminine beauty with large eyes, and the stiff, angular veils are Indian in character. As will be noted,

the predominantly Persian traits of this style were absorbed into the later traditions of Indian painting in Malwa and the Deccan.

It is an easy step from the style of these pictures to a group of miniatures painted in Malwa in the first half of the seventeenth century. We may choose as an example of this manner an illustration of the *Vibhāsa Rāgini*, in which we see Kāma Deva loosing an arrow at the cock whose crowing announces the end of love's dalliance [278]. This represents the purest style of Rājput painting. The aim of the illustrator is the most direct and legible presentation of the theme, with little thought for any graces of draughtsmanship or composition. The treatment, again, could be described as conceptual or popular. The figures and the architecture of the bower are presented as

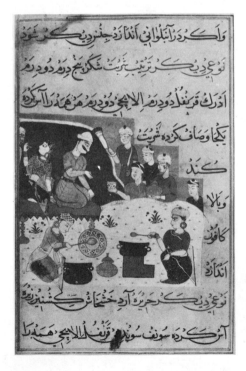

277. The Sultan refreshed with a Sherbet in the *Nimatnāma* from Mandu. *London, India Office Library*

278. Kāma Deva in the *Vibhāsa Rāgini* from Malwa. *Boston, Museum of Fine Arts*

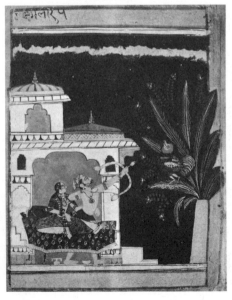

completely flat silhouettes. The cock in the plantain tree is enormously enlarged, so that he may be easily recognized. The background is a dark bluish-black, except for a wavering band of white that symbolizes the coming of the dawn. The drawing, again, is entirely freehand and even crude in the abbreviated definition of forms. The lyricism of pages like this derives from the moving directness of presentation and the abstract pattern of the enamel-like colours.

Painting in the Deccan was patronized by the rulers of the three kingdoms of Ahmadnagar, Bijapur, and Golconda from the sixteenth to the eighteenth centuries. It was the confederation of these three States that brought about the fall of Vijayanagar in 1565, and there are indications that all the Deccani schools inherited something from the painting tradition of this famous capital. These Central Indian States also had close connexions with Iran, so that elements of Persian origin are far more apparent than in any other Indian schools outside the Mogul Empire. The scarce examples of Deccani miniatures vary so greatly in their combination of Hindu, Mogul, and Persian elements that it is difficult to select a single example to illustrate the character of the school. One of the most beautiful Deccani miniatures is a page from a Rāgamāla series, representing the *Hindola Rāga* [279]. This picture was painted at Ahmadnagar in the last quarter of the sixteenth century. The subject is Krishna and his beloved seated in a swing suspended from a flowering mango tree; two girls spray them with saffron water, while a third attendant approaches, carrying a stringed instrument, or vina. The picture is a poetic dreamland, in which the immortal lovers enact an exquisite charade in a flowering garden of unmistakable Persian type. Every element in the setting – the golden sky, the chalky ground strewn with flowers, and the star-shaped pool in the foreground – is of Persian origin. Although certain elements, like the types of costumes, are recognizably Indian, the minute realism of the trees suggest the miniatures of Akbar. The sprightly animation of the delicate forms appears characteristic of the Indian styles of miniature painting, as does the Rājasthāni device of the enlargement of the soulful eyes.

The painting of Jaipur follows the formulae of earlier traditions, both Rājput and Mogul, in a school dedicated to recording the pleasures of court life and the status of the rajah. A number of pictures from the late eighteenth century were made as cartoons for mural painting. A typical example is the large coloured drawing in the Metropolitan Museum in New York.[8] Other pages, like the *Lady arranging her Hair* [280] in the Victoria and Albert Museum, have the same largeness of conception. This is a perfect illustration of the timeless quality of Hindu art. The metaphorical treatment of such details and the arched bow of the eyebrows belongs to all periods of Indian painting. It is in the peculiar refinement of linear definition and in the soft, nacreous beauty of the body that this picture is especially expressive of Rājput civilization. The pale, warm shading of the face and body, which serves to give a suggestion of relief and to impart a kind of translucency to the complexion, is only the last refinement of the abstract chiaroscuro employed in the ancient classic schools of Indian painting. The figure is typically Rājput, too, in the essentially flat pattern of the form. The minutely exquisite realism of the flowered background and the ornamented balustrade are borrowings from the Persian Mogul tradition.

280. Lady arranging her Hair from Jaipur.
London, Victoria and Albert Museum

Certainly, one of the most individual styles to evolve in Rājasthān was the mode that flourished in the late eighteenth century at the court of Kishangarh. The rulers of this state were devoted to the cult of Krishna, and a local artist, perhaps Nihal Chand of Delhi, invented a peculiarly personal type of beauty to represent the immortal lovers Krishna and Radha [281]. The facial types, with their wildly attenuated eyes and soaring brows, are a suave Mannerist exaggeration of the Jaipur formula. They have a fragile elegance and a wan, neurasthenic refinement that are like an echo of the beauty of Ikhnaton's queen.

281. Krishna and Radha from Kishangarh.
Cambridge, Mass., private collection

The style of Rājasthānī painting which flowered in Kotah State in the late eighteenth century under the patronage of Rājah Umed Singh (1771–1819) reveals how, artistically as well as politically, Kotah was an extension of the State of Bundi. The Bundi painters of the eighteenth century had evolved a style of harsh simplification, in which episodes from the hunt were isolated as they had been a thousand years earlier in the famous scenes of the chase in Sasanian metalwork. Something of the same sort, with an admixture of Mogul realism, appears in the Kotah miniatures representing the rulers indulging their passion for shooting lions and tigers [282]. The painting illustrated, with its precise and isolated forms placed in a kind of luxuriant undersea landscape, might at first remind us, as W. G. Archer has noted, of Rousseau's jungles, palpitant with symbols of erotic anticipation.[9] The ardour of the Kotah paintings is not, however, the passion of love, but the reckless ardour of the chase and its fulfilment in the slaying of the quarry. Although certain details, such as the characterization of the hunters, suggest the realism of Mogul art, this naturalism does not extend to the strange fungiform rocks and the trees, like ornaments in coral or jade, more reminiscent of Persian than Indian tradition. Kotah painting has a naïve directness of narration and a simple ornamental beauty which may have been directed to the taste of the childlike ruler who sponsored it.

What was in many ways the most enchanting chapter of Rājput painting unfolded in the many small courts that had their seats in the secluded valleys of the Punjab Hills. Nominally under Mogul suzerainty, the rulers of these isolated principalities were able to cultivate their political and artistic tastes in relative security during the eighteenth and nineteenth centuries. There is no evidence for the existence of any earlier traditions in the Pahāṛi centres before the emergence of these court schools of miniature painting.

Basohli was the earliest of the schools of painting in the Punjab Hills and provides a transition from the Rājasthānī style to the elegantly refined manner which became the

282. Rajah Guman shooting Tigers from Kotah.
London, Victoria and Albert Museum

Pahāri tradition. The Basohli artists retained something of the primitive simplicity and rather rigid angular quality of Mewar and Malwa painting, combined with a fondness for warm colours of burning intensity. Except for the use of a suggestion of abstract shading, the Basohli miniatures are completely different from any Mogul manner in their smouldering brilliance of colour and savage distortion. A typical example is a late-seventeenth-century illustration of the *Rasamanjari* of Bhanu Datta [283]. The poetic theme is drawn from the Krishna legend. Radha in a forest pavilion desperately awaits the return of her errant lover. The composition is alive with symbols of erotic

283. Radha awaiting Krishna in the *Rasamanjari* from Basohli.
London, Victoria and Albert Museum

anguish. In the attic of the plaisance the cat and the empty bed are emblems of Radha's unrequited desire, and the prowling rat a reference to Krishna's wayward loves. This is a typical example of the use of objects from everyday life to symbolize sexual feelings.

In the early decades of the eighteenth century there was an infiltration of Basohli artists into the court of Guler, which, by its location near the Plains, was of all the Pahāri States most subject to outside influences. The painting of

284. Lady with a Hawk from Guler.
London, Victoria and Albert Museum

Guler shows us for the first time a peculiarly idealized provocative canon of feminine beauty that is the ultimate and specifically Pahāṛi refinement of earlier tradition. Guler painting, as represented by the painting of *The Lady with a Hawk* [284], is concerned with the ageless theme of romantic love, in this case meditation on the absent lover. The flat, geometric areas of colour proclaim the inheritance from Basohli, as does the still angular schematic drawing. The red background is, as usual, a metaphor for burning passion, and the rigid cypresses are a further veiled reference to the lady's thoughts. Typical of Guler and the later Pahāṛi schools is the cadenced rhythm of line and the slender frail physique. These qualities and the entranced preoccupation with the ecstasies of love are removed at once from Mogul symbolism and the primitivism of the Rājasthānī schools.

The final florescence of Rājput art is to be seen in the paintings of the Pahāṛi capital of Kāṇgrā. This magnificent development took place largely under the patronage of Rājah Samsar Chand, who ruled from 1775 to 1823. This ruler had a particular sensibility for painting and was passionately attached to the cult of

Krishna. We may suppose that, as must often have been the case, the illicit loves of Krishna and Radha provided a special sublimation for the sexual ideals of the patron, if not a justification for covert amorous adventures. Frequently, the setting for the events from the Krishna legend is in the fantastic palaces and gardens at Nadaun. Kāngrā art began with the immigration of artists from Guler in 1780, and the Kāngrā style is only a more exquisite, softer refinement of this neighbouring school.

We may take as a typical example the beautiful page of the *Hour of Cowdust*, representing Krishna returning with the cows to Brindaban, welcomed by the adoring *gopis* [285]. We notice in the first place that in this school of Rājput painting the intention of the artist is realistic. The entirely intuitive attempts at rendering complicated effects of perspective and foreshortening are based on observation. This point of view, together with a suggestion of a kind of atmospheric perspective in the hazy outlines of trees in the background, may very possibly reflect the influence of Mogul, or even European, painting on the Kāngrā style. The question of possible foreign influences, beyond making for a more effective expression, is unimportant beside the real, and in many ways new, beauty of the Kāngrā style. The Kāngrā miniatures can best be defined as coloured drawings, since their peculiarly lyric quality depends almost entirely on the exquisite, meaningful definition of forms in linear terms. The female figures are imbued with an attenuated, moving grace. Although conceived as types, they have an entirely individual quality of voluptuousness and attraction, imparted perhaps most of all by the rhythmic elegance of their pose and gestures. The drawing of the herd of cows is masterly in its suggestion of the animals pressing towards the village gate and in the artist's realization of the essential articulation and movement of individual beasts. The colours are only inci-

dental to the perfection of the brittle, linear skeleton. There is a soft, powdery harmony in the pattern of the chrome-yellow and vermilion notes of the women's garments, set off by the chalky whiteness of the architecture which is peculiar to the Kāngrā school. So animated and natural in terms of everyday life is this presentation of an event from the legend of Krishna that it may be described as a kind of loving idealization of the village life of Hindustan, a transfiguration of day-to-day experience in much the same way that Duccio's 'Entry into Jerusalem' commemorated a sacred event in terms of the life of fourteenth-century Siena. This illustration is completely typical of Indian art in the way in which the realm of sacred legend is, as in the Ajantā frescoes, presented as contemporary experience. It is but one more example of the endless variety which could be achieved within the set themes of Hindu art, themes within which the artist was expected to express his originality. Hindu art, both hieratic and vernacular, has always been more or less a national art, determined by the wish to have certain groups of ideas constantly represented.

The State of Garwhāl with its capital at Śrinagar produced the last phase of Pahāṛi art in the late eighteenth and early nineteenth centuries. The principal formative influence in this school, as at Kāngrā, seems to stem from Guler and reveals itself in the precisely etched heads and the lyric delicacy of drawing. Peculiar to Garwhāl painting is the emotional palette of dark greens and blacks and the emotionally turbulent landscapes and the setting for dramas of passion. A particularly notable example is *The Night of Storm* [286], painted in the last decades of the eighteenth century. As W. G. Archer has so admirably analysed it, the picture is a web of symbols alluding to the plight of the lovesick girl racing through the tempestuous night to meet her love.[10] The cobras slithering on the ground

286. The Night of Storm from Gaṛwhāl.
London, British Museum

suggest danger, and their imminent mating anticipates the girl's desire. The ribbon of lightning in the sky not only echoes her frail beauty and the zigzag gold of the hem of her garment but, as a poetic metaphor, symbolizes the climax of desire. Like a musical refrain, the twining net of branches repeats the rhythms of the cobras and the lines of the girl's body. This cadence of lines, the calculated fragility of form, and the poetic setting unite to enhance and interpret, metaphorically, the passion of love, and stylistically present the last refinement of Pahāṛi art.

We have followed the course of Indian art for a period of more than three thousand years. In that span of centuries we have seen hardly any deviation from a way of presenting the divine in artistic terms which was already fixed in that immemorial time of the Indus civilization. If there has been deviation from the tradition, it has been not so much change as variety, imposed by new iconographical demands and the gradual acquisition of a greater and greater technical skill in all the crafts serving the Indian religions. Just as the essentials of the Indian temples of the Gupta Period and the Hindu Renaissance are iconographically and technically present in the prehistoric ashlar dolmens and the Vedic altars of brick, so that final triumph of the Dravidian genius, the Naṭarāja, is only slightly removed from the mysterious dancing figure from Mohenjo-daro. In architecture either the simplest or the most baroque fabric can symbolize the world and the body of God, just as the elementary ideograph of a dancer in sandstone and the dynamic image of the Chola metalworker's art can symbolize the endless change within the cosmic scheme. These similarities,

this continuity in a tradition spanning more than thirty centuries, do not constitute monotony or repetition. Indian art in the great variety of its expression has only the limitations of what was to be expressed, and, as an art both hieratic and popular, has perforce repeated themes from the epics, the romances, as well as the incarnations of the great gods that are a part of the race, its heritage and its desire.

We are apt to forget that anything like art can be a necessary part of a racial or national heritage. It is this, together with the gradual growth of methods of making icons and temples appropriate to Indian needs, that makes for a sense of unity and continuity in the art of India unmatched in any other racial tradition. Many instances could be cited of the survival of the tradition of technical skill and iconographic observance in building and image-making even in modern times. Something of this continuity may be seen in the constitution of the Indian flag, dominated by the *dharmacakra* and composed of three bands of colour typifying the various mystic meanings of the number three in Indian metaphysics. Similar, but less happy, is India's adoption of a 'restored version' of the Aśoka lion capital at Sārnāth as a national emblem.

The concern of Hindu, Buddhist, and Jain art has always been the directing of men to union with the Great Beings that it reveals in tangible form. To that end no skill, nor time, nor patience could ever be too much. The works of art were guide posts to lead men by slow apprehension or sudden intuition to find the treasure hid in the shrine of their own hearts, the seat of the Buddha, of Vishnu, of Śiva. In our own quest, religious or aesthetic, they may discover for us a similar treasure.

INDIAN ART IN CEYLON AND SOUTH-EAST ASIA

CHAPTER 20

CEYLON

The beginnings of civilization in the island of Ceylon are known only by the legend that in the fifth century B.C. a Prince Vijaya from the Ganges country espoused a native princess and established a Singhalese dynasty. It is only with the accession of Devānam-Piyātissa (247–207 B.C.) that we may speak with any certainty of the history of the island and its art. The reign of this king witnessed what was perhaps the single most important event in Singhalese culture: the visit of the son of the Emperor Aśoka, Mahinda, and the introduction of Buddhism by this missionary prince. Anurādhapura was then made the capital of the island, and there a slip of the original bodhi tree at Gayā and the religion it typified, introduced by Mahinda, took root. One other early Singhalese king is worthy of mention, Duṭṭha Gāmaṇi (101–77 B.C.), who is known as the Aśoka of Ceylon for his zeal in the propagation of Buddhism.

In the period of more than twelve hundred years, from the times of Duṭṭha Gāmaṇi until the final renaissance of the thirteenth century, the inspiration for both sculpture and architecture came from India; especially, as we shall see, from the Later Āndhra civilization of the eastern coast. In the second century Singhalese monks were in residence at Nāgārjunakoṇḍa.[1] Also throughout this period the Singhalese were almost continuously engaged in repelling the incursions of the Tamils of South India; as early as the eighth century Anurādhapura had

finally to be abandoned to these invaders from the mainland; Poḷonnāruwa, which succeeded as the centre of government and religion, was taken by the Tamils in the fifteenth century. There ensued a melancholy period, in which the older capitals and, indeed, the whole fertile portion of the North gradually reverted to jungle. There, the ancient temples and palaces have slept amid the forest greenness until their ruins were gradually recovered in the course of excavations in the last hundred years.

Ceylon provides a setting particularly congenial to the study of Buddhist art, not only because of its great beauty and the amiability of its people, but also because there, in the great veneration accorded the ancient monuments by the people – sometimes carried to unfortunate extremes of renovation – the student feels that the subject is much more part of a living tradition than in the deserted Buddhist foundations of India, only a very few of which, such as the famous temple at Bodh Gayā, are maintained in worship today.

We are in a remarkably fortunate position in the study of art in Ceylon in having for our reference the *Mahāvaṁsa*, the Great Chronicle of Ceylon, which, based on earlier recensions, gives a precise account of the reigns and building activities of the Buddhist kings through fourth century. A later chronicle, the *Culavaṁsa*, carries the history into the eighteenth century. Often these descriptions are invaluable

in enabling us to reconstruct the original appearance of temples almost totally destroyed or remodelled; no less important are the accounts of methods of building and the ceremonies attending the dedication of the shrines.

In the green darkness of the forest at Anurādhapura there rise the ruins of nearly a thousand years of Singhalese history. Palaces, monasteries, and stupas, once completely engulfed by the jungle waves, have been reclaimed in half a century of conservation, so that some idea of the extent and grandeur of this Buddhist capital is afforded the visitor. If he finds these ruins rather austere – in some cases little more than stone skeletons – he has only to remember that at one time, like the ancient monuments of Taxila and Nālaṇḍā in India as described by Hsüan-tsang, they shone with a splendour only faintly echoed in the tawdry décor of the modern temples of Colombo and Kandy. Dominating the landscape at Anurādhapura are the great stupas or *dāgabas*,[2] some still so covered with vegetation that they appear literally like small mountains rising above the forest. In Ceylon the dāgabas are classified by the shape of the dome, designated by such poetic terms as 'bell-shaped', 'bubble-shaped', 'lotus-shaped', etc.

The typical Singhalese dāgaba is divided into the threefold base (trimala), the dome (aṇḍa), and the superstructure comprising the harmikā and yaṣṭi or mast. As in Indian religious architecture, the strictest ritual governed the laying of the magical foundation stones, and no less rigid proportions fixed the dimensions of these monuments. As far as we can rely on a rather corrupt text dealing with such instructions to the builders, the height of the cupola, which is three-fifths of the diameter of the ground plan, represents one-third of the total height of the dāgaba, and is equal to the height of the spire (including its base) and to the height of the threefold base.[3] The essential division into three parts is probably no accident, but a pur-

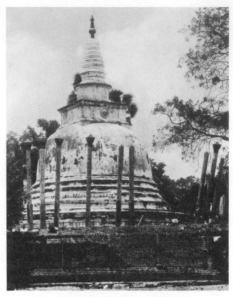

287. Anurādhapura, Thūpārāma dāgaba

poseful incorporation of the number three, with its symbolical allusion to the Buddhist Trinity and concepts such as the three planes of existence and other similar magical properties of this number in Buddhist philosophy.[4]

According to the *Mahāvaṁsa*, some of the ruined tumuli were founded in the reign of Devānam-Piyātissa in the third century B.C., although probably all were enlarged or remodelled at later periods. An example is the Thūpārāma, said to have been dedicated in 244 B.C. [287]. In its present form it is a characteristic Singhalese dāgaba: the monument is dominated by a 'bubble' dome of brick, which rests on three circular bases or 'bracelets' set upon a round paved foundation [288]; the cupola is surmounted by a balcony-like member corresponding to the harmikā of the Indian stupa, and, over all, is the traditional ringed spire with a series of seven umbrellas telescoped together, so that in profile this member resembles an inverted child's top. Leading to the

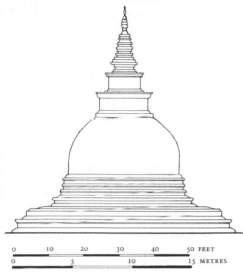

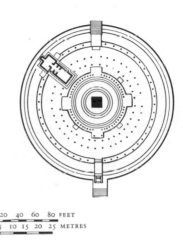

| 0 | 10 | 20 | 30 | 40 | 50 FEET |

| 0 | | 5 | | 10 | 15 METRES |

| 0 | 20 | 40 | 60 | 80 FEET |

| 0 | 5 | 10 | 15 | 20 | 25 METRES |

round platform supporting the dome were stair-cases, and the monument was surrounded by three concentric rings of stone pillars which were probably intended as supports for a wood-and-metal domical roof, sustained by wooden rafters and entirely enclosing the whole stupa.[5] Structures of this type, known as *thūpa gharas*, are referred to in Singhalese texts, and presum-ably have a relationship to ancient circular shrines in India proper, the appearance of which may be divined from occasional rock-cut replicas.[6] Here, as in all Singhalese stupas, the main approach was from the south, the direc-tion associated with the sun at its highest point in the heavens and with the supreme moment of the Buddha's career, his Enlightenment. Al-though, obviously, no trace of them has been found, it has been assumed that the dāgabas were originally surrounded by wooden railings and toraṇas after Indian originals in stone.

One of the largest of all the stupas in Ceylon is the Ruvanveli dāgaba at Anurādhapura, which,

in origin at least, goes back to the time of Duṭṭha Gāmaṇi. This monument has undergone such a complete renovation in the course of the last seventy-five years that a better idea of its original elevation may be had from a miniature stupa on the platform of the great dāgaba [289].

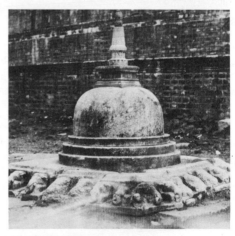

289. Anurādhapura, Ruvanveli dāgaba, dedicatory stupa

The monument is roughly one and a half times the size of the Great Stupa at Amarāvatī: the diameter of the dome is two hundred and fifty-four feet, and the height of the finial more than a hundred and eighty feet above the ground. The dimensions of this and other dāgabas at Anurādhapura are as great as all but the largest of the Egyptian pyramids.[7] As in many of the Singhalese dāgabas, the relics in the Ruvanveli were contained in a chamber built in the interior of the solid brick dome. This chamber, according to the *Mahāvaṁsa*, contained a jewelled bodhi tree of precious metals and was originally painted with 'rows of four-footed beasts and geese',[8] probably the same

directional beasts as we shall encounter in Singhalese sculpture. This stupa is built on two square terraced basement platforms. A typical element of Singhalese dāgaba architecture is present in the four altar-frontispieces or *wāhalkadas* situated at the cardinal points of the monument. These sculptured platforms bear the strongest resemblance to the similar offsets on the Later Āndhra stupas of Amarāvatī and Nāgārjunakoṇḍa,[9] although the five *āyaka* pillars of the Indian stupas are never found in Ceylon.[10] It is likely that these altars, together with most of the sculpture found at Anurādhapura, date from the second or third centuries A.D. All the ancient dāgabas were

290. Anurādhapura, vihāra near Thūpārāma dāgaba

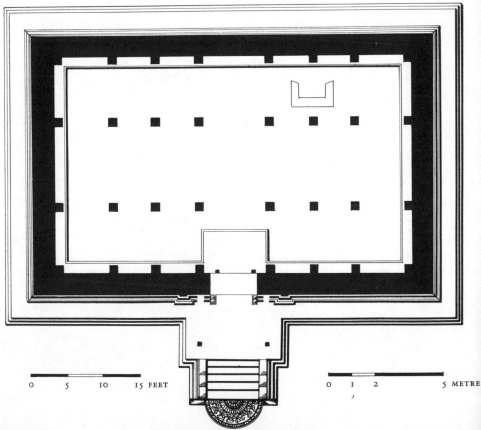

0 5 10 15 FEET

0 1 2 5 METRES

originally covered with *chunam* plaster painted white, and this technique has been recreated in the restoration of many of them, such as the Thūpārāma and Ruvanveli.

Singhalese Buddhist temples, known as *vihāras*,[11] such as those attached to all the great dāgabas at Anurādhapura, have a characteristic rectangular plan, generally with a single entrance on the long side of the building [290]. The walls were originally of brick, and, together with the rows of pillars inside, supported a roof of wood and metal. The pillars, seen on the platform of the Thūpārāma and the 'vihāres' of Anurādhapura, belong to an order that is peculiar to Ceylon. The columns have square or octagonal shafts; at the top, below a constricted neck, is a carving of garlands held by lion heads, and, above, a lotus capital, square or eight-sided, crowned by a band of beast-forms or yaksha caryatids.

Among the most ancient and famous monuments at Anurādhapura is the Lohapāsāda or 'Brazen Palace', built by King Duttha Gāmani. Unfortunately all that survives is the foundation, consisting of a forest of some sixteen hundred granite pillars standing in an area two hundred and fifty feet square. The account of this building in the *Mahāvaṃsa*[12] enables us to reconstruct this royal monastery as a nine-storeyed structure in which the monks were accommodated hieratically on the different floors according to their level of enlightenment. The entire superstructure was built of wood and precious fittings of jewels and ivory and roofed with sheets of copper. Destroyed by fire in the fourth century, the building was reconstructed in five storeys. As has been suggested above (p. 299), it seems possible to see a reflexion of this type of terraced building or prāsāda in the Dharmarāja rath at Māmallapuram.

Although the Buddhism of Ceylon can in general be designated as Hinayāna in character, there were certain periods of Mahāyāna penetration. The buildings erected during these times differ from the usual types of Hinayāna structures. A monument that can positively be identified as Mahāyānist is the Indikatusaya dāgaba in the jungle-clad hills at Mihintale above Anurādhapura. Excavated copper plates, inscribed with invocations of Prajñāparamitā, the Supreme Wisdom, by the nature of the epigraphy confirm this affiliation and the date in the eighth century.[13] The stupa proper at Mihintale rests on a raised quadrangular basement faced with stone. During the course of excavations it became apparent that the brick dome of the monument was originally of the elongated type, possibly with a high drum, found, for example, in the Dhāmekh stupa at Sārnāth.

Something has already been said of the connexions between the earliest Singhalese architecture and the Later Āndhra foundations at Amarāvatī. This relationship is even more apparent in the fragments of sculpture dating from the second and third centuries A.D. Chief among these examples of Singhalese carving are a number of Buddha statues originally arranged around the base of the Ruvanveli dāgaba.[14] Two of these dolomite images are standing Buddhas, and a third, traditionally identified as a likeness of Duttha Gāmani, is perhaps more likely the Bodhisattva Siddhārtha. The Buddha figures have an awe-inspiring hieratic quality induced by their massive scale of proportions and the rather archaic rigidity of pose [291]. It needs but a glance to see in them a Singhalese adaptation of the type of Buddha image fashioned at Amarāvatī under the Later Āndhra Dynasty. To an even greater degree than the Āndhra prototypes these statues have a heaviness and grandeur immediately suggestive of the very earliest Indian Buddha effigies made under the Kushans at Mathurā. The treatment of the drapery of the sanghātī, with the folds represented in a combination of incised lines and raised ridges, follows the style of the Amarāvatī workshops, and another characteristic trade

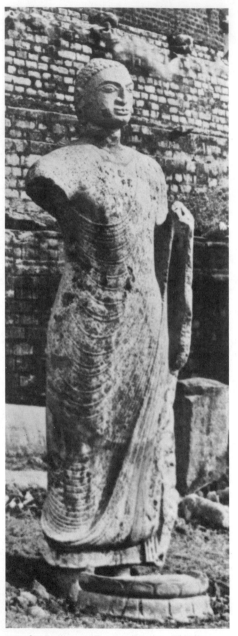

291. Anurādhapura, Ruvanveli dāgaba, Buddha

mark of this south-eastern Indian style is the voluminous billowing fold at the bottom of the robe.

We may further mention a bronze Buddha, probably made at Anurādhapura, which was found in the ruins of Dong Duong in Champa. This is by far the most perfect example of the style known [292].[15] A certain attenuation and a nervous elegance in the hands differentiate the image from the true Amarāvatī type and anticipate later Hindu metal images in Ceylon.

In connexion with these earliest Singhalese Buddha images it is well to mention the relations between Ceylon and China in the first centuries of the Christian era: an embassy bearing a jade image arrived in China between 405 and 418; later, in 428, the king of Ceylon dispatched a Buddha statue from the temple of the Tooth Relic.[16] Presumably these statues were of the Anurādhapura type, and it is possible that they may have exerted some influence on southern Chinese sculpture during the Six Dynasties Period.[17]

Although no exact precedents exist for it at Amarāvatī, the so-called Duṭṭha Gāmaṇi statue [293] is a combination of the fullness of Mathurā sculpture with a certain stiffness that may be the result of inexperience in the carving of portrait-statues in Ceylon.[18]

The seated Buddha images from this early period of Singhalese sculpture are, if anything, more interesting and aesthetically moving than the examples of the standing type. As in the statues at the Ruvanveli dāgaba already discussed, the style of the figures of the Buddha in yoga pose has been to a large extent conditioned by the nature of the granulitic stone, which does not permit any special refinements of carving. The resultant abstraction of form and surface and the largeness of conception bestows upon these figures a particularly moving dignity and serenity.

The massive statue of a Buddha in dhyāna mudrā in the Colombo Museum – formerly, as

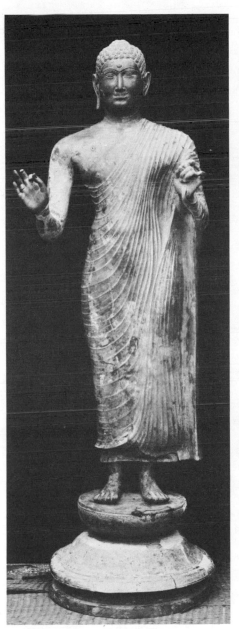 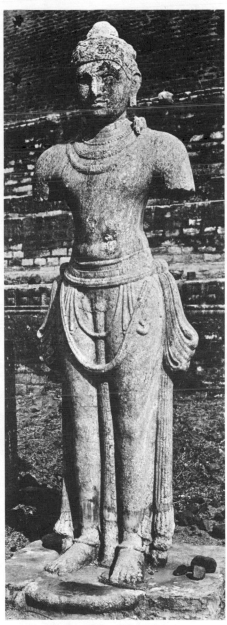

292. Bronze Buddha from Dong Duong.
Hanoï, Museum

293. Anurādhapura, Ruvanveli dāgaba,
'Duṭṭha Gāmaṇi'

our illustration shows, more picturesquely and appropriately located in a grove at Anurādhapura – is a perfect example of the type [294]. Although some seated Buddhas from Anurādhapura are related to Later Āndhra models, the Indian prototype for this statue is to be sought in such Kushan images as the Buddha from Katra [98]. We note the same herculean physical proportions and the complete revelation of the form by the sheath-like mantle. In this later aspect and the employment of the snail-shell curls the Anurādhapura image approaches some of the masterpieces of the Gupta Period at Sārnāth, although, probably, it is to be dated no later than the third century A.D. In few other representations of the Buddha in yoga trance do we get such a sense of the complete self-absorption and serenity of the Enlightened One. This impression of the perfect embodiment of the idea of *samādhi* is conveyed through the very simplicity of the conception; the perfect material equilibrium of the figure connotes the perfect mental state of Śākyamuni through the massive stability of the triangular base formed by the locked legs, surmounted by the erect columnar body which supports the perfectly impassive mask-like face.

It is important for us to examine in connexion with these Buddha images the method of manufacturing statues in modern Ceylon, a technique which is very probably of great antiquity. According to Coomaraswamy,[19] the icon is made as one would expect, according to the traditional proportions of five thalams to the total height of the seated figure. For the actual carving of the image from the block of stone, the sculptor employs a kind of pointing machine or *lamba tatuwa*, a wooden frame from which plumb lines are suspended to indicate the exact amount of cutting necessary at various points to disengage such features as the tip of the nose, the ears, shoulders, etc. The diagrams of the frame itself and the suspension of the

294. Anurādhapura, seated Buddha

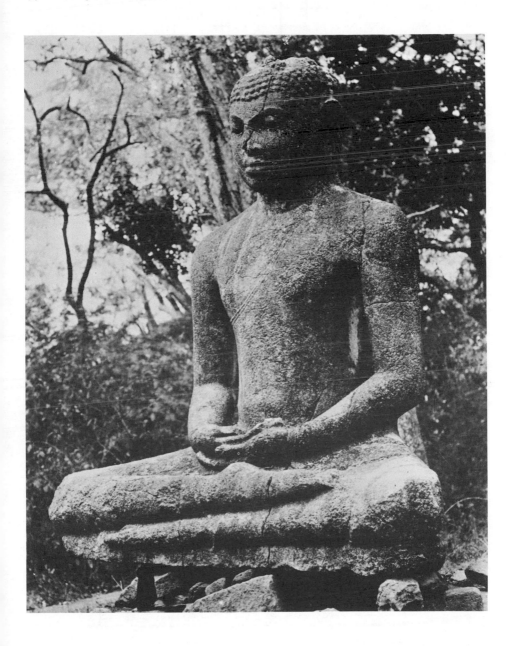

295. Diagram of Buddha image
and 'pointing frame'

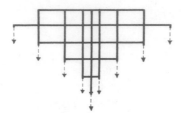

Level of frame (lamba tatuwa) from
which plumb lines are suspended

SCALE OF 'FACES' AND 'INCHES'

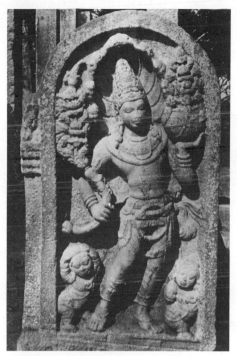

296. Anurādhapura, dvārapāla

297. Anurādhapura, 'Queen's Pavilion', moon stone

cords in front of an actual image are self-explanatory [295]. Although the use of such a mechanical device might appear to result in complete deadness, it must be remembered that machines like this and the system of proportions were merely aids which the artist's particular inspiration and skill was expected to utilize to the full measure of his technical and aesthetic capacity.

Common subjects in the early sculpture at Anurādhapura are the reliefs of gate guardians or dvārapālas, usually in the shape of nāgas with nine-headed cobra hoods; their svelte and elegant proportions again recall the work at Amarāvatī [296]. The elaborate jewelled accessories and conical head-dresses are close to Gupta representations of Bodhisattvas. These nāgarājīs carry jars emblematic of prosperity and good luck.

The visitor to this ancient capital will find a characteristic type of threshold-stone placed at the entrances to many of the shrines [297]. Usually called moon stones from their semi-circular form, these reliefs are extremely

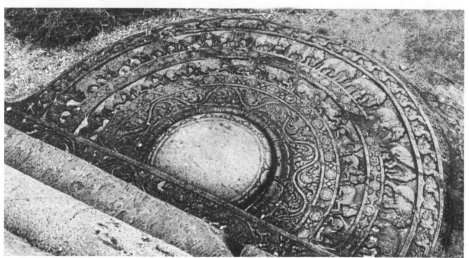

interesting from both the stylistic and icono-
graphic points of view. The decoration consists
of concentric zones of ornament, comprising
the four beasts of the cardinal points – horse,
lion, ox, and elephant – exactly as figured on
the Aśokan column at Sārnāth, together with a
row of haṁsa enclosing a central lotus boss.
Although these carvings are presumably no
earlier than the third or fourth century A.D., the
style is strangely reminiscent of the Mauryan
originals. Iconographically there can be little
doubt that the same cosmic symbolism implicit
in the pillar at Sārnāth is intended here, with
the beasts standing at once for the points of the
compass, the great rivers of India, and possibly
the seasons as well; the haṁsa, represented on
the Maurya pillar at Sāñchī, were the symbols

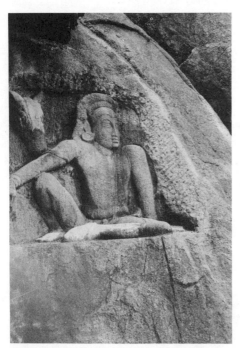

298. Anurādhapura, Īsurumuniya Vihāra,
Parjanya and Agni

of the fifth direction or zenith, so that the whole
forms a complete cosmic diagram.[20]

The unbroken cultural relationship between
Ceylon and south-eastern India is revealed by a
number of sculptures at the Īsurumuniya
Vihāra, near Anurādhapura. There, carved on
the face of a low cliff of granulitic boulders over-
hanging a partly artificial tank, we may see
carvings in a pure Pallava style. Isolated in a
kind of niche is a relief of Parjanya and Agni,
personifications of the rain cloud and the
warmth that brings seeds to blossom[21] [298].
Not only are the proportions of the figure of the
holy man remarkably close to the work at
Māmallapuram, but the suggestion of the
form's emergence from the matrix of the rock is
in the same technique that we have analysed in
the account of the styles of the Hindu Renais-
sance. Presumably these works date from the
period immediately before the final retreat from
Anurādhapura in the eighth century.

Although no actual examples earlier than the
sixth century survive, it may be assumed that
the tradition of painting in Ceylon is just as
ancient as that of sculpture and architecture;
fragments of decorative painting were dis-
covered on some of the early structures at
Anurādhapura, and the *Mahāvaṁsa* describes
lost cycles of wall-painting ornamenting the
stupas and vihāras.

The only considerable cycle of early painting
in Ceylon is the decoration in the hill of
Sīgiriya. These paintings are located in a pocket
of the great rock at Sīgiriya ('Lion Rock') that
was the fortress of the parricide, King Kassapa,
from 511 to 529; at that time this now isolated
cave must have formed part of a system of apart-
ments and galleries which completely clothed
the face of the cliff. The subject of the frieze of
wall-painting is a parade of opulent celestial
females, apsaras or devatās, advancing singly
and in pairs [299]. The divinity of these almost
oppressively sensuous queens is indicated only
by the clouds that veil them below the waist and

by a sort of ūrṇā on the forehead, a device regularly used to designate divine beings in India.

In studying these works we are struck at once by the robust strength of both the drawing and colouring. That the draughtsmanship was entirely freehand becomes apparent when we note the many corrections, not only changes in the contours but complete alterations of the positions of the hands of certain figures. The swelling, nubile breasts, the tiny waist – hardly greater than the girth of the neck – the shapely tapered arms and exquisitely poised flower-like hands – these are all elements of the same canon that determined the types of physical beauty in the wall-paintings of India proper. Here these charms are rendered even more provocative through their exaggeration. The resemblance of these figures to the maidens of the Amarāvatī reliefs suggests their derivation from a lost school of Āndhra painting. If the boldness of the drawing and the brilliance of the colours are recognizable as typically Singhalese, the actual physical types represented, with heavy-lidded eyes, sharp aquiline noses, and full lips, may be taken as direct reflexions of actual Singhalese types.

A rather distinctive technical feature of the Sīgiriya paintings is the method of drawing the noses. Of these there are two distinct types: in one of these conceptual presentations the nose is represented in profile, although the face may be in three-quarters view; the second method shows the nose in three-quarters view, with the

299. Sīgiriya, wall-painting of apsaras

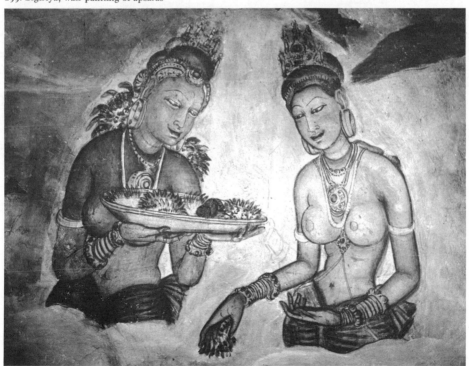

farther nostril clearly defined.[22] Another interesting technical aspect is the manner in which the individual brush-strokes, as in the painting of the breasts, make a surface pattern and at the same time reinforce the form.

As has already been noted, the continued raids by the Tamils of South India finally forced the abandonment of Anurādhapura in the eighth century. From 781 to 1290 the capital was located at Poḷonnāruwa. The ruins are situated on the beautiful Lake Topawewa in the deep jungles of north-eastern Ceylon; there,

rock-cut Parinirvāṇa image nearly fifty feet in length; the style, as seen particularly in the rendering of drapery folds in a series of parallel ridges with the characteristic billow at the lower hem, is simply an enormous enlargement of the standing Buddha images of Anurādhapura, here, for the purposes of a Nirvāṇa image, placed in a recumbent position. More unusual and of great impressiveness is the standing figure of Buddha or Ānanda, nearly twenty-five feet high, carved from the rock next to the head of the Nirvāṇa Buddha. The figure has very

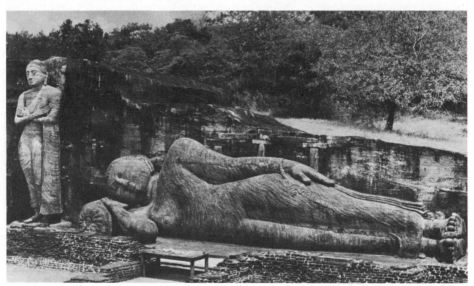

300. Poḷonnāruwa, Gal Vihāra, Parinirvāṇa image

at certain seasons, one can still see growing at the water's edge the enormous red lotuses, originally planted a millennium ago. The great period of artistic activity at this site coincides with the reign of Parākrama Bāhu I (1164–97), the last notable monarch of the Singhalese dynasty.

One of the principal sculptural dedications of this period is the group of images at the Gal Vihāra [300]. The most impressive is a colossal

much the same feeling of grandeur, through the massive plastic realization of the form that characterizes the Buddha statues of the earlier period; the representation of Śākyamuni, his arms folded, one leg slightly bent at the knee, has an extraordinary feeling of serenity and strength, qualities which, as we have already seen, are always notably present in the Singhalese sculptor's realization of the peace of Enlightenment. There is a certain archaistic

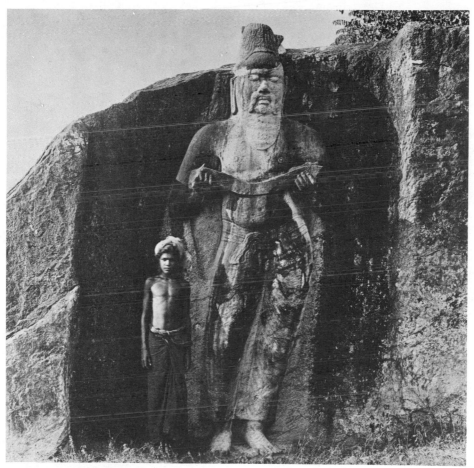

301. Poḷonnāruwa, Parākrama Bāhu

quality in all the later work at Poḷonnāruwa, probably the result of a conscious effort to revive what was then considered the great period of Buddhism and its art.

Of similar nobility and magnitude is the colossal figure of a Buddhist king, sometimes identified as a portrait of Parākrama Bāhu himself, that is carved from a large boulder overlooking the waters of Lake Topawewa [301]. This representation of a bearded sovereign holding a yoke as emblem of the king's burden is one of the finest pieces of sculpture in Ceylon. It combines a feeling for volume and weightiness comparable to the great yakshas of the Maurya Period; and with them it shares a feeling for pent-up inner energy realized in the swelling convex planes of the construction of the body. At the same time the image is animated by the seemingly momentary lifting of the head and by the slight *contrapposto*; in this respect, and

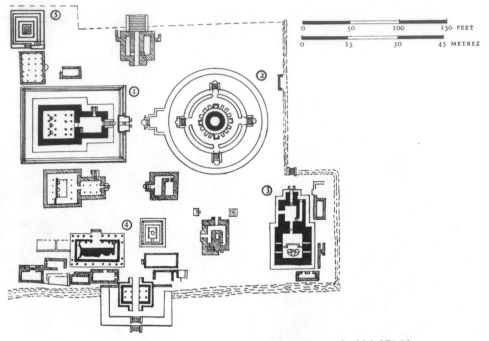

302. Poḷonnāruwa, great quadrangle
 1. 'Häta-da-ge'
 2. Wata-da-ge
 3. Thūpārāma
 4. Nissaṅka Mallā Maṇḍapa
 5. Sat Mahal Pāsāda

303. Poḷonnāruwa, Sat Mahal Pāsāda

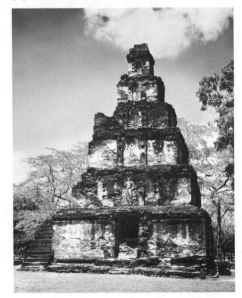

in spite of its great scale and weight, it has something of the feeling of the bronzes of the Chola Period – the suggestion of a moment of suspended animation, and the communication of the idea that the figure may at any moment stir into action.

Perhaps the most notable group of later architectural monuments is associated with the reign of Nissaṅka Malla (1198–1207); this is the collection of temples and vihāras in the so-called Great Quadrangle, in what at one time must have been the centre of the capital [302]. Only a few can be selected for analysis, but they are among the most beautiful and satisfyingly proportioned buildings in the entire Indian world. In the extreme north-east corner of this precinct is the pyramidal shrine, perhaps originally a stupa, known as the Sat Mahal Pāsāda [303]. Its shape conforms to what in the śāstras would be designated as a Meru temple, with the seven successive storeys of the terraced structure representing the imagined hieratic

configuration of the world mountain. Actually, the building is much closer in style to many of the pre-Angkorean shrines of Cambodia and the San Mahapon at Lamp'un in Siam[23] than any structure known in India proper. It may well be that this temple was put up expressly for the benefit of the Cambodian mercenaries of the Singhalese kings, so that its unique elevation could be explained as an intentional imitation of one of the more familiar Khmer types.

Nearby is the Tooth Relic Temple, misnamed 'Häta-da-ge'[24] [304]. This structure is built entirely of finely cut and fitted blocks of ashlar masonry. It rests on an encircling podium ornamented with panels of seated lions. The walls proper are left bare, except for two rectangular areas on the façade enclosed in a sunken relief pattern of haṁsa and containing inscriptions incised into the face of the wall. The effect produced by these large areas of wall surface, relieved only by the most delicate surface ornament, is not unlike that produced by

304. Polonnāruwa, 'Häta-da-ge'

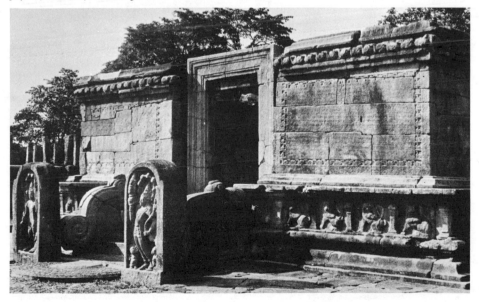

the similar contrast of plain ashlar surface and sharply shadowed frieze in the Ionic Treasury of the Syphnians. The doorway is unornamented, save by the mouldings of almost Attic simplicity. At the top of the wall is a continuous entablature with a delicately carved band of haṁsa, which provides another accent for the undecorated wall surfaces.[25] The entrance is flanked by two makara balustrades which are preceded by reliefs of nāga guardians. These can hardly be distinguished from the dvārapālas of Anurādhapura.

Immediately adjoining this sanctuary is one of the loveliest examples of Singhalese architecture, which may perhaps be identified as the Wata-da-ge – 'round temple of the tooth relic' – built by Parākrama Bāhu I, mentioned in the Culavaṁsa [305].[26] The entire structure was at

one time covered by a roof of wood and tiles, supported in part by the row of pillars. The resemblance of the plan [306] is so close to that of the Thūpārāma at Anurādhapura that the connexion between these two thūpa-gharas is probably more than coincidence. Indeed, in thirteenth-century texts, the Thūpārāma is also referred to as a 'Wata-da-ge'.

The circular sanctuary rests on an undecorated base; on the inner circumference of the wide platform rises the wall of a second terrace, its podium carved with superimposed friezes of lions and dwarfs separated by short pilasters. Above this rises the railing of the upper processional path, divided into panels with a delicate lotiform ornament; this wall originally supported a succession of stone pillars, intended, like the columns surrounding

305. Polonnāruwa, Wata-da-ge

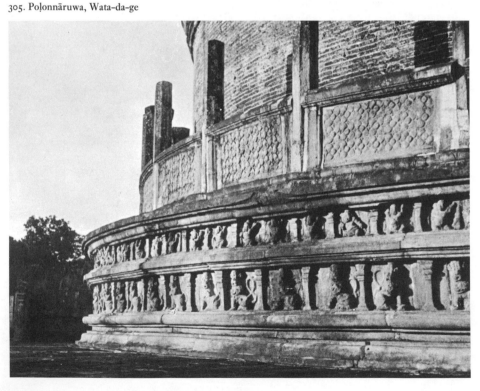

306. Poḷonnāruwa, Wata-da-ge

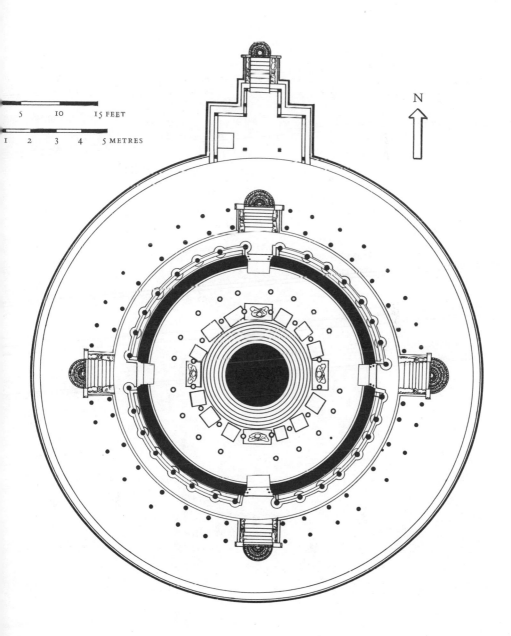

5 10 15 FEET

1 2 3 4 5 METRES

N

the early stupas at Anurādhapura, for the support of the domical roof. This level of the shrine is reached by stairways at the four cardinal points; girdled by the pradakṣina is the inner round brick shrine enclosing a low stupa with images of Buddhas facing the four directions.[27] As in the adjoining Shrine of the Tooth Relic, the beauty of the Wata-da-ge depends on the subtlety of its proportions and delicate contrasts of plain and ornamented surfaces. Special attention must be called to the loveliness of the rhythmically repeated curvature of the mouldings and railings and central shrine, as seen particularly well in illustrations 305 and 306.

Another unique type of Singhalese architectural monument is also to be found in this same quadrangle [307]. This is the Nissaṅka Latā Maṇḍapaya; it consists of a rectangular stone enclosure patterned after the ancient stupa railing or vedikā; within, on a raised platform, rises a granite clump of columns in the shape of curling lotus stems with capitals in the form of opening buds. The visitor has an immediate and curious impression of beholding Bernini's baldacchino suddenly transported to the jungles of Ceylon. Although these columns may have upheld a wooden superstructure, their primary function was purely and simply a figuration in stone of the great symbolic flower of Buddhism, appropriate to a shrine intended for offerings to the deity of the same flowers sold outside every temple today. The effect is one of extreme chastity and Baroque fancy that has no rival in any Indian shrine.

Another contemporary structure is the so-called Northern Temple from its location in that quarter of the city of Poḷonnāruwa [308].

307. Poḷonnāruwa, Nissaṅka Latā Maṇḍapaya

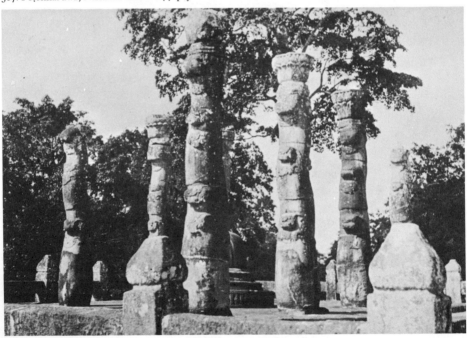

The exterior of this large rectangular brick edifice was originally completely ornamented in stucco, with a series of niches housing statues of deities and separated by attenuated pilasters

modelling of the nude torso and the clinging drapery of the dhoti is reminiscent of Gupta workmanship. Coomaraswamy has noted certain parallels to the so-called Parākrama Bāhu

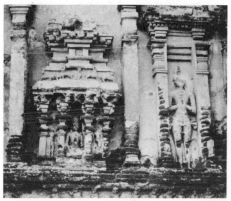

308. Polonnāruwa, Northern Temple, detail

reminiscent of the style of Chola architecture.[28] Of even greater interest were the paintings of Jaṭaka scenes, which at one time completely covered the interior walls of the sanctuary; unfortunately these have deteriorated to such an extent that no photograph can give any adequate idea of their style. Like the earlier Sigiriya paintings, they have a provincial flavour that may be the Singhalese equivalent of a South Indian style.

Examples of Singhalese metal-work are known from the very earliest period of Buddhist art. Somewhat later in date is a splendid female statue of pale, gold-coloured brass in the British Museum [309]. This is one of the finest specimens of Singhalese Hindu metal-work. The figure is traditionally identified as Pattinī Devī, and is said to have come from the north-eastern part of the island. The great beauty of the

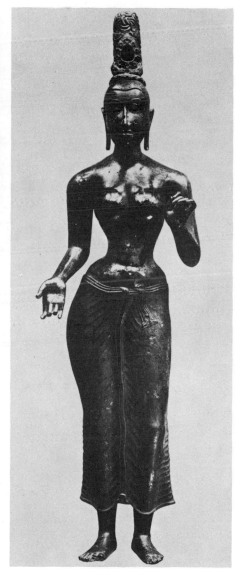

309. Brass Pattinī Devī from north-eastern Ceylon. *London, British Museum*

statue at Polonnāruwa,[29] but actually the closest stylistic comparison for this figure is in the apsaras of the Sīgiriya frescoes: we note the same exaggerated fullness of the breasts and narrow waist combined with an elaborate towering head-dress as in the Sīgiriya nymphs. On the basis of this comparison it seems justifiable to assign the image to the sixth to eighth centuries.

Mention should be made of the various Hindu temples or Śiva Devales, uncovered in the jungles of Polonnāruwa. These sanctuaries were probably erected during the period of

massive ashlar blocks and the exterior ornamented with a series of niches and pilasters that are unmistakably from the same workshop as the Great Temple at Tanjore.[30]

In the ruins of this and other Hindu shrines were recovered some of the finest bronzes of the Hindu Renaissance, earlier than any specimens known in India proper. It is likely that these were cast by Tamil śilpins in accordance with the techniques and canons employed in eleventh-century Tanjore. The date of the temple's desecration furnishes a *terminus ante quem* for their manufacture. Among the finest

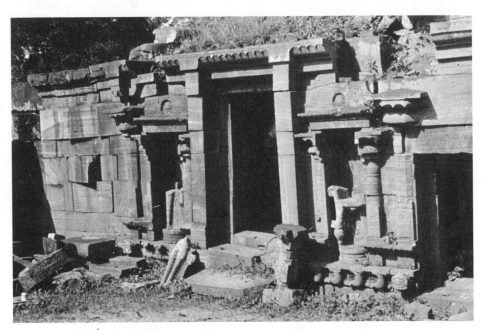

310. Polonnāruwa, Śiva Devale No. 1

Chola occupation in the eleventh century and were desecrated by Parākrama Bāhu II in the thirteenth century. As might be expected, shrines like the Śiva Devale No. 1 are no more nor less than miniature constructions in the style of Chola architecture in southern India [310]. The building illustrated is constructed of

of these statues is the beautiful Naṭarāja in the Colombo Museum, already discussed in our chapter on the metal images of the Chola Period.

The statue of Sundaramūrtiswāmi from Polonnāruwa is a fitting object with which to close our account of Singhalese art [311]. Probably made by artisans imported from the

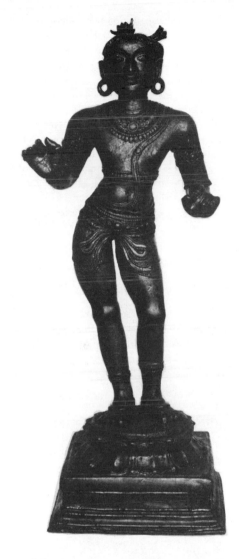

311. Bronze Sundaramūrtiswāmi from Poḷonnāruwa. *Colombo, Museum*

Tamil country, it reveals the same wonderful ecstatic radiance and is animated by the same suggestion of complete balance and imminent movement that characterizes the great examples of Hindu metal images in South India.

With the final conquest of Poḷonnāruwa by the Tamils in the thirteenth century Singhalese art fell on evil days; scarcely a monument worthy of serious consideration survives from the various later capitals, including the final stronghold at Kandy. Some of the old architectural forms and a debased sculptural technique do survive, and so, in a state of considerable degeneration, does the tradition of

painting; but beyond a certain felicity in the carving of architectural details on some of the Kandy temples, nothing of real artistic worth was produced after the Renaissance under Parākrama Bāhu I.

It is with regret that we leave the subject of art in Ceylon, an art which, over a period of more than fifteen hundred years, reveals great vigour and exquisite taste in architecture, sculpture, and painting, a marvellous integration that can scarcely be matched anywhere in the Buddhist world. The best of the architecture and the best of the sculpture have a truly classic quality of balance and perfection and constitute final models of technical probity.

*

What must be one of the earliest examples of the decorative arts in Ceylon is a carnelian seal from the Yatthala dāgaba, which has been dated from the third to the second century B.C. [312]. Represented on this gem is a king seated on a wicker throne. The nude figure in its elegant and attenuated proportions suggests the earliest style of Amarāvatī as represented by the reliefs

from Jaggayyapeṭa [34]. Wicker chairs of a similar type make their appearance both in Kushan and Amarāvatī carvings of the early centuries of our era.

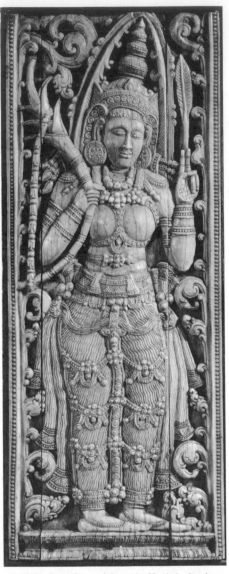

312 (*left*). Carnelian seal from the Yatthala dāgaba. *Manchester, Museum*

313. Ivory plaque with Rati from Ceylon. *Cambridge, Mass., Fogg Art Museum*

Singhalese ivories, even as late as the seventeenth century, continue to preserve traditional motifs with little indication of further influence from the Indian mainland. Notable are the large ivory plaques with representations of richly bejewelled divinities [313]. These rather drily carved figures appear enveloped in a network of jewelled ornaments, but their descent, both iconographically and stylistically, from the stone-carvings of dvārapālas of the earlier periods is immediately apparent (cf. 296). The heavy undercutting is the craftsman's exploitation of the pictorial possibilities of his medium. Represented is Kama or Rati, gods of love, with flower arrow and sugar-cane bow.

Singhalese craftsmen have been distinguished in the art of metalwork since early times, and ornaments in precious metals, exquisite in design and technique, have been made until modern times.[31] Bronze vessels dedicated to temple use and dating from the twelfth century and earlier have been found at many sites throughout the island. There are, for example, bronze lamps, some recalling ancient Roman shapes and others in the form of lotus plants like similar types found in Cambodia. A remarkable example of this kind of temple furniture is a lamp in the shape of an elephant standing in a basin, found at Dedigama, the legendary birthplace of the great King Parākrama Bāhu, and dated to the twelfth century [314]. The magnificent plastic form of the elephant stands in a basin, and when the oil in this vessel burned to a low level, an ingenious mechanism caused the pachyderm to urinate a fresh supply into this receptacle. As in the case of so many objects of Singhalese metalwork of this final renaissance, it is impossible to tell whether this object is of local manufacture or an import from South India. It bears a certain resemblance to the famous lamp from the Jogeśvari caves [262] and the carved elephants of the Ruvanveli dāgaba at Anurādhapura [289].

Singhalese jewellers have always excelled in varieties of goldsmith work, notably in filigree work and the embedding of tiny jewels in a setting of soft gold. These exquisite objects – necklaces, clasps, and single beads, usually hollow and made of wire and seed-like gems – have an exquisite and rarefied delicacy of workmanship that can never be appreciated in photographic reproductions.[32]

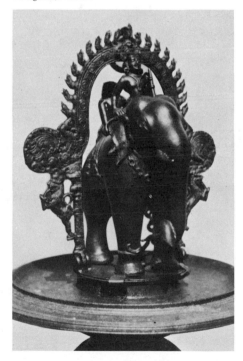

314. Bronze lamp from Dedigama.
Dedigama, Museum

CAMBODIA:

THE ART AND ARCHITECTURE OF THE KHMERS

In 1860 Henri Mouhot, a French botanist in Siam, stirred by natives' reports of empty cities lost in the jungle, pushed onward into the great forests of the Mekong River, until, one burning tropic dawn, he looked upon the incredible spectacle of the towers of Angkor rising like some fantastic mirage of mountain peaks above the sea of jungle. There had, to be sure, been discredited tales of vanished cities by Spanish missionaries as early as the seventeenth century,[1] but Mouhot's discovery was the first the modern Western world knew of one of the great civilizations of Asia.

Even until quite recently, after more than eighty years of research had largely resolved the problems of the history of the builders of Cambodian civilization, it used to be fondly believed – and the legend probably survives in 'science-fiction' – that the colossal ruins in Indo-China were the work of a race whose origins are as mysterious as its disappearance. In this chapter we shall be concerned with tracing the history of art in Cambodia, culminating in the great monuments of Angkor.

I. THE PRE-KHMER PERIOD

According to Chinese legend, Funan, the most ancient kingdom in present day Indo-China, was founded in the first century A.D., when a Brahmin adventurer, Kaundinya, espoused a native princess; according to native variants of the story, this princess was a nāginī, one of those half-human, half-serpentine beings, who in India are the spirits of the waters.[2] This earliest kingdom comprised the territory of Cambodia,

Cochin China, and southern Siam. Presumably it marked a development from the earliest settlements by peoples of Sino-Tibetan origin, who even earlier had occupied the land around the mouths of the Mekong and Menam rivers. From this earliest period of Cambodian history there is abundant evidence, both in the form of finds, and of reports of Chinese visitors, to confirm the close relations between the kingdom of Funan, India, and China.[3] There are indications, too, that during these same centuries Indian colonists established themselves in many parts of Cambodia and the Malay Peninsula; indeed, the finds of sculpture in the style of the Later Āndhras in Java and even the Celebes indicate the extent of the spread of Indian Buddhism and its art over all south-eastern Asia. The kings of the earliest dynasty had already adopted the Pallava patronymic –varman (protector), a very sure indication of the origins of their culture. All the monuments of this pre-Khmer civilization of the fifth, sixth, and seventh centuries point to the Indian origin of this earliest style. Pre-Khmer or Indo-Khmer is the name given to this period from the first to the seventh century.

The earliest architecture of Cambodia, like the population of the region, is a mixture of indigenous elements and forms imported by Indian cultural invasions. The temples consist invariably of an isolated sanctuary, a form determined by the necessity for individual shrines to house the cult images of the deified ancestors of the royal house.[4]

The largest centres of what is properly called Pre-Khmer civilization are located at Sambor

and Prei Kuk, the ancient capitals of Funan, in the almost impenetrable jungles near Kompong Thom on the road from Saigon to Angkor. There one may see literally dozens of towered shrines in brick and stone, most of them covered with vines or crushed in the octopus grasp of giant banyans rooted in the spires. Forecasting a technique of later Khmer temple planners, numbers of the individual cells set within a walled enclosure are grouped around a more impressive central edifice. These towers, each originally containing a cult image or lingam, are either square or rectangular in plan. The super-structure rises in gradually diminishing stages so that the buildings are conical in profile. The only ornament is massive stone lintels with a frame of makaras and carved brick panels set in the main wall faces. These panels generally represent a miniature prāsāda, perhaps a replica of the shrine itself. The sanctuaries at Sambor,

overgrown with vegetation and scarcely visible in the green half-light of the jungle, cannot be adequately photographed: the drawing in illu-stration 315 will give the reader an idea of the general appearance of most of them.

Both the use of brick as a material and its employment for carved exterior decoration suggest Indian precedents, such as the temples at Sīrpur and Bhītārgāoṅ. A similar employ-ment of brick ornament may be seen in the early temple at Bayang [316]. The main temple of Śiva, dramatically crowning a hilltop, was built in the first years of the seventh century. It is a rectangular shrine – a plan occasionally found at Sambor, too – surmounted by a keel roof of the vesara type that calls to mind the form of Bhima's rath at Māmallapuram [233]. The building rises in three diminishing storeys demarcated by cornices with blind chaitya windows. These storeys, unlike the similar

315. Sambor, shrine

316 (*right*). Phnom Bayang

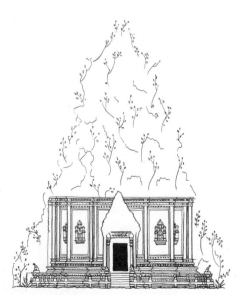

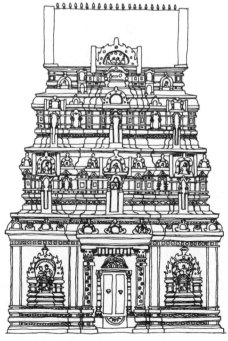

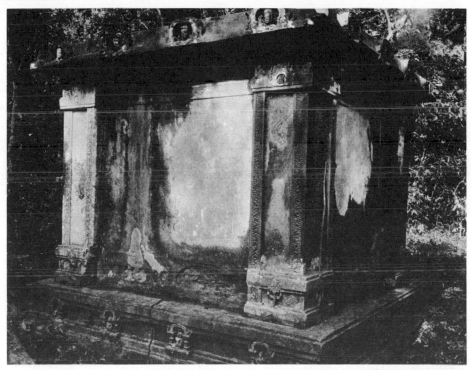

317. Prei Kuk, cella

terraces of Indian temples, are not functional but entirely decorative – evidently borrowings from a Gupta type. The employment of the vesara roof as a finial is anticipated in such Indian monuments as the porch of the Kailāsa Temple at Kāñcīpuram [239]. The ground plan of the Bayang temple is again an adaptation of an Indian model, such as the shrine at Bhumara [165]; it shows an interior cella separated from the outside wall by a passage intended for ritual circumambulation. These earliest Khmer shrines at Sambor and Bayang are a parallel, though not directly related, to many Javanese temples. Both are derived from the same Indian prototypes.

Although the majority of pre-Khmer temples are of brick, a few constructed entirely of sand-

stone have been found at Sambor and elsewhere.[5] One of these is a small cella at Prei Kuk [317]: rectangular in form, it has plain walls subdivided by pilasters and a monolithic flat roof which is girdled by a roll cornice ornamented by the device of chaitya arches. These arches enclose heads of deities, as we have already seen them in Gupta and Pallava architecture. It is possible that this stone cell was at one time preceded by a wooden maṇḍapa.

The sculpture of the pre-Khmer Period reveals an indebtedness to Indian models even more obvious than in the buildings surviving from these centuries; indeed, many of the Buddha images found at the centre of the earliest Indian settlements in Siam and Cambodia are so closely related to types of Gupta

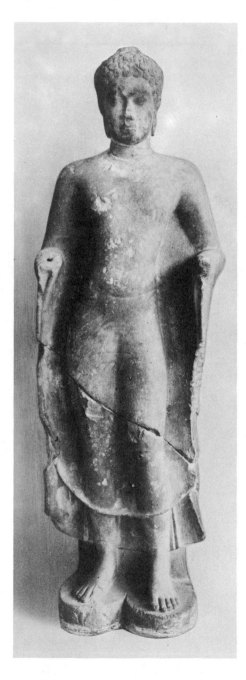

sculpture that one might well mistake them for works of actual Indian origin [318]. The possibility of their having been carved by imported craftsmen can of course not be disregarded. The Buddha images that have been found at Takèo and Prei Krabas have the same gentle *déhanchement* and transparent sheath-like robes as those which characterize the Gupta Buddhas of Sārnāth and some of the late Gupta rock-cut images in Cave XIX at Ajaṇṭā.

One of the most beautiful examples of the type is a specimen from northern Siam, now in the Seattle Art Museum [319]. The head alone, in the beautiful ordering of its parts, is one of the loveliest in Buddhist art. The arching swallow-wing eyebrows are made in conformity with the injunction of the śāstras, suggesting the leaves of the *neem* tree as a metaphor for the arched brows. The lotus-petal shape of the eyes is echoed in the curve of the full lips. Body and head alike have the simplicity and plastic solidity of Gupta Buddhas, but the whole is imbued with a new feeling of inner tension that makes it a veritable emblem of serenity and ecstasy.

Throughout the history of Cambodia we find a continuous alternation, sometimes from reign to reign, between Buddhism and Hinduism. This is true of the very earliest period, and some of the most remarkable pieces of sculpture in Further Indian art date from one of these periods of Hindu supremacy, presumably the seventh century, when the kingdom of Funan was divided, with one capital at Sambor.

The most often reproduced of these images is a free-standing statue of Harihara from Prasat

318 (*left*). Buddha from Prei Krabas.
Phnom Penh, Musée Albert Sarrant

319. Buddha from northern Siam.
Seattle, Art Museum

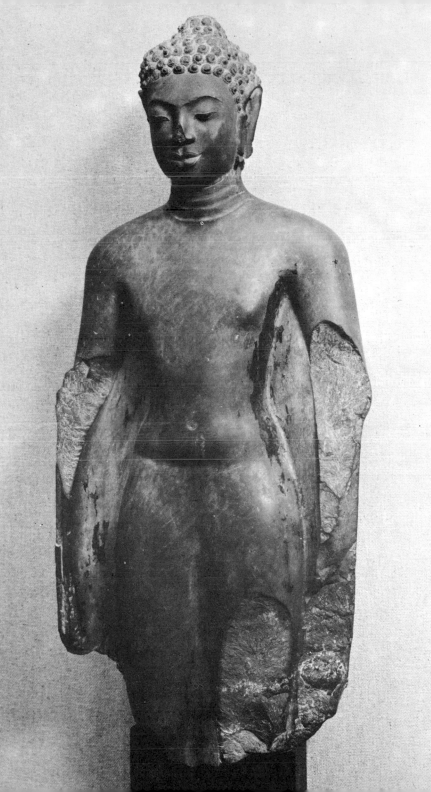

320. Harihara from Prasat Andet.
Phnom Penh, Musée Albert Sarraut

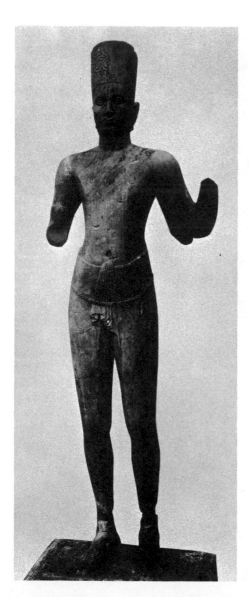

Andet near Sambor [320].[6] Although certain details, notably the cylindrical head-dress and piercing of the ears for earrings, are reminiscent of Indian sculpture from the Later Āndhra and Pallava Periods, the statue, perhaps more than any other single work of Cambodian sculpture, gives the impression of an original autonomous creation. As Coomaraswamy puts it, 'The Cambodian figure exhibits a miraculous concentration of energy combined with the subtlest and most voluptuous modelling. Works of this kind are individual creations – not, that is to say, creations of personal genius unrelated to the racial imagination, but creations of a unique moment.'[7] Partly this suggestion of 'energy' is imparted by the way in which the weight is distributed, so that the god seems about to move into the steps of a dance; it is in a sense very much the same type of balance and alternation of thrust that characterizes the Diadoumenos of Polyclitus. Not only the shape of the head-dress, but even more the minimal working of the sculptural surface, the suggestion of plastic volume in almost abstract terms, remind us of the perfection of the carvers of ancient Egyptian art. Early Brahmanic figures, like the Harihara and the torso of either Krishna or Lokeśvara in the Stoclet Collection in Brussels [321], have a wonderful athletic litheness about them, a feeling of resilient inner vitality. In contrast to the general simplification of the surface is the precise definition of details of drapery and textile patterns.[8] Characteristic of this first period of Cambodian sculpture are the eyes, represented entirely open, and the full lips with only a slight suggestion of the smile so typical of Khmer sculpture of later periods.

2. THE CLASSIC PERIOD: EARLY PHASE (800–1000)

In so far as it is possible to conclude on the basis of contemporary Chinese accounts, the first kingdom of Funan disintegrated in a period of

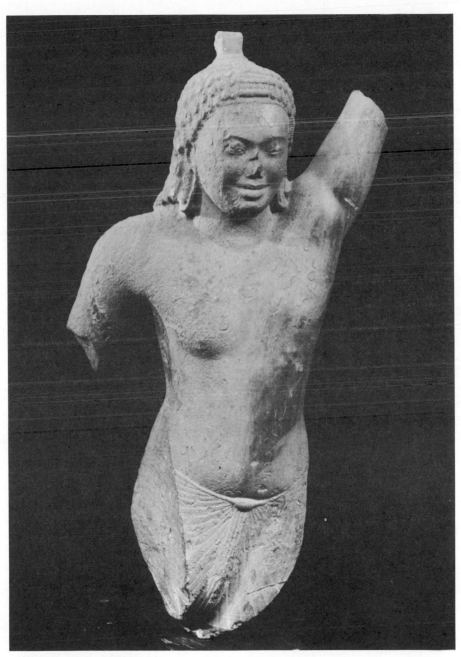

321. Lokeśvara from Cambodia.
Brussels, Stoclet Collection

warfare during the seventh and eighth centuries. It split into two principalities designated now as Chen-la of the Land and Chen-la of the Sea.[9] There are mentions for the first time now of the Khmers, who presumably were the Cambodian people from northern Indo-China who asserted their autonomy during this period of upheaval. Hereafter it is proper to speak of Khmer art as something replacing the earlier styles with their heavy dependence on Indian models.

The Khmer building tradition is composed of elements derived from an earlier indigenous wooden architecture and forms and techniques imported from India. According to the French scholar, Parmentier, the original timber buildings consisted of halls or galleries surmounted by angular tiled roofs, often multiplied or piled up in pyramidal fashion, as may be seen in the modern architecture of Cambodia, Siam, and Burma.[10] A distinction is also to be made between northern and southern elements. In

the earlier southern style of architecture based ultimately on wooden prototypes in ancient Funan, the tower, either singly or in groups, is the most important feature of temple-building. Northern architecture, derived from indigenous timber construction of Cambodian or Khmer origin in Chen-la, contributed the concept of towers joined by walled galleries. All these elements, native and Indian, northern and southern, merge in the last phase of architectural development at Angkor.

There are many monuments that could be chosen to illustrate the successive steps towards this solution. But within the limitations of this book we can mention only the dedications by Yaśovarman at Lolei (Roluos) near Angkor, remarkable for the concept of grouping a number of individual cellas on a single terrace and for the new cruciform plan of the individual towers [322]. This arrangement of many separate towers containing statues of divinities

322. Lolei (Roluos), towers

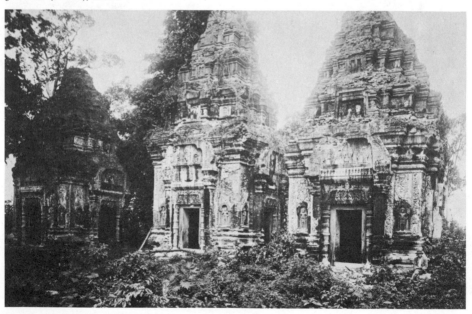

in a sort of maṇḍala has its origin in the very earliest precincts at Sambor and Prei Kuk. By the ninth century the tower form had reached a new stage in its development, already considerably removed from any dependence on Indian prototypes.

At Lolei the sanctuaries dedicated to Śiva and Pārvatī are cruciform in plan with massive projecting porticoes, real and false, forming the arms of a cross around the central square of the building. The superstructure rises in successively diminishing storeys in a manner faintly reminiscent of Dravidian temples; it was crowned by a stūpika or finial ultimately derived from the same source. Miniature replicas of the whole shrine stood at the corners of each level. The construction of these towers is brick, with sandstone for the doorways and niches, with stucco also employed for relief decoration. A distinctive feature for later Khmer architectural sculpture is the door lintels that are now heavily carved with foliate motifs framed in a reversed ∪, terminating in makara heads. Above this lintel, and supported by pilasters framing the whole doorway, is an even more massive tympanum, its shape suggesting a flattened trilobed chaitya arch. Beyond the fact that they stand together on an artificial platform, the shrines have no real architectural relationship one to another.

In the beginnings of the Classic Period of Khmer art, we notice the appearance in architecture of other completely new types of building methods and ornamentation. Most important and typical is the elevation of the cella of the pre-Khmer type to the summit of a stepped pyramid. The form of this type of sanctuary and its lofty stepped base are the result of the cult of the temple-mountain and of the Devarāja or 'God-king'.[11] The temple-mountain, simulating the imagined shape of either Mount Meru or Mount Kailāsa, is, of course, the importation of the old Indian concept of *pratibimba*, the making of either sacred

mountains or unseen celestial regions in architectural constructions.

With regard to the cult of the Devarāja[12] it it must be explained that the Khmer kings, even in their lifetimes, were regarded as incarnations of a deity like Śiva, Vishnu, or Lokeśvara, to whom the well-being of the realm was confided. The ritual and cult of the Devarāja centred around a sacred lingam which was imbued with the essence of divine kingship and installed in a temple-mountain, described in many inscriptions as being located in the centre of the capital and the Empire – and magically in the centre of the Universe. The consecration of this symbol and the continuance of a cult in perpetuity around it were to ensure the magic essence of kingship essential to the security of the state.

Of extreme importance to us in its relation to the cult of the temple-mountain and the development of Khmer architecture is the question of the chronology of the successive capitals established at the famous site of Angkor. Summarizing the results of brilliant researches by generations of French archaeologists on this vexing problem,[13] it can be stated that the first capital was founded by Yaśovarman I (889–910). It used to be believed that this city had as its centre either the Bayon temple or the shrine known as the Phiméanakas in the city of Angkor Thom. Actually, the city of Yaśodharapura, which took its name from the king, Yaśovarman, was built around the temple of Phnom Bakheng between Angkor Wāt and Angkor Thom [323]; this sanctuary was the centre of a vast quadrangle, nearly two miles on a side, and bounded on the east by the Siemreap River artificially deviated from its course to form a moat. Presumably this site remained the capital of the Khmer Empire until the founding of a new capital at Angkor Thom by Jayavarman VII (1181–1201), with the Bayon as its centre and temple-mountain.[14]

The temple-mountain in its simplest form may be illustrated by the shrine of Baksei

323. Angkor, Yaśodharapura and Angkor Thom

Moat of the first city

N

Western causeway

Ben Thom

Traces of an ancient canal

Southern causeway

Bakheng

Phiméanakas

Baphuon

Bayon

ANGKOR THOM

ANGKOR
WAT

Eastern causeway

Deflected channel of the Siemreap river

Chamkrong, dated 947, and standing in the shadow of Phnom Bakheng [324]. Here a tower of the type seen at Roluos and Lolei is placed on the summit of a pyramid of five storeys with staircases on all four sides. Originally there were sedent lions flanking these approaches at each level of the ascent. This temple was not, of course, the 'official' temple-mountain of the realm, but a lesser dedication, perhaps to a deified royal ancestor.

The Phnom Bakheng itself, sometimes designated as 'the resting place of Indra', was a true temple-mountain dedicated to the worship of the Devarāja, Yaśovarman, in the magic centre of his capital and realm [325].[15] It is located at the intersection of great avenues leading to gates in the city walls. The sanctuary is really an artful camouflaging of a natural hill in stone.

324. Angkor, Baksei Chamkrong

325. Angkor, Phnom Bakheng

This eminence has been made into a terraced pyramid in five levels. Five sandstone towers stand on the upper terrace, with smaller replicas on the lower stages of the elevation. Presumably at one time the spires at the top were auxiliary shrines grouped around a vanished central building, in which the symbol of the god-king was worshipped. The most important architectural aspect of this building is the location of a group of still isolated individual towers on the summit of a pyramid.

Before the solution of the riddles of the Bayon and Phnom Bakheng, it used to be maintained that the sanctuary known as the Phiméanakas or 'celestial palace' was the temple-mountain of Yaśovarman I [326]. This was presumably built in the tenth century as a subsidiary temple within the walls of Yaśodharapura. It is too small and inaccessible ever to have served as the

327. Angkor Thom, Phiméanakas

chief temple-mountain of the Empire. As it exists today, the monument consists of a three-storeyed pyramid faced with sandstone and surrounded on its topmost storey by a fene-strated stone gallery [327]. Stairways with lion guardians on each landing lead to the summit

326. Angkor Thom, Phiméanakas

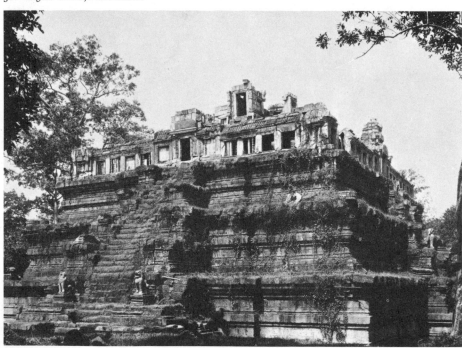

on all four sides of the massive base. The repetition of multiple horizontal mouldings around each terrace is a device adding to the sense of height that reappears in many later buildings. Probably the superstructure of the sanctuary was originally of wood. What is of chief import for us is the presence here of concentric galleries connecting the tower pavilions at the corners and over the entrances of the quadrangle on the top storey. This is the beginning of the employment of an element of northern architecture which was to be one of the most distinctive aspects in the final development of Khmer architecture. Probably here, as in many later and more grandiose temples, the galleries were intended either for the accommodation of pilgrims or for the storage and distribution of grain as alms. The openings in this peristyle at Phiméanakas were originally

filled with slender stone balusters, such as were universally employed in later Khmer buildings.

In Khmer architecture from its earliest beginnings we find a struggle between the horizontal and vertical elements of the structure. This was conditioned by the primitive character of the vaulting available to the builders, and by the demand for large sanctuaries with many chapels. Since it was impossible with corbelled vaulting to cover anything but the narrowest spaces, edifices covering a large area under one roof could not be built. The result was the development of a plan with many small individual units joined by narrow corridors or galleries. Opposed to this tendency towards horizontal distribution was the desire for verticality which arose from the need for buildings symbolizing the world mountain. The struggle was finally resolved by placing the

228. Angkor Thom, Takéo

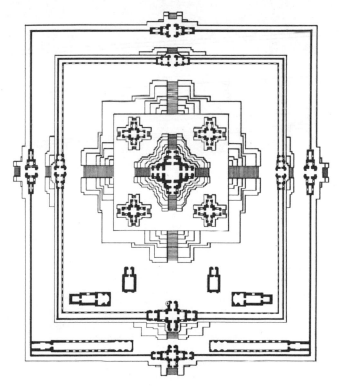

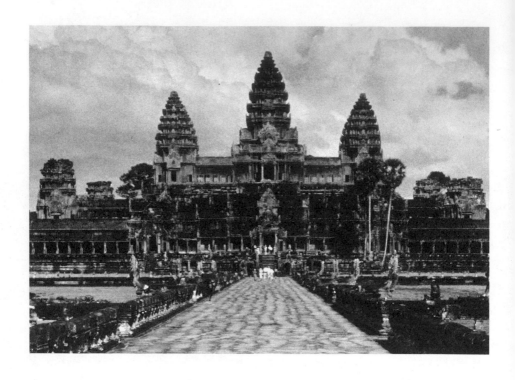

329. Angkor Wāt

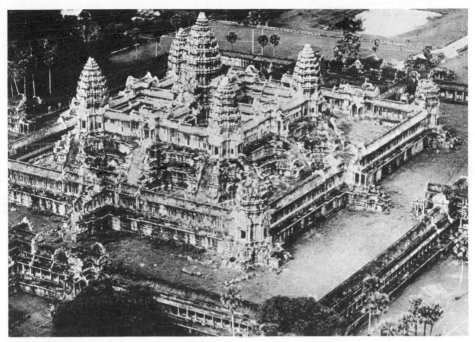

330. Angkor Wāt, air view

small sanctuaries all together on the top of one central pyramid and, as at Angkor Wāt, linking them by an elaborate system of connecting galleries.

Among the many steps in the resolution of this problem is one of the largest and most important Khmer temples of this transitional period: the unfinished Śaivite sanctuary of Takéo, founded in A.D. 889 [328]. In this structure we find a collection of eight separate towers located on the uppermost platform of a stepped pyramid. These sandstone spires were perhaps dedicated to eight manifestations of Śiva. As in the Phiméanakas, fenestrated galleries link the angle spires of the lowest terrace, but the towers remain isolated on the topmost level. It required only the joining of these individual shrines and separate levels of the

structure to produce the final and most complicated development of Khmer architecture.

This brings us to the task of analysing the grandest and most famous monument of Khmer civilization, the shrine of Angkor Wāt [329 and 330].[16] Every writer on the ruins of Angkor has complained of his inability to convey to his readers an adequate impression of this vast dead city rising silent above the jungle. Even Pierre Loti in *Le Pèlerin d'Angkor* wrote of his visit to Angkor as the greatest experience of his life: 'Au fond des forêts du Siam, j'ai vu l'étoile du soir s'élever sur les ruines de la mystérieuse Angkor.' Whether we see the monument at dawn, when the towers seem consumed by orange fire, or in the light of the full moon, when the effect is that of a range of incredible silvered peaks against the dark sky, the impression

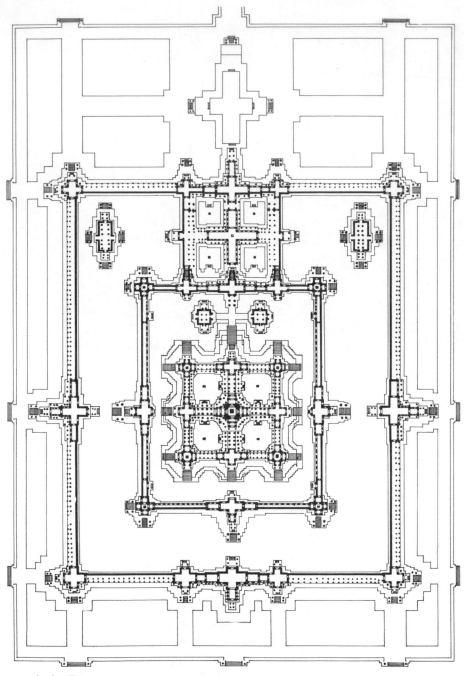

331. Angkor Wāt

which this fabulous ruin makes on the visitor is incomparable. This effect is only in part due to the beauty of the architecture; to an even greater degree it is caused by the immensity of the scale and the complete isolation of this great temple-mausoleum in the jungle stillness. Perhaps it might be compared to the impression that would be produced on a wanderer in another millennium coming suddenly upon the ruins of Manhattan rising silent and empty above the Hudson.

The city of Angkor Wāt was the creation of Sūryavarman II (1112-52), at once a monument to the Devarāja and the sepulchre of its founder. The monument is orientated towards the west and laid out on a rectangular plan, surrounded by a moat nearly two and a half miles in circumference [331]. The main entrance is over a causeway lined on either side by balustrades in the shape of giant nāgas that rear their enormous hoods at the beginning of this avenue. A monumental portal on a cruciform base forms the frontispiece to the temple proper. The foundations of the sanctuary are a vast stone platform, over three thousand feet on a side. After passing through the portico, the visitor finds himself in a vast gallery, more than half a mile in circumference, decorated for some two thousand five hundred feet of its length with reliefs from the legend of Vishnu and the Land of Yama, the Lord of Death. This cloistered arcade forms the outer perimeter of the entire plan. A stairway rising from the main portico leads to a square, crossed by galleries and containing four small open courts. From this level another staircase on the main axis brings us to the second level of the temple in the form of a great courtyard surrounded by colonnades and with towers at the corners. From the centre of this platform rises the mountainous turreted pyramid, itself the size of many earlier Khmer temples, that supports the innermost shrine of the sanctuary [332]. The steep declivity of this tremendous mound, with stairways on all four

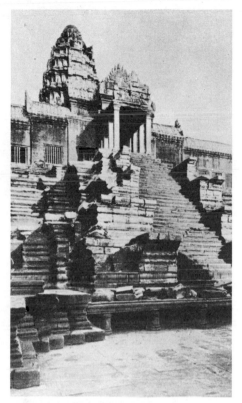

332. Angkor Wāt, central shrine

sides rising at precipitous angles, serves to increase the illusion of height. At the very summit looms the topmost spire, joined to the galleries surrounding the uppermost level by cruciform arcades. At the angles of this highest storey lesser śikhara towers echo the shape of the central spire, originally crowned by a golden lotus which rose over two hundred feet above the ground. Under this central tower which contained the image of the Devarāja was discovered a well, more than one hundred and twenty feet deep, in which a deposit of gold objects was found. It is likely that this shaft symbolized the world pivot that was the pestle

employed by the gods and giants in the churning of the Sea of Milk.

Here at Angkor Wāt the whole temple is in reality a vast, stepped pyramid, with its terraced levels completely unified by connecting galleries and staircases. Indeed, the temple marks a culmination of all the architectural refinements contained in earlier buildings. More than anything else, it is the cruciform plan, with its arms joining the enclosing galleries at each level, that made possible the architectural unity of this new and grandiose ensemble, a plan that, like another Versailles, was calculated to suggest the universal radiant power of a Roi Soleil or Devarāja [330]. Following a principle of Indian origin, the scale of the central mass is enhanced by lesser replicas of the innermost tower at successively lower levels on the corners of the galleries. Again typical of the originality and the sense of rhythm of the Khmer builders is the effect of scale obtained by subtle methods of transition from one level to another: the roofs of the galleries overlap or telescope one another, so that each lower level becomes progressively a smaller replica of the upper segment. The monument marks the final successful integration of vertical and horizontal elements which had always troubled the Khmer architects. 'As a correlation of parts to the whole, in the measured movement of the entire conception, in a word in the cadency of its articulation, it has few equals.'[17]

The individual spires at Angkor have a bombshell or pine-cone profile, only faintly suggested in the towers of earlier structures [332]. Ultimately, of course, the prototype is the Indian śikhara, but the towers of Angkor are as different from the śikharas of Bhuvaneśvar as a spire by Christopher Wren differs from its Gothic prototype. The bases of the towers at Angkor are square, but a transition to a star-shaped plan is made at the beginning of the curvature. Although in this latter regard it might be tempting to see a connexion with the favourite stellate plans of the temples of Mysore, it is really impossible to assign any one Indian antecedent to this Khmer form. The towers are built in nine levels or rings of masonry, and each one of these horizontal divisions is girdled by sharply pointed acroteria, their shapes vaguely suggestive of the chaitya arch form. All these projecting details, however, in no way interfere with the verticality of the soaring profile.

Just as the temple in its plan and elevation marks the high point of architectural design in Cambodia, so the hundreds of details comprising its fabric are individually and collectively the ultimate refinement of Khmer architectural decoration. Again, the development of each single type of moulding and fenestration could be traced step by step through an evolution beginning with the very earliest examples of Cambodian architecture.[18] Among the multiple elements worthy of special notice is the manner in which the curved roofs of the galleries are carved in imitation of earlier overlapping tile construction; each individual 'tile' is cut in the shape of a lotus petal. The openings of the cloister on the first level and all the windows of the temple were originally filled with slender balusters in continuation of a technique already observed at the Phiméanakas. It should be noted that there is no distinctive Khmer order in the pillars used for support in the structure of Angkor Wāt: these are for the most part square posts with a very simple lotiform necking at the top of the individual shafts in no way comparable with the elaborate pillars of the Indo-Aryan and Dravidian orders in India. The builders of Angkor Wāt displayed the greatest skill and taste in providing textural variety to the exterior in terms of light and shade; we have already seen evidence of this in the carving of the roofs; and it is especially notable in the depth and number of torus mouldings relieving, and at the same time strengthening by these bold horizontal accents, the façades of the

central pyramid. Even in such details as the individual profiles of these mouldings the architectural motifs appear to be original Khmer inventions in no way related to Indian models. As in all its predecessors, the vaulting of the galleries and towers of Angkor Wāt is constructed entirely on the corbel principle, with iron dowels used to hold together the superimposed courses of masonry.[19] The structure is mortarless and is supported by weight and gravity. At Angkor Wāt we have what is only a more complicated combination of many small elements to form a larger whole, a method of building which, as has already been explained, was necessitated by the Khmer architects' ignorance of any but the most primitive types of vaulting.

What most impresses the visitor to Angkor Wāt beyond its gigantic scale and clarity of plan is the great beauty and variety of sculptural ornament. This decoration is not only the finest achievement of the Cambodian sculptors, but of tremendous significance for an understanding of the iconography of the monument as a whole.

The development of relief sculpture in Cambodia, which attains its apogee in Angkor Wāt, follows step by step the growth of Khmer architecture from its strongly Indian beginnings to the final explosive Baroque style of the last period. In early Khmer architecture, as illustrated by the temples at Sambor, sculpture plays a subordinate role; in these buildings that are so closely derived from late Gupta or Pallava models the carving is limited to the decoration of the lintels and tympana and the insertion of figures in niches let in the walls. Some of the structures at Sambor are ornamented with medallions filled with reliefs, a type that almost certainly stems from the employment of this form at later Buddhist sites like Amarāvatī.[20]

During the next three hundred years there is a marked increase in the amount of sculptural ornament and in the richness of its carving; lintel and tympanum panels are filled to over-

flowing with deeply carved floral motifs or subjects from the *Rāmāyana* and the *Mahābhārata*; the wall is more and more broken up by niches containing images of deities; every pinnacle and crenellation is bristling with carving. As may be illustrated particularly well by the tenth-century decorations of the Baphuon [333], the figures and relief compositions are still confined to the limitation of panels and frames, as was the case with relief sculpture of the Gupta Period. The effect of the scenes from the legend of Vishnu on this monument is not unlike that of the Gupta stelae at Sārnāth, with separate episodes enacted by relatively few figures located in a number of superimposed individual panels.

333. Angkor Thom, Baphuon, scenes from the legend of Vishnu

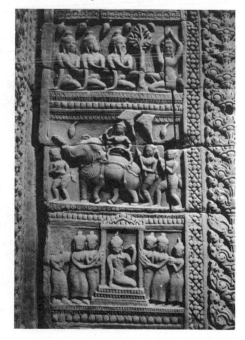

When we come to the sculpture of Angkor Wāt, the reliefs have completely burst their boundaries and are extended over the entire surface of the wall: even the figures of apsaras, sometimes still placed in niches, for the most part stand free of any encompassing framework [334]. In many details of costume, gesture, and pose, these celestial nymphs are the immortal sculptural counterparts of the dancers in the modern Cambodian ballet at Phnom Penh. The individual forms could be described as completely Khmer ethnically as well as stylistically. The square faces with wide eyes and enormous lips are seen in the Khmer Buddha type as well. This combination of the stereotyped smile, the delicacy of proportion, and the affected elegance of gestures lends a certain wistful charm and piquancy to the conception quite different from the much more frankly sensuous Indian conception of female beauty. The individual apsaras are relatively flat in carving, and the

rendering of details of costume and ornament provides a foil for the generalized treatment of the nude portions of the bodies.

The famous reliefs of the cloister at Angkor Wāt extend like a continuous stone tapestry around the entire lower circumference of the building [335]. They are executed in a few planes of very low relief, with some of the elements no more than incised on the surface; this technique, together with their strongly pictorial character, suggests that they may have been intended as a more permanent substitute for wall-paintings. It has been supposed from the generally unornamented interiors of Khmer shrines – in contrast to the richness of exterior decoration – that it was probably customary to decorate the insides of sanctuaries with paintings that have not survived the dampness of the climate and the ruin of the fabric.

The iconography of the building and its destination can be understood partly from an

334. Angkor Wāt, apsaras

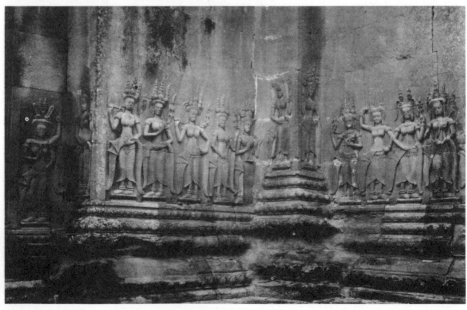

examination of the reliefs which cover the walls of the basement cloister. On entering the gallery through the western entrance, we find the reliefs reading from right to left; that is, the visitor was expected to perform a counter-clockwise circumambulation. The subjects include scenes from the *Rāmāyana*, legends of Vishnu and Krishna, the Churning of the Sea of Milk, and scenes of heavens and hells. These representations are partly historical, symbolizing events from the king's life that bore a resemblance to episodes in the legends portrayed. This, together with the counter-clockwise arrangement of the reliefs, indicates that the temple was a funerary monument, dedicated in Sūryavarman's lifetime to the powers of death. The dual character of the temple is completed by the nature of the statues originally installed in its towers: the central spire housed a statue of the king – the Devarāja – in the guise of Vishnu; the statues of other avatars of Vishnu which were

originally placed in the subsidiary towers were presumably likenesses of his ministers, the nineteen lords who are represented marching with the king to the realm of Yama in one of the reliefs of the south gallery.

It must be remembered that the bas-reliefs of Angkor Wāt were specially chosen, more as ornaments magically appropriate to the palace of a god than as didactic scenes destined for the edification of men. Their arrangement was certainly determined by a magic principle of orientation, which we do not know, rather than by a desire to instruct the visitors to the sanctuary.

3. THE CLASSIC PERIOD: THE LAST PHASE (1000–*circa* 1450)

The final phase of Khmer building can well be described by the term 'Flamboyant', since, as this word in its application to Late Gothic

335. Angkor Wāt, gallery,
Vishnu: The Churning of the Sea of Milk

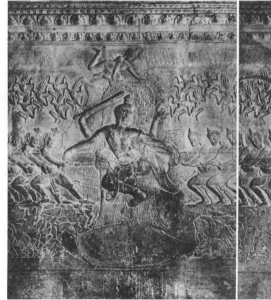
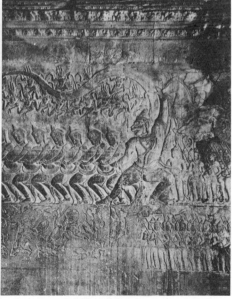

architecture implies, it is characterized at once by an almost overwhelming exuberance of sculptural methods. The great moment of this period is the reign of Jayavarman VII (1181–1201), but significant monuments on a somewhat reduced scale continued to be built well on into the fourteenth century.

One of these later constructions is a great gem of Khmer architecture. This is the sanctuary of Bantéai Srei, the ancient Iśvarapura, which was

336. Bantéai Srei, tower

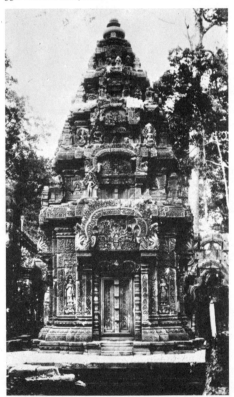

founded by the teacher and relatives of King Śrindravarman in 1304.[21] The group consists of three shrines dedicated to Śiva, placed on a basement platform. There are, in addition, two other buildings generally identified as temple libraries. This plan is essentially only a prolongation of the arrangement of separate towers placed in groups that we have seen at Sambor and Lolei. The whole precinct is surrounded by an enclosure with gopuras, a concept that seems ultimately related to South Indian architecture. The individual towers have the usual cruciform ground plan and are equipped with three false doorways repeating the form of the actual entrance to the cella [336]. They have the steep pyramidal elevation topped by a kalasa finial of earlier Khmer towers, but here the profile is much steeper and elegantly pointed. Small turrets at the corners of each level serve to cover the transition of the separate terraced storeys.

It is the sculptural decoration of this monument that gives it such a definite refinement and elegance. Every wall-space of the base has its niche with a divinity framed in elaborate scrolls of foliate carving. The portals, following a scheme going back to the earliest shrines at Sambor, are crowned with lintels, and in addition there is a massive tympanum framed in an omega-shaped border terminating in upraised nāga hoods. Not only this, but the tympanum, in reduced scale, is repeated at every successive level of the superstructure, as though to provide suitable entrances to the devalokas personified in these storeys. These tympana are only the final development of a Khmer form evolved as early as the seventh century.

One of these pediments from the eastern library building is particularly worthy of analysis [337]. It represents a tableau that we have already seen at Ellūrā: the giant Rāvaṇa shaking Mount Kailāsa.[22] Here, as in countless other Khmer architectural reliefs, the carving was evidently done after the sandstone blocks of the fabric were in place. In comparison with the Chalukya version of this theme at Ellūrā, the conception is about as original and far-removed from its precedent as, let us say, a

337. Bantéai Srei, tympanum
with Rāvaṇa shaking Mount Kailāsa

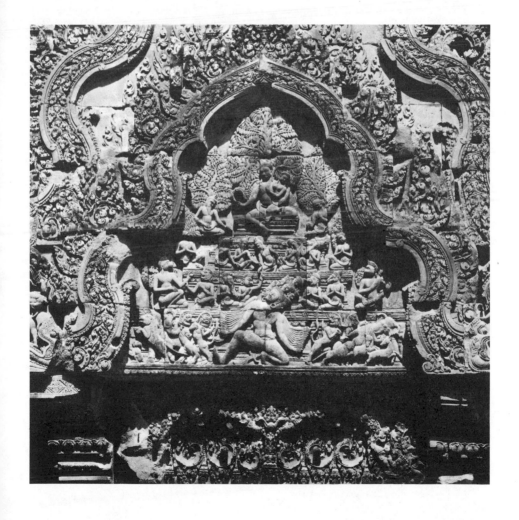

reclining Venus by Cranach is from the great Italian versions of the subject by Giorgione and Titian. From the illustrative point of view the composition is entirely clear, but it completely lacks the dynamic, awe-inspiring character of Indian reliefs of the *Rāmāyana*. There is a playful feeling about the representation, as though the figures were moving in the measures of an elaborate ballet. The pyramidal shape of the main compositional elements, of course, lends itself remarkably well to filling the chaitya form of the tympanum. The interior of the serpentine border framing the panel and surrounding areas is covered with a luxuriant floral ornament that has as its basic design a curling fern frond motif, not unlike the cloud and water patterns of Chinese T'ang sculpture. But this resemblance is certainly to be regarded as accidental.

This same basic floral design is even more noticeable in the lintels at Bantéai Srei [338]. These reliefs are, as in the case of the tympana, the last and most florid stage in the evolution of a member typical of Cambodian architectural decoration from its beginnings. Indeed, in this final example many of the essential features are copied from the arrangement of earlier reliefs. These borrowings would include the general composition with a single deity – in this case,

Brahma on a haṁsa – set in a kind of foliate polylobed embrasure, and the curling garlands in the shape of an ox-yoke or omega that run across the field of the panel. Every available space is filled with twining leaf-forms with inverted calyx cups suspended from beaded stems forming vertical divisions in the ornament. The carving is of a crispness and extravagant richness that are typical of this final 'Rococo' phase of Khmer art.

The most spectacular architectural achievement in this last chapter of Cambodian history was the laying out of the new capital at Angkor Thom by Jayavarman VII. This foundation and the earlier capital of Yaśodharapura were not cities in our, or the Indian, sense of the word as centres of population. The vast enclosure within the encompassing walls and moat was reserved only for temples, and the palaces of the king and nobles, together with buildings for the military and judicial branches of government. The great body of the population serving these institutions lived outside, around the various artificial reservoirs or *barais* and the banks of the Siemreap River. Vatican City, or the Kremlin in Tsarist days, offer themselves as remote European parallels for this type of capital planning; in India, one can think only

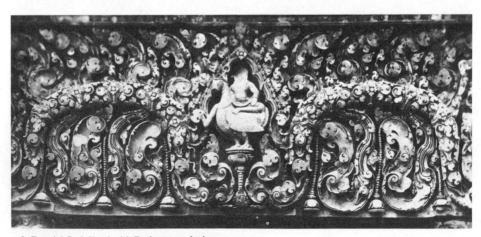

338. Bantéai Srei, lintel with Brahma on a haṁsa

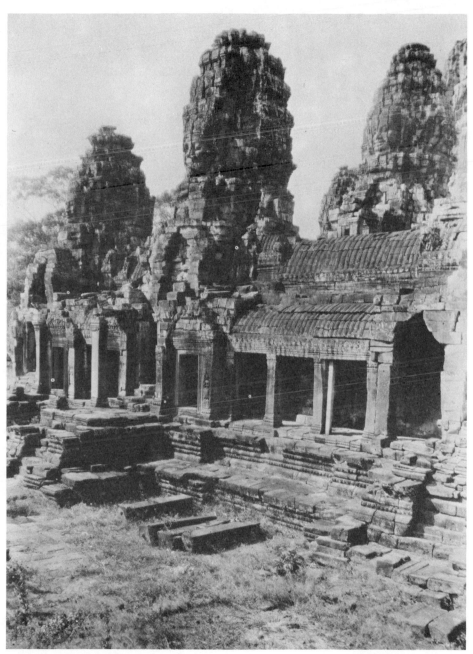

339. Angkor Thom, the Bayon

of the great temple cities of South India such as Madura, but these, of course, were sacred enclosures not comprising any secular buildings.

The last Khmer building of any size to be dedicated at Angkor was the Bayon, erected in the early years of the thirteenth century as the centre of the new capital of Angkor Thom [339]. The Bayon, as it stands to-day, represents four different remodellings [340]. It was first planned as a horizontal temple: of this stage only the outer galleries survive. There followed the erection of an inner gallery system, raised on a podium and connected by sixteen chapels to the outer system. Finally, the central tower and its subsidiary spires were built over the original structures. At a later (Hindu) period the sixteen chapels were entirely demolished. Probably the temple was finished and converted to Mahāyāna Buddhist usage by Jayavarman VII to celebrate his restoration of the capital following its sack by the Chams in 1177. The thirteenth-century Chinese pilgrim Chou Ta-kuan, who visited Cambodia in 1296, says of the royal city of Angkor Thom:

The city wall is twenty *li* in circumference. Outside the wall there is a wide moat, beyond which there are

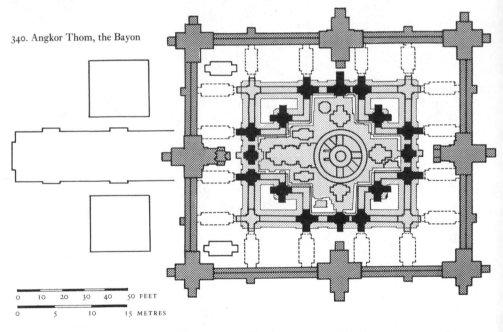

340. Angkor Thom, the Bayon

0 10 20 30 40 50 FEET

0 5 10 15 METRES

■ The inner galleries built in the form of a cross with recessed corners. This first stage corresponds to a primary state of the central block of which only a fragment of the basement has been recovered.

▢ The four angles of the inner galleries commenced at the same level as the preceding galleries but at a later date.

▨ The outer galleries.

⌐¬ The sixteen passages or chapels, which afterwards were intentionally demolished, and the two libraries.

causeways with bridges. On either side of the bridges there are fifty-four stone demons, like stone generals, gigantic and terrible. The five gates are identical. The parapets of the bridges are of stone, carved in the shape of nine-headed serpents. The fifty-four demons hold the serpents in their hands. . . . On the city gates there are five stone heads of Buddha, their faces turned to the west, the middle one being adorned with gold. The two sides of the gates are carved as elephants' heads. The wall is entirely built of superimposed blocks of stone. . . . The stones are carefully and solidly joined, and no weeds grow on them.[23]

We shall presently recognize all the elements mentioned in this precise account. Referring specifically to the Bayon, Chou Ta-kuan writes: 'The centre of the realm is marked by a tower of gold surrounded by more than twenty towers of stone and a hundred stone chambers', a succinct description of the sanctuary with its multiple spires and maze of galleries.

In its present form the monument has the essential pyramidal elevation of many earlier examples [339]. The most distinctive feature is the carving of gigantic masks of the Bodhisattva Lokeśvara – 'the Lord of the World' – on the four sides of each and every one of the towers.[24] Similar heads are repeated on the towers of the chapels, at the corners of the city wall, and, as Chou Ta-kuan noted, over the gateways at the four points of the compass. The Bayon is in the centre of the square city plan, from which intersecting avenues radiate to the portals in the walls [341]. These walls may be regarded as the outer enclosure of the sanctuary and symbolically intimately related to it.

The temple proper was the central mountain or Meru, like the centre of earlier Khmer capitals; here the symbolism extends to the city walls, which stand for the *cakravāla*, the circumambient mountain ranges around the mythical world mountain; and the outer moat completes the magic image as a likeness of the ocean that girdles the world. The import of this vast complex in architecture is completed by

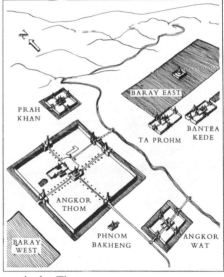

341. Angkor Thom

parallel rows of the colossal figures of gods and
giants – the 'demons' of Chou Ta-kuan's des-
cription – holding the coils of a great serpent, so
that they appear to be literally using the Meru –
the city of Angkor Thom itself – as the pestle
for their churning of the Sea of Milk [342].

Not only the four faces on each of the towers
of the Bayon [343], but also the head of the
Buddha image found in the ruins of the central
tower [344] are probably to be interpreted as
ideal portraits of the king as an incarnation of
the Bodhisattva Lokeśvara. This Buddha statue,
like the central deities or *lingas* of Hindu
Devarājas, was the very palladium of Empire.
The multiplication of the masks of Lokeśvara at
every point of the compass was intended to
indicate and magically to ensure the radiation of
the Devarāja's power to every corner of the
realm. There were not fifty Lokeśvaras but *one*
deity everywhere manifested. The chapels of the
Bayon were all inscribed with dedications from

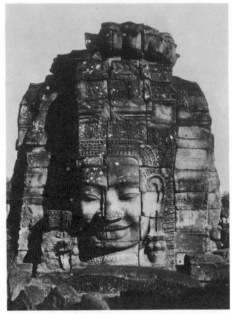

343. Angkor Thom, the Bayon, head of Lokeśvara

342. Angkor Thom, Gate of Victory

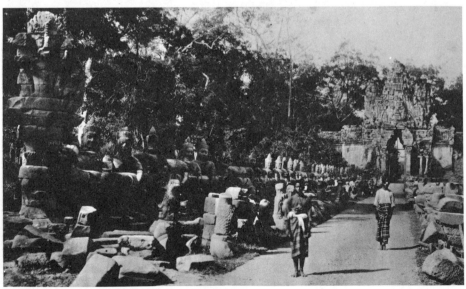

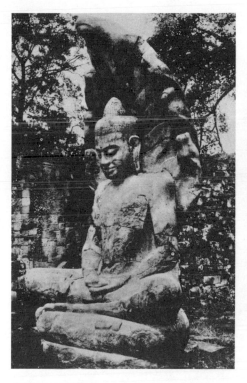

344. Angkor Thom, the Bayon, Buddha

345. Angkor Thom, the Bayon, outer wall, scene of military campaign

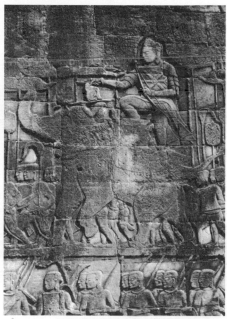

various provinces of the Empire, and had in them images, Brahmanic or Buddhist, which were locally worshipped in these places, in order to proclaim by this concentration in the central temple of the Empire that Jayavarman was king, not only at Angkor, but in every region of his Empire. It was the magic function of the masks of Lokeśvara and of the chapels of the provinces to maintain the essence of sovereignty, the divine power of the Devarāja, in every quarter of the realm.

The Bayon, transformed into a temple-mountain by Jayavarman VII, illustrates an arrangement of horizontal and vertical elements only somewhat different from that which determined the form of Angkor Wāt. The galleries are all roofed with corbelled vaults; the exterior of these roofs, as at Angkor Wāt, is carved in imitation of tiling. The towers, constructed as usual without any mortar, maintain their stability only through the sheer downward pressure of the enormous mass of masonry. The monument illustrates the final stage in a process whereby the sculptural ornament completely dominates and overwhelms the architecture that supports it.

The quantity of carving on the Bayon is so great that it is difficult to single out any individual details of sculpture for special analysis. The outer walls of the precinct are decorated with reliefs of scenes of peace and war within the Empire and subjects from the *Rāmāyana* [345]. This carving remains unfinished, and we can see in our illustration how the sculptors proceeded by first incising the design on the surface and then chiselling out the

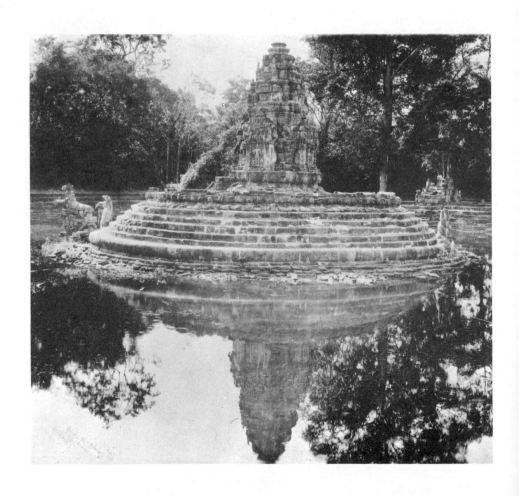

346. Angkor Thom, Néak Péan

background of the low relief. The compositions are even more densely crowded than those of Angkor Wāt, and, although the narration is extremely lively, the actual workmanship is cruder and more summary.

This last monument of Khmer building, the Bayon, is really not so much a work of architecture as one of sculpture, with the towers, like so many statues in the round, arranged as a great mandala in stone. Here, as at Angkor Wāt, circumscribed panels are not sufficient for the accommodation of the narrative reliefs: the whole building and the outer wall of its enclosure provide the background for the endless defile of moving figures. The sculpture has, in other words, overwhelmed the building, unconfined by any space or limitation. This development from a limited, almost classical, conception of relief to an overflowing Baroque manner exactly parallels the transition we have already studied in the evolution from the technique of Gupta relief sculpture to the dynamic conception of the medium under the Pallavas and later Hindu dynasties. It could be said, perhaps, that the immensely complicated and rich type of this late sculpture was exactly appropriate to the complexity of Vajrayāna Buddhism.

Without the walls of Angkor Thom is a small dedication of the late thirteenth century, known as Néak Péan [346 and 347]. The single tower of the sanctuary stands on a stepped lotiform plinth circled by two nāgas in the centre of a square basin of water. From this font radiate four smaller tanks fed from the main reservoir by gargoyles in the shape of the heads of a horse, a lion, an elephant, and a human face.[25] Iconographically this is a perfect reconstruction of the concept of that magic lake in the Himalayas, the waters of which pour out through the four great rivers to solace men and the spirits in hell. The tanks were intended for ritual ablution and the whole complex was dedicated to the merciful Bodhisattva Lokeśvara.

The central tower was erected on the usual cruciform plan. It was formerly entirely crushed and hidden in the network of roots from a banyan tree that grew from its summit, but has now been freed of this entanglement to reveal a tower culminating in a lotiform finial and in profile suggesting the fourteenth-century spires of Bantéai Srei. The false doors of the little building are carved with reliefs of the same Lokeśvara enshrined at the Bayon. The whole has a lightness and delicacy of conception, combined with an extremely complex icono-

347. Angkor Thom, Néak Péan

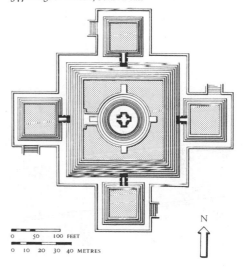

0 50 100 FEET

0 10 20 30 40 METRES

N

graphical meaning, that is entirely typical of this last period of Khmer religious architecture.

One has the feeling, in studying this and all the vast architectural dedications of these final centuries of Khmer history, that these enterprises were the result of the patronage of the nobility and entrenched priesthood with the collaboration of a privileged class of śilpins and the enforced assistance of what must have been whole armies of slave labour. Once this entire upper class and its patronage disappeared with

the military defeat by the Siamese in the fifteenth century, the culture it supported vanished forever.

Although the history of relief sculpture in Cambodia must properly form a part of the discussion of the architecture it decorates, the development of the cult image, generally free-standing, can be taken up as a separate topic. We have already examined the types of sculpture that flourished in the so-called Pre-Khmer Period, works under the strongest possible Indian influence, and a group of statues typified by the Harihara of Phnom Penh [320], in which signs of a completely native originality are apparent. It is in the period following the establishment of Khmer supremacy in the

348. Angkor, Phnom Bakheng, Śiva (?)

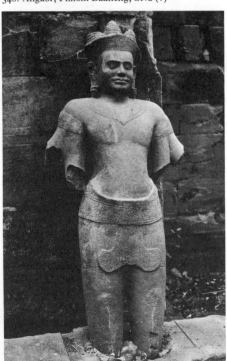

eighth, ninth, and tenth centuries that types of Buddhist and Hindu images completely Khmer in character are gradually evolved.

During this period Brahmanic figures prolonging the style of the pre-Khmer Period continued to be carved, but, as early as the tenth century, in the sculpture found at the sites of Phnom Bakheng and Koh Ker there are signs of the evolution of definite Khmer traits that remain more or less fixed for the entire later development. Taking as an example a four-armed statue from Phnom Bakheng [348] – probably the royal donor Yaśovarman in Saivite apotheosis – we notice first of all a tendency towards generalization. There is a certain rigidity and heaviness about the plastic conception. The modelling of the body is now little more than a definition of the main architectural mass of the strictly columnar form with a disappearance of the extraordinary sensivity and vital surface quality that distinguished the pre-Khmer statues.

The costume has undergone certain modifications, too; instead of the dhoti of the seventh-century images we have a pleated skirt supported by a belt and characterized by an anchor-shaped fold hanging down in front like a sporran. The figured design of the cloth is still indicated by incision, but has become rather obtrusive and lacking the delicacy of the carving of such details in the earlier statues.

In the Early Classic Period the heads of images retain the essentially block-like – one is tempted to say 'Polyclitan' – form typical of the very earliest works [349]. The sculpture, however, begins to assume a more hard, linear character in the incised definition of the features, as, for example, in the double contour lines of the eyes and lips. The brows now form an almost straight horizontal line across the face. The features also take on a definite Cambodian racial character, a degree of realism probably to be explained in part, at least, by the fact that many of them, although ostensibly representa-

tions of Buddha, Śiva, or Vishnu, are ideal portrait statues of the Devarāja. This ethnic flavour manifests itself in flat noses with flaring nostrils and the voluptuous fullness of the lips. The snail-shell curls of the Buddha heads and the hair and beards of heads of men, like the example probably from Koh Ker in our illustration 349, are rendered with an engraved precision of cutting that gives a certain hardness to the carving. This same laborious treatment of detail extends to the representation of the jewelled intricacies of head-dresses. The effect of these sculptures of the ninth and tenth centuries is already one of dryness and hieratic severity, lacking the feeling of vitality that distinguished the works of the Funan Period.

The Khmer heads of the period of Angkor Wāt continue the rather hard style of the pervious period of development [350]. The outline of the mass of the hair is separated from the face – sometimes by a broad band or edging – as though it were a cap pulled over the skull and ushnisha. The precise lineal definition of the features is somewhat less marked; the eyebrows are very often carved in raised relief; but, above all, these heads show a tendency in the direction of sweetness of expression, accented by the lowered lids and the set smile of the thick and broad lips. This suggestion of inner beatitude becomes a cliché of all later Khmer sculpture. It is a manner that can be just as meaningless and aesthetically displeasing as

349. Head of Vishnu from Koh Ker.
Boston, Museum of Fine Arts

350. Head of Buddha, Angkor style.
Philadelphia, Museum

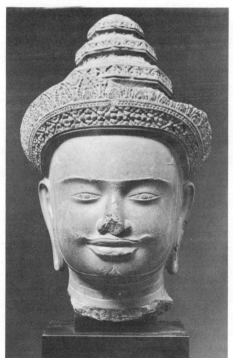
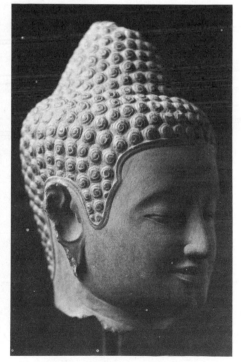

the expression of piety in European Baroque painting, through the upward-rolling eyes and gaping mouths of the saints by Guido Reni and his followers.

The tendencies towards generalization and formalized hardness persisting in the sculpture of Angkor Wāt reach a culmination in the style of the Bayon of the late twelfth and thirteenth centuries. Not only the giant heads of Lokeśvara [343], where scale might explain the lack of feeling, but all sculpture of this period is characterized by a mask-like fixity of expression enhanced by the exaggeration of the Khmer smile and an even more mechanical execution [344]. There is no longer in the end any indication of that striving for the rendering of the vitalizing structure and essential nature of the human body that marked the magnificent efforts of the sixth and seventh centuries.

The heads from the period of the Bayon in certain respects have a dreamy, soft quality which is due to the abandonment of that precise linear definition of details typical of the work of the Early Classic Period. The individual features do not stand out as separate parts affixed to the block of the head, but melt into this mass, so that to some degree there is a return to the strong plastic conception of the Funan Period. Many of the heads, however, notably the collection of masks on the Bayon, are so much alike that they might have been cast from the same mould. There is a monotony in this formula for expressing the peace of the Buddhist soul which totally lacks the wonderful feeling of individual creation and fierce striving for the solution of plastic form as we see it in the great masterpieces of the sixth and seventh centuries.

Examples of Cambodian metal-work of all periods are preserved in various collections in Indo-China and the West.[26] They are reasonably exact counterparts on a small scale of the monumental sculpture of the different periods

of development and are of a very high order of fineness of casting and craftsmanship. One of the loveliest and at the same time most unusual specimens, said to have come from the Bayon, is in the collection of the Museum of Fine Arts, Boston. It was probably part of a kind of flowering candelabrum representing a wonder tree in Indra's Paradise the fruit of which consisted of beautiful maidens for the pleasure of the gods. The fragment in our illustration 351 shows an apsaras dancing on an open lotus pod, while another celestial girl emerges from a bud at the left. In few pieces of Khmer sculpture do we find such a wonderful realization of the quality of stylized rhythm that is at the basis of all Cambodian design – in the dance, in architecture, in sculpture. The lines of the ogee-shaped floral enframement repeat the sinuous outline of the arms and legs of the dancer. The gesture of her upraised arms continues the wonderful suggestion of pliant growth in the supporting vine. Although badly corroded, enough of the original surface is visible for us to see the great refinement in modelling and in the rendering of the chased details of the floral accessories. The little figure of the dancer is so close to the representation of apsaras on the Bayon itself that there is no hesitation in dating this piece in the late twelfth or early thirteenth century.

This final period of Khmer civilization was one of gigantic architectural programmes, which in a way imposed mass production. One has the feeling that the labour involved in the erection of the vast complexes of the last century of Angkor more than anything else exhausted not only the Khmer genius, but the strength for any kind of resistance against the Siamese, who for long had been threatening the western frontiers. The end of Angkor came in the fifteenth century with a disastrous Siamese campaign. Although the shadow of a Cambodian monarchy continued for some centuries at Phnom Penh, the Khmer epic ends with this

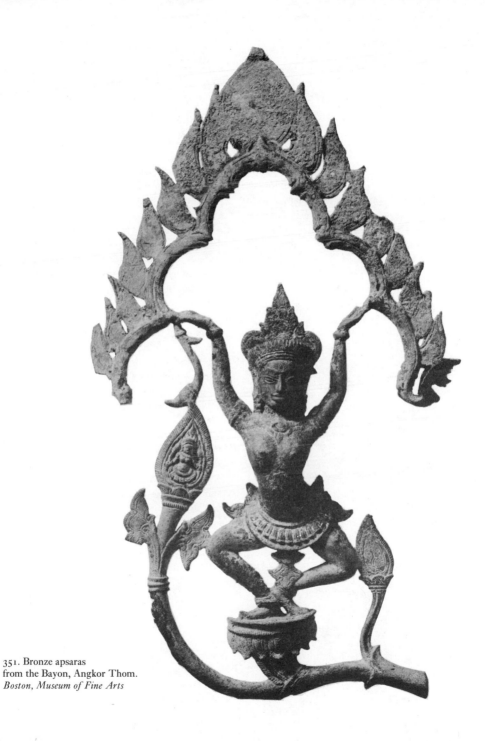

351. Bronze apsaras
from the Bayon, Angkor Thom.
Boston, Museum of Fine Arts

débâcle. Another reason that might be advanced for the disappearance of Khmer civilization is that, with the sweeping away of the Cambodian aristocracy and priesthood, folk-art replaced the grandiose dreams of a cosmos created in stone.

It is a commentary on the failure of the last century of Khmer religion that the people apparently were quite eager to abandon the complexity of Vajrayāna Buddhism and its

352. Pottery amphora.
Hanoï, Musée Finot

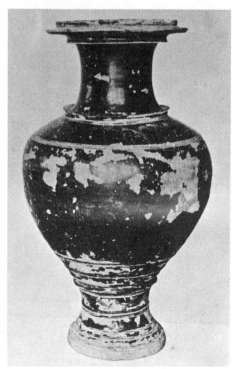

fantastic symbolic architecture in favour of the simple philosophic Pāli Buddhism which their Siamese conquerors offered.[27]

*

The finds of ceramics in the precincts of the ancient Khmer capitals include numerous vessels which are presumably Sung or early Ming imports or the productions of Chinese workmen attached to the local kilns. Other wares are almost certainly of indigenous manufacture. These are pottery vases, some in the shape of animals, covered with a brownish glaze.[28] A particularly splendid shape is an amphora with an elegant profile that recalls the curvature of the balusters of the Angkor style [352].

A fitting object with which to close our consideration of the minor arts in Indo-China is the Prah Khan, or sacred sword, a relic returned by the Siamese in 1864 for the coronation of the first Cambodian king and presumably still preserved as part of the royal palladia in the palace at Phnom Penh.[29] The two-edged steel blade and its hilt are heavily encrusted with relief decoration in gold [353]. The ornament comprises representations of a *kirtimukha* or monster mask, Indra on a three-headed elephant, and Brahma. The same type of long sword without guard may be seen in many reliefs at Angkor Wāt and the Bayon, so that it would seem possible to date this precious object, to which many fantastic legends are attached, to the twelfth or thirteenth centuries. The actual relief ornament is executed with the same precision of craftsmanship that distinguishes all Khmer sculpture. As a kind of symbol of the passing of Khmer power into the hands of the Siamese, the scabbard of the sacred sword [354], executed in an elaborate gold filigree, originally studded with rubies and green and red enamel, is almost certainly of Siamese workmanship comparable to objects in the famous golden treasure of Ayudhyā.[30]

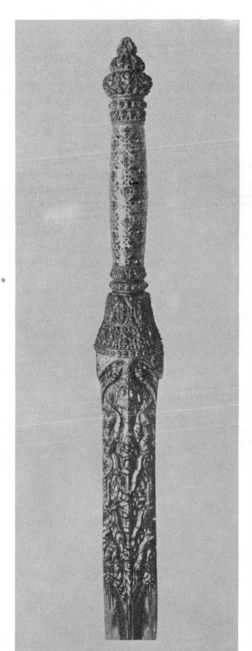

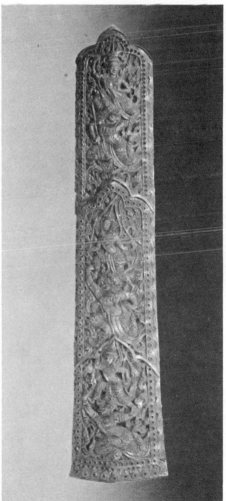

353. Sacred sword.
Phnom Penh, Royal Palace

354. Scabbard.
Phnom Penh, Royal Palace

ART AND ARCHITECTURE IN SIAM

Although in the early periods of its development the art of Siam can scarcely be differentiated from the tradition in Cambodia, it is worthy of a separate consideration, not only for certain unquestioned masterpieces of Oriental sculpture, but for the lesson contained in the decline of a traditional art, with which Siamese work of the later centuries furnishes us.

In so far as it is possible to be definite about the hazy beginnings of the Siamese kingdom and its art, it can be said that probably in the early centuries of the Christian era Indianized groups of the Mon people from lower Burma gradually settled themselves in the Mekong Valley, where they merged with the Lao-Thai, originally from Tibet and South China. About A.D. 550 the Mon invaders were able to assert their superiority and to found the Empire of Dvāravatī with themselves as the ruling class. This first Siamese dynasty maintained its sovereignty until *c.* 1000, when the territories around the Gulf of Siam were reconquered by the Khmers. Although scientific excavation has been limited to only a few sites, a considerable amount of material, sculpture in both stone and metal and fragments of architecture, has been brought to light and enables us to form some idea of the character of this earliest Siamese culture.

Like the contemporary Buddhist sculpture of Cambodia, the Siamese images of the sixth century reveal an unquestionable dependence on the prototypes of the Gupta Period in India, but even these statues from ancient Ayudhyā and Romlok show the emergence of certain definitely recognizable Siamese characteristics [355].[1] This is to be discerned particularly in the type of heads and features. The heads are

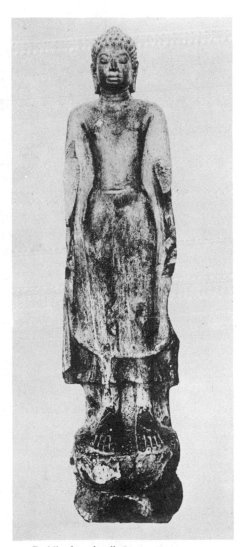

355. Buddha from Ayudhyā.
Bangkok, National Museum

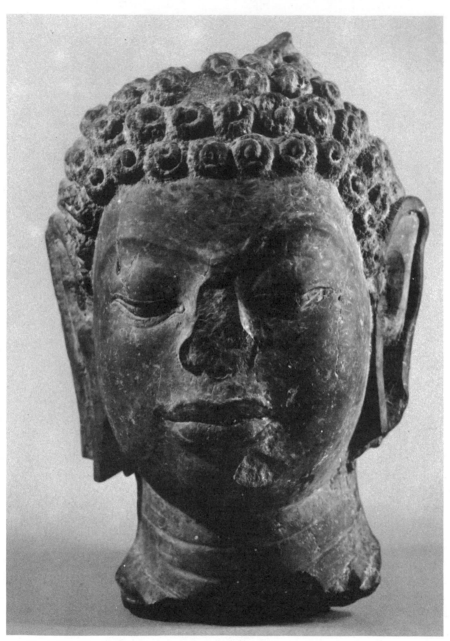

356. Head of Buddha from Siam.
Schiedam, Holland, C. S. Lechner

more often than not too large for the bodies, so
that there cannot have been any strict observance of the Indian canonical systems of proportion. In the example illustrated there is a
definite suggestion of a Siamese ethnic type in
the broad face with a relatively flat nose and
enormously full lips. Another characteristic
of the Buddhas of the Dvāravatī Period is the
size and prominence of the individual snailshell curls that cover the head like a cap. The
actual carving of the body, which is entirely
revealed through the simplified sheath-like
robe, is derived from the style of the Buddha
images of the Gupta Period at Sārnāth and
Ajaṇṭā. The extremely beautiful head reproduced in our illustration 356 is typical of this
Indianized phase of Siamese Buddhist art. It
has certain characteristics in common with the
image in Seattle, specifically the very patternized flower-like shapes of the eyes and lips that
may be regarded as a Siamese interpretation of
the Indian metaphorical method of representing
the Buddha's features. Although the arched
brows and lotiform eyes are here entirely integrated with the thoroughly sculptural conception of the head, this tendency to patternize the
features – treating them as parts of a decorative
appliqué to an inorganic mask – was to end,
many centuries later, in the disintegration of
Siamese sculpture into an empty ornamental
formula.

As in Cambodia of the Pre-Khmer Period,
Indian missionary activity included the introduction of Hindu as well as Buddhist ritual art;
a number of Brahmanic images of the sixth
century are extremely interesting, and quite
different from contemporary work in Cambodia.
A typical example is the standing image of Vishnu in the National Museum at Bangkok [357].
Certain technical factors relate this statue to the
Pallava style of the sixth and seventh centuries.
Not only the conception of the figure in terms of
mass and simplified planes, but the manner in

which the form appears to emerge, as though not
entirely disengaged, from the plain background
of rock is immediately reminiscent of the masterpieces of Pallava carving at Māmallapuram.
The rather pointed face with high cheekbones
is again more closely related to Indian originals
than the contemporary Buddha images of this
period.

357. Vishnu from Siam.
Bangkok, National Museum

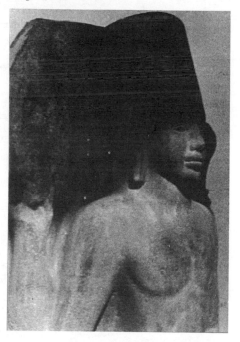

358. Torso of Bodhisattva from Jaiya.
Bangkok, National Museum

One of the great masterpieces of early Siamese sculpture is a bronze torso of a Bodhisattva, most likely a form of Avalokiteśvara, preserved in the National Museum at Bangkok [358]. The term Śrīvijaya has been applied to this and a few related images to indicate that they date from a period of Javanese dominance of the Malay Peninsula. This object is very closely related to the late Buddhist art of Bengal, as represented by the bronzes of Nālandā and the ninth- and tenth-century sculpture of the Pāla Dynasty. The exquisite precision in the complicated details of jewelled accessories and the way the sharpness and hardness of these features contrast with and enhance the softness of the flesh parts are not far removed from the style of the Sāñchī torso of the Pāla Period [197]. The sinuous twist of the body indicates that, when complete, the figure was cast in the pose of the three bends (tribhanga), the

déhanchement that is almost universal in Indian images of all periods.

The end of the Dvāravatī Empire comes with a Khmer invasion in the tenth century and the establishment of a viceroyalty at the capital of Lopburi, about eighty miles north of Bangkok. This is a phase of art in Siam that is simply a local off-shoot of the developed Khmer style of the Angkor Period [359]. The Buddha heads of this period, difficult to distinguish from actual Cambodian work, are characterized, as were the very earliest icons, by certain very definite Siamese traits: the very straight overhanging brows, pointed noses, and broad, prominent chins are all hall-marks of the Lopburi style, as is the fondness for a particularly elaborate conical ushnisha.[2]

As early as the ninth century, groups of the Thai people of Yunnan in south-western China had again begun to move westward into what is

359. Buddha from Wāt Mahādhātu, Lopburi. *Bangkok, National Museum*

360. Head of Buddha from Chiengmai. *Bangkok, National Museum*

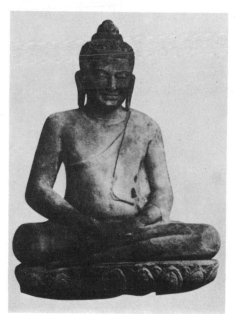

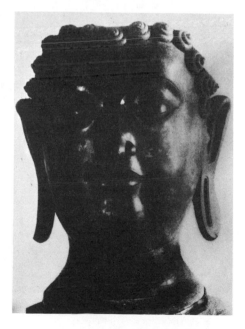

to-day northern Siam. By the thirteenth century these invaders had so strongly established themselves that they were able to expel the Khmers and to found the first national Siamese dynasty at Chiengmai (Chiengsen) in the northern Menam Valley. The Buddhist art of this period marks the first definite emergence of what can accurately be described as a Siamese style and ideal, although influenced to a certain extent by Pāla prototypes from Burma. The Chiengmai Buddha type is distinguished by the arched eyebrows, the exaggerated almond eyes with a double-upward curve in the lids, the hooked sharp nose and rather small and delicately modelled lips [360]. Bronze now almost entirely supplants stone as a material for sculpture.

In the last seven hundred years of Siamese history it is possible, of course, to differentiate among many different local schools and to trace the gradual transformations in the stylistic evolution of sculpture, but the aesthetic value of this enormous amount of material is, most of it, so insignificant that such an analysis need not detain us.

The later history of sculpture in Siam is one of decadence towards the evolution of the final stereotyped Buddha image manufactured during the Ayudhyā Period. The statues made during the Suk'ot'ai Period (thirteenth to fourteenth centuries) are marked by a gradual simplification of the formulas of the Khmer and Chiengmai types. A particularly attractive head in the Museum of Fine Arts, Boston, belongs to this period of transition from a Khmer to a purely Siamese expression [361]. In this head, which is of stone covered with gold lacquer, the shape of the brows and the mouth, sharply defined by linear incision, is still suggestive of the Khmer type, but the elongation of the face and the appearance of an indefinable sentimental quality – a softness partially due to the gilt appliqué – unmistakably mark the evolution towards the sculpture of the Ayudhyā Period.

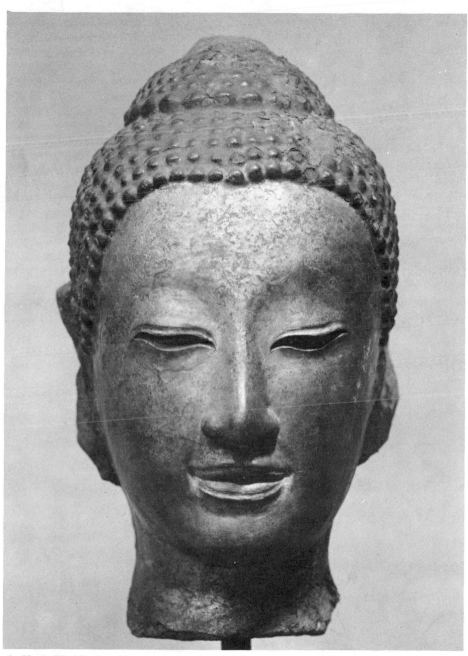

361. Head of Buddha from Siam.
Boston, Museum of Fine Arts

In the bronze images of the fifteenth century and later we find a pronounced exaggeration of the linear definition of the features. The parts of the face are treated in a decorative rather than a structural manner, so that the area between the eye and eyebrow is modelled continuously with the side of the nose [362]. This dry, decorative manner extends to the treatment of the hands with fingers often of equal length, and the stiff, formless bodies are set off by meaningless Rococo swirls of drapery sometimes heavily encrusted with gold relief in imitation embroidery texture [363].

Siamese architecture in its development exactly parallels what has been revealed by the analysis of sculpture in the historical periods; we find, as is to be expected, a kind of Indian colonial architecture in the early periods, succeeded by structures, first in a purely Khmer,

363. Śiva from Ayudhyā.
Bangkok, National Museum

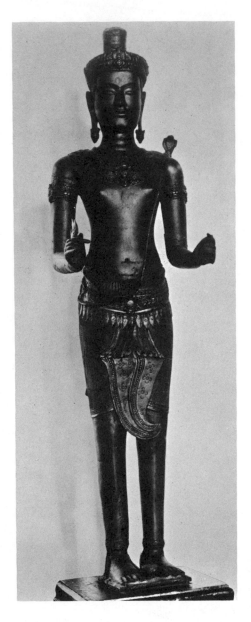

362. Head of Buddha from Ayudhyā.
Bangkok, National Museum

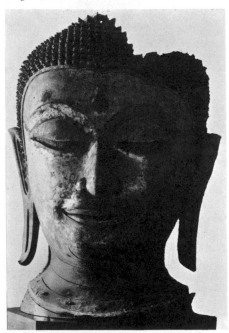

and later a Burmese style of building; the final development of Siamese architecture, like that of sculpture, is in the direction of Rococo richness of detail and a decorative rather than functional consideration of structure. The earliest sanctuaries in Siam proper, like the temples at Śrī Deva, are the exact equivalents of the sixth- and seventh-century buildings in Funan. The form of the śikhara tower and the employment of the roll cornice and protome window are, like the pre-Khmer spires at Sambor, at once reminiscent of the Pallava style.[3]

The shrines at Lopburi, the capital of the Khmer Period, are closely related to the tenth- and eleventh-century buildings at Angkor. Wāt Mahādhātu (Mahat'at) at Lopburi is a typical example of the Siamese temple of the Khmer Period [364]. In plan it consists of a śikhara preceded by a closed maṇḍapa, so that the resemblance to Indian temple plans is obvious. Both elements are set on a common basement storey in the manner of some of the shrines at Paṭṭadakal. The śikhara itself bears a certain resemblance to the towers of Angkor Wāt. Although constructed in diminishing storeys, the division into horizontal rings of masonry is not present, as in the great Khmer sanctuary. On the spire of Wāt Mahādhātu the corners of each level are marked by spiky acroteria, which serve to make a vertical transition from level to level. Plainly derived from Khmer prototypes are the richly carved lintels and flame-shaped pediments. It will be noted that the successive stages of the śikhara have diminishing repetitions of the pediment shape, as in some of the towers of the Late Classic Period in Cambodia.

A rather puzzling but interesting monument of Siamese architecture is Wāt Kukut at

364. Lopburi, Wāt Mahādhātu

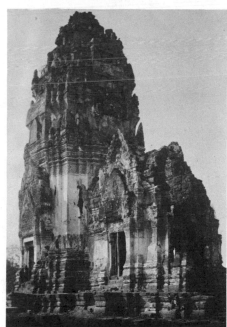

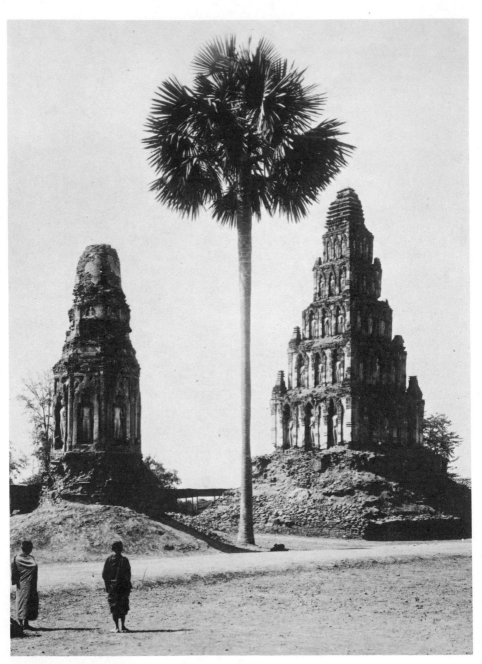

365. Lamp'un, Wāt Kukut

Lamp'un, erected by the Mon King Dittarāja (1120–50) [365]. The form of the principal tower is that of a terraced pyramid, a shape that will immediately recall the Sat Mahal Prāsāt at Poḷonnāruwa. Probably no direct relationship between these two buildings should be inferred, but, rather, a common derivation from the simplest form of the Khmer temple-mountain, as seen in a shrine like Baksei Chamkrong. At Lamp'un the stepped pyramidal base of the Cambodian shrine has become the temple proper, and the form of the tower shrine at the summit of the Khmer prāsāda is suggested only by the spire at the topmost level of the building.[4] At Wāt Kukut the niches on every level of the structure are filled with Buddha images that represent an archaistic revival of the Dvāravatī style.

Near Chiengmai in northern Siam is a dedication of the Thai Period, which presents us with yet another illustration of the kind of borrowing from foreign models that went on uninterruptedly through every phase of Siamese architecture. This is Wāt Chet Yot, a massive brick structure that is clearly a copy of the Mahābodhi temple at Pagān [366 and 367]. It was built, most likely, shortly after the visit paid to this Burmese temple city by King Meng Rai in 1290. Ultimately, of course, the sanctuary is a replica of the original Mahābodhi temple at Bodh Gayā. Copying famous Indian shrines, like the making of replicas of venerable Indian images, was an act of merit that was believed magically to transport to the new site, through such imitations, something of the essence of the Buddha attached to the prototype in India.[5]

Examining the illustration of Wāt Chet Yot, we notice that the replica closely embodies the main masses of its prototypes in the form of the lofty basement surmounted by a central truncated pyramidal tower with four auxiliary turrets. The figural sculpture on the exterior was

366. Chiengmai, Wāt Chet Yot

367. Pagān, Mahābodhi temple

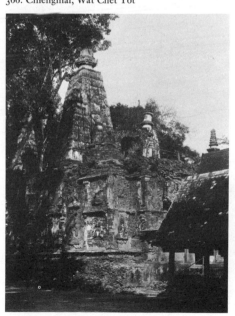

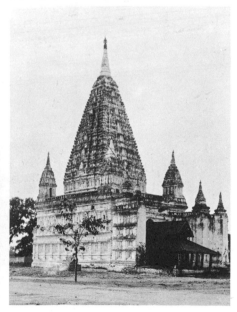

added at a later period, but, in its arrangement, attempts to imitate the Mahābodhi shrine as it was in the Pāla Period. Certainly the Great Temple at Gayā was the most copied edifice in the Buddhist world, but its replicas in Burma, Siam, and in the Far East are always in a sense original creations, just as the different versions of the basilica of St Peter's are original architectural designs.

The ruins of Ayudhyā, the capital from 1350 to 1767, when it was destroyed by the Burmese, present us with many examples of the characteristic Siamese development of the stupa form [368]. These monuments or *prachedis* were intended as shrines for the ashes of Buddhist holy men and the Siamese kings. They are round in plan, with a series of diminishing rings leading up to the bell-shaped dome, from which rises a tapering, onion-like finial. The Siamese prachedis are composed of a variety of borrowings from Singhalese and Burmese models: the ringed base and bell-dome suggest the dāgabas of Ceylon, and the peculiarly pointed form is related to Burmese examples.

The last phase of Siamese architecture is represented by the numerous palaces and temples erected in Bangkok since 1782.[6] The *bots* or sanctuaries are built largely of wood with

368. Ruins of Ayudhyā

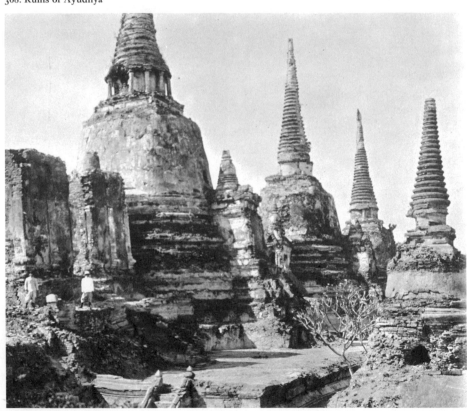

elaborately carved barge-boards and gables. One of the most distinctive features of these modern buildings is the projecting 'ox-horns' on the gables. These are actually stylized representations of nāgas. The decorative accessories of these later structures are a hodge-podge of borrowings from ancient Siamese and modern Chinese sources. Although often verging on the garish in the variety of materials and colours employed, they are extremely pleasing in the contrast between the white walls and columns and the richly inlaid gables and tiled roofs. The overlapping or telescoped roofs that are such an inevitable part of these structures recall the galleries of Angkor Wāt, but in actuality both are ultimately descended from the employment of this technique in early wooden buildings both in Cambodia and Siam.

369. Gold crown from Chiengmai. *Wāt Cetiya Luang, Siam*

Siamese painting, including work in lacquer, survives only from the Ayudhyā Period mainly in illuminated manuscripts, with occasional wall-paintings and temple banners. The archaistic style, exactly paralleling the final development in sculpture, reveals only the exhaustion of a highly mannered and ornate decorative tradition, in which the individual forms are reduced to the same patternized emptiness that characterizes the Buddhist statues of the seventeenth century and later.

The end of art in Siam is decadence; whereas 'art and craft were once indivisible, the craft now predominates'.[7] The traditional formulae, exhausted by meaningless simplification, are reduced to an unhappy combination of archaism and sentimentality, just as the panels of the Sienese painters of the early fifteenth century reveal only an empty and decorative repetition of the work of Duccio and Simone Martini.

*

The surviving examples of Siamese metalwork from the early periods are most of them in the form of votive objects recovered at various sacred sites. An example is the jewel-studded golden crown of the sixteenth century from Chiengmai [369], an object probably presented by royalty as a token to the Buddha and more like a metal wig comprised of snail-shell curls

than an actual diadem.[8] A particularly beautiful metal object from the treasure of Ayudhyā is a golden plaque in the form of a swan or haṁsa [370].[9] The moving abstraction of the bird's

370. Gold plaque from Ayudhyā.
Bangkok, National Museum

tail, part flame, part plant, recalls the relief ornaments of the Classic period of Angkor [338], here reduced, in typical Siamese fashion, to an even more heraldic pattern.

The Siamese from classical times excelled in the ceramic art. The earliest type of indigenous Siamese pottery was made during the Lopburi Period and, like the architecture and sculpture of this famous Buddhist site, reveals strong Cambodian influence. The example illustrated [371] resembles the terracotta amphoras of the Angkor type [352], and, like them, is partially covered with a brownish paint. These native wares were replaced in the fourteenth and fifteenth centuries by decorated glazed stoneware vessels made in imitation of the designs of the Tz'ū Chou kilns of Sung China.[10] This type of pottery was made at Sukhodaya and Swankalok and also includes local imitations of celadon. These types were continued in the fifteenth-century kilns of Chiengmai. In addition to this one should mention the Chinese wares made for the Siamese market in the eighteenth and nineteenth centuries. The design consisted of a polychromatic decoration under a colourless glaze made in imitation of Siamese designs of the Ayudhyā Period.

371. Pottery amphora from Lopburi.
Bangkok, National Museum

THE ART AND ARCHITECTURE OF BURMA

Although for most Europeans the idea of art in Burma conjures up a vision of elaborately carved wooden palaces and gilded pagodas, as a suitable background for Kipling's *Road to Mandalay*, the classical period of artistic achievement must be sought in a far earlier epoch of the history of the region. The history of Burmese art may be roughly divided into three periods. The first extends from the second to the eighth or ninth centuries A.D. This is followed by a classical, or truly Burmese, period from the ninth to the thirteenth centuries. After the disastrous invasions of Kublai Khan and the Siamese in the thirteenth century, Burmese art in its last period, completely severed from its connexions with Buddhist and Hindu India, assumed the character of a folk art, typified at once by exuberance and poverty of expression.

The original races of Burma in the first millennium B.C. comprised the Pyus of Central Asian origin, who had settled in the North, and the Talaings of Mon-Khmer stock, settled in the South. This division continued until the eighth century, when the Talaings conquered the northern provinces and established a new capital at Pagān. Indian colonies in Burma certainly existed as early as the first century A.D., and Buddhism was firmly established by the fifth century, with the country divided between Mahāyānist centres in the North and Hinayāna Buddhism flourishing in the South.[1]

The earliest surviving monuments of architecture date from the tenth century. Perhaps the first shrine is the Nat Hlaung Gyaung at Pagān, a temple traditionally dated in 931 and one of the few Hindu monuments in the history of Burmese architecture. Even this structure has certain characteristics of Burmese architecture of all periods.[2] The construction is of solid brick-work with mortar as a binding medium, and only a sparing use of stone. It is square in plan, with enormously thick walls. Above the basement storey the building ascends by terraces marked by string courses to a conical superstructure that is suggestive more of terminal members of Singhalese stupas than any monuments in India proper. Other temples of this early period at Pagān, such as the Ngakye Nadaun of the tenth century, recall the form of Gupta stupas, such as the Dhāmekh stupa at Sārnāth.[3]

The most distinctive Burmese structures date from the period of unification under King Anawratā of Pagān and his successors, a period when no fewer than five thousand pagodas were erected in the capital. The buildings may be roughly divided between stupas and temples that in varying degrees represent a Burmese assimilation and re-working of many familiar foreign elements.

The most typical example is the Mingalazedi stupa of A.D. 1274 [372]. The monument consists of three stepped terraces surmounted by a stupa consisting of a circular basement, likewise arranged in terraces or rings, and a drum supporting a tapering finial. This shape, which is suggestive of the terminal stupa of Barabuḍur, is echoed in smaller replicas at the four corners of the uppermost terrace. Smaller members, shaped like the Indian kalasa, are located on the corners of the terraces of the basement. Characteristic of the Burmese stupas are the stairways at the four points of the compass, giving access to the upper portions of the monument. Perhaps

the most distinctively Burmese aspect of the Pagān Period is the emphasis on verticality, stressed by the terraced recession culminating in the tapering slenderness of the superstructure of the stupa proper. The shrine as a whole bears a certain resemblance to Javanese monuments in the relationship of square terraces and circular superstructures. Like some Javanese classical buildings, such as Barabuḍur and the Śiva temple at Prambanam, the walls of the terraces at Mingalazedi were decorated with relief sculpture leading the pilgrim to the summit of his circumambulation.

The closest relations between Burma and the late Buddhist kingdoms of Bengal are evident not only from the style of early Burmese sculpture, but from an actual copy of the Mahābodhi temple at Gayā, dedicated at Pagān in 1215

[367]. The copy repeats such features of the original as the enormously high and solid basement and the shape of the truncated pyramid or central tower with lesser replicas of this spire at the angles of the podium.[4]

The most famous temple at Pagān is the Ānanda temple, rising like a great white mountain of masonry topped with pinnacles of gleaming gold [373], This sanctuary is the first to strike the eye of the visitor to the ancient city of Buddhist ruins. It is one of the most venerated and popular temples in Pagān, and has been in worship since the day of its dedication. According to tradition, the temple was first constructed by Buddhist friars from India during the reign of King Kyanzittha (1084–1112). Legend has it that the temple was intended to reproduce the general appearance of the cave where the Indian

372. Pagān, Mingalazedi

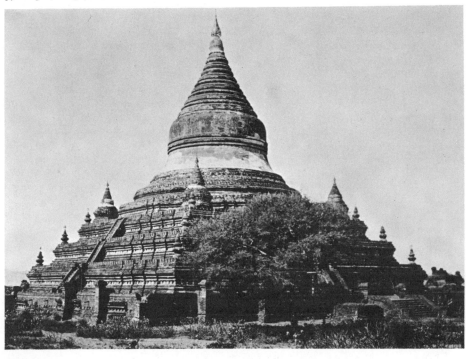

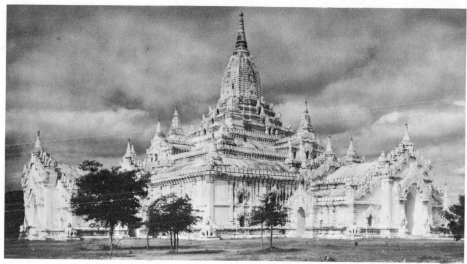

373. Pagān, Ānanda temple

monks dwelt on Nandamula Hill.[5] Although
probably greatly restored, the temple preserves
the plan and essential fabric, dating from its
dedication in A.D 1090. The plan is that of a
Greek cross [374], the arms formed by massive
porticoes radiating from the centre of the struc-
ture. The central portion of the building consists
of an immense solid block of masonry that rises
to support the central śikhara. In the interior
are two concentric narrow corridors that enable
the visitor to perform a circumambulation
around the thirty-foot statues of Buddhas, set
in recesses at the four sides of the central core.
The dim illumination that filters into these gal-
leries through small lancet windows gives the
effect of a deep natural grotto, and lends some
support to the legend regarding the derivation
from the Indian cave temple. The elevation is
simply an elaboration of earlier buildings with
an enormously high basement storey sur-
mounted by a terraced pyramid supporting the
central spire. Smaller replicas of this member,
placed at the corners of the terraced platform,
serve to enhance its scale and to give an interest-

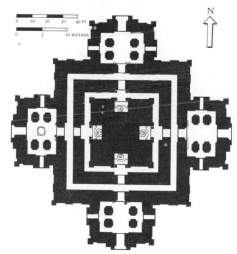

374. Pagān, Ānanda temple

ing variety to the silhouette. Although extended
to a very thin and tapered finial, the essential
shape and construction of the terminal stupa at
Pagān, with vertical ribs and horizontal bhūmis,
are not unlike those of characteristic Orissan

temples. The construction of this enormous pile, over one hundred and sixty feet high and three hundred feet wide, is, as usual, almost entirely of brick with walls of great thickness and true vaults and arches of the type described above, employed in the porticoes and interior corridors. Much of the exterior decoration is of an almost incredible extravagance and floridity. Although a great deal of this carving, typically Burmese in its exuberance, may be a modern embellishment, the terra-cotta decoration of the exterior terraces and the stone reliefs of the interior corridors represent work of the Classic Period of Burmese art.

The Ānanda temple gives the impression of a compact plastic unit in much the same way as do the temples of the Classic Period in Cambodia. The only possible Indian prototype for the Ānanda temple and Burmese structures related to it is the great Brahmanical temple at Paharpur in Bengal [195]. The plan of this temple in the shape of a Greek cross and the elevation in a series of terraces leading to a central spire are features dramatically adapted in the Burmese reworking. The decoration of the façades of the successive terraces with countless relief plaques is another feature repeated in the shrine at Pagān. In view of the close connexions between Burma and Bengal throughout the Classic Period, it is not at all surprising that the shape of the great temple should have been determined by such a North Indian prototype.

The history of sculpture in Burma is marked by an original derivation from Indian models towards the formation of a Burmese style that exactly parallels the evolution of architecture. Little or nothing is known of the sculpture of the early periods. Such fragments as have appeared are only provincial variants of the Gupta style. Among the earliest examples of relief sculpture are the the panels decorating the Nat Hlaung Gyaung. The style of these carvings, which illustrate the avatars of Vishnu and date presumably from the tenth or eleventh century,

has something of the hieratic elegance and refinement of detail characteristic of Hindu and Buddhist sculpture under the Pāla Dynasty in Bengal. The most frequent subjects for illustration in the Burmese reliefs of the Classic Period are the Jātaka stories. These evidently enjoyed an enormous popularity after the introduction of Singhalese Hinayāna Buddhism to Pagān in A.D. 1057. The style of the reliefs decorating the Mingalazedi pagoda seems to have little to do with any Indian or Singhalese prototypes. In each panel the principal or key episode is presented in a conceptual, archaic manner, in which directness and conciseness of portrayal were the sculptor's principal aim.[6]

Most typical of Burmese sculpture of the Classic Period are the countless reliefs illustrating the Jātakas and the life of Buddha in the Ānanda pagoda at Pagān. Perhaps in the interest of directness and the opportunities for picturesque elaboration of detail, the sculptors have entirely abandoned the traditional method of continuous narration, in favour of a system in which each episode of the story is presented in a separate panel. These reliefs also have a certain stiff, archaic quality, but are characterized by qualities of clarity, animation, and grace, together with a fondness for the elaboration of decorative minutiae, that are typically Burmese.

The remains of painting of the early period in Burma are so scanty that little can be said of its development. Such fragments of thirteenth-century wall-paintings as survive in various shrines near Pagān are clearly derived from the style of Tantric painting of Bengal.[7]

After the disastrous invasions of the twelfth century, all art in Burma falls to the level of a folk art that is known mostly in the enormously elaborate wood-carving of the declining centuries of the dynasty. At the very end of this last period – the nineteenth century – were produced the hideously sentimental and miserably carved alabaster Buddhas, images that are a final, sorry degeneration of sculpture in Burma

of the older Indian tradition from which it stems.

The setting of the last chapter in the artistic history of Burma is that romanticized in Kipling's *Road to Mandalay*, the fantastic architecture of wooden palaces and gilded pagodas in the capital of Mandalay, founded in 1857. The palace structures are supported by whole forests of gigantic teak pillars and crowned by multiple roofs and spires decorated with the most lavish inlay of gold and lacquer. The towers rise in storeyed slenderness, the sensation of soaring elegance and attenuation enhanced by the wavering flame-shaped acroteria that make these structures appear like something out of a fairy-land of architectural fancy. The multiple overlapping roofs are perhaps an indication of an ultimate relationship to the primitive northern Cambodian wooden architecture from which this same device was adapted to the stone sanctuaries of Angkor.

Just as these buildings, for all their elaborateness, are the ultimate descendants of old Indian palace architecture, the typically Burmese technique of lacquer decoration goes back at least to the period of florescence at Pagān in the thirteenth century. Actually, this final phase of Burmese culture, because, rather than in spite of, its provinciality, reveals a truly indigenous expressiveness in the native genius for exuberant wood-carving and inlay that has the vigour and imagination of what might be described as a sophisticated folk art, no longer consciously dependent on any outside traditions.

For centuries Burmese craftsmen have been famous for work in lacquer as well as silks and embroideries, mostly the work of hill tribes.[8] The most spectacular examples of the minor arts in Burma are part of the royal regalia, exhibited for many years in the Victoria and Albert

375. Gold stupa from Burma.
London, Victoria and Albert Museum (formerly)

376. Amber duck from Burma.
London, Victoria and Albert Museum (formerly)

Museum and comprising crowns and ritual objects of all kinds in gold and other precious materials. Many of these, like the golden reliquary stupa [375], are highly suggestive of Singhalese forms [cf. 287 and 289], and the heraldically stylized duck, carved from a single piece of amber [376], is strangely reminiscent of ancient Near Eastern forms.

JAVA

The history of religion and art in the island of Java was determined by the continuous infiltration of immigrants from eastern and southern India. That some of these settlements took place as early as the fourth century A.D. is attested by the presence of Sanskrit inscriptions in western Java, although no architectural or sculptural monuments from this period survive. The first great period of Javanese art comes with the establishment of religious pilgrimages in Middle Java in the seventh and eighth centuries. The great complexes of temples on the Dieng Plateau were not located within the precincts of the Javanese capital, but were isolated religious centres inhabited exclusively by priests. The majority of these temples are dedicated to Vishnu, and in their resemblance to Gupta, Pallava, and Chalukya prototypes are actually more Indian than Javanese.

A typical example of the Dieng temple is Caṇḍi Bhīma [377]. It consists of a box-like cella with a small projecting porch. Above the cella rises a pyramidal tower of terraces repeating the form of the base in progressively decreasing scale; on some of the higher levels are projecting āmalaka quoins recalling this form in Indo-Aryan temples. Presumably the structure was crowned with a completely stylized lotus of the same āmalaka type. The storeys of the tower are also decorated with chaitya niches enframing heads and busts of deities, ornaments that recall Pallava architecture of Māmallapuram. The individual heads are carved with a primitive vigour and fine plastic simplification [378]. The

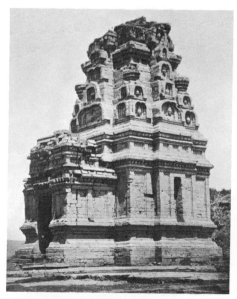

377. Caṇḍi Bhīma, Dieng

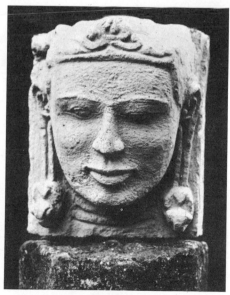

378. Head from Caṇḍi Bhīma.
Batavia, Museum

mask-like character of these heads, seen especially in the flatness of the definition of the planes of the face, is quite un-Indian, and is perhaps to be taken as an early indication of the Indonesian genius in the fashioning of theatrical masks in the modern period. The principal architectural and truly Javanese elements of the building are the placing of the entire structure on a raised base or podium, and in the construction of the walls in small blocks of local stone without mortar. The superstructure was always erected on the corbel principle. Neither in this nor in later Javanese temples are pillars or columns employed, and the entire structure has a completely plastic and closed appearance. A distinctive Javanese form of ornament appears on the Dieng temples in the shape of a kirtimukha lintel. This motif was to reach in later architecture an enormous decorative complication.

The great period of building activity in Middle Java came under the reign of the Śailendra Dynasty in the eighth and ninth centuries, when Java, Sumatra, Malaya, and Indo-China were ruled by a race of kings of East Indian origin. This period is marked by the introduction of Mahāyāna Buddhism, and one of the earliest temples at Kalasan was dedicated to Tārā in A.D. 778 [379]. The plan is that of the cubical cella of the early Dieng types converted into a Greek cross by the addition of four subsidiary chapels. The temple is only an elaboration of the box-like form of Caṇḍi Bhīma with the same emphasis on the horizontal in the form of repeated string courses and projecting entablatures. The sculpture is marked by a greater elaboration of the characteristic Javanese kirtimukha pediment and by the employment of figure sculpture in shallow niches as a part of the exterior ornamentation. Actually this temple seems much closer to contemporary building in Cambodia than to any Indian originals, and, together with eighth- and ninth-century buildings at Angkor, might be cited as the beginning of a truly Indonesian style.

A somewhat different type of the temple complex is represented by the ninth-century shrine of Caṇḍi Sewu, in which a central temple of roughly the same plan and elevation as at

379. Caṇḍi Kalasan, temple

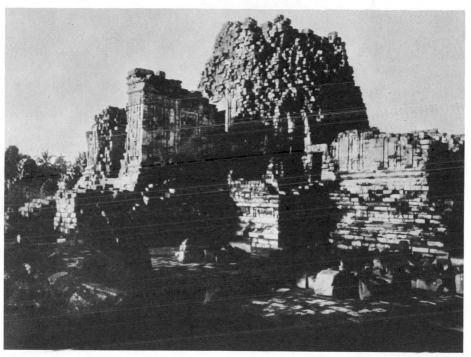

380 and 381. Caṇḍi Sewu, temple

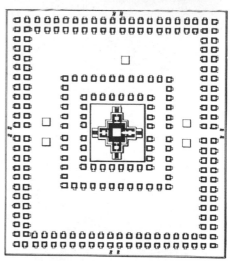

N

Kalasan is surrounded by no less than two hundred and fifty small chapels repeating its shape in smaller scale [380 and 381]. It is highly likely that the whole collection of buildings was designed as a kind of architectural maṇḍala with the separate chapels dedicated to the deities comprising the esoteric cosmic diagram or maṇḍala.

The individual shrines at Caṇḍi Sewu are small square cellas [382]. They appear to be adaptations for Buddhist usage of the Dravidian temples, with a bell-shaped stupa crowning a terraced superstructure with small replicas of the terminal member on the lower levels. The recessed cruciform plan of the main temple of Caṇḍi Sewu is extremely similar to the plan of the Pāla temple at Paharpur [195]. The close relations between Java and Bengal in the eighth and ninth centuries, already suggested by the

382. Caṇḍi Sewu, shrine

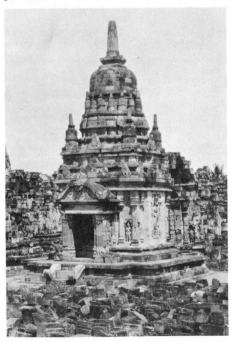

inscription of the Javanese Baladeva at Nālandā and the presence of Nālandā bronze images in Java, is confirmed again by this very obvious architectural connexion between Caṇḍi Sewu and the architecture of Buddhist India. As will be revealed in greater detail presently, there is every reason to believe that the Buddhism of Java in the eighth and ninth centuries was the same esoteric phase of the religion known as Vajrayāna as spread from Gangetic India of the Pāla Period to Tibet and Nepal, and ultimately to the Far East.

The supreme monument of mystic Buddhism in Java, a building which in its style and iconography is one of the great masterpieces of religious art in Asia, is the stupa of Barabuḍur. In this final chapter on Indian art we shall analyse this one monument as a supreme illustration of how here, as in all the great examples of religious art in the Indian world, the iconography or religious purpose of the temple ultimately determined its particular shape and form, from the conception of the whole to the least detail.

Barabuḍur – the very name has a majestic and mysterious sound – could well be described as the most important Buddhist monument in greater India, a monument which holds locked within its hidden galleries the final development of Buddhist art in Asia. This sanctuary is really a rounded hill, terraced and clothed in stone, and is marvellously situated in the plain of central Java, rising like a mountain to rival the towering volcanic peaks that frame the horizon [383]. The name of this famous building has always been a source of dispute among scholars: the translation offered by Paul Mus – 'the vihāra of the secret aspect' – seems best to describe the deep mysteries it holds. As puzzling as the meaning of its name are the origins of the temple: the consensus of present opinion seems to be that it was raised during the reign of the dynasty founded by Śailendra, the mysterious 'King of the Mountain and Lord of the

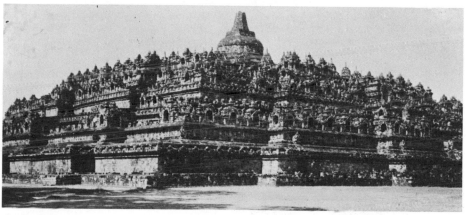

Isles' who, setting out from southern India, made himself an Empire of the Malay Peninsula, Sumatra, and Java in the middle of the eighth century A.D. From the time of the decline

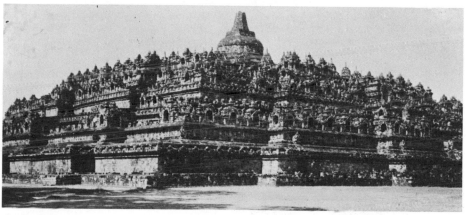

383. Barabuḍur

of the Śailendra power in the ninth century, until the rediscovery of Barabuḍur in the nineteenth, nothing is known of the history of the temple – beyond the usual story of decay and neglect that has been the lot of so many great sanctuaries of the Eastern world. There is no need to linger over the details of the restorations and depredations that went on during the nineteenth century, following the excavation of the shrine by Sir Thomas Raffles, except to mention the discovery made in 1885 that the ground immediately around the foot of the monument had at some time been filled in to cover a whole series of reliefs decorating what was the original basement storey of the building.

Let us at this point examine the architectural arrangement of the temple and then the reasons for this arrangement. It consists of five walled-in galleries or terraces on a rectangular plan [384]; above these are three round platforms open to the sky, on which are seventy-two bell-shaped stupas and a sealed terminal stupa at the very summit and centre of the monument; a

ninth storey is present, though unseen, in the form of the hidden basement.

A great many scholars have busied themselves trying to prove that the Barabuḍur we see to-day is the result of innumerable alterations and architectural refinements, and that we must therefore assume the existence of a primitive Barabuḍur, limited to three galleries. One of the proponents of this theory points out – among other things – that the reliefs illustrating scenes from the life of Buddha were deliberately terminated with the portrayal of Śākyamuni's First Preaching, and that the later master-builder arbitrarily decided to devote the subsequent gallery to a different legend: actually the Buddha legend at Barabuḍur ends with the First Sermon, because the reliefs are illustrations of the *Lalita Vistara* sūtra which concludes with this event in the Buddha's career and not for any architectural reason. If space allowed, it would be possible likewise to refute all the other arguments on the remodelling of Barabuḍur. These arguments constitute a warning to those who, with no knowledge of the details, attempt to approach the Buddhist art of this period only through the architectural technique, forgetting that we have here an art and a religion

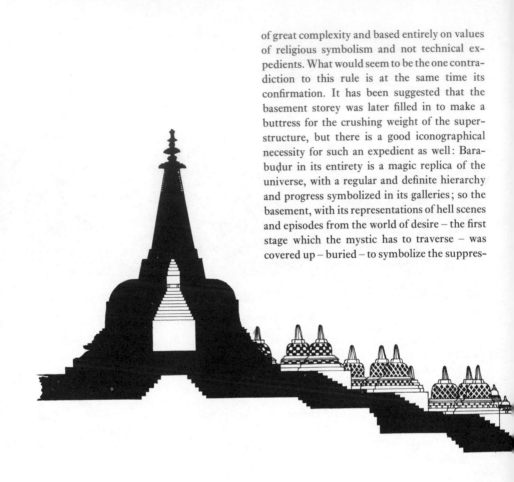

of great complexity and based entirely on values of religious symbolism and not technical expedients. What would seem to be the one contradiction to this rule is at the same time its confirmation. It has been suggested that the basement storey was later filled in to make a buttress for the crushing weight of the superstructure, but there is a good iconographical necessity for such an expedient as well: Barabuḍur in its entirety is a magic replica of the universe, with a regular and definite hierarchy and progress symbolized in its galleries; so the basement, with its representations of hell scenes and episodes from the world of desire – the first stage which the mystic has to traverse – was covered up – buried – to symbolize the suppres-

sion of the world of desire. The presence of that
world – even though unseen – was, however,
magically necessary for the symbolism of the
monument: its metaphysical mechanism de-
manded this basement as an integral part, just
as the simplest magic diagram, in order to
'work', requires a certain number of fixed lines
or circles.

The opinions on the outward form of Bara-
budur have been most eloquently and con-
clusively set forth by Paul Mus.[1] The total mass
is a dome cut by galleries – trenches open to the
sky [384 and 385] – which disappear from view
when the monument is looked at in profile. The
outline then becomes that of a stupa. What we
have is a pyramid or prāsāda inside a stupa, the

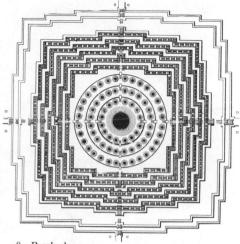

384. Barabuḍur

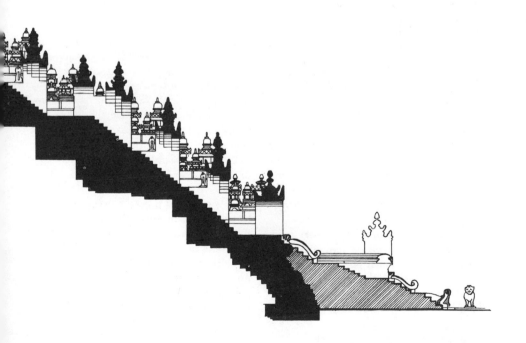

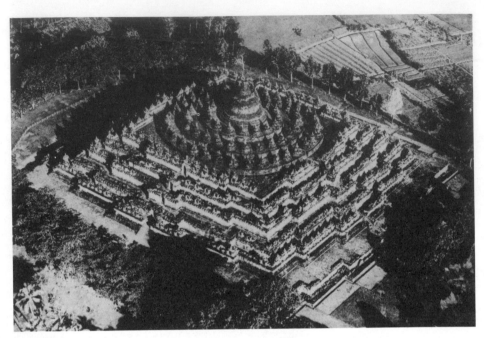

385. Barabuḍur, air view

familiar form of the Indian relic mound; this is an exact and accurate architectural representation of the concept of the sky as a solid vault covering the world mountain, Meru. The number of storeys – nine – corresponds to the levels of the Indian Meru and the number includes the subterranean Meru which was believed to extend underground to the foundations of the world – here eloquently represented by the hidden basement. Barabuḍur is, then, once again an architectural replica of the world structure and the number of storeys was definitely and unavoidably fixed by this conception.

On entering Barabuḍur, the pilgrim penetrates the world of Buddha to read in its reliefs the story of man's journey down the long night of birth and death to ultimate enlightenment with the culmination of the career of the Bodhisattva in the realms of the mystic Buddhas.

The whole plan and elevation of Barabuḍur as a sealed world apart seems to state plainly that its secrets were not to be grasped at once nor lightly taken, but rather to be apprehended by degrees. At first the monument seems completely solid and impenetrable – one has to hunt for the entrances opening like caves in a magic mountain.

The heavily garnished and massively constructed balustrades cloak the galleries in a veil of stone. At the bottom is the buried and inaccessible basement gallery with its relief of the Kāmadhātu. The bas-reliefs of the galleries, like these passages themselves, are completely invisible from the exterior. Even the Dhyāni Buddhas in their niches are only half-seen, so masked are they in their deep architectural grottoes. On the three upper terraces sit seventy-two Buddhas under stupas which are really

stone grilles and which again veil *them* from view [392]. Finally, at the very zenith, is the supreme Buddha, completely hid under the solid stone bell of the terminal stupa.

The reliefs of Barabuḍur are divided as follows: On the now concealed basement, the world of desire and the ceaseless action of karma. On the chief wall, top row, of the first gallery the story of Buddha who showed the way of escape from karma. On the bottom row of the back wall are illustrated Jātakas and *Avadānas* – the acts of faith by which the Bodhisattva prepared himself for his task. These continue around the inner wall of the balustrade and on the second gallery. The third gallery illustrates a text devoted to Maitreya, the Buddha of the Future. Less important Maitreya texts are pictured on the balustrade of the third and fourth galleries. The wall of the fourth gallery deals with Sāmantabhadra, the last Buddha of the Future, and is based on a text evidently connected with the Dhyāni Buddhas and thereby directly related

to the mysterious upper reaches of the sanctuary.

In walking around the monument in the rite of pradakṣina – that is, describing a sunwise turn with the right shoulder to the wall – the pilgrim dynamically enacted a spiritual experience, following in the footsteps of him who had already entered Nirvāṇa. In stupas of the primitive type, like the famous tope at Sāñchī, the worshipper performed a metaphysical journey through a maṇḍala of a very simple type; the psycho-physical pilgrimage there was only on one plane, just as in Hinayāna Buddhism one life is one step towards release. At Barabuḍur the architecture provides for a spiral ascension to the very summit of the pyramid and to the very zenith of life.[2] Barabuḍur was dedicated to a phase of Buddhism in which all men were believed to have the quality of Bodhic mind and could attain Buddhahood in one life. The physical climb through the architecture magically symbolizes and effects the escape from the materialism and change of the world of the flesh

386. Barabuḍur, first gallery,
Mriga or Ruru Jataka

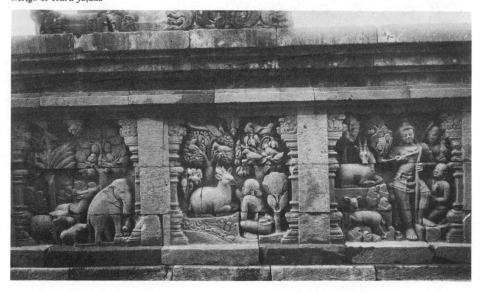

to the final absorption in the Void or Absolute, which is symbolized in that strange mirage in stone that greets the worshipper when he emerges into the centre of the maṇḍala in the empty spaces of the upper terraces. Thus each floor of Barabuḍur could be said to represent a separate world or plane of life.

The differences in style that exist between the reliefs on the levels of Barabuḍur are not due to the 'aesthetic urge' of various craftsmen nor the desire for 'decorative' variation: these styles, as will be noted in further detail, are determined by the nature of the texts the reliefs illustrate. The carvings of the covered basement representing scenes from hell and the world of men are, as was appropriate for these episodes from

the 'real' world, carved with evident realism and a wealth of circumstantial detail reminiscent of that vigorous directness of true popular art that we find in early India. None of these abstract canons of physical beauty reserved for images of Buddha and the gods is here evident in these figures of men and demons.

The same style is evident in the Jātaka reliefs of the first gallery [386]. In the scenes dealing with the life of Buddha, however, the informality of arrangement and crowding of picturesque details give way to a more ordered, one might say, more classic composition [387]: we are conscious that the figures are enacting a heroic and universal truth and not participating in the changeable and unreal actions of the world of

387. Barabuḍur, first gallery.
Upper register: The Bath of the Bodhisattva.
Lower register: Hiru lands in Hiruka

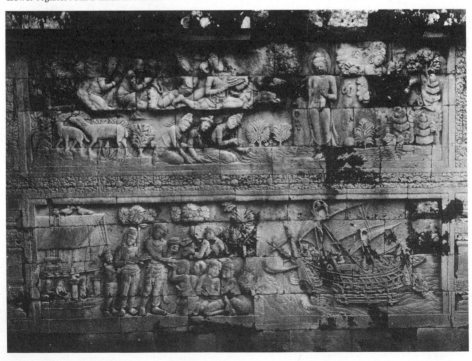

men. In these reliefs the Buddha appears appropriately as an abstractly conceived form in marked contrast to the persisting realism of the setting and figures that surround him.[3]

The Maitreya story of the third gallery consists of a seemingly endless repetition of a scene representing the disciple Sudhāna interviewing one or another of his teachers human and divine [388]. Sometimes the variations consist only of slight changes in setting and in the attributes of the personage involved. The regular stock set is a rich canopy, under which the teacher is seated with the pilgrim Sudhāna kneeling in front of him. Here we find a curiously static, empty style in comparison with the rich reliefs of the Jātakas and the Buddha story which are so filled with movement and genre detail. In comparison with the crowded more Indian panels of the lower galleries, these reliefs are even more 'classic' and depopulated.

Finally, with the reliefs given over to the Sāmantabhadra text on the fourth level, the compositions assume a yet more abstract and hieratic quality: rigid groups of numerous Buddhas around a central figure – a composition seemingly endlessly repeated, arranged with the formality of a maṇḍala [389]. Certainly the very nature of the texts to be illustrated conditioned the character of these reliefs; that is, their generally more metaphysical nature did not lend itself to anything approaching the liveliness of narrative treatment which we see

388. Barabuḍur, third gallery,
illustration from the Sudhāna legend, Maitreya text

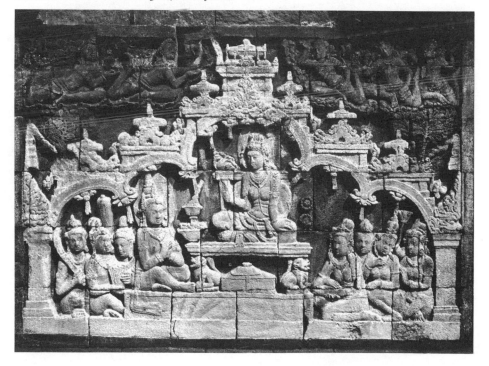

in the lower galleries. We have a change from exoteric to esoteric doctrine, suggesting the similar division in the text of the Lotus Sūtra (*Saddharma Puṇḍarīka*). The change coming here at the fifth level is significant, for it is on leaving the fourth and entering the fifth level of his trance that the yogin begins to become integrated with the One. Moreover, it does seem probable that what we describe as generally more empty and static in the compositions of these final reliefs in the Barabuḍur cyclorama in stone may be deliberate in another way: they are preparing the pilgrim for the great emptiness of the upper terraces where sit the Buddhas of the world beyond form and thought. These

the upper terraces really implies the transition from exoteric to esoteric, from the material world to the spiritual world. The limited, fixed square is expressive of the world of experience and material phenomena. The circle has no corners, no directions, it implies an infinite radiation from its centre – without limit – the realm of boundless spirit, the empyrean. With the pilgrims to Barabuḍur we, too, have emerged from the long stone corridors girdling the pyramid, and are now face to face with the last great mysteries.

The innermost secrets of Barabuḍur are linked up with the identity and function of the Dhyāni Buddha images that cover the monu-

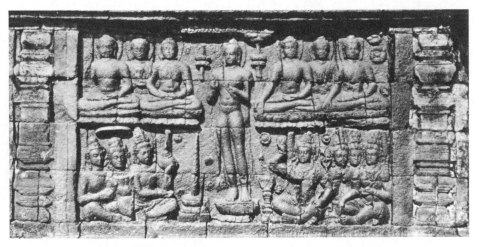

images on the last platforms, isolated against the sky, are the most eloquent and dramatic representation that art could devise of the great void which is the Creator and the last home of the soul that has wandered down the worlds so long and wearily.

The idea of this final emptiness and absence of form is already prophesied in the austerity of setting, the frozen and solemn formality of the reliefs that illustrate the more esoteric texts of the fourth gallery. The transition from the square terraces of the pyramid to the circles of

ment from top to bottom: Akṣobhya, Ratnasambhava, Amitābha, Amoghasiddhi [390]; these are the mystic Buddhas associated with the four directions, who are all recognizable by their characteristic mudrās and are placed in niches on the exterior of the balustrades of the first four galleries on the East, South, West, and North respectively. On the fifth gallery on all four sides are images of another Buddha in teaching mudrā, who is to be identified as a form of Vairocana. There are also seventy-two Buddhas in dharmacakra mudrā, half-hidden

389 (*opposite*). Barabuḍur, fourth gallery,
illustration from Sāmantabhadra text

390. Barabuḍur, first gallery and balustrade

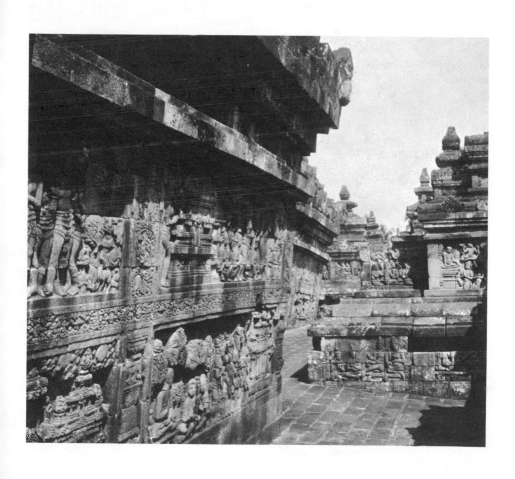

from view under their lattice-work stupas on the upper terraces [391 and 392]. And lastly there is the image originally enshrined under the closed stupa in the exact centre and at the very zenith of this vast cosmological machine in stone.

Before attacking this most complicated and difficult problem in Oriental iconography and art, we may seek a momentary respite in analysing the style of these images and its derivation. These Buddha statues in the refinement of their abstraction may be compared with the great masterpieces of Gupta art in India – as for example the famous Buddha of Sārnāth and certain images found at Lalitagiri in Orissā [390 and 391].[4] This resemblance is particularly interesting since Orissā is immediately adjacent to Kalinga, which was the original home of the Śailendra kings. The Buddhas of Barabuḍur are made with great mathematical nicety of measurement from one of those regular systems of proportion for sacred images known and followed in the Indian world.

The finest of them represent such a beautiful realization of plastic mass and volume and breathing life and such a transcendent spiritual clarity of expression that they may rank among the greatest examples of the sculptural genius in the world. There is scarcely any longer the suggestion of real flesh, but these figures seem to be made of an imperishable and pure spiritual substance – the incorruptible and radiant and adamantine nature of the Diamond, of the Buddha's eternal body.

The curious perforated construction of the stupas of the upper terraces is not a decorative caprice on the part of the architect [392]. It has been proposed that the seventy-two Buddhas are half-hidden in these latticed domes to suggest the fact that they are beings in a world without form, the realm of the Dharmakāya which may be apprehended but not seen by mortals.

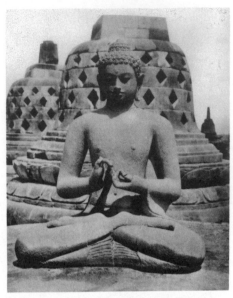

391. Barabuḍur, upper terrace, Buddha Vairocana

Returning to the problem of the Dhyāni Buddhas and the meaning of the whole monument, it is evident first of all that we have to do with a maṇḍala – a solid maṇḍala in stone – and that these images represent a mystic hierarchy clustered like a constellation around the mysterious figure which is their Pole Star and sovereign. A maṇḍala, similar to that portrayed by the Buddha statues on the first five galleries, is shown in a relief of the fourth gallery with Vairocana in the centre surrounded by the four other mystic Buddhas. In addition to this we may think of a second maṇḍala, separate and yet inseparable, joined to this magic diagram, consisting of the Buddha in the terminal stupa surrounded by the seventy-two Buddhas under lattice-work domes. The two maṇḍalas could be said to be joined like two concentric shells of a Russian Easter egg. These two maṇḍalas are essentially the *Ryōbū mandara* of Shingon Bud-

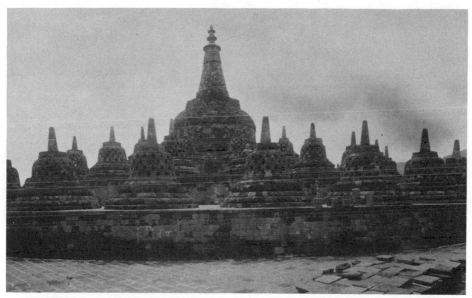

392. Barabuḍur, upper terraces and terminal stupa

dhism in Japan – the maṇḍalas of the material and spiritual world, each presided over by a form of Mahāvairocana the creator. In other words, the first five galleries express the maṇḍala of the material world, and the maṇḍala of the upper terraces is the diagram of the spiritual world. Stating the solution of this problem in the briefest possible terms, the latter symbolize the Dharmakāya – 'Law Body' or Logos – of Vairocana, whereas the Buddhas of the fifth terrace stand for the *Rūpakāya* or form body, the manifested shape of the same supreme Buddha, like the Mahāvairocana of the *Kongōkai mandara* in contrast with the Vairocana of the *Taizōkai mandara.*

Why are there seventy-two Buddhas in stupas? Possibly this is a selection of the famous mystic number and represents the building of the quality of time into the monument. Every seventy-two years, as was well known to the ancients, marked a change of one degree in the precession of the equinoxes, and so the presence of seventy-two Buddhas – the number present in all the reckonings of the great cycles – would be a plastic-architectural representation of the existence of the Buddha Law throughout all the past and future kalpas of Time. It is probably no accident that the number seventy-two corresponds to the total of the principal deities in the Kongōkai mandara.

And what of the final riddle – the Buddha of the chief stupa? There has been a great deal of controversy about the Buddha actually found in the ruins of the main stupa: whether it is the original image intended for this place or not; why it is in such an unfinished condition; why this image, which seems to represent Akṣobhya, is placed in the holy of holies above Vairocana. What would really be more to the point is to ask oneself what sort of image might appropriately

have been installed in the central dome of the monument and then see if the actual statue fits these requirements. The interpretation of the idol of the terminal stupa – and indeed the interpretation of the whole monument – is intimately related to the cult of the Devarāja centring around such replicas of the world scheme in architecture as the Bayon at Angkor Thom in Cambodia.[5]

In Java, there is evidence that the Devarāja in the form of a lingam was worshipped as early as the sixth century. A later inscription reads:

Having set up with due devotion the statue of the king who was consecrated in the shape of Mahākṣobhya ... I his humble servant have prepared this description by order of the priest Vajrajnāna.[6]

In other words, the great kings were regarded as manifestations of the Buddhas, too.

This leads us to the conclusion that the statue of the chief stupa, following Cambodian precedent, would have been that of a divinized king – a Devarāja or Buddharāja – the great Śailendra or King of the Mountain. The seventy-two Buddhas, like the multiple heads of the Bayon towers – in addition to their time symbolism – stood for the extension and emanation of the royal and divine power to every part of the Śailendra Empire; that is, there are really not seventy-two Buddhas, but one Buddha everywhere manifested. The whole shrine is then the complete world and its order, the succession of points visited by the sun in its round, the cycle of time materialized in space constituting the Law rendered visible in the geographic, political, and spiritual centre of the realm.

The chief statue may have been another Vairocana. What it was, or if there was any statue there at all, does not matter materially. This central highest point is important as the summit of the hierarchy, and the terminal stupa, empty or with an image in it, would stand for the Supreme Buddha and the apotheosis of the sovereign. The image or symbol at the highest and innermost point represents – like the highest form in the two maṇḍalas – the reduction of multiplicity into essential unity, since in Vairocana all is One. It is the Universal King and Perfect Sage who, placed at the centre of the cosmic wheel, sets it in motion and is himself unmoved as the Pole whereon he reigns. It would represent at once the universal rule and the extension of that rule to every atom in every world of the cosmic system and, as at Angkor, the magic centre where was enthroned the divine essence of kings.

Vairocana is actually the historical Buddha idealized in Dharmakāya, the eternal body of the Law or Logos. The Jātaka tales and the Buddha legend carved in the galleries of Barabuḍur are of course properly part of the esoteric teaching, as they illustrate at once the way to Buddhahood and reveal Śākyamuni as the material earthly appearance of Vairocana. The whole monument with its hundreds of reliefs and statues is a vast maṇḍala that shows every phase of existence at all times and in all places as so many corporeal manifestations of the divine and indescribable and yet universal essence of Vairocana, with which the essence of the king has been merged in supreme apotheosis. Every detail of sculpture and every aspect of the architectural form have been dedicated to the expression of this hieratic scheme: what we generally refer to as the 'style' of both the architecture and the sculpture has been completely determined by the nature of the magical conception that the monument was destined to express.

Just as the general architectural form of Barabuḍur shows an obvious dependence on Indian prototypes iconographic and architectural, so, too, its sculptural ornamentation reveals an ultimate dependence on the plastic tradition of India proper. But, just as the plan and elevation of the building dedicated to the exposition of a phase of esoteric Buddhism seem to mark an entirely new and different employment of the

traditional Indian forms of the stupa and prā-sāda, so, too, the style of the sculpture is re-made in Javanese terms to meet the requirements of what was essentially a complete plastic embodiment of a cosmic diagram. As has already been suggested, there are not one, but many, styles of relief carving. The piquant naturalism of the Jātaka and Avadāna panels is in some ways reminiscent of the carvings of Sāñchī. The relief has an orderliness, both from the point of view of composition of the main elements of figures and settings and its inevitable presentation in not more than two distinct planes, that is at once very rich in a decorative sense and also architecturally appropriate. This is a quality that perhaps may be recognized as distinctly Javanese, since the description could apply with equal validity to the sculpture of many other monuments of the Middle Javanese Period. The reliefs of the upper galleries in their greater simplicity and the isolation of forms against a plain background seem like a development out

of the Gupta reliefs of the Sārnāth workshops [174].

The great temple of Barabuḍur is the final monument of Mahāyāna Buddhism in Java. Indeed, it was not long after its completion that the worship of Śiva became the official religion of the realm. One of the principal monuments of this final phase of art in eastern Java was the temple at Loro Jongrang near Prambanan that was apparently intended as a Hindu rival to Barabuḍur [393 and 394]. There are three main shrines dedicated to Brahma, Vishnu, and Śiva, surrounded by no less than one hundred and fifty individual chapels, all placed on an artificial terrace. The principal shrines are repetitions of the cruciform plans of some of the earlier temples. The Śiva Temple at Loro Jongrang, datable A.D. 860–915, consists of a shrine with projecting porches placed at the summit of a steep truncated pyramid; stairways at all four sides convert the plan into a cruciform shape. The elevation is immediately suggestive of the

393 (*left*). Loro Jongrang, Śiva temple

394. Loro Jongrang, Prambanan

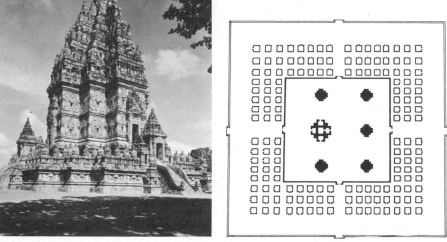

Khmer temple mountain and the plan appears as an ultimate derivative from the shrine at Paharpur in Bengal [195]. The most notable feature of the decoration of this sanctuary is the frieze of reliefs illustrating the *Rāmāyana* on the exterior of the balustrade of the upper terrace [395]. The style of carving corresponds to that of the panels devoted to the life of Buddha at Barabuḍur. Owing perhaps to the nature of the subject matter, the actual compositions are more dramatically conceived and more dynamic in execution.

Belonging to the same period as Barabuḍur is the Buddhist shrine of Caṇḍi Mendut, notable for the magnificent trinity of Buddha with attendant Bodhisattvas [396]. Like the Buddhas of Barabuḍur these images reveal a marvellously plastic translation of the Indian Gupta formula into Indonesian terms. What distinguishes these statues particularly is the wonderful sense of

396. Caṇḍi Mendut, Buddha and Bodhisattvas

form combined with a reduction of the volumes of heads and bodies to interlocking spheroidal and cylindrical shapes that imparts a feeling of almost architectural simplification and makes them such moving symbols of the serenity of samādhi.

The end of the great period of art in central Java comes with the unexplained desertion of the Dieng Plateau in 915 and the removal of the centre of government and religion to eastern Java. The next centuries marked the emergence of Java as a great commercial power and the development of a maritime trade linking the island with the entire Far Eastern world. The final revival or renaissance in Javanese art begins in the thirteenth century with the Singasari and Majapahit Dynasties. The monuments

395. Loro Jongrang, Śiva temple,
Rāma and the Crocodile, scene from the *Rāmāyana*

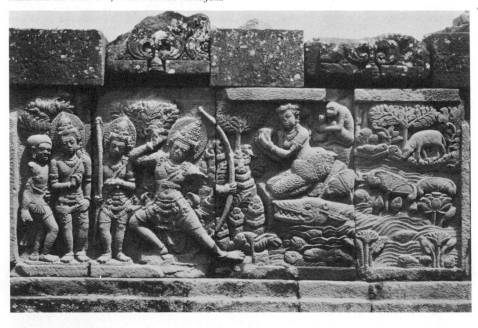

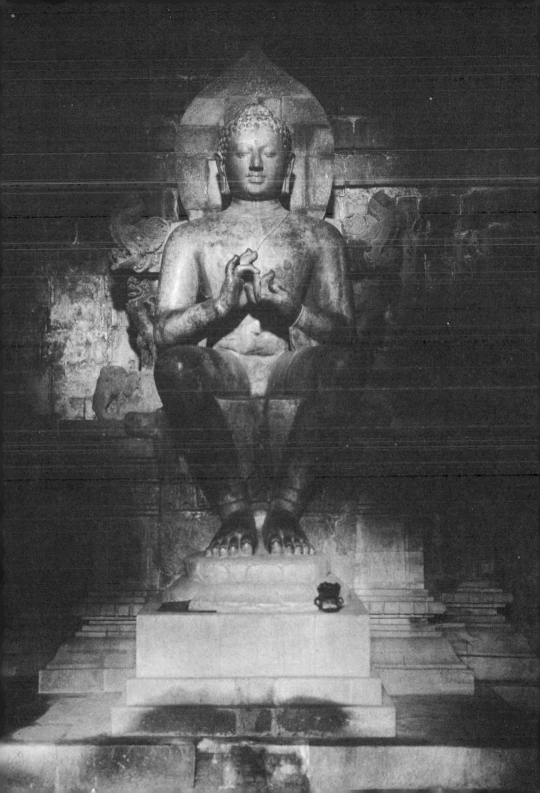

of this final period belong to a post-classical, picturesque style that is more Indonesian than Indian and more ornamental than structural.

A typical example of this final phase of Javanese architecture is the temple at Panataram, completed in *c.* 1370 [397]. It consists of a group of unrelated buildings originally erected to enshrine the ashes of the princes of the ruling house. The individual sanctuaries are erected in a style purely Javanese and only remotely related to the Indian architecture of the Middle Javanese Period. These buildings still retain the essentially cubic form of the very earliest shrines, but in every other respect the elevation has assumed a distinctive Indonesian character. The doorways are surmounted by immense and weighty kirtimukha masks. The superstructure consists of a heavy pyramidal tower, its stages emphasized by massive string courses and surmounted by a square box-like member that

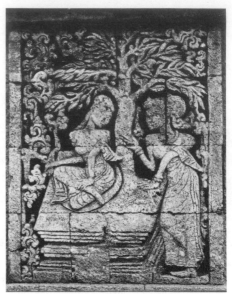

398. Panataram, Śiva temple, Śitā and attendant, relief from the *Rāmāyana*

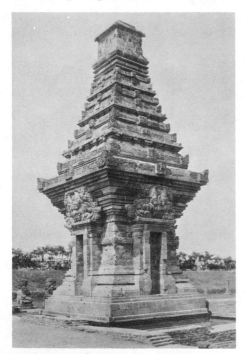

397. Panataram, Śiva temple

replaced the kalasa motif of earlier sanctuaries. The most characteristically Javanese feature of this late temple is the relief sculpture on the platform supporting the shrines: it illustrates the *Rāmāyana* and the legend of Krishna [398]. The technique of these reliefs shows not the slightest resemblance to the classic Indian styles of the Middle Javanese Period. The entirely flat figures in a setting of fantastically patternized trees and clouds are only parts of a decorative scheme. These carvings are closely related in form to the most famous expression of later Javanese folk art: the puppets of the Wayang shadow play. This last phase of art in Java, now entirely removed from Indian precedent, can be described as a true Indonesian style, characterized at once by its savage vigour and ornamental expressiveness.

*

The decorative arts of Java, which comprised many exotic native crafts, may be typified by the Wayang images, the batik, and the supreme creation of the armourer, the kris.[8] The history of the Wayang show and its puppets goes back to at least the year 1000. The performers are flat leather puppets, which are made to cast their shadows on a canvas screen to the sound of music and the narration of the puppet master [399]. The subjects of this theatre are the epic Indian dramas. The performances always satisfied a mystical need in the audience which identified the shadow-actors as real apparitions from the invisible world. The individual figures are enormously stylized symbols of divine and demoniacal forms and appear to be a further abstraction of the relief style of Panataram [398].

Of all the infinite varieties of Indonesian decorative arts batik has the character of a national craft [400]. The basic technique consists of covering the parts of the design to be reserved with beeswax, before plunging the cloth into the dye vat. The designs include both swastikas and varieties of chequered and patchwork-quilt patterns [400]. The technique developed from early one-colour batiks to barbarically splendid multi-colour patterns.

The Javanese national weapon is the kris [401]. This dagger, the armourer's final triumph, was made for both practical and ceremonial use. In the forging of the blade the craftsmen performed a ritual ceremony, perpetuating the ancient tradition of the gods' gift of weapons to man. The blades, formed of meteoric ore, are either straight or wavy and invariably include stylized representations of the Nāga. The hilt, separately fashioned of wood or ivory, is always a simplification of a demoniacal human form designed to ward off evil spirits. The kris was

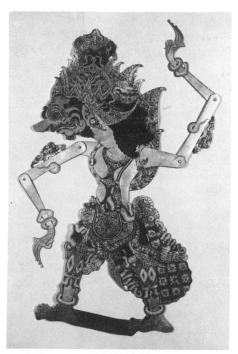

399. Wayang puppet from Java.
London, Victoria and Albert Museum

400. Batik from Java.
London, Victoria and Albert Museum

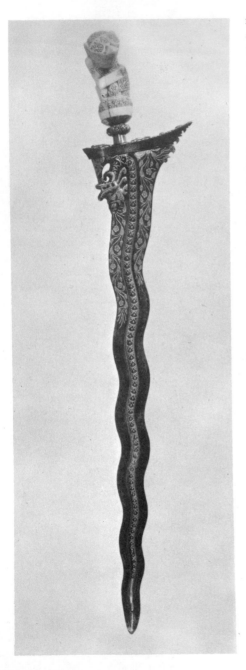

not only the supreme example of the Eastern armourer's art but also, as in the mystique of weapons throughout all the ancient traditional world, these blades, like Excalibur, were regarded as the very palladia of kingship and imbued with baleful magic power.

＊

We may very fittingly end our account of art in Java and the Indian world with one of the finest examples of Buddhist sculpture: the head of a monk or a divinized king from Caṇḍi Sewu [402]. Here is the final perfect example of the portrait in traditional art, a presentation of inward reality rather than outward appearance. As a wonderful abstract and telling embodiment of the ghostly in human form, it takes its place beside the great masterpieces not only of Indian art, but of those supreme personifications of spirit that are the Buddhist portraits of Japan. In its finality and crystalline simplicity, this icon recalls the words of St Augustine on Eloquence: 'The more genuine, as it is so simple; the more terrible, as it is so unadorned: truly, an axe hewing the rock!'

401. Kris from Java.
London, British Museum

402. Head of a monk from Caṇḍi Sewu
Batavia, Museum

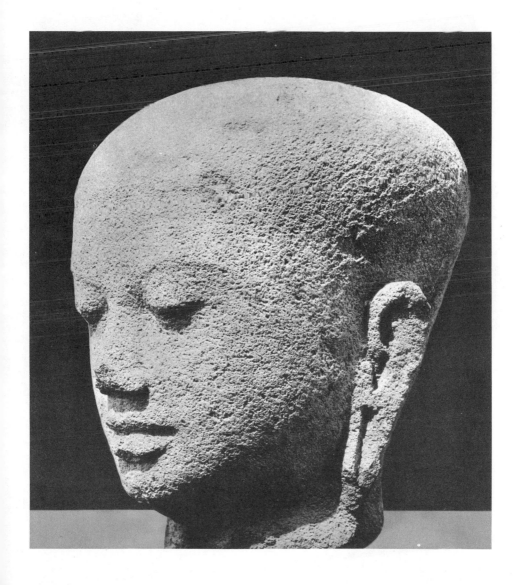

NOTES

Bold numbers indicate page reference.

CHAPTER 1

24. 1. As an illustration of the probable influence of climatic conditions on Indian culture and art, it has been suggested that the shifting of the monsoons leading to the desiccation of what is to-day the province of Sind was responsible for the disappearance of the early civilization of the Indus Valley.

2. Although in disrepute among anthropologists, the terms Dravidian and Aryan are so generally used to describe the two main divisions of Indian culture, beyond the universally accepted linguistic grouping, that it seems desirable and convenient to retain them, even if from the ethnic point of view they may not accurately describe the character of the early races of India.

25. 3. Marco Pallis, *Peaks and Lamas* (London, 1939), xvii.

27. 4. In further explanation of the practice of yoga, it could be said first of all that it is an effort on the part of the practitioner to clear his mind of all superficial sensory preoccupation in order to concentrate his entire being upon a single crystallized object or idea. The initiate in yoga, through the practice of certain callisthenics and breathing exercises designed to concentrate stores of vitality in the nerve-centres of the body, is enabled to perform great feats of physical endurance and to raise his mental efficiency to an almost supernatural level. In advanced yoga meditation the practice of concentrational discipline lessens the attachment to self and emotions and enables the yogin to concentrate with tremendous and undisturbed intensity upon that single being or idea which is the focus of his unencumbered mind. In this state the mind is no longer distracted by any perceptions or idle curiosities, but draws to itself as from a vasty deep the final form of the icon to which the concentration was originally directed. We have, in other words, a kind of identification of subject and object that suggests a Western parallel in Dante's observation that 'he who would paint a figure, if he cannot be it, cannot draw it'. This is only one of many indications in the writings of the medieval period in the West that European artists and mystics intuitively discovered a process which had for ages been the property of Indian sages.

29. 5. A. K. Coomaraswamy, *History of Indian and Indonesian Art* (New York, 1927), 178.

CHAPTER 2

31. 1. For a complete report of the Indus civilization, the reader is referred to the following publications: Sir John Marshall, *Mohenjo-daro and the Indus Civilization*, 2 vols. (London, 1931); E. J. H. Mackay, *Further Excavations at Mohenjo-daro*, 2 vols. (1937); M. S. Vats, *Excavations at Harappā*, 2 vols. (Delhi, 1940); S. Piggott, *Prehistoric India* (Harmondsworth, 1950). A useful short account is E. J. H. Mackay's *The Indus Civilization* (London, 1935 and 1948).

2. This script consists of pictographic signs some 386 in number. There are too many of these signs to conclude that this script was phonetic, and too few to suggest that it was an ideographic language like Chinese. Attempts have been made, largely unconvincing, to show that certain letters in later Indian alphabets are derived from these signs, and certain romantically minded investigators have attempted to relate the Indus pictographs to the writing of Easter Island.

3. For the latest discussion of the date of the Indus culture, see Sir Mortimer Wheeler, *The Indus Civilization* (Cambridge, 1953). 84 ff. and Piggott, 207 ff.

32. 4. The allusions in the Vedic Hymns to the storming of cities under the leadership of the god Indra might be regarded as references to the violent subjugation of the Indus capitals by the Aryan invaders. See Wheeler, *op. cit.*, 90-1.

5. A theory proposed by the French scholar, Charles Autran (*Mithra, Zoroastre, et le Christianisme*), identifying the peoples of the Indus culture with the Phoenicians is suggestive rather than convincing. This proposition is based mainly on the resemblance of certain Dravidian and Aegean place names, a similarity which, although striking, is insufficient evidence for identifying the Indus people with the great traders of the Mediterranean world.

6. Percy Brown, *History of Indian Architecture,* I (Bombay, n.d.), I.

34. 7. Unless otherwise noted, the remains of the Indus culture are in the local archaeological museums established at Mohenjo-daro and Harappā. Some of the more important objects are exhibited in the National Museums at Karachi and New Delhi.

8. One of these is reproduced in the *Journal of the Bihar and Orissa Research Society,* Dec. 1937, opp. 247.

35. 9. These holes may have had something to do with the support of the arms which, like the missing head, were separately attached to the torso. (Illustration in Vats, plate lxxx.)

37. 10. It is only fair to state that some authorities have questioned the date of this figure which has been placed in the period of the florescence of the Indus culture in the late third millennium B.C. Actually, there is nothing comparable to it in the art of this period either in India or in any other part of the ancient world. The closest stylistic comparisons to the Harappā torso are to be found in the yaksha statues of the third century B.C. which unmistakably exhibit the very qualities revealed in the Harappā torso. As one would expect in such a traditional and isolated civilization as that of India, this similarity might well be explained as a mere continuation in Indian sculptural tradition of the ends and means that actuated the carver of the Harappā torso. Vats (*Excavations at Harappā,* 76) implicitly defends its prehistoric origin on the basis of the circumstances of discovery, material, technique, and style.

11. Sir John Marshall, *Mohenjo-daro and the Indus Civilization* (London, 1931), plate xciv, 6–8.

12. Seals of Indus Valley origin have been found at Tel Asmar in Iraq at a level datable *c.* 2500 B.C. (H. Frankfort, 'The Indus Civilization and the Near East', *Annual Bibliography of Indian Archaeology for 1932* (Leyden, 1934), 1–12); imports from Sumer in the shape of seals, vessels, and beads are known at Mohenjo-daro (Mackay, 639).

13. The motif bears a curious resemblance to certain bronze forms that have been discovered in large numbers in Luristan, the mountainous region of south-western Iran. Very little is known about the Lurs, but it appears that their religious beliefs, as well as the stylistic character of their art, were survivals of the great religious traditions of Mesopotamia. The Luristan culture flourished from *c.* 2200 B.C. to as late as 600 B.C. The motif of the polycephalic bull found on the Indus seals occurs frequently in the bronze cheek-pieces from Luristan, in which a bovine creature is shown with animal heads or vegetable forms literally springing from his fertile flanks.

38. 14. Further evidence for the cult of a 'Proto-Śiva'

exists in the discoveries of phallic emblems suggesting the lingam of later Saivism.

15. In speaking of what is real to the traditional artist and what is real to the naturalistic artist of the Renaissance, an analogy suggests itself in the form of the heart on a Valentine: all of us can recognize as appropriate and understand the bright red emblem on the Valentine as a symbol of the site of tender feelings; we would be horrified if on 14 February we received a card with an anatomically realistic heart, complete with auricles, ventricles, veins, and arteries, in place of the accepted symbol; the medically accurate heart would obviously distract the recipient from the thought it was meant to express. Exactly the same parallel can be drawn between non-representational and naturalistic form in traditional or religious art.

39. 16. Some scholars, notably the late N. Majumdar, have made a distinction between different types of Indus pottery that is not without its importance for our conclusions on the whole problem. In addition to the 'black-figured' ware described above, characteristic of finds at Mohenjo-daro and Chanhu-daro, there is a thin ware with a buff slip painted with designs in black and reddish-brown that is found mainly at Amri on the Indus. This type is considered to be earlier, and shows very definite affinities not only with finds in Baluchistān, but with the pottery of Susa I in Iran and Al-Ubaid and Jemdet-Nasr in Mesopotamia. Majumdar describes this ware as an 'intrusive element' in the Indus culture. It is interesting to speculate whether this does not offer a parallel to the Sumerian elements in the seals and sculpture of the Indus civilization which again could be described as 'intrusive' or foreign in relation to the truly Indian factors in these media of expression. Since the Mesopotamian concepts in the seals are present in objects found at all levels, it would be impossible to draw the conclusion that the Sumerian types represent the earliest phase of the Indus culture. (For Majumdar's account, see 'Prehistoric and Protohistoric Civilization', *Revealing India's Past* (London, 1939), 106.)

40. 17. G. Glotz, *Aegean Civilization* (London, 1925), 245.

41. 19. J.-M. Casal, *Fouilles de Mundigak, Mémoires de la délégation archéologique française en Afghanistan,* XVII (Paris, 1961).

CHAPTER 3

43. 1. The earliest commentary on the Vedas (Yāska's *Nirukta*), written about 500 B.C., contains some speculation on the anthropomorphic nature of the gods: 'Some say they resemble human beings in form, for their panegyrics and their appellations are like those of

sentient beings'. (See Ramaprasad Chanda, 'The Beginnings of Art in Eastern India', *Memoirs of the Archaeological Survey of India*, No. 30 (Calcutta, 1927), 1.)

44. 2. This term describes the Buddhist relic mound or tope: pronounced *stūpa*, the word will be written in its anglicized form – stupa – throughout.

45. 3. Percy Brown, *History of Indian Architecture*, 4.

4. E. B. Havell, *The History of Aryan Rule in India* (New York, n.d.), 23–4.

5. S. Beal, *Buddhist Records of the Western World*, II (London, 1906), 165. (It is necessary also to point out that even the great capital of the Maurya Period, Pāṭaliputra, had a rampart of teak logs joined by iron dowels.)

6. Beal, *loc. cit.*

7. *Archaeological Survey of India, Annual Report* (hereafter referred to as A.S.I.A.R.) (1906–7), 119 ff., plates xxxix and xl. More recent excavations suggest that these mounds were actually stupas, perhaps as late as the Pāla Period. The core and foundations, as in the case of Nepalese stupas, may still be dated in the pre-Maurya era.

8. The symbolic aspect of these masts is suggested in the words of the *Rig Veda* (x, 18): 'May the manes hold this pillar for thee'.

9. G. Jouveau-Dubreuil, *Vedic Antiquities* (London, 1922), figures 3–5; A.S.I.A.R. (1911–12), 159 ff.

10. The dating of these 'hollow stupas' in the Vedic Period has been questioned by some scholars; e.g. Hiranda Shastri in A.S.I.A.R. (1922–3), 133.

46. 11. Jouveau-Dubreuil, figure 1.

12. Jouveau-Dubreuil, figures 7 and 8.

13. James Fergusson, *Rude Stone Monuments* (London, 1872), 474, figure 215.

14. Indian sculpture of all periods may be described as 'additive', in the sense that the body is not conceived as a biologically functioning unit, but is composed of so many parts individually fashioned according to manuals of artistic procedure and mechanistically joined to form a symbol and not a realistic representation of a deity. In other words, the individual parts of the anatomy are not copied from their counterparts of any human model, but are metaphorically made to approximate certain shapes in nature which these parts of the body resembled, so that the eyes are shaped like lotus petals. It is as though the often extravagant metaphorical descriptions in the *Song of Songs* were literally translated into a sculptural or pictorial representation of the female body.

15. A. K. Coomaraswamy, *Bulletin of the Museum of Fine Arts,* Boston, Dec. 1927.

16. Compare, for example, the types found at Susa and in Luristan, illustrated in *A Survey of Persian Art,* ed. by A. U. Pope (New York, 1938), IV, plates 74 A–D, and 45B.

47. 17. For the finds at the Bhir mound, see Sir John Marshall, *Taxila,* I (Cambridge, 1951), 87–111.

18. Cf. J. E. van Lohuizen-de Leeuw, 'South-East Asian Architecture and the Stūpa of Nandangarh', *Artibus Asiae,* XIX, 3/4, pp. 279–90.

CHAPTER 4

49. 1. The word 'Dravidian', regardless of its linguistic or ethnic implications, is used here for convenience to describe the autochthonous, pre-Aryan religion of India.

2. In its beginnings the Aryan or Vedic religion in India was, of course, identical with the Aryan religion in Iran. A gradual transformation that took place long before the time of Zoroaster in the seventh century B.C. changed the Iranian religion into a cosmic dualism of Good and Evil dominated by Ahura Mazda (the Holy Wisdom), who is engaged in eternal conflict with the powers of evil or Daevas. The rift between the two branches of the Aryan religion must have taken place at a relatively early period, for, already in the *Brāhmaṇas*, the word *deva* means 'god', and *asura*, 'demon'. They are derived from the same original terms that in Iran had come to signify the exact opposite: 'ahura' for Holy Wisdom and 'daeva' for demon.

50. 3. The word *Veda* means 'knowledge'. It is the general name given by European scholars to four collections of religious works, which contain the sacred knowledge necessary for the performance by the priests of the rites of the Brahmanical religion. The Hindus themselves use the word Veda in a much broader sense to include other collections of sacred writings such as the *Brāhmaṇas* and *Sūtras*.

4. The names of all the principal gods of the Vedic pantheon may be recognized in the 'Aryan' Hittite inscriptions at Boghazkeui dating from the fourteenth century B.C.

51. 5. Earlier, Śiva and Vishnu were separately worshipped in the triune aspects of Creator, Preserver, and Destroyer. The final development of the Trinity including Brahma was probably a compromise to resolve sectarian disputes.

52. 6. The word Brahmin, although a corruption of the Sanskrit Brahman, is a convenient one to designate the highest caste. It should not be confused with the words *Brāhmaṇa*, an early liturgical text, or Brahma, the first member of the Hindu trinity. The word Brahmanic is occasionally used as a synonym for Hindu, and Brahmanism for Hinduism.

53. 7. By definition a Buddha (Enlightened One) is a being who has in countless earlier incarnations added to his store of merit by which in his ultimate life on

earth he becomes enlightened, possessed of supreme wisdom, and endowed with superhuman powers enabling him to direct all creatures to the path of salvation. This definition does not apply to the 'Pratyeka Buddhas' who seek salvation only for themselves.

54. 8. As an illustration of the survival or reworking of far earlier concepts in Buddhism, it may be pointed out that the 'Eightfold Path' is no more than an analogy based on the Eightfold Path of circumambulation in the plan of the Indo-Aryan village.

55. 9. The Tushita Heaven, lowest in the tier of paradises or *devalokas* rising above the sky, is the residence of the Thirty-three Gods presided over by Indra.

10. In a relief sculpture at Bhājā, the Vedic gods Sūrya and Indra appear as symbols of the Buddha's spiritual and temporal power.

56. 11. One factor that led to the Buddha's ultimate deification was his identification with the ancient Indian concept of the universal ruler or Cakravartin: his 'royal' character was implicit in the cicumstances of his birth, in his possession of the cosmic tree and the solar wheel, typifying his Enlightenment and Preaching. Aśoka conferred royal honours on his remains; the umbrella, emblem of royalty and of the sky, crowned his relic mounds. The occasional representations of Cakravartin with the Seven Jewels of his universal power may be simply interpreted as allegorical representations of the Buddha, (See, for example, the relief from Jaggayyapeṭa of the Early Āndhra Period reproduced in L. Bachhofer, *Early Indian Sculpture* (New York, 1929), plate 107.)

57. 12. The relative 'realism' or 'abstraction' of the multiple representations of Buddhas at Barabuḍur in Java are so qualified in accordance with this concept. The crowned and bejewelled Buddhas of Pāla-Sena times have been interpreted as representations of the body of bliss.

58. 13. Vajrayāna Buddhism was introduced to Japan as early as the ninth century, and survives there in the Shingon sect.

CHAPTER 5

60. 1. Since, as the Buddhist texts inform us, the superman designated by the thirty-two *lakṣaṇas* or magic marks has before him at his birth the choice of becoming a Cakravartin or adopting a career leading to Buddhahood, the concept of the universal ruler is a kind of temporal complement to the spiritual idea of the Buddha.

2. Aelian, *Nat. Anim.*, XXII, 19. The discovery of an Aśokan inscription in Greek and Aramaic near Kandahar makes the connexion with the Hellenistic world appear even closer.

3. Beal, LV.

65. 4. The striking resemblance between the decoration of the façade of the Lomas Rishi cave and certain ivories of the first century A.D. found at Begrām in Afghanistan has led Philippe Stern to date the Barabār cave early in the Christian era. (Cf. P. Stern, 'Les ivoires de Begram et l'art de l'Inde', in J. Hackin, *Nouvelles recherches archéologiques à Begram*, Paris, 1954, p. 38 f.)

5. Examples with their sculptured capitals still intact have been discovered at Saṅkīsa, Basārh, Rāmpurvā, Lauriyā Nandangaṛh, Salempur, Sārnāth, and Sāñchī.

6. A relief of the Śunga Period in the Provincial Museum, Lucknow, shows us a man and woman circumambulating a free-standing column of the Maurya type – a clear indication of the veneration accorded such memorials. (Illustrated in *Indian Historical Quarterly*, 1935, opposite 136.)

67. 7. This site was selected by Aśoka possibly because it was, as we have seen, the site of a royal cemetery of pre-Maurya date.

8. One is reminded of St Patrick's practice of carving Christian sentiments on pagan monuments in Ireland.

9. Beal, II, 46.

10. We can form some idea of its original appearance from a relief at Sāñchī that portrays a similar *stambha* with a lion capital supporting the Wheel of the Law. (See Sir John Marshall, *The Monuments of Sāñchī*, II, plate xxvii.)

70. 11. The four beasts of the Evangelists and four seasonal animals of China are only variants of this geomantic symbolism. The Siamese ceremony is described in Margaret Landon, *Anna and the King of Siam* (New York, 1944), 299 ff.

12. We find them again as gargoyles attached to a tank at Néak Péan in the ancient Khmer capital of Angkor; here, they were associated with the worship of Lokeśvara, the merciful Bodhisattva, who causes the water of the sacred lake to flow downward for the relief of souls in hell. In Ceylon, they are invariably represented on the 'moon stones' at the entrances of sanctuaries; the excavation of actual metal effigies of these beasts buried at the four quarters around a stupa lends further support to their identification as directional symbols (See Vincent Smith, *History of Art in India and Ceylon* (Oxford, 1930), 18, n. 2.)

72. 13. The bull, of course, is an emblem of Śiva; the lion, sacred to his consort, Durgā. The epithet *Śākyapriṅgava*, meaning 'bull, hero, eminent person', is sometimes applied to Buddha.

14. W. Andrae, *Die Ionische Säule* (Berlin, 1933).

15. D. S. Robertson, *A Handbook of Greek and Roman Architecture* (Cambridge, 1939), 60, suggests a theory related to this problem: 'It may be that the classical Ionic form is an adaptation of the Aeolic . . . to a special type of timber construction, the "bracket-

capital" so often found in modern wood buildings.'

16. R. E. M. Wheeler, 'Iran and India in Pre-Islamic Times', *Ancient India*, No. 4, July 1947–January 1948, plate xxix B.

17. In addition to the example from Pārkham, the museum at Muttra also contains a fragment of a yaksha statue from Baroda that originally must have been more than twelve feet high. Two other yaksha figures found near Patna are in the Indian Museum at Calcutta. Female figures in the same style include a colossal yakshī from Dīdarganj in the Patna Museum and another image of the same deity from Besnagar in Calcutta. They are all illustrated in Bachhofer's *Early Indian Sculpture* and in N. R. Ray's *Maurya and Śunga Art* (Calcutta, 1945). The latter author seriously questions the dating of these figures in the Maurya Period and prefers to assign them to the Śunga Period (*Maurya and Śunga Art*, 48 ff.). The dating of all these statues in Maurya times rests on the somewhat insecure basis of their generally archaic quality and the presence of the same Maurya polish found on the Aśokan columns.

73. 18. It has been suggested that possibly the yaksha was worshipped as the protective deity of a guild. The inscription may contain the name of the yaksha, i.e. Manibhadra.

75. 19. The figure of a female divinity from Dīdarganj has, like the so-called Maurya yakshas, been a subject of considerable controversy. Actually, only the fact that it was found near Patna, the Maurya capital, and the fact that the stone has the same high polish of the Aśokan columns lend any conviction to a dating in the Maurya Period. From the point of view of stylistic development, the statue is actually in advance of any of the figure sculpture, not only of the Maurya but also of the Śunga Period (185–27 B.C.). The closest comparison is with the representations of yakshīs on the gateways of the stupa at Sānchī, which were carved in the closing decades of the first century B.C.: for this reason its analysis is postponed to the chapter on the Early Āndhra Period.

CHAPTER 6

77. 1. It should be suggested as a possibility that, just as in the funeral customs of people in all parts of the ancient world, the burial place was intended to simulate the surroundings of the deceased in life, the domical forms of both the rock-cut Vedic tombs and the earliest tumuli may have been conscious replicas of the shape of the Vedic hut. This does not of course exclude the possibility that over and beyond its practical function the form of the original hut, the cave, and the burial mound was also a symbolical or magic reconstruction of the imagined shape of the sky, like a dome covering the earth.

79. 2. Mahāpuruṣa or Prajāpati was that great being whose body comprised the universe and who, by the sacrifice and division of that body at the beginning of the world, brought all things to birth.

82. 3. These yaksha guardians are the ancestors of the Guardian Kings of Far Eastern art.

86. 4. The concept of the Cakravartin stems from the ancient Babylonian idea of the Universal King.

88. 5. The French scholar Philippe Stern would date the Jaggayyapeta relief as late as the first century A.D. He describes the crudity of this relief as 'un archaisme de maladresse' and explains this style by the remoteness of the site and the lack of sculptural precedent in Eastern India. (Cf. P. Stern, 'Les ivoires de Begram et l'art de l'Inde', in J. Hackin, *Nouvelles recherches archéologiques à Begram*, Paris, 1954, p. 45.)

6. 'Airāvata' means, literally, 'lightning–cloud'.

90. 7. Some of the reliefs on the uprights, such as that of a yakshī climbing into her tree, are much more fully modelled and suggestive of the figure's existing in space than anything found at Bhārhut and Sānchi. Indeed, the sensuous definition of the form and its articulation seem but a step removed from the work of the Kushan Period. See Bachhofer, *History*, plate 34.

8. Certainly even in primitive Buddhism, Śākyamuni had come to be identified with the sun-god, and his nativity likened to the rising of another sun. For a full discussion of this iconography see my article, 'Buddha and the Sun-god', *Zalmoxis*, 1 (1938), 69–84.

91. 9. In its most practical explanation this symbolism connotes the old gods doing homage to the Buddha. Indra's bringing of the straws has a deeper metaphysical interpretation, in that it offers a correspondence between the spreading of the sacrificial straw on the Vedic altar, to be kindled by the fire god, and the Bodhisattva's sitting on the grass to rise enlightened to the skies, like the fiery column of Vedic sacrifice.

92. 10. Although there is some dispute about the precise meaning of this iconography, it seems clear that such representations of Lakshmī as the present example came to symbolize the birth of Buddha. Lakshmī, who was the very personification of existence and maternity, was by association identified with Māyā, the mother of Buddha.

11. M. N. Deshpande, 'The Rock-Cut Caves of Pitalkhora in the Deccan', *Ancient India*, XV (1959), 66–94.

CHAPTER 7

97. 1. N. R. Ray, *Maurya and Śunga Art*, 73.

99. 2. A. K. Coomaraswamy, *Yakṣas* (Smithsonian Institution, Washington, D.C., 1928), 33. A number

of passages in the classic text are the literary equivalents to the conception at Sāñchī. Aśvaghosa in the *Buddhacarita* (IV, 35) describes women who 'leaned, holding a mango bough in full flower, displaying their bosoms like golden jars'. In the *Mahābhārata* (III, 265) one of the heroes challenges a tree spirit, 'Who art thou that bending down the branch of the kadamba tree, shinest lonely in the hermitage, sparkling like a flame at night, shaken by the breeze, O fair-browed one?'

101. 3. In the relief of the Buddha's Return to Kapilavastu on the northern jamb of this same gateway, the Conception of Māyā, an event that had taken place many years before, is by this principle included in the composition with perfect propriety (illustration 15).
102. 4. John Irwin in *Indian Art*, ed. by Sir Richard Winstedt (New York, 1948), 72.
104. 5. The gorge at Ajaṇṭā, formerly sacred to a Nāgarāja who had his seat in the waterfall at the head of the valley, was taken over by communities of Buddhist monks as early as the second century B.C. These Buddhist settlers began the work of hollowing out the twenty-six cave-temples and assembly halls that was not completed until the sixth century A.D. The early paintings in Cave X are so darkened and damaged that the composition can be studied better in a tracing than a photograph.
107. 6. O. M. Dalton, *The Treasure of Oxus*, 3rd ed. (London, 1964), plate xxviii, 199–200; Sir A. Cunningham, *The Stūpa of Bhārhut* (London, 1879), plate xxxiii; Sir J. Marshall and A. Foucher, *The Monuments of Sāñchī*, III (London, n.d.), plate lxxvi, ii.
108. 7. Marshall and Foucher, *op. cit.*, III, plates lxxiv ff.
 8. A. Maiuri, 'Statuetta eburnea di arte indiana a Pompei', *Le Arti*, I, 1939, 111 ff.
111. 9. Other examples of ivory carving from the Begrām treasure are discussed under the Kushan Period (pp. 161-2). It is apparent to me that this collection of ivories, like the accompanying Greco-Roman objects, represents work of several different periods.

CHAPTER 8

116. 1. Walter Spink, 'On the Development of Early Buddhist Art in India', *The Art Bulletin*, XL, 2 (June 1958), 97–8.

CHAPTER 9

122. 1. The most famous ruler of the Śaka Dynasty was Gondophares or Gunduphar. He is known by an inscription at Takht-i-Bāhi datable in A.D. 45, and in Christian legend as the ruler visited by St Thomas the Apostle on his mission to India.

 2. It is important to note, however, that the era of 58 B.C., established by the Śaka ruler Azes, continued as a method of dating by the Kushans and their successors in the Peshawar region.
 3. *A.S.I.A.R.* (1908–9), 48 ff.
124. 4. R. Ghirshman, 'Fouilles de Begram (Afghanistan)', *Journal Asiatique*, Années 1943-5, 59–71.
 5. *Op. cit.*, 63.
125. 6. Both the position and the policy of the Kushans in India have a close parallel in the history of the T'o-pa Tartars who conquered northern China in the fourth century A.D. These foreign invaders, excluded from the national religions of China, became fervent propagandists of Buddhism, and imported artisans from the 'Western Countries' (Turkestan) to decorate their religious foundations.
 7. In many cases the closest comparisons for Gandhārā sculpture are to be found not in Rome itself, but in such centres as Palmyra, Antioch, and Seleucia, as well as in the Classical forms in Iranian art of the Parthian Period.
 8. Sir John Marshall, *A Guide to Taxila* (Calcutta, 1936), 78–100, and below. See also Marshall, *Taxila*, I, 112–216, and II, 517, 518, etc.
126. 9. D. Schlumberger, *Comptes rendus de l'Académie des Inscriptions* (1965), 36–46; D. Schlumberger and P. Bernard, *Bulletin de Correspondance hellénique*, LXXXIX (1965), 590–657; P. Bernard, *Comptes rendus* ... (1967), 306–24.
 10. Following ancient Oriental custom, it was the practice in India to date events in years reckoned from accession of a living ruler or from the first year of a dynasty. In Gandhārā it remains an unanswered question whether a Śaka era of 150 B.C. or a dating from 58 B.C., the regnal date of Azes I, is to be applied to the inscribed Gandhāra fragments. For many reasons the former of these two systems is preferable, because it serves to place some of the best or most classic examples of inscribed sculpture in the great period of Kushan power; that is, before the Sasanian invasion of A.D. 241.
 11. See, for example, the Buddha images from Loriyan Tangai (Indian Museum, Calcutta) and Hashtnagar, dated in the 318th and 384th years of the era of 150 B.C., or A.D. 168 and 234 (illustrated in Bachhofer, II, plate 142). Presumably the finest specimens from Chārsada, Takht-i-Bāhi, and Sahri Bahlol also belong to this period of florescence. The character of the masonry at these sites corresponds to the type assigned to the second and third centuries A.D. by Sir John Marshall on the basis of his excavations at Taxila.
 12. For comparisons, see B. Rowland, 'Gandhāra and Late Antique Art', *American Journal of Archaeology*, XLVI (1942), No. 2, 223–36.

13. It has been suggested that the raising of the Buddha to divine status in the Mahāyāna creed parallels the Roman deification of the Emperor in the same way that the aspiration to a creed promising salvation may be discerned in later Buddhism, Roman literature of the Imperial Period, and in Christianity.

127. 14. B. Rowland, 'Gandhāra and Early-Christian Art: Buddha Palliatus', *American Journal of Archaeology*, XLIX (1945), No. 4, 445–8.

128. 15. Although Buddhism and its foundations in Gandhāra were not destroyed by the Sasanian conquest, with the end of the Great Kushan dynasty, its royal patronage was at an end. It is very doubtful if any new artistic enterprises were feasible in the period of confusion after the debacle of 241. Probably the only work between this date and the invasion of the White Huns in A.D. 450 was in the nature of repairs to the earlier decorations in stone and stucco.

130. 16. The fact that a Chinese or Central Asian imitation of this type of drapery is to be seen in some of the figures in the Buddhist temples at Yün Kang (A.D. 460–94) should make it possible to date the Begrām prototype no later than A.D. 400.

17. It has been argued by some authorities that the representations of seated figures on the Indo-Parthian or Saka coins of the first century B.C. (illustration 65D) are representations of the Buddha. However, these are no more than portraits of the rulers themselves in a seated position. Iconographically, of course, there is a remote precedent for the seated Buddha type in the representations of Śiva in yoga pose on seals of the Indus Valley Period.

133. 18. The closest Classical parallel to our relief is to be found in the silver hoop of the Marengo Treasure in Turin, but since this is a late second-century derivation from Augustan sculpture, the comparison illustrates a parallel, not a true influence.

19. The curious variety of goblets depicted in one of the carvings in this style corresponds to actual silver vessels excavated at Taxila under conditions suggesting a date as early as the first century A.D. (For an illustration of the relief, see B. Rowland, 'A Revised Chronology of Gandhāra Sculpture', *The Art Bulletin*, XVIII (1936), figure 12, and for the drinking vessels *A.S.I.A.R.* (1926–7), plate xxxvii, 6.)

134. 20. It might be pointed out that the cornice of serpentine dragons at the top of the panel is almost a duplication of a band of decoration on the Roman sarcophagus from Melfi, dated A.D. 170.

21. Cf. S. Beal, *Buddhist Records of the Western World*, London, 1906.

135. 22. It may be, of course, as has already been suggested above (p. 126) that the style is a mixture of the archaic technique of the Early Indian Schools combined with borrowings from Classical sources.

136. 23. H. H. Wilson, *Ariana Antiqua* (London, 1841), 71.

24. Sir John Marshall maintains that the early school of Gandhāra sculpture came to an end with the Sasanian invasion of Shāpur I, when 'Buddhism was deprived of the influential support extended to it by the early Kushan Emperors, and for the next 140 years . . . Buddhist art in this part of India ceased virtually to exist.' He believes that only with the re-establishment in Gandhāra of the Kidara Kushans from Bactria in the late fourth century did a new period of artistic activity begin. This final florescence, he tells us, was characterized entirely by work in stucco. It seems difficult, however, to conceive of such an artistic interregnum, not only because few of the inscribed stone statues appear to be datable in the period after the Sasanian conquest, but also because the stucco sculpture appears as a contemporary manifestation in a different medium of exactly the same style as the carving in slate. Some examples of stucco at Taxila may be dated to the first century A.D. (See Sir John Marshall, 'Greeks and Śakas in India', *Journal of the Royal Asiatic Society* (1947), 16–17)

138. 25 Apollonius of Tyana, who visited Taxila in A.D. 44, describes a temple which may well have been the edifice at Jandial. 'And they saw a temple, they say, in front of the wall which was not far short of 100 feet in size, made of porphyry; and there was constructed within it a shrine somewhat small as compared with the great size of the temple which is also surrounded with columns, but deserving of notice.' Apollonius goes on to describe some bronze tablets engraved with the exploits of Porus and Alexander, adorning the walls of this chamber. Actually, no figural sculpture of any kind was uncovered in the ruins of the Jandial temple, a fact usually interpreted as supporting the theory that it was a Zoroastrian dedication. (See Philostratus, *Vita Apollonii*, II, 25.)

141. 26. Beal, civ.

142. 27. This famous building must have exercised a powerful influence on the development of the Far Eastern pagoda type; see, for example, such early Chinese pagodas as the Pei t'a at Fang-shan hsien (Chih li) and the Sung-yüeh-ssŭ on Sung-shan (Honan) reproduced in O. Sirén, *History of Early Chinese Art*, IV, *Architecture* (London, 1930), plates 75 and 105.

144. 28. Daniel Schlumberger, 'Surkh Kotal, a Late Hellenistic Temple in Bactria', *Archaeology* (Winter, 1953), 232 ff.

145. 29. K. V. Trever, *Monuments of Greco-Bactrian Art* (Academy of Science of U.S.S.R., Moscow–Leningrad, 1949), plates i and ii. The elephant itself is reminiscent of the representations of this beast on the

coins of Antiochus III of Syria (222–187 B.C.), who invaded Bactria during the reign of Euthydemus I.

30. Dalton, plate xxvi, 197.

31. B. Rowland, 'Gandhāra, Rome, and Mathurā, The Early Relief Style', *Archives of the Chinese Art Society of America*, x, 1956, 12.

147. 32. F. Petrie, *Arts and Crafts in Ancient Egypt*, plate xxxiv, nos. 23–31; J. Evans, 'Some Vessels of Steatite from Egypt', *Soc. of Antiquaries Proc.*, xxii, 1908, 89.

CHAPTER 10

149. 1. The divine character of Kanishka is suggested by the shoulder flames on his coins and his association with the deities of sun and moon on the drum of the Peshawar reliquary.

2. Groups at Kārlī and Kaṇherī, near Amarāvatī, have been identified as donors. Belonging to the same period, they are entirely Indian in style.

150. 3. E. Herzfeld, *Am Tor von Asien* (Berlin, 1920), plate xxv.

153. 4. Another statue of the identical type and dedicated by the same Friar Bala was found at Śrāvastī and is now in the Indian Museum at Calcutta.

154. 5. There are, of course, many examples of such trinities in Gandhāra art, and even the representation of Kanishka between the sun and moon on his casket might be regarded as a primitive form of the composition which is echoed in the group of three free-standing figures on loti that crown the reliquary.

162. 6. John Rosenfield has pointed out to me that both the archaic style of the figures and the banana tree dividing the scenes resemble a relief in the Muttra Museum (No. 3768), dedicated by Sodaśa, the Kushan satrap of Mathurā in the first century A.D.

163. 7. Coomaraswamy, *History . . .*, figure 62.

8. The Mahābodhi temple was very widely copied not only in India but also in Burma and even China in Ming times. Most of these replicas show the shrine after the addition of the four buttressing turrets.

9. Cunningham argues, however, that this masonry was an addition at the time of the Burmese reconstruction of the thirteenth century. (See Sir Alexander Cunningham, *Mahābodhi* (London, 1892), 85.) Similar construction may been seen in the ruins of Burmese temples at Pagān and Prome. (See H. Marchal, *L'Architecture comparée dans l'Inde et l'Extrême-Orient* (Paris, 1944), plate xv.)

164. 10. The circular and square plaques forming the belts on the portrait statues of Kanishka and Chashtana are perhaps an indication of the continuation of this Kushan craft in India.

11. Although the invasion of Shāpur I of Iran in A.D. 241 brought to an end the first Kushan dynasty founded by Kanishka in north-western India, there is no indication that this military *débacle* produced a complete interregnum in the development of art in these territories. Some development and production went on at least until the invasion of the White Huns in the fifth century laid the monastery of Gandhāra in ruins. (See p. 475, n. 15.)

CHAPTER 11

166. 1. Beal, 1, 55 ff.

2. Beal 1, 54.

3. The surviving finds from Haḍḍa are equally divided between the Musée Guimet in Paris and the Kabul Museum at Darul-Aman. Before proper protective measures could be taken, vast quantities of excavated sculpture were ruthlessly destroyed by the iconoclastic Moslem population of Jelālābād incited by the hostile Mullahs.

4. Stucco had been employed for achitectural ornament as early as the first century A.D., but it was not until about the third century that it largely replaced stone as a medium.

5. Beal, 1, 91.

168. 6. This piece belongs to a group of sculpture originally advertised as having been excavated at Tash Kurgan in Central Asia. Actually, this claim is a complete fabrication intended to lend greater interest and importance to objects acquired in the market at Peshawar.

7. This asymmetry may be due to the fact that the head was originally part of a relief, so that one side was flattened against the back wall of the composition.

170. 8. One writer, Silvio Ferri (*L'Arte romana sul Danubio* (Milan, 1933), n. 1), describes the sculptures of Haḍḍa as stylistically situated between archaic Greek and the Romanesque of Toulouse.

9. G. Rodenwaldt, *Die Kunst der Antike* (*Propyläen Kunstgeschichte*, iii), Berlin, 1927, 652–5.

10. G. Pougachenkova, 'La Sculpture de Khaltchayan', *Iranica Antiqua*, v, 2 (1965), 116–27; G. A. Pugachenkova, *Khalchayan* (Tashkent, 1966).

11. Shahibye Mustamandi, 'A Preliminary Report on the Excavations of Tapa-i-Shotur in Haḍḍa', *Afghanistan* (Spring, 1968), 58–69.

12. Shahibye Mustamandi, 'The Fish Porch', *Afghanistan* (Summer, 1968), 68–80.

13. A. M. Belenitskii and B. B. Piotrovskii, *Skul'tura i Zhivopis' drevnego Pyandzhikenta* (Moscow, 1959), tab. xxvii–xxxiv.

171. 14. Beal, 1, 51: 'Its golden hues sparkle on every side, and its precious ornaments dazzle the eyes by their brightness.'

15. *Idem.*

172. 16. We have already seen how the dome, an ancient Near Eastern symbol of the sky covering the earth, was incorporated into the symbolism of the stupa (see the definitive article on the dome by A. C. Soper, ' "The Dome of Heaven" in Asia', *The Art Bulletin*, Dec. 1947, 227 ff.).

174. 17. T. Wiegand, *Baalbek*, II, plate 45, and Karl Lehmann, 'The Dome of Heaven', *The Art Bulletin*, XXVII, March 1945, figure 9. Not far from Bāmiyān is the Valley of Kakrak, where a number of domed rock-cut chapels were investigated by the French Archaeological Mission. The cupolas contained paintings of Buddhas in contiguous circles around a central Buddha. These painted maṇḍalas are presumably a later development from the architectural schemes at Bāmiyān.

176. 18. Other paintings of an entirely Sasanian character are to be found in the vestibule of Group D, a complex immediately adjoining the smaller colossus. There the entire ceiling was painted with a decoration of medallions, exactly imitating designs from Sasanian textiles like boars' heads and birds holding necklaces in their beaks. Illustrated in J. Hackin and J. Carl, *Nouvelles Recherches à Bāmiyān* (Paris, 1933), plate x.

179. 19. The earliest sculpture and painting in the Thousand Buddha Caves (Ch'ien Fo-tung) at Tun-huang on the north-western border of China is in reality only an eastward extension of the styles of Turkestan. No publication of this site exists, beyond a collection of illustrations published by Paul Pelliot (*Les Grottes de Touen-Houang*, Paris, 1914 ff.). The earliest caves were dedicated in A.D. 366. At least one dated inscription of the year 538 in Cave 120N serves to date the style of the wall-paintings closest to the murals at Bāmiyān and Kizil in Turkestan. Coloured photographs of the sixth-century paintings at Tun-huang reveal that the same colour scheme with a predominance of lapis-lazuli blue and malachite green, employed at Kizil, was followed by Central Asian artists at Tun-huang.

180. 20. Most likely datable in this period is the enormous ruined wall-painting of an enthroned king at Dukhtar-i-Nōshirwān that is in every way the pictorial equivalent of the rock-cut memorials of the Sasanian kings in Iran proper. Illustrated in J. Hackin, A. and Y. Godard, *Les Antiquités Bouddhiques de Bāmiyān* (Paris, 1928), figure 25. It seems inevitable to conclude that the Sasanian paintings at Bāmiyān and Dukhtar-i-Nōshirwān are the most positive evidence we have for the extension of Sasanian power to the East after the invasion of 241 A.D.

21. Wall-paintings, some Sasanian, others Indian in style were also found at this site in the Ghorband Valley. See J. Hackin and others, *Diverses Recherches Archéologiques en Afghanistan* (Paris, 1961).

CHAPTER 12

185. 1. McCrindle's *Ancient India as described by Ptolemy*, ed. S. M. Śāstri (Calcutta, 1927), 12 ff.

186. 2. Fragments of painting in a Late Antique style have been found in Gandhāra, notably at Haḍḍa and at Bāmiyān, but none of these cycles is as complete as that of Mirān (see J. Hackin, *L'Œuvre de la Délégation archéologique française en Afghanistan, 1922–32* (Tokyo, 1933), figures 27 and 34).

187. 3. For illustrations of the sculpture at the Rawak vihāra, see M. A. Stein, *Ancient Khotan*, I (Oxford, 1907), figures 61–6.

188. 4. Many moulds for individual details of sculpture were found by the German expeditions to Central Asia. (See A. von Le Coq, *Die Buddhistische Spätantike in Mittelasien*, v (Berlin, 1926), plate 6.)

189. 5. Some but not all of the hundreds of examples of wall-paintings brought back by von Le Coq and installed in the Ethnological Museum in Berlin were destroyed during the Second World War. Some idea of their brilliance can be gained from the colour plates in his publications and the small fragments of actual wall-paintings preserved in various American museums. For coloured reproductions see the volumes published by von Le Coq under the title *Die Buddhistische Spätantike in Mittelasien*.

194. 6. The wall-paintings in the Cave of the Red Dome contain inscribed portraits of three kings of Kucha who are known to have reigned in the late sixth and early seventh centuries A.D. Actually, most of the paintings must date from c. 500–50, since they are in exactly the same style as the frescoes at Tun-huang, dated in the middle of the sixth century.

7. Chinese art historians of the late T'ang Dynasty, in describing the style of the seventh-century painter, Wei-ch'ih I-sêng, who came from either Tokhāra or Khotan, speak of his line as like 'bent and coiled iron wire', a definition that could be very well applied to the Kizil wall-paintings analysed above. (See T. Naitō, *The Wall-paintings of Hōryūji*, trans. and ed. by W. R. B. Acker and B. Rowland (Baltimore, 1943), 196 ff.)

196. 8. See F. H. Andrews, *Wall-paintings from Ancient Shrines in Central Asia* (London, 1948), plates xii–xxx.

9. See A. von Le Coq, *Die Manichäischen Miniaturen*, *Buddhistische Spätantike*, II (Berlin, 1923).

197. 10. E. Herzfeld, *Am Tor von Asien* (Berlin, 1920), plate lxiv.

11. J. Hackin and J. Carl, *Nouvelles recherches archéologiques à Bāmiyān*, *Mémoires de la délégation archéologique française en Afghanistan*, IV, plates x and lxxxiv, figure 102.

12. M. A. Stein, *Serindia*, iv (Oxford, 1921), plates xviii, xix.
13. *Monumenta Serindica*, 5 (Kyoto, 1962), No. 8 (colour plate).

CHAPTER 13

199. 1. Ushkur is the ancient Huvishkapura, built by the Kushan king Huvishka, Kanishka's successor. For an account of the remains at Ushkur and Harwan, see Ram Chandra Kak, *Ancient Monuments of Kashmir* (London, 1933), 105–10, 152–4.
2. This plan with the sanctuary in the centre of a vast open court has a haunting suggestion of the temple of Baal at Palmyra and its Iranian counterpart at Kangawar. For the plan of Avantipur, see Kak, *Ancient Monuments of Kashmir*, plate lxviii.
203. 3. See, for example, the representations of pedimented temple fronts on the shrine of the Double-headed Eagle at Sirkap, Taxila (illustration 76). The style of relief decoration of the Kashmir temples survives in the relatively modern carving of the wooden shrines of Chamba State. Cf. W. Goetz, *The Early Wooden Temples of Chamba* (Leiden, 1955).
4. See *A.S.I.A.R.*, 1906–7, plates lxiii, lxiv, lxx, and A. H. Franke, *Antiquities of Indian Tibet* (Calcutta, 1914), plate vi.
205. 5. See above, p. 180.
6. See Kak, plates xlv, 1; Coomaraswamy, *History*, figure 272.

CHAPTER 14

207. 1. In this connexion, see the account by R. E. M. Wheeler of the discovery of a Roman trading post at Arikamedu in *Ancient India* (July 1946), 17–125. For a discussion of the subject of Roman trade with India, consult the same author's *Rome Beyond the Imperial Frontiers* (Pelican Books) (London, 1954).
208. 2. Nāgārjuna, one of the 'Church Fathers' of Mahāyāna Buddhism, was active in the Āndhra Empire in the second century A.D. He is specifically remembered as the founder of the esoteric Vajrayāna branch of the Great Vehicle. It is natural to suppose, therefore, that all the Later Āndhra monuments were dedicated to the Buddhism of the Great Vehicle. For Nāgārjuna, see K. R. Subramanian, *Buddhist Remains in Āndhra* (Madras, 1932), 53–63.
3. A great many reliefs representing the stupa as a whole have been found at all the Later Āndhra sites. Probably they were intended to stress that the monument, incorporating a relic of the Buddha, was itself an icon as worthy of adoration as the images of the divinity.
4. These are referred to as *Āyaka* pillars, and, since they are always in groups of five, may have symbolized

the Five *Dhyāni* Buddhas, but the presence of the Buddhist emblems suggests a Hinayāna origin.
5. Coomaraswamy (*Elements of Buddhist Iconography* (Cambridge, 1935), plate I) identifies these subjects as figurations of the Buddha as Supernal Sun, the columns themselves representing the Axis of the Universe.
209. 6. Although it is difficult to point to any exact prototypes, this treatment of the lower hem of the sanghāti has a certain resemblance to Roman draped statues, so that it may be a borrowing direct from Western techniques through cameos or gems brought to Roman trading posts in Āndhra.
210. 7. Coomaraswamy, *History*, figure 342.
8. *Annual Bibliography of Indian Archaeology*, 1933 (Leiden, 1935), plate viii.
9. See above, p. 86 and illustration 34.
212. 10. These figures are perhaps Indo-Scythian or Yavana bodyguards of the royal house. See 'The Buddhist Antiquities of Nāgārjunakoṇḍa', *A.S.I. Memoirs*, No. 54, plate x (c) and (d).
11. For the Begrām ivories, see illustrations 56, 105, and 106; Coomaraswamy, *History*, 71.
12. Beal, II, 221.
13. Legend has it that the Buddhist monuments at Amarāvatī were wrecked by Hindu fanatics.
14. T. N. Ramachandran, 'Buddhist sculpture from a stupa near Goli Village', *Bulletin of the Madras Government Museum*, I, part 1 (1929), 21–2.
213. 15. Compare the plan and section of the stupa at Ghaṇṭaśāla (Alexander Rea, *South Indian Buddhist Antiquities* (Madras, 1894), plate xiv).
16. It is sometimes suggested that the cupola symbolizes the *aṇḍa* or cosmic egg containing all elements and from which all worlds were created by Vishnu and Brahma at the beginning of time. See Paul Mus, *Barabuḍur*, I (Paris, 1935), 109.

CHAPTER 15

216. 1. Coomaraswamy, *History*, 90, n. 5.
221. 2. Coomaraswamy, *History*, 6, n. 1.
223. 3. The absence of a śikhara and the rugged and simple 'cave-like' appearance almost suggest a derivation from a cave prototype, such as the vihāra at Ajaṇṭā.
224. 4. It is perhaps possible to assume that the eight surrounding squares were dedicated to the Regents of the Eight Directions of Space, like planets grouped around the central axis of Śiva. The whole immensely complicated subject of these magic temple plans, of which there are literally hundreds of variants, has been magisterially treated by Stella Kramrisch in her book, *The Hindu Temple* (Calcutta, 1946).
230. 5. Beal, I, 145.

237. 6. In the life of Hsüan-tsang (Beal, I, XX) we read how this famous Chinese traveller brought back to China from India a small collection of images, some originals, some copies of famous Indian cult images. His collection included examples in gold, silver, and sandalwood. This passage is often cited as one of the means whereby styles of Indian art were introduced to the Far East. See also B. Rowland, 'Indian Images in Chinese Sculpture', *Artibus Asiae*, X, I (1947), 5–20. Note particularly the 'copies' of Gandhāra statues found in China.

238. 7. The method of indicating drapery folds by lines incised in the surface is frequently found in stucco images in Gandhāra; it is natural that this method would have been used in preparing the equally malleable wax mould for the metal statuette.

239. 8. Another metal image of a somewhat different type is in the Museum of Fine Arts, Boston. This is said to have been found in Burma, but was almost certainly made in India. It is not difficult to see how closely this figure repeats the formula of the stone sculpture at Sārnāth in such particulars as the smooth, rather attenuated proportion and limbs sheathed in a robe that completely reveals the body beneath. With the figure from Sultāngañj, which it resembles in its general form, this statuette must be assigned to the high point of Gupta sculpture in the fifth century. See Coomaraswamy, *History*, figure 159.

240. 9. S. Kramrisch, *Indian Sculpture* (Calcutta, 1933), 171.

10. *Vishnudharmottaram*, part III, chapter 43.

242. 11. The term *cetana* (movement of life) seems to imply the necessity for endowing living things with a feeling of vitalized existence with attention to their specific growth and articulaion that is to be understood by the first of Hsieh Ho's Six Principles of Painting (see S. Sakanishi, *The Spirit of the Brush*, Wisdom of the East Series (London, 1929), 47 ff.).

12. A. K. Coomaraswamy, 'The Painter's Art in Ancient India', *Journal of the Indian Society of Oriental Art* (1933), 28.

243. 13. This appearance of the talented amateur is paralleled in China in the T'ang Period. In the Far East the work of the non-professional 'gentleman painter' comes to be preferred over the 'uninspired' traditional products of the professional artist.

14. A. K. Coomaraswamy, *History*, 90–1.

244. 15. This method has its exact equivalent in the church art of the Middle Ages in Europe: the twelfth-century aesthetician Witelo remarked that almond eyes were preferable to the actual shape of any human eye for representations of the Virgin and saints.

16. It was this effect of relief in painting that never failed to surprise and confound the Chinese, when this manner was introduced in the Six Dynasties

Period (A.D. 220–589). See the many quotations on the Liang Period painter, Chang Sêng-yu, in T. Naitō, *The Wall-Paintings of Hōryūji*, 199 ff.

17. A. K. Coomaraswamy, *History*, 90.

250. 18. As an indication of the essential unity of the arts in Gupta India, it may be mentioned that the same compositions of fantastic animals and floral forms as seen in these ceiling-paintings may be found in the sculptured decoration of Cave XIX.

251. 19. For the Bādāmī paintings, see Rowland and Coomaraswamy, plate 23, and S. Kramrisch, 'Paintings at Bādāmī', *Journal of the Indian Society of Oriental Art*, IV, I (June 1936), 57. The Sittanavāsal decorations are discussed in *A.B.I.A.*, 1930, 9. Coloured reproductions of details of the Bāgh paintings are to be found in Rowland and Coomaraswamy, plates 21–2.

252. 20. M. Chandra, 'Ancient Indian Ivories', *Bulletin of the Prince of Wales Museum*, Bombay, No. 6, 1957–9.

253. 21. Sir J. Irwin, 'Textiles', in *The Art of India and Pakistan*, Sir L. Ashton, ed. (London, 1950), 201 ff.

254. 22. A. S. Altekar, *The Gupta Gold Coins in the Bayana Hoard* (Bombay, 1954), 296, plate xxxvii.

CHAPTER 16

255. 1. Tāranātha, a seventeenth-century Tibetan historian of Buddhism, speaks of an 'Eastern school' of Buddhist art under the Pāla Dynasty, which, he states, included two famous artists, Dhiman and Bitpalo, painters and sculptors, active in the ninth century (see Vincent Smith, *History of Fine Art in India and Ceylon* (Oxford, 1911), 304–7).

2. S. Beal, *The Life of Hiuen-tsiang* (London, 1911), 111–12.

256. 3. S. Beal, *Buddhist Records*, II, 173–4. This is only one of a number of mentions by Hsüan-tsang of copies of the great temple at Bodh Gayā; another similar tower was described by the Master of the Law at Sārnāth (*idem*, 47–8).

259. 4. See above, p. 180.

262. 5. See A. J. Bernet Kempers, *The Bronzes of Nālandā and Hindu-Javanese Art* (Leiden, 1933).

264. 6. Imbedded in the foundations of the Nepalese stupas was a square stone chamber divided, like the maṇḍala of Hindu temple plans, into nine compartments in the centre of which was fixed the wooden mast. In Nepal this axial member is known as the lingam, a clear indication of the Hindu character of late esoteric Buddhism.

7. Presumably all the chaityas in Nepal were dedicated to Ādi-Buddha, the Creator and Preserver, and the five mystic Buddhas of his creation.

266. 8. These manuscripts are discussed and illustrated

by A. Foucher in *L'Iconographie bouddhique de l'Inde* (Paris, 1900).

Researches conducted by Dr Stella Kramrisch in the preparation of an exhibition of Nepalese art in Asia House in New York in 1964 have produced the first systematic chronological ordering of the sculpture of this remote Himalayan kingdom. As early as the fifth century Nepalese stone sculpture was a provincial echo of Indian art of the pre-Gupta period. Indigenous Nepalese traits reveal themselves in the strangely cruel expression of the faces and in the beauty of surface and detail. Later, both in metal and stone, Nepalese craftsmen imported and modified the styles of Hindu reliefs of the seventh century and for centuries perpetuated the canons of the Pāla art of Bengal (see Stella Kramrisch, *The Art of Nepal*, The Asia Society, Inc., New York, 1964).

268. 9. For an illustration, see G. Tucci, *Indo-Tibetica*, IV, iii (Rome, 1941), figures 119–20.

10. The Tibetan Buddhists set great store by the rite of circumambulation, which is believed to store up merit for the future, rather in the manner of the granting of Indulgences from Purgatory. It appears that the separate tiers were identified with Buddhist virtues so that the ascending *pradakṣiṇā* provided the pilgrim with a kind of vicarious exposure to the chief spiritual powers of the Buddha.

269. 11. These same subjects are to be seen in examples of wall-paintings in Tibetan lamaseries. For illustrations, see the plates in G. Tucci's *Indo-Tibetica*, Rome, 1932–41.

270. 12. See above, p. 25.

13. D. R. Sahni, *Catalogue of the Museum of Archaeology at Sarnath* (Calcutta, 1914), plate xix.

271. 14. *Catalogue of the Tibetan Collection . . . in the Newark Museum* (Newark, N.J., 1950), 30 ff.

15. S. Kramrisch, 'Pāla and Sena Sculpture', *Rūpam*, Oct. 1929, figure 21.

16. Kramrisch, figure 43.

CHAPTER 17

274. 1. P. K. Acharya, *Mānāsara on Architecture and Sculpture* (London, 1933–4).

2. N. K. Bose, *Canons of Orissan Architecture* (Calcutta, 1932).

3. Stella Kramrisch, *The Hindu Temple* (Calcutta, 1946).

275. 4. For a complete account of the systems of proportion in Hindu architecture, see *ibid.*, 207 ff.

5. *Ibid.*, 208.

6. One of the classical definitions of the *nagara* type of temple specifies that these shrines are likenesses of the chariots Brahma created for the gods to carry them on their heavenly ways. As the gods are

accommodated in heaven, so are they accommodated on earth.

276. 7. 'The temple resembling a mountain shines white' (quoted by Stella Kramrisch, *The Hindu Temple*, 123, n. 78).

277. 8. H. Cousens, *Chalukya Architecture* (Calcutta, 1926), 61.

280. 9. The view illustrated is taken from the porch roof and shows the opening to an upper shrine that was a feature of many Jain sanctuaries.

282. 10. The temple is sometimes referred to as the 'Black Pagoda', a title given the monument by the skippers of the Indiamen who used it as a landmark in steering for Calcutta.

285. 11. Cf. the panel from Stupa No. 2 at Sāñchī (illustration 33) and the doorway of the Gupta temple at Deogaṛh (illustration 163).

12. 'A man embraced by a beloved woman knows nothing more of a within or without.' (*Brihadāranyaka Upanishad*, IV. 3. 21.) M. R. Anand, *Kāma Kāla*, Geneva, 1958.

13. The practice of sexual intercourse with a śakti is permitted certain classes of adepts in yoga. It has been suggested that an esoteric Magian phase of sun worship, perhaps originating in the famous temple at Multan, was followed at Koṇāraka.

290. 14. Kramrisch, *The Hindu Temple*, 370.

292. 15. See *A.S.I.A.R.*, 1908–9, plate xli.

16. *Idem*, plate xl(b).

294. 17. Some idea of their original appearance may be gathered from the maṇḍapa of the Sās-Bahu temple at Gwalior.

296. 18. Percy Brown, *Indian Architecture (Buddhist and Hindu)* (Bombay, 1942), 149.

19. Coomaraswamy, *History*, 112.

299. 20. The term *rath* means a chariot or a processional car used to transport the idols of the Hindu gods on festal days. Its use to designate a type of temple probably stems from the concept that the sanctuary was a reproduction of the celestial chariots of the deities.

21. The famous Lohapāsāda at Anurādhapura in Ceylon was a structure of nine storeys, in which the accommodation of the priesthood was arranged on an hieratic basis, so that the highest storeys were reserved for arhats or great sages, and the lower for novices and those who had acquired higher grades of sanctity.

301. 22. In the usual metaphorical way, the shape of the leaf of the pipal tree comes to replace the ovoid contour of the face in earlier periods.

302. 23. H. Zimmer, *Myths and Symbols in Indian Art and Civilization* (New York, n.d.), 119.

304. 24. This group is a perfect illustration of the words of the American sculptor, John Flannagan: 'To that instrument of the subconscious, the hand of the

sculptor, there exists an image within every rock. The creative act of realization merely frees it.'

25. Durgā is another manifestation of Devī or Pārvatī, the *śakti* or wife of Śiva. Like Śiva himself, 'The Devī is the Absolute in action, manifestation, and variety; Nature in all her multiplicity, violence, and charm, dispersing impartially birth and death, illusion and enlightenment.' (A. K. Coomaraswamy, *Museum of Fine Arts Bulletin* (Boston, April 1927), 23–4.)

306. 26. As noted above (p. 277), there is evidence that the Virūpāksha temple at Paṭṭadakal was a 'copy' of this temple at Kāñcīpuram.

307. 27. It should be stated that the Kailāsa temple is only the most grandiose and impressive of a whole series of rock-cut temples and cave sanctuaries, Hindu, Buddhist, and Jain, that were carved at Ellūrā over a period of many centuries. The reader is referred to Percy Brown's *Indian Architecture (Buddhist and Hindu)*, 86 ff.

310. 28. Kramrisch, *Indian Sculpture*, 88.

314. 29. Zimmer, 199.

317. 30. See below, p. 330.

319. 31. R. Sewell, *The Story of a Forgotten Empire* (London, 1904), 240–1. Presumably for Domingo Paes, the word 'Romanesque' meant work he had seen in Rome . . . either Baroque or Antique . . . and not the modern use of the term to designate the art of the pre-Gothic period in western Europe.

32. Percy Brown, 113.

CHAPTER 18

327. 1. These holy men recommended a personal faith based on devotion, rather than on ritual and formula, a doctrine that lent an air of catholicity to the Saivite faith, and invited to its creed all classes of persons without distinction of caste.

2. A wax model was prepared and over this was fashioned a clay mould. When this mould had hardened, the wax was melted out and the amalgam poured into the clay mould. When the metal had cooled, the mould was broken and the image was given its final chasing and burnishing.

330. 3. Winifred Lamb, *Greek and Roman Bronzes* (London, 1929), plate lxxvii(a).

4. The legend or story of the Dance of Śiva has little to do with the metaphysical meaning of these images. The tale relates to Śiva's dispute with a group of heretical *rishis* who endeavoured to destroy the Lord by their incantations and magical devices. They first loosed against him a tiger which he caught and flayed with the nail of his little finger. A monstrous serpent of their production was placed around his throat as a garland. A final monstrosity in the form of a dwarf

rushed upon the god as he began the measure of his dance. This emblem of evil Śiva crushed beneath his foot and proceeded with his dance, the performance of which converted the heretics.

5. A. K. Coomaraswamy, *Bronzes from Ceylon, Chiefly in the Colombo Museum* (Colombo, 1914), 10.

6. The attributes of the Naṭarāja include the drum in the upper right hand, which in its vibration symbolizes the god's creative activity. The fire on the left hand both destroys and cleanses the impurity of the soul. The lower right hand is in the gesture of reassurance, and the lower left points to the god's foot as the place of refuge and salvation for the worshipper. The dwarf is Illusion and the sense of the Ego which the devotee must overcome. The flaming halo represents the informing energy in all matter.

333. 7. C. Sivaramamurti, *South Indian Bronzes* (New Delhi, 1963), 114.

8. H. Zimmer, *The Art of Indian Asia*, II (New York, 1960), plate 241.

334. 9. M. R. Anand, *Kama Kala* (Geneva, 1958); J. Auboyer and E. Zannas, *Khajurāho* ('S-Gravenhage, 1960).

335. 10. R. Pfister, *Les toiles imprimées de Fostat et l'Hindoustan* (Paris, 1938).

11. A. K. Coomaraswamy, *History*, figure 185.

12. Pfister, plate 1a, and our illustration 275.

336. 13. John Irwin, 'The Commercial Embroidery of Gujarat in the Seventeenth Century', *J.I.S.O.A.*, XVII, 1949, 51 ff.

14. John Irwin, 'Golconda Cotton Paintings of the Early Seventeenth Century', *Lalit Kala*, 5 April 1959, plate xx. Our illustration 269 is an Āndhra textile from the Kalahasti region.

15. See the earlier hardback editions of this work, plate 134A.

CHAPTER 19

342. 1. The Ellūrā frescoes are in many ways so different from the cycles at Ajaṇṭā and Bāgh that they may be the earliest known specimens of what Tāranātha described as the 'Western school'. See above, p. 480, n. 1.

2. Karl Khandalavale, *Indian Sculpture and Painting* (Bombay, n.d.), plate viii.

343. 3. Douglas Barrett and Basil Gray, *Painting of India* (Geneva, 1936), 42.

4. See A. Foucher, *Étude sur l'iconographie bouddhique de l'Inde* (Paris, 1900).

344. 5. The essential qualities of Mogul and Rājput painting are well summarized by J. V. S. Wilkinson in *Indian Art*, ed. Winstedt, 140–1.

6. A. K. Coomaraswamy, *Rājput Painting* (Oxford, 1916), 4.

7. Sherman Lee, *Rajput Painting* (The Asia Society, Inc., New York, n.d.), 3.

348. 8. B. Rowland, *Art in East and West* (Cambridge, Mass., 1954), figure 12, and plate 134A in the earlier hardback editions of the present volume.

350. 9. W. G. Archer, *Indian Painting in Bundi and Kotah* (Victoria and Albert Museum, London, 1959), 50.

354. 10. W. G. Archer, *Garwhal Painting* (London, n.d.), 12.

CHAPTER 20

359. 1. See above, p. 212.

360. 2. The word dāgaba is a combination of the Sanskrit words *dhātu* (relics) and *garbha* (womb, chamber, or receptacle). The implication is that the relics, planted like a quickening seed in the womb of the structure, exert an eternal animating influence on this seemingly dead mass of masonry, generating and perpetuating for all time and all men the spiritual power of the Buddha.

3. A. B. Govinda, 'Some Aspects of Stupa Symbolism', *Journal of the Indian Society of Oriental Art*, II, 2 (Dec. 1934), 99–100. There is some question as to whether this division is based on a relatively modern system, only part reflecting the canon employed for the oldest dāgabas.

4. *Ibid.*, 101.

361. 5. See S. Paranavitana, 'The Stupa in Ceylon', *Memoirs of the Archaeological Survey of Ceylon*, V (1047), 81 ff.

6. See Percy Brown, plate vi, 7.

362. 7. The largest of all, the Jetavana dāgaba, is approximately three hundred and seventy feet in diameter. It has been conjectured that the number of bricks in the fabric of a single one of the larger Singhalese dāgabas would be sufficient to construct a town the size of Coventry or to build a wall ten feet high from London to Edinburgh.

8. *The Mahāvaṁsa*, trans, by Wilhelm Geiger, Oxford, The Pali Text Society, 1912, 203. For illustrations of actual metal objects, including a gold-leaf lotus reliquary, found at the Ruvanveli dāgaba, see *Illustrated London News*, 11 Jan. 1947, 52–3.

9. See above, p. 208.

10. Single octagonal columns, similar to the Āndhra pillars, have been found in the ruins of some early Singhalese stupas. It is conjectured that these *yūpas*, descended from Vedic sacrificial posts, were set within the masonry of the dome as magic replicas of the Axis or Tree of the Universe.

363. 11. This world is derived from the Sanskrit vihāra, a monastery, and is applied indiscriminately by association to all the various religious edifices in the stupa precinct.

12. *Mahāvaṁsa*, Geiger, trans., 184–5. 'The pāsāda was four-sided, on each side a hundred cubits, and even so much in height. In this most beautiful of palaces there were nine storeys Surrounded by a beautiful enclosure and provided with four gateways the pāsāda gleamed in its magnificence like the hall of the thirty-three (gods). The pāsāda was covered over with plates of copper, and thence came its name "Brazen Palace".'

13. Hsüan-tsang (Beal, II, 247) mentions a Mahāyānist community at Anurādhapura at the time of his visit in the seventh century. For an illustration *see* Paranavitana, plate xx(a).

14. These statues have been 'restored' with such execrable taste and insensitivity that it is necessary to study them in old photographs to get an idea of their original qualities.

364. 15. Another metal image of the same type has been found in East Java. See *Choix de Sculptures des Indes* (The Hague, 1923), plate X. A stone Buddha statue actually imported from Amarāvatī has recently come to light in Ceylon.

16. For these references to relations between Ceylon and China, see A. C. Soper, 'Literary Evidence for Early Buddhist Art in China', *Oriental Art*, Summer, 1949, 3 ff. See also L. Bachhofer, 'Die Anfänge der buddhistischen Plastik in China', *Ostasiatische Zeitschrift*, New Series 10, 1/2 (1934), 36.

17. All that remains of early South Chinese sculpture is a few rather crude gilt bronze images of the fifth century that have only a remote resemblance to Indian prototypes. See O. Sirén, *History of Chinese Sculpture*, II (London, 1925), plate 15.

18. Its resemblance to Pallava sculpture suggests a date as late as the eighth century. Cf. H. Zimmer, *The Art of Indian Asia*, plates 281, 283, 289.

366. 19. A. K. Coomaraswamy, *Medieval Singhalese Art* (Broad Campden, 1908), 152 ff.

370. 20. In the course of excavations around the early stupas in Ceylon there have been found buried at the cardinal points small bronze figures of the same directional animals, leading us to the inevitable conclusion that the same geomantic magic implicit in the laying out of the Indian stupa was scrupulously followed in Ceylon. Sometimes the animal statuettes, together with the relics, were deposited in a nine-compartmented receptacle or *yantragara* beneath the foundation stone of the monument. (See *Archaeological Survey of Ceylon*, XII (1896), 16 and plates xii–xxv). Many passages in the *Mahāvaṁsa* confirm the semi-magical nature of these Buddhist relic mounds and the hypothesis that they were literally reconstructions of the cosmos in architecture. For some

Singhalese scholars the moon stone is not so much a cosmic symbol as an emblem of Time and the World, a reminder also of the miseries and dangers of the world which the devotee steps over on his way to the Truth enshrined in the sanctuary. Cf. S. Parana-vitana, 'The Significance of Sinhalese Moonstones', *Artibus Asiae*, XVII (1954), 197 ff.

21. S. Paranavitana, 'The Sculpture of Man and Horse near Tisāvāva at Anurādhapura', *Artibus Asiae*, XVI, 3 (1953), 167 ff.

372. 22. These formulas of drawing reappear in the (lost) eighth-century wall-paintings of Hōryūji at Nara (Japan). *See* Naitō, *Hōryūji*, plates 50–3.

375. 23. Paranavitana, plate xxi.

24. This shrine (the Dala-da-ge) was built under Parākrama Bāhu I. Hāta-da-ge (House of sixty relics) and Ata-da-ge (House of eight relics) are modern misnomers.

376. 25. A continuous haṁsa frieze may be seen on the basement of the Rājrājeśvara temple at Tanjore and so may the inscription used as rustication.

26. *Culavaṁsa*, II, trans. Geiger, 39 ff.

378. 27. The presence of these four statues need not be taken as an indication that this was a Mahāyāna temple and the Buddhas representations of the Dhyāni Tathāgatas: even in Hinayāna Buddhism the association of various events of the Buddha's life with the points of the compass would explain the duplication of images of Śākyamuni himself at the four directions.

379. 28. The décor is strikingly suggestive of the exterior ornamentation of such monuments as the Rājrājeśvara temple at Tanjore.

380. 29. Coomaraswamy, *History*, 167.

30. The exterior decoration of the Thūpārāma at Poḷonnāruwa shows a similar importation of Chola motifs, used here to decorate a Buddhist shrine. Coomaraswamy, *History*, figure 303.

383. 31. A. K. Coomaraswamy, *Arts and Crafts of India and Ceylon* (New York, 1964).

32. *Op. cit.*, figures 120–9.

CHAPTER 21

385. 1. The Dominican father, Gabriel Quiroga de San Antonio, who was engaged in preparing for a Spanish conquest of Cambodia, published an account of the ruins in 1604.

2. Most likely this tale is of Indian origin, where a similar legend is attributed to the founder of the Pallava Dynasty. At all events, a cult of nāgas appears to have been native to Cambodia before the intrusion of Indian influences. It survived into the great days of the Khmer civilization at Angkor when, it is related by the Chinese historian, Chou Ta-kuan, the king

slept every night with a nāginī, in a kind of magic renewal of the power of kingship.

3. Thus for instance Han settlements have been found in Annam, and, testifying to trade relations with the Roman world as well, a Roman lamp at P'ong-tuk. See *Annual Bibliography of Indian Archaeology*, 1927 (Leyden, 1929), plate viii. See also the finds of Indian Classical and Sasanian objects at Oc-Èo in Cochin China (*Annual Bibliography of Indian Archaeology*, 1940–7 (Leyden, 1950), li and plate vii.)

4. These images could be described as 'portrait statues' of the kings as Śiva, Vishnu, Harihara, etc.

387. 5. A stone temple in the shape of a pyramidal tower surmounted by a kalasa finial has been found at Aśrām Mahā Rosěi. Its elevation is vaguely reminiscent of such Pallava monuments as the Shore Temple at Māmallapuram. See *Annual Bibliography of Indian Archaeology*, 1935 (Leyden, 1937), plate xi.

390. 6. Harihara is a combination of Śiva and Vishnu, a synthesis indicated in this statue by the differentiation of the two halves of the head-dress. The present image was found in a vesara temple of the type seen at Bayang.

7. Coomaraswamy, *History*, 183.

8. As may be seen in other examples preserved in the Musée Albert Sarraut at Phnom Penh, it appears likely that both the Harihara and the Stoclet statue were originally enclosed in a horse-shoe shaped frame, which was at once a nimbus and a technical precaution to prevent the breaking off of the arms of the deity and to ensure its stability.

392. 9. Related to Chen-la is the modern word, Cambodia, which stems from Kambuja, 'born of Kambu', the founder of the dynasty that originally reigned in the northern portions of present-day Indo-China. It was, in other words, the Kambujas or Khmers who overran Funan and gave their name to the country.

10. H. Parmentier, 'The History of Khmer Architecture', *Eastern Art*, III (1931), 147 ff.

393. 11. The pyramidal terraced form of structures like Baksei Chamkrong was intended as an architectural replica of the supposed shape of the world mountain Meru. The installation in the centre of the capital of such a facsimile of the mountain at the centre of the world was designed magically to transfer the navel of the world to the Khmer capital and to ensure the dominance over all the Empire.

12. This concept was introduced by Jayavarman II (802–53), who came from Java. An inscription of 802 reads in part, 'The Brahman Hiranyadama having carefully extracted the essence of the śāstras, with full knowledge and experience of the mysteries, established for the increase of the prosperity of the world the magic rites of the Devarāja. This Brahman,

learned in magic lore, came from Janapada because H. M. Parameśvara invited him to perform a ritual to insure Cambodia's independence from Java and to the end that there might be in this land a Cakravartin.'

13. See the excellent summary of this problem by Gilberte de Coral Rémusat in her splendid book, *L'Art Khmer, Les Grandes Étapes de son Evolution* (Paris, 1940), 27–33.

14. It is sometimes suggested that the building known as the Baphuon within the present walls of Angkor was the centre of a capital in the tenth and eleventh centuries.

395. 15. Chou Ta-kuan, describing this structure, writes, 'In the palace there is a golden tower, on the top of which the king sleeps. In the tower there is the spirit of a nine-headed serpent, master of the earth and of the whole kingdom. It appears every night in the form of a woman with whom the king must sleep. If the king fails to be there on a single night some misfortune takes place.'

399. 16. Angkor is a corruption of the Sanskrit *nagara*, 'city'; Wāt is Siamese for any Buddhist building. The name may be translated, then, as 'city temple', or – better – 'Temple of the Capital'.

402. 17. Percy Brown, 220.

18. For an admirably detailed treatment of all the architectural features of the Khmer style, see H. Marchal, *L'Architecture Comparée dans l'Inde et l'Extrême-Orient* (Paris, 1944).

403. 19. There is evidence at Angkor Wāt and in many other Khmer buildings of a practice of introducing wooden beams into the masonry for purposes of further reinforcement. Obviously the disintegration of these has wrought havoc on the stability of the structures. Occasionally one finds attempts to 'dovetail' adjacent blocks of stone in imitation of a method suitable only for building in wood.

20. Gilberte de Coral Rémusat, plate xxiv, 87–8.

406. 21. The temple is built on an earlier foundation of A.D. 969, which used to be accepted as the date of the complex as it now stands. The site of Bantéai Srei is about twenty-five kilometres north-east of Angkor Thom.

22. It is interesting to note in relation to the concept of the temple-mountain that the Kailāsa in this relief is in the shape of a stepped pyramid.

411. 23. P. Pelliot, 'Mémoires sur les Coutumes du Cambodge', *Bulletin de l'École Française d'Extrême-Orient*, II (1902), 141 ff. Pierre Loti has left us an account of his visit (1901) to Angkor Thom: 'To reach the Bayon, you have to cut your way with a stick through a jumble of brambles and trailing creepers. On all sides, the forest hems it in narrowly, smothers and crushes it; huge fig-trees, completing the destruction, have gained a foothold everywhere, right up to the top of the towers that serve as its pedestal. You come to the gates: like so many ancient locks of hair, countless roots drape them with a thousand fringes. At this rather late hour, in the darkness shed by the trees and the cloudy sky, they are like big shadowy holes that give you pause. By the nearest entrance, a troop of monkeys gathered there for shelter and who had been squatting in a circle, as though holding a council, scamper off in a leisurely fashion and without their usual chattering: it is as though, in a place like this, the silence must not be broken.'

24. Before the discovery of the central Buddha image in a well under the main tower, it used to be thought that these faces were representations of Śiva. Lokeśvara is an esoteric form of Avalokiteśvara, who himself creates or radiates the five Dhyāni Buddhas from his person.

415. 25. With the exception of the human or Buddha head, these are the same creatures found on the Sārnāth column and on the moon stones of Ceylon.

418. 26. *See* G. Groslier, 'Les Collections Khmères du Musée Albert Sarraut', *Ars Asiatica*, XVI (Paris, 1931).

420. 27. The present work omits any consideration of Cham art. This culture, located in the region of modern Annam, flourished for nearly 1000 years until the ninth century A.D. The architecture and sculpture are a provincial reflection of Cambodian forms with some borrowings from Chinese sources. The brick tower sanctuaries of Mi-son are a prolongation of the isolated *śikharas* of pre-Khmer times. The sculpture, although cast in Indian and Cambodian mould, is characterized by a floridity and barbaric vigour of decoration, such as often distinguishes the best in folk art. Readers especially interested in this subject should turn to Philippe Stern, *L'Art du Champa*, Toulouse, 1942; Henri Parmentier, *Les Monuments Cams de l'Annam*, Paris, 1909; Parmentier, 'Les Sculptures Chames au Musée de Tourane', *Ars Asiatica*, IV, Paris, 1922.

28. H. Th. Bossert, ed., *Geschichte des Kunstgewerbes* (Berlin, 1930), 309–10.

29. S. E. Thiounn, 'L'épée sacrée du Cambodge', *Arts et Archéologie Khmers*, 1921–3, 59 ff.

30. T. Bowie, ed., *The Arts of Thailand* (Bloomington, Indiana, 1960), figures 133–6.

CHAPTER 22

423. 1. Possibly the statue in the Seattle Art Museum, discussed under pre-Khmer sculpture, is a Dvāravatī image (illustration 319).

427. 2. The conical ushnisha is by no means an infallible means of identification, since in Cambodia, as well as Siam, such terraced top-knots were special emblems of Lokeśvara.

431. 3. H. G. Quaritch Wales, *Towards Angkor* (London, 1937), 100.

433. 4. The Lamp'un temple might be described as a return to the Dravidian form of prāsāda, like the Dharmarāja rath at Māmallapuram, in which the terraced pyramid itself is the shrine and not merely its base.

5. In accordance with the same principle, the Buddhist cave temples at Lung Mên in China were oriented to overlook the capital of Loyang, just as the Vulture Peak, sacred to Buddha's preaching the Lotus sūtra, overlooked ancient Rājagriha.

434. 6. It should be noted that even late Siamese architecture is, like all the religious architecture of the East, based on the principle of pratibimba - the reflexion of the image of the great world in man-made buildings. Even in the nineteenth century, the German architect-scholar Döhring tells us, King Chulalongkorn was so unwilling to depart from the traditions governing the laying out of buildings that the whole orientation of the palace being built for him had to be altered, although the foundations were already laid.

Palaces, as well as temples and stupas, were geomantically laid out according to the concept of the four directions around the world mountain Meru. These ideas spring as much from Brahmanic as Buddhist influences. The Meru idea of course is original to Brahmanism; Siamese Buddhism – like Cambodian Buddhism – has at various times in its history been tinged with Brahmanic ideas.

435. 7. Coomaraswamy, *History*, 178.

436. 8. Bowie, No. 138, figure 114.

9. Bowie, No. 149, figure 133.

10. Bowie, No. 186, figure 70.

CHAPTER 23

439. 1. The earliest examples of Buddhist art found in Burma are a number of metal objects, including a silver relic casket discovered in a stupa at Prome. They are almost certainly importations from India proper and are dated in the sixth century A.D. (*Annual Bibliography of Indian Archaeology*, 1928 (Leyden, 1930), plate x.) A number of unpublished stupas from this period also exist at Prome.

2. Coomaraswamy, *History*, figure 305. There are other early Hindu temples at Pagān, such as the Nanpaya, dedicated to Brahma.

3. Coomaraswamy, *History*, figure 306.

440. 4. The Burmese copy of the Mahābodhi temple is valuable in showing the appearance of the original in the thirteenth century. This replica agrees with the various small models of the shrine at Gayā in showing the main tower surrounded by smaller duplications of its shape at the four corners. The vaults and arches used in the interior of the Mahābodhi temple at Pagān and other Burmese sanctuaries of the Classic Period correspond so closely to the fragments of this type of construction existing at Bodh Gayā before the nineteenth-century restoration that it seems possible to believe that the vaulted construction of the original Mahābodhi temple was introduced into the fabric by the Burmese craftsmen who went to repair the shrine in the fourteenth century. In this method of vaulting the voussoirs of the arch are composed of courses of bricks mortared one on top of the other. These bricks, it should be emphasized, are not laid face to face, but edge to edge. The method is particularly well illustrated by photographs of ruined structures at Pagān, published by Henri Marchal, plate xv.

441. 5. It has been suggested that the name of the temple – Ānanda is a corruption of the name, Nandamula, or that the name derives from the Ananta cave at Udayagiri in Orissā. (See Charles Duroiselle, 'The Stone Sculpture in the Ānanda Temple at Pagān,' *A.S.I.A.R.* (1913–14), 66.)

442. 6. For illustrations, see *A.S.I.A.R.* (1912–13), plate lvi.

7. Coomaraswamy, *History*, 172, figures 311 and 312.

443. 8. A useful account of these and other native crafts appears in Coomaraswamy, *History*, 174.

CHAPTER 24

451. 1. Paul Mus, *Barabuḍur* (Hanoi, 1935).

453. 2. This extension of the processional path to more than one level as well as the indented ground plan of Barabuḍur is perhaps ultimately derived from the temple at Paharpur in Bengal. See above, p. 257.

455. 3. The panel in illustration 387 is also of interest in showing a detailed view of a Javanese ship under full sail.

458. 4. Devaprasad Ghose, 'Relation between the Buddha images of Orissā and Java', *Modern Review*, LIV, 500. For the recent excavations of another Orissan Buddhist foundation with statuary related to the Barabuḍur style, see William Willetts, 'An Eighth Century Buddhist monastic foundation (Ratnagiri)', *Oriental Art*, IX, 1 (1963), 15.

460. 5. See above, p. 410.

6. See B. R. Chatterjee, 'India and Java', *Greater India Society Bulletin*, 3 (Calcutta, 1933), 78.

464. 7. Generally speaking, it is this last phase of East Javanese art that is perpetuated in the architecture, painting, and sculpture of the mixed Hindu and Buddhist culture of the island of Bali.

465. 8. F. A. Wagner, *Indonesia, The Art of an Island Group* (New York, 1959), 119–62.

BIBLIOGRAPHY

PERIODICALS

GENERAL

Archives (Chinese Art Society of America)
Ars Asiatica
Ars Orientalis
Artibus Asiae
Bulletin de l'École Française d'Extrême Orient
(B.E.F.E.O.)
East and West (Istituto per il studio del Medio ed Estremo Oriente, Rome)
Journal of the Royal Asiatic Society (J.R.A.S.)
Oriental Art
Revue des Arts Asiatiques

INDIA

Ancient India
Annual Bibliography of Indian Archaeology
Archaeological Survey of India, Annual Reports
(A.S.I.A.R.)
Archaeological Survey of India, Memoirs
(A.S.I., Mem.)
Bulletin, Museum and Picture Gallery, Baroda
Bulletin of the Prince of Wales Museum of Western India, Bombay
Indian Antiquary
Indian Archaeology
Indian Historical Quarterly
Journal of Indian History
Journal of the Asiatic Society of Bengal (J.A.S.B.)
Journal of the Indian Society of Oriental Art
(J.I.S.O.A.)
Lalit Kalā
Mārg

OTHER

Ancient Pakistan
Archaeological Survey of Ceylon, Annual Reports
(A.S.C., A.R.)
Archaeological Survey of Ceylon, Memoirs
(A.S.C., Mem.)
Bangladesh Lalit Kalā
Pakistan Archaeology

INDIA

GENERAL WORKS

AGRAWALA, V. S. *Indian Art.* Varanasi, 1965.
ASHTON, L., ed. *The Art of India and Pakistan, Catalogue of the Exhibition of the Royal Academy of Arts, London, 1947-8,* London, n.d.
AUBOYER, J. *Introduction à l'étude de l'art de l'Inde.* Rome, 1965.
BARRETT, D., and GRAY, B. *Painting of India.* Lausanne, 1963.
BROWN, P. *History of Indian Architecture (Buddhist and Hindu).* Bombay, n.d.
BUSSAGLI, M., and SIVARAMAMURTI, C. *5000 Years of the Art of India.* New York, n.d.
CHANDRA, M. *Stone Sculpture in the Prince of Wales Museum of Western India.* Bombay, 1974.
CODRINGTON, K. de B. *Ancient India.* London, 1926.
COMBAZ, G. *L'Évolution du Stupa en Asie.* Louvain, 1933-7.
COOMARASWAMY, A. K. *Arts and Crafts of India and Ceylon.* London, 1913.
COOMARASWAMY, A. K. *Bibliographies of Indian Art.* Boston, 1925.
COOMARASWAMY, A. K. *Catalogue of the Indian Collections in the Museum of Fine Arts, Boston.* 5 vols. Boston, 1923-4.
COOMARASWAMY, A. K. *The Dance of Śiva.* New York, 1918.
COOMARASWAMY, A. K. *History of Indian and Indonesian Art.* New York, 1927.
COOMARASWAMY, A. K. *Viśvakarma.* London, 1914.
DENECK, M. M. *Indian Sculpture.* London, 1962.
DEVA, K., SHARMA, Y. D., SRINIVASAN, K. R., and SARKAR, H. *Archaeological Remains, Monuments and Museums.* 2 vols. Archaeological Survey of India, 1964.
FERGUSSON, J. *History of Indian and Eastern Architecture.* London, 1876.
FISCHER, K. *Schöpfungen Indischer Kunst.* Cologne, 1959.
FISCHER, K. *Dächer, Decken und Gewölbe Indisches Kultstätten und Nutzbauten.* Wiesbaden, 1974.
FRANZ, H. G. *Buddhistische Kunst Indiens.* Leipzig, 1965.

FRÉDÉRIC, L. *L'Inde, Ses Temples, Ses Sculptures.* Paris, 1959.
GOETZ, H. *India (Art of the World).* New York, 1959.
GROUSSET, R. *Civilizations of the East, vol. 2: India.* New York, 1931.
GROUSSET, R. *De la Grèce à la Chine.* Monaco, 1948.
GROUSSET, R. *De l'Inde à l'Indo-Chine.* Monaco, 1950.
GUPTE, R. C., and MAHAJAN, B. D. *Ajanta, Ellora and Aurangabad.* Bombay, 1962.
HACKIN, J. *La Sculpture indienne et tibétaine au Musée Guimet.* Paris, 1931.
HÄRTEL, H., and AUBOYER, J. *Indien und Sudostasien (Propyläen Kunstgeschichte, XVI).* Berlin, 1971.
HAVELL, E. B. *Ideals of Indian Art.* London, 1911.
KRAMRISCH, S. *The Art of India through the Ages.* London and New York, 1954.
KRAMRISCH, S. *Drāviḍa and Kerala in the Art of Travancore.* 1953.
KRAMRISCH, S. *Indian Sculpture.* Calcutta, 1933.
LAL, B. B. *Indian Archaeology since Independence.* Delhi, 1964.
LEE, S. E. *A History of Far Eastern Art.* New York, 1964.
MITRA, D. *Buddhist Monuments.* Calcutta, 1971.
MUKERJEE, R. *The Culture and Art of India.* London, 1959.
PIGGOTT, S. *Some Ancient Cities of India.* Calcutta, 1945.
RAJAN, K. V. Soundara. *Indian Temple Styles.* New Delhi, 1972.
ROWLAND, B., and COOMARASWAMY, A. K. *The Wall-Paintings of India, Central Asia, and Ceylon.* Boston, 1938.
SANKALIA, H. D. *Archaeology of Gujerat.* Bombay, 1941.
SINGH, M. *Himalayan Art.* London, 1968.
SIVARAMAMURTI, C. *Naṭarāja in Art, Thought and Literature.* New Delhi, 1974.
SMITH, V. A. *Fine Art in India and Ceylon,* 2nd edition revised by K. de B. Codrington. Oxford, 1930.
SPINK, W. *Ajanta to Ellora.* Bombay, 1967.
VOLWAHSEN, A. *Indien, Bauten der Hindus, Buddhisten und Jains.* Munich, 1968.
ZIMMER, H. *The Art of Indian Asia.* New York, 1955.
ZIMMER, H. *Myths and Symbols in Indian Art and Civilization.* New York, 1946.

RELIGION, ICONOGRAPHY, CUSTOMS, ETC.

AUBOYER, J. *Le Trône et son symbolisme dans l'Inde ancienne.* Paris, 1949.
AUBOYER, J. *La Vie publique et privée dans l'Inde ancienne.* Paris, 1969.
BANERJEA, J. N. *The Development of Hindu Iconography.* Calcutta, 1941; completely revised, 1956.

BASU, B. D., ed. *Sacred Books of the Hindus* (translated by various authors).
BEAL, S. *Buddhist Records of the Western World. (Si-yü-ki).* London, n.d.
BEAL, S. *The Life of Hiuen-tsiang.* London, 1914.
BEAL, S. *The Travels of Fa Hian and Sung yün.* London, 1869.
BHANDARKAR, R. G. *Vaiśnavism, Śaivism, and Minor Religious Systems.* Strassburg, 1913.
BHATTACHARYA, N. B. *The Indian Buddhist Iconography.* London, 1924.
COOMARASWAMY, A. K. *Elements of Buddhist Iconography.* Cambridge, 1935.
COOMARASWAMY, A. K. *The Mirror of Gesture.* Cambridge, Mass., 1917.
COOMARASWAMY, A. K. *The Transformation of Nature in Art.* Cambridge, 1934.
COOMARASWAMY, A. K. *Yakṣas.* 2 vols. Washington, 1928-31.
GETTY, A. *The Gods of Northern Buddhism.* Oxford, 1928.
GLASENAPP, H. von. *Der Hinduismus.* Munich, 1922.
HACKIN, J. *Les Scènes figurées de la vie du Bouddha.* Paris, 1916.
HACKIN, J., and others. *Asiatic Mythology.* London, 1932.
HUMPHREYS, Christmas. *Buddhism.* Harmondsworth, 1951.
JAINI, J. *Outlines of Jainism.* Cambridge, 1916.
JOUVEAU-DUBREUIL, G. *Iconography of Southern India.* Paris, 1937.
LANNOY, R. *The Speaking Tree.* London, 1971.
MALLMANN, M.-T. DE. *Introduction à l'étude d'Avalokiteśvara.* Paris, 1948.
MALLMANN, M.-T. DE. *Les Enseignements iconographiques de L'Agni-purāṇa.* Paris, 1964.
MALLMANN, M.-T. DE. *Introduction à l'iconographie du Tantrisme Bouddhique.* Paris, 1975.
MUKHERJEE, B. N. *Nanā on Lion.* The Asiatic Society, 1969.
MULLER, M., ed. *The Sacred Books of the East.* 50 vols. (Translated by various authors).
RAO, T. A. G. *Elements of Hindu Iconography.* 4 vols. Madras, 1914-16.
RHYS-DAVIDS, T. W. *Buddhism.* London, 1920.
SECKEL, D. *Kunst des Buddhismus (Kunst der Welt).* Baden-Baden, 1962.
VASU, S. C. *Daily Practice of the Hindus.* Sacred Books of the Hindus, vol XX.
VIENNOT, O. *Le Culte de l'arbre dans l'Inde ancienne.* Paris, 1954.
VIENNOT, O. *Les Divinités fluviales Gangā et Yamunā.* Paris, 1964.
VISVANATHA, Sahitya Darpana. *The Mirror of Composition.* (Translated by P. Mitra.) Calcutta, 1875.

VOGEL, J. Ph. *Indian·Serpent-lore*. London, 1926.
ZAEHNER, R. C. *Hinduism*. Oxford, 1966.
ZIMMER, H. *Kunstform und Yoga im Indischen Kultbild*. Berlin, 1926.
ZIMMER, H. *Philosophies of India*. New York, 1951.

HISTORY

ALLCHIN, B. and R. *The Birth of Indian Civilisation*. London, 1968.
BASHAM, A. L. *The Wonder that was India*. London, 1954.
DANI, A. H. *Prehistory and Protohistory of Eastern India*. Calcutta, 1960.
DERRETT, J. D. M. *The Hoysalas*. Madras, 1957.
GEIGER, W. *The Cūlavaṁsa*. London, 1929.
GEIGER, W. *The Mahāvaṁsa*. London, 1912.
MCCRINDLE, J. W. *Ancient India: as described by Megasthenes and Arrian*. London, 1877.
MCCRINDLE, J. W. *Ancient India: as described by Ptolemy*. Calcutta, 1885.
MAJUMDAR, A. K. *Chaulukyas of Gujerat*. Bombay, 1956.
MAJUMDAR, R.C. (ed.). *The History and Culture of the Indian People*. 7 vols. Bombay, 1955-63.
MAJUMDAR, R. C., RAYCHAUDHURI, H. C., and DATTA, K. *An Advanced History of India*. 3rd ed. London, 1967.
MAJUMDAR, R. C. (ed.) *History of Bengal*, I, *Hindu Period*. Dacca, 1943-8.
MOKKERJI, R. *The Gupta Empire*. Bombay, 1947.
MUNSHI, K. M. (ed.) *The Glory that was Gurjaradeśa*. Bombay, 1943.
NARAIN, A. K. *The Indo-Greeks*. Oxford, 1957.
RAWLINSON, H. G. *Bactria*. London, 1912.
RAWLINSON, H. G. *India*. London, 1937.
RAWLINSON, H. G. *Intercourse between India and the Western World*. Cambridge, 1926.
SASTRI, N. K. A. *History of South India*. London, 1955.
SASTRI, N. K. A. *The Colas*. 2nd ed. Madras, 1955.
VAIDYA, Chintamani V. *History of Medieval Hindu India*. Poona, 1921-6.
WATTERS, Thomas. *On Yuan Chwang's Travels in India*. London, 1904.
YAZDANI, G. *History of the Deccan*. Oxford, 1952.

INDUS VALLEY PERIOD

CASAL, J.-M. *La Civilisation de l'Indus et ses énigmes*. Paris, 1969.
CHANDA, R. *Survival of the Prehistoric Civilization of the Indus Valley*. A.S.I., Mem. No. 41.
DIKSHIT, K. N. *Prehistoric Civilization of the Indus Valley*. Madras, 1939.

MACKAY, E. *Early Indus Civilizations*. London, 1948.
MACKAY, E. *The Indus Civilization*. London, 1935.
MARSHALL, J. *Mohenjo-Daro and the Indus Civilization*. London, 1931.
PIGGOTT, S. *Prehistoric India*. London, 1950.
SANKALIA, H. D. *Indian Archaeology Today*. New York, 1962.
VATS, M. S. *Excavations at Harappā*. Delhi, 1940.
WHEELER, R. E. M. *The Indus Civilization*. Cambridge, 1953. (Supplementary vol. of The Cambridge History of India.)

MAURYA, ŚUNGA, AND EARLY SĀTAVĀHANA PERIOD

BACHHOFER, L. *Early Indian Sculpture*. 2 vols. New York, 1929.
BARUA, B. *Barhut*. Calcutta, 1934-7.
BARUA, B. *Gayā and Buddha-Gayā*. 2 vols. Calcutta, 1931 and 1934.
BURGESS, J. *Ancient Monuments, Temples, and Sculpture of India*. 2 vols. London, 1892.
CHANDA, R. *Beginnings of Art in Eastern India*. A.S.I., Mem. No. 30.
COOMARASWAMY, A.K. 'La Sculpture de Bodhgayā', *Ars Asiatica*. XVIII. Paris and Brussels, 1935.
COOMARASWAMY, A. K. *La Sculpture de Bharhut*. Paris, 1956.
DEHEJIA, V. *Early Buddhist Rock Temples*. London, 1972.
DEO, S. B., and JOSHI, J. P. *Pauni Excavations 1969-70*. Nagpur, 1972.
FERGUSSON, J. *Tree and Serpent Worship*. 2nd edition. London, 1873.
FERGUSSON, J., and BURGESS, J. *Cave Temples of India*. London, 1880.
GRÜNWEDEL, A., and WALDSCHMIDT, E. *Buddhistische Kunst in Indien*, I. Berlin (Ostasiatisches Museum), 1931.
MARSHALL, J. *A Guide to Sāñchi*. Calcutta, 1918 and 1936.
MARSHALL, J., and FOUCHER, A. *The Monument of Sāñchi*. 3 vols. London, n.d.
MITRA, D. *Udayagiri and Khandagiri*. Dir. Gen. of Archaeology, 1960.
MITRA, R. *Bodh Gayā*. Calcutta, 1878.
RAY, N. R. *Maurya and Śunga Art*. 2nd ed. Calcutta, 1965.
WADDELL, L. A. *Report on the Excavations at Pataliputra*. Calcutta, 1903.

KUSHAN PERIOD: GANDHĀRA AND MATHURĀ

BARGER, E., and WRIGHT, P. *Excavations in Swat and Explorations in the Oxus Territories in Afghanistan*. A.S.I., Mem. vol. 64. Calcutta, 1941.

BARTHOUX, J. *Les Fouilles de Hadda.* Paris, 1930.
BURGESS, J. 'Gandhāra Sculptures', *Journal of Indian Art.* vol. 8. London, 1898–1900.
BUSSAGLI, M. 'Osservazioni sulla persistenza delle forme ellenistiche nell'arte del Gandhāra', *Rivista dell'Istituto Nazionale di Archaeologia e Storia dell'Arte*, N.S.V.–VI, 1956–7.
COOMARASWAMY, A. K. 'The Indian Origin of the Buddha Image', *J.A.O.S.*, vol. 46, 1926.
COOMARASWAMY, A. K. 'The Origin of the Buddha Image', *Art Bulletin*, June 1927, 287–328.
DOBBINS, K. Walton. *The Stūpa and Vihāra of Kanishka.* The Asiatic Society, Calcutta, 1971.
FOUCHER, A. *L'Art Gréco-Bouddhique du Gandhāra.* 2 vols. Paris, 1905–18.
FOUCHER, A. *La vieille route de l'Inde de Bactres à Taxila.* Paris, 1942.
FOUCHER, A. *Beginnings of Buddhist Art.* London, 1918.
HACKIN, J. *L'Œuvre de la Délégation Archéologique Française en Afghanistan, 1922–23.* Tokyo, 1933.
INGHOLT, H. *Gandharan Art in Pakistan.* New York, 1957.
LE COQ, A. von. *Die Buddhistische Spätantike in Mittelasien: Die Plastik.* Berlin, 1922–4.
MARSHALL, J. *Excavations at Taxila*, A.S.I., A.R., 1911-12 ff.
MARSHALL, J. *A Guide to Taxila.* Calcutta, 1918 and 1936.
MARSHALL, J. *Taxila.* 3 vols. Cambridge, 1951.
MIZUNO, S. (ed.). *Haibak and Kashmir – Smast.* Kyoto, 1960.
ROSENFIELD, J. M. *The Dynastic Arts of the Kushans.* Berkeley, 1967.
ROWLAND, B. 'A revised Chronology of Gandhāra Sculpture', *Art Bulletin*, XVIII, 1936 (and other articles in *Art Bulletin* and *American Journal of Archaeology.* 1940 ff.).
ROWLAND, B. *Gandhāra Art from Pakistan.* New York, 1962.
SMITH, V. A. *The Jain Stupa of Mathurā.* Allahabad, 1901.
STEIN, Aurel. *On Alexander's Track to the Indus.* London, 1929.
TARN, W. W. *The Greeks in Bactria and India.* Cambridge, 1938.
VOGEL, J. Phil. *Catalogue of the Archaeological Museum at Mathurā.* Allahabad, 1910.
VOGEL, J. Phil. 'La Sculpture de Mathurā', *Ars Asiatica*, XV. Paris and Brussels, 1930.
WALDSCHMIDT, E. *Gandhāra (Kutscha–Turfān).* Leipzig, 1925.
WHEELER, R. E. M. *Rome Beyond the Imperial Frontiers.* Harmondsworth, 1954.

LATER ĀNDHRA PERIOD

BARRETT, D. *Sculptures from Amaravati in the British Museum.* London, 1954.
BURGESS, J. *The Buddhist Stupas at Amarāvati and Jaggayyapeṭa.* A.S.I., London, 1887.
BURGESS, J. *Notes on the Amarāvati Stupa.* Madras, 1882.
LONGHURST, A. H. *The Buddhist Antiquities of Nāgārjunakoṇḍa (A.S.I., Mem., LIV).* Delhi, 1938.
RAMACHANDRA, T. N. *Nāgārjunikoṇḍa (A.S.I. Mem., LXXI).* Delhi, 1933.
RAO, P. R. Ramachandra. *The Art of Nāgārjunakoṇḍa.* Madras, 1956.
REA, A. *South Indian Buddhist Antiquities.* Madras, 1894.

GUPTA PERIOD

CUNNINGHAM, A. *Mahābodhi or the Great Buddhist Temple at Bodh Gayā.* London, 1892.
FERGUSSON, J., and BURGESS, J. *Cave Temples of India.* London, 1880.
GRIFFITHS, J. *Paintings in the Buddhist Cave Temples of Ajaṇṭā.* 2 vols. London, 1896–7.
HARLE, J. C. *Gupta Sculpture.* Oxford, 1974.
HERRINGHAM, Lady, and others. *Ajantā Frescoes.* Ind. Soc. London, 1915.
MARSHALL, J., and others. *The Bagh Caves.* Ind. Soc. London, 1927.
MEHTA, R. N., and CHOWDHARY, S. N. *Excavation at Devnimori.* Baroda, 1966.
SINGH, M. *India, Paintings from Ajantā Caves.* New York, 1954.
YAZDANI, G., and others. *Ajanta.* 3 vols. Oxford, 1931–46 (with colour-process photographs).

THE HINDU RENAISSANCE

ACHARYA, P. K. *A Dictionary of Hindu Architecture.* London, 1927.
ACHARYA, P. K. *Mānasāra on Architecture and Sculpture.* London, 1933–4.
ANAND, M. R. *Kāma Kāla.* Geneva, 1958.
ARCHER, W. G. *Indian Miniatures.* London, 1960.
ARCHER, W. G. *Paintings of the Sikhs.* London, 1966.
ARCHER, W. G. *Indian Painting from the Punjab Hills.* 2 vols. London, 1973.
BALASUBRAHMANYAN, S. R. *Early Chola Art*, pt 1. London, 1966.
BALASUBRAHMANYAN, S. R. *Early Chola Temples.* New Delhi, 1971.
BARRETT, D. *Early Cola Architecture and Sculpture.* London, 1974.
BARRETT, D. *Early Cola Bronzes.* Bombay, 1965.

BRUHN, K. *The Jina Images of Deogarh.* Leyden, 1969.
BURGESS, J., and COUSENS, H. *The Architectural Antiquities of Northern Gujerat.* London, 1903.
CHANDA, R. *Medieval Indian Sculpture in the British Museum.* London, 1936.
CHANDRA, P. *Stone Sculpture in the Allahabad Museum.* Poona, 1971.
COUSENS, H. *Antiquities of Sind.* Calcutta, 1925.
COUSENS, H. *Chalukyan Architecture of the Kanarese Districts.* Calcutta, 1926.
COUSENS, H. *Medieval Temples of the Dakhan.* Calcutta, 1931.
COUSENS, H. *Somanatha and other Medieval Temples of Kaṭhiāwād.* Calcutta, 1931.
DHAKY, M. A., and NANAVATI, J. M. *The Maitraka and the Saindhava Temples of Gujerat.* Ascona, 1969.
GANGOLY, O. C. *Art of the Chandelas.* Calcutta, 1957.
GANGOLY, O. C. *The Art of the Pallavas.* Calcutta, 1957.
GANGOLY, O. C. *Konarak.* Calcutta, 1956.
GANGOLY, O. C. *Orissan Sculpture and Architecture.* Calcutta, 1956.
GANGOLY, O. C. *South Indian Bronzes.* London, 1915.
GANGOLY, O. C., and GOSWAMI, A. *The Art of the Rashtrakutas.* Calcutta, 1958.
GANGULY, M. M. *Orissa and her Remains: Ancient and Medieval.* Calcutta, 1912.
GOETZ, M. *The Art and Architecture of Bikaner State.* Oxford, 1950.
GOLOUBEW, V., and others. 'Sculptures Çivaites', *Ars Asiatica.* III. Paris and Brussels, 1921.
GUPTA, P. L. (ed.). *Patna Museum Catalogue of Antiquities.* Patna, 1965.
HARLE, J. C. *Temple Gateways in South India.* Oxford, 1963.
JOUVEAU-DUBREUIL, G. *L'archéologie du sud de l'Inde: L'Architecture.* Annales du Musée Guimet. Paris, 1926.
KHANDALAVALA, K. *Pahari Miniature Painting.* Bombay, 1958.
KRAMRISCH, S. *The Hindu Temple.* Calcutta, 1946.
KRAMRISCH, S. *A Survey of Painting in the Deccan.* London, 1937.
KRISHNA, A. *Malwa Painting.* Varanasi, 1963.
PANIGRAHI, K. C. *Archaeological Remains at Bhubaneswar.* Calcutta, 1961.
RAWSON, P. *The Art of Tantra.* London, 1973.
SHAH, U. P. *Akota Bronzes.* Bombay, 1959.
SIVARAMAMURTI, C. *Nataraja.* New Delhi, 1974.
SIVARAMAMURTI, C. *South Indian Bronzes.* New Delhi, 1963.
SIVARAMAMURTI, C. *South Indian Paintings.* New Delhi, 1968.
SRINIVASAN, K. R. *Cave-Temples of the Pallavas.* New Delhi, 1964.

SRINIVASAN, P. R. 'Bronzes of South India', *Bulletin of the Madras Government Museum,* N.S. VIII (1963).
ZANNAS, E. *Khajuraho.* The Hague, 1960.

ARTS AND CRAFTS, INCLUDING FOLK ART

BHUSHAN, J. B. *Indian Jewellery, Ornaments and Decorative Designs.* Bombay, n.d.
BUSSABARGER, R. F., and ROBINS, B. D. *The Everyday Art of India.* New York, 1968.
CHANDRA, M. V. *Costumes, Textiles, Cosmetics and Coiffure in Ancient and Medieval India.* Delhi, 1973.
IRWIN, J. *Shawls.* London, 1955.
IRWIN, J., and SCHWARTZ, P. R. *Studies in Indo-European Textiles.* Ahmedabad, 1966.
MAURY, C. *Folk Origins of Indian Art.* London, 1969.
MEHTA, R. J. *The Handicrafts and Industrial Arts of India.* Bombay, 1960.
SWARUP, S. *The Arts and Crafts of India and Pakistan.* Bombay, 1957.

SOUTH EAST ASIA

ARTHAUD, J. and GROSLIER, B. *Angkor.* New York, 1957.
BEZACIER, L. *L'Art Viêtnamien.* Paris, 1954.
BOISSELIER, J. *La Statuaire Khmère et son Évolution.* 2 vols. Saigon, 1955.
BOISSELIER, J. *Tendances de l'Art Khmer.* Paris, 1956.
BRIGGS, L. P. *The Ancient Khmer Empire.* Philadelphia, 1951.
CHAND, E. and YIM-SIRI KHIEN. *Thai Monumental Bronzes.* Bangkok, 1957.
COEDÈS, G. 'Bronzes Khmères', *Ars Asiatica.* V. Paris and Brussels, 1923.
COEDÈS, G. 'Les Collections archéologiques du Musée Nationale de Bangkok', *Ars Asiatica.* XII. Paris and Brussels, 1928.
CORAL RÉMUSAT, C. DE. *L'Art Khmer. Les grandes étapes de son évolution.* Paris, 1940.
DÖHRING, K. S. *Buddhistische Tempelanlagen in Siam.* Berlin, 1920.
DUPONT, P. *L'Archéologie Mône de Dvāravati.* 2 vols. Paris, 1959.
DUPONT, P. 'La Statuaire Préangkorienne', *Artibus Asiae,* Supplementum XV. Ascona, 1955.
FINOT, L., and others. *Le Temple d'Içvarapura.* Paris, 1926.
GANGOLY, O. C. *The Art of Java* (Little Books on Asiatic Art). Calcutta, 1928.
GRISWOLD, A. B. 'Dated Buddha Images of Northern Siam', *Artibus Asiae,* Supplementum XVI. Ascona, 1957.

GROSLIER, B. P. *Angkor: Hommes et Pierres*. Paris, 1956.
GROSLIER, B. P. *The Art of Indochina (Art of the World)*. New York, 1962.
GROSLIER, G. *Angkor*. Paris, 1924.
GROSLIER, G. *Recherches sur les Cambodgiens*. Paris, 1921.
GROSLIER, G. *La Sculpture Khmère ancienne*. Paris, 1925.
GROSLIER, G. 'Les Collections Khmères du Musée Albert Sarraut à Phnom Penh', *Ars Asiatica*. XVI. Paris, 1931.
HALL, D. G. E. *A History of South-East Asia*. New York, 1955.
HEEKEREN, H. R. VAN. *The Stone Age of Indonesia*. The Hague, 1957.
HEEKEREN, II. R. VAN. *The Bronze-Iron Age of Indonesia*. The Hague, 1958.
KEMPERS, A. J. B. *Ancient Indonesian Art*. Cambridge, Mass., 1959.
KROM, N. J. *Barabudur, Archaeological Description*. The Hague, 1927.
KROM, N. J. 'L'Art Javanais dans les Musées de Hollande et de Java', *Ars Asiatica*. VIII. Paris and Brussels, 1926.
KROM, N. J., and VAN ERP. *Beschrijving van Barabudur*. The Hague, 1920.
LAJONQUIÈRE, LUNET DE. *Inventaire descriptif des Monuments du Cambodge*. Paris, 1902 11.
LE BONHEUR, A. *La Sculpture indonesienne au Musée Guimet*. Paris, 1971.
LE MAY, R. *A Concise History of Buddhist Art in Siam*. Cambridge, 1938.
Le Temple d'Angkor Vat. Paris, 1930-2. (Mémoires Archéologiques publiées par l'École Française d'Extrême-Orient.)
LUCE, G. H. *Old Burma - Early Pagán*. 3 vols. New York, 1970.
MARCHAL, H. *L'Architecture comparée dans l'Inde et l'Extrême-Orient*. Paris, 1944.
MARCHAL, H. *Les Temples d'Angkor*. Paris, 1955.
MUS, Paul. *Barabudur*. Hanoi, 1935.
PARMENTIER, H. *L'Art Khmer Classique*. Paris, 1939.
PARMENTIER, H. *L'Art Khmer Primitif*. Paris, 1927.
PARMENTIER, H. *History of Khmer Architecture*. Eastern Art. III. 1931.
PARMENTIER, H. *Les Monuments Çams de l'Annam*. Paris, 1909.
PARMENTIER, H. 'Les Sculptures Chames', *Ars Asiatica*. IV. Paris and Brussels, 1922.
SIVARAMAMURTI, C. *Le Stupa de Barabudur*. Paris, 1961.
STERN, P. *Le Bayon d'Angkor et l'évolution de l'art Khmer*. Annales du Musée Guimet. Paris, 1927.
VERNEUIL, M. P. *L'Art à Java: Les Temples de la période classique Indo-Javanaise*. Paris and Brussels, 1927.
WAGNER, F. A. *Indonesia (Art of the World)*. New York, 1959.
WALES, H. G. Q. *Towards Angkor*. London, 1937.
WITH, K. *Java*. The Hague, 1920.

AFGHANISTAN

BARTHOUX, J. *Les Fouilles de Hadda*. 2 vols. Paris, 1930, 1933.
BERNARD, P. *Fouilles d'Aï Khanoum*. 2 vols. Paris, 1973.
Exhibition of Ancient Art of Afghanistan. Tokio, 1963.
HACKIN, J., and others. *Les Antiquités Bouddhiques de Bāmiyān*. Paris, 1928.
HACKIN, J., and others. *Nouvelles recherches à Bāmiyān*. Paris, 1931.
HACKIN, J., and others. *Recherches archéologiques à Begram (Mémoires de la délégation archéologique en Afghanistan, IX)*. Paris, 1939.
HACKIN, J., and others. *Nouvelles recherches archéologiques à Begram*. Paris, 1954.
HACKIN, J., and others. *Recherches au col de Khair Khaneh*. Paris, 1936.
HACKIN, J., and others. *Diverses recherches archéologiques en Afghanistan (Mémoires de la délégation archéologique en Afghanistan, VIII)*. Paris, 1959.
MEUNIÉ, J. *Shotorak*. Paris, 1942.

KASHMIR, TIBET, AND NEPAL

COLE, H. H. *Ancient Buildings in Kashmir*.
GOETZ, H. *The Early Wooden Temples of Chamba*. Leiden, 1955.
GORDON, A. K. *The Iconography of Tibetan Lamaism*. New York, 1939.
HUMMEL, S. *Geschichte der Tibetischen Kunst*. Leipzig, 1953.
KAK, R. C. *Ancient Monuments of Kashmir*. London, 1933.
KRAMRISCH, S. *The Art of Nepal*. New York, 1964.
PAL, P. *The Arts of Nepal*, I, *Sculpture*. Leiden, 1974.
PAL, P. *Bronzes of Kashmir*. Graz, 1975.
PAL, P. *Vaiṣṇava Iconology in Nepal*. The Asiatic Society, Calcutta, 1970.
RAY, S. C. *Early History and Culture of Kashmir*. Calcutta, 1957.
ROERICH, G. *Tibetan Paintings*. Paris, 1939.
SNELLGROVE, D., and RICHARDSON, H. *A Cultural History of Tibet*. London, 1968.
TUCCI, G. *Indo-Tibetica*. Rome, 1932.
TUCCI, G. *Tibetan Painted Scrolls*. 3 vols. Rome, 1959.

WADDELL, L. A. *The Buddhism of Tibet*. Cambridge, 1934.

CENTRAL ASIA

ANDREWS, F. H. *Wall-paintings from Ancient Shrines in Central Asia*. London, 1948.

BUSSAGLI, M. *Painting of Central Asia*. Geneva, 1963.

GRÜNWEDEL, A. *Alt-Buddhistische Kultstätten in Chinesisch-Turkistan*. Berlin, 1912.

GRÜNWEDEL, A. *Alt-Kutscha*. Tafelwerk. Berlin, 1920.

GRÜNWEDEL, A. 'Bericht über archäologische Arbeiten in Idikutschan', *Abhdlg. d. kgl. Bayer. Ak. d. Wiss., I. Kl., XXIV, V., I. Abt.* München, 1906.

KLEMENTZ, D. 'Turfan und seine Altertümer', *Nachrichtenüber die von der K. Ak. d. Wiss. zu St. Petersburg im Jahre 1898 ausgerüsteten Expedition nach Turfan*. St Petersburg, 1899.

LE COQ, Albert von. *Auf Hellas Spuren*. Leipzig, 1926.

LE COQ, Albert von. *Bilderatlas zur Kunst- und Kulturgeschichte Mittel-Asiens*. Berlin, 1925.

LE COQ, Albert von. *Die Buddhistische Spätantike in Mittelasien*. I–VII. Berlin, 1922–33.

LE COQ, Albert von. *Chotscho*. Berlin, 1913.

PELLIOT, P. *Mission en Asie Centrale*. Comptes-rendus de l'Académie d'Inscriptions et Belles-Lettres. Paris, 1910.

STEIN, Aurel. *Ancient Chinese Figured Silks Excavated by Sir Aurel Stein at Ruined Sites of Central Asia*. Bernard Quaritch. London, 1920.

STEIN, Aurel. *Innermost Asia*. Oxford, 1929.

STEIN, Aurel. *Sand-buried Ruins of Khotan*. Oxford, 1907.

STEIN, Aurel. *Serindia*. 4 vols. Oxford, 1921.

STEIN, Aurel. *Ruins of Desert Cathay*. 2 vols. London, 1912.

STEIN, Aurel. 'Explorations in Central Asia, 1906–08'. *Geographical Journal* for July and September, 1909.

WALDSCHMIDT, E. *Gandhara, Kutscha, Turfan*. Leipzig, 1925.

CEYLON

BANDARANAYAKE, S. *Sinhalese Monastic Architecture*. Leiden, 1974.

COOMARASWAMY, A. K. *Arts and Crafts of India and Ceylon*. Edinburgh, 1913.

COOMARASWAMY, A. K. *Bronzes from Ceylon*. Colombo, 1914.

COOMARASWAMY, A. K. *Mediaeval Sinhalese Art*. Broad Campden, 1908.

DEVENDRA, D. T. *Classical Sinhalese Sculpture*. London, 1958.

GEIGER, W. *Culture of Ceylon in Mediaeval Times*. Wiesbaden, 1960.

MODE, H. *Die buddhistische Plastik auf Ceylon*. Leipzig, 1963.

PARANAVITANA, S. *Art and Architecture of Ceylon. Polonnaruva Period*. Arts Council of Ceylon, 1954.

PARANAVITANA, S. *Ceylon: Paintings from Temple, Shrine and Rock*. (UNESCO Series of World Art). Paris, 1957.

PARANAVITANA, S. *The Stupa in Ceylon*. A.S.C., Mem. V. Colombo, 1947.

PAKISTAN

AHMED, N. *Mahasthan*. Karachi, 1964.

FACCENNA, D., and others. *Reports on the Campaigns 1956–58 in Swat (Pakistan)*. Rome (ISMEO), 1962.

FACCENNA, D. *Sculptures from the Sacred Area of Butkara*. 2 vols. Rome (ISMEO), 1962, 1964.

KHAN, F. A. *Architecture and Art Treasures in Pakistan*. Karachi, 1969.

KHAN, F. A. *Banbhore*. 2nd ed. Karachi, 1963.

WHEELER, R. E. M. *Five Thousand Years of Pakistan*. London, 1950.

LIST OF ILLUSTRATIONS

The location of a work of art is given in italic, the photographer's name in brackets. Where no photographer's name is quoted, the location is also the source of the photograph.

89. Gold amulet boxes from Taxila. L.2cm: $\frac{4}{5}$in. *Taxila, Archaeological Museum*

90. Gold plaque with Cupid and Psyche from Taxila. H.4·5cm: 1$\frac{5}{8}$in. *Taxila, Archaeological Museum*

91. Ear pendant from Taxila. L.12·1cm: 4$\frac{3}{4}$in. *Taxila, Archaeological Museum*

92. Silver anklets from Taxila. D.15·9cm: 6$\frac{1}{4}$in. *Taxila, Archaeological Museum*

93. Steatite dish with Diana and Actaeon from Gandhāra. *London, British Museum*

94. Pāñcika and Hāritī, grey schist. H.2·13m: 7ft. *Oxford, Ashmolean Museum, Department of Eastern Art* (Gift of Major P. C. Hailey)

95. Wima Kadphises from Mathurā. H.2·08m: 6ft 10in. *Muttra, Archaeological Museum* (Courtesy Mr V. S. Agrawala)

96. Kanishka from Mathurā. H.1·63m: 5ft 4in. *Muttra, Archaeological Museum* (Courtesy Mr V. S. Agrawala)

97. Bodhisattva dedicated by Friar Bala from Mathurā. H.2·48m: 8ft 1$\frac{1}{2}$in. *Sārnāth, Archaeological Museum* (The late Dr A. K. Coomaraswamy)

98. Seated Buddha from Katra. H.69cm: 2ft 3$\frac{1}{4}$in. *Muttra, Archaeological Museum* (Courtesy Mr V. S. Agrawala)

99. Head of Buddha from Mathurā. H.57cm: 1ft 10$\frac{1}{2}$in. *Muttra, Archaeological Museum* (Author's photo)

100. Railing pillars with yakshīs from Bhūteśar. H.1·40m: 4ft 7in. *Muttra, Archaeological Museum* (Professor S. Amanuma)

101. Railing pillar with yakshī from Jaisinghpura. H.88·5cm: 2ft 10$\frac{3}{4}$in. *Muttra, Archaeological Museum* (Author's photo)

102. The yaksha Kuvera and his court from Pal Khera. H.53·8cm: 1ft 9$\frac{2}{5}$in. *Muttra, Archaeological Museum* (Josephine Powell)

103. 'Herakles and the Nemean lion' from Mathurā. H.75cm: 2ft 5$\frac{1}{2}$in. *Calcutta, Indian Museum* (Archaeological Survey of India)

104. Relief with scenes from the life of Buddha from Mathurā. *Lucknow, Provincial Museum* (John M. Rosenfield)

105. Ivory plaque with harem beauties from Begrām. H.29cm: 11$\frac{3}{8}$in. *Paris, Musée Guimet* (Josephine Powell)

106. Ivory plaque with harem beauties from Begrām. H.of figure 11cm: 4$\frac{3}{8}$in. *Paris, Musée Guimet* (Josephine Powell)

107. Ivory comb from Mathurā or Uttar Pradesh. 5·1 × 6·4cm: 2 × 2$\frac{1}{2}$in. *London, Victoria and Albert Museum*

108. Bodh Gayā, Mahābodhi temple (Josephine Powell)

109. Bodh Gayā, Mahābodi temple, vaults before restoration (Archaeological Survey of India)

110. 'Antinoüs' from Haḍḍa. H.48cm: 1ft 6$\frac{7}{8}$in. *Paris, Musée Guimet*

111. Head of Brahmin ascetic from Haḍḍa. H.11cm: 4$\frac{3}{8}$in. *Paris, Musée Guimet*

112. Head of Devatā from near Peshawar. H.17·5cm: 6$\frac{7}{8}$in. *Boston, Museum of Fine Arts*

113. Bāmiyān, 120-foot Buddha (Author's photo)

114. Bāmiyān, 175-foot Buddha (Josephine Powell)

115. Bāmiyān, Cave G, section and plan

116. Bāmiyān, lantern roof (Courtesy Musée Guimet, Paris)

117. Bāmiyān, Cave XI, dome (Author's photo)

118. Bāmiyān, Cave XI, reconstruction of dome

119. Bāmiyān, painting of sun god on vault of niche of 120-foot Buddha (Courtesy Musée Guimet, Paris)

120. Bāmiyān, painting of flying divinities in niche of 175-foot Buddha (Courtesy Musée Guimet, Paris)

121. Bāmiyān, painting of Bodhisattva on vault of niche of 175-foot Buddha (Author's photo)

122. Bāmiyān, painting of female figure on vault of niche of 175-foot Buddha (Author's photo)

123. Bāmiyān, Group E, painting on vault (Author's photo)

124. Bodhisattva from Fondukistan. *Kabul, Museum* (Frances Mortimer)

125. Buddha from Fondukistan. *Paris, Musée Guimet*

126. Mirān, sanctuary, detail of painting on dado (Sir Aurel Stein)

127. Kara-Shahr, stucco reliefs (Sir Aurel Stein)

128. Dandān Uiliq, wall-painting of female figure (Sir Aurel Stein)

129. Buddhist relief from Tumshuq. *Paris, Musée Guimet*

130. Kizil, Cave of the Painter, wall-painting. *Berlin-Dahlem, Staatliche Museen*

131. Kizil, Treasure Cave, wall-painting of female figure (from photo of an object formerly in the Ethnological Museum, Berlin)

132. Arhat from Kizil. H.1·65m: 5ft 5in. *Berlin-Dahlem, Staatliche Museen*

133. Two divinities from Kizil. H.2·20m: 7ft 2$\frac{1}{2}$in. *Berlin-Dahlem, Staatliche Museen* (from photo of an object formerly in the Ethnological Museum, Berlin)

134. Buddha from Bezeklik. H.3·25m: 10ft 8in. *Berlin, Museum für Völkerkunde (formerly)* (from photo of an object formerly in the Ethnological Museum, Berlin)

135. Silk textile from Astāna. 37·5 × 31·2cm: 14$\frac{3}{4}$ × 12$\frac{1}{4}$in. *New Delhi, Museum for Central Asian Antiquities*

136. Pottery amphora from Khotān. 45 × 31cm: 17$\frac{3}{4}$ × 12$\frac{1}{4}$in. *Berlin-Dahlem, Staatliche Museen*

137. Wooden chair from Niya. W.45·7, L.68·6, H.55·9cm: 18, 27, 22in. *London, British Museum*

192. Coin of Kumaragupta I from the Bayhana hoard. *New Delhi, National Museum*
193. Nālaṇḍā, stupa at Site No. III (Archaeological Survey of India)
194. Bodh Gayā, Mahābodhi temple, detail of façade (Author's photo)
195. Paharpur, temple, plan
196. Buddha from Bengal. H.45cm: 1ft 5¾in. *Boston, Museum of Fine Arts*
197. Torso of a Bodhisattva from Sāñchī. *London, Victoria and Albert Museum* (Courtesy Victoria and Albert Museum, London)
198. Bronze Buddha in abhāya mudrā from Nālaṇḍā. H.c.35cm: 1ft 1¾in. *Nālaṇḍā, Museum* (Archaeological Survey of India)
199. Bhatgāon, Nepal, Bodhnath stupa (Frances Mortimer)
200. Pāṭan, Nepal, Buddhist temple (E. A. Waters)
201. Pāṭan, Nepal, Durbar Square (Frances Mortimer)
202. Bronze Padmapāṇi from Nepal. H.30·5cm: 1ft. *Boston, Museum of Fine Arts*
203. Tārā from Nepalese manuscript dated A.D. 1136. *Boston, Museum of Fine Arts*
204. Chorten in Western Tibet (Lent from the Asiatic Research Bureau, Fogg Art Museum, Harvard University, Cambridge, Massachusetts)
205. Gyan-tse, chorten, plan
206. Banner of Avalokiteśvara from Tun-huang. H.67·3cm: 2ft 3in. *London, British Museum*
207. Banner of the White Tārā. H.42·5cm: 1ft 4¾in. *Cambridge, Mass., B. Rowland* (Author's photo)
208. Ivory Buddhist Trinity. 8·4×5·1cm: 3 1/16×2in. *New York, Private Collection* (Courtesy Fogg Art Museum, Harvard University, Cambridge, Mass.)
209. Silver dharmacakra. H.51·4cm: 20¼in. *Newark, New Jersey Museum*
210. Phurbu. *London, British Museum*
211. Ivory plaque with scenes from the life of Buddha from Tibet. *London, Victoria and Albert Museum*
212. Paṭṭadakal, Virūpāksha temple (The late Dr A. K. Coomaraswamy)
213. Paṭṭadakal, Virūpāksha temple, section and half-plan
214. Paṭṭadakal, Galaganātha temple (Archaeological Survey of India)
215. Paṭṭadakal, Jain temple (Archaeological Survey of India)
216. Bhuvaneśvar, Paraśurāmeśvara temple (Archaeological Survey of India)
217. Bhuvaneśvar, Lingarāj temple (Johnston & Hoffman)
218. Koṇāraka, Sūrya Deul temple (Josephine Powell)
219. Koṇāraka, Sūrya temple, detail of basement storey (Johnston & Hoffman)

220. Koṇāraka, Sūrya temple, erotic figures (Author's photo)
221. Koṇāraka, Sūrya temple, Sūrya (Johnston & Hoffman)
222. Khajurāho, Kaṇḍāriya Mahādeo temple (Josephine Powell)
223. Khajurāho, Vamana temple, apsaras (Lent from the Asiatic Research Bureau, Fogg Art Museum, Harvard University, Cambridge, Massachusetts)
224. Osiā, Sūrya temple (Archaeological Survey of India)
225. Delhi, Quṭb mosque, pillars from Hindu temples (Johnston & Hoffman)
226. Sunak, Nilakantha temple, elevation
227. Modhera, Sūrya temple (Archaeological Survey of India)
228. Modhera, Sūrya temple, plans
229. Mount Ābū, Tejpal temple, dome (Johnston & Hoffman)
230. Gwalior, Teli-ka-Mandir (The late Dr A. K. Coomaraswamy)
231. Gwalior, Teli-ka-Mandir, relief (Author's photo)
232. Gwalior, Great Sās Bahu temple (Lent from the Asiatic Research Bureau, Fogg Art Museum, Harvard University, Cambridge, Massachusetts)
233A. Māmallapuram, Dharmarāja rath (Eliot Elisofon, T.L.P.A. © Time Inc. 1976)
233B. Māmallapuram, Sahadeva rath (Eliot Elisofon, T.L.P.A. © Time Inc. 1976)
234. Māmallapuram, The Descent of the Ganges (Walter Rawlings, London)
235. Māmallapuram, The Descent of the Ganges, detail (Josephine Powell)
236. Māmallapuram, monkey family from The Descent of the Ganges (Author's photo)
237. Māmallapuram, Durgā slaying the demon buffalo
238. Māmallapuram, Shore temple (Walter Rawlings, London)
239. Kāñcipuram, Kailāsanāth temple (The late Dr A. K. Coomaraswamy)
240. Ellūrā, Kailāsanāth temple (Walter Rawlings, London)
241. Ellūrā, Kailāsanāth temple, plan of upper storey
242. Ellūrā, Kailāsanāth temple, Rāvaṇa and Jatayu (Author's photo)
243. Ellūrā, Kailāsanāth temple, Rāvaṇa shaking Mount Kailāsa (Archaeological Survey of India)
244. Elephanta, Śiva temple, plan
245. Elephanta, Śiva temple, Śiva Mahādeva (Archaeological Survey of India)
246. Elephanta, Śiva temple, Betrothal of Śiva and Pārvatī (Archaeological Survey of India)

INDEX

Names and other matters in the notes are indexed
only where some matter is referred to that is of special
importance or is not evident from the main text: in
such cases the page on which the note appears, its
chapter, and the number of the note, are given thus:
471(3)[14].

Praise for C. B. George's
THE *DEATH* OF REX NHONGO

NAMED ONE OF THE BEST BOOKS OF THE YEAR
BY THE *BOSTON GLOBE*

"A brilliantly unsettling book; its shrewd, measured, darkly atmospheric prose describes the societal, familial, and psychological conditions that make it possible to find burnt corpses in fireproof houses." —Helen Oyeyemi, author of
What Is Not Yours Is Not Yours and *Boy, Snow, Bird*

"This is a superbly intricate novel, but perhaps the best part is George's vivid portrayal of Zimbabwe as a kleptocracy, a failed state ruled by fear." —*Publishers Weekly*

"Political instability registers as a quiet quake beneath the feet of ordinary people, tilting them this way and that, as they attempt to navigate everyday matters of family, love, and betrayal....Intimate and revealing." —F. T. Kola, *The Guardian*

"A terrific novel—absolutely compelling and chilling. A wonderfully astute and forensic blend of fact and fiction, lies and truth."
—William Boyd, author of *Restless*

"An intimate panorama of life in a dangerous city...set within a larger context of greed, lust, sacrifice, hypocrisy, and horror."
—Tom Nolan, *Wall Street Journal*

"A remarkable juggling act.... George has a keen ear for the cultural divisions between Africa and the West." —*Kirkus Reviews*

"Muscular, confident.... A sympathetic exploration of the intersection between five troubled marriages lived in the sour miasma of a morally bankrupt African police state."

—Michela Wrong, *The Spectator* (UK)

"Cleverly plotted and suspenseful.... A deft commentary on the nuances of race and culture in a politically corrupt postcolonial society.... In this painfully resonant story, we see the absurd fragility of our own humanity."

—Ausma Zehanat Khan, *Washington Post*